The Letters of
Henri de Toulouse-Lautrec

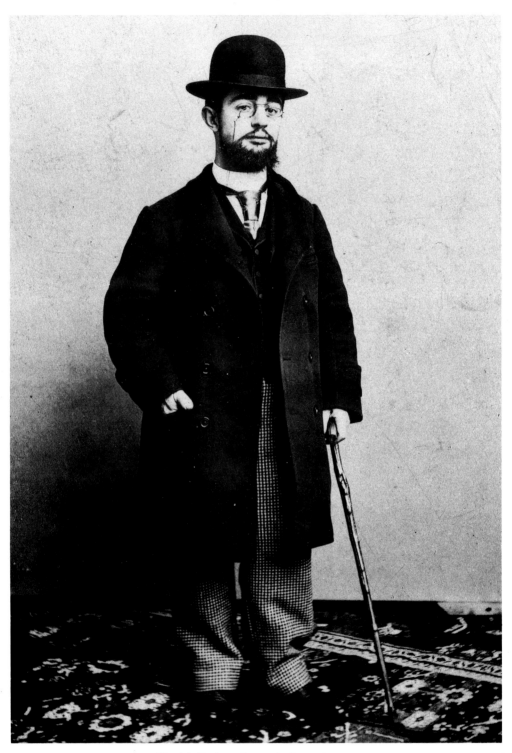

Henri de Toulouse-Lautrec (1864–1901), *c.*1892

The Letters of
Henri de Toulouse-Lautrec

Edited by

Herbert D. Schimmel

and Translated by Divers Hands

Introduction by

Gale B. Murray

OXFORD UNIVERSITY PRESS

1991

Oxford University Press, Walton Street, Oxford OX2 6DP

Oxford New York Toronto
Delhi Bombay Calcutta Madras Karachi
Petaling Jaya Singapore Hong Kong Tokyo
Nairobi Dar es Salaam Cape Town
Melbourne Auckland

and associated companies in
Berlin Ibadan

Oxford is a trade mark of Oxford University Press

Published in the United States
by Oxford University Press, New York

British Library Cataloguing in Publication Data
The letters of Henri de Toulouse-Lautrec.
1. French paintings. Toulouse-Lautrec. Henri de. 1864–1901
I. Schimmel. Herbert D.
759.4
ISBN 0–19–817214–1

Library of Congress Cataloging in Publication Data
Toulouse-Lautrec, Henri de, 1864–1901.
[Correspondence. English]
The letters of Henri de Toulouse-Lautrec/edited by
Herbert D. Schimmel and translated by divers hands; introduction by Gale B. Murray.
Translated from French.
Includes bibliographical references and index.
1. Toulouse-Lautrec, Henri, 1864–1901—Correspondence.
2. Artists—France—Correspondence. I. Schimmel, Herbert D., 1909–. II. Title.
N6853.T6A3 1990
760'.092—dc20
[B] 90-19511
ISBN 0–19–817214–1

Typeset and Printed in Great Britain by
Butler & Tanner Ltd, Frome and London

Editor's Note

Two hundred and seventy-three of the letters here printed, 237 by the artist, were published in 1969 by Phaidon, London and New York, under the title *Unpublished Correspondence of Henri de Toulouse-Lautrec*, edited by Lucien Goldschmidt and Herbert Schimmel, with an introduction by Jean Adhémar and Theodore Reff, and translation by Edward B. Garside.

In addition to those mentioned, twenty-nine more of the letters by the artist here printed were published in 1972 by Gallimard, Paris, under the title *Henri de Toulouse-Lautrec Lettres 1871–1901*, with the same editors and introduction; translation by Annick Baudoin.

In 1983, forty-seven of the letters here printed, thirty-five by the artist, were published by Dodd, Mead & Company, New York, under the title *The Henri de Toulouse-Lautrec W. H. B. Sands Correspondence*, edited by Herbert D. Schimmel and Phillip Dennis Cate; translation by Minna K. Bond.

A total of 272 letters by Toulouse-Lautrec have been previously published in English and 266 have been previously published in French.

H.D.S.

New York
1988

To Ruth K. Schimmel

Acknowledgements

Some correspondence of Henri de Toulouse-Lautrec has been previously published in the three volumes described in the Editorial Note. These letters have been collected by the editor continuously from 1955, and the Schimmel Collection now contains 348 items of which 301 have been published. Including the above, a total of 648 letters have been gathered from institutions, private collections, and other sources, and are published here.

The information was compiled from original manuscripts, photographs of manuscripts, manuscript copies in others' hands, transcriptions, facsimiles, and printed sources. The provenance and/or source of publication is shown at the end of each letter, and the key to the location is given in the list of abbreviations.

Work on this volume began with the first purchase of a letter by the editor in 1955 and continued through the various publications. In 1985 the first request letters were circulated worldwide to institutions, collectors, and dealers for co-operation in order to publish this volume.

There are four persons who contributed most toward the ultimate completion of this book and to whom I am deeply and sincerely grateful.

Lucien Goldschmidt, book- and print-dealer and bibliophile for more than fifty years, was, on earlier volumes, co-editor and on this project, from its inception, an adviser and associate. It is difficult to describe the importance of his contribution, influence, and friendship over the forty years of our relationship, and this volume could not have been completed without him.

Phillip Dennis Cate, Director of the Zimmerli Art Museum, Rutgers University, co-edited those letters that were published as the Lautrec–Sands Correspondence. His studies of printmakers, printers, and dealers of the Lautrec period and his unsurpassed knowledge of the technology of original printmaking and of the reproductive print processes of the era have been of extreme and continuing value during our nearly fifteen years of association.

Ronald Pickvance, originally the co-editor of this volume, was forced to retire from the project due to the continuing and mounting demands upon his services in the scholarly study of, and curatorial expertise in exhibiting, the work of Vincent van Gogh. It is regrettable that he was not available to complete the valuable work that he started on for this volume, but his advice and friendship continue.

Mariel Frèrebeau Oberthür, whose prior experience as Assistant to Jean Adhémar at the Bibliothèque Nationale, Paris, and then as Adjunct Curator of the Musée Montmartre provided her with the unusual and essential qualifications for research and guidance in the intricate and sometimes difficult library, archival, and museum world of France. As a research associate she proved to be invaluable.

I am grateful to the following persons and institutions whose help has made this volume as inclusive as it is:

The late M. Jean Adhémar of the Bibliothèque Nationale, Paris; M. Georges

Alphandéry; M. Gérard d'Amade; M. Georges Beaute; M. Pierre Berès; M. Pierre Birtschansky; M. Thierry Bodin; M. Arsène Bonafous-Murat; Mr. Herbert J. F. Cahoon of the Pierpont Morgan Library, NYC; M. Michel Castaing of Maison Charavay; Mr. Han van Crimpen of the Rijksmuseum Vincent van Gogh, Amsterdam; Ms Kit Currie of H. P. Kraus, Ms France Daguet of Durand-Ruel et Cie, Paris; M. Guy-Patrice Dauberville of Bernheim-Jeune et Cie, Paris; M. Dominique Denis; M. Jean Devoisins of the Musée Toulouse-Lautrec, Albi; the late Mme G. Dortu; M. Jean Favier of the Archives de France, Paris; Ms Ruth E. Fine of the National Gallery of Art, Washington, DC; Ms Eleanor M. Garvey of the Houghton Library, Harvard University, Cambridge, Mass.; Ms Denise Gazier of the Bibliothèque d'Art et d'Archéologie des Universités de Paris; M. Ferdinand de Goldschmidt-Rothschild; Mr Les Guzik; Ms Joan U. Halperin of Saint Mary's College of California; M. Carlos van Hasselt of the Fondation Custodia, Paris; Ms Sarah F. Hill of Sotheby's, New York; Mr Sinclair Hitchings of the Boston Public Library; Ms Suzanne Houbart of the Musées Royaux des Beaux-Arts de Belgique, Brussels; Mr James H. Hutson of the Library of Congress, Washington, DC; Ms Anahid Iskian; Dr Karpman-Boutet; Mr Eberhard W. Kornfeld; M. Marcel Lecomte; Mr Herman W. Liebert; M. B. Mahied of the Archives de France, Paris; Ms Kathleen T. Mang of the Library of Congress, Washington, DC; Mr George W. Martin; Mr Stephen Massey of Christie's, New York; Ms Grace Mayer; Mr Paul Mellon; Ms Colette Merklen; Professor Gale B. Murray; Mr Robert Nikirk of the Grolier Club, NYC; H. Pauwels of the Musées Royaux des Beaux-Arts de Belgique, Brussels; Ms Marie-Louise van der Pol of the Fondation Custodia, Paris; Mr Kenneth W. Rendell; Mr John H. Rhodehamel of the Scriptorium; M. Charles de Rodat; Ms Anne Roquebert of the Musée d'Orsay, Paris; M. Paul Rozès; M. Jacques Salomon; Mr Sam Schaefler; Mr Ross Scott; M. Bruno Sepulcre; Ms Arlette Serullaz of the Musées Nationaux au Louvre, Paris; Mr Pierre Simon; Mr Trevor D. Spiro; Mr Charles F. Stuckey; Mr Richard Thomson; Mr David Tunick; Mr Mario Uzielli; M. Bertrand du Vignaud de Villefort; Ms Nicole Villa of the Musées Nationaux au Louvre, Paris; Sylvia and Irving Wallace; M. Jean Warmoes of the Bibliothèque Royale Albert I⁰ᵉʳ, Brussels; Mr René R. Wetzel of the Fondation Martin Bodmer; Mr John Wilmerding of the National Gallery of Art, Washington, DC; M. Marcel Wormser of the Musée Clemenceau, Paris; Mr Wolfgang Wittrock.

A number of persons have translated the Lautrec letters during the preparation of the various volumes for publication.

Edward Garside translated letters from French for the *Unpublished Correspondence of Henri de Toulouse-Lautrec*. Translation of material into French for *Henri de Toulouse-Lautrec Lettres 1871–1901* was by Annick Baudoin, and the Lautrec–Sands correspondence was translated from the French by Minna K. Bond. Translations from the French for this volume were mainly by Eileen Hennessy, with a small number by various other persons. All the letters were reviewed by Michèle Scher in an attempt to maintain a continuity of style.

She also supplied many of the answers to the numerous problems created by Lautrec's word usage and literary references.

In all the translations of Lautrec letters we have attempted to render them as accurately as possible and in a style close to his own. Changes were made in punctuation and paragraphing which are confusing in the originals. Lautrec's use of Provençal and Gascon words and phrases and his invention of phrases have been noted.

Dating the letters was a difficult problem and was accomplished by various means. Some letters, of course, are fully dated in the manuscript, while others, partially dated, were often relatively simple to place in the finished manuscript.

Dates of all the other letters were determined sometimes by postmarks on the accompanying envelope or on the document itself. Most of the letters, however, were dated by correlation of internal information, comparison of letters, letter paper, or handwriting with each other, with biographies of the artist and others, together with other available biographical data.

Date and place information not in Lautrec's hand are bracketed to distinguish the difference.

References in the footnotes cite only the author of the publication. Full bibliographical information is contained in the Select Bibliography.

Biographies of individuals mentioned or referred to in the letters are given at the first occurrence of the name, the location of which is revealed in the Index.

Contents

List of Illustrations

Henri de Toulouse-Lautrec (1864–1901), 1892
photograph: Beaute

Frontispiece

(between pp. 54–55)

1. Henri de Toulouse-Lautrec, *c.* 1870
 photograph: Beaute
2. Adèle-Zoë Tapié de Céleyran
 photograph: Beaute
3. Alphonse de Toulouse-Lautrec
 photograph: Beaute
4. Charles de Toulouse-Lautrec
 photograph: de Rodat
5. Château de Bosc
 photograph: de Rodat
6. Château de Céleyran
 photograph: Dortu
7. Château de Malromé
 photograph: Schimmel Collection
8. Map of Southern France, 1897
 photograph: Baedeker
9. Toulouse-Lautrec with his grandmothers, the Tapié de Céleyran family, *et al.*
 photograph: Schimmel Collection
10. Amédée Tapié de Céleyran, his wife Alix-Blanche de Toulouse-Lautrec, *et al*
 photograph: de Rodat
11. Amédée Tapié de Céleyran with six sons
 photograph: de Rodat
12. Some Toulouse-Lautrecs and Tapié de Céleyrans
 photograph: de Rodat
13. Letter from Henri de Toulouse-Lautrec to Charles de Toulouse-Lautrec, 1881
 photograph: Collection Maison Natale
14. Letter from Henri de Toulouse-Lautrec to Charles de Toulouse-Lautrec, 1881
 photograph: Collection Maison Natale
15. Léon Bonnat
 photograph: Potin

(between pp. 342–343)

List of Abbreviations

A Provenance of Manuscripts

I. INSTITUTIONS

AC	Archives de l'Art Contemporain, Brussels, Belgium
Albi	Musée Toulouse-Lautrec, Albi, France
AF	Archives de France, Paris, France
BN	Bibliothèque Nationale, Paris, France
Bodmer	Fondation Martin Bodmer, Bibliotheca Bodmeriana, Cologny-Geneva, Switzerland
BPL	Boston Public Library, Boston, Mass. USA
BRA	Bibliothèque Royale Albert I^er, Brussels, Belgium
Brussels	Musées Royaux des Beaux-Arts de Belgique, Brussels, Belgium
Clemenceau	Musée Clemenceau, Paris, France
Custodia	Fondation Custodia (Coll. F. Lugt), Institut Néerlandais, Paris, France
Doucet	Bibliothèque d'Art et d'Archéologie, Fondation Jacques Doucet, Université de Paris, Paris, France
Harvard	Houghton Library, Harvard University, Cambridge, Mass., USA
LA	Musées Nationaux au Louvre—Archives, Paris, France
LC	Library of Congress, Lessing J. Rosenwald Collection, Washington DC, USA
LD	Musées Nationaux au Louvre—Archives, Cabinet des Dessins, Paris, France
Maison Natale	Collection: Maison Natale de Toulouse-Lautrec, Albi, France
Morgan	Pierpont Morgan Library, New York City, USA
Nancy	Musée Historique Lorrain, Nancy, France
Van Gogh	Rijksmuseum Vincent van Gogh (Vincent van Gogh Foundation), Amsterdam, The Netherlands

II. PRIVATE OWNERS

Adhémar	M. Jean Adhémar, Paris, France
Alphandéry	M. Georges Alphandéry, Montfavet, France

d'Amade	M. Gérard d'Amade, La Celle Saint-Cloud, France
Beaute	M. Georges Beaute, Réalmont, France
Burg	Mr Gerald Wm. Burg, Beverly Hills, Calif., USA
Denis	M. Dominique Denis, St Germain-en-Laye, France
Dortu	Mme G. Dortu, Paris, France
Guzik	Mr Les Guzik, Brunswick, Ohio, USA
Iskian	Ms Anahid Iskian, New York City, USA
K.B.	Dr Karpman-Boutet, Paris, France
Lecomte	M. Marcel Lecomte, Paris, France
Mayer	Ms Grace M. Mayer, New York City, USA
Mellon	Mr Paul Mellon, Upperville, Virginia, USA
Private	Private Collector, Basle, Switzerland, (I) and (II)
	Private Collector, New York, USA (I)
	Private Collector, Paris, France (I)[1] and (II)
Rozès	M. Paul Rozès, Toulouse, France
Salomon	M. Jacques Salomon, Paris, France
Schimmel	Mr and Mrs Herbert D. Schimmel, New York City, USA
Scott	Mr Ross R. Scott, New York City, USA
Simon	Mr Pierre F. Simon, New York City, USA
Spiro	Mr Trevor D. Spiro, London, England
Wallace	Sylvia and Irving Wallace, Los Angeles, Calif., USA
Wittrock	Mr Wolfgang Wittrock, Düsseldorf, Germany

III. DEALERS: MANUSCRIPTS

Berès	Pierre Berès, Paris, France
Bernheim	Archives de la Galerie Bernheim-Jeune, Paris, France
Birtschansky	Pierre Birtschansky, Paris, France
Durand-Ruel	Archives Durand-Ruel, Paris, France
Elliott	Elliott Galleries, New York City, USA
Goldschmidt	Lucien Goldschmidt Inc., New York City, USA
Privat	Mme G. Privat, Paris, France
Rendell	Kenneth W. Rendell, Inc., Newton, Mass., USA
Scriptorium	The Scriptorium, Beverly Hills, Calif. USA

[1] Collection broken up and sold through dealers, and auction houses, 1983–6.

B Provenance of Published Letters

IV. PUBLICATIONS

Amour	*L'Amour de l'Art*, No. 4 (Paris, 1931)
Annales	*Annales de l'Est*, 5^e Série, No. 3 (Berger-Levrault, Nancy, 1962)
Attems	Comtesse Attems, (née Mary Tapié de Céleyran), *Notre Oncle Lautrec*, 3rd edn. (Pierre Cailler, Geneva, 1963)
Beaute I	Georges Beaute, *Il y a cent ans: Henri de Toulouse-Lautrec* (Pierre Cailler, Geneva, 1964)
Beaute II	Georges Beaute, *Toulouse-Lautrec vu par les photographes, suivi de témoignages inédits* (Edita Sa, Lausanne, 1988)
Carco	Francis Carco, *Nostalgie de Paris* (J. Ferenczi & Fils, Paris, 1945)
Charles-Bellet I	L. Charles-Bellet, *Le Musée d'Albi* (Syndicat d'Initiative, Albi, 1951)
Charles-Bellet II	L. Charles-Bellet, *Toulouse-Lautrec, ses amis et ses maîtres* (Musée d'Albi Exhibition Catalogue, Albi, 1951)
Cocotte	Henri de Toulouse-Lautrec and Étienne Devismes, *Cocotte* (Éditions du Chêne, Paris, 1953)
Coquiot	Gustave Coquiot, *H. de Toulouse-Lautrec* (Auguste Blaizot, Paris, 1913)
Czwiklitzer	Christophe Czwiklitzer, *Lettres autographes de peintres et sculpteurs du XV^e siècle à nos jours* (Éditions Art-C.C., Basle, 1976)
DGA	Mme Georges Dortu, Madeleine Grillaert, and Jean Adhémar, *Toulouse-Lautrec en Belgique* (Quatre Chemins-Editart, Paris, 1955)
Dortu	Mme Georges Dortu, *Toulouse-Lautrec et son œuvre*, i–vi (Collectors' Editions, New York, 1971)
Gazette	*Gazette des Beaux-Arts*, Paris, France
GSE	Lucien Goldschmidt and Herbert D. Schimmel, eds., *Unpublished Correspondence of Henri de Toulouse-Lautrec* (Phaidon, London, 1969)
GSF	Lucien Goldschmidt and Herbert D. Schimmel, eds., *Henri de Toulouse-Lautrec: Lettres 1871–1901* (Gallimard, Paris, 1972)
HD	Philippe Huisman and Mme George Dortu,

	Lautrec par Lautrec (Edita Lausanne, La Bibliothèque des Arts, Paris, 1964)
Hyslop	Francis E. Hyslop, *Henri Evenepoel à Paris: Lettres choisies 1892–1899* (La Renaissance du Livre, Brussels, 1972)
Joyant	Maurice Joyant, *Henri de Toulouse-Lautrec 1864–1901*, i. *Peintre* (H. Floury, Paris, 1926)
Kinneir	Joan Kinneir, ed., *The Artist by Himself* (St Martin's Press, New York, 1980)
Loncle	*Estampes originales, Livres illustrés, Dessins aux crayons de couleur de Henri de Toulouse-Lautrec, Collection M.L., Auction sale Galerie Charpentier* (Paris, 1959)
Martrinchard	Robert Martrinchard, *Princeteau 1843–1914* (Bordeaux, 1956)
Nocq	Henry Nocq, *Tendances nouvelles: Enquête sur l'évolution des industries d'art* (H. Floury, Paris, 1896)
R.-M.	Donation Claude Roger-Marx, Collection Paulette Asselain, Musée du Louvre, 27 November 1980 to 19 April 1981, Paris, France
SC	Herbert D. Schimmel and Phillip D. Cate, *The Henri de Toulouse-Lautrec W. H. B. Sands Correspondence* (Dodd, Mead & Company, New York, 1983)
Schang	F. C. Schang, *Visiting Cards of Painters* (Wittenborn Art Books Inc., New York, 1983)
Toulouse-Lautrec	Henri de Toulouse-Lautrec, *One Hundred Ten Unpublished Drawings* (Boston Book and Art Shop. Boston, 1955)

V. DEALERS: CATALOGUES AND LISTINGS

Altman	B. Altman Co., New York City, USA
Argonautes	Librairie 'Les Argonautes', Paris, France
Berès	Pierre Berès, Paris, France and New York City, USA
Bodin	Thierry Bodin, Paris, France
Bonafous-Murat	Arsène Bonafous-Murat, Paris, France
Charavay	Maison Charavay, Paris, France
Fleury	G. Fleury–J. H. Pinault, Paris, France
Goldschmidt	Lucien Goldschmidt Inc., New York City, USA
Kraus	H. P. Kraus, New York City, USA

Loliée, B.	Bernard Loliée, Paris, France
Loliée, M.	Marc Loliée, Paris, France
Matarasso	H. Matarasso, Paris, France
Privat	Georges Privat, Paris, France
Rendell	Kenneth W. Rendell Inc., Newton, Mass., USA
Saffroy	Cabinet Henri Saffroy, Paris, France
Tausky	Théodore Tausky, Paris, France
Tunick	David Tunick Inc., New York City, USA

VI. AUCTION HOUSES: CATALOGUES

American	American Book Auction, New York
Ancien	L'Art Ancien SA, Zurich
Charpentier	Galerie Charpentier, Paris
Christie	Christie, Manson & Woods, Ltd, London
Dörling	F. Dörling, Hamburg
Drouot	Hôtel Drouot, Paris
Erasmushaus	Erasmushaus, Haus der Bücher AG, Basel
Fontainebleau	Hôtel des Ventes, Fontainebleau, France
Gutekunst	Gutekunst & Klipstein, Berne
Hamilton	Charles Hamilton, New York
Hauswedell	Dr Ernst Hauswedell, Hamburg
Kornfeld	Kornfeld und Klipstein, Berne
Kundig	W. S. Kundig and Hellmut Schumann, Geneva and Zurich
Parke-Bernet	Parke-Bernet & Co., New York
Rauch	Nicholas Rauch S.A., Geneva
Sotheby	Sotheby & Co. (also Sotheby Parke-Bernet & Co.), London
Stargardt	J. A. Stargardt, Marburg

Introduction

THE letters of Toulouse-Lautrec, assembled here for the first time in a full edition, offer an opportunity to assess this major artist and his work from the basis of a body of important factual documentation. Despite the passage of nearly a century since his death, his popularity with the public, and the accumulation of a large body of literature, many aspects of Lautrec's art have remained surprisingly inaccessible. During his own lifetime, his work was most often evaluated on the basis of moral judgements about his character and life-style. Precisely these aspects of Lautrec have, in turn, fascinated the twentieth century and led to the colourful mythologizing of the artist as the tragic, drunken Bohemian of Montmartre, whose physical deformity drove him to depict the 'deformed' aspects of society. As a consequence, in most accounts of Lautrec, the compelling human story has overshadowed his artistic production. Even the literature which deals more closely with his work tends to focus on Lautrec's personality and to see it as the determining basis of his art. The lack of accessible documentation has also contributed to this situation, making in-depth study of Lautrec's art extremely difficult and leaving unresolved major questions about his artistic genesis and place in later nineteenth-century developments. The primary material on Lautrec, for the most part, has been limited to reminiscences by his friends and supporters. The material published here presents a much more complete picture than that previously available, expanding and enriching our knowledge of the artist and his work.

Prior to 1969, no edition of Lautrec's letters had been published. Only a small number of letters had appeared in print and they were scattered through a variety of publications. Some of these letters were mere fragments or excerpts, quoted out of context or prudently edited by friends of the artist; many were assigned erroneous dates. The unpublished letters were dispersed through numerous private collections and remained largely inaccessible. Then, in the 1950s, Herbert Schimmel embarked on the formidable task of searching for and collecting Lautrec's correspondence and systematically organizing it into a coherent chronology. The initial product of this effort was his publication in 1969, together with Lucien Goldschmidt, of a volume of 273 letters by and about Lautrec from his own collection, entitled *Unpublished Correspondence of Henri de Toulouse-Lautrec*. This was followed in 1972 by a French edition, expanded to include some 29 additional letters. In 1983, together with Phillip Dennis Cate, Schimmel edited a third volume of letters from his own collection, a more

specialized publication devoted to Lautrec's correspondence in the late 1890s with his English publisher W. H. B. Sands, regarding Sands's commission of two lithographic albums from Lautrec.

The current edition, nearly twenty years in preparation, supersedes all earlier publications of Lautrec's letters. It brings together virtually all the known extant correspondence from the collections of Schimmel and a variety of others, including some 619 letters by Lautrec and a selection of relevant letters and documents by individuals close to him. It incorporates all previously published letters (many presented for the first time in their entirety) and introduces over 300 unpublished ones. In addition, it contains an appendix of descriptions of 29 letters whose present locations are unknown. The notes elucidate individuals, events, places, and works mentioned, as well as other allusions in the letters, with reference to contemporary exhibition catalogues, reviews, and other source materials, including two recently compiled *œuvre* catalogues.[1] The dating of the many letters that do not contain explicit dates has been accomplished by a painstaking correlation of internal and external evidence. In many cases the dating of letters that appeared in earlier publications has been revised and other inaccuracies have been corrected.

Lautrec's letters span his entire life and career, with the earliest dating from 28 April 1871 when he was only six years old and the latest from 23 July 1901, just seven weeks before his death. The bulk of the early letters were written to family members, but as Lautrec's career progressed, he addressed a relatively greater number to professional friends and acquaintances—dealers, journalists, editors, publishers. However, despite the fact that he was a prolific letter-writer, Lautrec did not, like van Gogh for instance, use letter-writing as a vehicle for personal catharsis or self-revelation—his letters for the most part are concerned with practical matters. He tended not to be introspective in them, nor did he theorize about art or ideas, discuss issues of artistic style and content, or even describe his works, except in rare instances. By contrast, most of his contemporaries of both the Impressionist and Post-Impressionist generations, such as Degas, Monet, Pissarro, Cézanne, Gauguin, and Redon (as well as van Gogh), generally revealed more in their private writings about their artistic intentions. Lautrec's letters are typically brief, and his writing, like his art, is spare and succinct in style and lacking in detail.

None the less, the letters do provide interesting and often amusing or poignant insights into Lautrec as both a personality and a professional. They reveal, for example, his sense of humour, which often emerged in an ironically cynical self-appraisal; his affectionate nature; his appreciation for the life of the senses at all levels, from the delights of the palate to those of the palette; his seriousness about his

art and keen ambition for professional success—manifested in his unusual efforts to keep critics *au courant* with his work and his persistent desire to exhibit and sell his art, despite his family's wealth and willingness to support him with a generous allowance; and the ambivalent pulls between traditional and avant-garde values, both in art and life-style, to which he was subject. Above all, the letters are rich in factual data and contain numerous important art-historical revelations, which allow us to document a variety of Lautrec's artistic projects, their dates, and the conditions under which they were created (in some cases with extreme precision) and to chart his interests, travels, aspects of his exhibition and sales history, and his relationships with individuals represented in his work and with fellow artists, critics, and dealers. They fill in many of the gaps in our knowledge of Lautrec's artistic development as we follow him from the bright optimism of his conventionally aristocratic childhood, through the height of his powers as an avant-garde artist, to his tragic deterioration, breakdown, and early death.

Child and Schoolboy: 1864–81

Had Henri de Toulouse-Lautrec outlived his father, he would have become the Count of Toulouse-Lautrec-Monfa. Indeed he was heir to an illustrious noble line that could trace its prestige and power in his native region back beyond the time of the Crusades. In the nineteenth century Lautrec's grandfather, father, and uncles, like others of their class, attempted to perpetuate the old noble life-style, especially through their nostalgic pursuit of skilled horsemanship and the hunt, particularly falconry, which were among the last vestiges of a nearly obsolete way of life. The large body of correspondence from Lautrec's youth, written in the years between 1871 and early 1882, when he went to study art in Paris, allows us to follow an early development that was dominated by the aristocratic life, values, and aspirations of his family. As early as 1872, the evidence of budding interests in the equestrian pursuits of the older male members of the clan begins to emerge in his letters. The first mention of his artwork is in a letter of 1876; Lautrec had in fact been drawing since the early 1870s. In this too he imitated his father and uncles, all of whom were amateur artists as well as sportsmen.

It was undoubtedly his growing physical disabilities which prompted the youngster to turn increasingly to drawing and painting in the later 1870s as a compensation and a pastime, as his health problems compelled him to abandon the active outdoor life. In May of 1878, at the age of 13, he fell and fractured his left thigh bone; fifteen months later, in August of 1879, he fractured the right one. His growth slowed

noticeably; following the fractures, he grew no more than an inch and his full adult height was about five feet. He also experienced difficulty walking due to stiffness in his knees and/or hip-joints and was forced to use a cane for support. Lautrec's arrested growth was long attributed to the fractures, but, starting in the 1940s, physicians who studied his case began to theorize that the growth and leg problems had begun much earlier and that they were the result of some common underlying condition that was also responsible for the fractures. Lautrec's early letters support this theory, indicating that he did indeed suffer difficulties with his legs and had received treatment well before the fractures occurred. The problems seem to have become accentuated at least from the age of 10 or 11 on, as disclosed in a number of letters from 1875 to 1878. For instance, in 1875 Lautrec stated: 'Papa ... was satisfied with my legs. Also with my health.' In 1877 he reported that his mother had taken him out of class at the Lycée in Paris for electric-brush treatments intended to stimulate circulation in his legs, and declared that he was 'awfully tired of limping with my left foot now that the right one is cured'. And in a letter written in June 1878, when he was recuperating from his first fracture, he already ruefully noted his short stature. Although the exact diagnosis of Lautrec's infirmity remains controversial, experts generally agree that he suffered from some kind of genetic disorder. More than likely, the disease was pycnodysostosis, first identified in 1962 by Maroteaux and Lamy.[2] The symptoms of this rare inherited bone disorder closely correspond with Lautrec's: shortened stature with the trunk reaching normal size but the legs remaining stunted; small hands and feet; a larger than normal cranium; slightly coarse facial features with a receding chin; a tendency to fractures; and joint stiffness. Parental consanguinity is frequently a factor in the disease, which is transmitted as an autosomal recessive trait, and indeed Lautrec's parents were first cousins.

The two fractures brought Lautrec's health situation to crisis; they were followed by long periods of convalescence at home and at the spas to which his mother took him in the hope of a cure. In June 1878 a bedridden young Lautrec wrote, 'I draw and paint the most I can do, so much so that my hand gets tired of it', and in January from Nice, where he was taken to continue his recuperation from the first fracture, he jokingly referred to his art instruments as his inseparable companions: 'the three of us (me, my palette, and my brush)'. By February 1880, now recuperating from the second fracture, he spoke of his 'rage for painting', and by the year's end, of his guardian angel ' St Palette'.

By the time he embarked upon his academic training, Lautrec had produced a coherent body of juvenilia with a characteristic style and subject-matter. Not surprisingly, he had become a specialist in painting

and drawing animals, especially horses, which he depicted in sporting scenes of the hunt, the race-track, in promenades with modish riders and carriages, and occasionally in military scenes. His first attempts at painting, made in 1878 and 1879, were halting and uncertain—his drawing was as yet stiff and awkward and his palette muddy. But as he gained experience his technique improved. His drawing became more proficient and his work took on a new liveliness and animation. He became adept at rendering the horse in motion and developed a spontaneous manner of applying the paint loosely, with short staccato hatchings that produced a bravura sketchiness, and he adopted a brighter, more luminous palette.

Clearly Lautrec's early paintings reflected his family's aristocratic way of life. His first tastes in subject-matter originated in his family milieu. Not only were equestrian pursuits the dominant pastimes of the males of his family circle, but they were also the subjects of their amateur art productions. In the work of contemporary professional artists, the family taste, predictably enough, inclined towards that of the so-called *animaliers* and *peintres sportifs* (painters of animal and sporting subjects), practitioners of a minor genre long fashionable with and reflecting the life-style of the sporting set of French aristocrats. Artists such as René Princeteau (a family friend who offered Lautrec informal instruction in this period), Edmond-Georges Grandjean, John-Lewis Brown, Georges de Busson, Clermont-Gallerande, Jean-Richard Goubie, and others like them specialized in pictures of the equestrian hobbies of an elegant anglophile society. Their subjects evoked the pleasures of a fading privileged way of life, and family values with which the youthful Lautrec as yet identified.

When Lautrec took up the brush in the late 1870s it was naturally these artists he emulated. In both drawing and painting he made numerous direct copies and adaptations of their paintings or elements in them. His mother's letters confirm that he copied his mentor Princeteau's work. He also made drawings after bronzes of sporting subjects and imitated English sporting prints on horse-racing and coaching themes. From all these sources he established a repertoire of models to re-utilize in his own paintings. In style as well, he was attempting to follow the work of these artists, particularly Princeteau and Brown. Like many artists of the conservative middle ground, Princeteau and Brown were practising (as an alternative to both the more adventurous avant-garde and more traditionalist academics) a diluted form of Impressionism that, despite its sketchlike and unfinished appearance and lighter palette, was acceptable in official circles because of its firm underlying structure of drawing and conservative composition and modelling. No doubt Lautrec initially hoped to become a fashionable sporting painter like the artists he admired.

Lautrec's letters from the summer of 1879, the time of the second fracture, to early 1882 document that he was increasingly turning to Princeteau as his unofficial master. Princeteau, a deaf-mute and an important role-model for Lautrec, encouraged him to make art his vocation. By the spring of 1881 Lautrec was sent to Paris to study with Princeteau; from there he wrote a letter in which he excitedly revealed his formal decision to become a professional artist and his plans to study at Cabanel's studio at the École des Beaux-Arts. First, however, he had to pass his *baccalauréat* examinations. He failed them that spring, but finally passing them the following November, he declared himself 'free' to pursue his chosen career. He returned to Paris to study with Princeteau in the winter of 1882 (probably while trying unsuccessfully to secure admission to Cabanel's atelier, one of three public studios at the École des Beaux-Arts where unmatriculated students could prepare for the school's entrance examination) and began his formal training that spring.

Lautrec undertook academic training, apparently at Princeteau's urging, because he wanted to overcome his deficiencies and improve his skills. He needed especially to gain proficiency in drawing and modelling the human face and figure: these skills were the corner-stone of academic training. Moreover, such training was a prerequisite to professional success in the French art establishment. Academic study was, therefore, a logical continuation of the conventional directions in which he had begun. But the course of events that followed was to become its own law, and Lautrec ultimately would take a somewhat different path in his chosen career from the one on which he started. However, he did not begin to depart from his original goals until he had studied the academic lessons seriously for several years.

Art Student: 1882–6

Lautrec did not study in the atelier of Cabanel at the École des Beaux-Arts as he had originally planned, but enrolled instead in the private ateliers of Léon Bonnat and Fernand Cormon, where he none the less underwent the customary stages of academic training. In these ateliers he intended to prepare for the entrance examinations (*concours des places*) to the École: passing these exams was a requirement for matriculation and eligibility to participate in the École's various regular competitions, leading to the annual Prix de Rome contest. This coveted scholarship for study at the French Academy in Rome was awarded only to one painter per annum. It practically guaranteed a young artist's professional success and commanded such prestige that the entire academic course of study revolved around it. This was Lautrec's chosen route, and once he was enrolled at the École, like most French art

students in the nineteenth century, he planned to continue to receive practical instruction and to prepare at the private ateliers for the competitions, as his letter of 22 March 1882 indicates. However, Lautrec never did matriculate at the École, and whether he chose not to take the entrance exams or failed them remains conjecture.

Lautrec's letters establish that he spent only a brief period at Bonnat's studio, from 17 April 1882 until early summer. When he learnt, during summer vacation, that the master was closing his atelier in order to accept a professorship at the École, he transferred, along with several of his fellow students, to the studio of Cormon. When Lautrec entered Bonnat's atelier, he began to withdraw from the animal and sporting subjects he had previously favoured in order to direct his attention to the acquisition of the skills needed to portray the human figure. Bonnat, a conservative academician, offered intense training in drawing. 'Draw, draw, that's the rub!' Lautrec quipped in one letter, and in another he revealed that the master found his drawing 'atrocious'. Under Bonnat's tutelage Lautrec passed from drawing after engravings and plaster casts to his first attempts at drawing a live model.

He began working at Cormon's in December 1882 and his letters testify that he pursued his studies there assiduously at least till spring 1886. The reminiscences of his friends and fellow students show that he remained at Cormon's into early 1887.[3] Cormon, a history painter who specialized in prehistoric subjects, also offered an essentially conservative programme of instruction. However, his teaching was apparently less strict and rigorous than Bonnat's, a fact which at first disappointed Lautrec, as noted in his letters of late 1882 and early 1883. Under Cormon, Lautrec laboured to gain technical skills; his more proficient academic drawings of plaster casts and the nude model date from the Cormon period and show his improved mastery of anatomical construction, modelling, perspective, and foreshortening. Under Cormon he also progressed to making painted sketches of the nude and of entire compositions. These freely executed preliminary works were a crucial part of the instructional programme at all academic ateliers. In the subjects of his compositional sketches, Lautrec emulated his master, choosing romantic treatments of early human history, as well as allegorical and mythological themes.

During his years at Cormon's he developed a pattern of daily activity typical of academic students of the day. Mornings he worked at the atelier of the master on *académies* and painted sketches; but in the afternoons he worked independently, painting more informal portraits and outdoor studies, in a conservative style. A letter reveals that one of these portraits, that of his friend Gustave Dennery (Paris, Musée du Louvre), was resoundingly rejected by the Salon Jury of 1883. Correspondence also affirms that he continued his outdoor work on

summer holidays at the family's rural estates. There, during the summers of 1883, 1884, and 1885, he painted landscapes and peasant figures in the sunlight with a lighter palette and relatively loose and airy style which reflected the modified Impressionism of the popular Salon painters Jules Bastien-Lepage and Léon Lhermitte, who specialized in peasant subjects. Like these artists, Lautrec relied on painstaking traditional methods of draughtsmanship for his preparations.

In his last phase at Cormon's, from later 1885 through early 1887, while Lautrec still pursued his academic studies, he began simultaneously to experiment with newer, more progressive trends in the work he did outside the atelier. Cormon, who was relatively open-minded, provided an atmosphere in his atelier that was conducive to experimentation without actually advocating it, and he allowed diversity to flourish up to a point. Consequently, a number of young future radicals, including Émile Bernard, Vincent van Gogh, and Louis Anquetin, as well as Lautrec, found sustenance there in these years. As friends and fellow students they must have generated an exciting atmosphere of mutual stimulation and support as they first turned towards Impressionism and subsequently to the more radical trends, which ultimately were to estrange them from Cormon and lead them to abandon the traditional avenues of success.

Lautrec's artistic experimentation coincided with his attraction to a Bohemian life-style, which increasingly distanced him from his family's values. Montmartre, the district where Lautrec lived and where Cormon's studio was located, was a meeting-place for intellectuals, artists, and radicals; at the same time it was a rough working-class district inhabited by the poor and the purveyors of vice—pimps, prostitutes, and petty criminals. Bohemians gravitated there in search of freedom from the strictures of conventional society, so that by the 1880s the district had come to symbolize anti-establishment values. These features also promoted, in the course of the decade, the growth of Montmartre as a commercial pleasure centre, in whose dance-halls and cabarets bourgeois and upper-class Parisians and tourists could vicariously participate in a titillating atmosphere of risk, sexuality, and rebellion. Together with his fellow students, Lautrec began to frequent the Montmartre night-spots. His letters of the spring and summer of 1886 reveal a tug-of-war with his father over whether he should rent his own studio in Montmartre or in the more fashionable Arc de Triomphe/Champs Elysées district preferred by the Count. Several times he referred to his drinking, and on one occasion, in a letter to his mother, he reproached himself for being a 'bad son', making reference to his 'evenings out on the town'. And significantly, in a letter of December 1886, in which he characterized his latest work as 'outside the law', he expressed ambivalence about the 'Bohemian life'

he was leading and at the same time a recognition that he would have to leave behind 'sentimental considerations' (i.e. conforming to family expectations) in order to pursue his new interests.

During this last year and a half at the atelier, Lautrec's strictly academic works decreased in number while his experiments became more numerous, forming a body of work distinct from his academic studies. His gradual move away from the atelier began with these developments. Although he made no abrupt break with his formal training, in his independent work he did make a series of increasingly bold essays with such Impressionist devices as coloured shadows and reflections, and compositions viewed from oblique angles and boldly cropped at the edges, as in the art of Degas and his followers. But Lautrec's most radical advances were in subject-matter. Now he made his first representations of the naturalistic themes that were to become typical of his maturity: the modern urban entertainments—the ballet, dance-hall, cabaret—and the marginal types from the depths of society, the prostitutes, alcoholics, and poor workers. At this time Lautrec was establishing a career as a popular illustrator, making drawings for photomechanical reproduction in the popular Parisian journals; it was a way of gaining public recognition and earning money from his art. The illustrated press of the 1880s was instrumental in his choice of these new themes, which were its commonplace ones, and it was in his illustrative work that they first appeared. He imitated the treatments of these subjects by such illustrators as Steinlen, Forain, and Raffaëlli.

The journals Lautrec worked for popularized the Montmartre spirit, with its assault on middle-class respectability and moral hypocrisy and its desire to shock the bourgeoisie. Epitomizing that spirit was Aristide Bruant, the popular song-writer and singer, who opened his Mirliton Cabaret in Montmartre in autumn 1885. He befriended Lautrec in this period and became an important formative influence on the young artist, encouraging him to make the transition away from his original aristocratic and traditionalist orientation. Bruant sang his own compositions nightly at his cabaret; they were written in Parisian slang and celebrated the poor street-types of the city while protesting their exploitation at the hands of the upper classes. Lautrec in this period made paintings and drawings illustrating Bruant's lyrics, particularly a series of songs about street-walkers from the poor districts of Paris. And in an illustration for Bruant's journal Le Mirliton of 29 December 1886, he also made his first representation of the *quadrille naturaliste*, or cancan, a theme that would preoccupy him for years to come. Notorious for the uninhibitedness and raw impropriety with which the women raised their legs and revealed their flesh in the high kick, this dance too was aimed at shocking the conventionally-minded and was an expression of contempt for bourgeois prudishness.

These lower-class and vulgar associations that Lautrec was bringing to his work, along with his newly unconventional stylistic forays and his growing allegiance to the world from which his new themes came, all contributed to his approaching break with the establishment. Some time in the first half of 1887 he moved out of Cormon's orbit entirely. None the less, the prolonged period he spent there was decisive in his development of an interest in and skill at draughtsmanship, which was to be of the utmost importance for his mature orientation. It might have been his lack of success in the academic competitions (which letters show he participated in through spring 1886) and with the Salon juries that led him away from the world of official art. But certainly he was irresistibly compelled by the general climate of daring, independence, and disdain for traditional values that he encountered in Montmartre.

Artist: The Early Years: 1887–91

No longer a student, Lautrec now identified himself as a member of the avant-garde and as a professional artist. In the period from 1887 when he left Cormon's until late in 1891 when he made his first lithograph, Lautrec entered the mainstream of advanced art. He moved from experimentation to the initial phase of his artistic maturity, in which he created his first works of a distinctive personal nature.

Lautrec's letters of 1887 convey his new sense of professionalism. And from this point on his correspondence, personal as well as business, increasingly refers to his art—his projects, exhibitions, and sales. 'I'm busy enough to exhibit right and left', he wrote proudly in July of 1887. And, indeed, he now had begun to solidify his identification with the avant-garde by participating in its public exhibitions. Although he had shown his work previously on a few occasions, the first major avant-garde exhibition in which he took part was the February 1888 showing of Les Vingt in Brussels. The Belgian group Les Vingt sponsored an annual exhibition, which presented work representative of new tendencies in art and played an important role in giving exposure to young progressive artists. The group's discovery of Lautrec, and its invitation to him, revealed in his correspondence of summer and autumn 1887 and winter 1888, also signified the first formal recognition of his art by the avant-garde.

The years from 1889 to 1891 saw Lautrec's expanding and increasingly successful participation in avant-garde exhibitions and his growing confidence about the viability of a radical art. His letters document his participation in the 1890 exhibition of Les Vingt, and in 1889, 1890, and 1891 in the major Parisian exhibition of new art, the Salon des Indépendants. Founded in 1884 by a group of dissident artists

who had been rejected by the Salon jury, the jury-free Indépendants exhibitions provided an alternative to the official Salon, offering artists who did not practise the styles sanctioned by the artistic establishment an opportunity to exhibit. In March of 1890, Lautrec jubilantly reported the success of the opening of the Salon des Indépendants to his mother, noting that it had given the official Salon 'a slap in the face from which it will recover, perhaps, but which will give many people something to think about'. Letters record that he also showed his work in a number of smaller exhibitions in these years, including those of the Cercle Volney, the Salon des Arts Libereaux, and late in 1891, at Le Barc de Boutteville's 'Exposition de peintres Impressionistes et Symbolistes', the newest Parisian show-case for the avant-garde. And as he gained visibility for his art and a greater reputation, the press recognized him in reviews, and some of the major critics of the day who were sympathetic to progressive art, like Émile Verhaeren, Félix Fénéon, and Gustave Geffroy, began to take approving notice of his work.[4] Moreover, he caught the attention of the contemporary artist he most revered, so that in September of 1891, Lautrec was able proudly to announce that 'Degas has encouraged me'.

In 1887 and 1888 Lautrec continued his stylistic experimentation in painting. He did not yet develop a distinctive original style; rather he completed his assimilation of Impressionism and moved on to make his own variations on the colour theory and pointillist method of Neo-Impressionism. He also continued to explore Naturalist subjects, especially in his illustrations, but he did not yet fully integrate these relatively daring and unconventional subjects into his more formal paintings. The core of his painted *œuvre* remained a series of relatively circumspect and straightforward portraits and outdoor studies. Such paintings assured him a degree of respectability, while he felt freer to experiment in the lesser medium of illustration, which he could rationalize as a sideline.

At this time he shared a common context with the other young emergent artists he had met at Cormon's, including Anquetin, Bernard, and van Gogh, and to whose circle he still belonged. Van Gogh called them the 'Impressionists of the "Petit Boulevard"' to distinguish them from the older, more established Impressionists who exhibited and sold their work at the fashionable galleries on the Grands Boulevards. They exhibited together only once, in a small show organized by van Gogh late in 1887 at a restaurant on the Avenue de Clichy but unfortunately not mentioned by Lautrec in his letters. As young unknown radicals in search of a viable style, they followed, albeit at different paces, much the same pattern of development in these years— moving from an Impressionist- and Neo-Impressionist-influenced Realism and Naturalism to more abstract and decorative styles. But in

1888, when Anquetin and Bernard had already rejected Neo-Impressionism and ventured on to develop the more extreme Cloisonnist style characterized by flat surfaces and simplified forms with closed outlines, Lautrec lagged behind them, not yet prepared to follow his peers in their more dramatic advances.

The other Petit Boulevardists all undertook humble, lower-class, vulgar themes from the contemporary urban scene, such as cabaret life and prostitution, and considered them to be another facet of their artistic modernism. Although Lautrec's commitment to such content was stronger and more permanent and continued even as theirs waned, the Petit Boulevardists gave him an important precedent for treating naturalistic subjects in a simplified, abstracted style—the formula much of his mature work was to follow. For the time being, however, Lautrec remained content largely to confine such subjects to his popular illustrations and their painted preparations and to treat them in a relatively conservative realistic style. In 1887 and 1888, he expanded his career as an illustrator, publishing four illustrations in Bruant's *Le Mirliton* and five in *Paris Illustré* (whose appearance he announced in a letter of July 1888) and making numerous other preparations for illustrations which were never published.

Lautrec had advanced into avant-gardism with a degree of prudence in the years immediately following his extended period of academic study. In the period of 1889–91, however, he evolved a novel and consistent style appropriate to his new subjects and created works of a distinctly personal nature, which brought him to the first stage of his maturity. In these years he temporarily suspended his work as an illustrator and fully turned his energies to painting as his primary means of expression; this was his heroic period as a painter. He concentrated on assimilating the naturalistic themes of his illustrations into major easel paintings and developing formal devices to enhance this subject-matter and unite it with a more advanced style. Lautrec had inherited the ambition to make monumental history paintings from his academic masters and the tradition of the Salon. In several large-scale paintings of 1889 and 1890 he began to reconcile this traditional idea with a modern subject. He found immediate sources of inspiration for paintings like *Au Bal du Moulin de la Galette* (Chicago Art Institute) of 1889 and *Au Moulin Rouge, la danse* (Philadelphia, McIlhenny Collection) of 1890 in the imagery of the popular illustrated press, but now he took its vulgar themes from popular life and daringly monumentalized them as high art. Lautrec continued to produce portraits in these years and he also treated naturalistic subjects, like the toilette and café, in paintings of a smaller format.

In all these paintings he now adopted a distinctive way of applying the paint thinly, in long striated brush-strokes, without regard for the

surface textures of the objects depicted. He layered the pigments, setting them down loosely and sketchily enough to leave underlying layers visible and areas of the support exposed to function positively as colour. His paintings, with their long, dry streaks, have the appearance of having been drawn with the brush. He also took up, in a modified way, the advances of Cloisonnism, heightening his manipulation of the abstract elements of colour, contour, and shape to accentuate emotional expression and mood in his paintings. He was beginning to organize his paintings around distinctive shapes and large blocks of colour. Although his work was, as yet, less decorative and stylized than that of the Cloisonnists, he was paving the way for the greater transformation of style that was to occur in his work by late in 1891.

In the course of 1891 the manipulation of line and the abstract play of sinuous curves and shapes became more pronounced in Lautrec's paintings. His formal sensibility was growing increasingly acute. He made a number of small-scale paintings, including a series of portraits of elegantly attired male friends, which are documented in his letters of that winter. However, he produced no monumental oils in 1891; rather, his major composition was his first poster, *Moulin Rouge–La Goulue*, which his letters reveal he created at the end of the year—no doubt it was commissioned to advertise the new season at the Moulin Rouge. With this poster, which was also Lautrec's first original lithograph, the monumental history painting ideal gave way to a renewed involvement with popular forms. And with it his art also entered a period of heightened aestheticism and stylization. The poster, which established Lautrec's reputation overnight, ushered in the second phase of his maturity, in which he embraced a more advanced and daring style, but without altering his basic naturalistic themes.

Like much of Lautrec's lithographic work of the coming years, the poster carried the abstract and reductive tendency of his paintings to an exaggerated extreme. He had clearly been absorbing the lessons of the Japanese print as well as those of the most up-to-date developments in his own milieu—Cloisonnism, Gauguin's Synthetism, the art of the Nabis—all with their self-consciously decorative effects and simplified stylized drawing. An equally important factor in determining the bold visual impact, abbreviated style, and racy presentation of subject of the Moulin Rouge poster was its purpose as commercial publicity. In this respect it introduced another element characteristic of much of Lautrec's lithography, and particularly his posters, of the 1890s.

Artist: The Middle Years: 1892–7

The middle years found Lautrec at the height of his powers. This was his

most busy, productive, and successful period and consequently the richest in terms of correspondence concerning his professional activities. His work was now in great demand by dealers, exhibition societies, and publishers and was increasingly recognized by avant-garde editors and critics. Letters show that several of these figures promoted his career by publicizing his work and helping him obtain commissions. And one commission followed so quickly upon the previous that he was able to report, with combined pleasure and exasperation, in a letter of late 1894, 'I'm up to my ears in work.'

He participated in an increasing number of the smaller exhibitions of radical groups of painters and printmakers, both at home and abroad. He continued to show with the Nabis group and other young innovators at the gallery of Le Barc de Boutteville, and he added to his list, most notably, the exhibitions of the Salon des Cent, the Société des Peintres-Graveurs, and the Poster Exhibition at the Royal Aquarium in London. At the same time his rejection by and subsequent resignation from the fashionable Cercle Volney, revealed in a letter of January 1893, spelt the end of his lingering ties to the conservative establishment. He continued to channel his annual output to two major group shows every year, in Paris the Indépendants and in Brussels, in 1892 and 1893, Les Vingt, and thereafter La Libre Esthétique, the organization which succeeded Les Vingt. Moreover, his friend and dealer Maurice Joyant gave him in 1893 a two-person show (with Charles Maurin) at the Boussod, Valadon & Co. (Goupil) Gallery in Montmartre, and in 1896, at the Manzi–Joyant Galleries, his first one-person exhibition.

During these middle years printmaking eclipsed painting as the focus of Lautrec's attention. The 1890s saw a printmaking renaissance in France, and Lautrec, once having discovered lithography late in 1891, was swept up in this movement. This was the period in which he produced most of his posters and major lithographs; late 1892, according to his letters, was the date of his first limited edition, and thereafter he also made numerous sheet-music covers, theatre programmes, menus, and book illustrations, all while his painting efforts more or less took a back seat. It is not surprising, therefore, to find him writing to a painter friend in February 1894, 'The Indépendants have no gallery and are having no luck trying to find some place to leave their daubs. Personally, it's all the same to me because I'm wrapped up in lithography.' He returned to working for the popular press as well, and his illustrations appeared in such journals as *Le Figaro Illustré*, *L'Écho de Paris*, *L'Escarmouche*, and *Le Rire*. In fact, in a letter of December 1893 he expressed a strong identification with the Parisian illustrators, whom he referred to as 'us magazine people', and proposed that they be given their own 'separate show window' at the forthcoming exhibition of La Libre Esthétique.

La Libre Esthétique championed the ideals of the contemporary Art

Nouveau movement, which sought to integrate the fine arts and crafts, and consequently the organization put an emphasis on the decorative and applied arts. No doubt Lautrec felt encouraged by these ideals in embarking on numerous projects with utilitarian, practical, and even commercial purposes, projects which made art accessible to people's everyday lives and which existed at the boundary between the fine and applied arts.[5] He even tried his hand at designs for stage-sets, ceramics, and stained glass in these years, and an extensive correspondence, carried on from 1893 to 1895, discloses some of the details of his collaborations with the Nancy bookbinder René Wiener. Lautrec attended the 1894 opening of the La Libre Esthétique's annual show in Brussels, where he must have heard the leading Belgian exponent of Art Nouveau, the architect and designer Henry van de Velde, lecture on 'L'Art futur'. He may have visited with van de Velde at this time; a number of his letters from this point on reflect his interest in both Belgian and English modern furniture and decorative objects. He also adopted the predominant stylized, curving line of Art Nouveau in much of his work of this period. That he subscribed to the movement's ideals is evident in a rare and revealing theoretical statement that he made in a letter to Henri Nocq in 1896. In it he recommended as a role-model William Morris, the founder of the English Arts and Crafts Movement, whose ideology was the inspiration for much of Art Nouveau theory, and stated as his own credo: 'Fewer artists and more *good workers*. In a word: more craft.'

In his prints of these years Lautrec continued to draw upon his earlier repertoire of naturalistic subjects, dealing with the socially marginal, nonconformist, and low-life characters of the modern urban environment, but he concentrated particularly on themes of the hedonistic pursuit of pleasure in scenes of entertainment and night-life, including the brothel. He still depicted the Moulin Rouge and the café-concert, but more often now he turned his attention from the clientele to the individual performers, like Jane Avril, Aristide Bruant, and Yvette Guilbert. The production of his album devoted to the latter is documented in a group of letters of 1893 and 1894. He balanced such popular café-concert subjects with a new interest in the legitimate theatre and its stars. In both types of images his tendency was to summarize incisively the character of his subject.

During this second phase of his maturity Lautrec's art took on more decorative and stylized features. Nevertheless, he tended to work simultaneously in alternative styles in his prints of this period, and both his choice of style and treatment of subject were related to the purpose of a particular print. In some prints, primarily his posters, he made exceptionally daring and striking stylistic essays, exploiting boldly reductive and proto-abstract flat colour areas, decorative two-dimensional shapes, and strong outlines, as well as caricatural exaggeration and distortion. The posters and other commercial works were meant for the rapid glance of

the undiscriminating passer-by and so conveyed their messages in an abbreviated, eye-catching manner, attempting to titillate the public eye with both form and subject in order to lure the viewer to the momentary and sensational attractions they promised. At the same time, in his prints of a less public nature, those destined for the thoughtful eye of the connoisseur and done in smaller editions, he tended to work in a relatively restrained, realistic, tonal style, creating more substantial, modelled figures, and using greater subtlety and complexity of style to probe below the surface and reveal more profound psychological truths. For example, as Linda Nochlin has pointed out, while a number of Lautrec's posters exploit the sexuality of their subjects and use modernist and *japoniste* devices to sell the 'products' they advertise, the lithographs in his album *Elles* (1896), which deal with the life of the brothel and were meant for a more restricted audience, are remarkably unerotic images. They treat sympathetically and sensitively female life in the brothel in its private, intimate moments, and employ, for the most part, a relatively naturalistic style to do so.[6]

Lautrec's correspondence reveals the specific dates of appearance of many of his major posters, as well as the pride he took in them. He went out of his way to call each new poster to the attention of the critics. And when he was asked in December 1892 to make a poster for Yvette Guilbert (never executed) he bragged to his mother: 'This is the greatest success I could have dreamed of— because she has already been depicted by the most famous people.' None the less he was fully cognizant that such work would be considered vulgar in his family circle and added that 'the family won't take any pleasure in my joy'. On the other hand, another letter to his mother, written in 1893, possibly played more to family values in reporting that he had invented a new printmaking process (to create the spatter effect) 'that can bring me quite a bit of money'.

Lautrec's painting of this period constitutes a high-art counterpart to his work in the graphic arts. He still maintained the ambition to create large-scale, complex figure paintings in the tradition of the Salon, but at times it was overshadowed by his activity in printmaking. There was a relative decline in the number of paintings he produced, and most were small-scale; moreover, many of his paintings originated as preparatory sketches for prints. While portraits continued to be the mainstay of his painted *œuvre*, Lautrec also explored many of the same themes in his formal paintings as he did in his prints, continuing on occasion to monumentalize subjects from popular life. In 1894, in *Au Salon de la rue des Moulins* (Albi, Musée Toulouse-Lautrec), he audaciously treated the brothel theme on a grand scale, and he also painted numerous smaller variations on themes from the brothel. And in 1895 in another large-scale work, *Au Moulin Rouge* (Chicago Art Institute), he used colour and figural distortion to expressively recreate the perverse and nightmarish aspect of the dance

hall.[7] His last major painting of the period, '*Chilpéric*' of 1896 or 1897 (New York, private collection), monumentalized a theatre subject, the performance of an operetta by Hervé at the Théâtre des Variétés.

Lautrec's painting style in these years was generally more cautious and less boldly innovative than that of his publicity prints. He did carry over some of the stylized and decorative qualities, but to a lesser degree. For much of the period, he still applied the paint thinly in his habitual long, dry streaks, but he emphasized more than previously the abstract play of line, silhouette, and large shapes of colour on the paintings' surfaces, though the forms were not nearly so flat and decorative as those of his posters. And in the course of the period as a whole his tendency in painting was gradually to move away from stylization and abstraction and back toward Naturalism, so that by 1896 he painted with a decidedly more modelled style, and by 1897 he moved also toward a heavier, more painterly application of the paint. Moreover, in his paintings, he did not use the modified modernist techniques for commercial purposes, but to penetrate more deeply the psychological realities and underlying mood of the modern environment.

Artist: The Last Years, Breakdown, and the End: 1898–1901

The last phase of Lautrec's life was one of tragic decline, ending in his death in 1901 just a few months before his thirty-seventh birthday. His gradual debilitation and untimely death can most likely be attributed to the accelerating effects of alcoholism, combined with those of late-stage syphilis, and perhaps exacerbated by the symptoms of his hereditary disease. The deterioration of his health, emotional as well as physical, inevitably had its effect on his work, resulting in a slackened pace and diminished output. In this period he exhibited less widely, no longer participating in the shows of La Libre Esthétique or the Indépendants. Moreover, some critics have discerned a falling-off of quality in his art. There is no doubt that his work became more uneven as he weakened. However, a great deal of the negative criticism of his late work has been based on his apparent forsaking of avant-garde stylistic features. He now adopted, as his primary direction in both painting and lithography, the more conservative realistic style that he had practised as an alternative to modernism in his middle years. He developed a more heavily hatched manner of drawing and he painted with denser brush-strokes, working to create an emphatic sense of volume and play of light. In reality these developments seemed to evolve naturally out of the direction he had been following for some years. Moreover, he was moving away from commercial popular work, namely posters, and it also follows that he would have set aside the quasi-abstract effects he had developed for such work.

The rapid decline in Lautrec's health was clearly evident from 1898 on, but signs of it were already beginning to appear in 1897. According to the accounts of his friends, his drinking—already excessive—had become out of control by 1897, and his behaviour had become increasingly restless, irritable, and undignified. He was frequently enervated and overcome by fatigue. In a letter written in November of 1897, he reported difficulty working. And in another letter, written early in 1898, he declared, 'I'm in a rare state of lethargy ... the least effort is impossible for me. My painting itself is suffering, in spite of the works I must get done, and in a hurry.'

None the less, Lautrec remained busy and productive for much of 1898, working with tremendous energy even after long nights of drinking. In 1898 he produced some sixty lithographs, including his two albums for the English publisher W. H. B. Sands. He also branched out in his printmaking, trying his hand at dry-point etching. He participated in two group exhibitions and organized a show at his own studio, and in spring, at the London branch of the Goupil Gallery, he had his second and last major one-person exhibition, which unfortunately received harshly negative reviews. Although his production of lithographs continued to outpace that of his paintings, he still made a number of oils in 1898, mostly on a small scale. He failed, however, to complete preparations for a poster for Job Cigarette papers, perhaps because by the end of the year his condition was worsening appreciably. By November his drinking and profligate spending had led him into financial straits. His family must have reduced his allowance, which angered him deeply. He began to write to his dealers and publishers, demanding the return of his work and the settlement of his accounts.

This was the immediate prelude to the crisis that began in the autumn of 1898 and lasted through the following winter. In these months, Lautrec's behaviour became increasingly erratic, he was perpetually intoxicated and often aggressive, and he suffered from insomnia, hallucinations, paranoid fears, memory-lapses, and tremors. His mother fled Paris early in January, distressing him further and precipitating what he referred to in a letter of 16 January as 'the nervous breakdown caused by my mother's unexpected departure'. She left her housekeeper, Berthe Sarrazin, to look after a resentful Lautrec, who accused his mother of '*having me spied on by maids*'. And indeed Berthe's daily letters provide a vividly detailed and poignant picture of the artist's breakdown. She describes in detail his drunkenness and the pathetically irrational behaviour (including 'varnishing his pictures with glycerine and rubbing them down with a sock') that led to his internment in late February or early March in the sanatorium of Dr Sémelaigne in Neuilly. There he underwent detoxification, and his condition rapidly improved. The press exploited the episode and turned

it into a scandal: several journalists attacked Lautrec's character and his art and set a precedent by linking the artist's work with his presumed 'madness' and his physical deformity. 'The man himself, deformed, lame, grotesque, was that rare phenomenon, a symbol of his own work', declared Alexandre Hepp in *Le Journal* of 20 March. A controversy ensued, during which Lautrec's friends and supporters, most notably Arsène Alexandre in *Le Figaro* of 30 March, defended his character and praised his work as the product of 'his passion for truth'.

Few works remain from the immediate period of the breakdown, and those that do seem to provide evidence of Lautrec's unbalanced state. He made several absurdly incoherent lithographs, hastily scrawling them on the stone. One, dated 8 February, depicts a bizarre encounter between a dog and a parrot who sports a little hat and smokes a pipe. In the course of his confinement, as Lautrec's condition improved, his creative energies began to return. He requested watercolours and drawing materials and set to work on a series of drawings of circus subjects, which he drew from memory, in the hope of proving his sanity to the doctors and thereby gaining his release. By 12 April he wrote 'Tell Maurice [Joyant] his album is growing'. Lautrec ultimately produced about forty colour drawings, some recalling circus themes he had treated a decade earlier, but which create an uneasy effect that may relate to his precarious mental state.

In mid-May he exulted, 'Lautrec is out of jail.' He had been released from the clinic. In order 'to organize his life a little', as Joyant put it, Lautrec's family placed his allowance under the firm control of the family steward and solicitor, while Joyant managed the income from his work. The artist was provided with a male guardian, Paul Viaud, who was to help restrain his behaviour and keep him from drinking. Although Lautrec's output for the year naturally fell off and he did not participate in any exhibitions, he did go on, in the period of regained health directly following his confinement, to create a number of lithographs and paint several fine portraits, including that of Miss Dolly, the English barmaid at the Star tavern in Le Havre (Albi, Musée Toulouse-Lautrec) in July. And in Paris the following autumn and in the winter of 1899–1900, he painted the courtesan Lucy Jourdain, in *Au Rat Mort* (London, Courtauld Institute of Art), as well as several equestrian scenes of jockeys and *amazones*. He made his last two posters in 1899 as well, one that was never used of Jane Avril, with the motif of a serpent entwined around her dress, and the other for the première of Jean Richepin's play *La Gitane* at the Théâtre Antoine. Appropriately, Lautrec returned in these posters to the flat, patterned effects that had largely disappeared from the rest of his work.

Tragically, by autumn 1899 he was once again drinking heavily, concealing liquor from Viaud in a hollow walking stick, and seeming

to his friends to be deliberately trying to hasten his own demise. His physical condition so deteriorated that in mid-April, when the Universal Exposition opened, he toured it in a wheelchair. According to his letters, in June of 1900 he left Paris with Viaud, travelling to Bordeaux, where they remained from the autumn of 1900 until April 1901. During this period he made no attempt to hide his drinking and once again became belligerent, as his family sought to further reduce his allowance. His works were now commanding high prices and he repeatedly wrote to Joyant demanding funds, asking him in December 1900 to 'send me without delay ... the "dough" that will allow us to run around'.

Lautrec was also losing the will to work. In the last two years of his life, he made only five lithographs. Nevertheless his final decline was punctuated by brief rallies. In the spring of 1900 he completed several more portraits, and in May he once again organized an exhibition of his own. Later in the year and in the winter of 1901, in Bordeaux, he worked again for a while with his old intensity, producing a series of paintings of theatrical subjects, including six based on Lara's opera *Messaline*. But his work was becoming increasingly feeble and by mid-1901 his production had slowed nearly to a standstill, as his health continued to degenerate.

On 2 April 1901, he wrote to Joyant, 'I'm living on nux vomica, so Bacchus and Venus are forbidden.' Knowing the end was near, he returned in late April one last time to Paris to put his studio in order. He remained there, perhaps attempting to work, until July, at which time he returned to Bordeaux and Taussat. In August he suffered a cerebral haemorrhage, which left him slightly paralysed. He was brought to his mother's estate at Malromé, where, according to his father's description in a letter of late August, he weakened further: the paralysis spread, he became nearly deaf, and his lungs were diseased. He lapsed into a coma and died on 9 September with his parents at his bedside.

The obituaries renewed the controversy of 1899: hostile critics condemned Lautrec as 'an eccentric and deformed individual whose approach to the world around him was somewhat coloured by his own physiological defects' (Jumelles, *Lyon Républicain*, 15 September 1901), while his supporters lauded him as a tireless seeker of 'reality, not the shams and illusions which falsify truth and distort the past' (N.N., *Journal de Paris*, 10 September 1901). But it was the artist's father who summed up the essential personal tragedy of Lautrec's short life. In a letter written following his son's death he explained that Lautrec's 'physical disabilities' and 'distressing misfortunes' were 'made all the more painful for him by the fact that he would have liked the elegant, active life of all healthy, sports-loving persons'.

Lautrec's correspondence undoubtedly went beyond what is pub-
lished here. He must have written to other artists and writers in his
circle, such as Louis Anquetin, Henri Rachou, François Gauzi, Maxime
Dethomas, Édouard Vuillard, Jules Renard, and Tristan Bernard, as
well as to the singer Yvette Guilbert and to his friend Dr Bourges.
Probably his correspondence with René Princeteau, Maurice Joyant,
the Natanson brothers, and other dealers, printers, and publishers
was also more extensive. Some of this correspondence has not been
preserved. Other letters are scattered in collections in France and
abroad, and, despite exhaustive efforts, it has not been possible to trace
them. None the less, Lautrec's extant letters shed light on virtually
every phase of his artistic career. They clarify especially the nature of
its origins in a closely knit, aristocratic family milieu and establish the
dates of his period of academic study, as well as the seriousness of
his commitment to it. They lead us through his transition from a
conservative to a progressive outlook and his emergence as a pro-
fessional in the later 1880s. For the 1890s, they reveal specific details
relating to a variety of his projects as a mature artist, and, finally,
they illuminate some of the personal and professional circumstances
surrounding the decline of his last years.

ENDNOTES

1 M. G. Dortu, *Toulouse-Lautrec et son œuvre* (6 vols.; New York, 1971); Wolfgang
 Wittrock, *Toulouse-Lautrec: The Complete Prints*, trans. Catherine E. Kuehn (2 vols.;
 London, 1985).

2 Pierre Maroteaux, MD, and Maurice Lamy, MD, 'The Malady of Toulouse-
 Lautrec', *Journal of the American Medical Association*, 191, no. 9 (1 Mar. 1965), 715–
 17. For other diagnoses, see Vagn Schmidt, MD, *Toulouse-Lautrec, sa vie, sa maladie,
 sa mort* (Paris, 1968).

3 See especially A. S. Hartrick, *A Painter's Pilgrimage through Fifty Years* (Cambridge,
 1939), pp. 48, 91; François Gauzi, *Lautrec et son temps* (Paris, 1954), p. 16 and
 passim; and Émile Bernard, 'Des Relations d'Émile Bernard avec Toulouse-
 Lautrec', *Cahiers d'Arts Documents*, 18 (Mar. 1952), 13–14.

4 See e.g. Émile Verhaeren, 'L'Exposition des XX à Bruxelles', *La Revue Indépendante*,
 6, no. 17 (Mar. 1888), 456–7, and review of the Salon des Indépendants in *L'Art
 Moderne*, 21 (5 Apr. 1891), 112; Félix Fénéon, review of the Salon des Indépendants
 in *La Vogue* (Sept. 1889); and Gustave Geffroy, *La Vie artistique* (Paris, 1892), i.
 305, entry dated 22 Apr. 1890 and i. 309, Apr. 1891.

5 See also Richard Thomson, 'The Imagery of Toulouse-Lautrec's Prints', in
 Wittrock, i. 25.

6 Linda Nochlin, 'Lautrec the Performer and the Prostitute: Advertising and the

Representation of Marginality', unpublished typescript of a lecture given at the Museum of Modern Art, New York, 1985. See also Richard Thomson's discussion of Lautrec's publicity work in 'Imagery of Lautrec's Prints' in Wittrock, i. 13–34.

7 On the redating of this painting from 1892 to 1895, see Reinhold Heller, 'Rediscovering Henri de Toulouse-Lautrec's "At the Moulin Rouge"', *Museum Studies*, 12 (1986), 114–35.

1

CHILD AND SCHOOLBOY

CHRONOLOGY
1838–1881

1838	10 August	Albi	Birth of Alphonse-Charles de Toulouse-Lautrec, father of the artist.
1841	23 November	Narbonne	Birth of Adèle-Zoë Tapié de Céleyran, mother of the artist.
1863	9 May		Marriage of Alphonse and Adèle
1864	24 November	Albi	Henri de Toulouse-Lautrec born—Hôtel du Bosc, 14 rue de l'École-Mage.
1867	28 August	Albi	Birth of brother, Richard de Toulouse-Lautrec.
1868	27 August	Loury	Death of brother.
1871	28 April	Céleyran	Earliest known letter.
	23 December	Le Bosc	Death of grandfather, 'Prince Noir'.
1872		Paris	Family takes up residence at the Hôtel Pérey, 5 cité du Retiro, near the rue du Faubourg Saint-Honoré and rue Boissy d'Anglas.
	October	Paris	Enters Lycée Fontanes (Condorcet), Classe de Mantoy.
	30 December	Paris	Writes to grandparent.
1873	19 January	Paris	Writes to grandparent.
		Amélie-les-Bains	Visits.
	23 August	Céleyran	Writes to grandparent.
	August	Le Bosc	Visits.
	December	Paris	Returns to school.
1874	January	Paris	In school.
	29 March	Paris	Letter to cousin Madeleine.
	July	Paris	Graduates from eighth form, Lycée Fontanes; studies under supervision of his mother.

		Amélie-les-Bains	Visits.
		Nice	Visits. Pension de famille anglaise.
	30 September		Letter to aunt with drawing of spider.
	23 November	Paris	Returns to school.
	31 December	Paris	Letter to grandparent.
1875	9 January	Paris	Leaves school.
		Amélie-les-Bains	Visits.
	September–October	Paris	Writes to mother and grandparent referring to his legs.
	2 November	Paris	Writes to grandparent.
	December	Paris	Writes to grandparent, first mention of Princeteau.
1876	11 May	Paris	Passes exams.
	12 June	Paris	First Communion.
		Le Bosc	Visits.
	December	Paris	Writes to grandparent.
1877	1 March	Paris	Writes to grandparent: 'Limping with my left foot'.
	July	Barèges	Visits.
	December	Le Bosc	Visits.
1878	9 March		Letter of Dr Gemeys about Henri's health. Sulphur treatment.
	April	Paris	Writes to grandparent.
	Before 22 May	Albi	Hôtel de Bosc. Fractures left leg. Letter dated 22 May to Raoul.
	July	Albi	Writes to grandparent, signed 'Your crutch-walking godson'.
	August	Le Bosc	Draws scenes of manœuvres.
	2 September	Albi	Writes to Charles Castelbon: 'I'm beginning to walk with a crutch'.
		Barèges	Meets Devismes. Stays at Maison Gradet.
		Amélie-les-Bains	Visits.
	December	Céleyran	Writes to grandparent.
1879	January–February	Nice	Stays at Pension Internationale. Writes to Devismes—Cocotte Letter No. 1.
	April	Albi	Levée de l'appareil fixée au 24.
	August	Lourdes	Visits with mother.
	August	Barèges	Visits. Stays at Maison Gradet.

			Fractures right femur, writes to grandparent, signs 'Your clumsy godson'.
	1 September	Barèges	Levée de l'appareil.
	September	Barèges	Writes to Devismes—Cocotte Letter No. 2.
	December	Céleyran	Writes to cousin Raoul.
1880	13 January	Nice	Writes to grandparent.
	11 February	Nice	Writes to Devismes—Cocotte Letter No. 3.
	March	Nice	Writes to father.
	September	Le Bosc	Writes to Uncle Charles.
	30 December	Céleyran	Writes to grandparent.
1881	January	Nice	Visits, writes to Cousin Madeleine. Cahiers de Zig-Zags
	April	Paris	Father and Princeteau 'littéralement transportés à la vue des "chefs-d'œuvre"'.
	May	Paris	Mother reports he is copying a painting by Princeteau.
	July	Paris	Fails first attempt at baccalaureate.
	August	Lamalou-les-Bains	Writes to Devismes—Cocotte. Letters Nos. 4 and 5.
	October	Lamalou l'Ancien	Writes to Devismes—Cocotte. Letter No. 6.
	October	Le Bosc	Writes to Devismes—Cocotte. Letter No. 8.
	November	Toulouse	Passes baccalaureate (second attempt).
	November	Albi	Writes to Devismes—Cocotte. Letter No. 7.
	29 December	Céleyran	Visits, writes to grandparents.

1 *To Mme L. Tapié de Céleyran*

Château de Céleyran,[1] 28 April [18]71

My dear Godmother,[2]

I kiss you with all my heart, and tell me please if Mlle Julie is well,

if Annou, Justine, and Antoine[3] are well. Another kiss for you, and that is all for now.

<div align="right">henri</div>

Prov.: Schimmel
Pub.: GSE1, GSF1

[1] The property of Madame Tapié de Céleyran; near Narbonne, Department of Aude.

[2] Louise d'Imbert du Bosc (1815–1907), wife of Léonce Tapié de Céleyran; Lautrec's maternal grandmother and also godmother, and the sister of his paternal grandmother. Lautrec uses the word 'Marraine'.

[3] Annou is probably an affectionate name for Annette, who had been his nurse, and whose name recurs frequently in this correspondence. Antoine was the gardener at the Château du Bosc. Justine was a chambermaid there. Cf. Rodat, p. 126.

2 *To Mme L. Tapié de Céleyran*

<div align="right">[Late December 1871]</div>

[1]My dear Godmother,

I am very happy to be writing to you for New Year's Day. I wish you a happy New Year. I wish one, too, to everyone I know, uncles, aunts, cousins, etc....Tell Madeleine[2] I would like to see her again very much. A kiss for everybody, and for Godmother most of all.

<div align="right">Your grandson,
Henry de Lautrec</div>

Prov.: Schimmel
Pub.: GSE2, GSF2

[1] This letter occupies one page of four. The other three, written by Lautrec's mother, concern the accidental death while hunting, on 23 December 1871, of Count Raymond-Casimir de Toulouse-Lautrec, the 'Black Prince', Lautrec's grandfather.

[2] Madeleine Tapié de Céleyran (1865–82), daughter of Amédée and Alix Tapié de Céleyran. A favourite cousin of Lautrec's, she often appears in his correspondence. She died at the age of 17.

3 *To Mme L. Tapié de Céleyran*

<div align="right">[Albi, Spring 1872]</div>

My dear Godmother,

I am very happy that I can send this letter to you with the letter of my dear Uncle Amédée.[1] I'm very annoyed not to see my Tapié cousins or my Albi cousins; they have the whooping-cough. Henry de Barbeyrac was better, but he ate a biscuit and had to be put back on quinine. Charles has been ordered to vomit, and he's so pleased that all you have to do to make him obey is to threaten him with not vomiting. I want to send my cousins some of the sweets that Aunt

Stéphanie and Grandma de Lautrec gave me. Mlle Claire wrote to Mama and she hasn't forgotten you. I bought some handsome lead soldiers in Toulouse. Goodbye, my dear Godmother, I send you a thousand kisses for yourself and everybody.

<div align="right">Your little godson,
Henry de Lautrec</div>

Prov.: Custodia

[1] Amédée Tapié de Céleyran (1844–1925), husband of Alix Tapié de Céleyran (1846–1918); *née* Alix-Blanche de Toulouse-Lautrec), Lautrec's maternal uncle and paternal aunt.

4 *To Mme R. C. de Toulouse-Lautrec*

<div align="right">Paris,[1] 30 December 1872</div>

My dear Grandma,[2]

I am awfully glad to be sending you this letter, for it is to wish you a happy and prosperous New Year. I am anxious to be back at Bosc[3] for my holiday, although I don't mind it here in Paris. We are on holiday right now, and I am trying to have as much fun out of it as I can. Too bad I have pimples that make me lose a lot of time scratching. Please tell Aunt Émilie[4] that my little canary Lolo sings very well, he is awfully nice. I have bought him a very pretty cage with my New Year's gift.

Goodbye, dear Grandma. I kiss you with all my heart, my Aunt Émilie, my Uncle Charles[5], and my Uncle Odon[6] as well, and please accept, all of you, my best wishes for a happy New Year.

<div align="right">Your respectful grandson,
Henry</div>

Prov.: Schimmel
Pub.: GSE3, GSF3

[1] Lautrec was now living with his parents in Paris, at the Hôtel Pérey, an aristocratic lodging-house at 5 cité du Rétiro, near the rue du Faubourg Saint-Honoré and the rue Boissy d'Anglas. He was attending the Lycée Fontanes (now the Lycée Condorcet), which he had entered in October 1872, and was in the eighth preparatory class, a class between the normal ninth and eighth forms.

[2] Gabrielle d'Imbert du Bosc (1813–1902), widow of Raymond-Casimir de Toulouse-Lautrec (1812–71); Lautrec's paternal grandmother and the sister of his maternal grandmother. Lautrec uses the words 'Bonne Maman', as he always did in addressing her.

[3] The property of Madame Raymond-Casimir de Toulouse-Lautrec; at Naucelle near Rodez, in the Department of Aveyron.

[4] Émilie d'Andoque de Seriège, wife of Lautrec's paternal uncle, Charles. She should not be confused with Émilie le Melorel de la Haichois, the wife of another uncle, Odon.

[5] Charles de Toulouse-Lautrec, Lautrec's paternal uncle. A gifted draughtsman and very much interested in art, he was Lautrec's favourite uncle, to whom he wrote letters reporting artistic events in Paris.

[6] Odon de Toulouse-Lautrec (1842–1937), another of Lautrec's paternal uncles.

5 *To Mme R. C. de Toulouse-Lautrec*

[Paris, late December 1872]

My dear Grandma,

I am sending you my best wishes for the New Year a little early because I have something to ask you. Papa would like me to translate a chapter in a big, red English book, easy to recognize because it's so heavy and from the pictures about sports in it.[1] It looks like a Bouillet dictionary. Please be good enough to send it right away. Mama thinks it is in her linen closet, but perhaps it's in her desk or in the chest at the foot of my bed. Papa is asking me to do this translation as my *New Year's gift* to him, and you will understand my desire to please him. We were disappointed at not having him here for Christmas, but he will be here for New Year. I am very happy to be working at M. Mantoy's[2] with Louis Pascal.[3] Paul is grown up now, and Joseph[4] is a tall young man. I have a good time in Paris, however I am looking forward to going back to Bosc. Goodbye, dear Grandma. I kiss you with all my heart, wishing you a prosperous and happy New Year.

Mama asks me to send you her fondest regards. I suspect my birds are asking me to send something nice to you, for they are singing their very best.

Your respectful grandson,
Henry de T. Lautrec

P.S. Please be kind enough to wish Urbain[5] and the other servants a happy New Year for me.

Prov.: Schimmel
Pub.: GSE4, GSF4

[1] Since Joyant identifies the author as Salvin, the book was either *Falconry: its Claims, History, and Practice*, by Francis Henry Salvin and Gage Earl Freeman (London, 1859), or *Falconry in the British Isles*, by Salvin and William Brodrick (London, 1855; 2nd edn 1873). Most biographers state that Lautrec translated the entire book.

[2] Lautrec's first teacher at the Lycée Fontanes.

[3] One of Lautrec's maternal cousins; his father, Ernest, was the Prefect of the Department of the Gironde, and his mother, Cécile, was a first cousin of Lautrec's mother. In 1878 Louis Pascal, who was born in 1864, founded a small newspaper, *L'Écho Français*, which printed Lautrec's story, 'L'Histoire du pélican et de l'anguille'.

[4] Paul and Joseph Pascal, Louis's brothers, were born in 1856 and 1861.

[5] A valet in the home of Madame de Toulouse-Lautrec. Cf. Rodat, p. 126.

6 To his mother

[Paris, December 1872]

Dear Mama,[1]

This is to wish you a happy New Year. I should like you to be always happy and in good health. I shall be very good in order to please you.

Farewell, dear mama.

I send you a kiss.

Your
Mushroom

Prov.: Beaute
Pub.: Beaute II, p. 90 (ms reproduced p. 91)

[1] Lautrec evidently wrote this greeting to his mother even though she was in Paris with him.

7 To Mme L. Tapié de Céleyran

Paris, 19 January 1873

My dear Godmother,

Thank you for your nice gift, for which I'm not thanking you soon enough. Oh! how happy I was when Mama opened the letter and gave me ... 50 francs! I never had so much money all at once before. I am as happy as Cinderella, who also had a very generous godmother. We went to see this beautiful story played by puppets at the Miniature Theatre.[1] I now have a very nice cousin staying at the Hotel Pérey: it's Jeanne d'Armagnac.[2] She is 15 years old, but she plays with me. Goodbye, my dear little Godmother: give a kiss for me to Bébé and to Doudou, Bibel, and Poulette as well. You are right in thinking my biggest hug is for you and that I am not forgetting my aunt and uncle. I would ask you to kiss M. l'Abbé[3] for me, only you wouldn't do it.

Your respectful grandson,
Henry

Prov.: Schimmel
Pub.: GSE5, GSF5

[1] A popular puppet theatre, located at 12 boulevard Montmartre in Paris.

[2] One of Lautrec's cousins, later Madame de Castellane.

[3] The Abbé Peyre, chaplain of Céleyran and Lautrec's former tutor, to whom he later referred as 'my Uncle l'Abbé'.

7A *To his mother*

[Paris 19 June 1873]

My dear Mama,

When I was asking you to stay, I had no idea of the pain that a person feels when he is leaving his mama; I call out for you constantly and would be very happy to see you again.[1]

All the same, you can be sure that I'm working as hard as I can, to please you. Today I'm stuck in the house because of the rain. M. Lévi[2] sends you his regards. I'm alone with the Lolottes[3] in the bedroom, since I didn't finish my homework, and am very sorry that I'm not with you. I didn't have time to write English. Yesterday evening the son of Mme Michel, on orders from M. Mantoy,[4] threw me against the bars that support the flight of stairs at the Lycée.[5] I complained to his mother, who ordered him punished. In the morning we went to High Mass.

Goodbye, my very dear and beloved Mama.

<div style="text-align: right">Your dear pet,[6]
H. de T. Lautrec</div>

Say hello to everybody for me.

Prov.: Unknown
Pub.: Beaute, 1988, p. 93 (ms reproduced)

[1] Lautrec was still in Paris, his mother having preceded him to Céleyran (cf. Letter 8).
[2] Cf. Letter 36 Note 3.
[3] His canaries (cf Letter 10 Note 4).
[4] Cf. Letter 5 Note 2.
[5] Lautrec's story may have been conceived in order to get sympathy from his mother; otherwise it does not seem probable.
[6] Lautrec uses the word 'coco'.

8 *To Mme L. Tapié de Céleyran*

Céleyran, 23 August 1873

My dear Godmother,

I am writing to wish you a happy nameday,[1] since it is Monday and the feast day of St Louis. As I am the only one of the grandchildren in the house who knows how to write, I am doing it for all. We leave on Monday for Bosc and I hope you will soon be coming to meet us there again. At the moment I am writing (9 o'clock) Gabriel[2] is being naughty and Aunt Alix[3] is saying she has a good mind to put him in prison with the frogs. Yesterday we saw M. Vié,[4] who found all the sick cured. Aunt Marie Delmas came on Thursday with Bébé Lamothe and we played hide-and-seek. Yesterday we went up to the top of le

Pech,[5] and saw François and Augustin Renaud, the latter was scared of us. The storm made an awful racket last night, but Annou and Madeleine didn't even hear it. The lightning struck near Marie Bouisson's house, but no one was hurt. Goodbye, dear Godmother. Mama hopes you have a nice name day, also Aunt Alix, who hasn't had time to write, she has been so busy. Goodbye, and a thousand, thousand kisses.

<div style="text-align:right">Your respectful godson,
Henry</div>

P.S. Hello to Miss Rosette.[6]

Prov.: Schimmel
Pub.: GSE7, GSF7

[1] The feast day of St Louis, 25 August (his grandmother's name was Louise).
[2] Gabriel Tapié de Céleyran (1869–1930), son of Amédée and Alix Tapié de Céleyran; Lautrec's cousin and later his faithful friend and companion, who often appears in his paintings.
[3] Cf. Letter 3 Note 1.
[4] Evidently a family doctor. He is mentioned again in 1881 (cf. Letter 63).
[5] Le Pech Ricardelle, a wine-growing estate, had been the property of Lautrec's great-grandfather in the eighteenth century, like the estate of Céleyran which it adjoins. Around 1882, it was acquired by his parents: cf. Letter 72 Note 1.
[6] A servant in the household of Madame Tapié de Céleyran.

9 *To Madeleine Tapié de Céleyran*

<div style="text-align:right">[Paris, January 1874]</div>

My dear Madeleine

I hasten to answer your very well-written letter. You made me think about myself and I am ashamed of scribbling as I do. I am anxious to be having a good time with you all in the Gravasse[1] or the big driveway at Céleyran. Do you remember Mme de Béon, at whose house at Arcachon[2] I skinned my nose? She has made me a present of two pretty little canaries, which are getting along famously with the others. During my holidays I went to an American circus, where I saw eight elephants who walked on their heads. There was a cage full of lions who would have scared Raoul[3] very much. I would like very much to go walking with you on the boulevards, where there are so many dolls you wouldn't know which one to pick. Please thank my godmother and aunt Alix for me for their nice letters.

Goodbye, dear cousin, I wish you a happy New Year, sending you all my love, and ask you to do as much for me with all the others.

<div style="text-align:right">Your cousin who loves you very much,
Henri de T. Lautrec</div>

Prov.: Schimmel
Pub.: GSE8, GSF8

[1] A forest near the Château du Bosc.

[2] A summer resort in the Department of Gironde, near Bordeaux. Lautrec later spent many holidays there.

[3] Raoul Tapié de Céleyran (1868–1937), Lautrec's cousin, son of Amédée and Alix Tapié de Céleyran.

10 *To Madeleine Tapié de Céleyran*

<div align="right">Paris, 29 March, 1874</div>

My dear Madeleine,

They tell me you would like to have a letter from me. There's nothing I'd like better than to write to you, providing you write back. I think you would have an awfully good time seeing all the dolls here dressed in blue, white, pink, etc. ... I'd be glad to pick one out for you, but they cost too much for my purse. Raoul would rather watch all the thousands of omnibuses and carriages rolling along. Gabriel would prefer the sweet shops with barley sugar in all different colours and the Punch and Judy shows; I think Rémi would like that, too; as for Emmanuel,[1] we'll find out later what he'd like. I have a French teacher who puffs like a *grampus*, and an English teacher who takes *snuff* and gives us exercises to do with stories about *cotton* and *thistles*, but in spite of that I like them very much.[2] I must tell you that Aunt Pérey[3] has let her little bird be eaten by her cat. At first she scolded her precious *Moumoune*, but pretty soon they made it up. *Lolotte*[4] has grown tame and will perch on your finger; when she's out of the cage *Lolot* sings like mad wanting her to come back, and when Lolotte gets back he greets her with big pecks. Adine has had nine babies, now reduced to two, the others having taken a bath in the Seine from which they will never return.

Goodbye, my dear Madeleine. Give my best to Grandma Louise, your Papa, your Mama, Mlle Albanie, Aunt Armandine,[5] Doudou, Gabriel, Odon and Emmanuel, who will hardly understand anyway. A thousand, thousand kisses.

<div align="right">Your loving cousin,
H de T Lautrec</div>

Prov.: Schimmel
Pub.: GSE9, GSF9

[1] Emmanuel Tapié de Céleyran (1873–1931), Lautrec's cousin, son of Amédée and Alix Tapié de Céleyran.

[2] In the eighth form at the Lycée Fontanes at the end of July 1874 the French teacher was M. Jammes and the English teacher M. Legrand. Lautrec won First Prizes in French grammar, English language, Latin prose and Latin unseen, Third Honourable Mention in History–Geography, Fifth Honourable Mention in Arithmetic, and Second Honourable Mention in Recitation. Others in this graduating class were Maurice Joyant (cf. Letter 69, Note 2) and the future painter, lithographer Jean Veber (1864–1928).

³ The owner of the Hôtel Pérey (cf. Letter 4 Note 1).

⁴ Lolotte and Lolot are obviously the canaries mentioned in Letter 9. Cf. Letter 4, where a canary is called Lolo.

⁵ Armandine d'Alichoux de Sénégra (d. 1893) was the sister of Julie de Sénégra, first wife of Léonce Tapié de Céleyran; her nickname was 'Tata'. She helped to supervise Lautrec's early education.

11 *To an aunt*

[Paris, 30 September 1874]

¹My dear Aunt,

I thought about writing you a letter with a spider as my heraldic device. Mama felt that I would be giving you a nasty animal as a gift, but I pointed out to her that you trapped passing hearts with your kindness just as the spider traps all the flies ...

Prov.: Unknown
Pub.: HD, p. 18

¹ Fragment of a letter.

12 *To Mme L. Tapié de Céleyran*

Paris, 31 December 1874

My dear Godmother,

I am sending you a quail as messenger of my best wishes for a happy New Year. I am instructing him to tell you that your godson still loves you very much and hopes to spend a good part of this coming year with you. Raoul is very lucky to be with you all the time.

Last night Brick¹ went to the Vaudeville with Papa, his impressions of the theatre amuse us very much, but they would be too long to put down here, he'll tell you all about them himself. I am having a few days' holiday, which I don't mind at all. I have bought a very amusing toy called an American Circus. There is a little Polish boy here who has a room just filled with toys. Goodbye, my dear Godmother, and please pass along my best wishes for a happy New Year to my aunt and uncle, not forgetting M. l'Abbé and Mlle Albanie. A kiss for all my cousins in a line, starting with the last and ending with the first. Wish a happy New Year for me to Annou and Rosette. I kiss you with all my heart, dear Godmother, begging you to accept the fondest wishes of

Your godson,
H de T Lautrec

Prov.: Schimmel
Pub.: GSE10, GSF10

¹ Lautrec's father's steward, whose death is mentioned in 1881 (cf. Letter 68).

13 *To his mother*

[Neuilly, September–October 1875]

[1]My dear Mama,

I have received Marraine's [Godmother's] letter yesterday. We could not go out today because it rained very much. Miss Braine[2] brings me decalcomanies, and I do them well. M. Verrier[3] does all he can for you may be satisfied on your arrival. I am very happy. I will do all I can for you may be satisfied. We have just taken a little groom for the pony. Goodbye my dear mama, I kiss you very much, and everybody too.

Your loving son
H. de T. Lautrec

My kiss

Prov.: Schimmel
Pub.: GSE11, GSF11

[1] This entire letter was written in English.
[2] An Irish governess who remained with the family for many years. Lautrec still refers to her in 1885 (cf. Letters 107, 109).
[3] A physician who prescribed a treatment for Lautrec's legs.

14 *To Mme L. Tapié de Céleyran*

[Paris, September 1875]

My dear Godmother,

I just got Mama's letter and will answer it right away. Papa came the day before yesterday and was satisfied with my legs, also with my health.

On Thursday we had a big dinner party and I made the place-cards. Well, dear Godmother, I just had a silly notion that if I could leave my legs here and go off in an envelope (just to kiss Mama and you), I'd do it.

Today I'm going to the Zoological Gardens with Miss Braine. I'm afraid poor Brick[1] won't be coming to Paris for a long, long time. Tell Mama we have to go to Rueil[2] on Thursday. Raoul must be a big boy now, and Gabriel too. When you see Mlle Ronron again, say hello to her for me.

I'm feeling marvellous and would like to lose weight but I don't

think I'll be able to do anything about it. Goodbye now, dear God-
mother, I kiss you with all my heart and Mama as well.

<div style="text-align: right">Your respectful godson,

H. de T Lautrec</div>

Prov.: Schimmel
Pub.: GSE36, GSF37

[1] In another letter Lautrec mentions Brick's death (cf. Letter 68).
[2] A town near Versailles, where Lautrec's uncle, Georges Séré de Rivières, presumably lived (Cf. Letter 23 Note 5).

15 *To his mother*

<div style="text-align: right">Neuilly, 22 September [18]75</div>

[1]My dear Mama,

I was very glad of receiving such a pretty letter and I will tell you
very good news. My Greek master was very satisfied with me and he
put on a piece of paper 'I am very satisfied of the lessons as well as of
the tasks.' He gave me a Latin version [unseen] to do. I have read my
Latin Grammar this morning and I am going to do Miss'[2] tasks.
Yesterday I went to the bath and I have looked for the plate. M.
Verrier[3] was very satisfied with my legs. When you will return I hope
you will find me well. Give my love to every one and return soon. If
I had wings I should go to see you but I have none. I finish my
letter by telling you that everybody send you his compliments and
particularly your boy who kisses you 10000000000000000 million times.

<div style="text-align: right">Yours affectionate boy

Coco de Lautrec</div>

P.S. Don't drawn you or send me a telegram [*sic*]

<div style="text-align: right">My kiss[4]</div>

Prov.: Dortu
Pub.: HD, p. 20 (manuscript reproduced p. 21)

[1] This entire letter was written in English.
[2] Cf. Letter 13 Note 1.
[3] Cf. Letter 13 Note 2.
[4] Lautrec drew a small circular figure representing a kiss.

16 *To Mme L. Tapié de Céleyran*

<div align="right">[Paris] 2 November 1875</div>

My dear Godmother,

It's not very long since I last wrote to you, but I must thank you for the nice gift you had Mama bring me. I know just what you would want me to do with it, that is, have as much fun as possible with it. On Thursday I go to be examined and hope to be admitted to the Catechism of the First Communion.[1] The director's name is M. l'Abbé Paradis; he has promised me he'll put me in the first row. I shall do the best I can to be well prepared for my First Communion and I hope you will come to watch me take it. Goodbye, by dear Godmother. I kiss you with all my heart and beg you to give my warmest respects to my Aunt Joséphine; also please give all my relatives at Albi all my regards.

<div align="right">Your affectionate godson
Henry de T Lautrec</div>

Prov.: Schimmel
Pub.: GSE12, GSF12

[1] Lautrec's First Communion took place on 12 June 1876 at the church of St Louis d'Antin in Paris.

17 *To Mme R. C. de Toulouse-Lautrec*

<div align="right">[Paris, December 1875]</div>

My dear Grandma,

I regret very much not being able to wish you a happy New Year in person. I haven't been as lucky as my cousins in spending vacations at Bosc. I haven't any idea when I shall be able to see you again; I hope it will be as soon as possible. I have been having a good time during the Christmas holidays and hope the same for the New Year. I have been with Mama to see M. Princeteau's[1] big picture showing Washington on horseback.[2] He is going to send it to the big exhibition in America. For Christmas I bought a beautiful book, drawn by CRAFTY, on the Acclimatizing Gardens.[3] The falconer whom Papa admires so much is in Ireland just now and I am consoling myself with my friend Toby.

Goodbye, my dear Grandma, I'm not very good at letter-writing, but I love you very much and kiss you with all my heart, wishing you a happy and prosperous New Year.

<div align="right">Your respectful grandson,
Henry de T Lautrec</div>

Prov.: Schimmel
Pub.: GSE13, GSF13

[1] René Princeteau (1843–1914), a French painter born in Libourne near Bordeaux. A deaf-mute, he was a good friend of Lautrec's father and a teacher who specialized in horse and hunting scenes. He influenced Lautrec's early pictures of these subjects and taught and advised him until the early 1880s. He remained a family friend until the end. He exhibited at the Salon of 1868 and for years afterwards.

[2] *The 19th of October, 1781, Washington*, later shown at the International Exhibition in Philadelphia from 10 May to 10 November 1876. Cf. United States Centennial Commission, *International Exhibition 1876: Official Catalogue* (Philadelphia, 1876), Department of Art, p. 38, No. 193.

[3] *Jardin d'Acclimatation*, by J.C. Fulbert-Dumonteil (Paris, 1874), illustrated with drawings by Crafty. The latter, whose real name was Victor Géruzez (*c.* 1840–1906), specialized in drawing horses for publications such as *Paris à Cheval*, *La Province à Cheval*, etc. The garden, in an enclosed part of the Bois de Boulogne, was founded in order to introduce foreign plants and animals into France and acclimatize them.

18 *To Mme L. Tapié de Céleyran*

[Paris, late December 1875]

My dear Godmother,

I am late in writing and this letter, intended to arrive before New Year's Day, will probably get there afterwards. I wrote what little I had to tell to Grandma Gabrielle[1] and she will pass it on. I send you a big hug, too, which is not a mere repetition, and please wish Aunt Alix (*to whom I shall write soon*) a happy New Year for me, also my uncle, and not forgetting M. l'Abbé, who, I believe, is with you. Thank you for your lovely presents and with that another kiss and a happy New Year!!!

Your grandson and godson,
Henri

Prov.: Schimmel
Pub.: GSE28, GSF28

[1] This was probably in Letter 17.

19 *To his Mother*

[Château du Bosc, 1876]
[4 sketches at the top of letter of sails, etc.[1]]
[2]My dear Mama,

Things have been alright since you left. I went for a walk yesterday morning and this morning as far as the lightning tree. I went along when Papa took Grésigue[3] for a walk.

Prov.: BPL
Pub.: Toulouse-Lautrec

[1] Cf. Dortu D.607.
[2] Fragment of a letter which was probably written in 1876.
[3] Cf. Letter 20 Note 1.

20 *To his Mother*

[Château du Bosc, 1876]

My dear Mama,

Your nice letter made everybody so happy. I am going for walks the same as always, and this morning I went along hunting with Papa and Grésigue,[1] who flew up into the top of a tree and didn't want to come down. Aunt Alix[2] asks me to tell you that Laroque will be sure to be waiting for you at the 8 o'clock train on Wednesday morning. She would very much like you to come and see her for a little while on Tuesday evening. Poor Doudou died last night. Béatrix[3] has lost a little of her wobbliness.[4] I have been having fun building a hippopotamus trap and I am going to make one to catch the mouse. On Thursday I went all the way down to the bottom of Vergnasse Brook (I think that's what they call it).

Goodbye, dear Mama. I kiss you with all my heart, and ask you to do as much for me to Aunt Joséphine.[5]

Your son, who wants to see you soon,

Henri de Toulouse Lautrec

P.S. Please bring me four drawing-board pins for spares.

Prov.: Schimmel
Pub.: GSE6, GSF6

[1] The name of one of the falcons kept by Lautrec's father for hunting.

[2] Alix Tapié de Céleyran (cf. Letter 3 Note 1).

[3] Béatrix Tapié de Céleyran (1875–1913), one of the daughters of Alix and Amédée Tapié de Céleyran, and Lautrec's cousin and goddaughter. He usually calls her 'Kiki'.

[4] Lautrec uses the word 'guincharderie', translated as 'wobbliness'. It is evidently an invention of his based on the patois word 'guincher', 'balance'.

[5] Lautrec's great-aunt; known as Mademoiselle du Bosc, she owned the Hôtel du Bosc in Albi, where he was born.

21 *To Robin*

[Paris, *c.* 1876]
Letter to Robin,[1] a friend in
Rouen for the first performance
of *Le Cid*[2]

My dear Friend,

This is to tell you about the greatest event of the century; the most glorious conquest of the French spirit ...

You will undoubtedly remember that very modest young author[3] whose natural aptitudes looked so promising; since he was your compatriot, I made him as welcome as I could in Paris, and gave him every piece of advice and every facility that was in my power. Habit brought us together; he called me his father. Well, one day he told me, I've found a good subject in a Spanish author.[4] He set to work. The play is called *Le Cid*.

It was performed. I'm incapable of telling you the effect it had. The subject is very moving. The Cid loves Chimène. But her father has insulted the Cid's father, and the Cid has to avenge the honour of his name; he kills his fiancée's father; but he saves Seville, the scene of the action, by repelling the Moors; however, Chimène can't marry him and she selects a champion who will fight the Cid and she will marry the winner; the Cid * him * she doesn't marry him, she makes him wait for her consent.

Nothing like it has ever been shown in any theatre as regards hideous crimes and horrible massacres. Here are two great emotions locked in combat: love and honour—the latter more imperative, the former more irresistible; the Cid satisfies both.

HTL[5]

Prov.: Birtschansky

[1] This is not a letter but a school exercise in the form of a letter. Lautrec's copy of *Le Cid* is included in *Théâtre classique annoté par Ad. Régnier*, Librairie de L. Hachette et Cie (Paris, 1853) (Collection Schimmel). Robin may be Robin Langlois. Cf. Letter 497 Note 1.

[2] *Le Cid*, a tragi-comedy. 'The production, in 1637, of this play very different in character from any that had preceded it, marked an epoch in the history of French drama' and 'inaugurated French classical tragedy'. (Cf. Harvey and Heseltine, pp. 136, 137, 169, 170, Braun, pp. 46, 47, 65.)

[3] Pierre Corneille (1606–84), writer of classical drama, born in Rouen. His many plays, including *Le Cid*, created a new form of dramatic art.

[4] *Las Mocedades del Cid*, a play written in 1621 by Guilhem de Castro.

[5] There are seven sketches on the two sides of this single page, not in Dortu.

* Illegible.

22 *To Mme L. Tapié de Céleyran*

[Paris, December 1876]

My dear Godmother,

I would very much like to be at Céleyran with all the cousins to wish you a happy New Year. I can better say what I feel by talking than by writing. Which means I must be satisfied with wishing you a happy New Year and the best of health. I won't add 'and a numerous posterity' as they do in stories, for the reason you already have them, with me having the honour of being No. 1. My mouth is just watering

to try the chocolate and the *crottins*.[1] Thank you very much for remembering my sweet tooth. Would you kindly tell M. l'Abbé that thanks to him my professor is very pleased with my Greek verbs.[2] Louis Pascal is big and strong and your godson is a handsome fellow with a beautiful moustache. Joseph is a tall young man who hates school now that he's getting ready for his baccalaureate. Unfortunately Louis is one class behind me in school.[3]

Goodbye, my dear Godmother. I send you a great big package of good wishes for the New Year, and am asking you to divide up a part of them among everybody while keeping the biggest part for yourself. I kiss you with all my heart.

<div style="text-align:center">Your godson, who loves you very much
Henry de T. L.</div>

P.S. My birds are singing you their best wishes for a happy New Year. Kiss my goddaughter[4] for me, until she is able to do as much for her godfather. Mr Willie Matheson[5] sent me this pretty little picture for her.

The chocolate has just come. Thank you!

Prov.: Schimmel
Pub.: GSE14, GSF14

[1] A kind of pastry, a speciality of Albi.
[2] Having left the Lycée Fontanes in January 1875 because of ill health, Lautrec may have been in another school but was probably being tutored.
[3] Most biographers state that Louis and Lautrec were in the same class, but that was no doubt at the Lycée Fontanes, his first school (cf. Letter 5 Note 3).
[4] Béatrix Tapié de Céleyran (cf. Letter 20, Note 3).
[5] Probably an English groom employed by Lautrec's father.

23 *To Mme R. C. de Toulouse-Lautrec*

<div style="text-align:right">Paris, 1 March [18]77</div>

My dear Grandma,

I should have thanked you long before this for the book by Stonehenge,[1] but I haven't much time for correspondence. I have more free time just now because Mama has taken me out of the professor's classes[2] so they can give me the electric brush treatment[3] that once cured my Uncle Charles. I am awfully tired of limping with my left foot now that the right one is cured.[4] Hopefully it's only a reaction after my treatment, so Dr Raymond says; I already feel better. We are definitely going to take the waters in the Pyrenees this year, won't you

come there with us? ... My Uncle Charles left us the day before yesterday and I am very sorry that he has gone. Papa is still here. The day my Uncle Charles left, Mama and I had dinner at my Uncle de Rivières[5] house. My Uncle de Castellane and his wife and Monsieur and Madame de Bonne[6] were there. Hélène[7] is awfully sweet and polite. Monsieur de Bonne advised her to marry *anyone at all* rather than stay an old maid. My Uncle Odon and his *family* are having fine sunny weather since they moved. Raymond is starting to speak English and Odette to understand it.[8] Raymond can sing a lot of songs and continues to like me very much. Odette has become more pleasant, but still persists in not wanting to talk, although she understands two languages.

Goodbye, my dear Grandma. I kiss you with all my heart, likewise Aunt Joséphine. Please don't forget to give my fondest regards to all the family and above all to my Uncle the Abbé. Mama wants me to tell you she is thinking of you, as is Papa.

<div align="right">Your respectful grandson,
Henry de T. Lautrec.</div>

Prov.: Schimmel
Pub.: GSE15, GSF15

[1] The pseudonym of John Henry Walsh (1810–88), an English writer who specialized in books on sports and physical fitness. The most popular was the *Manual of British Rural Sports*, published in 1856 and in many subsequent editions until 1878.

[2] See Letter 22, Note 2.

[3] Evidently a kind of massage intended to stimulate the circulation in his legs (cf. Letters 78 and 138).

[4] This shows that, contrary to what is usually stated, Lautrec had persistent trouble with his legs even before breaking them.

[5] Georges Séré, Baron de Rivières (b. 1849), grandson of namesake who had married Caroline d'Imbert du Bosc (of the family of Lautrec's grandmothers). The younger Georges was the Procureur de la République in Fontainebleu, and was known as 'le bon juge' because of his leniency.

[6] Distant relatives of Lautrec; listed as such in the obituary notice of Raymond-Jean-Bernard de Toulouse-Lautrec, 23 December 1888 (Collection Schimmel) Cf. Letter 7, Note 2.

[7] Hélène Séré de Rivières, sister of Georges. She married Philippe Guinau de Mussy in 1881.

[8] Raymond and Odette were the children of Odon and Émilie de Toulouse-Lautrec, the former being a younger brother of Lautrec's father. Odette was also called 'Dédette'.

24 *To Charles de Toulouse-Lautrec*

<div align="right">[Paris] Easter [April 1878]</div>

My dear Uncle,

Everything is steadily improving. The appetite has more than come back, it's ravenous. The doctor says not to get up yet to be on the

very safe side. But probably he will allow it tomorrow.[1] Mama is very cheerful and has a good time reading and talking. Fondest regards to all.

<div align="right">Your nephew,
Henri.</div>

Prov.: Schimmel
Pub.: GSE115, GSF117

 [1] Cf. Letter 23 Notes 3 and 4, and Letter 25.

25 *To Mme R. C. de Toulouse-Lautrec*

<div align="right">[Paris] 17 April [1878]</div>

My dear Grandma,

 I am writing to have a little chat with you today. I think a lot about Adèle[1] now that she is *married* and must admit it strikes me as very extraordinary. Awfully comical, isn't it, having a new cousin who wasn't so at 8 o'clock, but is so at noon. Too bad I couldn't have been with my Uncle Charles to stop him from having indigestion from so many truffles!!!!!! I have been feeling much better the past four days and am able to be up and around the house. But I haven't got back to going outdoors yet and Mama still hasn't made up her mind about it. Papa is waiting for M. Ramier and still hasn't come back, which has been a disappointment to M. de Chantérac, who had been stopping over at the Hôtel Pérey, hoping to see him. He is going to leave for Orléans because his grandmother is ill. Uncle Odon is posing on a horse for M. Princeteau.[2] Aunt Odette[3] is feeling very well. Raymond is hardly coughing at all any more; Odette is the one worst off now, but it's not serious. I have started a theatre with Louis Pascal which has 60 (puppet) actors. My Béon canary is hatching 3 eggs, promising additions to the family.

 Goodbye, my dear Grandma. I kiss you with all my heart and ask you to give my fondest regards to Aunt Joséphine and to my uncle and aunt. Please pass along my congratulations to Adèle when she is not so busy; and don't forget to remember me to my Uncle the Abbé.

<div align="right">Your respectful grandson,
Henry de TL</div>

Prov.: Schimmel
Pub.: GSE16, GSF16

 [1] Adèle Bouscher, daughter of Adolphe de Gualy de St Rome and Zoë Séré de Rivières. She married Joseph de Bouscher de Bernard.
 [2] Probably one of Princeteau's entries in the Salon of 1878: No. 1878, *Portrait équestre du comte de T.L.*
 [3] i.e. Aunt 'Odon', his uncle Odon's wife. Cf. Letter 51, where Lautrec also refers to her in this way.

26 *To Madeleine Tapié de Céleyran*

[Paris, April 1878]

My dear Madeleine,

Thank you for your letter and for the portrait of our goddaughter.[1] I like it very much, especially the eyes, though the rest could be improved on; she stretches out her fingers like a *wand*[2] although it would be nice if she did have them that long so as to play the piano well and charm me in my old age. The others are very good likenesses and I take great pleasure in seeing them again; but I would like to have yours, too, and also Raoul's. Tell Raoul that his friend Bébelle is sitting on three eggs; I hope to have some *little ones*[3] out of them. I am hoping to see you all again and have some fun. I feel all right, but I'm still not very nimble. I have a good time playing comedies with Louis Pascal. We have 60 puppets about 10 centimetres tall. They are worked from the end of wires. Tell me what happened to my chrysalides. Tell M. l'Abbé that my *Greek Grammar* is having a rest and to the great joy of all the students they have done away with Greek Roots. Be so kind as to remember me to him; I hope soon to serve Mass for him.

Goodbye, my dear Delon, I kiss you on both cheeks, also all your brothers and sisters and especially my goddaughter: Also kiss Grandma and your Papa and Mama for me, and don't forget to give my best to Mlle Albanie and everybody.

Your cousin
H. de T. Lautrec

P.S. Raymond was very happy to see his friend Toto again.

Prov.: Schimmel
Pub.: GSE17, GSF17

[1] Béatrix Tapié de Céleyran.
[2] Lautrec writes 'mouinette' (*mouillette*—a piece of bread one dips into a soft-boiled egg (*œuf à la mouillette*), a *baguette*.
[3] Lautrec writes 'cagonits', a Gascon term for 'little ones'—in this case, little birds.

27 *To Raoul Tapié de Céleyran*

Albi, 22 May [1878]

[1] My dear Raoul,

I have to call upon my mother for help in order to write to you, and, believe me, this is not easy or pleasant. As you've been told, I

broke my left leg. They've tied me up in an apparatus, and all I have to do is be still. In this way my leg doesn't hurt. I am sending you my picture, I hope you'll like it. Give it to your mother or put it into a small frame and hang it over your bed. Please ask Augé[2] for me which address the carriages such as the sleigh and the brougham are being sent from and write to me quickly. Grandma is fine and Rosette keeps me company with stories about my canaries. Be sure to tell everyone that my leg no longer hurts and that I'm anxious to get back to school. Give my love to everybody, and especially to my little Finet, along with some good advice about not breaking his little paw.

<div style="text-align: right">

Your cousin,
Henry—Broken-Paw!!!

</div>

Prov.: Unknown
Pub.: Attems, p. 180.

[1] This letter was dictated by Lautrec to his mother and addressed to his cousin, Raoul Tapié de Céleyran.
[2] Cf. Letter 28 Note 2.

28 *To Madeleine Tapié de Céleyran*

<div style="text-align: right">

[Albi, May 1878]

</div>

My dear Madeleine,

I'd like to know whether Raoul has received my letter asking him to find out at Augé's,[2] through you, the address where the sleigh and brougham are coming from. Write to me as soon as you find out. I'm not having too bad a time and I kiss you.

<div style="text-align: right">

Henry

(this is my first letter)[3]

</div>

Mother Superior,

Emery is feeling better. We have bought a donkey and made a carriage like the dog-cart. Tell Moujik[4] that his daughters will be going out riding in the donkey cart, a picture of which follows [a pen sketch].
Tell Monsieur Tapié[5] to write to me, or write to me yourself.

<div style="text-align: right">

Your devoted
Philéas Fogg[6]

</div>

Prov.: Schimmel
Pub.: GSE18, GSF18

[1] This letter is written on a folded sheet of paper; the first page is addressed to Madeleine, while the third page contains the facetious letter published below.

[2] A shopkeeper in Narbonne, who at this time was ordering from Paris a child's dog-cart and brougham for Lautrec and his cousins. Lautrec himself laid out miniature roads, like those in the Bois de Boulogne, on the lawn at the Château du Bosc, on which he planned to play with his cousins.

[3] Lautrec broke his left thigh bone toward the end of May 1878, when he slipped from a chair onto the floor (cf. Letter 34). Hence he means his first letter since the accident, or rather his first written one, since he had dictated to his mother a letter for his cousin Raoul on 22 May (cf. Letter 27).

[4] The Russian word for 'peasant', familiarly used in France. It probably refers to Lautrec's uncle, Amédée Tapié de Céleyran. The daughters mentioned would be Geneviève, Béatrix, and Madeleine herself.

[5] Probably Lautrec's cousin, Raoul Tapié de Céleyran.

[6] Lautrec was enamoured of Jules Verne's *Le Tour du monde en quatre-vingts jours*, whose hero was Phileas Fogg. It was first published in 1873 and performed as a play in 1874.

29 *To an unidentified correspondent*

[Albi, June 1878]

[1] I am completely alone all day long, I read a little, but ultimately I get a headache. I draw and paint as much as I can, so much so that my hand gets tired of it, and when it starts to get dark I wait to find out whether Jeanne d'Armagnac will come near my bed. Sometimes she comes, and I listen to her speak, not daring to look at her, she is so tall and beautiful and I am neither tall nor beautiful.

Mr One-Foot[2]

Prov.:Unknown
Pub.: HD, p. 23

[1] Fragment of a letter.
[2] Lautrec signs 'Monsieur Cloche-Pied'.

30 *To Madeleine Tapié de Céleyran*

[Albi, July 1878]

[1] ... Now I'm having the cormorants swim in the pools of the gardens. I've drawn a dog-cart with the driver dressed in green and a man in red sitting in the back seat. Please have the Abbot give my 'boney'[2] cousin 'strict' orders to give me news about the children's vehicles that Augé, a dealer in Narbonne, has been ordered to send me from the capital ...

Philéas Fogg

Prov.: Unknown
Pub.: Attems, p. 53

[1] Fragment of a letter.

[2] Raoul Tapié de Céleyran (cf. Letters 27, 31). According to Attems, that is the way Lautrec referred to his cousin.

31 *To Mme L. Tapié de Céleyran*

[Albi, Mid-July 1878]

My dear Godmother,

Thank you for your unanimous good wishes relative to the name day of my great patron, the famous Saint Henry[1] (whose name day, parenthetically, is also my own). But if you would like to fill my cup of joy to overflowing, which to my over-excited imagination is already brimming to the ears from seeing I have not dropped as much as a single rung in your affectionate esteem, please see to it that the following carefully weighed request is passed along to M. l'Abbé Peyre, namely, that I would very much like him to intimate to my boney cousin[2] a strict order to be kind enough to send me at once a little epistle giving me news about the whole personnel at Céleyran and of the children's vehicles that Augé, the shopkeeper at Narbonne,[3] has been told to have sent to me from the Capital of France. Now I have the honour of informing you that, in person no less, flesh and bone, I delivered myself in a chariot drawn by fiery horses to the Metropolitan church of this Albigensian city, there to consummate an audition of the Divine Office. And now, having given you this patibulary information forasmuch as it has to do with the improvement of my locomotor system, I will proceed to inform you about the mild constipation suffered by my person from the furious manducation of a certain paste made from the fruit of the quince. Having no more to relate, I shall take the liberty of pressing a tender kiss on your right cheek, begging you to do the same for me to everybody.

Your crutch-walking godson,[4]

Henry de Toulouse

Prov.: Schimmel
Pub.: GSE19, GSF19

[1] The feast day of St Henry, 15 July.
[2] Cf. Letter 30 Note 1.
[3] Cf. Letter 28 Note 2.
[4] His leg was in plaster for forty days; he used a crutch for some time after.

32 *To Raoul Tapié de Céleyran*

[Albi, July 1878]

[1]My dear Raoul,

Augé had said that he would send me a brougham and a dog-cart
... but now here you go talking to me about a landau. Tell him bluntly
that if he doesn't send these vehicles to me, well, I don't want any
others (unless you can find me a light two-wheeled carriage) and if
there are none, a four-wheeler: with the horse unhitched, I want black-
and-yellow harnesses, and a dog-cart. Remember ... a two-wheeler, if
it's possible. Tell Godmother to take care of my order. Send your
carriages as a model, and also tell me what the landaus are like.

Philéas Fogg

Prov.: Unknown
Pub.: HD, p. 17
[1]Fragment of a letter.

33 *To Mme L. Tapié de Céleyran*

[Albi, late August 1878]

My dear Godmother,

I regret very much not being able to wish you a happy name day in
person as in the two previous years. But although the personage who
had the inopportune idea of breaking his leg cannot be with you to
express his best wishes in his big ugly voice (but not big enough just
the same to wish you a happy name day so that you'll hear it in
Lamalou),[1] his heart will be with you on the Day of St Louis.[2] Happy
name day! happy name day!...

I kiss you ninety-two times

Your godson,
Henri TL

Prov.: Schimmel
Pub.: GSE20, GSF20

[1]Lamalou-les-Bains, a spa in south-west France, in the Department of Hérault, between Albi and
Céleyran. Lautrec spent the summer of 1881 there.
[2]The feast day of St Louis, 25 August cf. Letter 8 Note 1.

34 *To Charles Castelbon*

[Albi, 2 September, 1878]

My dear Charles,[1]

I'm sure you'll forgive me for not writing to you sooner when I tell you the reason for this delay.

I fell off a low chair onto the ground and broke my left thigh. But it's mended now, thank God, and I'm beginning to walk with a crutch and an assistant.

I'm sending you the first watercolour I've done since I got back on my feet. It's not very nice-looking, but I hope you'll look simply at the intention, which was to give you a souvenir.

We don't know yet when we'll be able to go to Barèges.

My grandma and my cousins are going, but the doctor is afraid that the waters won't be good for me.

My uncle Raymond de Toulouse came to visit me, but he wasn't able to tell me anything about you.

Goodbye, my dear friend. Mama asked me to pass on her best wishes to you and yours. Please remember me to your mother and your sister.

<div style="text-align: right">Regards,
Henry de Toulouse-Lautrec</div>

P.S. Hôtel du Bosc, rue École Mage, Albi, Tarn.

Prov.: Albi
Pub.: HD, pp. 19 and 24, and Kinneir, p. 25.

[1] The envelope is addressed to Monsieur Charles Castelbon, Puylaurens, Tarn.

35 *To Mme R. C. de Toulouse-Lautrec*

[Céleyran, late December, 1878]

My dear Grandma,

Every letter that comes reports snow, snow...!!! Papa wrote just this morning that there's been snow for twenty days[1]...!!! Here, on the contrary, Winter's Down has only briefly whitened the roofs. Uncle Amédée has killed four woodcocks, and a wounded one gave him a brave fight. It was nice weather for Midnight Mass and they sang Christmas carols in the dialect, but we had to do without the *Minuit Chrétien*[2] when Uncle Albert[3] failed to show up. Kiki is very changeable and as wilful as can be. We are impatiently waiting for the Soréziens[4] on Tuesday. I was very happy to learn that Zibeline[5] did so well hunting rabbits, please give her my congratulations and encouragement. I will write to Papa about her exploits.

Goodbye, dear Grandma. My most sincere wishes for a happy New Year to you, Uncle Charles, and Aunt Émilie, whom I ask you to give a hug for me.

<div align="right">Your respectful grandson,
Henry de Toulouse Lautrec</div>

P.S. My best, if you please, to Lolo.

Prov.: Schimmel
Pub.: GSE27, GSF27

[1] The winter of 1878–9 was the longest cold spell in Paris memory. Cf. Félix Buhot's etching *L'Hiver à Paris 1879* (B128) and Simond, p. 189.

[2] A Christmas carol, known in English by the French name *Cantique de Noël*.

[3] An uncle whom Lautrec mentions again in the 'Cahier de Zig-Zags' (cf. Letter 56), and again as being late for a rendezvous.

[4] Cf. Letter 43 Note 6.

[5] A ferret whch belonged to Lautrec.

36 *To Madeleine Tapié de Céleyran*

<div align="right">Pension Internationale, Nice [Alpes Maritimes January–February 1879][1]</div>

My dear Déloux,[2]

After a fine trip in the company of a bishop we are settled in the Pension Internationale. It's a pretty hotel, surrounded by a fair-sized garden planted with palms and aloes. Coming on the train we saw Cannes and the sea. It is excessively pretty. It made me think of the Villa des Cactus, the Pearl, etc. Arriving at Nice I saw a little boy who looked exactly like David Louzéma except for the way he was dressed. We are going to take a walk on the Promenade des Anglais, which is magnificent. It runs along by the sea and you can watch tartans, cutters, etc., etc. The harbour is splendid compared with anything I've seen up to now. There are quite a few merchant vessels and an English yacht that is a veritable jewel. They rent boats for sightseeing, but Mama is afraid to get in them. Monsieur Lévi[3] and his sister have welcomed us with open arms, but we haven't yet seen Mme Peragallo. Monsieur Lévi goes to Monaco twice a week to play. There's a little nine-year-old Russian girl here who speaks French and German. The food is all right but dinner is too long, even though there are five waiters in tails lined up to serve it. One of them is very funny, and skips all the time. They are going to give a ball next week. We are eating excellent tangerines, but the Nice oranges are as bad as the ones with which I used to play 'Pretty Baby'.[4]

Goodbye, my ideal cousin, I respect and admire you and ask you to give my regards to Grandma, Tata, your Mama, your Papa, Uncle

Odon, Aunt Odette, Mademoiselle Maurin, Odon, Toto, Bibou, Kiki (kiss her fifty-three times), little Ermaine,[5] Raymond, and Odette. Once again please be assured of my most complete admiration.

Your graceful cousin,
Henry de Toulouse Lautrec

P.S. Give my compliments to all the servants.

Prov.: Schimmel
Pub.: GSE22, GSF22

[1] Lautrec was in Nice, accompanied by his mother, to recuperate from his leg injury. The Pension Internationale was located at 4bis rue Rossini.
[2] Madeleine Tapié de Céleyran.
[3] A friend who is also mentioned in Letter 38.
[4] i.e. making figures and dolls out of fruits and vegetables.
[5] Ermaine is Germaine Tapié de Céleyran (b. 1878), Lautrec's cousin, daughter of Alix and Amédée Tapié de Céleyran.

37 *To Étienne Devismes*[1]

Nice, Sunday [January 1879]

You can't imagine, my dear friend, the great impression your accident made upon me, even though you laughed it off. You tell me you suffered for three long months—and to think I was fed up after only forty days, during which I wasn't in pain half the time. Oh, how I wish I could have kept you company, if I had been sure of being able to distract your attention even if twenty times or a hundred times less than the pleasant time you offered me at Barèges. Do you remember those splendid elongated shrouds, pulleys, and bob-stays? You say you'd like to see one of my masterpieces or attempts. I'd like to send you something suitable, and what is more, I don't know in which genre. You're going to think my menu is very varied, but that's not the case at all, far from it! You have a choice between horses and sailors. The former are better. As for landscapes, I'm completely incapable of doing them, I can't even do the shading: my trees are spinach and my sea looks like just about anything at all.

The Mediterranean is the toughest thing in the world to paint, precisely because it's so beautiful.

The navy didn't come back, but I was very moved when I saw the Russian frigate in the roads at Villefranche; it had such a self-confident air, from the truck of the mainmast to its waterline, excluding the sailors, because they're a rough-looking lot. Speaking of sailors, I found this song in a book by Paul Féval:[2]

Here's the stone for grinding knives
Knives, knives,
The grinding stone, the grinding stone
There's no one more swaggering
Than the Sailor
Who's washed his ugly face
 His ugly face
In five or six waters
He's the mackerel
Who's at home in the water.

You can see what a poetic reminiscence it is.

Well, let's summarize the situation. Write and tell me as soon as possible what you want from the three of us (me, my palette, and my brush), and I'll send you a crust[3] you can live on during a long voyage on the port tack with a nice spanking breeze.

Farewell, dearest Étienne. I hope this letter doesn't give you a migraine headache, because it's not worth it.

My warmest personal regards to you. Please remember me respectfully to your mother and affectionately to André.

Henri de T.L.

Prov.: Unknown
Pub.: *Cocotte* 1

[1] Étienne Devismes (*c*.1861–after 1910), a young man whom Lautrec first met at this time and often said to be two or three years older. His purported portraits by Lautrec (Dortu, P.124 and P.202) have been retitled in Murray (II). He entered a monastery in 1910.
This is the first in a series of eight letters written to him between 1879 and 1881, and was first published in 1952 together with the illustrated story, *Cocotte*, by Devismes. *Cocotte* contained seventeen drawings by Lautrec (Dortu D.2020–36) which are included in the total of thirty-eight drawings and sketches relating to the book (Dortu D.2015–52).
[2] Paul Féval (1817–87), French author of popular literature.
[3] Lautrec uses the word 'croûte', both a crust of bread and a daub.

38 *To Mme L. Tapié de Céleyran*

[Nice, January–February 1879]

My dear Godmother,

I am writing to ask you if you will tell Grandma Gabrielle to save me all the Egyptian stamps my Uncle Odon may send her. I have a fine professor, twenty years old, who has a boat and hunts seagulls. He is going to sail at the regattas. We are very sorry that Uncle Amédée didn't come. We went to Monte Carlo. M. Lévi played for me and

doubled my money.[1] I thank Madeleine for her letter. Could you send me some more cancelled Napoleon stamps.

<div align="right">Your godson, who loves you very much

HTL</div>

Prov.: Schimmel
Pub.: GSE23, GSF23

[1] His mother recounts the same incident in an undated letter from Nice (cf. Attems, pp. 174–5).

39 *To Armandine d'Alichoux de Sénégra*

<div align="right">Nice, Pension Internationale [January–February 1879]</div>

My dear Tata,[1]

I'm having quite a good time in Nice, the weather is almost always fine, pleasant hotel, good food, good friends, an *ideal* teacher, and the sea! What more can a person want when he has an Auntie to look forward to???

The hotel is large, there are about 70 guests, Englishmen, Frenchmen, Russians, Americans, Canadians, Spaniards, Germans, and Austrians. The servants and the manager are Swiss. We almost always go out twice a day; we take a walk under the palms. Carnival here is magnificent; everybody puts on a mask and throws *confetti*, little plaster balls the size of a pea. We've already bought masks. We went to Monaco one day with M. Lévi and Madame Moss. M. Lévi won 6.50 francs profit on a five-franc bet.[2] The Casino is the most beautiful thing you could ever want to see, and the theatre is gilded. So you see, you should take advantage of the opportunity and come to see all this.

We've had two concert-balls at the hotels; it was fun. A conjuror came too.

Please tell Kiki that I'm looking for a big doll for her.

Goodbye, my dear Tata. Hugs from me, please, to Godmother, my uncle, my aunt, Madeleine, Nini, Toto, Bébé, Kiki, and the big granddaughter, and my respectful regards to Monsieur l'Abbé and Mlle Maurin.

<div align="right">Your big nephew who wants to have you here and hug you

otherwise than on paper,

Henry de Toulouse Lautrec</div>

Prov.: Schimmel

[1] Cf. Letter 10 Note 5.
[2] Cf. Letters 36, 38.

40 *To Mme R. C. de Toulouse-Lautrec*

Pension Internationale, Nice [January–February 1879]
My dear Grandma,

I am writing to see, knowing that Uncle Odon used French stamps when he wrote to you, whether you would mind asking him in your next letter to buy me the Egyptian collection for five or six francs and send it to you; I would also like you to ask him to try and get me some Turkish and Suez Canal stamps through M. de Blignières.

I hope that you'll soon be able to give us some better news about fat Raymond,[1] which regrettably is not as good as that about the Béon family, including Lolo. Once again, would you be so kind as to ask Aunt Joséphine[2] to send me some old Napoleon stamps (all of them are good) because there are stamp-lovers here who'll want them.

Goodbye, dear Grandma. Be so good as to give my fondest regards to Aunt Joséphine, and to remember me most warmly to Uncle Charles, Aunt Émilie, Raymond, and Dédette.[3]

Your grandson (collector) who loves you very much,

HTL

Prov.: Schimmel
Pub.: GSE24, GSF24

[1] Either Raymond-Bertrand de Toulouse-Lautrec (b. 1870) or Raymond de Toulouse-Lautrec (b. 1874), both of whom were Lautrec's cousins—but probably the latter, who was Uncle Odon's son.
[2] Cf. Letter 20 Note 5.
[3] Odette de Toulouse-Lautrec, Lautrec's cousin, sister of Raymond.

41 *To Charles de Toulouse-Lautrec*

Monday, 24 March [1879]
[1] Lautrec writes that his mother has just had a serious carriage accident, and he gives his family the news, in a telegraphic style:

Better and better her bed can be made, she's gay and is talking well. Saved, thank God!!...

Prov.: Unknown
Source: Privat, Catalogue No. 322, June 1961, No. 4322

[1] Fragment of a letter.

41A *To an Unidentified Recipient*

[Spring–Summer 1879]

[1] ... because in his riding lessons he moves his right leg frantically, as if it were equipped with an invisible spur, then he told us about how nice Madeleine was. During all this time the only thing I smelled was the imitation leather of his armchairs, but when he led us into Father Lacordaire's study he leaned on my shoulder, and then!!! ... aromas[2]

Then we visited the room where the keepsakes are displayed, the chapel, the museum, and so on. ... we picked up the cousins and after a hearty lunch we set out in a curtained break[3] for Saint Ferréol. We saw the vaults and the water column[4] ... my cousins jumped up and down and *gluttonated* alfresco with admirable enthusiasm. We had drinks in the...

Prov.: Unknown
Pub.: Beaute II

[1] Fragment of a letter describing a tour and visit, led by an unidentified person, through the School of Père Lacordaire in Sorèze where Lautrec's cousins were students.

[2] At this point in the letter Lautrec drew a caricature of a nose, lips, and chin with the word 'parfums'.

[3] A large wagonette (1874).

[4] Saint-Ferréol. A small town about thirty miles south of Albi, where the Bassin de St-Ferréol is still among the sights to visit.

42 *To his Great-Aunt*

Maison Gradet, Barèges, Hautes Pyrénées[1] [August 1879]
My dear Aunt,[2]

We arrived yesterday evening, after a trip that was very good although a bit warm. Our railway carriage was full almost the entire time. There was a baby who was also making the pilgrimage,[3] and whose nappy had to be changed from time to time, and who overturned a large glass of wine with his fists. We made several visits to the grotto and we remembered you to the Blessed Virgin, we did the things Flavie had asked us to do. The singing at Sunday vespers was very good, and a worthy priest read us a story about a miracle, but he spoiled his talk by adding that since the event, which took place last year, the woman who was cured had gained *twenty pounds*. Please tell this to Mlle Bosc.[4] We left the following day at eight o'clock, and arrived at our destination safely after several long hours in the stage-coach.[5]

We have the same apartment as last time,[6] namely, three bedrooms and a dressing-room. We're taking our meals at the hotel.

Goodbye, my dear Aunt. Please transmit my good wishes to every-
one around you. Please present my respects to Mademoiselle Bosc.

<div align="right">Your respectful great-nephew,
Henry de Toulouse Lautrec</div>

P.S. Say hello to Mélanie, Flavie, Benjamin[7] and a pawshake to Miss.[8]
Thank you for the pâté, which was excellent.

Mama has done your errand at Lourdes.

Prov.: Formerly Mme Privat, Paris, at present unknown

[1] Barèges, a spa in the heart of the Pyrenees, south-east of Lourdes.
[2] Lautrec signed 'Your Great-nephew' and refers in the letter to Mlle Bosc, his great-aunt Joséphine
d'Imbert du Bosc, so it is presumed he is writing to another great-aunt, one of her sisters.
[3] Lautrec was returning from a pilgrimage to Lourdes with his mother.
[4] Joséphine d'Imbert du Bosc: cf. Letter 20 Note 5.
[5] Lautrec drew a stagecoach on the bottom of p. 3.
[6] Lautrec had visited Barèges in 1877 and 1878.
[7] Three servants at the Château du Bosc (cf. Rodat, p. 126).
[8] A dog who belonged to Mademoiselle (Joséphine) du Bosc.

43 *To Mme L. Tapié de Céleyran*

<div align="right">[Barèges,[1] August–September 1879]</div>

My dear Godmother,

I am sure you will be pleased to hear that I am as well as can be
expected and that I have no pain.[2] I'm not too bored either, and hope
you won't fret too much about my case because a clumsy fellow like
me just isn't worth it. I suppose out here they will call Mlle Fides my
very honourable *cuisine* Fidèle or Fidèlou,[3] and that at home they'll
give her the name Fifi. Excuse this playing on words, but I don't have
many things to keep my brain working. The doctor is delighted at
the prospect of a cure. The Andoques[4] have just arrived and are very
well; they will stay for the afternoon.

Goodbye, my dear Godmother. I kiss you as best I can and please
give my best to everybody.

We have just received Monsieur l'Abbé's letter and are expecting
Grandma and Papa.

Kindly give my regards to Tata,[5] Uncle Amédée, Aunt Alix, all the
cousins, the Soréziens,[6] Kiki, and Gordon.[7] My regrets to M. l'Abbé
and Mlle Maurin.

<div align="right">Your clumsy godson,
Henri de Toulouse</div>

Prov.: Schimmel
Pub.: GSE25, GSF25

[1] Lautrec was at the Maison Gradet, in Barèges, to recuperate from his leg injury.

[2] Lautrec had fallen and broken his other leg. He assumes that it was due to his clumsiness, not realizing the physiological causes. In a letter of 2 September 1879 (Collection Schimmel), his grandmother Louise indicated that an apparatus holding his right leg in place had been removed the day before and that they hoped to leave shortly thereafter. According to the same letter, the doctor recommended that Lautrec refrain from walking for fifty days.

[3] Fides Tapié de Céleyran (1879–1900), Lautrec's cousin, daughter of Alix and Amédée Tapié de Céleyran. He puns here on the words 'cousine' (cousin) and 'cuisine' (kitchen), and also on her name 'Fides' and the word 'fidèle' (faithful).

[4] Evidently relatives of his Aunt Émilie d'Andoque de Seriège (cf. Letter 4 Note 4).

[5] His nickname for his aunt Armandine d'Alichoux de Sénégra.

[6] His nickname for some of his cousins who went to school at Sorèze, a small town south-east of Toulouse.

[7] A setter dog that belonged to Lautrec.

44 *To Étienne Devismes*

[Barèges, September 1879]

[1] Maybe there's nothing as swaggering
as a splendid boat
that might have been owned by Mr Devisme
to f... up his kiddle.[2]

but, since you were no longer there, we had to go ahead with the big clumsy paws you're familiar with. The surgical crime was consummated on Monday, and the fracture, very admirable from the surgical point of view (not from mine, needless to say), was brought to light. The doctor was delighted and left me in peace until this morning. Then this morning, using the deceptive pretext of getting me up, he made me bend my leg at a right angle, thereby causing me atrocious suffering.[3]

Oh, if you were here just five little minutes a day, I'd feel as if I could face my future sufferings with serenity. I eat up my time by making the hatchways (the bob-stays and the shrouds for the bowsprits kept me busy for barely half a day).

But wouldn't it be better to make the ramming block in copper instead of wood, and should it be painted or simply polished?

Farewell, my dear friend, please convey my respects to your mother and my best regards to your brother.

Your devoted
Henri de Toulouse-Lautrec

Is it necessary to unhook the sheet from the main jib in order to change it?

P.S. Enclosed are a few requests that are annoying for you, but which I hope you'll be kind enough to honour.

Prov.: Unknown

Pub.: *Cocotte* 2

[1] Lautrec drew a sketch of a single-mast sailing-ship on the top of page one of this letter (Dortu D.2017).

[2] An arrangement of nets for catching fish.

[3] Cf. Letter 43 Note 2.

45 *To Béatrix Tapié de Céleyran*

[Barèges, September 1879]

My dear little creature who catches rabbits,

You are a very sensible girl and never do a thing without first knowing why. If you had been born in Solon's time, you certainly would have been named to the Areopagus; you would have looked very comical indeed in a pointed hat carrying a lot of big old books, and since you are so nice I'm going to give you a *praise-ent*; I'll give it to you at Bosc. First, the best part of it will be ... my godfatherly blessing, followed by a collection of little kisses,[1] and then something yellow wrapped in paper ... try to guess. There's only one fault I have to find with you and that's your choice of a spelling teacher, for he is a person with very little brains,[2] and if you don't believe it, run your little rabbit-catching paw over your brother's head and see if you don't feel a great big hole; it's so deep you'll be afraid of falling to the bottom; and now you ask me what connection there is between this big hole and your spelling teacher's brains. Here is the answer: the brain is a kind of gut that produces intelligence, it's in the head; there should be this brain I'm talking about instead of the enormous hole that scares you so, and that's why your dear spelling master isn't clever!!!! ... We go riding on donkey-back and if you want to pretend to do the same get up on your spelling teacher's back; don't be afraid if you hear sounds like farts going off, donkeys do it all the time; to correct this defect you just look brave and hold your nose. That's *the rub*.

There's a Prussian king here and I'm sure that if you were at Barèges you'd quickly wring his neck, even if he isn't a rabbit. Goodbye, my sweet little dear, and give my fondest regards to Grandma, my uncle, your brother, M. l'Abbé, Aunt Armandine, Mademoiselle Rose, and everybody, including my canaries.

I kiss you on both cheeks and on your pretty little phiz (not the other!).

Your Godfather,
Henry de T.L.

Prov.: Schimmel
Pub.: GSE21, GSF21

[1] Lautrec uses the Gascon 'poutous', a little kiss. Later he uses 'poutounégeade': cf. Letter 98 Note 1.
[2] Lautrec is referring to her brother Raoul (cf. Letter 27).

46 *To his Great-Aunt Joséphine (M^{lle} du Bosc)*

[Self-portrait sketch 'Céleyran' (1879)]

[1] My very dear Aunt

Look at that shape absolutely totally lacking in elegance, that big behind, that potato nose ... He is not good-looking, and yet, after knocking at the door, and without stopping when Flavie the concierge cries out in astonishment, ... it climbed the stairs as fast as its legs (broken twice, poor legs!...) allowed him. Crossing the rooms and knocking at Aunt Joséphine's door, and despite the barking of the little pack, ... it leaped like a jack-in-the-box into Aunt Joséphine's arms ... but the yappings of the little pack had changed into tail-waggings of joy...

<div align="right">H. de T.L.</div>

Prov.: Unknown

Pub.: Attems, illustration 23, Dortu D.2084. Both published only the first page with the illustration and three lines.

Source: Privat, catalogue No. 322, June 1961, No. 4324

[1] Fragment of a letter with self-portrait sketch at the top (Dortu D.2084).

47 *To Raoul Tapié de Céleyran*

<div align="right">Céleyran, D[ecem]ber [18]79</div>

My dear Raoul,

We got here the day before yesterday and my first letter is for you. I was telling myself, pleased as Punch, how we would soon be having a nice New Year's holiday together again. I took it for granted you'd try as hard as you promised me!!! And now here they tell me your marks have been so unsatisfactory that if you didn't do any better during the time you had left, you would not be coming at New Year at all!!! You can appreciate how painful that is to me and I am writing to urge you to do your very best so this punishment doesn't happen. And then how glad we would be. You would see the little Gordons[1] born this morning. We would have all kinds of fun, play trains and have signals, I don't know myself what we wouldn't do!!! But if you keep on *being lazy*,[2] if you continue to do nothing but *bad workmanship*,

as they say, they'll keep you in school until you're bored to death, and your Mama will be unhappy, and me, too!!! And if you get into the habit of just loafing along, where will it all end? Do you think people are going to come to see you at Mardi Gras, on St Cecilia's Day, at Easter, and even during the summer holidays!!! I don't think you'll settle for anything like that once you've seen that with a few trips to the dictionary everything will go just fine, as wanted by your cousin.

<div style="text-align: right">Henri</div>

Your mother asks me to tell you that she thanks you for your letter. She will write to you tomorrow and isn't at all satisfied with *your marks*.

Prov.: Schimmel
Pub.: GSE26, GSF26

[1] Cf. Letter 43 Note 7.
[2] Lautrec uses the colloquial expression 'acagnardir'.

48 *To Mme R. C. de Toulouse-Lautrec*

<div style="text-align: right">Nice,[1] 13 January, 1880</div>

My dear Grandma,

I'm getting down to sending you best wishes for the New Year not a little, nor very, but enormously late. I hope to make up for it by giving you some news hot off the griddle. On Saturday we had a lovely day at Cannes; the city is very pretty and my uncle's place superb. It's a very swanky villa on the shore, near the Villa of the Dunes, the Empress's[2] residence. Uncle Odon goes riding on horseback and has rented a landau for afternoons to go on drives up the mountain. We went with them there and climbed up to a place where you can see Nice and the coast of Italy, and then the sea so blue ...!!! The Babies are very well and are taking long walks with Soué,[3] who is delighted. Raymond[4] is taking lessons from a priest. A detail for Uncle Charles: Uncle Odon has bought a collection of pictures from an estate and the way it looks there are lots of them. As for us, we are quite well. The pension isn't as gay as last year. But on the whole the winter is more sunny and we go for a lot of walks. We haven't come across the Villeforts.[5]

Goodbye, dear Grandma. I wish you a belated happy New Year, thanking you again for your presents. Mama joins me in sending you love and in asking you not to forget to remember us to everybody.

<div style="text-align: right">Your grandson,
Henri de Toulouse Lautrec</div>

We ran into the pride of Amélie-les-Bains. That's for Aunt Émilie.

Prov.: Schimmel
Pub.: GSE30, GSF30

[1] Lautrec was in Nice, accompanied by some of his family, to recuperate from his leg injuries.
[2] Probably the former Empress Eugénie, wife of Napoléon III. The villa was located at the eastern end of boulevard de la Croisette.
[3] Probably Lautrec's nickname for Mademoiselle Suermond, the daughter of a German family then staying in Nice, with whom he was friendly.
[4] Raymond de Toulouse-Lautrec, son of the Uncle Odon who is also mentioned here.
[5] Michel de Vignaud de Villefort later married Jacquette Tapié de Céleyran, daughter of Gabriel Tapié de Céleyran and Anne-Marie de Toulouse-Lautrec.

49 *To Étienne Devismes*

Nice, 11 February, 1880

Mea culpa, mea culpa, mea maximissima culpa!!!![1] I'm searching in vain for other words to convey to you, my dear dear friend, how sorry I am not to have answered your delightful and agreeable letter. I have no desire whatsoever to be filed away in your mental pigeonhole allocated to *idiots* who are unable to dip their pens into ink to answer a friend.

We're in Nice and you're in Paris. We know this through my grandmother, who received your New Year greeting cards. I guess you'll try as little as possible to fall into melancholy with the charming weather the newspapers are so generously bestowing upon you.[2]

We were cooking here in the sun! I say *were cooking*, because two days ago (probably on account of Carnival) our Heavenly Father flung open the heavenly flood gates as far as they would go; I could almost have sailed the cutter in question in the garden.

As regards matters nautical, my enthusiasm has somewhat diminished, but it has merely changed its nature and become a rage for painting, my room is filled with things that don't even deserve to be called daubs. But it's a pastime.

How about you? What are you doing, which examination are you preparing for, and do you often go to the Naval Museum???

According to your Barèges plans, André should be at Arcueil and should be making splendid assaults on his compositions and translations—a miserable activity if there ever was one?!!! . . . I saw Ludovic de Solage again. He had shaved off his moustache to make it grow back more luxuriantly. Can you picture him?

Well, my dear friend, I have to say goodbye now. I have a Damoclean German lesson waiting for me. I hope to chat with you again like this

often, provided it doesn't bore you. Please extend my good wishes, and Mama's, to your mother.

Best wishes to you and André.

Your very devoted friend,
H. de Toulouse Lautrec

Prov.: Unknown
Pub.: *Cocotte* 3

[1] From the Latin rite of the Roman Catholic Mass: Through my fault, through my fault, through my most grievous fault.

[2] That winter in Paris the weather was extremely icy, and in early January the thaw caused several accidents that were severe enough to be noted in the chronicles.

50 *To Charles de Toulouse-Lautrec*

[Nice, early 1880]

[1] My dear Uncle,

We weren't really counting on your trip to Monaco, but we were disappointed even so. Uncle Odon didn't go there, as far as I know, but he had the pleasure of seeing the marksmen practising.[2] I write in my journal quite regularly, despite my German lessons.[3] When I go back to Céleyran I shall be able to translate the word werden[4] for you. I've put together a collection of menus for you, which I am sending.

Now with our co-descendants we'll talk about the Gordon family. About the little imp whom we shall call Bog, about the suckling of the Maid whom we shall call Caro, and the infant of the black bitch, whom we shall call Dirk.[5]... The Pension Internationale isn't what it was last year, from the point of view of cheerfulness, but as regards the cuisine, it's better...

Henri

Prov.: Unknown
Source: Stargardt, auction 11, 12 June 1986, Katalog 636, No. 588

[1] Fragment of a letter.

[2] He was visiting Cannes, in a villa at the eastern end of the boulevard de la Croisette near the Tir aux Pigeons, the shooting area located on the Pointe de la Croisette. Cf. Letter 48 Note 2.

[3] Cf. Letters, 49, 51.

[4] Lautrec writes this German word in gothic letters.

[5] Cf. Letter 47 Note 7.

51 *To his Father*

Nice, March [18]80

I preferred to wait until the boat races, dear Papa, before thanking you for the New Year's gift you kindly sent me. I used it to buy a very beautiful pair of naval binoculars, which have provided me with many enjoyable hours of watching the yachts manœuvering. Uncle Odon came, so did Aunt Odette.[1] ... Aunt Alix will probably come in May and stay until the end of the season with three of her daughters, who need to take sea baths. I am going to start soon, perhaps next week, as the weather is splendid, and some people already started quite some time ago. People were saying that the water was sixteen degrees yesterday. M. and Mme de Villefranche, who used to be neighbours of Uncle Narcisse, are here.

I'm learning German, and am making progress even though it's not very inspiring. We have in our hotel a Miss Blake, a former acquaintance of Pérey,[2] who completely detests him. M. Lévi[3] had no luck at roulette, and he is swearing by everything sacred that he will never go back to Monte Carlo. He went there twice on foot. As for my legs, they're improving, thanks to the heat and the exercise.

Goodbye, dear papa, and thank you.

Your respectful son,
Henri de T.L.

Prov.: Schimmel
Pub.: GSF31

[1] Cf. Letter 25 Note 2.
[2] Cf. Letter 4 Note 1.
[3] Cf. Letters 36, 38, 39.

52 *To Charles de Toulouse-Lautrec*

[1]Le Bosc S[eptem]ber [18]80

My dear Uncle,

The function of news reporter has devolved upon me. So I've sharpened my most beautiful quill!!!!!

Grandma having been ill, to the point that M. Fargoun had to be kept here for an entire night, as she wanted.

(Note. Grandma slept well, and the doctor's *snoring* prevented the Abbé from sleeping.) As I said, Grandma is much better, and at this moment she is stretched out in her chaise-longue conferring with Vidal and Morinni.

All the baby chicks are doing well, and those who are subject to imprisonment will soon be eating beans and roughing it.

Uncle Amédée shot *two* partridges at Preyssac.[2] His little bitch is very good and her energy is amazing: steel, whalebone, rubber, and Princeteau's index finger, that's what she's made of.

Astounding, as dear Ferréol[3] used to say. Topin[4] is very well-behaved, when we took him out he didn't chase chickens, while Tyro[4] on the other hand triumphantly brought me one of Lafleur's yellow chickens.

What a drubbing!!!!

The painting in the chapel is very nice. There are some admirable reliefs.

If you would be so kind, I'll ask you to bring me a French curve with five bends, the largest size, new. Mine is falling apart.

Farewell, my dear Uncle. I'm looking forward to seeing you again *in this house.*

Please convey my respects to Aunt Émilie.

 The nephew

Prov.: Maison Natale

[1] At the top of the letter Lautrec drew a sketch of himself writing (Dortu D.1641).
[2] Preyssac, a small town in the Dordogne.
[3] Ferréol Roudat, Albi goldsmith.
[4] Two family dogs.

53 *To a Dog*

 Le Bosc [1880]
Dear Madam,[1]

As your nice letter yesterday announced, maternity's joys are yours once again. There you are, once again the head of a family; grave responsibilities weighing down your curly little head. What care you will have to lavish on these warm and rosy little creatures, feebly stirring their tiny little paws at the bottom of your basket. I'm sure your nice mistress and Mélanie[2] will help you with this difficult task and that they will make as much and even more fuss over your children as you yourself. I also know you must have a crazy urge to eat the aforesaid Mélanie when she wants to touch your progeny and that the echoes of your G-r-r-G-r-r will resound in the living-room.

So, first of all, I implore you not to eat all of the above-mentioned Mélanie and to leave at least a little piece of her to care for your nice mistress; second, to lick your babies very thoroughly, so that the good

people of Castelnau[3] will be able to raise their hands to heaven and say, amid tears of emotion, 'Oh God, they're just like their mother!'[4]

In closing I send you my heartfelt congratulations, and pray you to lick your mistress's hand for me.

<div align="right">
I squeeze your little paw,

Henri de Toulouse Lautrec
</div>

P.S. Remember to give my best to Flavie, Mélanie, and Benjamin.

Prov.: Schimmel
Pub.:GSE29, GSF29

[1] The dog belonged to Lautrec's Aunt Joséphine, Mademoiselle du Bosc.
[2] Mademoiselle du Bosc's housekeeper.
[3] Castelnau de Montmiral, a town near Albi in the Department of Tarn.
[4] Lautrec uses the Gascon phrase: 'Chés, semblo sa mairé'.

54 *To Mme R. C. de Toulouse-Lautrec*

<div align="right">
Céleyran, 30 Dec[ember], [18]80
</div>

My dear Grandma,

It's awfully hard to write something different, above all in the case of New Year letters. But these commonplace letters with their commonplace compliments still have their value, more so indeed than the too interesting ones you have been writing to us these days. We were shaking, watching the postman come, but, thank God, this morning's letter came just in time to revive our hopes. Poor Aunty!!![1] How we thought of her!!! Hopefully the new turn she has taken will continue, and this run of bad luck will be no more, at least for her. Here everybody is just fine, except for Suzanne,[2] who's a little ailing and sick in her stomach. Aunt Armandine is leaving in an hour or two to go and meet Madelon.[3] As for me, I'm just fooling around with 'St Palette'[4] and the dogs. How is Uncle and his foot? The uncles here are at Carcassonne and Toulouse.

Goodbye, dear Grandma, for to begin with it's getting dark and then there isn't much room left to tell you how much I love you and how genuinely I wish you a prosperous and happy New Year, also Uncle and Aunt Émilie. Goodbye for now. Happy New Year. Happy New Year.

<div align="right">
Your grandson, who loves you enormously,

Henri
</div>

P.S. I am going to write to Aunt Joséphine.

Prov.: Schimmel
Pub.: GSE31, GSF32

[1] His Aunt Joséphine, Mademoiselle du Bosc, was ill this winter.
[2] Probably Suzanne Gonthier, who is mentioned in Letter 236.
[3] Madeleine Tapié de Céleyran.
[4] Lautrec playfully makes his palette his patron saint.
[5] See Letter 55.

55 *To his Great-Aunt Joséphine (Mlle du Bosc)*

[1] Céleyran, Dec[ember 18]80

Knock, knock!!!—Who's there?—It's me.—Ah, so it's you, Monsieur Henry.—How is my Aunt?—Much better.—Could I see her?—Yes, but don't tire her, you're such a chatterbox: Without listening to the rest I brush by Mélanie, almost knocking her down, and greeted by the barks in A minor of Miss and Follette,[2] I throw my arms around your neck, shouting from the bottom of my heart, happy New Year!!!

That's what I would have done if I'd stayed at Albi. But even though the distance between us makes it impossible to give you a real hug, the emotion I feel is just as great.

But it is useless to say any more, since you know very well I love you and all the paper and all the ink in the world would add nothing to that. That's why, my dear Aunt, I am asking you to accept the most sincere wishes for a speedy recovery, as well as for your happiness from your respectful great-nephew.

Henri

P.S. Please remember me to Flavie, Mélanie, and Benjamin.

Prov.: Schimmel
Pub.: GSE32, GSF33

[1] At the top of the letter is the drawing of a postman delivering an envelope (Dortu S.D.8).
[2] Two dogs which belonged to Mademoiselle du Bosc. Lautrec painted a dog named Follette (Dortu P.357, signed and dated [18]90).

56 *To Madeleine Tapié de Céleyran*

Nice, January [early] 1881
19 January, 1881
26 January, 1881

Notebook of zigzags belonging to H. de T.-L.[1]

Dedicated to my cousin Madeleine Tapié, with the worthy aim of distracting her a little from the lessons of Madame Vergnettes.—Nice 1881

FROM NARBONNE TO NICE

The weather was beautiful when we left Céleyran, but the ground was muddy because it had been raining. Mud. After saying goodbye to Grandma, Mama and I took turns cooling our heels in what one employee elegantly referred to, while I was keeping an eye on the basket, as 'the Great Hall'. Mama went outside and vice versa. Finally, in desperation, we went into the waiting-room, where there was (already) an English family with a big boy who looked like a mulatto, he was so yellow.

Uncle Albert finally arrived, and then we made our *exitus*. There (at the station restaurant) we saw a little boy ... who was about to be put back into a cooking pot from which he had been removed probably because of New Year's Day. After a snooze in the waiting-room a good-natured employee got us into the carriage going to Marseilles. It was around 11 o'clock, and there was a beautiful moon.

Our companion in the compartment was a creature of some sort (later I learned it was a man) who from time to time emitted sounds the source of which plunged me into the most total doubt. An ugly young man got in, forgetting to close the door until a sizeable quantity of chilling air had got into our compartment. Fooey! Bang! Bang! Bang! ... Push! ... Hah! Ohh! Tap! Push! Huff. Bang. Fooey. Oof. Oof. Oof!!! ...

This time we left for good. Morpheus, who is a very pleasant god (between you and me), enfolded me, awakened me once in Arles, then woke me up for good. Our fellow traveller had awakened, and I saw that he was a very chic man, a real gentleman. We were in Marseilles. Everyone changed trains. We got into the same carriage as the chic gentleman. We changed in Toulon, where we fell in with foreigners (Mother claimed they were Portuguese), consisting of the elderly father (an old fogey) of two daughters, a son (problematic), and a frightfully ugly old governess. Judge for yourself, oh cousin mine, by the (flattering) sketch I did of them. Our trip was sh...y from every point of view, because we were in the middle and we had to eat lunch in this (pozishun). I saw the fleet in the Gulf Juan, and the old patriarch produced a cotton night-cap, in the belief that he was taking out a handkerchief. This detail had escaped my perspicacity; I owe it to Mama. Tickets pleez. Nice!!! ...

We got off the train. No Adolphe. We hired a ragamuffin for 50 centimes and walked to the hotel.

Nobody was expecting us on this train. Monsieur Adolphe was busy making a screen that would turn our bedroom into two. It's Aunt Alice's bedroom.

NICE

We were happy to see our old friends again. We asked about the Suermondts. They're in a brand-new house. This reminds me of Isidore's brand-new perfumes (see Corentin Quimper). We went out to dinner after eating a tangerine that we owed to M^me Mosf's kind foresight.

Glaring China dogs!!! You were equalled and surpassed on this solemn evening.

My neighbour was a Mlle Lecouteur De Jessey. She is very mature. Sitting across from us were an Armenian and a young Russian doctor who is the nephew (and heir presumptive) of M. Nanikoff. The rest consisted more or less of ugly old Englishwomen. I should mention the elderly Captain Campbell (AN OLD FRIEND); the Misses Parson, Americans whom we had the privilege of meeting last year; and Mrs Elliot, who (I learned later) will soon be (s-h-h-h) 50 years old, and who looks 30 at most. She recently married M. Isaac, a Member of Parliament.

19 January.—Dear cousin, please forgive me! Laziness, and more particularly bad weather, kept me from writing!! Rain, ping, ping, slush, mud, botheration, our Eternal Father munificently bestowed it all upon us. Disgusting, isn't it?

Let me summarize. I have seen the Suermondts, who are still nice.... This makes me all the more sorry that they aren't at the hotel. It's not much fun here. I miss my Dutchman!! The fact that someone would turn to him for some cheering up tells you what the rest of the scene is like. At table I look at the Armenian and I pass the mustard to M^lle Lecouteur. There's about as much variety as there is in a monastery. M. Suermondt got back from his place yesterday. He came and was kind enough to give me some encouragement. Mademoiselle (you know she doesn't want us calling her Miss) also came. She had the bright idea to come late. So I wasn't able to pester her with my works. The exhibition has opened, and I did a portrait of Dash. The posing session was funny because he got annoyed with Eugène, who had been assigned to hold him.

Frau Bittmann rambles, she absolutely insists, Monsieur le Gonde, on inflicting her daughter on us at the tip of the nose. Luckily mama is determined to refuse her.

Whew!

Here's how it happened. M. Feltissoff (M. Nanikoff's nephew) has his brother who got married yesterday evening. For this occasion he gave a little family party, consisting of Madame Viroulet,[2] M. Lévi, M. and M^lle Virtain, M. and M^me Isaac, M. Louis and M. ..., and then Eugène. Having thus, I say, plotted all this for after dinner they

ornamented themselves (sic) in their best. When we left the table, they replaced us. I was in the gallery, pretty bored, when Mlle Lecouteur came and very kindly (if I had known) invited me to play parlour games. I went ahead and sat down near a very tall and very ugly Miss who arrived two days ago, when Adolphe came to tell me that a gentleman wanted to talk to me (if I had known!). I hurried to the lobby, but he dragged me into the dining-room. I had hardly got there when M. Feltissoff stuck a bouquet into my buttonhole (his own, no less), and Madame made me sit down and had four different glasses brought to me. I started to protest, but M. Feltissoff refused to listen. So I started with just a sip. Boom! Nice, isn't it? Well, you know, the first glass is the hardest.... Things were going along fine.... Meanwhile, they had already started some time earlier, and they were becoming maudlin. Toasts were made. To the newlyweds. Ah, Madame Viroulet!!! At this point the excitement was such that M. Morgan and M. Virtain hugged Madame Viroulet. Eugène was dancing like a Monkey, M. Lévi was shouting hip, hip, hip, hurrah!!!, while I had a splitting headache.

After a bit I went to bed completely crestfallen. Something was wrong. Ay-ee, I felt strange!!! Just as I was beginning to wonder whether it would last long, suddenly a powerful Bea-aou-rrra![3] put an end to my indecision. I needn't say any more! I'll spare you all the congratulations Mama bestowed upon me.

Wednesday, 26 January. After an unsuccessful try, we chipped in a few coins and we're going to have a dance this evening. I'm going to try to put you into it, at half past 5.

Dinner at half past 5. People were nervous, thinking about the great event. All of a sudden the table was removed, only a section of it being left for the buffet. I watched these preparations together with a quiet pipe-smoking Englishman; the canvas cloth was tacked on and soaped. We went to make ourselves beautiful. You can imagine how earnest this was when I tell you that I looked almost clean.

We went downstairs. People were already in the salon. There were two young Englishmen, from the room next to ours, magnificent, their two sisters who looked like umbrellas were there, dressed in pink, with a little Miss in blue, with red hair, guests. That's a type I've tried to create on horseback, but I didn't succeed.

I went to the gallery. There were musicians, a piano (belonging to the establishment), a cello, and a violin. (Gabriel, a pity you weren't there.) The male guests arrived. There were two officers, one of whom I remembered from two years ago. Jing-boom-boom, and the dance began, with four women dancing. People were beginning to hum, it wasn't worth it (two Misses from the hotel, women of the more enthusiastic type were ill), when a swarm of beauties came into view, I'll

mention M^lle Lecouteur (over 35), Mlle Armitèze (a female chimpanzee, sister of the clergyman, 50 years old in the dark), and Mlle Ludlou (who laughs like a chicken and in terms of age is mid-way between the other two). The first two had opened their hearts, and were revealing an extremely impressive show of violin strings.[4] Jing, boom, boom. . . . Perfect, two or three Misses and two young widows in black satin (mourning! where are you going to ensconce yourself). Jing, boom, boom. (This time here's my chance,) M^me V. in black velvet (imagine), and M. Fitissoff hastened into a corner near the buffet with captains Morgan and Campbell. I was congratulating myself on my place when Atchooo! A-a-a-t-choo! Everyone started sneezing. The women dancers stopped at 18[5] in order not to sneeze; the male dancers did the same; one of them left his 'partner' standing there and retired to a corner for a quarter of an hour. Old Captain Campbell was sure he had a heavy cold, and so was M. Lévy. Captain Morgan assured us that he was not at all under the general influence when . . .

It was a magnificent view.

18 J.[6] I had 'given it up', dear cousin, that is, dropped everything in this notebook in order to work.

But I'm going to tell you something impossible, unheard of, unbelievable?

M^me Ludet has her son, an officer; at first sight, he seemed to me quite smart and nice. He came to dinner, and everyone found him charming; so did I. Bubbling over with his engaging words, I went to see him today. Oh, what I saw!!! A big, pretentious, affected, pedantic, clumsy boy who quoted Boileau[7] and told me that he had recited poems!!! Oh, the monster!!! He also told me that he liked Greek, the Civil Code, and . . . a heap of things along that line; it sends shivers down my spine.

Prov.: Unknown
Pub.: *Amour*, pp. 172–6

[1] A journal written in an exercise book with pen and ink sketches on twelve pages (Dortu D.2064–2075).

[2] The owner of the hotel Pension Internationale.

[3] Possibly an attempt to reproduce the sound of vomiting.

[4] Lautrec may be conveying the idea that by displaying their décolletage they were revealing stringy necks.

[5] The usual expression is 'se tenir à 4'. It means 'try all you could to keep from'. Here it is playfully exaggerated to 18.

[6] This could mean 18 January, but if so then it would mean Lautrec had skipped around in his exercise book or the pages were placed in the wrong order at some later date.

[7] Nicolas Boileau-Despréaux (1636–1711), Parisian poet and critic, considered the theoretician of classicism.

57 *To Charles de Toulouse-Lautrec*

[1]Nizza [Nice, January 1881]
Here, dear Uncle, is what we've had and what we're having. The
window is open as I write to you. It's beautiful, beautiful. But before
!!! What a pain !! Rain, wind (?), and snow (!!!! . . .), which melted while
it was falling, but still, snow.

Please don't think I've come to bore you for no good reason. My
neighbour is an elderly (!!!!! if she were to hear me !!!!!) spinster or
rather lady who plays the piano pretty well and who would like to
know the true name and composer of a piece that Aunt Émilie de
Sérièges[2] plays, and also the name of the composer of the Pavane of
Louis XIV, and furthermore the name of the composer of the waltz
called 'Souvenirs' or 'Souvenir'. Phew!! Here I see quite a lot of Mlle
Suermondt[3] with her father. He complimented me (!!) on my gunners,
and is advising me more and more to paint.[4] Bad painter.[5]

Mademoiselle is a very skilful horseback rider. René would be very
good at that. As for me, I'm doing nothing, or rather I'm doing a
great deal of Greek, Latin, etc., with which I'm fed up. Luckily German
has been placed on the Forbidden index.

I'm looking forward to seeing you and my aunt in sprightly con-
dition when I get back. A hug for both of you, and for Grandma and
Aunt Émilie and Aunt Joséphine.

 Your nephew HTL

P.S. Please remember me to Joseph and to M. de Serres.
Please send me some brochures of Berville[6] on charcoal drawing.

Prov.: Maison Natale

[1] Two small sketches appear at the top of the letter (Dortu D.2276).
[2] Wife of Charles de Toulouse-Lautrec. Lautrec is using her full name to differentiate her from Aunt
Émilie, wife of Odon de Toulouse-Lautrec.
[3] Cf. Letters 56, 461.
[4] A small sketch of Lautrec painting (Dortu D.2277) appears at this point in the letter.
[5] Lautrec is referring to himself in the drawing.
[6] Lautrec's sketch *Croquis-Plume* (Dortu D.2258, dated about 1881) is drawn on paper with an
embossed monogram of a palette enclosing the name and address L. Berville 25 rue de la Chaussee
d'Antin, Paris (Collection Schimmel).

58 *To Alix-Blanche Tapié de Céleyran*

[Drawing] Tête du Chien 'Célestinoff' [1881]
[1]My dear Aunt,
I'm sending you the portrait, as good a likeness as possible (I copied

a large drawing that was approved by the owner) of a magnificent dog
that belongs to a Russian colonel who has one arm in a sling and
lives...

Prov.: Unknown
Source: Attems, Illustration 24, Dortu D.2078

[1] Fragment of a letter with a drawing of a dog at the top (Dortu D.2078)

59 *To Charles de Toulouse-Lautrec*

Paris, Saturday [May 1881]

[1]Prophet!!!! Prophet!!!!

Dear Uncle, rival of Mohammed, you predicted a chestnut foal, and
lo and behold, it's happened. My compliments to you, along with my
hope that 'mother and child are doing well', as the saying goes. What
studies in perspective.

I also wanted to write to you about my foal, because I have one: my
palette. I get as inflated as a Gambetta balloon[2] when I think of the
compliments I've received on it. All joking aside, I was flabbergasted.

Princeteau was ecstatic, du Passage cried, and Papa was completely
bewildered. We thought of everything, we even dreamed of Carolus
Duran.

Anyway, here is the plan that I think offers the best chance of suc-
cess. École des Beaux-Arts, Cabanel's studio, and attendance at René's[3]
studio. I did a portrait of Louis Pascal on horseback.[4] Well. I'm
carrying on, and I hope you'll be pleased, since you're the one who lit
the sketching spark in me.

Princeteau has a very successful picture in the Salon.[5] It's the
enlarged and modified reproduction of your picture at Le Givre.[6]

Please tell Grandma and Aunt Émilie about my nonsense and kiss
them for me.

Everything's fine. Goodbye, until we meet at Le Bosc under the
umbrella and on the folding chair.

What rapid sketches!!!!!

Your nephew Henri

Poor Tyro.[7] How are his legs, write to me with the details. Please.

Prov.: Maison Natale

[1] At the top of letter Lautrec drew a sketch of Princeteau and himself painting (Dortu D.2077),
which is related to the painting *Princeteau dans son atelier* (Dortu P. 130, dated 1881 by Lautrec).

[2] Léon Gambetta (1838–82), French statesman and orator, deputy in 1869 for Paris and Marseilles
and leader of the opposition party. When a Republic was proclaimed, after Sedan, in September 1870
he was a member of the Government of National Defence and when Paris was surrounded by the

Prussians in October 1870 he escaped from the city in a balloon. He was elected President of the
Chamber of Deputies on 31 January, 1879 and again on 20 January, 1881.

[3] René Princeteau.

[4] Not in Dortu or otherwise identifiable.

[5] Princeteau exhibited *Le Relais*, No. 1932, which won an honourable mention. The Salon opened
on 2 May, 1881.

[6] A small town in the Vendée near the Atlantic coast.

[7] A family dog.

60 *To Mme L. Tapié de Céleyran*

Lamalou-les-Bains[1] [August 1881]

My dear Godmother,

I don't know what broken-down hurdy-gurdy, what clumsy sermon,
or what nose—take your pick between mine and Madeleine's—could
begin to give you an idea of how long and dull our trip down was.
However, just as on noses there are some coloured warts, so there
were some little incidents en route to break the monotony. A big man,
who looked like Gambetta,[2] joked politely with Bibou and Kiki. Two
conductors rolled in the dust trying to tear each other's eyes out, an
enormous nun almost sat right down in Madeleine's lap, threatening
to smother her, and Mama left her suitcase on the train. Luckily they
found and returned it. But finally here we are with two baths taken,
three and a half glasses of the waters drunk, and me with an eye that
looks like a tomato. With that, dear Godmother, I give you a big hug,
and ask you to accept my best wishes for your name day.

Your grandson and godson,

H de Toulouse Lautrec

Prov.: Schimmel
Pub.: GSE33, GSF34

[1] The Hôtel des Bains at Lamalou (cf. Letter 33 Note 1).
[2] Léon Gambetta (cf. Letter 59 Note 2).

61 *To Étienne Devismes*

Lamalou-les-Bains [August 1881]

Dear Friend,

You must think I'm very *rancorous* if you believe that I've forgotten
your patience with my apparatus. I left Paris after flunking the French
dissertation portion of the baccalauréat ès lettres examination. I didn't
receive your gem of prose until the day before yesterday. Here I am
in a horrible hole of red earth, but the landscapes will be all right for

Bagnols. I'm going to get down to work, but I'm anxious to collaborate with you on your story. It's really too good of you to have taken a look at my paltry pencil, which will do whatever it can do, you can rest assured of that; however, I hope to do something on the subject of *Cocotte*. I'll try to be quick.

Thank you for not forgetting me. Please convey my respects to your mother and my best wishes to your brother, and to yourself.

<div align="right">H. de Toulouse Lautrec
Hôtel des Bains, Lamalou-les-Bains (Hérault)</div>

Prov.: Unknown
Pub.: *Cocotte* 4

62 *To Étienne Devismes*

<div align="right">[1]Lamalou [August 1881]</div>

Is he in Barèges?

That's the question that is pursuing me in my bath, between my sheets, and on my walks. The fact is that all the unsightly features of this unpleasant place are erased like a charcoal sketch in a gust of wind when I remember the hours you kindly spent with my apparatus.

You're going to say that I'm getting sentimental, but it's the true truth.

I'm now in Lamalou, a ferruginous and arsenical (*slightly*, as the doctor says) spa where I am steeping myself both within and without. It's much bleaker than Barèges, which is saying a lot,[2] but in any case you don't break your legs here (at any rate I haven't succeeded yet in doing so). Our winter in Nice came to an unpleasant end, *because* of my aunt, who was ill. I took advantage of this delay to continue with my dips in the sea. I got up to the nice round number of *50*, and reached the point where I was able to jump out of a boat I was sort of rowing. This proves two things to you:

1. That my locomotive extremities have made considerable progress.

2. That I've recovered my liking for the sea and therefore for small boats. In fact, right now I'm in the process of negotiating for the construction of a 60-centimetre houari; what annoys me is that all the ones I've seen have a very wide hull and sit level in the water, whereas I'd want mine to be very tapered.

But I realize that I'm chattering like an old magpie. Once again, please let me know the style of painting (it's devilishly daring and I'm going to get down to work), depending on the *inspiration* you want.

Lastly, my respects to your mother. Mama adds her good wishes to mine.

Hoping you're completely better, I send you, and André as well, my warmest regards.

A friend who hopes his letters are not bothering you too much,

Henri de *Toulouse* Lautrec

P.S. Looking forward to hearing from you. Please write to me at the Château de Céleyran, via Coursan (Aude).

Prov.: Unknown
Pub.: *Cocotte* 5

[1] On the top of page one of this letter Lautrec drew a sketch of a boat with a triangular sail attached in the style known as houari (Dortu D.2016).
[2] Lautrec used the Latin phrase 'quod non est paululum dicere'.

63 *To Mme L. Tapié de Céleyran*

Lamalou [-les-Bains, August–October 1881]

Dear Godmother,[1]

I am writing just to have a little chat, since as far as real news goes, it's quite impossible for me to give you any; in fact, there isn't anything interesting here, unless you'd care to know the temperature of my bath and the number of minutes I shower.[2]

I have the good luck to have a bath-man called Jacqrou, who has a face like a bulldog. The other day coming out of the shower he wanted to rub my back with a horsehair glove 'that would smooth the hide of a donkey'.[3] I soon had enough of that stuff, probably because I am one—an ass, that is. We also have the boundless pleasure of the company of this dear *Doctor* Salagade (Bedène) and on top of that of the sticky Bélugon. He has introduced us to Mme and Mlle de Beaufort and M. du Bernard or Dubernard or D'Ubernart,[4] or whatever, who, I may report, is feeling very well. Aunt Joséphine's illness nearly held up his departure (the dear *Doctor*'s). He only came here because of the *little strategem* of making him believe he was going into the country to pick violets and dandelions. Mlle Capus, looking like a Sphinx, is by her fountain; it is certainly a great pity she doesn't know how to draw, because if she did she could fill a whole album with all the grimaces of the guests drinking the waters. We also have the company of cousin, or uncle (take your pick) Georges Foissac,[5] with his better half. We discovered them at the *Temptation*; Cousin Félicie has quad-rupled in size since last year. A testimonial indeed to the kitchen at Castelnaudar-r-rys-s-s!!! Monsieur Bour-r-rges[6] is as gloomy as always and is still wearing that bristly moustache of his like the ar-r-r-se of a

sick chicken. At our table there's a pastryshop owner from Narbonne from the ancient house of Hortala, who's half-cracked. She bursts out laughing without rhyme or reason, and during one of these spells Madeleine claims to have heard a little ... well, a certain funny sound. Bathing-hour is drawing near and so I give you a great big hug, Tata as well. Please be so kind as to pass along all the celestialities of the occasion to M^lle Maurin, Uncle Amédée, Uncle Albert, Monsieur le Vicaire, and all the brats.

Your sticky and clean-as-a-whistle godson, thanks to all the water used up in his honour,

Henri

P.S. We also have M. Vié,[7] and what a Vié!! An adorable Vié, so elegant, so amusing that if I were M^me Vié I'd put him under lock and key for fear someone should steal him.

Prov.: Schimmel
Pub.: GSE34, GSF35

[1] Above the salutation Lautrec drew a portrait entitled Papa Thomson.
[2] Lautrec does not mention the *Cocotte* project.
[3] Lautrec uses the Gascon expression, 'qué lébario la pel dé sus un azé'.
[4] Probably guests at the hotel.
[5] The Foissac (Foyssac) family was related to the Séré de Rivières.
[6] Possibly the father of the Dr Bourges who later was Lautrec's close friend.
[7] Cf. Letter 8 Note 4.

64 To Étienne Devismes

Hydropathic Establishment of Lamalou l'Ancien [Hérault]
[October 1881]

My dear Friend,

I worked as well as I could, and am sending you by the same mail 23 drawings, including two copies[1] of one because of an accident. They're rough sketches and perhaps a little too mirthful, but it seems to me that the text is equally so. The poor priest! Since I'm completely at your disposal, write to me if you want changes made, and if you wish send me back the ones you are not going to use. If you'd like new drawings, I'm your man, because I'm so happy you took a look at my crude inspirations...

I tried for truth rather than the ideal. This may be a mistake, because I don't look with favour upon warts and I like to decorate them with playful hairs, make them round and give them a shining tip.

I don't know whether you have control over your pen, but when my pencil is moving I have to give it its head or crash! ... dead stop.

Well, anyway, I've done what I could, I hope you'll be lenient.

Wouldn't it be wonderful if..., but one shouldn't count one's chickens before they're...

Farewell, I send you my warmest regards. Please give my respects to your mother, and my good wishes to André (has he come by?).

A budding painter,

H. de T.L.

P.S. Please drop me a line quickly. Am excited.

Prov.: Unknown
Pub.: *Cocotte* 6

[1] *Tout un concert de rats* (Dortu D.2020, D.2021).

65 *To Étienne Devismes*

[1]Write to Château du Bosc, via Naucelle [Aveyron] [October 1881]
My dear Friend,

I thought I had gone a little crazy when I read your kind and indulgent letter. I never would have expected such a boon: that you would accept my miserable sketches and in addition thank me for them. Moreover, you're very scrupulous about my drawings. Use the ones you want. I still recommend the head with the rats, the anchor, and the skull among the helmets[2]. One of them in particular could be eliminated, and that is the sentimental thatched cottage![3] The rest, *ad libitum*. I know you'll make a good choice, and would be overjoyed if a single one could please you. I'm returning the manuscript that I kept in case other sketches had to be made.

Anyway, I'm wild, happy, crazy at the thought that maybe your prose will frame my rough sketches like ... fireworks, that you're holding out a helping hand on the difficult publicity road, and, lastly, that I was able to recognize to some extent the old friendship that improves with age.

Please convey my respects to your mother and my regards to André.

Yours,

H. de Toulouse Lautrec

Please keep me as informed as possible of what happens.

Prov.: Unknown
Pub.: *Cocotte* 8

[1] At the top of page one of this letter Lautrec drew a sketch of a spinning top (Dortu D.2018).
[2] *Horse's Head with Rats, Tout un concert de rats* (Dortu D.2020, D.2021). *The Anchor and the Skull among the Helmets* seems to have disappeared.
[3] This drawing seems also to have disappeared.

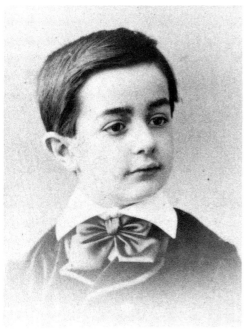

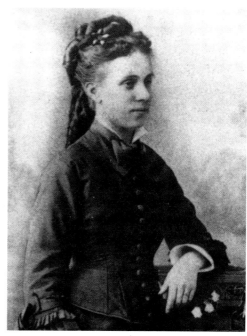

1. Henri de Toulouse-Lautrec, about 6 years old, *c*.1870

2. Adèle-Zoë Tapié de Céleyran, mother of the artist

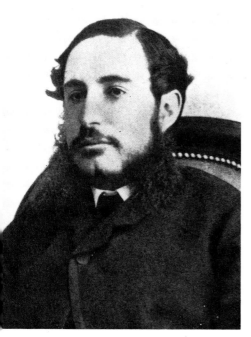

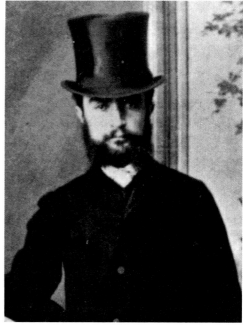

3. Alphonse de Toulouse-Lautrec, father of the artist

4. Charles de Toulouse-Lautrec, Henri's favourite uncle

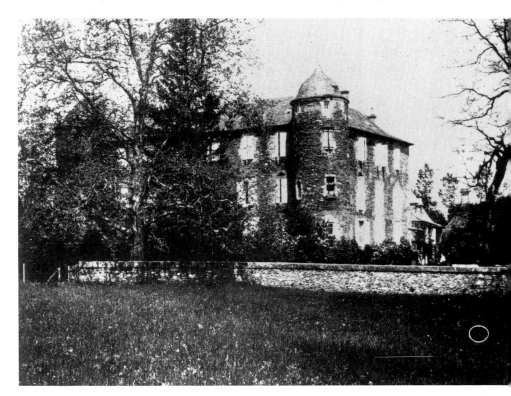

5. Château du Bosc, home of Henri's paternal grandmother

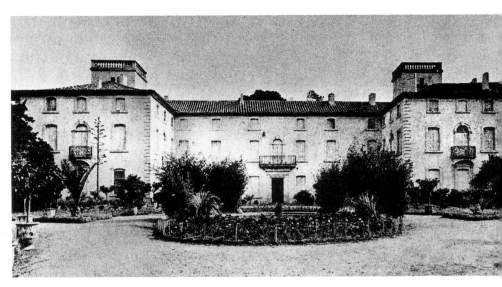

6. Château de Céleyran, home of Henri's maternal grandmother

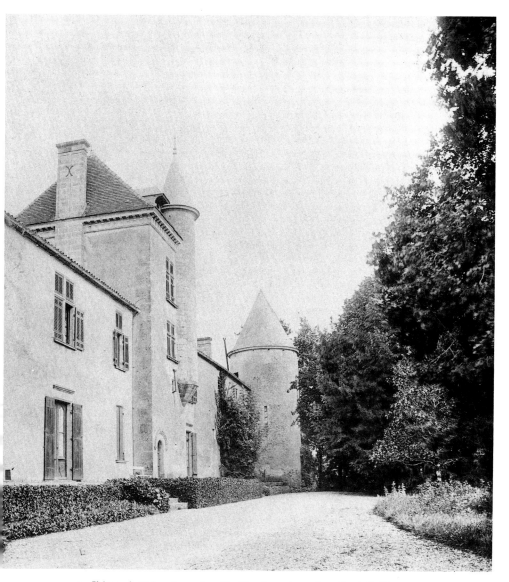

7. Château de Malromé, purchased by Henri's mother, where Henri died in 1901

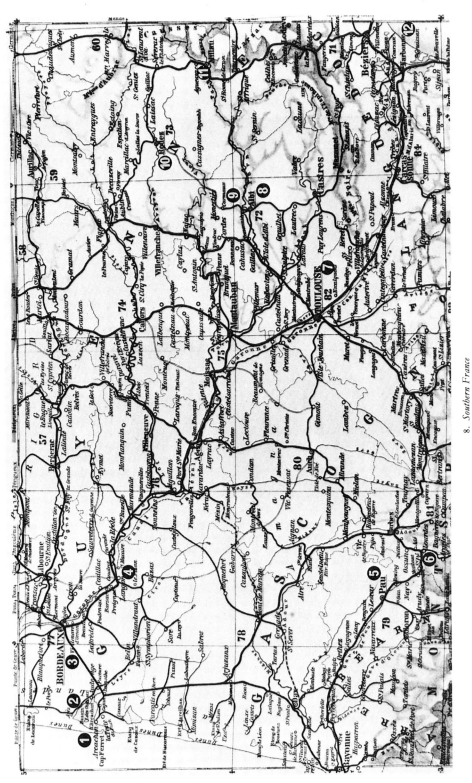

8. *Southern France*

1. Arcachon; 2. Taussat; 3. Bordeaux; 4. Langon/St Macaire; 5. Pau; 6. Lourdes; 7. Toulouse; 8. Albi; 9. Carmaux; 10. Rodez; 11. Millau; 12. Narbonne.

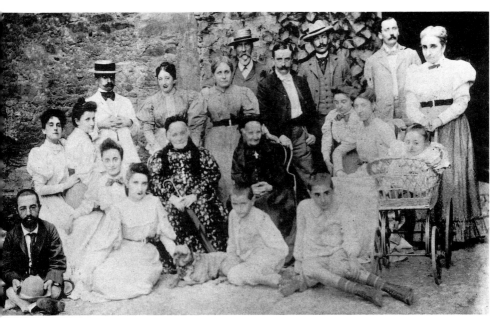

Henri with the Tapié de Céleyran family, his grandmothers, and some others. Left to right: (*back row*) Emmanuel, Cécile Pascal, Adèle de Toulouse-Lautrec, Amédée, Louis Pascal, Comte de Cordes, Raoul, Alix-Blanche; (*middle row*) Mme Raoul, Germaine, Geneviève, Gabrielle and Louise d'Imbert du Bosc, Béatrix, Mme Emmanuel, prob. Henriette; (*front row*) Henri, Marie, Tuck (dog), Alexis, Olivier.

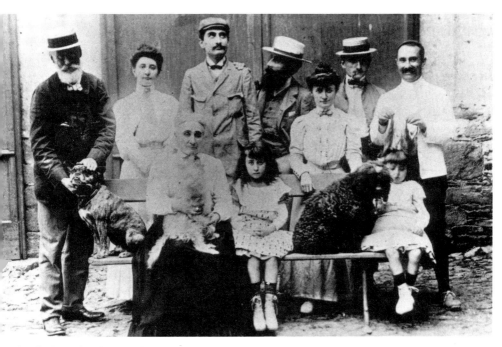

o. Amédée Tapié de Céleyran and his wife Alix-Blanche de Toulouse-Lautrec with some of their family. Left to right: (*back row*) Amédée, Marie, Raoul, Emmanuel, Germaine, Olivier, Alexandre d'Anselme; (*front row*) Tuck (dog), Alix-Blanche, Margot (dog), Gabrielle, possibly Boulett (dog), Raymonde.

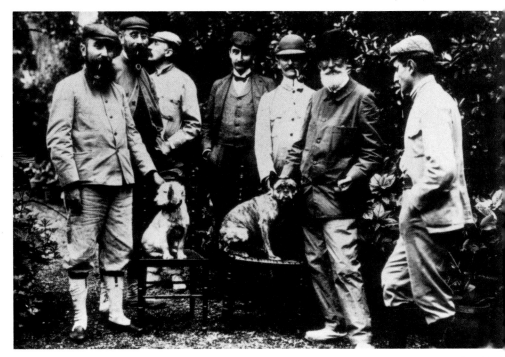

11. Amédée Tapié de Céleyran with six sons. Left to right: Amédée, Gabriel, Raoul, Olivier, Odon, Amédée, Alexi unidentified dog, and Tuck (dog).

12. Some Toulouse-Lautrecs and Tapié de Céleyrans. Left to right: Amédée, Germaine, Marie and Louise Tapié d Céleyran, Gabrielle and Odon de Toulouse-Lautrec, Odon Tapié de Céleyran, Odette de Toulouse-Lautrec, Mr Tanu

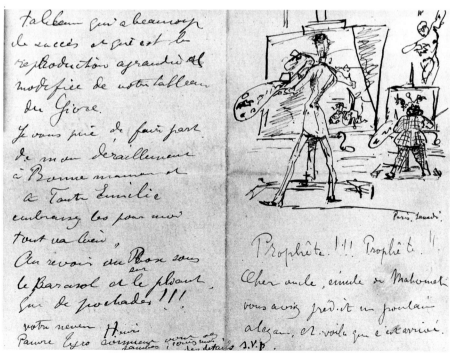

13. Letter to Charles de Toulouse-Lautrec, with self-portrait at the easel

14. Letter to Charles de Toulouse-Lautrec, with portrayal of Lautrec and his teacher Princeteau at their easels

15. Léon Bonnat

16. Fernand Cormon

17. Lautrec in 1883, by Henri Rachou

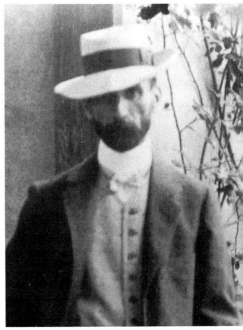

18. François Gauzi

66 To his Mother

Albi, Wednesday [late November 1881]

My dear Mama,

Little new here. Uncle Ernest[1] persists in remaining silent. Telegraph him within the hour to wring this authorization from him that is needed so much! ... Ad. Montey has invited us to lunch on Thursday or Friday with a preacher. Spiritual as well as other delicacies. What luxury! Aunt Joséphine keeps picking at me to go to her doctor. I'll just have to resign myself to it. Saint Edme has written to me. Carissime tibi totus.[2] What a card!!!

Goodbye for now. My letter is as dull as my thoughts, which are absolutely in a state of collapse after the tension of the exams.[3] Give hugs, lots of little smacks and kisses to everyone there for me, and *try to get Louis to come whatever the cost.*

Your son, back from the grandeurs of this world and above all
from those of the baccalaureate,

H.

Prov.: Schimmel
Pub.: GSE35, GSF36

[1] Ernest Pascal, father of Louis Pascal; cf. Letter 5 Note 3. The 'authorization' is for Louis to visit Lautrec in Albi.

[2] 'I'm all yours my dear.'

[3] Lautrec passed his baccalaureate examination in Toulouse in November 1882, after having failed it the previous July. Cf. Letter 67.

67 To Étienne Devismes

[1]Albi [Tarn] [22 November] 1881

Dear One,

Having been swept up in the whirlwind of the baccalaureate examination (this time I passed), I've neglected my friends, painting, and everything that deserves attention down here, in favour of the dictionaries and the *bon manuel*.[2]

Well, the Board of Examiners in Toulouse declared that I had passed, despite the silliness I displayed in answering them, *them*!! I cited non-existent quotations from Lucan, and the professor, wishing to seem erudite, greeted me with open arms. Anyway, it's over.

Would it be tactless to ask you what's become of *Cocotte*?

And did your brother come by?

All these things, and lots of others, are of interest to me.

I don't know whether I told you about my friendship with H. De Camus de Wailly? We had many good times together, and through

him I would have made your acquaintance if that had been necessary. It was fated.

You're going to find my prose quite flabby, but that's the effect of the psychological let-down that follows the examination tension. Let's hope it'll be better another time.

Please convey my respects to your mother and remember me to your brother. I remain,

<div style="text-align: right">Your friend,
H. de Toulouse Lautrec</div>

Prov.: Unknown
Pub.: *Cocotte* 7

[1] At the top of this letter Lautrec drew a sketch of himself being questioned by a professor across a table (Dortu D.2015). This letter, dated by Joyant, was probably written to replace the destroyed letter of the same date that has Dortu D.2019 at the top; *Portrait of Lautrec with Donkey's Ears and Pair of Scissors*, marked 'Baccalauréat ès Lettres'.

[2] A study handbook for the examination.

68 *To Mme R. C. de Toulouse-Lautrec*

<div style="text-align: right">Céleyran, 29 December, 1881</div>

My dear Grandma,

We're right in the middle of all the New Year uproar. Uncle Amédée is leaving for Bordeaux, Aunt Alix is getting the bedrooms ready; and so everything's at sixes and sevens. It would be a great day but for the fact that there are two sides to every coin. Poor Brick died last night and poor old Anna is on the way out, too. She couldn't be stopped from going to Midnight Mass, and caught cold. The result, congestion of the lungs, and they've already given her the last rites. No doubt about it, the race of good servants is dying out. Uncle Jules[1] is very low, all his daughters are with him. Hardly any hope for him left. Béatrix keeps on having attacks which are very trying for so small an object. The rest of the family just lives from one day to the next, all bawling and squawling. Have you any more Spanish letters? If so, I hope they won't be quite so animated as the other ones. Papa is limping and goes out with Uncle Amédée on the back of a bike. It's freezing here but the sun is so warm and *bright* that we don't mind it at all. How true it is that in a way you feel the cold much more through your eyes than your back. But I am losing sight of the real reason for my letter, which is to send you my tender if clumsy wishes for a happy New Year, gracefulness not being my strong point. Therefore, I send them to you and those around you as sincerely as can be, but from myself only (since the others here at Céleyran will be writing to you

on their own), and beg you to accept a thousand and one embraces from your respectful grandson,

H. de Toulouse Lautrec

P.S. I would like Uncle Charles to write and tell me what *Le Figaro* said about *Cabanel*.[2]

Prov.: Schimmel
Pub.: GSE37, GSF38

[1] Jules de Gualy de St Rome, married to Blanche, sister of Lautrec's grandmothers.
[2] Alexandre Cabanel (1823–89), a very successful painter and a teacher at the École des Beaux-Arts. Uncle Charles was regarded as an art expert within Lautrec's family. Cf. Letter 4 Note 5.

2

ART STUDENT

—————————— ❧ ——————————

CHRONOLOGY
1882–1886

1882	2, 17 January	Céleyran Paris	Writes to Uncle Charles. Studies with Princeteau, 233 rue Faubourg St Honoré.
	22 March	Paris	Writes to Uncle: 'Princeteau is going to introduce me'—referring to Bonnat.
	April		Mother writes to her sister: 'Notre futur Michel-Ange'.
	17 April	Paris	Writes to father reporting on reception at Bonnat's. The atelier was located at 71 impasse Hélène, off 41 avenue de Clichy.
	7 May	Paris	Writes to Uncle Charles saying that Bonnat judges his 'dessin' to be 'atroce'.
	August	Le Bosc	Visits.
	5 September	Le Bosc	Consecration of the new chapel of the château.
	September	Le Bosc	Writes to father about closing of Bonnat's studio.
	September	Paris	Bonnat closes atelier. Transfers to Cormon's studio located at 10 rue Constance.
	9 October	Paris	Writes to mother.
	28 December	Paris	Writes to grandparent.
1883	10 February	Paris	Writes to Uncle Charles: 'Cormon's criticisms are more lenient than Bonnat's'.
	April	Paris	Writes to mother. Discusses Céleyran and Malromé.
	20 May		Purchase of Malromé by his mother.

	September	Céleyran	Writes to Eugène Boch about returning to Cormon in October. The studio had moved to 104 bd de Clichy.
	8 September	Langon	Visits Respide. Writes to mother.
	October	Paris	
1884	January	Paris	Writes to grandparent.
	Spring	Paris	Writes to mother that he has been declared unfit for military service.
	June	Paris	Chosen to work on illustrated edition of Victor Hugo.
	Summer	Paris	Moves in with René and Lili Grenier, 19 bis rue Fontaine.
	August	Paris	Writes to grandparent.
	October	Paris	Writes to mother that he has settled down in his friend's place (Grenier), refers to cholera epidemic that had broken out earlier in Toulon and Marseilles.
	24 December	Paris	Writes to grandparent that he is taking a larger studio which he intends to furnish.
1885	January	Paris	Writes to mother regarding commission for Guide Conty–Nice and Monte Carlo.
	January	Paris	Writes to mother that Bourges has passed Part I Concours d'Externat.
	August	Le Bosc	Visits.
		Malromé	Visits.
		Taussat	Visits.
	Autumn	Normandy	Visits Anquetin's family.
	Autumn	Paris	Bruant's Mirliton opens at 84 bd Rochechouart.
	December	Le Bosc	Writes to grandparent.
1886	Spring–Winter	Paris	Writes to mother: 'I'm making some sketches for the *Courrier Français*. Looking at studios.'
		Paris	Permanent display of some of his work at Le Mirliton.

	Paris	Takes an atelier at 27 rue Caulaincourt (7 rue Tourlaque).
Summer	Malromé	
	Arcachon	
	Respide	Stays at Amédée's hunting lodge.
	Paris	Terminating activities at Cormon's atelier.
Autumn	Villier-sur-Morin	Paints murals at Auberge Ancelin.
17 October	Paris	Exhibits at Arts Incohérents under name Tolav-Segroeg, Hongrois de Montmartre.
19 December	Paris	Writes to mother regarding sharing an apartment with Bourges.

69 *To Charles de Toulouse-Lautrec*

 Céleyran, 2 January 1882
[1]My dear Uncle,

I have been asked to do something by the master (Princeteau); he wants me to trace a drawing from one of his albums for a picture now under way, undoubtedly, and this is to ask you please to bring those two Princeteau albums that are in Mama's linen cupboard (Grandma will open it for you), in the box that holds the falconry books. This is a white cardboard box with green borders, you've seen me rummaging in it often enough and you'll be kind enough to bring them to Albi.

On with painting!

 Nepos

Prov.: Unknown
Pub.: Joyant I, p. 53[2]

[1] This fragment is the first of twenty that were published by Maurice Joyant in the first (1926) volume of his Lautrec biography. Seventeen of these fragments are published without change while three of them that were partially reproduced in Dortu contain changes revealed in viewing portions of the original manuscript. Evidently Joyant published large fragments of the letters, editing out unwanted sections and on at least one occasion adding phrases not included in the manuscript. In light of these facts it may be necessary to reconsider the validity of the Joyant biographies in discussing or failing to discuss phases of the artist's life. Cf. Joyant, Dortu, and Letters 70, 71, 592, which are published as Dortu S.D.12, S.D.13, S.D.31.

[2] Maurice Joyant (1864–1930), the longtime friend and schoolmate of Lautrec (cf. Letter 10), who became associated with the art dealer and publisher Goupil and Company, later known as Boussod and Valadon; Boussod, Manzi, and Joyant; and finally Manzi-Joyant. He came into prominence in the firm when he became manager on the breakdown and death of Théo van Gogh. He arranged exhibitions of Lautrec's work during the artist's lifetime and after his death. He wrote the two-volume biography and catalogue published by Floury in 1926 and 1927. He remained a confidant of Lautrec's mother to the end, planning the Lautrec Museum in Albi, and the 1931 Exposition H. de Toulouse-Lautrec at the Musée des Arts Décoratifs, Palais du Louvre, which he did not live to see.

70 *To Charles de Toulouse-Lautrec*

Céleyran, 17 January 1882

My dear Uncle,

We were the quivering witnesses of indecisions and decisions about going to Albi and coming back. Has a decision been made? But what I want to talk about with you is the Princeteau sketch.

Since I don't want to keep him waiting too long, and since I'm not in Albi (obviously), I would ask you to be so kind as to make the tracing in question. It's the second or third drawing in the large album, showing dogs holding a *young* (Princeteau's word) boar by the ears;[1] you would send it to him, rolled up, at 233 rue *du Faubourg* St Honoré.

We were very pleased to learn that Aunt Joséphine is better ...

Your Nepos,
H. de Toulouse-Lautrec

Prov.: Unknown
Pub.: Joyant I, p. 54,[2] Dortu S.D.12
 [1] On page 3 of this letter Lautrec has drawn a sketch of dogs hunting boar (Dortu S.D.12).
 [2] Cf. Letter 69 Note 1.

71 *To Charles de Toulouse-Lautrec*

Paris, 22 March 1882

My dear Uncle,

I'm keeping my promise to keep you up to date. By unanimous opinion, I'm going to visit Bonnat[1] on Sunday or Monday. Princeteau is going to introduce me. I've been to see the young painter Rachou,[2] a student of Bonnat's and a friend of Ferréol's,[3] who is beginning to work alone; he is submitting a painting to the Exhibition.[4]

Princeteau is working on an immense painting of wild boars being hunted down.[5] It has a strong resemblance to the tracing of his drawing. He's working like a slave because he's fallen behind. At the Hôtel Pérey we have a lady from the island of Mauritius. You would love her coppery skin.

I went to see the Water-Colourists, a beautiful exhibition in a magnificent setting.[6] The outstanding works are a life-size head of a Béarn woman, by Jacquet,[7] and life drawings of scenes in Tunisia, by Detaille.[8]

I'm sending you the illustrated catalogue.

More of my plans. I'll probably get myself admitted as a student at the École des Beaux-Arts so that I can participate in their competitions while remaining with Bonnat.

All this is very engrossing, especially since on the horizon there's the Horse Show, the Marche, and Auteuil.[9] On Monday we had dinner at Uncle Odon's house. The hairdresser's scissors have made the rounds of this family. Raymond's hair has been clipped close to the temples, and Mlle Mahéas has got a fringe that is unruly and showy ...[10]

At this point, dear Uncle, a big hug for all of you from us. Please give my [regards] to my Aunt Joséphine, because I've ... been so busy I haven't been able to write to her.... That will be for Grandma ...

<div align="right">

Your nephew,
H. de Toulouse

</div>

Prov.: Unknown
Pub.: Joyant I, p. 56,[11] Dortu S.D.13

[1] Léon Bonnat (1833–1922), painter of portraits and historical subjects, was born in Bayonne, making his first salon appearance in 1857. Member of the Institute 1881 and Professor at École des Beaux-Arts. He maintained a studio for young artists which was attended by Lautrec in 1882. Grand Cross of the Légion d'Honneur 1900 and an important art collector.

[2] Henri Rachou (1856–1944), painter born in Toulouse, student of both Bonnat and Cormon. A lithograph of his appeared in L'Estampe Originale, plate 16 (vol. II, 1893). Chevalier and officer of the Legion of Honour, Gold medal, 1900 Exposition, and later Conservator of the Museum at Toulouse. Lautrec painted and drew his portrait (Dortu P.196 and D.2840).

[3] Ferréol Roudat, a goldsmith in Albi who was a friend of Rachou's brother.

[4] The Salon of 1882 where Rachou exhibited two paintings: No. 2233, Marchande de marée, and No. 2234, Intérieur d'atelier.

[5] Hallali, exhibited at the Salon of 1882.

[6] Société d'Aquarellistes Français—1882—Quatrième Exposition took place at rue de Sèze 8, the recently completed Galerie Georges Petit. This was considered the most beautiful exhibition space in Paris,

[7] Gustave Jean Jacquet (1846–1909), a portrait painter and water-colourist who exhibited at the Salon from 1865 and years after, winning his first medal in 1875 and the Legion of Honour in 1879.

[8] Jean-Baptiste Édouard Detaille (1848–1912), a popular 19th-century French painter who first exhibited in the Salon in 1867 and often thereafter.

[9] Marche, a park where steeplechase competitions were held; Auteuil, a race course.

[10] Lautrec's drawing of the head and shoulders of a young woman appears at this point in the letter (Dortu S.D.13).

[11] Cf. Letter 69 Note 1.

71A *To Mme R.C. de Toulouse-Lautrec*

<div align="right">

Paris, 6 April [1882]

</div>

[1] ... Princeteau took me to see Bonnat on Tuesday, 26 March.[2] I brought along two or three daubs, including a picture of Germaine sucking her thumb.[3] The Master stared at the perpetrator and the work, and said to me, 'Have you done drawing?' 'That's the only reason I've come to Paris.' 'Yes,' he said, 'You have some sense of colour, but you would have to draw and draw.' Whereupon he gave me his card and a note for the student in charge of his studio. I learned from Rachou (a young painter who was recommended by Ferréol, and

who is a student of Bonnat's) that it is difficult to get hold of the student in charge. Rachou is supposed to be making the arrangements with him at this very moment, and on Monday[4] I'll make my more or less triumphal entrance. Princeteau is getting more and more friendly. As for me, I'm trying to get ready to work, because painting is definitely not a sinecure . . .

Prov.: Unknown
Pub.: Beaute II

[1] Fragment of a letter.
[2] 26 March 1882 fell on a Sunday. Tuesday 28 March.
[3] *Mademoiselle Tapié de Céleyran (Germaine)* (Dortu P.183).
[4] Lautrec would be referring to Monday, 10 April 1882. Letter 73, clearly dated Monday, 17 April 1882, reveals the actual date he entered Bonnat's.

72 *To his Mother*

[Paris, Spring 1882]

My dear Mama,

I hardly ever see Papa these days and am resolutely waiting (feet firm on the ground) for my cousins. Papa finally told me that Le Bosc belongs to my aunt and that we were out in the cold.[1] You know my opinion of that. Useless to rehash the subject.

You ask about my journals. I'm still keeping one, with no great enthusiasm however. They'll all be published at once with a text written for this purpose.[2] Happy man of letters, happy public, and happy me if, as I hope, it proves worth my while. Paris continues to be warm and muggy with a few rays of sunlight every once in a while. I have finally met Lewis Brown,[3] who was very obliging to me. What's going to become of my cousins, give me your opinion. I'm very much afraid it won't be a glowing one.

Tell Louis the enclosed note will give him all the information he needs.

As for the cash, I need all I can get, that is to say, 500 francs *at once*. Of course you will have it by 1 July.

And now let's go and have lunch.

Yours,[4]
Henri

Prov.: Schimmel
Pub.: GSE38, GSF39

[1] Lautrec is referring to Alix-Blanche Tapié de Céleyran. There was apparently a settlement of family properties, whereby the Tapié de Céleyrans acquired Le Bosc and the Toulouse-Lautrecs acquired Ricardelle, an estate of some 10,000 hectares. (Cf. Letter 8 Note 5.) Through her oldest son Raoul and his descendants it is still occupied by her family.

[2] Evidently a series of drawings illustrating incidents in his life, such as he had already made in 1881 for the 'Cahier de Zig-Zags'. He may be referring to Dortu D.2160–208 (49 pages, 77 drawings), later published as *Submersion*. Cf. Curnonsky.

[3] John Lewis Brown (1829–90), a painter of hunting and military scenes who had influenced his early work. Brown's studio was in the same building as Princeteau's.

[4] Lautrec used the English word, as he will often do in signing letters.

73 *To his Father*

[Paris] Monday, 17 [April] [1882]

My dear Papa,

I was taken in this morning by the students of the Bonnat[1] studio. Thanks to the recommendation of Rachou,[2] a friend of Ferréol,[3] I had a good reception. By chance a young American from the hotel went in with me. They had us talk and pay for a toddy. That's all there was to it. Not so terrible. They made enough racket, but not too much actual fighting. There are a lot of English and Americans.

So, there I am, one of the boys, absolutely. Draw, draw, that's the rub. Mr Moore,[4] the deaf-mute American painter, has brought a lot of splendid Japanese bibelots here.[5] This young man is his friend. He has set up his studio in one of the large rooms at the Pérey.

Yesterday I saw Du Passage,[6] who asked me how things were with you. Yesterday, for *La Vie Moderne*,[7] he drew the different ways a horse jumps.

Princeteau is still at the hotel. He is charming to me and encouraging. Now to work!!

Goodbye, dear Papa. Be so kind as to remember me to everyone.

Your son,

H. de Toulouse Lautrec

Prov.: Schimmel

Pub.: GSE39, GSF40

[1] Cf. Letter 71 Note 1.

[2] Cf. Letter 71 Note 2.

[3] Cf. Letter 71 Note 3.

[4] Harry Humphrey Moore (1844–1936), an American painter who had studied art and travelled extensively. He had just returned from a trip to Japan.

[5] Lautrec's interest in Japanese art seems to date from this time.

[6] The Vicomte Charles-Marie du Passage (b. 1843), painter and sculptor, an acquaintance of Lautrec's father.

[7] A magazine of art and literature founded in 1879.

74 To Charles de Toulouse-Lautrec

[Paris] Sunday morning, 7 May 1882

My dear Uncle,

I've obtained very precise information, not from M. Bonnat, whose majesty prevents me from asking a single question, but from several exhibitors.

The Exhibition is open until 20 June, and will close for a week at the end of May so that the jury can make its decision about the medals to be awarded. So you still have time. But there's a lot to see. I'll mention Bonnat's *Portrait de Puvis de Chavannes*, Roll's[1] *Fête du 14 Juillet*, and *Les Derniers Moments de Maximilien* by J.-P. Laurens.[2]

Are you interested in hearing the type of encouragement Bonnat gives me? He tells me, 'Your painting isn't bad, it's stylish, but there's nothing wrong with that, but your drawing is simply atrocious'.

And I have to pluck up my courage and start all over again, and erase my work with breadcrumbs ...

Your nephew,
H.T.L.

Prov.: Unknown
Pub.: Joyant I, p. 58[3]

[1] Alfred Philippe Roll (1846–1919), painter of landscape, military, and marine pictures, first exhibited at the Salon of 1870 and regularly thereafter.
[2] Jean-Paul Laurens (1838–1921), painter of historical pictures, first exhibited at the Salon of 1863 and regularly thereafter.
[3] Cf. Letter 69 Note 1.

75 To Mme L. Tapié de Céleyran

Le Bosc [August 1882]

My dear Grandma,

I didn't want to let your name day go by without coming, my roll of congratulations in hand, with my best wishes (that classic image). So I do it as well as I can!!! There it is done, awkwardly enough, maybe, but gracefulness not being the key to my character, I am hoping to be pardoned, if not thanked, for it.

You may not be displeased to know how we've been living here in the fog or rather the mud of the Aveyron,[1] since it's raining hard. Take my word it's raining cats and dogs (choice expression indicating a serious study of slang on my part). Grandma ... , what is Grandma doing? She is putting up curtains and feels the clouds going by. Aunt Émilie is sewing the aforesaid curtains on the machine. Uncle Amédée is off massacring all he can and Uncle Charles is looking for excuses

(oh, diplomatic refinement) for his laziness, which shows through despite his protests. Mama, I think, is doing cut-out work on some moleskin, known by the fancy name of altar cloth. I am dividing my leisure time between painting and the toothache, an inexhaustible source of diverse enjoyments. Kiki sulks at anything not called a blanquette,[2] a floury christening. Mariette is curling her hair and Doctor Farguent has just come to give her her pills. And that's all there is.

We all send you our love, and I a great big kiss.

<div style="text-align: right">Your godson,
Henri</div>

Prov.: Schimmel
Pub.: GSE42, GSF43

[1] The Department of Aveyron, in south-western France, in which the Château du Bosc is situated. Lautrec uses the Gascon word 'bouillaque', i.e. 'boulhacas', meaning mud.
[2] A white sauce that accompanies a veal stew.

76 *To his Father*

<div style="text-align: right">Le Bosc, this Thursday [September 1882]</div>

My dear Papa,

Bonnat has let *all* his pupils go.[1] Before making up my mind I wanted to have the consensus of my friends and by unanimous agreement I have just accepted an easel in the atelier of Cormon,[2] a young and celebrated painter, the one who did the famous *Cain Fleeing with His Family* at the Luxembourg.[3] A powerful, austere, and original talent. Rachou sent a telegram to ask if I would agree to study there along with some of my friends, and I have accepted. Princeteau praised my choice. I would very much have liked to try Carolus,[4] but this prince of colour produces only mediocre draughtsmen, which would be fatal for me.

After all, I won't be married to the situation, will I? And the choice of teachers is by no means exhausted.

We are leaving for Respide,[5] where we are expecting to stay only briefly in order to get the indispensable work going again. Hoping to make a go of it, I shall be happy to have your approval of an unprejudiced choice based on serious argument. Everything is fine here and Aunt Blanche is with us. We all send you our love.

<div style="text-align: right">Your respectful son,
Henri</div>

Prov.: Schimmel
Pub.: GSE43, GSF44

[1] Bonnat, having been appointed a professor at the École des Beaux-Arts, had closed his private studio.

[2] Fernand Piestre, called Cormon (1854–1924), a student of Portaels in Brussels and Cabanel in Paris. He first exhibited in the Salon of 1863 and for many years after. Winner of the Cross of the Legion of Honour and many other medals, Professor at the École des Beaux-Arts and member of the Institute, he maintained an atelier in Paris for many years. His students during the Lautrec years included Louis Anquetin, Émile Bernard, Eugène Boch, Ernest Bordes, Gustave Dennery, François Gauzi, V. van Gogh, René Grenier, A. S. Hartrick, Lucien Metivet, and Henri Rachou. The studio was located at 10 rue Constance.

[3] It had been exhibited at the Salon of 1880, No. 877.

[4] Émile Auguste Carolus-Duran (1838–1917), a fashionable portrait painter.

[5] The Pascal's country home, near Bordeaux.

77 *To his Mother*

[Paris] 9 October [1882]

My dear Mama,

I've received your not very cheerful letter, but please give me details on the incidents that occurred. Are you officially ruled out of a share in the family spoils, or have you retired into absolute silence? Or has there been an arrangement, and in what terms?[1] Send me all the details because I'm completely at sea and wouldn't want to drop a brick. Everything here is as well as can be expected. I'm going to try to find a place to live but it isn't easy.

I kiss you.

Yours,
H.

Where is Jalabert?[2] Give me his address, please.

Prov.: Schimmel
Pub.: GSE44, GSF45

[1] Cf. Letter 72 note 1.

[2] Bernard Jalabert, the superintendent of his parents' property at Le Pech Ricardelle and continuing financial assistant to the family after the sale of the property.

78 *To his Mother*

[Paris, Autumn 1882]

My dear Mama,

I'm a little late but I know, first, that the fuss of getting ready to leave must have kept you terribly on the hop, and, second, that Louis must have told you about my plans. I have definitely resumed my treatment.[1] Gabriel has left with the Abbé who was taking him to Lille(?) without stopping to see us. Papa, hot-tempered as always,

gave an artilleryman a dressing down for shouting at his horse.[2] The sunshine is simply beautiful today and I am sending you a kiss in the hope of making it a real one next time.

Your
Henry

P.S. We will have to have a *serious* talk about the proposal to sell Ricardelle.[3] Papa having asked my opinion, I prudently kept it to myself. Did I do right?

Prov.: Schimmel
Pub.: GSE 48, GSF 49

[1] Probably the one with an electric brush mentioned in Letter 138. Cf. also Letter 23.
[2] The story is told in fuller detail in Mack, p. 16.
[3] Cf. Letter 72 Note 1.

79 *To his Mother*

[Paris, November 1882]

My dear Mama,
 My life is dull. I drudge along sadly,[1] and haven't talked to Cormon yet. In all events, I'll be at your feet on the 1st, with my friend Claudon,[2] a charming fellow. That will give us a lift.
 Dora looks to me as if she's all loused up. You find that Louis is getting big and fat. More power to him. I wrote to him to explain why I didn't see him before he left. Papa is going to leave??? Let's hope so.
 I kiss you.

Henri

Prov.: Schimmel
Pub.: GSE45, GSF46

[1] No doubt partly because his favourite cousin, Madeleine Tapié de Céleyran, had died that autumn.
[2] A fellow student at Cormon's studio.

80 *To Amédée Tapié de Céleyran*

[Paris] Friday, 1 December [1882]

My dear Uncle,
 Well, here we are at it again. You with your gadgets and me with my plumb line. Things are jogging along pretty well with me. Cormon gave me a warm welcome. He liked my drawings, particularly (beg your pardon) the one of Odon with his hands stuck in his pockets, in

other words: *hip! hip! hurrah.*[1] Princeteau preferred the bat and Rachou the one of *Uncle Charles* leaning on the table.[2]

We had a restful stay at Respide, a truly pretty place, where you can really go boating. Louis is grinding away for his baccalaureate on the 6th. Poor little fellow: they tell me Toto[3] made up his mind to put on a little pressure. I can't get over it. Tell him not to carry the thing too far.

My new boss is the thinnest man in Paris. He often drops in on us and wants us to have as much fun as we can painting outside the studio. I haven't seen Bonnat yet. Will I ever!!!! I knew all my fellow-students, so there's been no break. Uncle Odon and Aunt O.[4] are here. Their kids have gone to Albi. The parents leave tomorrow for Florida. They are going to have things planted and built. They look down in the mouth already. What will they be like by the time they get back!

I've heard about Uncle Bébert's marriage. Man overboard ... another one!!! Is he delighted!! May these two experiments succeed, and mine along with them!!!

My most friendly regards and endearments[5] to Dowager ladies and young ladies as well, meanwhile I shake your hand majestically by the forefinger.

<div align="right">Your nephew,
H Monfa</div>

Prov.: Schimmel
Pub.: GSE46, GSF47

[1] Lautrec uses here an invented onomatopoeic expression, 'raou, plaou, plaou'.
[2] *Odon Tapié de Céleyran (10 ans)* (Dortu D.2634), *The Bat*, unidentified; *Comte Charles de Toulouse-Lautrec* (Dortu D.2659).
[3] Probably one of Lautrec's Tapié de Céleyran cousins. Cf. Letters 349.
[4] Actually Lautrec's Aunt Émilie, to whom he occasionally refers in this way. Cf. Letters 25 Note 3. Florida was the name of their country villa.
[5] Endearments: cf. Letter 98 Note 1.

81 *To Mme R. C. de Toulouse-Lautrec*

<div align="right">[Paris] 28 December [18]82</div>

My dear Grandma,

I'm going to take the crowded New Year's Day train and spend some time before the fire that flames at your feet in Carmaux,[1] and tell you about the various stages I've passed through on the road of art.

Did I lose anything when I switched from Bonnat to Cormon? I should be tempted to answer, 'No.' The truth is that while my new boss does not *yet* have the astonishing prestige of my old boss, he is contributing to my training all the freshness of his early illusions, a

talent that bids fair to carry off the medal of honour for this year, and tremendous good will. With this one can go much further than I probably will. In any case, I devote myself all morning and afternoon to my brush. I also have to tell you about a little exposure of my own: I have a picture or at least a daub in Pau.[2] So now I'm an exhibitor.

Papa is in Orléans, wrangling between his horses and his coachman and pulling his beard with all his strength for lack of hair.

And we're going to have a visit from the Pascals, which will certainly enliven our evenings, which in the presence of Pérey senior and junior aren't at all exciting.

Mama saw Mme de Gironel. Her son is better, but he's still being bottle-fed.

Goodbye, my dear Grandma. A big hug from the bottom of my heart. Happy New Year to you and everybody in the family, particularly Uncle Charles, Aunt Émilie, and the two little Breton-speaking Bretons.

Another hug.

<div align="right">

Your respectful grandson,
H. de Toulouse Lautrec

</div>

P.S. I'm going to write to Aunt Joséphine and Uncle Charles.

Prov.: Scott

[1] A small town about 9 miles north of Albi.
[2] Cf. Letter 82.

82 *To Charles de Toulouse-Lautrec*

<div align="right">

[Paris] 10 February 1883

</div>

Dear Uncle, for a long time now I've been thinking about a chat with you, but the daily grind has prevented me from doing it. I hope you will not have lost anything in waiting for the torment of a dull reading. Well, I'm getting to know Cormon better, he's the ugliest and thinnest man in Paris. All because of necrosis. People even say he drinks. Cormon's criticisms are much more lenient than Bonnat's. He looks at everything you show him and gives you a lot of encouragement. This will amaze you—but I don't like it as much! The fact is that my former master's lashes put some ginger into me, and I didn't spare myself. Here, I'm a little bit on edge, and I need a lot of will-power conscientiously to do a drawing when something not quite as good would do just as well in Cormon's eyes. Still, in the past two weeks he has reacted and has expressed dissatisfaction with several students, including me. So I've gone back to work with vigour. A lot of

exhibitions: The Water-Colourists, pitiful; Volney, mediocre; and Les Mirlitons, bearable.

You'll notice that I'm disposing of all of them perhaps somewhat unceremoniously, but that's all they deserve.

Princeteau is in the Midi, supervising some cuttings.

Uncle Odon has returned with my aunt. They ate a lot of preserves and saw lots of rails.

Did you know that I have a little panel in Pau.[1] The exhibition period has opened up to my flappings of wings from a delicate arse. I sent good old Uncle Albert on an expedition to the Aveyron region to buy for me some faded, well-worn, darned blue skirts.

They've been hugely successful. Why don't you make a quick visit to the capital? You'd find things to see. Don't let the politics frighten you,[2] we feel safe and secure and we read the proclamations calmly.

Your nephew,
H. De T.-Lautrec

P.S. I hope that at least you haven't stopped painting?

Prov.: Unknown
Pub.: Joyant I, p. 60[3]

[1] At the 1883 exhibition of the Société des Amis des Arts, Pau, Lautrec exhibited under the name Henri Monfa. His painting *Un petit accident*, No. 369, is probably one of the two paintings entitled *Charrette embourbée* by Dortu, P140 of 1881 or P230 of 1884.

[2] On 1 January the news of the death of Gambetta, former President of the Council, caused a great shock in Paris. On 18 January Prince Jérôme-Napoléon Bonaparte was arrested for conspiracy. A new government was formed on 28 January, and on 3 February a law against pretenders (to the throne) was voted.

[3] Cf. Letter 69 Note 1.

83 *To his Mother*

[Paris, Spring 1883]

My dear Mama,

I've been happy about the good news you've been giving to Aunt Cécile,[1] showing that you approve completely of my move. While regretting that your return should be delayed, I can't blame you for making the most of your trip. I am continuing to eat with Princeteau. One day, since at Lucas[2] they've cut out the table d'hôte owing to a shortage of customers, I went to Longchamps with P.[3] to browse on the green grass. My work is progressing. I'm finishing the portrait of d'Ennery,[4] who very obligingly posed for me. Cormon is a little worn out by the jury work which wound up only last Saturday.

It's as warm as summer and an overcoat is becoming superfluous.

I'm calling a halt, for I'm just writing words, and with this send you
a kiss, and ask you to distribute salaams[5] and many kisses to whom it
may concern.

<div align="right">HTL</div>

Prov.: Schimmel
Pub.: GSE49, GSF50

[1] Cécile Pascal, wife of Ernest Pascal, was a first cousin and close friend of Lautrec's mother.

[2] A fashionable restaurant where Lautrec, like his father, often dined, located at 9 place de la
Madeleine and 28 rue Boissy d'Anglas.

[3] Probably Princeteau. Longchamps is a racetrack in the Bois de Boulogne.

[4] Gustave Dennery (1863–1953), a fellow student at Cormon's studio and exhibitor at the Salon
from 1887 and for many years afterwards. In addition to the oil portrait that Lautrec mentions (Dortu
P.223), he did charcoal sketches (Dortu D.2746 and D.2795).

[5] Cf. Letter 98 Note 1.

84 *To his Mother*

<div align="right">[Paris] Wednesday [April 1883]</div>

My dear Mama,

Aunt Cécile[1] has told you how, on Rouilat's[2] advice, I took my
pillow to 37 rue des Mathurins. The difficult part was finding a way
to do it without startling Princeteau, who wanted to bring me to the
Hôtel de Pivert in the passage de la Madeleine. He remained at the
Hôtel Pérey, and I see him every day around 6.30 when I go to put on
a fresh shirt. I bring Louis[3] along to sleep. The Péreys didn't howl.
They'll be lucky if they're not paralysed in a month. My life is going
along as usual, and yesterday I went to the monthly dinner, which is
definitely boring;

Dennery was rejected for the Salon by 38 votes to 2.[4] Uncle Ernest[5]
gave a talk on Sunday at a public gathering in Tivoli Vauxhall,[6] and
naturally he was delighted with the attitude of the populace.

What you tell me about Céleyran leads me to believe that we still
haven't seen the end of the matter, so I advise you not to wait for the
move. Aunt Cécile tells me again about offering you Respide as a
lodging instead of shaking up the dust of Malromé[7] with anything
except your fingertips.

So you see that everything is going very well.

Don't be in a hurry. But come back after you've calmly taken care
of all your little affairs. Chi va piano va sano.[8]

<div align="right">I kiss you.
HTL</div>

A hug for everyone.
Godmother ... (do I need to say it?)

Prov.: Doucet

[1] Cécile Pascal: cf. Letter 83 Note 1.

[2] Doctor Rouilat: cf. Letter 89.

[3] Louis Pascal: cf. Letter 5 Notes, 3, 4.

[4] Gustave Dennery: cf Letter 83 Note 4. The finished portrait was obviously rejected for the Salon opening on 1 May 1883.

[5] Ernest Pascal: cf. Letter 5 Note 3.

[6] Tivoli-Vauxhall, Bal d'été, located at 12–16 rue de la Douane, Paris, near the Château d'Eau, was open for dancing every evening.

[7] An old château set within a park, near St Macaire in the Department of Gironde, about ten miles from Respide, which Lautrec's mother was to buy in May 1883. In a letter to her mother, dated 20 May 1883 (published in Attems, pp. 211–13, and incorrectly dated 1889), she explains her reasons for doing so and outlines her plan for planting vines on part of the land, which is probably the 'strange project' that Lautrec refers to in his letter of 8 September 1883.

[8] 'Slow and easy is the best way.'

85 *To his Mother*

[Paris, April 1883]

[1] Vive la Révolution! Vive Manet![2]

The breeze of Impressionism is blowing through the studio. I'm overjoyed, because for a good while I've been the sole recipient of Cormon's thunderbolts.[3]

I spend my day working and my evening at Pezon's,[4] looking at the wild beasts.

Prov.: Unknown
Pub.: Carco, p. 161

[1] Francis Carco (1886–1958), poet and novelist of the artist life in Montmartre, owned the manuscript and published this fragment.

[2] Édouard Manet died on 30 April 1883.

[3] This does not seem to agree with earlier and later statements of Cormon's actions.

[4] Pezon's Menagerie—Lautrec made a group of sketches of animals, at that time, including one of a lioness which he signed 'Bellone, Ménagerie Pezon—16 avril 83' (Collection Schimmel). Baptiste Pezon, working with his brother Jean (Jean de l'Ours), was among the great Parisian animal acts of the time. With two lions named Brutus, his act, starting about 1865, ran for many years. His son Adrien had a tiger act at the end of the century and sold the last of the animals in 1909.

86 *To Eugène Boch*

Château de Céleyran near Coursan [Aude] [1 September 1883][1]

Dear Old Fellow,[2]

Don't be frightened by the black prospect of my sheet of paper. I'll try to keep it short ...

Before I get to Paris on 1 October I'd like to know whether Cormon has any sketching trips planned for then. Also, whether the studio is

finished and ready to shelter our young brains all simmering with the ferments of inspiration.[3] And whether the fellows are back, and which ones.

I don't blame you for sighing *with relief*. Well, so much for that. I'll spare you the recital of my ruminations in the sun with a brush in hand and spots of a more or less spinachy green, pistachio, olive, or shit colour on my canvas. We'll talk about that later.

All the best, hoping for a few concise words from you to give me the lowdown on the situation.

the young rotter,
H. de Toulouse Lautrec

Prov.: Schimmel
Pub.: GSE50, GSF51

[1] Noted on the back of the envelope in Lautrec's handwriting are the names: De Terratz (Armand de Terratz, a student at Cormon's); illegible name; Pollak (possibly Richard Pollak, a painter born in Prague, who exhibited in Paris); Bottomley (Reginald Bottomley, born in London, a student of Bonnat and Cormon); Anquetin (Louis Anquetin—cf. Letter 102 Note 5).

[2] Eugène Boch (1885–1941). A Belgian painter and a fellow student at Cormon's studio. He was later acquainted with and portrayed by van Gogh. Lautrec's letter is addressed to him at 22 rue Ganneron, which was also Rachou's address.

[3] Cormon had been looking for a new studio when Lautrec left Paris for the summer. He found one at 104 boulevard de Clichy.

87 *To his Mother*

Château Respide near Langon [Gironde], Saturday, 8 September [1883]

Dear Mama,

I have just received your letter, so filled with solicitude and affection, but devilishly worked up. I find it odd, having carried out your instructions *to the letter*, that you should reproach me for not sacrificing my afternoon chasing after a busy, will-o'the-wisp uncle. The trip went off perfectly in spite of my light clothing, which I had reinforced with one of Paul's waistcoats and a shawl from Madame Mèjean. We took a carriage and I rode all by myself till I arrived, after leaving Paul and my aunt at Toulouse.

They are at Lourdes today. Joseph is over the measles, they didn't amount to anything. Yesterday I went to Malromé with Louis and an old priest, who was delightfully bucolic. I've seen the shy Balade[1] fellow, who told me about your strange projects, which I'm falling in with, to be agreeable. I shall probably come to have a quite different idea of Malromé, living there in pleasant and cheerful quarters ...

The collar fits the horse we'll be trying out, Louis, Philippe, and I.

Please remind me of your other instructions which I have forgotten
A hug for all and a kiss for you.

<div align="right">Henri de Toulouse Lautrec</div>

P.S. Have seen Rachou, who'll be in Paris on Tuesday. I've taken it
on myself to send a groom to Malromé to tidy up our Bucephalus's[2]
hair.

Goodbye—and please forward my mail . . .

<div align="right">HTL</div>

Prov.: Schimmel
Pub.: GSE51, GSF52

[1] The Lautrecs' steward at Malromé. His name recurs in many later letters in which Lautrec requests
shipments of wine to Paris.
[2] The famous horse tamed and then ridden into many battles by Alexander the Great. Here used
simply to mean a horse.

88 *To his Mother*

<div align="right">[Paris, <i>c</i>. September 1883]</div>

My dear Mama,
 I saw my sweet Papa last night and he was in very good spirits.
Princeteau left abruptly without saying where he was going. It's odd.
We went to the station at 10 o'clock to wait for the Odons,[1] who
didn't arrive until the 11 o'clock train, which being the case I took off.
 Your news pleased me in the sense that you give me the impression
of feeling at home at Malromé. That means a lot and I imagine Tata
must be busy impressing an odour *sui generis* on M. de Forcade's[2]
bedroom:

Eau d'Addison	7/14
Little farts	8 30
Aq. dist.	1 1/2
Aunt Armandine[3]	

There you have the formula.
 On this I kiss you.

<div align="right">Yours,
Henri</div>

Prov.: Schimmel
Pub.: GSE52, GSF53

[1] i.e. his Uncle Odon de Toulouse-Lautrec and his family.
[2] The former owner of Malromé, whose widow sold it to the Lautrecs.
[3] Tata and Aunt Armandine are of course the same person.

89 *To Mme L. Tapié de Céleyran*

[Paris, January 1884]

My dear Grandma,

I am absolutely to blame for having put off sending you my good wishes for the New Year till now, and Pater will now be able to distil the most acid reproofs without fear of appearing unjust. Therefore, I bow my dauber's head in shame, because dauber I am right up to the ears. I'm working like a horse and don't even have the heart left to go for a walk in the evening, a pleasant habit I had acquired. Mama seems not to be unendurably bored. I'm very happy about that for I was afraid of her being more or less alone all the time. At least it's better than to condemn her to roost, as I do, in a quarter that continues to have its cut-throat character. Practical jokers set upon women walking alone and empty ink on their ... necks. A fine idea of fun that is. I've had sad news of the death at sea of my poor friend Doctor Rouilat. Feeling he was done for, he wanted to come back to Paris to die, but was taken on the way. Louis Pascal is going to work in the Comptoir d'Escompte.[1] A good place for this likeable old fool to end up in. Promise me you'll congratulate him.

Goodbye for now, dear Grandma, and please remember me to my uncle and aunt and to Tata. And lavish equitably floods of affectionate regards on all my cousins, but especially on Kiki.

I kiss you.

<div style="text-align:right">Your respectful godson and grandson,
Henri</div>

P.S. Please tell my uncle I haven't forgotten him. I haven't made up my mind yet about the hats. But for that I would already have done what he asked me.

<div style="text-align:right">HTL</div>

Prov.: Schimmel
Pub.: GSE54, GSF55

 [1] i.e. the Comptoir National d'Escompte, a large commercial bank in Paris.

90 *To René Princeteau*

[Paris, Spring 1884]

My dear and good Friend,

I am slow in extending my sympathy for the sad event that has happened to you. The reason is that I recently dislocated my shoulder, and today is the first day that I have been allowed to write. So my first

letter is to you. I trust that you and your family will accept my deepest sympathy—something which, I hope, you have never doubted.

<div style="text-align: right">Your pupil,
Toulouse-Lautrec</div>

Prov.: Unknown
Pub.: Martrinchard, p. 62

91 *To his Mother*

<div style="text-align: right">[Paris, Spring 1884]</div>

My dear Mama,

Just as I wrote to you as soon as I found out, the board declared me unfit for military service, without having to show any kind of medical certificate. M. Mullin was as kind to me as he could be and had me taken first with some Auvergnat fellows with smelly feet.

That evening I went to a party given by Mayet[1] in his studio. We all went to bed at 6 in the morning, rather tired. Not a sign of the handsome Louis. However, I have seen Bourges, who told me he is well. A new oculist has found his eyes to be in very good shape and since then he has gone back to the Comptoir d'Escompte.[2]

As for Paul, it appears that the lizards have taken over his room and, the rebellion having cut his supplies, he had to eat meat without bread. All this put together so delighted him that he has packed his trunks ... his father, I believe, plans to send him to Tonkin.[3]

There you have all the news. I don't know whether you read about the Count and Countess de Nattes's[4] accident, thrown with their carriage and runaway horses against the Seine parapet and hurled through the windows of the said carriage, just like Uncle Odon, whom, by the way, I have yet to see. With this is a kiss for you all, thanking you, my aunt, my uncle, and Tata (specially reserved places) for all the nice things you have all done for me, who have done so little for you.

<div style="text-align: right">All my love,
your
Henri</div>

P.S. My money is running low and pretty soon I'm going to find myself dead broke. I'm letting you know ahead of time so you can forward me something, and I can wait for you without touching my friends.

Princeteau: no news of him.

Prov.: Schimmel
Pub.: GSE55, GSF56

[1] Léon Mayet (b. 1858), another fellow student, had a studio at 15 villa des Artistes, impasse Hélène, where Bonnat's studio was too.

[2] The branch bank where Louis Pascal was employed.

[3] Tonkin was then a part of French Indo-China.

[4] The Count de Nattes had studied at Sorèze (cf. Letter 43 Note 6) before going on to St-Cyr and a military career; hence he was probably known to the Lautrecs.

92 *To his Mother*

[Paris, Spring 1884]

My dear Mama,

I have received your far from reassured letter. I've seen Papa, who had good news about Ricardelle, and Louis, who had bad news about Respide.[1] Anyway we are all right.

There has been a revolution at the studio. Cormon has fired the student in charge and plans to appoint another one. All this has stirred up more excitement than you could imagine. Rachou is our boss.[2] I think I mentioned that before. No wonder I'm writing nonsense, for I haven't been down from Montmatre for five days. I'm painting a woman whose hair is all gold.[3] My drawing for *Le Figaro*[4] isn't completely finished, but it's getting along. Phew! Have just eaten very quickly and am going to work.

I kiss you and Tata, too.

Yours,
Henri

P.S. I'll do your errand when I can.

Prov.: Schimmel
Pub.: GSE56, GSF57

[1] i.e. concerning the expected yields of the vineyards at Ricardelle, the Lautrec's estate, and at Respide, the Pascals' estate.

[2] Apparently Rachou had been authorized by Cormon to correct the students' work when he was not present. Cf. Letter 71 Note 2.

[3] Probably the Carmen series (Dortu P.243–6, dated 1885 by Dortu but redated 1884 by Murray).

[4] i.e. *Le Figaro Illustré*. Founded in 1882, it did not publish any of his drawings until July 1893 (cf. Letter 95). The drawing mentioned here has not been identified.

93 *To his Mother*

[Paris, June–July 1884]

My dear Mama,

I got your letter, which gives me hopes as to Pérey.[1] You can come to the Métropolitain[2] and I'll join you there, or I'll stay on at Grenier's,[3]

who's a peach of a pal, and even better, a friend. We've received Balade's multiple shipments, but unfortunately he sent very little red wine, which prompts me to ask for a second shipment, all red. You tell me you have a sore throat. I hope you're over it by this time. Aunt Armandine made a mistake moving. I would have been around to give her a hand in January and would have scrounged as much out of it as I could. The atelier is up in arms, they want to name a 'student in charge'. They'd like to give me this tiresome job, but I'm stubbornly refusing.

I'm happy that you're satisfied with what I'm doing.

I haven't replied to Louis and won't.

I find it terribly provoking the stubborn way most of the family insist on making fun of me. Luckily you have several votes on that ballot.

I kiss you, and, other than you, Aunt Armandine.

Your son,

H

Wire if I'm to meet you.

Prov.: Schimmel
Pub.: GSE57, GSF58

[1] i.e. the Hôtel Pérey, where Lautrec apparently hoped his mother would stay.

[2] The Hôtel Métropolitain, on the rue Cambon, where Lautrec's mother stayed. In a letter to her mother, dated 1885 (published in Attems, pp. 208–9), she expresses the hope that he will live there too, for she considers Montmartre 'a bad neighbourhood'.

[3] René Grenier (1861–1917), a friend and fellow student of Lautrec's at both the Bonnat and the Cormon studios. During the summer of 1884, Lautrec went to live with Grenier and his wife Lily at 19 bis rue Fontaine. According to some biographers, he lived there for two years; according to others, for only a few months. Both Grenier and Lily appeared in numerous works by Lautrec. Cf. Dortu P.252–3, P.302–4; D.2838, D.2983–5, D.3027; E.14, E.18.

94 To Mme L. Tapié de Céleyran

Paris, Thursday [June–July 1884]

My dear Godmother,

I don't believe it, I don't believe it!!! ... I have to play deaf, to beat my head against the wall! yes, and all that for an art that evades me and perhaps will never appreciate all the trouble I've gone to for it ...

Mama has just read your nice letter to me; she has just offered me a lovely trip with you at the end of it and I have to refuse. The truth is that I'm just getting back into the groove at the studio, after floundering around miserably for three long months.[1] Moreover, the July competition is facing me!![2] I don't have a minute, a second, to myself,

not even my Sundays, when I have to get dressed up and visit influential people.

Ah, dear Godmother, you'd be wise to never to get involved with painting. It's as difficult as Latin, when you take it seriously! Which is what I'm trying to do.

Mama will go alone to charm you, you won't be missing much on account of my slavery. I don't expect to be free before August, Oh, well! . . .

Please give everybody a hug from me, and a big hug for yourself.

Your godson,
Henri

Prov.: Unknown
Source: Rendell

[1] The changes at Cormon's studio evidently seriously hindered Lautrec's efforts. Cf. Letter 92.

[2] According to Murray, this must have been the Concours des Places (examination for admission) for the École des Beaux-Arts. (Cf. Murray II.)

95 *To his Mother*

[Restaurant] Lucas [Paris] Noon, 15 August [1884][1]
My dear Mama,

If I haven't written to you sooner it's because I've been snowed under by work. I worked as much as I could on my drawing for *Le Figaro*[2] but, Rachou not being satisfied with it, I didn't send it off. He pointed out to me that only the very best one can do should be submitted to the public. Well, my drawing really could have been better, I'm sure you won't mind my following this sensible advice. Since I'd had my nose to the grindstone right up to the deadline I went to work at night at the Bar.[3] Oh, well. Deuce take it!!!

I've seen nothing of Papa and don't know whether he has done your errands. I still haven't been able to do any of mine.

I kiss you, and Tata as well. Shall swallow a quick Mass and then reclimb the heights, where my model is waiting for me.

Yours,
Henri

Prov.: Schimmel
Pub.: GSE58, GSF59

[1] Exceptionally, Lautrec spent this summer in Paris, Cormon having asked him, as well as Rachou, to collaborate on an illustrated edition of Victor Hugo's works. Lautrec worked on drawings for *La Légende des siècles*. However, the publisher did not approve of Lautrec's drawings. Cf. his mother's letter to her mother, published in Attems, pp. 206–7.

[2] Cf. Letter 92 Note 4.

[3] This is the first indication that Lautrec is frequenting the Montmartre cafés.

96 To Mme L. Tapié de Céleyran

[Paris, late August 1884]

My dear Grandma,

In all the confusion of my poor existence my correspondence has fallen into arrears. I hope you'll forgive me so I may wish you a happy and prosperous name day. I don't know whether you're at Malromé, busy tasting our pigeons. But if this is the case, please tell Mama that Papa hasn't left yet. In case you're at Bosc, please give everybody a kiss, and particularly Grandma Gabrielle for poor old me.

I'd like to talk to you a little about what I'm doing, but it's so special!!! I prefer simply to wish you the best of the season and to kiss you twice, as grandson and as godson.

Your respectful grandson,
H. de Toulouse Lautrec

Prov.: Schimmel
Pub.: GSE59, GSF60

97 To his Mother

[Paris, late August 1884]

My dear Mama,

It's I who am going to be a little hard on you for your silence. I've been on the point of sending you a wire to find out what had become of you. I'm lunching tomorrow with my father and Rachou. He ran into M. Verrier,[1] who would like to have me to lunch. (He can whistle for it.) I've written to Grandma Louise to wish her a happy name day. It was only by luck I remembered. I've been a little *balked by the weather, because of working out of doors.* My meal at the Nababs[2] on Sunday was so copious that I lay down to snore after dinner. Fine thing indeed!! On that, I kiss you and Tata and everybody, while put out with you for leaving me without news.

Perhaps your letter got lost.

Henri

Prov.: Schimmel
Pub.: GSE40, GSF41

[1] Cf. Letter 13 Note 2.
[2] A general name for wealthy people: nabobs.

98 *To his Mother*

[Paris, late August 1884]

My dear Mama,

Have you broken your arm, or have you forgotten that your off-
spring exists? A brief word, if you will, to bring me up on what's
going on.

Everything's fine here. I'm working hard. All the best and a thousand
kisses.[1]

<div align="right">Yours

H.</div>

Prov.: Schimmel
Pub.: GSE41, GSF42

[1] Lautrec uses here 'poutounégeade', an invention on the Gascon words 'poutou' (a little kiss) and
'négade' (a drowning). Cf Letter 80 Note 5.

99 *To his Mother*

[Paris] Wednesday [1884]

My dear Mama,

I've just received your letter from Albi. Undoubtedly you'll find
Joseph, who leaves tomorrow, at Respide. Laura Pérey is waiting for
you to have a housewarming at the hotel, which has several new paying
guests.

I haven't sent you the photograph and think for the time being I
may wait for you to get back. Papa doesn't at all look as if he's going
to follow you to Malromé. Sorry about it.

<div align="right">I kiss you.

H.</div>

P.S. Please send the money to pay the *landlord*. It would be *better* not
to make him wait. Send it to Aunt Émilie's.

Prov.: Schimmel
Pub.: GSE60, GSF61

100 *To his Mother*

[Paris] Sunday [October 1884]

My dear Mama,

I haven't written to you sooner because I had several things to straighten out. Papa wrote me a *very friendly* letter asking me to pick up his *packages* from Pérey's where he'd left them. You can see that the break between us having petered out[1] it may not be as hard to make up as we had feared. Be calm and don't drop any *bricks*. I still haven't shown anything to Cormon,[2] but I've seen him and he was very nice.

I am very much settled down in my kind friend's place,[3] so much so indeed that I would be in danger of becoming an intruder were your arrival not in the offing.

No cholera, as far as I can see.[4] Bourges[5] gave me an awful going over when I told him how scared I was.

Poor Rabache[6] is having tooth trouble. They took out half his jaw teasing him free of one of his molars. He's drinking milk and is terribly down in the dumps and welcomed me like a long-lost brother. Rachou is at Toulouse.

There you have my little chronicle, short and sweet.

I kiss you ferociously, and tomorrow am going to get down to work.

Your son

Prov.: Schimmel
Pub.: GSE61, GSF62

[1] The first mention of any disagreement between Lautrec and his father, with whom he was in general on less close terms than with his mother.

[2] Cf. Letters 101 and 102.

[3] René Grenier's studio (cf. Letter 93 Note 3).

[4] A cholera epidemic had started in June in Toulon and Marseilles and almost caused the cancellation of the 14 July celebrations in France.

[5] Henri Bourges (1860–1942), a childhood friend of Lautrec's who in January 1885 became an Externe des Hôpitaux de Paris and in January 1887 an Interne. From early 1887, he shared an apartment with Lautrec at 19 rue Fontaine. He became a Doctor of Medicine on 29 January 1891 and at about that time they moved to 21 rue Fontaine. He married in late 1893, retaining the apartment while Lautrec moved.

[6] A fellow student at Cormon's studio; he appears in a photograph of the students there.

101 *To his Mother*

[Paris, October 1884]

My dear Mama,

I've just come out of one o'clock Mass after having lunch at Lucas's. That has civilized me a little, because these days I hardly ever budge

from my heights. I saw Cormon this morning.[1] He rather *congratulated* me, at the same time making me conscious of my ignorance. Anyway, it bucked me up a little. In a word, we haven't been wasting our time.

Rachou was bitten on the hand by a dog and that kept him from working. He's in Toulouse, where he has just started a new series of horse studies.

Rabache is up and about and my concierge is going to leave me to go into the oyster business, which I find very annoying. Your letter made me regret not having gone with you, but I'm definitely counting on coming to see you by the end of the year. Keep on reminding me of it.

You seem very happy to be home, and I'm glad of that. I haven't seen anyone, except Cousin Cupelet's blonde moustache from a distance. And there you have all my empty head can conjure up by way of news. Lots of kisses for both Grandmas and remember me to all. When will Papa be coming back? I suppose he doesn't know himself.

I kiss you and would like to see you (but well settled).

P.S. It was the big daub that Cormon preferred.[2]

HTL

P.P.S. Not a sound from our gang. I'm going to bed at 9. And deuce take the Cholera!![3]

Prov.: Schimmel
Pub.: GSE62, GSF63

[1] Cf. Letters 100 and 102.
[2] Probably the landscape to which Lautrec refers in Letter 102.
[3] Cf. Letter 100 Note 4.

102 *To his Mother*

[Paris, November 1884]

My dear Mama,

I thought I'd spoken about my poor daubs at Cormon's in my last two letters.[1] It appears I was mistaken. He thought my cattle[2] was bad, the little Laffittes[3] pretty good, and the landscape[4] really good. In sum, it's all very feeble stuff compared with the landscapes Anquetin[5] produced. Everyone is amazed. They're in an impressionist style that does him proud. One feels like a boy indeed beside workers of this calibre. I saw Papa on Sunday and couldn't tell you whether Uncle Odon is still in Paris.

I'm back in the old routine that will last until spring and then maybe I'll do some really bizarre things. All vague yet.

I haven't had the energy to go to the shirt-maker's. Too pooped even to think of going out. It's so nice in the evenings at Grenier's in the warm studio. It would be nice if you were to knit me a stocking cap and slippers. The café bores me, going downstairs is a nuisance, painting and sleeping, that's all there is.

I'll stop because I'm getting mumbly-wumbly.

And a kiss for the grandmas, aunts, and you.

<div style="text-align: right">Yours,
HTL</div>

I've seen Uncle Ernest.

Prov.: Schimmel
Pub.: GSE63, GSF64

[1] Cf. Letters 100 and 101.

[2] Probably the *Boeufs attelés à un tombereau céleyran* (Dortu P.154) or *Deux Boeufs sous le joug* (Dortu P.29, P.128, all redated by Murray).

[3] Not identifiable, but Lautrec is referring to paintings in an Impressionist style (Galerie Durand-Ruel, the Impressionist dealer, being located at 16 rue Laffitte).

[4] Probably *Le Viaduc de Castelvieil à Albi* (Dortu P.32) or the Bosc or Céleyran landscapes (Dortu P.49–58, P.61, P.71, P.135, P.136, P.178, all redated by Murray).

[5] Louis Anquetin (1861–1932) entered Bonnat's studio in 1882 where he met Lautrec, both moving later to Cormon's. He was a close friend of Émile Bernard and Édouard Dujardin and associated with van Gogh. Very influenced by the Impressionists, Japanese prints, and Pointillism, he painted in the Cloisonnist style before rejecting them all to become an imitator and impassioned supporter of P.P. Rubens.

103 *To his Mother*

<div style="text-align: right">[Paris, Autumn 1884]</div>

My dear Mama,

Your letter made me happy. I see you acting Juno Lucina with conviction.[1] Papa has moved on to Orléans[2] and I didn't see him. He quarrelled with Raymond's[3] teachers, who wouldn't hand him over.

There's a terrible fog here, streetcars are misty and noses red. It's pretty sad.

We're in the competition up to our necks[4]—there are so many people it's a nuisance. In short, it's simply more of a bore than other weeks.

It would be very nice of you to send me 4 tins of goose-livers. That ought to be easy and I'll send 2 of them to M^me Dennery[5] and two to Grenier, who very much enjoyed the other. That would be a sensible way of acknowledging their kindness. Two more wouldn't hurt. *I'm very serious about this*— (I *under*line). I'd like to go everywhere to get pictorial impressions, but at night it's terrible to go to bed at two

o'clock knowing you'll have to get up at 8 and by candlelight. And Why??? ...

Well, we'll talk better ... cheeks reddened by the open fire—and soon, I hope.

I feel pretty well and have a desire to work. The deuce with everything else.

I kiss you.

a disillusioned old man,

<div style="text-align:right">Yours,
Henri</div>

Prov.: Schimmel
Pub.: GSE64, GSF65

[1] The Roman goddess of childbirth; he refers to a delivery at which his mother was present.
[2] His hunting lodge at Loury-aux-Bois, near Orléans.
[3] Raymond de Toulouse-Lautrec.
[4] As in letter 94, this may have been the Concours des Places for the École des Beaux-Arts (cf. Murray II).
[5] This may be the mother of Gustave Dennery; cf. Letter 83 Note 4.

104 *To his Mother*

<div style="text-align:right">[Paris, 1884]</div>

My dear Mama,

Nothing important to report. I keep jogging along as per usual. Studio in the morning with Rachou correcting, and he's not easy, the brute. Afternoons outdoors at Rachou's[1] and evenings the bar where I wind up my little day. I've seen Papa very occasionally. He has managed to quarrel with Lucas!!! I'm going there just the same. What a comical fellow he is. I missed Odon's family. I wouldn't put it past them to cut me off. I'm cutting this short because I was just about to go out, and send you a kiss, and Tata and Grandma as well, but you especially.

<div style="text-align:right">Your offspring, darling of the Graces,
Henri</div>

Prov.: Schimmel
Pub.: GSE65, GSF66

[1] i.e. in a little garden of Rachou's studio at 22 rue Ganneron, where Lautrec painted figures seated outdoors. Rachou's memoir of this period (published in Huisman and Dortu, p. 44) gives the same information, as well as in an interesting picture of Lautrec.

105 *To his Mother*

[Paris, December 1884]

My dear Mama,

I intended to write you only a simple postcard, but M. Dufour having this morning collected (from the verb collect) the payment for the first of the year, that is, three months in advance, the result has been a considerable diminution of my finances. I'm not broke, but would be if I paid what I owe. Except for this I'm on top of the world and the work is progressing. I've seen Bourges, who's beginning his two-month exam[1] and who's bored stiff. And there you have it.

I send a kiss to all of you and beg you to excuse the financial character of my letter. I have been sensibly working away at a fellow-student's place, on a female pierrot powdered white. I've been advised to start something for the Salon: I am waiting for Cormon to speak to me about it himself, but I'm not going to start anything for fear of getting slapped down.

All this is very ambitious and needs some thinking over.

I kiss you.

Yours
HTL

P.S. Send money.

Jeannette Hathaway[2]

Prov.: Schimmel
Pub.: GSE66, GSF67

[1] i.e. the first part of the Concours d'Externat, a major medical examination.

[2] Presumably an invention, since no such person or fictional character is known. The last four lines of the letter are written in English.

106 *To Mme L. Tapié de Céleyran*

Paris, 24 December [1884]

My dear Grandma,

I'm availing myself of the impending New Year to give you some news of our daily routine. Uncle Odon's arrival with his numerous family has made things brighter for us, for we, or Mama, I should say, have been rather lonely. Not being caught in the toils of the studio, she has plenty of time to become highbrow. She is assiduously following the metaphysical lectures of our dear master Caro (of the French Academy)[1] and enjoying the perfumed prose of the old codger, who's just as affected as ever.

Papa has left us to go and see his groom, who, in my opinion, was spending a lot more money than he should have.

As for myself, I'm working and am about to quit my little makeshift studio and move into a larger place which I intend to furnish.[2] And here is just the point to send the thanks I owe you for the money that Mama sent me on your behalf and which will come in very handy. It will probably go into rugs. I'm told you enjoyed my handsome friend Louis's charming ways and patent leather shoes. You ought to find him an heiress and throw her into his arms. He's not much good, I'd say, for anything else. And now I'm going to make up for this meanness by wishing you a happy New Year, so momentous that you can distribute slices of it among the whole family, Uncle, Aunt, cousins of both sexes and *abbés* . . .

And I kiss you.

Your respectful grandson and godson,
H. de Toulouse Lautrec
Imitation artist

Prov.: Schimmel
Pub.: GSE53, GSF54

[1] At the Sorbonne, Lautrec's mother followed the course of the fashionable and conservative philosopher Elme Caro (1826–88), who had been a professor there since 1864 and a member of the Académie Française since 1875.

[2] Lautrec moved from the Grenier's at 19 bis rue Fontaine. His mother suggests the rue Lepic (cf. Attems, pp. 204, 206). Mack (p. 71) suggests 22 rue Ganneron with Rachou. Huisman and Dortu (p. 54) suggest the move was never made.

107 *To his Mother*

[Paris, January 1885]

My dear Mama,

I admit that I'm a little late. I saw Papa on Sunday, and he told me that the Odons had arrived. I haven't had time yet to go and see them. I'm just about to be given a commission. I did a small drawing at the Café Américain, and a journalist I know showed it to M. Conty, the man who does the Conty guidebooks,[1] and who is doing one on Nice and Monte Carlo.[2] He liked the drawing, and I'm doing the flower festival for his guidebook.[3] Maybe this will be the lucky break I've been dreaming of.

This just to show that if good luck comes while you're sleeping, sometimes it comes while you're drinking.

We have at the studio the son of the architect[4] who restored Sainte-Cécile, and who knows the general[5] and his sons well. He looks like A. Daudet, and his name is Dalli or Daly.

I believe my drawing won't be too bad, since the competition is mediocre.

We had snow yesterday, and its melting today, in a splendid sunshine.

I don't know a thing about the relationship between Papa and M. Cugny. I'll try to question Miss Braine.

A hug, and hope to see you soon.

Yours,
Henri

Prov.: Schimmel

[1] *Guides pratiques Conty*, 4 boulevard des Italiens, directed by Henry-Alexis de Conty (1828–96).

[2] The guide, titled *Paris à Nice*, was published in Paris in 1889 in both French and English versions. There does not seem to be an earlier publication date. The section on Nice (pp. 236–60) was illustrated with six drawings by Humbert.

[3] The guide provides a very detailed description of this event but does not illustrate it. Lautrec's drawing *Bataille de fleurs: Mail-coach à Nice* (Dortu D.2844), a drawing in pen and China ink on Gillot paper, if submitted was not used, Murray (II) dates it autumn 1886. Since Lautrec did the illustration drawing on earlier experiences, and did not visit Nice during these years, it is possible for him to have done it at any time up to the unknown date of delivery to the publisher.

[4] César Daly (1811–94), architect, restorer of the Cathedral of Sainte-Cécile, Albi, between 1843–1876.

[5] Raymond Séré de Rivières, general in the French army and father of Georges 'le bon juge'.

108 *To his Mother*

[Paris] Monday evening [January 1885]

My dear Mama,

I had a very good trip and was lucky enough to find Grenier at home. He was leaving again for the country and wanted to take me along with him. Naturally I held out against that. He has left me in charge of his keys and his bed, which will permit me to look around. I'm thinking of going to Ottoz's[1] as the good fellow I told you about is still there. That would be company for me. I found everything in order, but it appears I'm a quarter's rent behind (!) and I had miscalculated, sure enough. The only thing to do is groan and pay. I'll write to you if it becomes urgent, but I'll have to wait until Papa has forwarded me some money.

I kiss you all, and you above all.

Yours,
Henri

Prov.: Schimmel
Pub.: GSE74, GSF75

[1] Émile Ottoz, a fellow student at Cormon's studio.

109 *To his Mother*

<div style="text-align: right">[Paris, January 1885]</div>

My dear Mama,

I've got everything straightened out, or nearly, and can send you some news. I've seen Papa just *once*. He was very pleasant and gave me some cash and his blessing. We went together to see Uncle Odon. I've been to see my aunt,[1] Raymond, and Odette. That visit was a very sad affair. Really harrowing. I've yet to see Louis who wrote me a curt note. I did not hurry to reply, then an angry note arrived. I'm answering it with an invitation to dinner. Can hardly be more obliging than that.

Bourges is passing his exams, his grades up to now have been brilliant. Cormon hasn't seen my splotches yet. He's going to tomorrow morning. He has postponed the competition because there are people still away in the country.

Oh, what fun Dayot[2] made of us! We took up stations at the Café de Bordeaux. We had our dinner there Dutch treat and Deforges arrived very late, telling us that ... anyway, making perfectly inadequate excuses. As for Joseph, he could have found us easily enough, since we stayed within the same ten square metres the whole evening. So much the worse for us.

There you have it, Mama, my little tale complete. You will excuse me for not having overdone with a lot of trifling messages that would never have caught up with you.

When I see Papa I'll give him your messages.

I kiss you and please hug my grandmas, too,

Do your best to purify kisses as soiled as mine are as you pass them on. Keep one for yourself.

<div style="text-align: right">Yours,
HTL</div>

I've seen Miss Braine, who's a bit off, I think.

Prov.: Schimmel
Pub.: GSE67, GSF68

[1] His aunt Émilie le Melorel de la Haichois, mother of Raymond and Odette.

[2] Possible Armand Dayot (1856–1934), a journalist and art critic who published reviews of the Salons of 1882 (under the pseudonym of Jean Merien), 1884, and 1890, but more likely just an acquaintance of Lautrec's.

110 *To his Mother*

[Paris, late January 1885][1]

My dear Mama,

Your remonstrances missed the mark, since it crossed with a letter to Grandma. I'm happy to see that you have lost your fear of cholera,[2] since you've now become the shepherd of a tour.

If I had an exercise book of the sort I used to have, I think Cormon would have given me a grade of 'Good'. He was pleased with my work in my studio, I'm pleased that I'm not working all the time for nothing. Bourges, with whom I had dinner last night, passed part one of the Concours d'Externat.[3] He did very well, in fact brilliantly.

We killed a couple of bottles in honour of this event.

There are very few opportunities for dancing.

I have not received the wine, or the armoire, notwithstanding M. Balade's letter announcing them.

I have nothing else to add to these comments, so I give you a big kiss. I kiss you.

H.

Prov.: Unknown
Pub.: Joyant I, p. 75[4]

[1] Joyant had dated this letter July 1884.
[2] Cf. Letters 100,101.
[3] Cf. Letters 105, 109.
[4] Cf. Letter 69 Note 1.

111 *To his Mother*

[Paris, *c.* March 1885]

My dear Mama,

I got your news through Grandma. There is indeed a canine epidemic. Two of Rachou's little ones have died. The third is in the hospital. It's a kind of cholera[1] or puppy diarrhoea.

The weather has turned fine, which allows me to work hard. I took a physic this morning. Aah ... Just about everybody is making an energetic effort for the Salon. Bordes,[2] Rachou,[3] etc. The latter has just had a portrait commissioned and at a very nice price. I'm telling you all this because I hope to interest you. Perhaps I'll bring you two guests instead of one. You should gather together the girls of the neighbourhood and teach them to pose a little so that all we would

have to do is get down to work. There you are, my little chronicle
ended. I kiss you and the grandmas too, if they are there.

Your

H

Haven't seen Papa!!

Prov.: Schimmel
Pub.: GSE68, GSF69

[1] A continuation of the cholera epidemic first mentioned in Letters 100 and 101.
[2] Ernest Bordes (1852–1914), a native of Pau and a fellow student of Lautrec's in the studios of
Bonnat and Cormon. He began as a genre painter and later specialized in portraiture. His entry in
the Salon of 1885 was No. 314, *La Marée à Cayeux*.
[3] Rachou's entry in the Salon of 1885 was No. 2053, *Portrait*.

112 *To his Mother*

[Paris, April 1885]

My dear Mama,

I must be wicked indeed to have you write such cruel things to me.
I'm not angry with you about it. I think the rain has a lot to do with
your bad temper. What you say to me about my friends leads me to
believe that you think I'm downright stupid, if you really think I'm
capable of letting wolves into your chicken-run. I simply wanted to
oblige a charming, *very well-bred* fellow and one regarding whom you
will certainly have nothing to complain about. We will work to the
best of our ability and do justice to your wine. What more do you
want?

Let's get on to the second matter.—You don't see, then, that I
didn't want to let myself be influenced by an old memory. I have a
definite appointment this very day with my expert and won't have lost
anything by waiting. Calm Tata, I beg you. Hasn't she rubbed off on
you a little and aren't you getting rather ticklish.[1] If that's it, I'll lock
myself up in the North Tower with my friend and old St Arnaude.
We'll play bézique[2] with two dummies, a rare sight. I'd very much like
to bring Grenier, but he doesn't seem to be too anxious about it.
However, all is not lost.

I've seen Papa, who is supposed to send you some precious stones
from the Caucasus.

There you have it, you dreadful old bogey, all I had to say.

I'm eagerly looking forward to the date of the Langon[3] fair, and

kiss you, or rather offer you my infant brow, adorned with what very little stuffing you've left there.

<div align="right">

Your unworthy son
Henri

</div>

Kiss Tata for me, please.

Prov.: Schimmel
Pub.: GSE69, GSF70

[1] He writes 'trébadizez', derived from the Gascon word 'trebauda', to agitate violently.
[2] A complicated game which can be played with several packs of cards. In 1895, Lautrec represented people playing bézique in an oil sketch and a lithograph; cf. Dortu P.565 and Wittrock 112.
[3] A town in the Gironde, near Malromé. The fair took place in May and September.

113 *To his Mother*

<div align="right">

[Paris, Spring 1885]

</div>

My dear Mama,

Your letter is friendly though ironic as regards my still legitimate request.[1] I don't insist. I've seen all the family. Uncles Charles, etc., etc. Except Uncle Amédée, who's spending all his time at Puteaux.[2] But I haven't got the time to chase after him. I'm spending all my time at work, which leaves me hardly any opportunity to have new things to recount to you. Tell me if you're going to Bosc at the beginning of August. I would join you there and, about the 20th of the same month, we would get back home, unless I do something with my cousins. Think it over and let me know.

I kiss your hands.

<div align="right">

Yours,
Harry

</div>

Prov.: Schimmel
Pub.: GSE70, GSF71

[1] i.e. to bring his friends to Malromé. Cf. Letters 111 and 112.
[2] A town near Paris, now part of its suburbs.

114 *To his Mother*

<div align="right">

[Paris] Friday [July 1885]

</div>

My dear Mama,

My *interview* was relatively successful[1] and I *hope* not to have to appeal to your generosity. I'm still ready to leave on the 20th or 22nd. About the 30th we'll move on to Malromé and after a short stay will

go to spend a fortnight at *Taussat*[2] or *Caussat*. I don't know the spelling but it seems to be very wild. At Robert Wurst's.[3] It's settled. I'll undoubtedly see my uncles and aunts tomorrow. The weather continues to grate on my nerves but the approaching departure cheers me up. As if I'd pulled a fast one on St Médard.[4] I'm glad your trip was a success and here are little kisses for you.[5]

<div style="text-align: right">

Your son,
Harry

</div>

Prov.: Schimmel
Pub.: GSE73, GSF74

[1] With his father, to ask for money.

[2] Taussat-les-Bains, a resort town in the Department of Gironde, near Arcachon, where Lautrec often went during the summer from this year until 1900.

[3] Probably the doctor, and later professor of medicine at the Sorbonne, whom Lautrec portrayed conducting a medical examination of Gabriel Tapié de Céleyran. Cf. Dortu P.727.

[4] According to a popular belief, if it rains on 8 June, the feast day of St Médard, it will rain for forty days thereafter. St Médard was the patron saint of the corn-harvest and the vintage. Cf. Letter 164.

[5] Cf. Letter 98 Note 1.

115 *To René Princeteau*

<div style="text-align: right">

Malromé near St Macaire, Gironde [August 1885]

</div>

Dear Maître,

I'm here for about a week. My mother wants you to come, and so do I. Drop me a line to tell me that you are going.

Afterwards I'll go back to Libourne with you, and will be very happy to see your good parents again. My mother is delighted with her visit to the Libourne region.

I send you all my warm regards and I hope I'll soon be doing so in a different way and more directly.

<div style="text-align: right">

Your loyal student,
Monfa

</div>

Prov.: d'Amade

116 *To Raoul Tapié de Céleyran*

<div style="text-align: right">

[Taussat, August 1885]

</div>

My dear Raoul,

I've had a small animal in bronze sent to you. I hope you'll like it.

You ask me what I would like. Some wine. Moreover, we'll drink

it together, I hope. Here's what I'll do. I'm going to look over some samples of red wine. I'll let you know what they cost and you'll send me the number of bottles you want. Few but good.

<div align="right">
Cordially yours,

Henri

at M. Fabre's, Taussat, via Audenge, Gironde
</div>

Prov.: Schimmel

Pub.: GSE231, GSF259

117 *To his Mother*

<div align="right">
[Paris, Autumn 1885]
</div>

My dear Mama,

Your letter is short and has nothing really new to tell.—I've been to see Grenier at Villiers.[1] It's very cool down that way. Paris is dark and muddy, which doesn't prevent me from trotting in the streets after the musicians of the Opéra,[2] whom I'm trying to charm so as to sneak into the temple of the arts and of boredom. Which is not at all easy. I haven't seen Papa for a long time. Grenier is due to go deer-hunting in the Sologne[3] this winter, or ... to warm himself by the fireside.

I'm doing the portrait of the beautiful sister[4] of one of my friends, which is a lot of fun. I'm going there right now and am writing to you while sipping my coffee (otherwise known as 'java').

I kiss you and am waiting for you.

<div align="right">
Your boy,

Harry
</div>

Prov.: Schimmel

Pub.: GSE75, GSF76

[1] Villiers-sur-Morin (Cf. Letter 131 Note 1).

[2] Probably Désiré and Henri Dihau. Désiré Dihau (1835–1909) was first bassoonist at the Opera, and was portrayed by Degas as well as by Lautrec. Cf. Dortu P.379, P.380. D.3043, D.3381, D.3383.

[3] A region in the Loire Valley.

[4] Probably Jeanne Wenz, sister of Frédéric Wenz, a fellow student at Cormon's studio. Cf. Dortu P.264, P.307, D.3089.

118 *To his Mother*

<div align="right">[Normandy, late Autumn 1885]</div>

My dear mama,

I'm writing to tell you that my ears are cold and that I'm drinking a lot of cider. The countryside is quite white with hoar-frost but still has its charms. M. and Madame Anquetin[1] are delightful as always. We're hunting crows with enthusiasm but no success. I hope you've sent my daub to the big newspaper. Apart from this, nothing new, except that I kiss you and beg you to do the same to this scrap of paper representing me.

<div align="right">Your son,
Henri</div>

Till tomorrow Wednesday evening, Midnight.

Prov.: Schimmel
Pub.: GSE76, GSF77

 [1] The parents of Louis Anquetin; they lived at Étrepagny in Normandy.

119 *To his Mother*

<div align="right">[Paris, late Autumn 1885]</div>

My dear Mama,

I've come back from Normandy, where I've been hunting crows. A lovely day. I'm going to come back to Le Crotoy[1] with Bourges to hunt seal. The country is terribly pretty and I can well understand that you are sorry to leave it. I'll tell you the details at Rivaude.

Papa is in a very good mood because Princeteau is here. He has become hypochondriacal, but is very kind just the same. Try to get hold of Kiki if you can. Use all your diplomacy and think how nice it would be for me to have fresh air and work both together.

I kiss you.

<div align="right">Yours,
Harry</div>

Prov.: Schimmel
Pub.: GSE77, GSF78

 [1] A port in the Department of Somme, on the English Channel, where Lautrec, Bourges, and their friends often went as late as 1900.

120 *To his Mother*

[Paris, late Autumn 1885]
...[1] Well, the work is moving along, I'm going to work on sculpture at the Carrier-Belleuse studio.[2] ...

[Lautrec talks about his comrade Anquetin]

... the pride of the studio ...

[He describes his visit to Anquetin's home in the country]

... His father is a very good friend of Lecouteulx de Cauteleu,[3] the great falconer. This old man was very nice, and talked to me about papa, whom he knows ...

[He was delighted to see unfamiliar Normandy]

... the sight of the tremendous labour accomplished by my competitor has filled me chock-full with wonderful resolutions ...

Your art student

Prov.: Unknown
Source: M. Loliée, Catalogue 85, No. 125

[1] Fragment of a letter.
[2] Albert Carrier-Belleuse (1824–87), a sculptor who first exhibited at the Salon in 1851 and continued thereafter, eventually winning the Salon Medal of Honour and being decorated with the Legion of Honour. Thomson suggests that Cormon, who had painted a portrait of Carrier-Belleuse in 1877, had possibly introduced Lautrec to him. Cf. Richard Thomson, 11. 80–4.
[3] Lautrec had painted *M. Le Couteulx, jeune à âne*, (Dortu P.122) some years earlier.

121 *To his Mother*

[Paris, late Autumn 1885]
My dear Mama,
 I was very much distressed to learn about the unhappy state of your stomach, for I'm afraid the cold won't do it a bit of good and that Paris and above all Rivaude will only mean more of the same only worse. Luckily I am out of danger, as is Uncle Odon, who has left again for La Haichois[1] cleansed from head to toe. I had lunch with Papa today. We went to call on Du Passage, who dribbled his healing spittle on my young brow. So, I'm saved, by the laying on of hands by that fat giant. I paid my respects to his ailing wife. And that is all I have new to tell.
 My work still isn't very brilliant, it's so hard to buckle down again. Enough to take all the pleasure out of rest, the reaction afterwards being truly painful. We've received the wine, for which many thanks.

And now, dear little Mama, pay heed to your old son, take good care of yourself and above all do take it easy.

<div align="right">Yours,
Harry</div>

Prov.: Schimmel
Pub.: GSE100, GSF101

[1] The family estate of Uncle Odon's wife, Émilie le Mélorel de la Haichois.

122 *To Mme L. Tapié de Céleyran*

<div align="right">[Paris, December 1885]</div>

My dear Grandma,

I wish you a very happy New Year and beg you to pass along my best wishes to everyone. Mama must have told you about my small doings, so I won't repeat myself, because whatever she tells you, *we* tell you together, I would have hoped really to kiss you, but I hadn't reckoned on emergencies. If the beard isn't there,[1] the heart is. And a happy New Year.

<div align="right">Your respectful godson and grandson,
Henri</div>

Prov.: Schimmel
Pub.: GSE47, GSF48

[1] Lautrec now wears a beard, a traditional part of the artist's appearance. Cf Letter 123.

123 *To Mme R. C. de Toulouse-Lautrec*

<div align="right">Château du Bosc [December 1885]</div>

My dear Grandma,

I'm writing to you from Château Bosc, which at the moment is far from resembling the one where Sleeping Beauty lived, in view of all the young males frolicking up and down the long corridors. We are all sorry you aren't here to preside at this family reunion, the first I've been to for a long while. We are passing the time photographing animals and people to the great delight of the cook, who seems to fancy himself a knockout, the way he poses in front of the lens.

The weather (to imitate the eloquence of Monsieur Alary) is a little chilly but very clear. When we stick our noses outdoors they start to run right away, and it is the pipe, the horrible pipe, seducer that it is, that lures us round the hearth, where we smoke away all in a row, like so many Shoubersky[1] portable stoves (the only stove with castors

found in the Place de l'Opéra for one hundred francs). Rereading my letter I see that I have forgotten the main thing I had in mind, that is, to send you, dear Grandma, my most sincere wishes for the New Year. I hope they will be as agreeable to you coming from my now bearded lips as they have always been heretofore. Please be so kind as to give my uncle and aunt, all snugged in their nest, my fondest regards, and thanks for all the good things you have showered on Mama on my account.

<div align="right">
With a hug,

Your respectful grandson,

Henri
</div>

Prov.: Schimmel
Pub.: GSE78, GSF79

[1] According to the Bottin, 'a portable stove invented by De Choubersky' was being sold at 6 place de l'Opéra.

124 *To his Mother*

<div align="right">
[Paris, Spring 1886]
</div>

My dear Mama,

My tonsillar troubles are ended, but my model is threatening to leave me. What a rotten business painting is. If she doesn't respond to my ultimatum the only thing I can do is bang out a few illustrations and join you in August. I shall go to Arcachon for a dip. Papa has given me some money, but I don't know whether I'm going to have enough to pay my rent and live on it, too. In which case you will help me, if it pleases Your Ladyship. Seeing we'll spend quite some time in the country, that will even things up. Perhaps I shall come to spend the month of September in Paris and return in October to see the grannies. Papa has spoken to me again about a studio quite near the Arc de Triomphe and I have explained to him clearly that that would never be anything but a salon. Perhaps he'll take it and leave me mine. There you are, a brand-new combination, opening up the prospect of five o'clock teas. Think about all that, and about your boy, who slaves away as best he can and kisses you through his Auvergnat whiskers.[1]

<div align="right">
Yours,

Henri
</div>

Papa is going to shoot ducks at Rivaude.[2]
Uncle Charles and his wife are well.

Prov.: Schimmel
Pub.: GSE79, GSF80

[1] Lautrec generally uses this term to describe something coarse since the Auvergne was a somewhat primitive region and its inhabitants were often considered simple. He also refers to his beard in Letters 122 and 123.

[2] The hunting estate of Amédée Tapié de Céleyran, in the Department of the Loiret.

125 *To his Mother*

[Paris, Spring 1886]

My dear Mama,

I don't understand your postcard. I'd written to you two days before. The person I gave my letter to post must have forgotten! I've seen Papa, who claims to be broke and by the same token would have me the same. I tell you this frankly though I'm not hard up enough to call on you for help. We'll talk about all that again another time, right now let it go. I've seen Uncle Odon and Aunt Odette who are bored and talking (don't spread it around) of going to Cannes.

I'm going to make some sketches for the *Courrier Français*.[1]

Papa still has a quaint notion of going to the Arc de Triomphe section of town.[2] We've even been to look at studios. Still no change.

They tell me you'll be coming with Uncle Amédée. Is that true? Nothing new apart from that. Cormon was satisfied with my work on Sunday. The competition will be judged on Wednesday. I kiss you hard.

Yours,
Henri

Prov.: Schimmel
Pub.: GSE80, GSF81

[1] A newspaper founded in 1884 by Jules Roques. The first drawing by Lautrec to be published in it was *Gin-cocktail*, which appeared in the issue of 26 September 1886. When Roques refused to pay Lautrec for his drawings, and moreover sold them at auction, Lautrec took legal action. Cf. Dortu D.2964–2965.

[2] A fashionable quarter near the Champs Élysées where wealthy artists had studios. Cf. Letter 124 and Milner, pp. 171–98.

126 *To his Mother*

[Paris, Spring 1886]

My dear Mama,

I've finally seen Louis, and he was very nice. I've seen Papa, who has a little white topcoat that's a knockout. Beyond this nothing to report. I had dinner with Claudon's family, his mother and brother. They were extremely pleasant. Everybody's looking forward with a

certain impatience to seeing you and we shall be having some merry dinners together, I hope. It seems to me that the heir-apparent is putting on airs and keeping people waiting on purpose. Anquetin is going to leave for the south, somewhere near Nice. Now that really annoys me and if I felt strong enough I swear I'd follow him. It's dismal here.

Cormon is down in the dumps and doesn't have a penny.

My publisher, M. Richard,[1] is in all kinds of lawsuits. All to the good.

As for the Frayssinet affair, here's what it was: M. Gervex,[2] having painted Mme de F.'s portrait, boasted, according to some, of having shared in the conjugal bliss of the handsome Jacques. Whereupon the latter is supposed to have given him a couple of slaps, which were answered by a sword-thrust. There are other versions, which I shall tell you about personally.

There you have it, my chronicle.

<div align="right">A kiss for you and the Grandmas,</div>

<div align="right">H</div>

Prov.: Schimmel
Pub.: GSE81, GSF82

[1] Probably Jules Richard (Maillot) (b. 1825), journalist and writer. A 'M. Richard' is identified by Joyant (I. 261) among the spectators in Lautrec's painting, *Le Refrain de la chaise Louis XIII au cabaret d'Aristide Bruant, 1886*. Cf. Dortu P.260.

[2] Henri Gervex (1852–1929), a successful artist at the time. He had painted a female nude, the face covered by a mask. In his *Souvenirs* he alleged that he had portrayed a professional model, but various rumours contradicted this explanation. The artist had to meet an irate husband in a duel, and later a lawsuit was brought against him. One of his entries in the Salon of 1886 was No. 1047, *La Femme au masque*. (Cf. Gervex.)

127 *To his Mother*

<div align="right">[Paris, Spring 1886]</div>

My dear Mama,

I received news of you through Uncle Charles, always thundering. Otherwise my life is very dull, and I swear to you that evenings out on the town are not always completely joyous occasions. Which means that even though I'm such a bad son I miss you. I can't send you the dog because a young beauty took it from Eustache. I went to visit Grenier, but the country is so raw and chilly that it would be absolutely impossible to install a nude model on the grass.

We opened the fishing season in driving rain, and all I caught was a miserable gudgeon. I returned to Paris and waited for your letters, which reached me at the same time because my concierge had been

very careful not to bring them to Ricci's[1] place, where I am working in the garden.

This explains my silence, because all I saw was your letter to papa.

I haven't appeared in the newspapers yet, but it's going to happen. Finally!

My drawing for the *Courrier Français*[2] is still in embryonic state, but I'm going to do it.

It doesn't look as if Papa is going to leave, but if he tries to make me leave before I feel the time is right, I count on you to *help me* remain in Paris, because it's better to rest when it's nighttime.

Besides, you know what I think. I won't bother you with it again.

A big hug from me to you and to the grandmas too. A special bow to Tata (who must be very embarrassed to be in the same room with you, since she must release inadvert gases).[3]

Your boy

Prov.: Morgan

[1] Giuseppe (Joseph) Ricci (1853–1902), an Italian painter who was a student of Bonnat and Cormon and was influenced by Carrière and Besnard. His studio was located at 22 rue Ganneron. He remained a friend of Lautrec's for many years. Cf. Letters 294, 422.

[2] Cf. Letter 125 Note 1.

[3] Cf. Letter 88.

128 *To his Mother*

[Paris, early July 1886]

My dear Mama,

I spent a day with Grenier and I'm finishing my page like a good little boy: but I'm the worse for it because I realize that working outdoors in the sunshine is an amazing thing and resting in the shade is a pleasure of the gods. I'm having a kind of reaction of laziness which is very distressing because struggle brings with it a febrile work that is worthless and it might be better to let things go.—This line of reasoning is going to make you double up. It's unfortunate but that's the way things are. I'm amazed by my cousins' enthusiasm over the baccalaureate. I wish I could have that much confidence about what I'm doing. Everybody here is fine, Paris is empty and it's very boring to go to rue Cambon[1] in the evening.—It's not much more interesting to go there in the morning, for that matter. As for the horizon, it's tricoloured for this stupid Juliette the fourteenth holiday.[2] Rum and water, an awful mixture.

I end up playing with this letter which is neither brilliant nor substantial but which at least is short. I hug you.

Send the rent money to me at 27 rue Caulaincourt before the end

of the week. Papa would like me to make myself scarce. This feeling is not the least touching. As for wanting to make me give up the studio, I don't think so.—I'm too shrewd[3] for that.

I'm going to send two more daubs with lines. Who knows whether there will be any result.

I hug you like an old son.

Yours,
Henri

Prov.: Unknown
Source: Rendell

[1] Lautrec was probably staying at the Hotel Métropolitain on rue Cambon where his mother was living. Cf. Letter 93.
[2] Lautrec uses Fête de Quatorze 'Juliette' for the 14 July celebration.
[3] Lautrec writes 'trop auvergnat'.

129 *To his Mother*

[Paris, July 1886]

My dear Mama,

I received your package in good shape. Unfortunately I wasn't able to come up with the 30 additional francs needed to pay the rent without completely emptying my purse. I'll pay up the first day I get my monthly allowance, since Papa went to Rivaude and then disappeared. I've been having a very good time lately here at the Chat Noir.[1] We organized an orchestra and got the people dancing. It was great fun, only we didn't get to bed until 5 in the morning, which made my work suffer a little that morning. Right now I'm making a drawing at a sculptor's on the avenue de Villiers,[2] who's a very handsome fellow and irreproachably correct. It's very pleasant, but that won't prevent me from going to the country to take a break with no regrets, and at Archachon a good soaking[3] is very much indicated.

I'm a little knocked out because it's very hot and stormy as well (ah, the clouds that pass by). I still haven't found the photograph which M[gr] Guibert[4] wants. I . . . but I feel I'm going to repeat what you wrote in your last letter—which is useless. So I kiss you warmly.

Yours,
Henry

Prov.: Schimmel
Pub.: GSE82, GSF83

[1] The name of a 'cabaret artistique' founded in 1881 by Rodolphe Salis in his former studio at 84 boulevard Rochechouart in Montmartre. It was the first of its kind. In 1885 the cabaret moved to 12 rue Victor-Massé.
[2] Possibly René de Saint-Marceaux (1845–1915), a medal-winning sculptor and Chevalier de la

Légion d'Honneur who lived at 23 Avenue de Villiers. Lautrec wrote about him in an article on the Salon of 1884. Cf. Joyant I, p. 63.

[3] Lautrec writes 'trempadou', which is apparently derived from the Provençal word 'trempade', a wetting.

[4] Monseigneur Joseph-Hippolyte Guibert (1802–86), Archbishop of Paris.

130 *To his Mother*

[Paris, late September–early October 1886]

My dear Mama,

This time it's you who let your inkwell run dry, in such a fashion that, Papa having gone away (for a day or two, I think, to Orléans), here I am, absolutely an orphan. I am working as much as I can outdoors. As for going to Grenier's, I think I might be off there in a week or two, subject to leaving if I can't work. That is, if I don't decide to hire a model with Claudon and go to Cernay.[1] All very complicated. Claudon himself is due back from the country, where he had started to work with a model from Paris. They quarrelled immediately.

(A serious question). If Papa doesn't come across with my rent (which he doesn't look like doing) I am counting on you. I'll telegraph you '*Send Money*', but only in case of emergency, which will mean send the necessary 335 francs, 33 centimes by telegraph (to 27 rue Caulaincourt).[2] My illustrations are yet to be finished, thanks to the stereotyper who made them as black as my hat.[3]

Everything is fine apart from that and I kiss you like the faithful old campaigner that I am.

Henri

Prov.: Schimmel
Pub.: GSE88, GSF89

[1] A small town in the Department of Seine-et-Oise, near Rambouillet.

[2] One of the addresses of the large studio in Montmartre (the other address was 7 rue Tourlaque) that Lautrec used from late 1886 to 1898.

[3] Lautrec may be referring to his drawings for *Le Courrier Français* or *Le Mirliton*. Cf. Letter 153.

131 *To his Mother*

[Villiers-sur-Morin,[1] autumn 1886]

[2] I've started a small head of a boarder[3] at the inn[4] where I've done some panels[5]—extremely consumptive, but very pretty. I'm sorry that I can't bring this young girl to Malromé to paint her and then bury her afterwards.

Prov.: Unknown
Pub.: H.D., p. 240

[1] A village in the Department of Seine-et-Marne, east of Paris, where the Greniers had a house. During one of his sojourns there with Grenier in 1886, Lautrec painted four murals in the public room of the inn.
[2] Fragment of a letter.
[3] *Profil de jeune fille*, (Dortu A.196).
[4] L'Auberge Ancelin.
[5] Cf. Dortu P.239, P.240, P.241, P.242, redated by Murray.

132 *To his Mother*

[Paris, early October 1886]

My dear Mama,

I just received your letter as I got back from Villiers, where I spent half a day. Rob[1] is a real jewel, he looks like a big rat and is beginning to growl. Grenier will keep him all winter. I still haven't heard from Papa, or seen hide or hair of Bourges. I have an appointment with Roques[2] and have nearly got an entrée to the Eden.[3] Things are indeed picking up. Which makes me kiss you gaily, even though I have a cold which is stuffing up my nose. Kiss the grandmas.

Yours,
Henri

Prov.: Schimmel
Pub.: GSE83, GSF34

[1] Probably the dog depicted in the painting *Little Dog* (Dortu P.323), inscribed on the back by Grenier as given to Lautrec for his mother, and also in the painting *Little Dog Couchée* (P.324).
[2] Cf. Letter 125 Note 1.
[3] Eden-Théâtre, 7 rue Boudreau. It was at this location that the Exposition des Arts Incohérents was held from 17 October to 19 December 1886. Lautrec was invited, and exhibited under the name Tolav-Segroeg, No. 232.

133 *To His Mother*

[Paris] Tuesday [1886]

My dear Mama,

Nothing of importance to tell you. I often see Papa and Gabriel. I've begun to work again!!! However, it's very hard to keep oneself shut up indoors. It's beautifully sunny and despite a sharpness in the air I enjoy taking a walk in the morning. My friend Lesclide[1] came close to going down on a trip from le Havre to Cherbourg. The men were terrified and sick and he had to steer and manoeuvre alone in a frightful sea. It's a miracle he came out of it alive.

I had lunch with Gaston Bonnefoy[2] and his very pleasant wife.

However, he's beginning to find that it's no sinecure. He gets up at 6
O'CLOCK. Raoul, off looking for discoveries, has two properties under
consideration. Still under the seal of secrecy. I kiss you, and thank you
for your grapes, which we enjoyed very much.

<div align="right">Yours,
H</div>

Prov.: Schimmel
Pub.: GSE85, GSF86

[1] Richard Lesclide (1825–92), writer and journalist, Victor Hugo's secretary from 1876 to 1881, and
director of *Le Petit Journal*. Lautrec had probably met him in working on the projected illustrated
edition of Victor Hugo's work in 1884; cf. Letter 95 Note 1. In 1875 Lesclide had published Mallarmé's
translation of *The Raven*, with illustrations by Manet.

[2] A friend who was also known to Lautrec's family and was painted by Lautrec in 1891 and 1894
(cf. Dortu P.410, P.516).

134 *To his Mother*

<div align="right">[Paris, late 1886]</div>

[1] ... things are going wonderfully for me and I am waiting for Bourges
who has plans for sharing an apartment with me. We'll have to see.
I've just written to Papa to ask for money. Would you please send me
300 francs as soon as possible, by registered letter, it's easier. I think
that will be enough for the time being, but one can't be sure of anything
... *I'M GOING TO WORK HARD AND TRY NOT TO DRINK.*
Gentle Albert presents his respects to you, and as for me, I hug you
as hard as the poor body allows me ...

Prov.: Unknown
Source: Tausky, List 58, November 1958, No. 142

[1] Fragment of a letter.

135 *To Lili Grenier*

<div align="right">[Paris, 1886]</div>

Duchess,

I want to remind you that tomorrow we are eating together. The
waiters at the Ermitage[1] told me the other day you were there waiting
for us, with an old man. Kindly forget him in some cupboard.

I kiss your little hands.

<div align="right">HTLautrec</div>

Prov.: Schimmel
Pub.: GSE86, GSF87

[1] Bal de l'Ermitage, 6 boulevard de Clichy. Degas lived at this address during his last years and died on the fifth floor in 1917.

136 *To an Unidentified Correspoodent*

27 rue Caulaincourt [Paris, late 1886]

Dear Sir,

I shall be at home on Saturday at 4 o'clock. I hope to see you there. Sir, you may be assured of my full respect.

H. de Toulouse Lautrec

Prov.: Schimmel

137 *To Mme R. C. de Toulouse-Lautrec*

[Paris, 28 December 1886]

[1]I'm not in the process of regenerating French art at all, and I'm struggling with a hapless piece of paper that hasn't done a thing to me and on which, believe me, I'm not doing anything worthwhile.

I'd like to tell you a little bit about what I'm doing, but it's so special, so 'outside the law'. Papa would of course call me an outsider— I had to make an effort, since (you know as well as I do), against my will, I'm living a Bohemian life and I can't get used to this atmosphere. The fact that I feel hemmed in by a number of sentimental considerations that I will absolutely have to forget if I want to achieve anything makes me all the more ill at ease on the hill of Montmartre ...

Prov.: H. D., pp. 45, 48

[1] Fragment of a letter, partial dating from Privat records.

3

ARTIST
The Early Years

—◆—

1887	March	Paris	Takes apartment with Bourges at 19 rue Fontaine where he remains until 1891.
	Spring	Paris	Writes to Théo van Gogh.
	15 May	Paris	Writes to Uncle Charles. Exhibits in Toulouse under name Tréclau.
	June	Paris	Writes to mother about his large circus painting.
	July	Paris	Meets van Rysselberghe and is asked to exhibit with Les XX in Bruxelles in 1888.
	August	Malromé	Visits, paints Juliette Pascal.
		Arcachon	Visits. Fishing party with cormorant killed by an eel.
	October	Paris	Van Rysselberghe writes to Maus: 'Le petit bas-du-cul isn't bad at all ...'.
	October	Paris	Van Rysselberghe writes to Maus: 'T. Lautrec is delighted to exhibit with us ...'.
	November	Paris	Writes to Octave Maus thanking him for official invitation to Les XX; approaches Forain on behalf of Maus.
1888	January	Le Bose, Céleyran, Albi	Visits, writes to mother.
	January	Paris	Writes to mother about visit to van Gogh studio and sale to Manzi.
	January	Paris	Writes to dealers Théo van Gogh, Paul Durand-Ruel, and Arsène Portier.

	1 February	Brussels	Visits and shows with Vᵉ Exposition des XX which opened on 2 February.
	July	Villiers-sur-Morin	Visits Greniers.
	24 November	Paris	Writes to mother on 24th birthday.
1889	March	Paris	Writes to Jules Lévy regarding Bal des Incohérents of 27 March.
	Spring	Paris	Writes to Théo van Gogh: 'Come to 6 rue Forest.'
	May	Paris	Exhibits at Exposition Universelle des Arts Incohérents under name Tolav-Segroeg from 12 May to 15 October.
	June	Paris	Exhibits at Cercle Artistique et Littéraire Volney.
	July	Paris	Included in invitation for opening of Hostellerie de la Pomme de Pin.
	September	Paris	Exhibits at Fifth Salon des Indépendants from 3 September to 4 October.
	October	Paris	Writes to Maus regarding VIIᵉ Exposition des XX in 1890.
	December	Paris	Influenza.
1890	January	Paris	Writes to grandparent.
	14 January	Paris	Writes to Maus about opening of VIIᵉ Exposition des XX.
	January	Brussels	Exhibits at VIIᵉ Exposition des XX from 16 January. Visits and defends van Gogh against de Groux.
	March	Paris	Writes to mother about opening of Salon des Indépendants.
	March	Paris	Exhibits at Sixth Salon des Indépendants from 20 March to 27 April.
	6 July	Paris	Lunch with van Gogh at Théo's.
	31 July	Paris	Writes to Théo van Gogh about Vincent's death.
	30 August– 2 September	Taussat	Trip to Biarritz, San Sebastián, Biarritz, Fuenterrabia, and back to Taussat.
	October	Paris	Théo van Gogh, manager of

			Boussod-Valadon, 19 bd Montmarte, has breakdown and is hospitalized on 12 October. He is replaced by Joyant.
	December	Paris	Writes to mother.
1891	January	Paris	Exhibits at Cercle Volney, January and February.
	February	Paris	Writes to mother: 'Painting three portraits.'
	February	Paris	Writes to mother: 'Pretty much settled on an apartment at 21 rue Fontaine', and again: 'definitely going to rent the apartment at 21 rue de Fontaine'.
	March	Paris	Exhibits at Seventh Salon des Indépendants from 20 March to 27 April.
	May	Paris	Exhibits at Salon du Palais des Arts Libéraux from 28 May.
	June	Paris	Writes to mother about his argument with Roques at *Courrier Français*.
	August	Arachon, Malromé	Visits during summer.
	Autumn	Paris	Gabriel Tapié de Céleyran, his cousin, arrives and becomes externe at St Louis Hospital under Dr Péan. Begins working in lithography.
	October	Paris	Writes to mother.
	November	Paris	Writes to Maus about IXe Exposition des XX.
	December	Paris	Writes to mother: 'waiting for the poster' (Moulin Rouge, La Goulue), and later: 'My poster is pasted today on the walls.'
	December	Paris	Exhibits at First Exhibition at Gallery Le Barc de Boutteville.
	December	Paris	Writes to Maus reconfirming intention of exhibiting with Les XX in Brussels, 1892. Asks to exhibit his just-published poster.

138 *To his Mother*

[Paris, Winter 1887]

My dear Mama,

I'm glad to be able to tell you that Papa has been able to go hunting and kill pheasants and woodcocks. It's given him a lot of courage and he has come without complaint to resume the electric treatment[1] that Bourges is having him take every day. He's having himself massaged by his coachman and is doing his arm rotation exercises several hours a day. These pursuits, if hardly amusing, are keeping him busy and preventing him from dying of boredom.

As for me, the lack of a model has me out of a job. I'm making up by eating a lot, my appetite not having run out yet. As for the apartment, we've been to look at it together but even he seems to feel that it has some shortcomings.[2] So, everything's all right more or less, which is just what I wish for you, and kiss you.

<div align="right">

Yours,
Henri

</div>

Prov.: Schimmel
Pub.: GSE87, GSF88

[1] A treatment with brushes that was popular at the time (cf. Letters 23 and 78).
[2] Lautrec's father was still considering living with his son in Paris (cf. Letters 124 and 125). But in March 1887 Lautrec and Bourges took an apartment at 19 rue Fontaine, where they lived for almost four years.

139 *To Théo van Gogh*

[1][Paris, early 1887]

Dear Sir,[2]

I am bringing you a drawing. Please leave a word for me *tomorrow* at rue Fontaine[3] to let me know whether you can spend an hour or two with me on Sunday afternoon or Monday, any time. My time will be yours. One of my friends would like to have your opinion about a picture. Thank you in advance.

<div align="right">

Cordially yours,
H. de T. Lautrec

</div>

Prov.: van Gogh

[1] On letterhead of Boussod, Valadon & Cie, Successeurs, 19 boulevard Montmarte, Paris.
[2] Théo van Gogh (1857–91), younger brother of Vincent van Gogh, correspondent, confidant, and dealer. They lived together in Paris from 1886 to 1888, Théo working for Boussod Valadon at that time and until his death when he was replaced by Maurice Joyant.
[3] Lautrec moved to rue Fontaine in March 1887.

140 *To Charles de Toulouse-Lautrec*

[Paris] 15 May 1887

My dear Uncle,

The Salon closes on 20 June. Now for a piece of advice. Several very interesting exhibitions are open right now that perhaps will not be if you wait: Millet, the Internationals, etc. The Chantilly Derby is also on, and is worth seeing. It's very kind of you to speak of admiration for my painting exhibited in Toulouse[1] under the name Tréclau, the name I've permanently adopted,[2] when all I deserve is a little indulgence and a 'Good, young man, keep it up'. And that's it!

Your nephew
T.L.

Prov.: Unknown
Pub.: Joyant I, p. 106[3]

[1] Lautrec is probably referring to his portrait, *Madame A. de Toulouse-Lautrec, mère de l'artiste* (Dortu P. 277). In his detailed review in *Le Messager de Toulouse*, 24 June 1887, of Lautrec's exhibition entry, De Lamondès describes a profile figure with violet hair, seemingly the portrait of the Countess.

[2] Lautrec occasionally uses this signature between late 1886 and 1888. In the January 1887 issue of *Le Mirliton* he signs his drawing with the HTL monogram but titles it *Sur le pavé, par Treclo*. The following month the drawing is signed HTLautrec and titled *Sur le pavé, par Treclau* (change of spelling). By March 1887 he signs the drawing HTreclau and titles it *Le Dernier Salut, par Tréclau* (adding the accent). Cf. Dortu D.3005, D.3001, D.3004.

[3] Cf. Letter 69 Note 1.

141 *To his Mother*

(Paris, late Spring 1887)

My dear Mama,

Your belated letter amused me very much. A madly merry one. I'm so knocked out by the heat that I'm leading a spa sort of life, shower, tub, plus work, which is tiring. I'm not giving in to Grenier and Anquetin who are taking turns at trying to drag me off to the country, for I know only too well I'd never get anything done there.

We presented Cormon with a ridiculous silver palm which he received with much emotion.[1]

What are your plans, and, with all the brood at Le Bosc, won't you soon be drawn there? If you were there, what lovely walks we'd take in the evening ... and we'd enjoy each other's company much more than in the wintertime. Now say that I have a heart of stone. But right now we'll have to settle for enjoying Papa, who persists in not giving

me any appointments for a meeting, which in any case he wouldn't keep if he did.

I kiss you, perspiring profusely.

<div style="text-align: right">

Yours,
Harry.

</div>

Prov.: Schimmel
Pub.: GSE71, GSF72

[1] At the Salon of 1887, Cormon's entry No. 594, *Les Vainqueurs de Salamine*, depicted figures holding triumphal palms and was awarded a silver medal. His students gave him a present in honour of the occasion.

142 *To his Mother*

<div style="text-align: right">

[Paris, mid-June 1887]

</div>

My dear Mama,

We are all dazed by the first heat spells, which have begun very suddenly. I've started working outdoors. I even caught a slight case of neuralgia. I'm busy doing a large panel for the circus.[1] Unfortunately I'm afraid I shan't be able to finish until this winter at the reopening.[2]

Aside from that, I have nothing from Papa except on the day of the Grand Prix.[3] He was very friendly.

Unfortunately I lose my appetite the minute the good weather arrives. Loathing for food—etc., and the older I get the less patient I am in enduring it.

Hug everybody, and Roby,[4] for me.

<div style="text-align: right">

Your Boy,
Henri

</div>

P.S. Send Broch immediately to rue Fontaine.

Prov.: Durand-Ruel

[1] *Au Cirque Fernando, L'Écuyère* (Dortu P.312) or *The Missing Écuyère* in Murray, p. 88.
[2] In 1887 the circus closed on 12 June and reopened on 24 September.
[3] The Grand Prix de Paris was run on 5 June and won by the French mare Ténébreuse. That evening the Nouveau Cirque presented La Revue du Grand Prix.
[4] One of Lautrec's dogs, born in the autumn of 1886. Cf. Letter 132.

143 *To his Mother*

[Paris, June 1887]

My dear Mama,

Your unexpected change is a problem I shall not even try to understand. Why this sudden detour to Rivaude? One wonders. I'm going to ask you to do me a favour. Could you say *for sure* whether I will be able to work with Juliette unencumbered,[1] and whether you think I might get on steadily with the work without interruption.

To change the subject, where are Uncle Amédée's family going to spend their holiday? If need be, you could bring Kiki to Malromé for a while. I might be able to do something interesting of her. I'll need a reply about this right away because I'll decide on that basis whether to leave Paris at the beginning or end of July, which will definitely get me back to Paris by the end of October. These are fine plans. What to tell about myself? Well I'm *all alone*, not a friend in sight except my neighbour Gauzi,[2] as Bourges is staying at the hospital. He intends to go to Scotland in the middle of August. Princeteau has made reservations at the Hôtel Pérey.

Goodbye for now, dear Mama, and try to cut short your unexpected detour, the more quickly to be face to face with this horribly abject being, who is your despair and who signs himself

Yours,
Harry.

Kiss Tata for me. She'll probably stay with her aunt. You are wrong to let her go.

Prov.: Schimmel
Pub.: GSE103, GSF104

[1] Lautrec was planning to paint a portrait of Juliette Pascal (Dortu P.279).

[2] François Gauzi (1862–1933), painter. Born in Fronton, Haute-Garonne, he studied in Toulouse prior to going to Paris where he met Lautrec in 1885 at Cormon's atelier, being introduced by Rachou. He had a studio near Lautrec on the rue Tourlaque. He was encouraged by Puvis de Chavannes and many of his paintings depict the landscapes of Toulouse and the Midi. He returned permanently to Toulouse and married Germaine Marty in 1900. Lautrec painted two portraits of him (Dortu P.276, P.297) and depicted him in three others (Dortu P.261, P.361, P.428) and in drawings (Dortu D.2892, D.3043).

144 *To his Mother*

[Paris, July 1887]

My dear Mama,

I haven't any word about you from anywhere, though I've often seen my uncle and aunt and Papa as well. Anything new? No doubt

you have more news than I, who am leading a dull life and if I didn't
have showers to take and work to do I'd be bored to death. Bourges,
who's not feeling well, is probably going to go to Mont Dore?[1] And
I'll be alone with my disgrace. That's cheerful. Too bad?

If you were here we'd have the use of the carriage in the evenings
on the Champs Élysées. There's an idea to think over. You'd see more
of me, everybody having skipped off.

<div align="right">Your boy,
Harry</div>

Prov.: Schimmel
Pub.: GSE94, GSF95

[1] A popular health resort in the Auvergne, in the Department of Puy-de-Dôme.

145 To Arsène Portier

<div align="right">[Paris, July 1887]</div>

My dear Portier,[1]

I shall be at my studio and free to receive you every day, i.e.
Wednesday, Thursday, Friday, and Saturday, from 3.30 to 4. Albert[2]
told me that you want to bring a gentleman to see me.

<div align="right">Cordially,
HTLautrec</div>

Between 3.30 and 4

Prov.: Schimmel

[1] Arsène Portier (1820s–1902), an art dealer who had transactions and relationships with C. Pissarro,
Théo and Vincent van Gogh, Armand Guillaumin, Degas, et al. He lived and worked at 54 rue Lepic
where the brothers van Gogh lived.
[2] Adolphe Albert: cf. Letter 152.

146 To his Mother

<div align="right">[Paris, July 1887]</div>

My dear Mama,

For two days I've been in a ghastly mood and don't know what's
going to come of it. The sky is unsettled and is sprinkling us with an
unconcern that proves how little feeling the Eternal Father has with
regard to outdoor painters. Other than this, business is all right. I'm
going to exhibit in Belgium in February, and two avant-garde Belgian
painters[1] who came to see me were charming and lavish with, alas,

unmerited praise. Besides, I have sales[2] in prospect but don't count your chickens[3] before they are hatched.

I am feeling wonderfully well, and give you a kiss. Gaudeamus.

<div align="right">Yours,
Harry.</div>

Prov.: Schimmel
Pub.: GSE90, GSF91

[1] Théo van Rysselberghe and Eugène Boch (cf. Block, p. 99 n. 94).
[2] Vincent van Gogh wrote in the summer of 1887: 'I saw de Lautrec today; he has sold a picture, I think through Portier.' Cf. van Gogh, No. 461.
[3] Lautrec uses the Gascon expression 'Canta abaud d'avé fa l'iovu.'

147 *To his Mother*

<div align="right">[Paris, July 1887]</div>

My dear Mama,

I spent the day with Papa, who is very amiable, and to me appears little disposed to flee from the enchanting precincts of the Capital, though the weather is thundery-muggy, that is, somewhat enervating. My work is getting along pretty well and I'm busy enough to exhibit right and left, which is the only way to get your work seen. I'm going to take care of sending you the portrait by Rachou.[1] As for Miss J. Matheson,[2] the best would be to go to Mlle A. Dubos,[3] 56 rue du Bocher. I think it's 10 francs a lesson, but that isn't bad. (Just between us, she's a friend of Juliette's.) Did I tell you I am going to have a showing in Brussels in the month of February? Invited by the Vingtistes.[4] On which note I kiss you and Grandma and Tata as well.

<div align="right">Yours,
Harry</div>

Prov.: Schimmel
Pub.: GSE92, GSF93

[1] i.e., the portrait of Lautrec that Rachou painted in 1883. It is now in the Musée des Augustins in Toulouse. Cf. Letter 149.
[2] Probably a relative of Willie Matheson: cf. Letter 22 Note 5.
[3] Angèle Dubos, an art teacher.
[4] Cf. Letter 146 Note 1.

148 *To his Mother*

[Paris, July 1887]

My dear Mama,

Your horse question is hard to solve. As long as you entrust your animals to *fools*, it's useless to look for anything but nags. In which case there's no point in my getting mixed up in it.

However, if you've made up your mind to forbid anyone but the *coachman* to use the horses, I'm willing to look into the matter. M. Anquetin would like nothing better. With this restriction, I'm at your command. Louis must have come to see you as he's at Respide. So you must have had a chance to have it out with him. For my part I'm busy moving[1] and the work is suffering from it. Besides, the weather is so sultry that the models sleep on their feet. I've sold some studies and am about to sell some others.[2] Papa hardly stirs. But I'm very much afraid that the heat will drive us out of Paris before long. Where will I go? For the time being I sometimes go boating at Asnières.[3] It smells awful and bears only the faintest resemblance to the sea ... rather to sh ...

Write to me and tell me your plans, pure or otherwise. And I kiss you warmly.

Yours,
Henri

Prov.: Schimmel
Pub.: GSE72, GSF73

[1] Probably completing his move to 19 rue Fontaine.
[2] Cf. Letter 146.
[3] A town on the Seine, now part of the suburbs of Paris, where Lautrec went boating with the Greniers.

149 *To his Mother*

[Paris, July 1887]

My dear Mama,

It's frightful weather, which makes me groan all the more since I wasted two days going to see Grenier in the country. You really should send him some wine. You really should keep your promise to this fellow. I hope you will send him good quality, and to me a list so as to know how he can go about getting hold of what he wants, and some samples if possible. I am having a packing case made for the portrait by Rachou.[1] As for my plans, I have hardly any. Do what you like and I'll manage as best I can. I will send you Brédif's bill (a

mystery), which comes to 114 francs, if you want to send me the money directly. Or send it to him.

Bourges is at Mont Dore for his lungs. He's going to come back here. No doubt you heard about the death of his aunt, murdered in Bordeaux.

I kiss you, Tata and Grandma and you.

<div align="right">Yours,
Henri</div>

Prov.: Schimmel
Pub.: GSE96, GSF97

[1] Cf. Letter 147 Note 1.

150 *To Mme L. Tapié de Céleyran*

<div align="right">[Arcachon, Summer 1887]</div>

My dear Grandma,

First, thank you for the book, which arrived without a hitch. I'm happy to give you news about Papa. He's getting better slowly, but he seems to be bearing up patiently under his problem. Besides, he has something to do now: he goes every day to the hospital for electric treatments[1] and to be stirred up by my friend Bourges, who dances around him, a very funny little step.

I came down here rather suddenly, I'm ashamed to say, having taken a liking to the lazy life on the boat to Arcachon, where I brilliantly maintained the family tradition by fishing with a cormorant that came to a sad end, internally bitten by an eel that may have merely blocked its throat, causing it to die from *lack of air*, as the man from Marseilles put it.

Right now I'm carrying on with more perseverance than results, being taken by the ear to my studio which is very limited compared to the Basin.[2]

What are my cousins Raoul and Gabriel up to? ... Bertrand isn't doing brilliantly at Saint-Cyr. ... Good for him!!!

As for me, I remain your respectful grandson who gives you a hug and asks you to remember him to everybody there.

<div align="right">Henri</div>

Prov.: Schimmel

[1] Cf. Letter 138.
[2] The Bassin d'Arcachon.

151 *To Octave Maus*

Paris, Nov[ember 18]87

Dear, Sir,[1]

I received your kind letter and the official notice of the charming reception being offered for us by Les XX. I went to see Forain,[2] who did not give me any kind of affirmative answer. But I have good hopes. He is still located at 233 rue Faubourg St Honoré. I believe that a note from you will cause him to make up his mind fully.

As for my membership, it is yours and all I have to do is designate my paintings, which I shall do very soon.

Yours faithfully,
H. de Toulouse Lautrec
27 rue Caulaincourt

P.S. Forain promised me that he would write to you himself.

H. de TL

Prov.: Brussels

[1] Octave Maus (1856–1919), Belgian lawyer, art patron, and one of the founders of the periodical *L'Art Moderne* in 1881. He was secretary of Les XX from its inception and first exhibition in 1884 to its termination in 1893, continuing with the successor, La Libre Esthétique, until its end in 1914. In October van Rysselberghe had written to Maus: '... *Le petit bas-du-cul* isn't bad at all ... the chap has talent.' In another October letter to Maus he wrote: 'T. Lautrec is delighted to exhibit with us ... he will definitely come to Brussels in February ... We'll have Forain also through the short-ass ...'. Cf. Chartrain-Hebbelinck, Nos. 7 and 8.

[2] Jean-Louis Forain (1852–1931), a painter, draughtsman, and printmaker greatly admired by Lautrec. He accepted the invitation on 18 December to exhibit at the Exhibition in 1888. The catalogue does not reveal if indeed he submitted anything to the exhibition, but he was never invited again by Les XX. He appeared in 1912 with La Libre Esthétique.

152 *To Théo van Rysselberghe*

[Paris, November 1887]

My dear Théo,[1]

I'm writing to thank you for the invitation which obviously I owe more to your recommendation than to my personal merit. I've made some overtures to Forain,[2] who will very probably send something, and I do hope he does, for his works are a real treat. Now, may I ask you a favour without abusing your good nature? One of my good friends, Albert,[3] who has shown with the Intransigeants this year in Paris, wants me to ask you to think of him if there are any more invitations to go out. He would be very happy to show his paintings with yours and ours. Forwarding this request I beg you to do for him

what you have so kindly done for us. Thanking you in advance, believe me to be most cordially yours,

H. de T. Lautrec
27 rue Caulaincourt

Prov.: Schimmel
Pub.: GSE91, GSF92

[1] Théo van Rysselberghe (1861–1926), a Belgian painter and printmaker who studied in Ghent and Brussels. He was a founding member of Les XX in 1883 and exhibited with them every year except 1888. La Libre Esthétique, founded in 1894, replaced Les XX and he exhibited with them in 1894, 1898, 1905, and sometimes thereafter, exhibiting also at the Salon des Indépendants, Le Barc de Boutteville, etc.

[2] Cf. Letter 151.

[3] Adolphe Albert, a French painter and printmaker and a fellow student of Lautrec's at Cormon's studio. He exhibited with the Artistes Indépendants from 1886 to 1938, the Société Nationale des Beaux-Arts, and the Salon d'Automne. He made several series of etchings and became Secretary of the Société des Peintres-Graveurs Français. He remained a close friend of Lautrec's to the end and was the subject of the lithograph *Le Bon Graveur—Adolphe Albert* (Wittrock 297) in November 1898. His brother Henri was the Paris editor of the magazine *Pan*. Another brother, Joseph, was a friend of Maurice Joyant's and confidant of Lautrec during his stay at Dr Sémelaigne's sanatorium. Adolphe Albert was not invited to show with Les XX.

153 *To his Mother*

[Paris, mid-November 1887]

My dear Mama,

My letter had to catch up with you, which explains your telegram. Since my letter on Sunday, nothing new to report. I am delivering some photos of my Mirliton panels to Roques.[1] What will become of them is hard to tell, my other drawing was declared bad after being reduced.[2] A nuisance.

I think I wrote to you what Papa told me and what I thought about it. Miss Matheson hasn't written yet. It's not surprising that Grandma should have lots to do. But it's not so funny, her not sending you what I write, because you get into a tizzy so easily and full of protective worry about what your duckling is up to. We had a snowy day[3] and it melted so fast I was dumbfounded. Besides this I've had an attack of indigestion from eating some pâté. As two of my fellow-students were equally sick, we assume that some sort of poison or other was the cause. Verdigris or bad meat? That is the question.[4] Well, it's over. Let's not talk about it. I was running both ways copiously, with perfumes as varied as they were delicate.

I keep on with my regular routine and kiss you and the whole clan of Albi to boot.

Yours,
Henri

Prov.: Schimmel

Pub.: GSE93, GSF94

[1] i.e. *Le Refrain de la chaise Louis XIII au cabaret d'Aristide Bruant* and *Le Quadrille de la chaise Louis XIII, à l'Élysée-Montmartre*, both painted in 1886 to decorate Bruant's cabaret, Le Mirliton. Neither was finally reproduced in *Le Courrier Français*. Cf. Dortu, P.260–1, D.2973–4.

[2] Cf. Letter 130 Note 3.

[3] The first snowstorm of the year in Paris was on 14 November.

[4] Lautrec writes this allusion to Hamlet's famous soliloquy in English.

154 *To Arsène Portier*

[Paris, late 1887]

Dear Portier,[1]

Please give the bearer 100 francs on the Elias[2] account. Thank you and drop me a line and tell me in short yes or no. The maids garble things.

Yours cordially,
HTLautrec

Prov.: Unknown
Pub.: Hauswedell, Auction 162, 23 November 1968, No. 1929

[1] Arsène Portier: cf. Letter 145 Note 1.

[2] Julius Elias, Berlin art and literary critic and art collector. The French Impressionists' first real showing in Germany was due to his efforts with Durand-Ruel.

155 *To Arsène Portier*

[Paris, late 1887]

My dear Portier,[1]

Could you send me 100 francs on account of the Elias note from whom I have received to date 400 francs.

Cordially,
HTLautrec

Remit by the bearer, if possible.[2]

Prov.: Unknown
Source: Rendell Inc., Catalogue 102, No. 112

[1] Arsène Portier: cf. Letter 145 Note 1.

[2] Written across the top of the note.

156 *To Théo van Gogh*

[Paris, December 1887–January 1888]

Dear Sir,

Please go to Clauzel's[1] to give him some advice about the framing of the study that he has.[2] He'll tell you my idea and we shall make a decision. Thank you in advance and excuse me for disturbing you.

Yours,
HTLautrec

Prov.: van Gogh

[1] P. Clauzel, 33 rue Fontaine St Georges, Paris, Lautrec's framer.
[2] Lautrec may be referring to his portrait of Vincent van Gogh (Dortu P.278). This pastel portrait, now in the Rijksmuseum van Gogh in Amsterdam, still contains Clauzel's paper label affixed to the back of the mount. It is believed to be one of the eleven paintings Lautrec exhibited in Brussels at the Ve Exposition des XX, February 1888, No. 8, *Étude de Profil*.

157 *To his Mother*

[Château du Bosc] 1 January [18]88

My dear Mama,

New Year is going off very well, everybody's just fine and congratulating each other right and left. It's really too bad that circumstances hastened your departure, for you would have cut a fine figure at the family table, where I am the oldest male (the Abbé not being counted as such). This dear man has invented a long evening prayer with a preamble he made up himself which gives Gabriel fits of uncontrollable laughter. Godmother sends you all sorts of greetings. Grandma Gabrielle is looking absolutely tops. It appears that the move to Albi is going to take place, all the workmen having left the apartment. My goddaughter is showering me with kind attentions! Hosanna!!! Marie de Rivières[1] is entering the Sacred Heart (not having found a husband). This is my own idea of it and I think it's right. And that's it.

We're going to climb Miramont[2] this afternoon, and as I look out at it I kiss you. Nothing from Papa.

Yours,
Harry

Prov.: Schimmel
Pub.: GSE89, GSF90

[1] A cousin of Lautrec's.
[2] A hill in the Department of Lot-et-Garonne, west of Albi.

158 *To his Mother*

<div align="right">[Paris] Monday [9 January 1888]</div>

My dear Mama,

Aunt Émilie must have given you the details of our stay in Albi and the dignity with which I, embellished with black cotton gloves (at 2.25 francs, if you don't mind), pontificated. I was followed by Louis, having persuaded him that his presence was indispensable. He was delighted with the Société Albigeoise and the tasty lunch given by Dr Lalagarde, whose kindness was such that he even accompanied us to Tessonières.[1] I had a very good trip, and returned home to the rue Fontaine without problems. I found Bourges very glowing. I washed and went out. I went to the studio of van Gogh, who told me that one of the paintings I did this summer is going to be sold this week to the director of the Goupil photoglyphy, M. Manzi,[2] whom I've known for a long time. On the one hand, this means I have to give him a special low price; on the other hand, it offers the advantage that my painting will be seen by a lot of people. So I'm satisfied. Gaudeamus igitur!!

Then I went to say hello to Papa, who was crying amid his packages, which he can't free himself from. He's going to leave at daybreak. Nothing new on that score.—Uncle Odon is arriving this evening at the Hôtel Pérey, to find a job for Raymond, I believe.—I'm going to see him tomorrow.

And that's it. My diarrhoea stopped when I touched the woody bread—an unhoped-for result!! A hug for you and Grandma as well.

<div align="right">Yours [sic] boy
Henri</div>

I've just received your letter.

Prov.: Schimmel

[1] A small town about 10 miles from Albi on the road to Toulouse.

[2] Michel Manzi (1849–1915), draughtsman, art dealer, publisher of art journals, specialist in the photographic reproduction of paintings, and art collector. He first became associated with Goupil in 1881 and in 1893 became Joyant's partner in Boussod, Valadon & Cie where he helped organize exhibitions of Lautrec's work. The partnership lasted until his death in 1915 although they had some disagreements in the later years. Lautrec painted his portrait in 1901 (Dortu P.730). Manzi purchased Lautrec's 1887 paintings *Au Bal Masqué de l'Élysée Montmartre* (Dortu P.285) and *Au Bar* (P.288). The Manzi sale in 1919 included fifteen works by Lautrec, Nos. 185–199.

159 *To Octave Maus*

[Paris, January 1888]

My dear Sir,
 I am sending you herewith my sketch[1] and the list of my submissions. The ones that I do not send tomorrow I shall bring with me when I go up to Brussels on 1 February.

Cordially yours,
H. de T. Lautrec
27 rue Caulaincourt

Prov.: Brussels

[1] The catalogue of the Vc Exposition des XX has illustrated pages of entries by most of the artists. Lautrec drew *Clown* (Dortu D.3034) and submitted a hand-written list of his eleven entries. The exhibition opened on 2 February 1888 in Brussels.
[2] This seems to be Lautrec's first visit to Brussels.

160 *To Théo van Gogh*

[Paris, 12 January, 1888]

Received from Mr van Gogh,[1] the sum of one hundred and fifty francs, for my picture: *Woman seated at a table.*[2]

HTLautrec
Lautrec

Prov.: van Gogh

[1] Receipt in the hand of another signed by Lautrec and signed lower right Lautrec by Théo van Gogh. It also contains a stamp, over-written Paris, 12 January, 1888.
[2] *Poudre de riz* (Dortu P.348), now located at Rijksmuseum Vincent van Gogh, Amsterdam, having been in the collections of Théo van Gogh and V. W. van Gogh. It was obviously painted in late 1887, having been exhibited in the Vc Exposition des XX which opened on 2 February, 1888. Dortu mistakenly dates this 1889.
 Vincent van Gogh, in three letters to Théo from Arles in the spring of 1888, wrote: 'On Sunday I shall write to Bernard and de Lautrec, because I solemnly promised to, and shall send you those letters as well.' (Cf. van Gogh, No. 469). 'Here is a line for Bernard and Lautrec, whom I expressly promised to write to. I send the letters to you; you can hand them over when you have a chance, but there is no hurry whatever, and it will be an excuse for you to see what they are doing and hear what they have to say. If you want to.' (Cf. van Gogh, No. 470.) 'Has de Lautrec finished his picture of the woman leaning on her elbows on a little table in a café?' (Cf. van Gogh, No. 476.)

161 *To Paul Durand-Ruel*

[Paris] 18 January, [18]88[1]

Dear Sir,

I want to exhibit[2] the drawing[3] that I have on deposit with you, signed Tréclau.[4] I therefore ask that you give it to my framer, M. Clauzel.[5]

<div align="right">Yours faithfully,
H. de T. Lautrec</div>

Prov.: Durand-Ruel

[1] Written across the letter underneath the date is the notation: 'Received the said drawing for M. Clauzel 33 rue Fontaine 20 January, 1888, L. Durdan.'

[2] Lautrec's only recorded exhibition in 1888 was at the V^e Exposition des XX which opened on 2 February, 1888.

[3] Of the eleven catalogue entries in the exhibition only one, No. 4, *Portrait of Mme A. de T.L.*, was signed Tréclau. Lautrec may be referring to this portrait of his mother Adèle de Toulouse-Lautrec (Dortu P.277) as a drawing.

[4] Lautrec used this signature on occasion during the years 1886–8 (cf. Letter 140).

[5] Clauzel, Lautrec's framer, was probably framing all his work going to the exhibition. Cf. Letter 156.

162 *To Octave Maus*

[Paris] 21 February, [18]88[1]

Dear Sir,

May I ask you please to send my mother (Mme de Toulouse, Hôtel Pérey, 35 rue Boissy-d'Anglas, Paris) 10 catalogues of the exhibition of Les XX,[2] against reimbursement, of course. I talked about this with Gasparo before my departure from Brussels, but a week has already gone by and like the sister I see nothing coming.[3] Please excuse the change, and believe that I remain,

<div align="right">Cordially yours,
H. de Toulouse Lautrec</div>

Prov.: Brussels

[1] Written on the letterhead of Hôtel Pérey, 35 rue Boissy-d'Anglas, 5 cité du Retiro, Paris.

[2] The V^e Exposition des XX (cf. Letter 159, Note 1).

[3] In using the phrase 'Je ne vois rien venir' Lautrec is alluding to Perrault's tale *Blue Beard*. The wife sends her sister to the tower to look for their brothers and asks, 'Ma Sœur, ne vois-tu rien venir?' The sister replies, 'Je ne vois que le soleil . . .', a popular French phrase when something takes a very long time to happen.

163 *To Paul Durand-Ruel*

[Paris, Winter–Spring 1888]

HENRI DE TOULOUSE LAUTREC[1]

asks M. Durand-Ruel[2] to give the black-and-white painting[3] to the bearer of this card so that the frame can be changed. The picture will be returned immediately.

H. de T. Lautrec
19 rue Fontaine St Georges

Prov.: Durand-Ruel

[1] This note was written by Lautrec on one of his visiting-cards. In addition, on the side of the card, in another hand, the name Toulouse-Lautrec is written.

[2] Paul Durand-Ruel (1831–1922), founder and director of one of the supreme international art galleries that represented Renoir, Monet, Pissarro, and Sisley among many artists.

[3] Lautrec may be referring to *Le Quadrille de la chaise Louis XIII à l'Élysée Montmartre* (Dortu P.261), *Au Moulin de la Galette, La Goulue et Valentin le Désossé* (P.282), *Bal masqué* (P.301), or *A L'Élysée Montmartre* (P.311), four paintings 'en grisaille', or the two black-and-white paintings *Un jour de Première Communion* (P.298) and *Cavaliers se rendant au Bois de Boulogne* (P.299).

164 *To his Mother*

Villiers-sur-Morin, Friday, 13 [July 1888]

My dear Mama,

 The rotten weather got me down to the point where I've come here to Grenier's in the country to cheer myself up a bit. Aunt Émilie must have told you my drawings have appeared.[1] I'll send them to you on Monday. We're still leaving on the 20th or 22nd. May the devil take St Médard and his watering can.[2] As for me, I'm feeling better since I got away from Paris and my models. For that matter it's raining just as much in the country as in Paris, but I sleep and digest my food without any trouble.

Your boy,
Henri

Write to me in Paris, I'm going back there.[3]

Prov.: Schimmel
Pub.: GSE95, GSF96

[1] There are four of the drawings that Lautrec had made for Roques in 1886, now used as illustrations for Émile Michelet's article, 'L'Été à Paris', published in *Paris Illustré*, No. 27, 7 July, 1888. Cf. Dortu P.298–300, D.3028–29, and Adhémar, p. ix.

[2] Cf. Letter 114, Note 4.

[3] Vincent van Gogh, in two letters to Théo from Arles, late July/early August 1888, wrote: 'The Lautrecs have just come, I think they are beautiful.' (Cf. van Gogh, No. 505.) 'You are shortly to make the acquaintance of Master Patience Escalier, a sort of "man with a hoe", formerly cowherd of

the Camargue, now gardener at the house in the Crau. The colouring of this peasant portrait is not so black as in the "Potato Eaters" of Nuenen, but our highly civilized Parisian *Portier*—probably so called because he chucks pictures out—will be bothered by the same old problem. You have changed since then, but you will see that he has not, and it really is a pity that there are not more pictures *en sabots* in Paris. I do not think that my peasant would do any harm to the de Lautrec in your possession if they were hung side by side, and I am even bold enough to hope the de Lautrec would appear even more distinguished by the mutual contrast, and that on the other hand my picture would gain by the odd juxtaposition, because that sun-steeped, sunburned quality, tanned and air-swept, would show up still more effectively beside all that face powder and elegance.' (Cf. van Gogh, No. 520.)

165 *To his Mother*

[Paris] Saturday [24 November, 1888]
I'm writing to you on my 24th birthday, dear Mama, first of all thanking you for *all* your presents, which arrived safe and sound. Smallpox is the fly in the ointment and I'm wondering whether I should expose myself—not having seen Bourges for the last two *times*. He has settled in at the hospital.

Gabriel comes to see me often and seems to be interested in what he's doing. All to the good. Beside this, I'm in fine fettle, doing three studies at the same time,[1] with a will. Besides the sky is bright, a rarity at this time of year, and here it lets me give free rein to my fine plans.

I shall see Papa tomorrow, and haven't seen him at all for several days, leading the life of a recluse as I do, and in the evenings only going out just enough to get a little exercise. Not very exciting, but very satisfying. So, no news, unless it's my old age, which has just marked up another notch, which does not prevent me from giving you a big hug and kiss.

Your son,
Harry.

Prov.: Schimmel
Pub.: GSE97, GSF98

[1] Probably the two portraits of Lili Grenier (Dortu P.302–3) and the portrait of René Grenier (P.304). The three portraits of Hélène Vary (Dortu P.318–20) are also a possibility, although Murray dates these 1889–90.

166 *To Jules Lévy*

H. de Toulouse-Lautrec
19 rue Fontaine [Paris, March 1889]
Dear Sir,[1]
My friend Desmet[2] has assured me that by writing to you I can get an invitation to the bal des Incohérents.[3]

I thank you in advance, asking you to believe me most faithfully yours.

<div align="right">H. de Toulouse Lautrec</div>

Prov.: Schimmel
Pub.: GSE109, GSF110

[1] Jules Lévy (1859–after 1938), executive at the publishing firm of Hachette in Paris, journalist, publisher, and founder, in 1882, of the Incohérents with whom Lautrec exhibited in 1886 and 1889 (cf. Letter 132 Note 2). An anti-semitic description of his appearance and activities was written by Arsène Alexandre: cf. *The Modern Poster*, Charles Scribner's Sons (New York, 1895), pp. 6–9.

[2] Probably Henri de Smeth (1865–1940), Belgian painter and illustrator. Cf. Block, p. 99, n. 110.

[3] Held on 27 March 1889 at the Eden Theatre, the costume colour requirements were black, blue, and white. The Incohérents had held balls in 1885 and 1886, and advertised 'Dernier Bal, 16 mars 1887'. However, one was held in 1889 and they continued for some years.

167 *To Théo van Gogh*

<div align="right">[Paris, Spring–Summer 1889]</div>

My dear Sir,

Can you come to the garden at *10 o'clock*. The address is 6 rue Forest.[1] I'll be there despite the rain. This is why I am sending you this note. Please reply.

<div align="right">Cordially yours,
HTLautrec</div>

Prov.: van Gogh

[1] Lautrec was painting portraits in the garden on rue Forest, including *Femme à l'ombrelle, Berthe la sourde assise dans le jardin de M. Forest* (Dortu P.360, redated in Murray II). On 16 June 1889 Théo wrote to his brother Vincent at Arles discussing the exhibition at the Café Volpini (L'Exposition de peintures du groupe impressionniste et synthétiste, Café des Arts, Volpini—located just outside the grounds of the Exposition Universelle of 1889—which opened in early May): 'As you know, there is an exhibition at a café à l'exposition where Gauguin and some others (Schuffenecker) are exhibiting pictures. At first I had said you would exhibit some things too, but they assumed an air of being such tremendous fellows that it made one sick. Yet Schuffenecker claims that this manifestation will eclipse all the other painters, and if they had let him have his way, he would have paraded all over Paris adorned with flags of all manner of colours to show he was the great conqueror. It gave one somewhat the impression of going to the Universal Exhibition by the back stairs. As always, there were exclusions. Lautrec, who had exhibited with a Centre [probably the Cercle Artistique et Littéraire Volney, where Lautrec exhibited during June 1889], was not allowed to be in it, and so on.' (Cf. van Gogh No. T.10.) About 1 July, 1889 the French artist Paul Gauguin (1848–1903) wrote to Théo van Gogh from Pont-Aven regarding the exhibition: '... As for Lautrec I believe that the truest reason is that Lautrec considers only one thing and that is himself and not others. So these gentlemen probably decided it was preferable to do the same thing, that is to make plans without him. My pictures are not very conspicuous. Since I've been showing I've always acted in the same way and Degas in our exhibitions has always acted the same way. And for the luxury of showing we've always acted differently from the others ...' (Cf. Cooper, pp. 100–7.)

168 *To Unidentified Correspondents*

[Paris, mid-July 1889]

[1]HOSTELLERIE DE LA POMME DE PIN
22 rue Joubert (Chaussée d'Antin)[2]
Electric Light—Telephone
Large Garden—Ballroom

Messrs[3] Boucher, Boutet de Monvel, Claudon, Fournier, Lasellaz, Jean Aman, Ista, Franc Lamy, Toulouse de Lautrec, Henri Martin, Recipon, Georges Sauvage, Tanzi, Willette, Yarz, Painters, Mr Charpentier, Sculptor, Messrs Grandpierre, Architect, Castella, General Contractor. Messrs Lemercier de Neuville, Paul Bourdeille, Artistic Directors, and Messrs Guillaume Livel and Paul Gaspari have the honour of inviting you to the opening evening party of the Hostellerie de la Pomme de Pin and the first performance of Coquin d'Amour! A Parody in 2 acts and 4 scenes which will take place in the garden of the Hostellerie. Ballroom, 22 July, 1889 at 8.30 p.m.

Prov.: Schimmel

[1] A printed invitation form illustrated by Stelman on the occasion of the opening of the cabaret.
[2] At 22 rue Joubert, a cabaret with a bad reputation was established about 1890. Cf. Hillairet, *Supplement*, p. 77.
[3] Alfred Boucher (1850–1934), probably; Louis-Maurice Boutet de Monvel (1851–1923), probably; G. Claudon; Louis Fournier (1857–1902), probably; Gustave Lasellaz; Edmond Aman-Jean (1860–1936); Auguste or Ernest Ista; Pierre Désiré Lamy (1855–1919), known as Franc Lamy; Henri de Toulouse-Lautrec (1864–1901); Henri Martin (1860–1943); Georges Recipon (b. 1860); Georges Sauvage; Léon Tanzi (1846–1913); Adolphe Willette (1857–1926); Edmond Yarz; Alexandre Charpentier (1856–1909).

169 *To his Mother*

[Paris, Summer 1889]

My dear Mama,

I am afraid as I take pen in hand (to write you this sh—y letter, as the infantrymen say)[1] to make you feel the backlash of the evil humour I'm in, thanks to the torrents of rain that haven't let up for the past 3 days. Nothing to do but look out at the rain coming down. I saw the family yesterday. Uncle Charles is buying daggers, windlass crossbows, and other assorted little toys to clutter up his *hostel*.

Your plans strike me as based on vague assumptions. You'll not be having to push on to Coursan[2] if you think it's urgent until towards the end of September. I doubt very much that the tribe will still be

there then, or at any rate still in Palavas.[3] I'd like to make some sort of Arcachon arrangement, but there are a lot of buts.

I end with a kiss soaked to the skin.

Your boy,
Henri.

I'm rereading my letter, it's not too much out of sorts. So much the better.

Prov.: Schimmel
Pub.: GSE98, GSF99

[1] Lautrec uses the phrase 'ce mot de lettre', an allusion to 'le mot de Cambronne' ('shit') the defiant refusal of General Cambronne (1770–1842) to the English request for surrender at Waterloo.

[2] A town in the Department of Aude, near Narbonne.

[3] Palavas-les-Flots, a resort town on the Mediterranean, near Montpellier.

170 *To his Mother*

[Paris, early September 1889]

My dear Mama,

We have been all wrapped up in the great pleasure of exhibition opening day,[1] which was quite gay despite the pouring rain. Uncle Odon and Auntie were there and asked me when and how you were going to come. I've also left word with Laura Pérey. Paul and Joseph have gone to Pauguiers and we are expecting them back tomorrow. I also have an appointment with Charles du Passage[2] to go and see some painting. Not a sign of life from Princeteau. Bourges is being unfaithful to me. He has to stay at the hospital, all the others being off in the country. Though for that matter his hospital is quite cheerful, little gardens everywhere. Perhaps I'll go there and do some studies of old women wearing white bonnets that make them look a little like milkmaids.[3]

Hoping to see you soon, I kiss you.

Yours,
Harry

and Tata, don't forget her.

Prov.: Schimmel
Pub.: GSE99, GSF100

[1] The Salon des Indépendants, which opened on 3 September, where he exhibited three works, *Monsieur Fourcade* (Dortu P.331), *Au bal du Moulin de la Galette* (P.335), and an unidentifiable *Étude de femme*. On 5 September Théo van Gogh wrote to his brother Vincent at Saint-Rémy: 'There are some Lautrecs, which are very powerful in effect, among other things a Ball at the Moulin de la Galette [P.335], which is very good.' (Cf. van Gogh, No. T.16.)

[2] Lautrec made three sketches of *Du Passage* (Dortu D.3013–15).

[3] Nothing seems to have come of this project.

171 *To Octave Maus*

[Paris, October–November 1889]
Dear Sir,

First of all, I should like to thank you personally for your very courteous invitation to show with Les XX.[1] I promise very quickly to send at least five canvases, which I shall select definitely by 15 December. I hope that the warm welcome already accorded to my efforts will not diminish.

Cordially yours,
HTLautrec

P.S. Please remember me to Messrs Théo van Rysselbergh[e] and Picard.[2]

HTL

Prov.: Brussels

[1] The VII^e Exposition annuelle des XX opened in Brussels on 18 January, 1890.
[2] Edmond Picard (1836–1924), Belgian lawyer, art collector, and critic, a militant socialist and co-founder of *La Liberté*.

172 *To Octave Maus*

[Paris] 11 December [1889]
Dear Sir,

Enclosed herewith I am sending you a list[1] of the works that I shall be sending to Les XX. Please be so kind as to let me know the packing agent and the date of the shipments. I shall come personally to Brussels for the opening. Looking forward to the pleasure of meeting you, I remain,

Very cordially yours,
HTLautrec

Prov.: Brussels

[1] Lautrec exhibited five works in Brussels in January 1890, including *Le Bal du Moulin de la Galette* (*Au bal du Moulin de la Galette*) (Dortu P.335), *Liseuse* (*La Liseuse*) (Dortu P.349), and three others, not easily identified, titled *Rousse*, *Étude*, and *Étude*.

173 *To Mme R. C. de Toulouse-Lautrec*

[Paris, January 1890]

My dear Grandma,

No doubt you're up on all our small affairs through Papa, who must be nearby keeping busy poking up the fire (if I'm not mistaken) and I am writing simply to kiss you and to wish you a happy 1890. Doing this I hope you won't catch my influenza, which I've had twice and which is still hanging on. I can barely open my eyes and for four days I've hardly worked at all, because when I get all set and look at my model I begin to cry like a baby, without good reason. Mama didn't escape it, either, but managed to throw it off quickly. We really are full of lamentations, aren't we!

At the end of January I'm going to carry the good work, or rather the good paintings(?) to Belgium—poor Belgians![1]

I'm devoting what is left of my paper to send you a kiss and ask you to remember me to everyone in your entourage who is the least bit interested in the efforts of your respectful grandson.

HTLautrec

Prov.: Schimmel
Pub.: GSE101, GSF102
[1] To the VII^e Exposition des XX, Brussels.

174 *To Octave Maus*

Paris 14/1 [14 January, 1890]

[1]When is the opening Regards Lautrec

Prov.: Brussels
[1] Written on a telegram form addressed to Mr Octave Maus 27 rue du Berger Br[ussels].

175 *To his Mother*

[Paris, 20 March, 1890]

My dear Mama,

I'm still reeling from the second exhibition opening. What a day![1] But what a success. The Salon got a slap in the face from which it will recover perhaps, but which will give many people something to think about.

You must be completely Albigensified just now and in a pleasant torpor induced by eating and boredom. I regret it's too early yet to go

down and brave the dangers of the bay of Arcachon. Here not much to do—models are scarce and serious models very scarce. Nothing interesting in all that.

Yesterday I saw Doctor Bonnefoy, very much worn out by 8 days of Paris, who tells me he has a little mare to sell you. Louis appears to be a little down on his luck. Papa and Princeteau, presided over by Nabarroy-Bey,[2] shed the lustre of their presence on Lucas. My servant is decidedly odious, and as for myself, I kiss you,

<div align="right">Yours,
Henry</div>

Prov.: Schimmel
Pub.: GSE102, GSF103

[1] Of the sixth Salon des Indépendants, which opened on 20 March, where Lautrec showed two works, No. 790 *Au Moulin Rouge, La Danse* (Dortu P.361) and No. 791 *Mademoiselle Dihau au piano* (P.358). On 19 March, after the 'vernissage', Théo van Gogh wrote to his brother Vincent at Saint-Rémy: 'de Lautrec has an excellent portrait of a woman at the piano, and a large picture which is very striking. Notwithstanding its scabrous theme it has great distinction.' (Cf. van Gogh, No. T.29.) The first opening would have been that of the VII⁰ Exposition des XX; cf. Letter 173 Note 1.

[2] Nabarroy-Bey was a friend of Lautrec's father.

176 *To Théo van Gogh*

<div align="right">[Paris] Thursday morning [31 July 1890]</div>

My dear Friend,

I received the letter with its news of your poor brother too late to go to his funeral.[1] You know what a friend he was to me and how anxious he was to prove it. Unfortunately I can acknowledge all this only by shaking your hand cordially in front of a coffin, which I do.

<div align="right">Sincerely yours,
HTLautrec</div>

Please remember me to Mme van Gogh.

Prov.: van Gogh

[1] Vincent van Gogh died on Tuesday, 29 July, and was buried on Wednesday, 30 July, with services at the church of Auvers. In mid-July, in one of his last letters from Auvers to Théo and his wife, Vincent wrote: 'Lautrec's picture, *Portrait of a Musician*, is amazing, I saw it with emotion.' Cf. van Gogh, No. 649. After leaving Saint-Rémy, he visited Paris for a short period in mid-May, arriving in Auvers on 21 May. He is probably referring to Dortu P.358.

177 *To an Art Dealer*

[Paris, August 1890]¹

My dear Sir,

The other day I forgot two pictures, one showing a 'seated woman in pink, full-face, leaning forward a little', the other 'a red-haired woman seated on the floor, seen from the back, nude'. These two pictures were shown this year in Brussels at the Vingtiste exhibition.² Be so kind, I beg you, as to confirm the fact that you have them. I am asking 300 francs for each.

Cordially yours,
H. de Toulouse Lautrec
27 rue Caulaincourt

Prov.: Schimmel
Pub.: GSE104, GSF105

¹ The recipient noted on the letter that he answered on 24 August, 1890.

² Two of the paintings shown there were entitled *La Liseuse* (Dortu P.349) and *La Rousse* (P.610). This latter painting, now titled *La Toilette* and dated 1896 by Joyant, Dortu, and all others (but redated 1889 by Murray) is in the Musée du Louvre, Paris. Murray has also redated *Femme à l'ombrelle, Berthe la sourde assise dans le jardin de M. Forest* (Dortu P.360) to 1889 and says it is probably the *Étude* exhibited at Les XX in 1890. Cf. Murray II.

178 *To his Mother*

Taussat, Wednesday, 3 September [1890]

My dear Mama,

I'm back in the fold after a very amusing but somewhat tiring excursion. On Saturday I left Taussat by train at 5 in the morning, arriving at Boucau, the station before Bayonne.¹ At noon lunched with one of my friends who's painting a picture of toreadors. Left for Biarritz² to get tickets for the bullfight. Dinner and bed after the Casino. Next morning I left for San Sebastián³ with some very nice people who are natives of the place (thanks to Bordes's being along everyone went out of their way to be nice to me). Spanish lunch and at 4 o'clock the bullfight with six 5-year-old bulls. Roaring crowd, eviscerations, smells, nothing was missing, and then back that evening by excursion train to Biarritz. We waited at the railway station for two hours jammed in a third-class coach and what heat!!!! Next morning I went to Fontarabie⁴ (having slept in Biarritz) with a Parisian journalist and returned the following morning to Taussat. I saw your town from a distance, it's perched up very high. I went bathing several times in the sea, with waves that roll you around rather briskly, but agreeably. I shall doubtless go back to Biarritz in a couple of weeks. We'll let you

know. I kiss you warmly, because here the sun is beating down hotly, too. Kiss my godmother for me.

<div align="right">Yours,
H.</div>

Prov.: Schimmel
Pub.: GSE105, GSF106

[1] Boucau and Bayonne, towns in the Department of Basses-Pyrénées, on the Gulf of Gascony.
[2] A town in the Department of Basses-Pyrénées, on the Gulf of Gascony, famous as a resort.
[3] i.e. San Sebastián, a port and seaside resort in Spain, on the Gulf of Gascony.
[4] i.e. Fuenterrabia, a town on the Gulf of Gascony, near Biarritz, but in Spain.

179 *To his Mother*

<div align="right">Taussat, Friday 11[1] [September 1890]</div>

My dear Mama,

I received your letter from Biarritz just as I was beginning to worry about you. Didn't you get my letter in Lourdes[2] describing the bullfight, and sent from Taussat where I am settled now, enjoying the last beautiful days and the swimming. My plan would be to go to Biarritz two days before you leave and to visit the Boucau[3] factories, then to go with you to Bosc for a week. Think about it, and plan. I would then leave for Paris. If your plans work out, I think this will take place at the end of the month. Otherwise I would go to Biarritz anyway and from there directly to Paris. I went fishing with my birds in the ponds where they were quite splendid. I close in kissing you and asking you for a detailed answer. Princeteau is coming to Arcachon on Sunday and I'll go to see him.

Kiss my godmother and tell her that I sympathize with her, knowing how unpleasant it is to be tied to one's bed without moving. Tell her also how much I wish for her recovery.

<div align="right">Your boy,
Henri</div>

I have heard from no one.

Prov.: Schimmel
Pub.: GSE106, GSF107

[1] Lautrec dates this letter incorrectly: Friday was 12 September.
[2] A town in the Department of Hautes-Pyrénées, which became a pilgrimage centre.
[3] There was an important metallurgical industry there.

180 *To his Mother*

[Paris, December 1890]

My dear Mama,

I was very glad to get your socks. I have enough for the time being. Now have 3 more pairs of them made, which you can bring along when you come back. I've passed on your news to Papa, who's having troubles with his tapestries being held as security by the landlords of Altamoura,[1] from whom Papa had sublet the studio.... There he is, delayed once again. I'm continuing to work despite the poor light. We had thick ice, and just when the skaters' festival opened a thaw set in. So much the better, but what a mess.

I wish you a merry Christmas, meanwhile looking forward to the New Year. Lots of kisses to all.

Your boy,
Henri

Prov.: Schimmel
Pub.: GSE107, GSF108

[1] Probably Alessandro Altamura (b. 1855), an Italian painter listed as living at 13 rue Washington, i.e. near the Champs-Elysées, and who exhibited at the Société Nationale des Beaux-Arts 1890.

181 *To his Mother*

[Paris, December 1890]

My dear Mama,

I have received your best wishes for a happy New Year and can only return them in kind. As for the mirror you offer me, first of all I thank you and then would like to ask you please to keep it under your wing for me until further notice.

Both of us, Bourges and I, have been celebrating the wine sent by his brother from Bergerac.[1] On the other hand the truffles didn't agree with me at all, and whether because of quality or quantity, I had to throw up what I owed to the turkey, without sufferings nor interruption of good spirits. You see how I'm upholding family tradition.

I've had it out quite calmly with Papa about why I'm in no hurry to go and see my uncle, and he *fully approved*. The whole thing very diplomatically, moreover. There you have it, a point made—let it be known.

It remains cold here, so much so that Bourges goes skating every day with a great deal of enthusiasm. He's very anxious to have some of the goose-livers you spoil me with and is impatiently awaiting their arrival. Will you remember?

1890 137


At this point, I am going to work, and I still kiss you in 90, as I will in 91.

I am going to write to the grannies. Please send me Aunt Armandine's address.

Lots of little kisses, etc., etc.[2]

Happy New Year!!

Yours,
Henri

Prov.: Schimmel

Pub.: GSE108, GSF109

[1] A town in the Department of Dordogne, famous for its wine and truffles.

[2] Cf. Letter 98 Note 1.

182 *To his Mother*

[Paris, January 1891]

My dear Mama,

Out of paper and I'm obliged to make do with the notebook kind. I've received Grandma Louise's presents and her pâté, which had an awful time of it. Tell her that for me, thanking her most kindly.

We are having a cold spell, very dry, but which continues to skin our hides. Bourges is skating like fury and would like it to last forever. However, he almost left for the Congo with two intrepid explorers for *five months*. The deal fell through and he's going to console himself by going to Beirut to make a report on the cholera. Every man to his poison! Papa is always saying he's going to go somewhere, sometimes to Albi, sometimes to establish himself in a studio in the cité du Rétiro? I'm still thinking of going to Belgium and Holland[1] in February as my exhibition at Volney's opens on the 26th[2].

Give me an idea for a present for Kiki, who has asked me to get her a mechanical *ostrich* which I haven't got time to go looking for. I'll send you whatever you think will be best and you can forward it to her or deliver it to her mother.

I kiss you and ask you to do the same for me to all whom it may concern.

Yours,
Henri

Gaston Bonnefoy, back from Saigon, has chalked up two new carriage accidents with no one hurt. 1. The Vathoins and the Massapins, overturned in the same break. 2. The Lanures' carriage with only the coachman aboard.

I think that your idea of a coachman is good.

Prov.: Schimmel
Pub.: GSE110, GSF111

[1] Cf. Letter 184.

[2] Exposition du Cercle Artistique et Littéraire, rue Volney, January–February 1891. Lautrec exhibited *Hélène Vary* (Dortu P.320), *M. Désiré Dihau, Basson de l'Opéra* (P.379), and *M. Henri Dihau* (P.381).

183 *To his Mother*

[Paris, January 1891]

My dear Mama,

It's not your son but an icicle that's writing to you. It snows, snows, snows, and in spite of all modern conveniences the cold pierces just the same. I hope that as soon as the thaw comes you'll come too, but it would be really risky to budge in weather like this. The merry Fabre is here and fighting off the cold with not a few brandies. I keep working happily, stamping my feet, but getting up in the morning is hard. I have friends who come to pose,[1] and so I wait like a coward for them to be here before I get up.

Nothing new apart from that. I hope your patient is on the mend and am counting a little on the famous 'no news is good news'.

See you soon, I hope, and little kisses,[2] as befits

Your son,
Henri

Prov.: Schimmel
Pub.: GSE172, GSF189

[1] Posing for Lautrec at this time were Henri Bourges, Georges-Henri Manuel, Paul Sescau, Gaston Bonnefoy, Louis Pascal (Dortu P.376–8, P.383, P.410, P.466–7).

[2] Cf. Letter 98 Note 1.

184 *To his Mother*

[Paris, January 1891]

My dear Mama,

I'm glad to see that food and wine are helping you to bear with the bad weather valiantly and that far from being down in the dumps you're bright, well, and eating like a house on fire.

Last night I just missed being roasted, a beam under my bedroom having caught fire. Fortunately the firemen put the fire out in a quarter of an hour. Actually, the thing happened last night at 11 o'clock and when I came home to go to bed all I found was a lot of smoke.

Is it Joseph Pascal who's getting married?[1] Bourges got a letter signed Joseph with no last name and the writing vaguely resembles his. I was amazed to realize I had forgotten the text of the card addressed to Papa—forgive me. Please answer the question about Béatrix.[2] Here everyone's freezing—no let-up in sight. Who knows when I'll be able to go to Belgium! Lots of kisses for grandmas and uncles and aunts and nephews. Best of everything to Papa. I kiss you.

<div style="text-align:right">Your son,
Henri</div>

Can you send us a good-looking Albi capon? I hope you can and am counting on it, also on the goose-livers.

<div style="text-align:right">Yours H</div>

Prov.: Schimmel
Pub.: GSE111, GSF112

[1] Joseph Pascal may have married Marguerite Sol at this time, although the first of his four children was not born until 1900.
[2] Cf. Letter 182.

185 *To his Mother*

<div style="text-align:right">[Paris, January 1891]</div>

My dear Mama,

I'm very happy to learn the good news in your letter. Now all I'm waiting for is the livers and other gastronomic supplies.[1]

Bourges will defend his thesis on Thursday and will finish his resident studies on Sunday.[2] Yesterday I inaugurated the Volney show.[3] My pictures are not badly positioned but they're in a light that's not as good as last year's.[4]

I sold two studies of dancers to Manzi,[5] the director of the Héliogravure Goupil. Did I tell you?

I haven't had Papa's knick-knacks picked up yet.[6] I was waiting for the Caulaincourt ice floes to melt, which will be today or tomorrow.

Paris was shaken by the explosion of melanite intended to blow up the ice floes on the Seine. Bourges even saw two swans dragged by the ice floes fluttering weakly between two bridges and falling exhausted onto the ice.[7]

I've seen quite a bit of Louis.[8] Gaston Bonnefoy[9] has just lost an aunt from whom he's expecting to inherit.—I heard that Davout buried

his aunt, which could mean the boat is practically assured for this summer. Now that's what I call egotism.

A hug from me to everybody.

<div style="text-align: right">

Regards,
Your
Henri

</div>

Prov.: Schimmel

[1] Cf. Letter 184.

[2] Bourges may have been planning his trips to the Congo or Beirut as a result of the completion of his residency. Cf. Letter 182.

[3] Exposition du Cercle Artistique et Littéraire, rue Volney, January and February 1891 (cf. Letter 182 Note 2).

[4] Lautrec is probably referring to the Exposition du Cercle Artistique et Littéraire, rue Volney, where he had exhibited in 1889. He did not exhibit with them in 1890. It is possible he may be discussing his exhibitions of 1890, VIᵉ Salon des Indépendants in Paris or Les XX in Brussels.

[5] Michel Manzi was the purchaser of *Danseuse ajustant son maillot* (Dortu P.371), which remained in his collection until it was sold in the first sale of the Manzi collection, 14 March, 1919, No. 95. The second painting is not identified but may be *Danseuse assise* (Dortu P.370).

[6] Lautrec is probably referring to his father's tapestries being held by a landlord. Cf. Letter 180.

[7] The cold weather, the ice, and the accidents are discussed in Letters 181, 182.

[8] Louis Pascal: cf. Letter 5 Notes 3, 4.

[9] Gaston Bonnefoy: cf. Letter 133 Note 2.

186 *To his Mother*

<div style="text-align: right">

[Paris, February 1891]

</div>

My dear Mama,

The whole family gathered here, and there you have it, the news of the day. I'm very much afraid my esteemed personage will be missing at this little party. We are enjoying splendid weather here. So good I had the buggy hitched up and with Gaston we've been out to breathe in the Bois de Boulogne air two or three times. I don't think Papa will have any objection, quite the opposite, since horse and carriage have had an airing—and me too.

I'm busy with my exhibition, with 3 portraits in the works: Gaston, Louis, and Bourges.[1] Louis has two sure positions lined up, thanks to Mgr Richard,[2] either in insurance or with the Transatlantique. So much the better. Come back quickly as I'm going to be on my own, with Bourges going to Africa early in March, a month on horseback all the way south with a promise of gazelle-hunting. What a pity I can't go with him. Perhaps Papa might be able to go. Bourges often speaks about him and asks me to send him his best.

Kisses to all and to you,

<div style="text-align: right">

Your boy,
Henri

</div>

Prov.: Schimmel

Pub.: GSE113, GSF114

[1] Lautrec exhibited *M. le Docteur Bourges* (Dortu P.376), *Gaston Bonnefoy* (P.410), and *Louis Pascal* (P.467), together with up to seven other works, at the seventh Salon des Indépendants from 20 March to 27 April, 1891. Other entries included *En meublé* (P.365), *A la mie* (P.386), *M. Henri Dihau* (P.381), and probably *M. Paul Sescau, Photographer* (P.383).

[2] François-Marie Benjamin Richard (1819–1908), Archbishop of Paris from 1886.

187 *To his Mother*

[Paris, February 1891]

My dear Mama,

I have nothing but praise for the capon, which was absolutely remarkable.

I still have plans for a trip to Albi.

Tell Papa that his odds and ends have been transported to his studio—as he indicated.

Bourges and I have pretty much settled on an apartment at *21* rue Fontaine. So moving won't be very perilous.

Enclosed is a very nice article published about me.[1] It complains about the location of my works, although the places assigned to me by the Circle[2] aren't too bad.—Given the Ancients who are entitled to be hung on the line ...

I've just done a portrait of Gaston Bonnefoy,[3] and have just begun one of Louis.[4]—I hope they won't be too ugly.

Hope you'll enjoy plenty of good eats for Carnival, before you have to face the more 'windy' Lenten fare.

And a hug to all of you.

Yours,
Henri

Prov.: Schimmel

[1] Article by Jules Antoine in *La Plume*, No. 44, 13 February, 1891: 'M. de Toulouse-Lautrec has something of the expressive draughtsmanship of Degas.'

[2] Exposition du Cercle Artistique et Littéraire, rue Volney, January–February 1891.

[3] *Gaston Bonnefoy* (Dortu P.410).

[4] *Louis Pascal* (Dortu P.467, dated 1893 by Dortu, redated 1891 by Murray).

188 *To his Mother*

[Paris, February 1891]

My dear Mama,

Looks to me as if the Albi carnival cannot have disturbed your family effusions to any serious extent. Here little excitement except for a traffic jam, such that I crossed the Boulevards with a police officer pulling my horse, or rather the horse of my carriage, by the nose between the two lines of policemen, holding back a roaring, red-faced crowd that reminded me a little of a riot. Very amusing, actually.

I saw Gérard de Naurois, very lively, at the Moulin Rouge.[1] We are definitely going to rent the apartment at 21 rue Fontaine,[2] it having been judged ideal. Émile Pérey[3] is not getting married yet, so there need be no concern about that. Louis hasn't said a thing about Respide, though he sees me all the time, since I'm doing his portrait.[4] No other news, not even on the horizon. A kiss for you all, and for you more than anyone,

<div align="right">Your boy,
Henri</div>

I'm sending you the flattering clipping I forgot last time.[5]

Prov.: Schimmel
Pub.: GSE 112, GSF 113

[1] A popular dance hall at 90 boulevard de Clichy, in Montmartre, and Lautrec's favourite pleasure spot.
[2] In March Lautrec and Bourges moved to this address from the one they had had at 19 rue Fontaine.
[3] Probably the son of Laura Pérey, on whom cf. Letter 4 Note 1 and Letter 10 Note 3.
[4] Cf. Dortu, *Monsieur Louis Pascal* (P.466–7, both improperly dated 1893, redated 1891 by Murray).
[5] Cf. Letter 187 Note 1.

189 *To his Mother*

[Paris, mid-March 1891]

My dear Mama,

Just now I'm very busy with the rush for the Exhibition, because the works must be delivered by Saturday at the latest.[1]

Your story about the chic young girl leaves me cold, because it's one more blunder on the list of things done by the person who had the thought, the young girl in question being only a simpleton who peddles stale news.

By the way, I hope you'll show up here in the next few days. Please bring me the period mirror you told me about. I hope there will be a place for it in the new apartment.

Bonnefoy has gone back to the Crédit Lyonnais, while Louis hasn't started yet, even though he is on the verge of being hired.

Goodbye, my dear. Kiss the grannies and the other ornaments on our genealogical tree for me.

<div align="right">

Yours,
Henri

</div>

Prov.: Schimmel
Pub.: GSF 115

[1] The Seventh Salon des Indépendants, which opened on 20 March and ran until 27 April. Lautrec exhibited ten paintings, including *En meublé* (Dortu P.364), *En meublé* (P.365), *M. le Docteur Bourges* (P.376), *M. Henri Dihau* (P.381), *M. Paul Sescau* (P.383), *A la mie* (P.386), *Gaston Bonnefoy* (P.410), *Monsieur Louis Pascal* (P.467), and two unidentifiable paintings.

190 *To his Mother*

<div align="right">

[Paris] Sunday [31 May, 1891]

</div>

My dear Mama,

I received your note—and had lunch today with Papa and Aunt de Gualy,[1] very cordially, moreover, and with a good appetite whetted by the cold which has gripped Paris since yesterday.[2] I was glad to put on my winter overcoat again, and have relit my studio fire. What do you think of that?

Thursday, a brilliant opening[3] with too many people but some painter friends. In all a good day. Except for this, nothing new. Our furnishing is coming along little by little and sometimes a very little. And I kiss you on your cheeks, stuffed with asparagus, at least as I suppose. You should send us a nice bunch.

<div align="right">

Yours,
Henri

</div>

Prov.: Schimmel
Pub.: GSE116, GSF118

[1] i.e. the Baroness de Gualy de St Rome. Cf. Letter 68 Note 1.
[2] On Tuesday, 19 May, there was a violent drop in temperature with the thermometer in Paris registering 4° centigrade.
[3] At the Salon du Palais des Arts Libéraux, which opened on 28 May. Lautrec exhibited a portrait of Sescau (Dortu P.383) and *Au Moulin de la Galette* (P.388).

191 *To his Mother*

[Paris] Friday [June 1891]
My dear Mama,

Your letter made a most painful impression on all of us. But Bourges would like to have details as to the kind of paralysis, that is if it's localized about the mouth, the eye, or the face in general, this last case being much less dangerous.[1] I've known several painters who suffered attacks of this kind and who are living with it. Besides, all those who work *outdoors* are doomed to it. Be getting as much myself no doubt in the future.

Aunt Émilie, her husband, and her brother have arrived, I haven't seen them at all yet. I saw Gabriel again, who told me of having worked hard and having profited by his experience. His father is going to come. My jaundice is *all over* and you will be able to count on seeing me by the end of July or the beginning of August. It would be very kind of you if you could see your way to send me, about 14 July, that memorable date, a few sesterces[2] to distribute among various merchants. If you can, you will make me very happy, because M. Roques is keeping me waiting indefinitely for his payments and not having any contracts in writing I'm very much afraid I may be stuck. Trust in people's honesty!!!

I kiss your hands, so dear, and remember me to Louis and my aunt.

Yours,
Harry

Prov.: Schimmel
Pub.: GSE117, GSF119

[1] Probably an attack suffered by his mother (cf. Letter 193).
[2] Literally, a kind of Roman coin. Here used simply to mean money.

192 *To his Mother*

[Paris, June 1891]
[1]... I can't help sharing your mental and other vexations, since I myself am overwhelmed by the steady rain.—Can't do anything whatsoever outdoors, and am sick and tired of working indoors. I've spent my free time suing the manager of *Le Courrier français*,[2] who ... hadn't paid me. This fellow having had the nerve to put up for sale original drawings[3] that for the most part had not been paid for, I ... obtained restitution and payment of the arrears.... We're finally getting to the end of our moving-in process.[4] But the weather is

preventing us from enjoying our decorating pleasures. . . . I don't see much of Papa, who always looks swamped . . .

I hug you.

Yours,
Henri

Prov.: Unknown
Source: Charavay, Catalogue 742, October 1971, No. 34614

[1] Fragment of a letter.
[2] Jules Roques (cf. letter 125).
[3] Première vente des dessins originaux du Courrier français—Hôtel Drouot, 1 June 1891: No. 122 *Les Vendanges* [Dortu D.2925]; No. 123 *Sortie du pressoir* [Dortu D.2926]; No. 124 *Gui* [*sic*—Gin] *cocktail* [Dortu D.2965]. Deuxième vente, 20 June, 1891: No. 302, *Gin Cocktail* [Dortu D.2965]; No. 303 *Jeune fille lisant* [Dortu D.2927]; No. 304 *Jeune fille tenant une bouteille de vin* [Dortu D.2928]. The three drawings were withdrawn from the first sale and one was put up again in the second sale. Lautrec may have settled with Roques between 1 and 20 June.
[4] Cf. Letter 189.

193 *To his Mother*

[Paris] Monday [June 1891]

My dear Mama,

I'm happy to learn your improvement is becoming more marked and hope you'll carry out your plan to leave. What more can I say.

I am impatiently waiting for you and kiss you

Yours,
H

I've received the book by Jalby, so there's no need for you to bother about it.

Is it true the Abbé[1] is going to be a canon, or is it just a story?

Prov.: Schimmel
Pub.: GSE118, GSF120

[1] The Abbé Peyre.

194 *To his Mother*

[Paris, early July 1891]

My dear Mama,

I thank you in advance for sending the 500 francs earmarked for the tradesmen. We are not neglecting you either, for tomorrow morning with Gaston Bonnefoy I'm going to take Musotte's 4 puppies[1] to Maison Alfort[2] to have their ears cropped. She will be a regular little

dog. Your future bow-wow is dappled, that is, iron grey with black spots. Madame Bonnefoy had invited us over to make us acquainted with this little family. Here we have a Nice-like sun and Bourges has bought a horse. Those are the only events that stand out. My maid is improving a little. Perhaps she realized I was going to sack her. Madame de Montecuculli strikes me as being a little in the clouds. I'm writing to Papa in this vein.

I kiss you and would like you to send me some news about Emmanuel's trial as soon as there is something new. Guibert[3] feels he'll never be able to get rid of his faithful (?) companion[4] and laughs about it in a forced sort of way. He shouldn't have got involved in the first place.

<div align="right">Yours,
H.</div>

Prov.: Schimmel
Pub.: GSE119, GSF121

[1] i.e. the four puppies of his mother's dog.
[2] A town outside Paris, which has a veterinary school.
[3] Maurice Guibert (1856–1913), a salesman for Moët-et-Chandon champagne, a bon vivant, 'of the whole capital the man who knew the prostitutes best'. He appeared in six paintings by Lautrec, including *A la mie* (Dortu P.386); others (P.361, P.427, P.478, P.479, P.591). There are twenty-five drawings of him recorded by Dortu. Cf. Perruchot, p. 143.
[4] Maurice Guibert's mistress was Mariette Berthaud.

195 *To his Mother*

<div align="right">[Paris, early July 1891]</div>

My dear Mama,

I'm asking you for a little time to make up my mind. *Because* I've just had a very bad attack of *dental* neuralgia, which is obliging me to take a course of treatment at a famous dentist's, *Cruet*,[1] a friend of Bourges'. (I'll have to touch you for some money to pay this man, who is charming, but expensive.) If all goes well, as I hope, I will come, if not I'll let you know by the 15th at the latest and *you will take Louis*. Other side of the coin, I've sold the young girl which was on exhibition at the Volney.[2]

I haven't seen Papa because I hardly ever go out on account of the humidity. Goodbye and don't worry. All this is only a matter of patience. My only mistake was not taking care of it sooner.

<div align="right">Your boy,
Henri</div>

Prov.: Schimmel
Pub.: GSE127, GSF130

[1] His practice was at 2 rue de la Paix. Lautrec continued to consult him as late as 1899.

[2] i.e. the *Étude de jeune fille, Hélène Vary* (Dortu P.320, redated in Murray II). Cf. Letter 187 Note 2; also, on its sale, Letters 196 and 205.

196 *To his Mother*

[Paris, early July 1891]

My dear Mama,

I'm happy to report that my jaw repairs are going much better, although I still have quite a bit to be done. I will *certainly* be able to come and pick you up and Papa has *almost* offered to do it, or at least to come along with me. What you tell me about Respide is more serious. It's useless to rehash such a painful subject. We've done it enough.

My treatment consists of pulling out the doubtful ones and fixing up the passable ones. Thanks to injections of *cocaine*, there's no pain at all. As for being confined to the house, luckily there's none of that.

Bourges is treating a little girl with the croup and has just successfully performed a *tracheotomy* on her.

Papa is playing with the idea of spending some time at M. Pothain's. It's dark and rainy. I've sold my thing for 200 francs over and above the dealer's commission[1]—which means I'm not losing on it, but I'm not gaining either.

I kiss you.

Yours,
Harry

Prov.: Schimmel
Pub.: GSE129, GSF132
[1] Cf. Letter 195 Note 2.

197 *To his Mother*

[Paris, June–July 1891]

My dear Mama,

I received your letter in which you say that Mars[1] is kinder than I am, and this doesn't surprise me in the least. My answer to this is that Mars doesn't have problems with his model. Whereas mine nearly collapsed, and I'm very much afraid that posing in the sunshine had something to do with it. So that my daub was again delayed, which annoys me more than you could believe. So, instead of accusing me of silence, you'd do better to thank me for having kept my bad mood

to myself. I'd like very much to make you pose again outdoors[2] and I suspect you won't escape. This threat constitutes my justification submitted in court.

<div style="text-align: right">

A hug from

Henri

</div>

P.S. Papa isn't in your room and anyway what's that to you?[3]

Prov.: Unknown
Source: Goldschmidt

[1] The Roman god of war.
[2] Lautrec had painted a portrait of his mother in her garden in 1884–5 (Dortu P.190, redated in Murray II).
[3] There are four sketches by Lautrec at the end of the letter: a skull smoking a pipe, a lantern, a young woman seated on the ground, and a cat viewed from the rear (Dortu D.3142).

198 *To his Mother*

<div style="text-align: right">

[Paris, early July 1891]

</div>

My dear Mama,

I'm a little late but for an excuse I have my new models, who have been making me blow my top. This lot is decidedly a menace to the painter's peace of mind, who unfortunately can't get along without them. Papa looks as if he *really* is of a mind to go and pick you up. He has ideas of going hunting with M. Pothain. Will he succeed in making a move? In all events he's in a good mood. My dentist continues to work on me very expertly. Look out for the bill.

It's beginning to rain hard, which isn't exactly cheerful.

Nothing more to tell you, except that I kiss you.

<div style="text-align: right">

Your boy,

Henri

</div>

Prov.: Schimmel
Pub.: GSE130, GSF133

199 *To his Mother*

<div style="text-align: right">

[Paris, early July 1891]

</div>

My dear Mama,

Bourges, who left yesterday for Respide, will tell you I'm fit as a fiddle.

A couple of weeks from now, or sooner, I'll be breathing the fresh

air of Malromé. I'm not counting on staying more than *one month* in all in the country. We'll go to the Narbonne area, to Bosc, etc. ... rapido, presto, subito.

Try to coax Aunt Cécile to let us take Louis with us on this Cook's tour. I kiss you.

<div align="right">Your Harry</div>

Prov.: Schimmel
Pub.: GSE120, GSF122

200 *To his Mother*

<div align="right">[Paris] Wednesday [July 1891]</div>

My dear Mama,

You must have received your long-eared daughter. I had to pay the postage. That makes 34.50 francs you owe me. She has a very gay and lively air.[1] I hope she'll get along well with the other little dogs but at all events she's of a breed that know how to take care of themselves. All of us are counting on going to Nîmes and I shall even bring my friend Guibert along, who will follow like the Doctor in *L'Histoire de M. Cryptogame.*[2]

I'll take advantage of the occasion to see Marseilles and will go by way of Ricardelle. I hope to be announcing my arrival very shortly, for I'm thirsting for the salt water. On Sunday I went to see Grenier, who has broken his leg falling out of a carriage. He's getting on as well as possible and was very nice. Claudon is not so hot, crippled with rheumatism.

Send me word about the young lady and I kiss you.

<div align="right">Yours,
H.</div>

P.S. I'll probably need to dip into the big sum to pay some bills. We'll talk about this again later.

Prov.: Schimmel
Pub.: GSE121, GSF123

[1] Lautrec writes 'esperpil', a Gascon word for 'bright-eyed'.
[2] A book by the Swiss author Rodolphe Töpffer (1799–1846), illustrated with humorous drawings: *Mr. Cryptogame* (J. J. Dubocher, Paris, 1846). The illustration referred to appears on p. 36 with the title 'Voyant cela, le docteur fuit et poursuit tout ensemble, sans y comprendre rien.'

201 *To his Mother*

Arcachon, 7 August [1891]

My dear Mama,

Everything's fine. I'm out boating all the time and have received a long letter from Papa, who seems to want me to take charge of Ricardelle directly, in case Jalabert[1] should happen to die. It's a big subject and needs to be discussed by us together. I'll have you look at the letter and we'll see what's to be done. I'll come to Malromé on Tuesday or Wednesday.

I kiss you.

Your
H.

Prov.: Schimmel
Pub.: GSE122, GSF124

[1] Cf. Letter 77 Note 2.

202 *To his Mother*

[Arcachon, August 1891]

My dear Mama,

I think it's useless for me to go to Narbonne. Therefore, I'll wait for you at Respide, or I'll come for you on MONDAY if you really think I ought. Everything here's in a state of confusion. No doubt it's just the moment Papa will pick to come, though I'm not really counting on it. So, I'll be at Arcachon until Saturday.

Write to me.

Your boy,
Henri

Prov.: Schimmel
Pub.: GSE123, GSF125

203 *To Mme L. Tapié de Céleyran*

[Malromé, August 1891]

My dear Grandma,

In the midst of the bizarre circumstances that are buffeting us (and you even more than us), I didn't want to let your name day go by

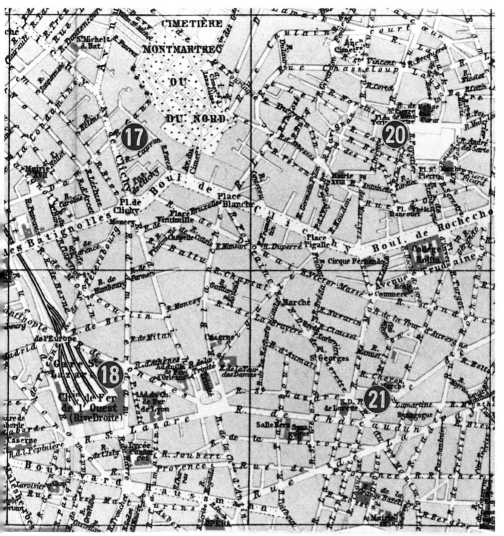

. *Montmartre and environs,*
00

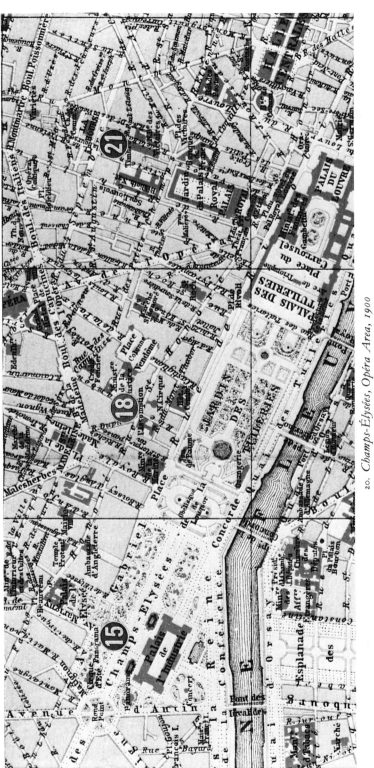

20. *Champs-Élysées, Opéra Area, 1900*

Section 15

Paul Leclercq, rue Marbœuf
Alcazar d'Été, Champs-Élysées
Palais de Glace, avenue d'Antin
Jardin de Paris, Champs-Élysées
Les Ambassadeurs, avenue Gabriel
L'Horloge, Champs-Élysées

Section 18

Opéra, place de l'Opéra
Bar Picton, 4 rue Scribe
Hôtel Pérey, cité du Retiro
Cercle Volney, 7 rue Volney
Café Weber, 25 rue Royale
Irish and American bar, 23 rue Royale
Thadée Natanson, rue St Florentin
Gabriel Tapié de Céleyran, rue St Florentin
Nouveau Cirque, 251 rue St Honoré

Section 21

Galerie Bernheim-Jeune, 8 rue Laffitte
Revue Blanche, 1 rue Laffitte
Alcazar d'Hiver, 10 rue du Fbg. Poissonnière
Galerie Boussod-Valadon, 19 bd Montmartre
Théâtre des Variétés, 7 bd Montmartre
Écho de Paris, 16 rue du Croissant
Le Rire, 10 rue St Joseph

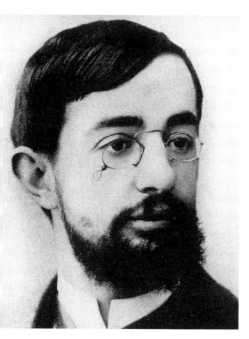

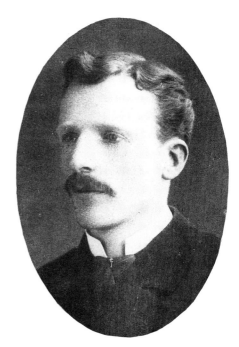

21. Lautrec, photographed about 1892

22. Théo van Gogh

23. Maurice Joyant

24. Michel Manzi portrayed by Lautrec about 1901

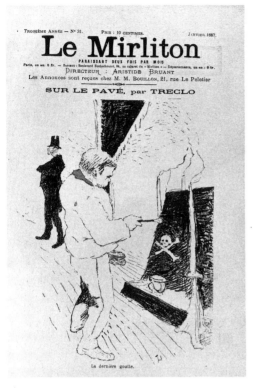

La dernière goutte.

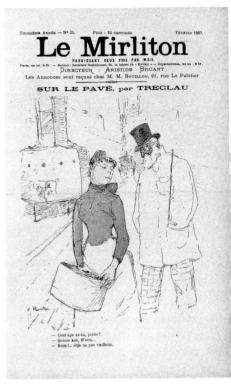

— Quel âge as-tu, petite ?
— Quinze ans, M'sieu...
— Hum !... déjà un peu vieillotte.

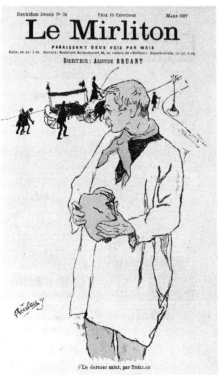

Le dernier salut, par TRÉCLAU

25–7. Lautrec's illustrations for the January, February, and March 1887 issues of Aristide Bruant's *Le Mirliton*

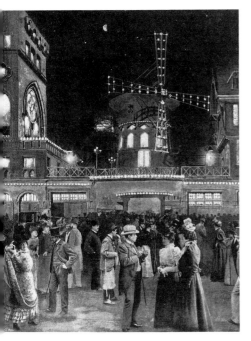

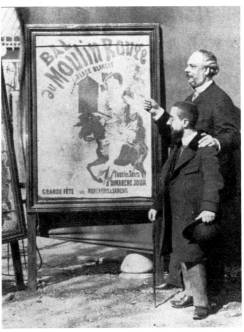

28. The Moulin Rouge entrance at 90 boulevard de Clichy, c.1895

29. Lautrec viewing Chéret's poster for the Moulin Rouge with one of the proprietors c.1892

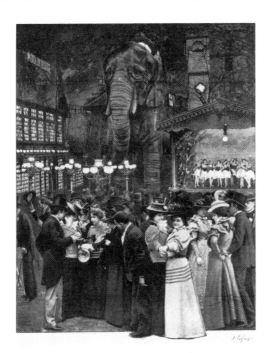

30. The Moulin Rouge garden c.1895

31. Lautrec painting *La Danse au Moulin Rouge* at his studio on rue Caulaincourt in 1890

BOUSSOD, VALADON & Cⁱᵉ
SUCCESSEURS

19 Boulevard Montmartre, Paris.
Adr·Télégr·Boussoval·Paris.

vendredi 27 Janvi

Mon cher Marx

 Samedi
Demain Nos tableaux seront
pendus et vous pourez venir
les voir . L'ouverture étant
lundi :
 Merci et mes voeux
Le demandons . . .
 Yours Lautrec

32. Letter from Lautrec to Roger Marx (Letter 218), with the letterhead of the Galerie Boussod-Valadon

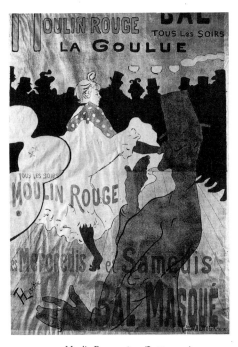

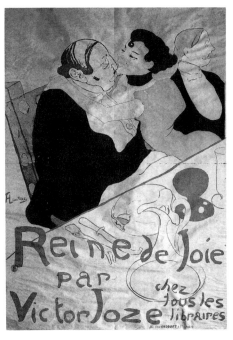

33. *Moulin Rouge*, 1891 (Letter 211)

34. *Reine de Joie*, 1892 (Letter 247)

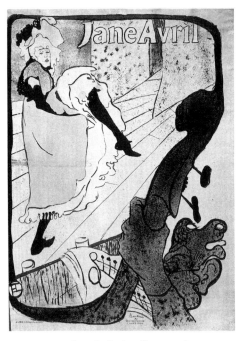

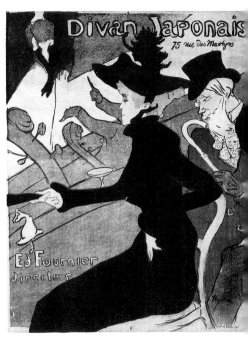

35. *Jane Avril*, 1893 (Letter 297)

36. *Divan Japonais*, 1893 (Letter 263)

without giving you a slightly choleriform bouquet. This time, judging by Mama's summary of your letters, you've been very sporadically head-to-head with the microbe. Everything ended well and now you're safe among the little mountains of Le Bosc.

Here we're living like bivalves and Mama is playing the dowager from the top of her turret.

The Pascals are at Respide and come by often. It's all very pleasant, but it tends to get in the way of work. So I'll be escaping soon with a detour via Le Bosc to hug you all. No news from my beloved father. Maybe he's with you?

I don't know whether you heard about the incoherent behaviour of my publisher,[1] who kept me waiting for a month. We had a row. All the better for the one whose turn it is!!!

I hug you gently because my chin is like an old shoe brush. Please convey all my love to everybody who's entitled to it, beginning with Grandma Gabrielle.

<div style="text-align:right">

Your grandson and godson,
HTLautrec

</div>

Prov.: Unknown
Source: Rendall

[1] Cf. Letter 192.

204 *To his Mother*

<div style="text-align:right">

[Paris, September 1891]

</div>

My dear Mama,

I had a magnificent crossing,[1] but when I arrived in Paris I found my maid in bed with a typhoid fever that will deprive me of her services, I'm afraid, for nearly a month. I shall probably have her taken to the hospital, to a room that will cost me pretty nearly 4 francs a day, and she will have everything there that she needs. It will also keep neighbours out of my apartment—devoted, true enough—but whose presence I can nicely do without.

I wasn't expecting this piece of bad luck. The poor girl is a sad sight to behold. Anyway, I'm going to try to manage the best I can. I hope my next letter will be less fussy, in all events, I kiss you.

<div style="text-align:right">

Yours,
H.

</div>

Prov.: Schimmel
Pub.: GSE124, GSF126

[1] In returning to Paris from the South, Lautrec usually went by boat from Bordeaux to Le Havre and then proceeded to Paris.

205 *To his Mother*

[Paris, September 1891]

My dear Mama,

Your letter arrived just as I was about to write to you. I've seen Uncle A., Gabriel, and Papa, who's in a charming mood. He has opened his cash box without any trouble. As for my uncle and Gabriel, they've gone back to Rivaude until the 5th, at which time the courses are to begin. Gabriel[1] will live in a hotel, in the Latin Quarter. Which one hasn't yet been decided. He looks happy and as for Papa he's always getting ready to go somewhere. Bourges has had jaundice and is horribly thin, practically unrecognizable.

I've seen my dealers. I am to get 200 francs for one study,[2] which means it was sold for 300 francs, a little boost in the scale. Outside of this, business is slack. Grenier, who came back to Paris yesterday, is more distraught than ever and Anquetin almost had another rheumatic attack. My piles are better thanks to the *populeum* ointment. Studio is being swept and cleaned, and I haven't really made up my mind yet what I'm going to do. Degas[3] has encouraged me by saying my work this summer wasn't too bad. I'd like to believe it.

I end with a kiss for Tata and you, and by asking to be remembered to all at Respide, where I'd like you to tell Paul that I've been introduced to M. Jouard.[4]

Kiss you
Yours Harry

Prov.: Schimmel
Pub.: GSE125, GSF127

[1] Gabriel began to work under Dr Péan at the Hôpital St Louis in Paris in 1891. He had been living in Paris at various times before this.

[2] *Étude de jeune fille, Hélène Vary* (Dortu P.320), mentioned in Letters 195 and 196.

[3] Lautrec had been introduced to the French artist Edgar Degas (1834–1917) by their mutual friend Désiré Dihau in 1889. Lautrec admired the older artist immensely.

[4] Probably the Jouard who is listed in the Bottin as an office manager of the Nationale insurance company, since Louis Pascal had worked for such a company (cf. Letter 186).

206 *To his Mother*

[Paris, October 1891]

My dear Mama,

I had sent you an acknowledgement of the receipt of the 150 francs. Did my letter go astray perhaps? I'm very glad your life-saving operation was carried out without a hitch and I hope you're not going to delay coming here, leaving Tata in good company, to see your son for

a little, whom you leave in the lurch as casually as you please, thanks, it's true, to numerous unexpected impediments; but it seems to me the hour for making amends has come and I hope you're not going to wait for New Year to transport yourself here bag and baggage. Nothing new apart from that. The weather is gloomy and everything's just carrying on along as usual. Papa talks about going away, without conviction. The exhibitions are getting under way.

And I close with a kiss for you,

<div align="right">Yours,
HTL</div>

Come soon.

Prov.: Schimmel
Pub.: GSE128, GSF131

207 *To Octave Maus*

<div align="right">Paris, 9 November [1891]</div>

My dear Maus,
Count on me for the Les XX[1] exhibition. Regards to our friends.

<div align="right">Cordially yours,
HTLautrec</div>

Prov.: Brussels

[1] IX^e Exposition des XX, February 1892. Lautrec exhibited two proofs of *La Goulue* (*Moulin Rouge*) (Wittrock P.1), the second state and the final state, and seven paintings: *Jeune fille* (not identifiable); *En meublé* (Dortu P.365); *En meublé* (Dortu P.364); *Femme rousse assise* (not identifiable); *Nocturne* (not identifiable); *Portrait d'homme* (not identifiable); *Femme brune* (not identifiable).

208 *To his Mother*

<div align="right">[Paris, early November 1891]</div>

My dear Mama,
I didn't want to write to you before Gabriel got back bringing E.[1] with him; I hope that thanks to a very possible set of circumstances everything is going to take on its proper proportion and turn into an escapade, whereby neither country nor family need be ruined. I am still at my daily routine, broken by words with my maid, who's hard pressed to take care of my studio and my apartment.

I spent All Saints Day with Bourges and his wife in Normandy at

M. Anquetin's. My friend Anquetin is doing the sculptures for his village church, just like the people of the Middle Ages.[2]

Guibert is going to send you the splendid photographs of Malromé,[3] big enough for Philemon and Baucis[4] to be appreciated by your Mama. Besides this, nothing new to report. Tell my uncle and aunt how much I've thought about them in all that, and try to instil a little optimism in them.

I kiss you.

<div align="right">Your very own son,
HTL</div>

Prov.: Schimmel
Pub.: GSE185, GSF203

[1] Probably Emmanuel Tapié de Céleyran. Cf. Letter 194, mentioning his trial.

[2] At Etrépagny, in the Department of Eure. The church, which dated from the fifteenth century, was largely destroyed by fire in 1929.

[3] The photographs of Lautrec and the others, taken by Guibert at Malromé over a period of several years, are in the Cabinet des Estampes, Bibliothèque Nationale. Cf. Letter 200.

[4] In Greek mythology, an old couple rewarded by the gods for their kindness and hospitality; the story is told in Ovid's *Metamorphoses*. In 1891 the Parisian painter Alexandre Lavalley (1862–1927) won the Prix de Rome—Grand Prix de Peinture with his painting *Philémon et Baucis*. The marionnette opera by Haydn was also entitled *Philemon und Baucis*.

208A *To an Unidentified Correspondent*

<div align="right">[Paris, 9 December, 1891]</div>

Miss,

Please tell your friend to come to my studio tomorrow, Thursday, at 1 o'clock, or to drop me a line.

<div align="right">Regards,
Lautrec
27 rue Caulaincourt</div>

Prov.: Unknown
Source: Saffroy, Catalogue 15, May–June 1989

209 *To his Mother*

<div align="right">Monday [November–December 1891]</div>

My dear Mama,

Your sad letter reached me in the fog. Things are going along as usual. Papa, Gabriel, and Bourges, in the company of the Prince de Bourbon, went to Rivaulde[1] and had a good time despite the cold. As

you can imagine, I certainly did not go with them. I am still waiting for the poster[2] to come out. Printing delays are holding it up. But it's fun; I had the feeling of being in control of an entire shop, and it was a new feeling for me.

I saw M. and Mlle de Coppet. The latter personally photographed Papa as a falconer.

Listen to this. Laura has got rid (her word) of her cousin. Louis is still the same . . . somewhat undecided about his plans(?) Gabriel seems to be interested in what he's doing. Now all we need is you to preside over the family dinner of veal accompanied by wild lettuce. My cormorants are being acclimatized.

And a hug.

<div style="text-align: right">Yours,
H.</div>

Don't forget the preserves.

Prov.: Schimmel

[1] Cf. Letter 210.
[2] *Moulin Rouge* (Wittrock P.1).

210 *To his Mother*

<div style="text-align: right">(Paris, December 1891)</div>

My dear Mama,

Why don't you come here? There is influenza, but it is not dangerous yet.[1] So come as soon as possible, ready to go to Albi later.

I've seen Papa, who has been hunting!!! with the Prince de Bourbon.[2] Everything is fine here. Everyone's working, myself included. Thank you for the ham, which arrived in good shape. Apart from that, nothing new. I've just sent Kiki a horrible Infant Jesus in wax, bought according to her directions. I hope she'll be satisfied with it. I kiss you and hope to see you put in an appearance one of these days.

<div style="text-align: right">Yours,
Henri</div>

Prov.: Schimmel
Pub.: GSE131, GSF134

[1] An influenza epidemic began in Paris in early December 1891.
[2] Louis Philippe Albert d'Orléans (1838–94), Comte de Paris, a member of the royal family.

211 *To his Mother*

[Paris, December 1891]

My dear Mama,

I begin by reassuring you about Papa's condition: he had a touch of influenza[1] and treated it at the Turkish bath. The steam room suffocated him and after a brief fainting spell he was quickly up on his feet thanks to a few glasses of kümmel. He's still watching himself but looks well enough.

What you tell me concerning Louis doesn't surprise me at all. You have long known my view on that subject. I feel there's nothing better you could do than help him. I thank you for the prospective truffles. If you send me a fowl stuffed with truffles, write on the address the weight: Fowl so much

Truffles so much

because the excise charges are exorbitant when this precaution isn't taken.

Another thing. Towards the end of next week and towards the end of the one after have a fowl—capon or chicken—sent to me. Bourges's brother, who usually supplies the poultry, is off on a two-week trip.

Has the goose-liver season started? If it has, remember to have a dozen tins sent to me. I am re-reading my letter and find it has a gastronomic character. My poster[2] is pasted today on the walls of Paris and I'm going to do another one.[3]

Affectionate regards to everyone around you whom it may concern. I kiss you.

Yours,
Henri

Prov.: Schimmel
Pub.: GSE126, GSF129

[1] Cf. Letter 210 Note 1 and Letter 212.
[2] i.e. *La Goulue au Moulin Rouge* (Wittrock P.1), Lautrec's first poster, and an immediate source of renown for him.
[3] Perhaps *Le Pendu* (Wittrock P.2), published in April 1892.

212 *To his Mother*

[Paris] 26 December [18]91

My dear Mama,

I have *had* the influenza. Thanks to my vigorous medication (Bourges had me running from both ends). I have my sight, appetite, and good spirits back after being sick for only 24 hours. It didn't amount to much and by being a little careful I got out of it easily, whereas Gabriel has had it for quite a few days. Not serious, to be sure, but painful. We've just opened a shop, a sort of permanent exhibition, in the rue Le Peletier.[1] The newspapers have been very kind to your offspring. I'm sending you a clipping written in honey ground in incense. My poster[2] has been a success on the walls despite some mistakes by the printer[3] which spoiled my product a little.

The sun is beautiful today. Bourges is skating like mad. Thanks for your capon which arrived safe and sound. I'm happy to be able to celebrate it with fitting respect. When do you think you'll come?! The sheltered life at Albi no doubt has its charms, but just see, it will soon be 3 months since we parted and I call for a little maternal sustenance.

I wish you a Merry Christmas and New Year.[4] I promise I'll write to the grandmas tomorrow or later.

I kiss you.

Yours,
Henri

Prov.: Schimmel
Pub.: GSE132, GSF135

[1] i.e. Le Barc de Boutteville's gallery, where many of the younger avant-garde artists exhibited as 'Les Peintres impressionnistes et symbolistes'. Cf. J. Darnelle's interviews with Lautrec and his colleagues in *L'Écho de Paris*, 28 December, 1891, quoted in Rewald, pp. 497–8. Lautrec exhibited seven paintings, including *Femme fumant une cigarette* (Dortu P.362); the other six are not easily identified.

[2] Cf. Letter 211 Note 2.

[3] 'Charles Lévy (Affiches Américaines) 10 rue Martel, Paris' is the printer's name that appears on the poster itself.

[4] 'Merry Christmas' and 'New Year' are written in English.

213 *To Octave Maus*

[Paris] 27 December [1891]

My dear Maus,

Didn't you receive my letter confirming my intention to show at Les XX.[1] Having received no instructions for the catalogue and the packing agent, I'm concerned and should appreciate your putting my mind at ease as soon as possible.

Cordially yours,
HTLautrec

Will I be able to show my poster[2] that has just been published? I hope the answer is yes, and that Les XX won't be afraid of it.

HTL

Prov.: Brussels
[1] Cf. Letter 207.
[2] Cf. Letter 211 Note 2.

4

ARTIST
The Middle Years

———————◦❀◦———————

CHRONOLOGY
1892–1897

1892	7 January	Paris	Writes to Maus with list of submissions for Les XX.
	January	Paris	Exhibits at Cercle Artistique et Littéraire, rue Volney, from 25 January
	25 January	Paris	Writes to mother that he intends to visit Brussels from 3 to 7 or 8 February
		Paris	Moulin Rouge reopens under Oller.
	6 February	Brussels	Writes to mother from Grand Hôtel: 'Exhibition opens today'.
	February	Brussels	Exhibits at Les XX (ninth exhibition) during February
	19 February	Paris	Writes to van Rysselberghe about Picard and Verhaeren.
	March–April	Paris	Exhibits at Eighth Salon des Indépendants 19 March–27 April.
	12 April	Paris	Writes to Roger Marx.
	May	Paris	Writes to Max Elskamp agreeing to exhibit in Antwerp
	May–June	Antwerp	Exhibits at first exhibition of Association pour l'Art.
	26 May	Paris	Writes to mother regarding delay in poster; has delayed departure for London.
	31 May–10 June	London	Writes to mother from Charing Cross Hotel.
	June	Paris	Writes to mother many times during month concerning sale of Respide and relations with Jalabert.

	July	Paris	Writes to mother: 'My excursion … pretty well set for 10 August.'
	August	Taussat	Leaves Paris on 10th for Bordeaux, Soulac, arriving in Taussat on 17th
	13 September	Taussat	Writes to mother that he will visit Malromé with Fabre and Viaud about 25 September.
	October	Paris	Writes to mother, Verhaeren, and Roger Marx about his first lithograph *Au Moulin Rouge, la Goulue et sa sœur.*
	November–December	Paris	Writes to mother about Pascals.
1893	14 January	Paris	Writes to Roger Marx about René Wiener.
	19 January	Paris	Writes to Marty and Roger Marx that poster *Divan japonais* is appearing the following day.
	January	Paris	Writes to Maus listing items to be exhibited at Les XX in February.
	January	Paris	Exhibits with Charles Maurin at Boussod-Valadon (Goupil), 30 January–11 February
	30 January	Paris	Writes to Marty requesting Yvette Guilbert's address.
	February	Brussels	Exhibits with Les XX (tenth and last annual exhibition) and shows posters at Ixelles.
	9 February	Paris	Writes to Marty that a cabinet minister visited Maurin–Lautrec exhibition.
	22 February	Paris	Writes to Roger Marx about *L'Estampe Originale.*
	26 February	Paris	Writes to Geffroy about meeting at Joyant.
	March	Paris	Writes to Marty asking him to announce Friday 17 March opening of ninth Salon des Indépendants.
	11 March	Paris	Writes to René Wiener: 'Address your letters to me at 21 rue Fontaine Saint-Georges, my home.'

March	Paris	Exhibits at ninth Salon des Indépendants, 18 March–27 April.
April	St Jean-Les-Deux Jumeaux	Stays with Aristide Bruant.
May	Paris	Exhibits at fifth Peintres-Graveurs Show.
	Paris	Writes to R. Wiener regarding book-binding design.
May	Antwerp	Exhibits at second exhibition of Association pour l'Art.
2, 4 May	Paris	Invites Marty and Marx to Zandomeneghi exhibition 3–20 May.
2 June	Paris	Writes to Marty and Marx: 'My latest work will go on display tomorrow – Jane Avril au Jardin de Paris.'
25 June	Paris	Writes to Firmin Javal about Jane Avril poster.
July	Paris	First works for *Figaro Illustré* published.
August–September		Vacation trip with Bourges, Fabre, Guibert, and Viaud from La Teste to Cazeaux and Mimizan.
September	Taussat, San Sebastián	Visits Villa Bagatelle. Writes to Geffroy, Wiener, Maurice Denis, Kleinmann, Marty.
October	Paris	Writes to Geffroy regarding second work for *Figaro Illustré*.
19 October	Paris	Writes to Marx regarding Maurin's brand-new creation.
23 October	Paris	Writes to Geffroy.
9 November	Brussels	Les XX decide to ask their members whether the group should disband. Octave Maus leads group called Libre Esthétique which replaces Les XX.
28–9 November	Paris	Writes to Geffroy.
1 December	Paris	Writes to Geffroy about meeting Suzanne Valadon.
December	Paris	Writes to Maus regarding Degas and *L'Escarmouche*.
9 December	Paris	*Café-Concert* (Montorgueil) published. Legally registered 13 December.

	10 December	Paris	Writes to Marty about Yvette Guilbert and Geffroy.
	21 December	Paris	Writes to mother and states he has two posters to deliver.
	29 December	Paris	Writes to grandmother discussing Bourges's forthcoming marriage and his new apartment.
1894	8 January	Paris	Writes to Marx.
	January	Paris	Writes to Maus about Libre Esthétique exhibition in February.
	Late January	Paris	Moves to apartment at 27 rue Caulaincourt (7 rue Tourlaque).
	9 February	Paris	Writes to Maus about opening of Libre Esthétique. Writes to Kleinmann about Jane Avril.
	12–15 February	Holland	Writes to mother from Amsterdam.
	16–20 February	Belgium	Visits Brussels. Stays at Grand Hôtel.
	17 February	Brussels	Exhibits at Libre Esthétique first exhibition. Attends opening.
	21 February	Paris	Writes to mother about trip to Brussels.
	20 March	Paris	Writes to Marty about Geffroy.
	26 March	Albi	Visits grandmothers for Easter. Writes to mother.
	4 April–27 May	Paris	Exhibits at tenth Salon des Indépendants.
	14 April	Paris	Writes to Durand-Ruel. Apologizes for being asleep.
	May	Paris	Exhibits at the *Dépêche de Toulouse*.
	5–12 May	Paris	Exhibits at Durand-Ruel.
	23 May	Paris	Writes to Geffroy about Yvette Guilbert luncheon.
	28 May	London	Writes to René Wiener from Morell's Private Hotel in London.
	To mid-June	London	Visits.
	18 June	Paris	Writes to Jules Cheret, Roger Marx, and Wiener.
	21 June	Paris	Writes to Geffroy of the expected proofs of *Yvette*.

August	Paris	French series of *Yvette Guilbert* published by André Marty at L'Estampe Originale. Arsène Alexandre asks for drawings for *Le Rire*.
August	Arcashon	Visits. Writes to Marty from Villa Richelieu about Jugement de Pâris menu.
August	Taussat	Visits.
August	Malromé	Visits. Writes to Marty about *Yvette* reviews.
September	San Sebastián	Visits, sees Darío de Regoyos and bullfights.
September	Burgos	Visits cathedral.
September	Madrid	Writes to mother from Grand Hôtel de la Paix.
September	Toledo	Visits.
October	Paris	Writes to mother about visiting London at end of month, and to van Rysselberghe: 'Leaving for London four days from now.'
October	London	Exhibits at Royal Aquarium poster show organized by Bella.
October	London	Visits preview of exhibition. William Rothenstein does not show up for dinner appointment.
Autumn	Paris	Writes to Bruant regarding Eldorado poster.
8 November	Paris	Tristan Bernard tells Jules Renard that Lautrec wants to see him.
November	Paris	Writes to Rothenstein about Marty, Bella.
26 November	Paris	Visits Jules Renard.
9 December	Paris	Tristan Bernard and Jules Renard visit Lautrec at his studio.
December	Paris	Writes to mother regarding stage designs for *Le Chariot de terre cuite*. *Yvette Guilbert* drawing in *Le Rire*.
1895 January	Paris	Writes to Bella about A. Hartrick and S. Bing.

5 January	Paris	*La Revue Blanche* publishes *Nib* by Tristan Bernard with Lautrec illustrations.
22 January	Paris	First performance of *Le Chariot de terre cuite*.
February	Paris	Writes to Maus regarding Libre Esthétique submissions.
16 February	Paris	Invitation for M. and Mme Alexandre Natanson's party.
23 February– 1 April	Brussels	Exhibits at Libre Esthétique II.
5 March	Paris	Drawing of Stéphane Mallarmé.
16 March	Paris	Lautrec's La Bouillabaisse menu, Sescau dinner.
25 March	Paris	Writes to Marty about Loïe Fuller.
9 April–26 May	Paris	Exhibits at eleventh Salon des Indépendants.
April	Paris	Writes to Wiener about design for binding.
25 April	Paris	Exhibits at Salon de la Société Nationale des Beaux-Arts— Tiffany window after Lautrec's *Papa Chrysanthème*.
31 May	Paris	Writes to Dujardin about Oscar Wilde portrait.
6 June	Paris	Writes to Édouard Dujardin.
2 July	Paris	Writes to Tristan Bernard.
12 July	Paris	Writes to Léon Deschamps: 'My new address 30 rue Fontaine.'
August	Malromé	Visits mother.
1 September– 28 October	Ghent	Exhibits posters at XXXVIᵉ Exposition Triennale.
8 September	Taussat	Writes to Henri Albert and Arsène Alexandre about Pan.
Late September	Malromé	Visits.
28 September	Paris	Exhibits at Centenaire de la Lithographie.
October	Paris	Writes to Deschamps about Chap Book poster.
October	Paris	Exhibits at XIV Salon des Cents, rue Bonaparte.
16 November	Paris	Gives Joyant receipt for sale of painting of Clown.
November	Le Bosc	Visits and tours area with cousins Gabriel and Odon and others.

November– December	Paris	Writes to mother regarding *Maîtres de l'Affiche*.
1896 January	Paris	Exhibits at Manzi-Joyant, 9 rue Forest, near 128 bd de Clichy. Closed room for paintings not for public viewing. Promises to be present with Joyant in January.
20 January	Paris	Writes to Édouard Dujardin.
8 February	Paris	Writes to Deschamps about Sescau.
30 March	Brussels	Exhibits at Libre Esthétique III.
25 February	Paris	Writes to and portrays Maurice Guibert in short note.
4 March	Paris	Writes to Geffroy about Thadée Natanson dinner on 10 March.
18 March	Paris	Authorizes Arnould to reproduce posters.
March	London	Exhibits at Second Exhibition of Posters Royal Aquarium.
March–April	Paris	Makes drawings at trials of Arton and Lebaudy.
22–3 March	Paris	Writes to Deschamps.
13 April	Paris	Writes to Geffroy.
22 April	Paris	Exhibits at XX Salon des Cents—*Elles* series.
23 April	Paris	Writes to Deschamps regarding *Elles* exhibition.
May	Paris	Writes to mother about new apartment (5 avenue Frochot).
June	London	Visits with bicycle racers. Plans Simpson-Lever chain poster.
6 July	Paris	Writes to W. H. B. Sands about future book *Treize Lithographies*.
August– September	Taussat, St- Eulalie	Vacations with Guibert.
19 September	Taussat	Writes to mother about visit.
September	Malromé	Visits.
October	Paris	
7–17 November	Reims	Exhibits at Exposition d'Affiches at Cirque de Reims.

2 December	Paris	Writes to Deman about *Rire* drawings.
2 December	Paris	Sylvain Menu dinner.
December	Paris	Takes new apartment at 5 avenue Frochot but continues to use 30 rue Fontaine also until November 1897.
22 December	Paris	Le Suisse Menu dinner.
23 December	Paris	Le Crocodile Menu dinner.

1897	4 January	Paris	Writes to Deman: 'Send me wire at 5 avenue Frochot.'
	2 February	Paris	Writes to Maus regarding Libre Esthétique.
	25 February– 1 April	Brussels	Exhibits at Libre Esthétique IV.
	24–8 February	Brussels	Visits opening of Libre Esthétique.
	3 April–31 May	Paris	Exhibits at thirteenth Salon des Indépendants.
	1 May	Paris	Writes to Georges Clemenceau about *Au Pied du Sinaï*.
	15 May	Paris	Invitation for a Cup of Milk at 5 avenue Frochot.
	2 June	Paris	Writes to Sands regarding *Treize Lithographies*.
	8 June	London	Writes to mother from Charing Cross Hotel.
	9 June	London	Writes to Wm Rothenstein about Charles Conder.
	20 June–5 July	Holland	Hires Dutch boat. Walcheren trip.
	July	Malromé	
	31 July	Paris	Au Bull de Palmyre Menu dinner.
	October	St Petersburg, Russia	Exhibits at International Poster Exposition.
	November	Paris	Moves to 5 avenue Frochot.
	17 November	Paris	Writes to Berthier at newspaper *L'Aurore*.
	23 December	Paris	Programme for Gemier benefit.
	25 December	Paris	Writes to Sands.

214 *To Octave Maus*

Paris, 7 January [18]92

My dear Maus,

Here is the list of my submissions.[1]

1. La Goulue (Moulin Rouge), poster, 2nd state
2. La Goulue (Moulin Rouge), poster, final state
3. Young Girl
4. Furnished room
5. Furnished room
6. Seated red-haired woman
7. Nocturne
8. Male portrait
9. Dark-haired woman

I am going to send you all the numbers, except the posters and item number 8, which is not finished. I shall bring them with me. My dear friend, please write to tell me the date of the opening, so that I can arrange my schedule accordingly.

My paintings are around 50 or 60 centimetres wide. As for my posters, they will be in the air where they will be all the better.

Cordially yours,
HTLautrec

Prov.: Brussels

[1] Cf. Letter 207 Note 1.

215 *To his Mother*

[Paris] 25 January [1892]

My dear Mama,

I've just come back from the opening of the Cercle exhibition,[1] where my daubs, although hung about as badly as possible, have had favourable mention in the press.

Besides this they're being very nice to me in the newspapers since my poster.[2] The *Paris*, a very republican paper (don't breathe a word to the family), has even seen fit to devote two columns to me,[3] in which they tell all about me down to the last detail. I am leaving for Brussels on 3 February and will be back on the 7th or 8th *at the latest*. So, pack your trunks accordingly. You'll still have time to get some digestive upsets. Papa is back from Chambord with a little recurrence of the influenza,[4] and very much affected by the death of his friend.

Adieu, my dear Mama. I hope this letter will be, if not the last, the

next to last, and that it won't be long before we see each other in the flesh.

Give my love to all whom it may concern.

Your son,
Henri

Prov.: Schimmel
Pub.: GSE133, GSF136

[1] i.e. the Cercle Artistique et Littéraire, rue Volney, where Lautrec exhibited one version of the painting *Celle qui se peigne* and another work. This was his last participation in the exhibitions there. In January 1893, the jury rejected his entries (cf. Dortu P.389–91). There are the three versions of *Celle qui se peigne* of which P.390 and P.391 were exhibited at the Salon des Indépendants in March 1892, suggesting that P.389 was shown at Volney. Cf. Letter 264.

[2] Cf. Letter 211 Note 2.

[3] Cf. Arsène Alexandre's article in *Le Paris*, 8 January 1892, the most perceptive review, thus far, devoted to Lautrec.

[4] Cf. Letter 210 Note 1.

216 *To his Mother*

Grand Hôtel, Brussels, Saturday [6 February 1892]

My dear Mama,

The exhibition opens today.[1] I arrived on Wednesday evening, and by Monday evening I'll be back in Paris. So you can pack your bags and leave. I don't need to tell you, do I, that the Belgians are very pleasant. I travelled with Dr de Lostalot, a doctor in Saliès[2] and a pal of Bourges, who came to open several Belgian centres. He's one of my long-time friends, so everything is for the best. I also don't need to add that my show is satisfactory, given my immense talent (see the fable of the owl, 'my little ones are adorable', etc.).

See you soon. Long-distance kisses from your good

H.

Regards to everyone there.

Prov.: Unknown
Pub.: DGA Illustration 12

[1] The IXᵉ Exposition des XX opened on 7 February 1892.
[2] A town in the Department of Tarn, near Albi.

217 *To Théo van Rysselberghe*

[Paris, 19 February 1892]

[1]Dear Maître,

Can you send me the periodicals (*Art Moderne*) and (*Mouvement Littéraire*) where they refer to the Vingtistes?[2] I would be very glad if

you would and happy to see what Picard[3] and Verhaeren[4] say about us. I hope this chore won't be too much of a bother.

Thank you, and please remember me to Mme van Rysselberghe.

Sincerely yours,

HTLautrec

Prov.: Schimmel
Pub.: GSE134, GSF137

[1] Addressed to van Rysselberghe at 422 avenue Louise, Brussels.

[2] *L'Art Moderne*, 13 March 1892, 'Clôture du Salon des XX'; *Le Mouvement Littéraire*, 23 February and 8 March 1892, 'Les XX'.

[3] Edmond Picard (1836–1924), Belgian lawyer, art critic, poet, playwright, and editor of the magazine *L'Art Moderne*. He had received Lautrec cordially during the latter's visit to Brussels in 1890.

[4] Émile Verhaeren (1855–1916), national poet of Belgium, dramatist, and critic whose work has often been compared to that of Walt Whitman. He had praised the works which Lautrec exhibited with Les XX in 1891.

218 *To Roger Marx*

[Paris, 12 April 1892]

[1]Dear Sir,[2]

Ibels[3] tells me that you want to photograph one of my pictures of La Goulue.[4] I *authorize you to take all the* PHOTOS you want. But no interpretation by a draughtsman, as in the magazine of unhappy memory.[5]

Faithfully,

HTLautrec

Prov.: Schimmel
Pub.: GSF139

[1] Pneumatic letter sent to R. Marx, Au *Voltaire*, 24 rue Chauchat, Paris 9.

[2] Roger Marx (1859–1913), a writer and art critic who helped to gain public acceptance for many painters. He was co-editor of *L'Image*, artistic editor of *Le Voltaire*, etc. His relations with Lautrec stretch from 1892 to 1899.

[3] Henri-Gabriel Ibels (1867–1936), illustrator and artist, a friend of Lautrec: like him he did eleven lithographs for *Le Café-Concert* of Georges Montorgueil in 1893. Lautrec painted and drew his portrait in 1893 (cf. Dortu P.463, D.3336).

[4] Louise Weber (1870–1929), called 'La Goulue', a café-concert dancer, was painted and drawn many times by Lautrec from 1886 to 1893. Cf Dortu P.261, P.282, P.399–402, P.422–3, P.427, P.527, P.590–2, A.199, D.3203, D.3219, D.3306, D.3311, D.3475–6, and Wittrock 1, 65, P.1. Lautrec is probably referring to *La Goulue entrant au Moulin Rouge*, 1892 (Dortu P.423), exhibited in the 1892 Salon des Indépendants, No. 1169.

[5] Lautrec is obviously referring to his problem with Jules Roques and *Le Courrier Français* (cf. Letters 125, 192).

219 *To Max Elskamp*

27 rue Caulaincourt, Paris [early May 1892]

Sir,[1]

I shall be very flattered to submit, to the best of my ability, to your show.[2]

Please tell me how many canvases I should send and how they should be sent. I passed on your invitation to Anquetin, who will also submit. But you would do well to remind him, because he forgets dates easily. His address is 62 rue de Rome.

Please thank van de Velde[3] for having gone to such trouble for us.

With warm personal regards,

HTLautrec

Prov.: BRA

[1] Max Elskamp, Belgian lawyer, poet, and secretary of *L'Art Indépendant*, Antwerp.

[2] Association pour l'Art, Antwerp, May–June 1892, the first exhibition by this group.

[3] Henry van de Velde (1863–1957), Belgian painter, architect, designer, and author. He exhibited with Les XX from 1889–1893 and with the Libre Esthétique in 1894, 1896, 1900, and some later years. In 1895 he designed a home and furnishings at Uccle where Lautrec was a guest during a short visit to Brussels.

220 *To his Mother*

[Paris] Tuesday morning [10 May 1892]

My dear Mama,

I hope you've now recovered and are happy in your fief surrounded by the Balade tribe.

I've gone back to work and am going to do a poster at the Chéret studios,[1] the director was delightful and everything has been put at my disposal.

Did you bring my father and his bird? Jalabert's last letter was favourable and promised deliveries. If this goes through I shan't need to draw on the reserve fund.

I'm still planning to leave on 14 July and to have finished by then everything that I have on the drawing board. In the meantime, a hug before I run off to the vernissage in the Champ-de-Mars.[2]

Yours

Henri

Prov.: Custodia

[1] *Ambassadeurs: Aristide Bruant* (Wittrock P.4).

[2] Société Nationale des Beaux-Arts. The Exhibition of 1892 opened on 11 May 1892 at the Champ-de-Mars.

221 *To Max Elskamp*

[Paris] 10 May [1892]

Dear Sir,
 Here is the list of my submissions:[1]
 1. La Goulue entering the Moulin Rouge with her sister
 2. The Moulin Rouge (poster, blue state)
 3. The Moulin Rouge (poster, yellow state)
 4. The Moulin Rouge, final version
 5. La Reine de Joie, poster
 6. La Reine de Joie, reduction[2] (6 proofs)

 Yours faithfully,
 H. de toulouse Lautrec

P.S. The painting of La Goulue is for sale at 500 francs.

Prov.: BRA
 [1] To the Association pour l'Art, Antwerp, May–June 1892. Lautrec actually exhibited a seventh item, *Liseuse*, a painting belonging to Émile Verhaeren which may be *En meublé* (Dortu P.365), exhibited at Les XX in February 1892, or *La Liseuse* (P.349), exhibited at Les XX in January 1890. The others were: No. 1 (Dortu P.423); No. 2 (Wittrock P.1), single-colour proof—in blue; No. 3 (Wittrock P.1), two-colour proof—in red and yellow; No. 4 (Wittrock P.1), final; No. 5 (Wittrock P.3).
 [2] No. 6 (Wittrock P.3), reduced version frontispiece for the book *La Reine de joie* by Victor Joze, published by Henry Julien (Paris, 1892).

222 *To Max Elskamp*

[May 1892]

Dear Sir,
 H. van de Velde has written to ask me for other paintings in addition to my announced submission.[1] If you don't consider the space I'll be occupying in the show to be adequate, you can always ask É. Verhaeren for the study of mine that is in his possession.[2] Théo v. Rysselberghe also owns one of my works.[3] But I don't want it to be shown publicly.
 Bonnard and Anquetin[4] must have written their review. Please send me the catalogue as soon as it comes out.

 Cordially yours
 H. de Toulouse-Lautrec

P.S. I have no open paintings available at this time moreover.

Prov.: BRA
 [1] Cf. Letter 221.
 [2] *Liseuse* (cf. Letter 217 Note 4).
 [3] Not identifiable.
 [4] Anquetin exhibited six numbers in Antwerp, and Bonnard two. Pierre Bonnard was listed as Paul in error.

223 *To Roger Marx*

[Paris, 25 May 1892]

Dear Sir,

The posters will only go up on the first,[1] please let it be known and bear it in mind in the notice you were kind enough to promise me.

HT Lautrec

Prov.: Schimmel
Pub.: GSE135, GSF138
 [1] Lautrec is probably referring to *Ambassadeurs: Artistide Bruant* (Wittrock P.4).

224 *To his Mother*

[Paris] Thursday [26 May 1892]
[Lautrec informs her that he has delayed his departure to London until next Monday[1] as he wanted to see his 'production' on the wall.[2]]

... Moreover, I was cheated, because there's still more delay,[3] and since this time my departure is irrevocable the result isn't obtained ...

[discussing family matters, complaining of the heat]

... In spite of everything I'm continuing to work hard, and have several *matters* in the works ...

. . . don't write to Louis it's absolutely useless he must not be required to deal with two persons at the same time.

We're having a torrid heatwave here that may cause me to head for the ocean sooner than usual.

Poutouigeades and Salamaleks.

Write to Bo ... ges[4].

A hug from

Yours
Henri

Prov.: Unknown
Pub.: Sotheby, Auction, 20 November 1979, No. 314.
 [1] Cf. Letter 225. Lautrec writes from London on Tuesday, 31 May, having just arrived.
 [2] Cf. Letter 223 Note 1.
 [3] Cf. Letter 225, Note 1.
 [4] Cf. Letter 225 Note 3.

225 *To his Mother*

Charing Cross Hotel [London] 31 May 1892

My dear Mama,

Here I am, installed at Charing Cross after a perfect trip,[1] the sea
like a lake and the sky like Nice. I'm already in the grip of the spell
arising from the London *hustle and bustle*. Everybody wrapped up in
his business and neither man nor beast letting out a superfluous cry or
word. The hansom cabs here have an air that would put plenty of
private carriages to shame. With me is my friend Ricci, who, moreover,
is a perfectly restful and good-humoured travelling companion. Tell
Papa that his letter of recommendation probably won't be able to do
me much good, the Sackvilles[2] being on the Continent and, above all,
our stay being very 'limited'. We ought to be back in Paris on the
10th. Bourges had got your letter[3] before I left and must have replied
to it. Goodbye, dear Mama. I am going to play at 'breakfasting' and
start my campaign with the National Gallery. I'm not going to mention
the names of the paintings so as not to be like Adèle Bouscher.[4]

I kiss you.

Yours,
Henry

Prov.: Schimmel
Pub.: GSE136, GSF140

[1] About a week's delay for Lautrec. Pissarro's letter to Lucien, 17 May 1892, informed him that he
might take the same train as Lautrec on 23 May. Cf. Rewald–Pissarro, p. 286, Bailly-Herzberg III,
No. 784, and Letter 224.
[2] A well-known English family, one of whose most prominent members was Sir Lionel Sackville
(1827–1908), who for a time was ambassador to France.
[3] Cf. Letter 224 Note 4.
[4] Cf. Letter 25 Note 1.

226 *To his Mother*

[London, 6 June 1892]

[1] ... I should have to write a whole book if I had to list for you just
the things I've seen in the past week. Paintings, pictures, sculptures,
tapestries, palaces, abbeys, and even street scenes that are interesting
because of the ease with which people spar. I saw a sweeper, beet-red
with indignation, knock an unfortunate old man down in the middle
of the road ... because he had urinated into the corner of a doorway.
I have also had the tiresome experience of a Sunday in London.
Everything is closed until six o'clock in the evening, there is no mail
delivery, you can scarcely get a meal in the hotel. But there are

compensations, in the libraries where the artworks are available to artists, with an obligingness unknown in France ...

<div align="right">Henri</div>

Prov.: Unknown
Source: Saffroy, Catalogue 30, 1954, No. 11220

[1] Fragment of a letter.

227 *To his Mother*

<div align="right">[Paris] Saturday [June 1892]</div>

My dear Mama,

 I've been so knocked out by the muggy weather since I got back from London that I've been sleeping *day* and *night*, which explains my silence. Woke up only yesterday and am making the most of it by writing to you. In case it shouldn't last—I'm sending my portrait aboard the boat from Dover to Calais.[1] Anyway it's a first instalment. I have no news from Respide except for the mediocre prices we'll have to accept in the end. Around 320,000 francs of which 280 are owed by my aunt.[2] I don't know what the story is with those ladies at St-Médard.[3]

 Let's talk about something else. Jalabert to me has the look of the heron with the gudgeon.[4] I would like a frank reply so as to know what I'm going to have to settle for, being at the end of my money, and certainly having the right to know where I stand since I've lived two years on one. Tell me what you think of all this. We will have to sell at any price. I haven't made up my mind on this and don't know what to do about it. I'm planning to go to Taussat about 14 July, unless my presence is needed here since I have a deal on the fire.

 I kiss you.

<div align="right">Yours,
HTL</div>

Prov.: Schimmel
Pub.: GSE137, GSF141

[1] Lautrec may be referring to *L'Anglais au Moulin Rouge: M. Warrener* (Dortu P.425), exhibited at the Royal Academy in London.

[2] i.e., his aunt Cécile Pascal, who lost the family estate of Respide as a result of the financial disaster mentioned here and in many of the following letters.

[3] St-Médard-de-Guizières, a small town in the Gironde, close to Respide.

[4] An allusion to La Fontaine's *Fables*, Book VII, No. 4. Jalabert seems to be holding out for a better offer and, like the heron in the fable, might be forced to settle for less.

228 *To his Mother*

[Paris, June 1892]

My dear Mama,

I have indeed received your letter. My uneasiness came from the fact that I was *broke* and was impatiently awaiting your letter in order to tap Jalabert, and you showed hardly any sign of understanding my impatience. *Charity begins at home.*

What you tell me about Respide was on the cards, but you know my way of looking at that situation. There's *nothing to be done* about it. Be guided by your own feelings and write to me. Unfortunately I'm too sceptical to believe in gratitude, but it mustn't be forgotten that in Respide we found what we looked for in vain elsewhere, a *home*.

I struggle against rain and models without bitterness, but also without enthusiasm.

We're going to move nearby, *rue Mansart* probably, into a larger apartment.[1] Bourges is opening a surgery in Paris. I'll have to pay a little more rent, but nothing to speak of (200–300 francs), which will be more than made up for by the lack of the servant's pilfering that I would have being alone. All this makes for grey hairs.

Goodbye, my dear mama.

Write to me with plenty of details.

Yours,
H

Prov.: Schimmel
Pub.: GSE138, GSF142

[1] This move was never made.

229 *To his Mother*

[Paris, June 1892]

My dear Mama,

I didn't want to write to you until after I'd seen Uncle Charles, but he was so tired out I was only able to say a quick good evening to him. I've seen Louis, who showed me your letter. He has sunk into a state of indifference, unfortunately justifiable. Short of acting like a tyrant, he cannot do a thing (at the risk of regretting it afterwards?). This completely personal opinion is well grounded.

Let's get back to *our* own affairs. Jalabert is keeping 11,000 francs at my disposal, with a contingent additional sum which, with those already advanced, gives me a share of 20,000 francs which will allow me to live a good part of next year. Your 25,000-franc share, therefore, is larger than mine. All this by way of record. We shall always see eye to eye, I have no doubt of that. I have preferred to let the money stay

in Jalabert's hands, first not wanting to look too greedy and in the second place wanting to have an understanding with you about investing it, or depositing it in a safe place. If you believe, however, I should CONVERT IT INTO CASH (PRUDENTLY PERHAPS), write to me specifying what I ought to do.

I kiss you affectionately.

Yours,
Harry

Prov.: Schimmel
Pub.: GSE139, GSF143

230 *To his Mother*

[Paris, June 1892]

My dear Mama,

What you say about Jalabert is definitely a nuisance, because I'm afraid he's a little fed up. This state of mind is especially terrible for the future, for if he's rebuked, he will send the whole business packing. Try to promote a *cordial* meeting between you and him and try to make him see things a little less pessimistically. As soon as you're at Malromé I think I'll make a quick run down there and back and we'll be able to talk at greater length about it, although wait is what we have to do now. I am up to my neck in drawings and am fairly well satisfied. Juliette, as you must know, has given birth to a boy by the name of *Marc.* This mark of courtesy no doubt will cost the family several pounds sterling.

I kiss you.

Yours,
Henri

Prov.: Schimmel
Pub.: GSE140, GSF144

231 *To his Mother*

[Paris, June 1892]

My dear Mama,

I am in receipt of a joyful note from Jalabert. He says that Papa has replied *satisfactorily,* and the work has been resumed.

Hosanna (for the moment).

I kiss you.

Yours,
H.

Prov.: Schimmel
Pub.: GSE141, GSF 145

232 *To his Mother*

[Paris, June 1892]

My dear Mama,

I was counting, in fact, on indirect news, of which, moreover, there has been no dearth, and was expecting what happened more than you, who are directly concerned. Bourges has briefed me on everything. It is useless, isn't it, to rehash the sad event and feel blue about it. I'll only tell you that I've been completely out of joint the whole week, having lost the feeling of time and place a little. What a state Joseph must be in!

Papa continues to talk about his fancied departure. Tell Louis I'll send him the document as soon as it is given to me. Probably tomorrow.

Tell me when Paul and Jo are to come and whether they intend to avail themselves of our more Scottish than comfortable hospitality. And now tell everybody again what you must already have told them, and what, I hope, there was no need of spelling out, my great concern over everything that has happened ... and will happen.

Your boy,
Harry

P.S. Forgive me for bringing up a financial matter, but I would be grateful if you would send me 500 francs, if you can, repayable by me on 1 July.

Your Boy
H.

I'll explain why when you come, and I hope this will be soon.

Prov.: Schimmel
Pub.: GSE142, GSF146

233 *To his Mother*

[Paris, June–July 1892]

My dear Mama,

I am indeed a model of rudeness, not to have answered your letter. I was thinking, a little mistakenly, that Paul and Joseph, having written a lot to Respide, would have given you my news. They are here and exposed to all the lawyers' chicaneries. Papa had us for lunch on Sunday and for dinner on Monday. He was very nice. I've seen Uncle Odon, who had nothing of importance to tell me. As for the way Papa spoke to me about Bosc, it was in a rather waggish tone. I know that Aunt Armandine is at Malromé. Do you know that Papa informed me that

Uncle Charles was decorated with the Order of Gregory the Great?[1] And Albi is in a tumult of joy. Mgr Fonteneau[2] is a marvellously clever man. Aunt Alix has also written to Papa, probably to sweeten the bitter pill. What a lot of diplomacy!

I'm looking forward impatiently to good weather. It's warm but stormy. Try to send us the sun as soon as possible and ask Tata to intercede with St Michael, who, I believe, is on very good terms with her.

Kiss her for me, and to you my Auvergnat kisses.[3]

<div style="text-align: right">Yours,
Henri</div>

Prov.: Schimmel
Pub.: GSE143, GSE147

[1] A pontifical order created by Pope Gregory XVI in 1831.
[2] Jean-Émile Fonteneau (1825–99) had become Bishop of Albi in 1884.
[3] Cf. Letter 124 Note 1.

234 *To his Mother*

<div style="text-align: right">[Paris] 15 July [1892]</div>

My dear Mama,

Your not very cheerful letter reached me this morning. It highlights the fact that the imminent catastrophe is going to spoil our season (sad!).[1] I've seen Louis who doesn't seem to be too down in the dumps. For that matter Gaston must have given you the news. Papa is complaining, not knowing where to dispose of his assorted belongings.

As for my plans, they are absolutely vague, but all adding up to going, no matter where, to breathe sea air! As for my excursion in the Tarn,[2] that's still pretty much set for about 10 August. Couldn't you keep the new sheets and send me some of the old ones immediately. Thanks for the wine. I shall be looking out for it.

In sum, the result of these rains is a great fidgetiness, which I try to overcome as best I can, but it isn't easy.

I kiss you.

<div style="text-align: right">Yours,
Harry,</div>

Prov.: Schimmel
Pub.: GSE144, GSF148

[1] The loss of Respide. Cf. the preceding letters.
[2] A Department near Albi, consisting of the old Languedoc and the southern part of the Massif Central.

235 To Roger Marx

[Paris, 23 July 1892]

[1]Dear Sir,

Could you have six proofs made of my picture, *reduction*, as plates[2]—
and send them to me?

Cordially,
HTLautrec

Prov.: Schimmel
Pub.: GSF149

[1] Pneumatic letter addressed to Mr R. Marx, 24 rue Saint-Lazare, Paris 9.
[2] Cf. Letter 218.

236 To his Mother

[Paris, late] July [18]92

My dear Mama,

According to latest reports, *very vague* ones, the Pascals are at Soulac[1]
at the seashore. In what circumstances? I'm totally in the dark about
it. I'd like to leave myself but it's hardly possible for a couple of weeks.

My little efforts have turned out perfectly and I've caught onto
something which can lead me quite far—so I hope.[2] I understand how,
in spite of your pleasure at being at Bosc, you should want to go back
to your nest. I want to go by Palavas[3] to look at the dark-blue sea
before going to the Atlantic. But, who knows. I'll be very grateful if
you'll send me by return the money you have at my disposal. Louis is
very philosophical and no longer makes useless complaints. I'm going
to have lunch with Georges de Rivières and Suzanne Gonthier.[4]

I kiss you.

Yours,
Henri

The photographs[5] will be sent to you.

Prov.: Schimmel
Pub.: GSE145, GSF150

[1] Soulac-sur-mer, a seaside resort in the Department of Gironde, near Royan.
[2] i.e. his experiments in the colour lithography of posters, which had begun in 1891 and greatly
absorbed him in 1892.
[3] A favourite sea-bathing resort on the Mediterranean, $7\frac{1}{2}$ miles from Montpellier.
[4] Probably the Suzanne who is first mentioned in Letter 54 and again in Letter 240.
[5] Cf. Letter 235.

237 *To his Mother*

[Paris] 26 July [1892]

My dear Mama,

I've received your package and thank you for it. Your letter, as far as it concerns my aunt, shows that the end is near and I'm very much afraid the medicine isn't doing any good at all.[1] Only Louis, although not very cheerful, is able to get something done. What good is it anyway talking about it, since even if you tried to help it would look as if you were interfering. I saw Georges yesterday, sentencing my victims,[2] who copped a fortnight to a month in a gaol.

There it is, all the news. I don't run into Papa very often, who in the summertime deserts Lucas for outdoor restaurants that don't appeal to me.

I kiss you.

Yours,
Henri

Prov.: Schimmel
Pub.: GSE146, GSF151

[1] Cf. Letter 253 Note 1.

[2] Probably the forgers of Lautrec's works who were arrested, tried, and convicted after he discovered their activities. One of them was a notorious forger who ended his career in exile in New Caledonia (cf. Mack, p. 351).

238 *To his Mother*

[Paris] Saturday [6 August 1892]

My dear Mama,

I'm writing to you at the height of the excitement of leaving. The Pascals have NOTHING left. Do therefore write, whatever it costs you, and offer my Aunt *temporary* lodgings at Pérey's, as that is what seems the most practical to me. The sons and daughter-in-law would stay at M. Niguet's.[1] Joseph will arrange something with Bourges as has been agreed.[2] (Where will they find money for the trip?) I hope to give you some clarifications when I arrive in the Gironde towards the middle of next week, but write to my Aunt of your accord, because, unfortunately, the *people* we are talking to are now absolutely down and out, please don't forget it and put aside all susceptibilities, *however justified they might be*. Be charitable, *absolutely*.

I kiss you.

Yours,
Henri

After Monday I'll be at Taussat near Audenge (Gironde), at M. Fabre's.[3]

Prov.: Schimmel
Pub.: GSE147, GSF152

[1] Paul Pascal's father-in-law, who lived in Neuilly, a suburb of Paris.
[2] Cf. Letter 250.
[3] Louis Fabre, a friend who owned the Villa Bagatelle in Taussat, where Lautrec liked to stay. Cf. Letter 514, addressed to Fabre at 63 rue Lepic, Paris.

239 *To his Mother*

[Paris] 9 August [1892]

Write to Taussat

My dear Mama,

You are definitely the hen who hatched a famous duck. I was amused this morning, while I was with Papa in the carriage, to take a flop in the place de la Madeleine without suffering a scratch, except for my pince-nez, which put my nose a little out of joint. I had a doctor friend check me out, and he found *nothing*. So I'm leaving tomorrow for Bordeaux, and I'll have lunch on Thursday at Soulac.

I'll write to you.

Yours,
Henri

I'm writing you this letter to spare you the gossip in the newspapers.

Prov.: Private Basle I

240 *To his Mother*

Taussat, 17 August [1892]

My dear Mama,

I spent 4 days at Soulac with my cousins, who were charming, and my poor aunt, who is doing her best not to appear crushed. I told her I would try to get you to come here, as the exchange of stern but fair letters has made her very sad. In case it wouldn't suit you to see Juliette, I think my aunt would come to see you, either at Malromé or wherever you like, where you could (I think) make her swallow the bitter pill of separation, an idea which so far hasn't entered her head. As for my lodging, your categorical reply gives me no room to insist. However, see what might be done and send me a reply—or COME to MALROMÉ. *We will talk*. After all, I'm there to back you up and I have had justice done to you. They admit you are the only one who has

shown any heart. As for the rest of the family, *they're not Simon Pure.* I left them in the presence of Suzanne Gonthier, who is giving the beach a lift with the *brilliance of her presence.* They are, incidentally, settled at Soulac for a more than modest sum: 4 adults, a maid and 3 children for 35 francs a day. I don't think they could live more economically and the rumours of exaggerated luxury are false indeed. Bourges thinks that for the time being the best thing for them to do is to stay where they are and wait for the winter to *look for* work.

So, come to Malromé, that will be best.

<div align="right">Yours,
Henri</div>

Prov.: Schimmel
Pub.: GSE149, GSF154

241 *To his Mother*

<div align="right">[Taussat, August 1892]</div>

My dear Mama,

Your letter had nothing to tell me. But I believe you are exaggerating in thinking you shouldn't come to the country. I *think* you should come to Malromé, on the chance of getting together with Bourges, and see how we can *switch* my aunt's situation at the critical moment. Writing wouldn't do any good. Everything has been said and re-said over and over again. Try to break through and COME TO THE GIRONDE. I'm taking advantage of the good weather to soak in the bay constantly. Other than this, nothing new.

<div align="right">Yours,
Henri</div>

Jalabert has received a little money. He must have told you.

Prov.: Schimmel
Pub.: GSE148, GSF153

242 *To his Mother*

<div align="right">[Taussat] 20 [August 1892]</div>

My dear Mama,

I've little news to tell you since yesterday and I'm writing simply to lend support to Bourges's letter, which brought you up to date on

Louis's sad situation, with figures to back it up. We'll really have to give him a hand if you don't want him to be ruined for good and lose everything that has been done up to the present. He's doing the best he can to live on the little money he has, but for all practical purposes it's impossible for him to pay off his back debts if you and my uncle (to whom Gabriel is writing on his own) don't help him out. So, for your part, send *two hundred* francs and we won't ask any more for him before the MONTH OF DECEMBER. You will only have to concern yourself with my aunt when M^me Niguet[1] has gone, which will inevitably happen if the plan to settle down in Neuilly[2] is carried out.

<div align="right">Yours
Henri</div>

Prov.: Schimmel
Pub.: GSE150, GSF155

[1] Paul Pascal's mother-in-law.
[2] Cf. Letter 238 Note 1.

243 *To his Mother*

<div align="right">[Taussat] 13 September [1892]</div>

My dear Mama,

Your doubts about the future don't make too disastrous an impression on me considering the current miseries I see. The *Pascals* (THIS JUST BETWEEN US) will only leave Soulac if they are kicked out. They owe for their hotel and board. I have all this from Bourges, who has been to Soulac, which has let me off from going there again. I think in a case like this the family won't have the cynicism to let them be sued and sentenced and that they will spare my poor aunt the shame of the *police court*. There you have it, a *frank* impression. Admit that it would ill become us to complain. To crown it all, Louis has fallen sick with nervous cramps and after a month's rest at St-Gratien[1] with good old Gaston the company will be obliged to buy him a *typewriter*. All this is no joke. Bourges has had a check done by experts and I'm very much afraid the poor chap may become completely impotent, making you a lady-companion. In short, it's better not to paint the future too black, when it's already black enough naturally without any additional colouring. I'll tell you all about it around the 27th. Kindly write to me and to Balade, as I intend to go to Malromé for a day or two about the 25th with Viaud[2] and Fabre, to have lodgings prepared for us. Tell me how to go about it, also about food and drink. Fabre would like

to see the country and is a friend of the purchaser of Respide. I can't refuse him that, he's too nice.—Adieu, my dear Mama, and see you soon.

<div align="right">Yours,
H.</div>

Regards to people who remember me.

Prov.: Schimmel
Pub.: GSE151, GSF156

[1] A town in the Department of Seine-et-Oise, near Pontoise.
[2] Paul Viaud, a native of Bordeaux, appointed by Lautrec's mother to be his constant companion and watchdog during the last two years of his life.

244 *To his Mother*

<div align="right">Paris, Tuesday morning [October 1892]</div>

My dear Mama,

My aunt's balance MUST be sent *right away*, DIRECTLY to the hotel-keeper, with the request for a receipt specifying that it's my aunt's personal account you're paying.

Paul and Juliette *are in Paris*. And Joseph and my aunt are only waiting for the payment of the aforementioned bill and the money for my aunt's trip—100 francs, a hundred francs that you'll send immediately to the address of whatever convent you like, into which she's ready to move. *I'll take her there myself.* So, everything's going the way you want. Hurry up and get the matter straightened out and give me orders.

<div align="right">Your son,
Henri</div>

I had a very good trip.

Prov.: Schimmel
Pub.: GSE152, GSF157

245 *To his Mother*

<div align="right">[Paris] 5 October [1892]</div>

[1] ... I am settled in the printing shop, where I'm writing to you while

waiting for them to pull my proofs.[2] So everything's going pretty well
(Gaudeamus igitur). This doesn't happen often ...

H

Prov.: Unknown
Source: Ancien, Auction XXV, 26 May 1955, No. 49

[1] Fragment of a letter.
[2] *Au Moulin Rouge, La Goulue et sa sœur* (Wittrock 1). Cf. Letter 246.

246 To Émile Verhaeren

[Paris, October 1892]

My dear Verhaeren,[1]
 You told me to let you know when something by me appeared. An
original colour print of La Goulue at the Moulin Rouge has just been
published.[2] The engraving is by me, based on my picture,[3] or rather,
it's a highly transposed interpretation of the picture. To obtain it, just
contact M. Joyant (c/o Messrs Boussod and Valadon, Goupil & Co.,
19 bd Montmartre). The price is one louis. The proofs are numbered
from 1 to 100, the stones were obliterated in my presence.
 I hope that this will be only the first in a series that I am doing and
which will at least have the merit of being very limited and conse-
quently rare.

Cordially yours,
HTLautrec

Prov.: BRA

[1] Émile Verhaeren: cf. Letter 217 Note 4.
[2] Wittrock 1.
[3] *La Goulue entrant au Moulin Rouge* (Dortu P.423).

247 To Roger Marx

[Paris] Friday [14 October 1892]

Dear Sir,
 Here I am back in Paris. My print[1] is on display at Goupil's and I
shall be much obliged if you will say a few words about it to your
readers. If you do, which I dare to hope you will, don't forget to

mention that these are *original prints in portfolio.* The series will be continued in 100-copy editions.

Thank you in advance, and regards.

HTLautrec

I shall be at home tomorrow from 3 to 6.

Prov.: Schimmel
Pub.: GSF158

[1] *Au Moulin Rouge, La Goulue et sa sœur* (Wittrock 1). The publishers Boussod-Valadon (successors of Goupil) announced it in their October 1892 catalogue (cf. Letters 245, 246). In a letter dated 11 October 1892, Camille Pissarro wrote to Julie Pissarro: 'As regards what Georges [Pissarro] said to me in connection with Lautrec's poster, there is a misunderstanding. Or else Esther [Pissarro] doesn't understand how daring art can be, how it can be the most moral thing in the world.' (Cf. Bailly-Herzberg, vol. 3 No. 822). The reference is probably to *Reine de joie* (Wittrock P.3).

248 *To his Mother*

[Paris, October 1892]

My dear Mama,

My trip was quite pleasant despite three Englishmen who sang until far into the night while playing cards and smoking pipes. You would have been miserable in my place.

I found Bourges annoyed at the sacristan, who is a dawdler and obsequious. To the point that it won't last long.

I saw Papa. Princeteau is arriving on Monday and is renting Carl Rosa's[1] studio. I feel lucky to meet up with this long-time friend again.

I'll end with a little story. Here's what I was told. My aunt Odette is supposed to have said—*My nephew gave me a painting.*[2] *I quickly stored it in the attic.* So there's no reason for this interesting branch of the family to have my portrait, whose outpourings must already be destined for the latrine. (*The moral of the story is, Never be in a hurry.*)

A hug from me for you and anybody around for whom you want to have it. Remember me to my uncle, who was very nice to me, and a warm handshake for Raoul.

Your
Harry

Prov.: Custodia

[1] Mario Carl-Rosa (1855–1913), French landscape painter and participant in the Salons from 1885, decorated with the Légion d'Honneur in 1899. His studios were located at 30 rue du Faubourg Saint-Honoré, 17 rue Cauchois, and 40 rue du Bac, Paris. It does not appear that Princeteau rented the studio.
[2] Lautrec gave a painting, *Danseuse assise sur un divan rose* (Dortu P.248), to his uncle Odon de Toulouse-Lautrec who wrote and signed on the back 'Cette toile m'a été donnée par mon neveu——Comte Odon de Toulouse-Lautrec'.

249 *To Oscar Méténier*

[Paris, October 1892]

My dear Méténier,[1]

Would it be possible for you, without going to an enormous amount of trouble, to obtain an audition for a young woman who is highly recommended to me?

She would like to join the Variétés,[2] if possible, and I believe that with a word from you, one of the establishment's favourite authors,[3] she could be considered.

Do this for me, unless you would prefer to see the woman herself. In that case, tell me when she should be sent to you, and where. Please leave a note addressed to Mlle Andrée Cléry.[4]

Thank you, and regards.

HTLautrec
27, rue Caulaincourt
(Monday afternoon)

Prov.: LA

[1] Oscar Méténier (1859–1913), a popular author and playwright, wrote for Théâtre Libre 1887–90, Variétés 1890–2, Casino de Paris, Gymnase late 1892, Bodinière, Théâtre Moncey 1893, and many more.

He was artistic director for the Théâtre Le Grand Guignol, 20 bis rue Chaptal. Méténier used Lautrec's poster of Bruant (Wittrock P.10) as the cover for his book on Bruant in 1893, and Lautrec dedicated his painting *Alfred La Guigne* (Dortu P.516) 'Pour Méténier d'après son Alfred La Guigne', after a character in Méténier's novel of the same name.

[2] Variétés: Le Théâtre des Variétés, 7 boulevard Montmartre., created in 1806 by a decree by Napoleon I, is one of the most important and continuous theatres in Paris.

[3] For Variétés Méténier wrote *Monsieur Betzy*, which opened on 3 March 1890, and *Bonne à tout faire*, 20 February 1892. Other contemporary authors were Henri Lavedan, Maurice Donnay, and Alfred Capus.

[4] M. Cléry and his wife Blanchette, hotel-keepers in Crotoy, appeared as the models in Lautrec's painting *L'Assommoir* (Dortu P.713), a preparatory painting for the theatre programme cover for the play directed by Lucien Guitry. It may be that Miss Cléry was related.

250 *To his Mother*

[Paris] Monday evening [October 1892]

My dear Mama,

I got my aunt settled in the convent[1] with Juliette and Joseph, who helped me with the job. Although her nerves were a little on edge, my aunt felt consoled by the private exit for women, which takes away the cloistered, militant aspect. The room assigned to her will be good if some improvements are made. I'll talk to you about this later.

Anyway, you can write and ask her yourself which toilet fixtures she may need, as the wash-stand area seemed to me to be skimpy in a

very old-fashioned way. Bourges settled Joseph in a hotel[2] in the rue de Constantinople, at the corner of the rue de Naples, a stone's throw from his mother. He's eating his meals with us. This arrangement is much more practical than the mattress on the floor, which is always inconvenient and uncomfortable. The Pauls are with their mother in Neuilly.[3] So everything seems to be fitting into place. I'm going to get back to work, but it's very hard to get back on the track.

I kiss you.

<div style="text-align:right">Yours,
H</div>

Prov.: Guzik

 [1] The convent of the Saint-Sacrement, 22 rue de Naples.
 [2] Probably Family hotel, 11 rue de Constantinople.
 [3] Mme Niguet (cf. Letters 238, 242).

251 *To his Mother*

<div style="text-align:right">[Paris] 19 October [1892]</div>

My dear Mama,

Your presence in Paris is urgently needed. Your intentions are good, but the results are negative. My aunt is being refused hot water after 6 o'clock in the morning, and firewood is not included in the board but payable separately. Moreover, the food isn't clean and the toilets are like those in a barracks. Either you didn't get across what you wanted to the management or there's a better way out and, in spite of the fact that my aunt is willing, it's impossible to leave her in this home, which doesn't provide even elementary comforts,[1] however it may look on the outside. You MUST come yourself to take care of all this, something which I'm just not up to. There are a lot of things a character of my type just can't handle. Therefore, I'm counting on you for next week and kiss you.

<div style="text-align:right">Yours,
H.</div>

Prov.: Schimmel
154
Pub.: GSE154, GSF160

 [1] Cf. Letter 252.

252 *To his Mother*

[Paris] Sunday, 23 [October 1892]

My dear Mama,

You're mistaken about my aunt's rebellion. She didn't make any categorical demands on me, and it was through Louis and Bourges that I learned the details of the faulty arrangement. She promised us that she would put up with it for a month, and I have written to the Superior asking her to find out which improvements (*such as a bidet etc ... which aren't within my competence*) she might need and to write and tell you what they are. You too should write along these lines, and COME, *please*, to Paris where everything can be taken care of much more quickly. More of the same old story: I laid out 70 francs for hotel rooms, carriages, etc., for my aunt. In addition, she has in storage at the railway station several chests of linens etc. rescued from the Respide shipwreck. Bonnefoy will keep them in one of his storage places until they can be used. *These trunks also contain clothes belonging to her and Joseph.* Bourges is paying Joseph's share, but my aunt's share is 100 francs. This amount may seem to you excessive, but keep in mind that unless she is fitted out with a new wardrobe these chests cannot be left at the railway station, where the storage charges are mounting up. Generous man that he is, Bonnefoy wanted to pay this out of his own pocket, but in my opinion he has enough to do taking care of Louis, and I beg you to send me this absolutely indispensable sum of money.

namely, 100 francs
plus what I laid out 70
 Total 170

Now, at the risk of being considered a bore, I'm asking you one last time to come instead of behaving like an ostrich and waiting until my poor aunt gets sick, which could very definitely happen.

I kiss you.

Yours,
H.

Prov.: Private Basle I

253 *To his Mother*

[Paris, October 1892]

My dear Mama,

I understand your alarm and unfortunately there is little hope. If poor Tata pulls through this adventure, overworked as she is, she will

indeed have St Michael to thank. I suppose you haven't yet got my letter in which I gave an account of the expenditures to be made for aunt Cécile whose situation fades into the background, given the regrettable precedence of Tata's illness.[1]

In case my letter should have gone astray, I am repeating my reckoning. Paid out by me, *70* francs, plus *100* francs I'll need to redeem the wreckage of Respide, my aunt's linen and winter clothing, which are being held at the station.

I regret insisting, but it's an emergency and we'll have to put up with it, unless she's to be fitted out anew.

I'm distressed that your arrival in Paris should be postponed until doomsday, and beg you to take care of yourself so you don't fall sick in your turn.

Kiss Tata for me, and a kiss for you.

<div align="right">Yours,

H</div>

Reply by return.

Prov.: Schimmel
Pub.: GSE153, GSF159

[1] His Aunt Armandine had been ill for some time, and in 1893 she died. Cf. Letter 237.

254 *To Octave Maus*

<div align="right">[Paris] 26 October [1892]</div>

My dear Maus,

Thank you for the charming invitation with which Les XX[1] have honoured me. And rest assured that I shall try to do my best. Just let me know the method of shipment at the right time.

Please also send me the address of Verhaeren[2] as soon as you can. I have to send him a message.

<div align="right">Very cordially yours,

HTLautrec</div>

Prov.: Brussels

[1] The X^e Exposition Annuelle des XX opened in February 1893.
[2] Émile Verhaeren: cf. Letter 217 Note 4 and Letter 255.

255 *To Émile Verhaeren*

[Paris, October 1892]

My dear Verhaeren,

If you're still here, let's get together tomorrow, Friday, at around 4 or 5 o'clock. We'll go to see Degas's picture.[1] Tell me when you can meet me, near the place Pigalle at *la Nouvelle Athênes*[2] if you like (between rue Frochot and rue Pigalle, at the corner).

Your
HTLautrec

Prov.: BRA

[1] Probably at the Dihaus' apartment (cf. Letters 117, 461), 6 rue Frochot, a short walk from the meeting site. The Dihaus owned Degas's portrait of Désiré Dihau, *Orchestra of the Opéra*, painted in 1868, and *Mlle Dihau at the Piano*, painted *c.* 1869–72, and possibly others.

[2] La Nouvelle Athènes, 9 place Pigalle, Paris, a café frequented by Lautrec, Forain, Maupassant, Méténier, *et al.*

256 *To François Gauzi*

[Paris, late October 1892]

My dear Gauzi,[1]

I have just received the news of your father's death,[2] and at this sad time I want to express my deepest sympathy.

Your old friend,
H. de Toulouse *Lautrec*

Prov.: Rozès

[1] François Gauzi: cf. Letter 143 Note 2.
[2] Gauzi's father died on 6 October 1892.

257 *To his Mother*

[Paris, October–November 1892]

My dear Mama,

I have no choice but to bow to the motives keeping you at Bosc. But I beg you to *re-read my letters* and see if your presence in Paris *wasn't clearly indicated* for you can't indefinitely remain a spectator of an admittedly grave situation[1] when your presence here is *urgently* needed. I've had to advance my aunt 100 francs to pay for mending jobs that were absolutely necessary, in Bourges's and my opinion. Please reimburse me by return. Moreover, I've authorized my aunt and her son to find a convent *or a family hotel* in the 300-franc range, where the

poor woman won't be tortured quite so much (they've even gone so far as to make her polish her own shoes).[2] And I think that I was not wrong to do this.

Please come and take care of all this business, because I've had *enough* of it and can't keep on covering up for a line of conduct that I see as too rigid. The Convent is fine as long as one doesn't overdo it. Come and see for yourself.

I kiss you.

<div style="text-align: right">Yours,
Henri</div>

If necessary I'll go and get you myself, if you don't come.

Prov.: Schimmel
Pub.: GSE155, GSF161

 [1] The grave situation is Aunt Armandine's illness.
 [2] Eventually, his mother invited his aunt Cécile to live with her.

258 *To an Unidentified Correspondent*

<div style="text-align: right">[Paris, Friday 19 November 1892]</div>

Lautrec writes on Friday, 19 November 1892, that he is at his studio, 27 rue Caulaincourt, on Saturday from 3 to 6 o'clock.

Prov.: Unknown
Source: Drouot, Auction 12 May 1936, No. 203-1.

259 *To his Mother*

<div style="text-align: right">[Paris] Friday [November 1892]</div>

My dear Mama,

I'm feeling well and have got back into circulation, but poor Aunt Pascal is in bed with an attack of asthma and can't sleep without morphine. My friend Fabre from Taussat, having come to Paris on a pleasure trip, is also confined in the Grand Hotel with an acute rheumatic attack. Bourges is doing what he can for him, but can't give much relief. There's a fellow who has no luck at all.

Come, everyone's anxious to see you, and I kiss you.

<div style="text-align: right">Yours,
Henri</div>

Prov.: Schimmel
Pub.: GSE156, GSF162

260 *To his Mother*

[Paris] Friday [December 1892]

My dear Mama,

At last you've understood that you have to come. I'm very relieved, especially since the snow that's falling here may perhaps delay you. Get started before the railways are shut down. Having fallen victim to the first freeze, I'm covered with iodine and cotton wool. But it's nothing serious, and I'm able to open my eyes, something that I couldn't do yesterday.

I saw my aunt, who is waiting impatiently for you and is afraid of frightening you. I reassured her.

Your natural kindness will inevitably be stirred by the good luck I've had. M. Jules Courtaut, who was in Nice with you, talked about me to Yvette Guilbert,[1] the singer, and yesterday in her dressing-room she asked me to make a poster[2] for her. This is the greatest success I could have dreamed of—for she has already been depicted by the most famous people[3] and it's a question of doing something very good. The family won't take any pleasure in my joy, but with you it's different.

Aside from that, the weather is gloomy. Mud, snowboots, and colds.

A hug from you and everybody around you.

Yours,
Henri

I received the 100 francs.

Prov.: Schimmel

[1] Yvette Guilbert (1865–1944), a Parisian-born singer and café concert performer, made her debut in 1887, becoming in a short time one of the most popular entertainers of her time, continuing in concert, theatre, and motion pictures until her death. She introduced many songs and monologues during the 1890s that are still sung today. She travelled extensively in France, Germany, England, and the United States. She was depicted by many artists of her time and was a favourite subject of Lautrec. Dortu lists 9 paintings, 24 drawings, and 1 ceramic and Wittrock includes 30 lithograph portraits.

[2] Lautrec painted a large portrait to be used as a poster, but it was never executed as one (Dortu P.519).

[3] Guilbert portraits and posters had already been executed by Charles Léandre, *Yvette Guilbert à Paris* 1890, Jules Chéret, *Concert parisien* 1891, and Ferdinand Bac, *Tous les soirs à l'horloge* 1892.

261 *To his Mother*

[Paris] Tuesday 20 [December 1892]

My dear Mama,

I hope to see you on Friday, but (please forgive the financial side of this letter) Louis has a payment due on the 23RD, and I beg you, if you postpone your trip, to send me *200 francs* AS SOON AS POSSIBLE by

registered post. We will consider this the last payment for this poor fellow who is really to be pitied, since he is still the only one to earn a fixed salary courageously. Paul is struggling with the newspaper editors with much energy, but without much result. I think you will not find this settlement inconvenient; besides, I did mention it to you before.[1] My aunt is better and sleeps a little.[2] I am cured now and am waiting for you. Meanwhile I kiss you.

<div align="right">Yours,
HTLautrec</div>

Prov.: Schimmel
Pub.: GSE159, GSF165

[1] Cf. Letter 242, where Lautrec also asked his mother (on 20 August) to send 200 francs for Louis Pascal, promising not to ask again until December.

[2] Cf. Letter 259 where Lautrec mentions his Aunt Pascal's attack of asthma.

262 *To Roger Marx*

<div align="right">[Paris, 14 January 1893]</div>

My dear Marx,

Could you send me as soon as possible the address of the binder[1] you told me about?[2] It's urgent.

<div align="right">Cordially
HTLautrec</div>

Prov.: Schimmel
Pub.: GSF166

[1] René Wiener, School of Nancy bookbinder (1855–1939), a cousin of Roger Marx. For the relationship between Roger Marx and René Wiener, see *Annales*, p. 221.

[2] Possibly on the night of 9 January 1893 when Lautrec attended a dinner given for Roger Marx by Les Artistes du Décor. The menu was designed by Chéret and each guest had a signed copy with his name. (Collection Schimmel).

263 *To André Marty*

<div align="right">[Paris] 19 January [1893]</div>

Dear Sir,[1]

My poster will appear tomorrow.[2] If you say a good word about it and about me, I should appreciate it if you would do so on Saturday morning.

Thank you, and regards.

<div align="right">HTLautrec</div>

Prov.: Schimmel

[1] André Marty, French publisher, author, and art dealer, a director of the *Journal des Artistes*. He became associated with Lautrec with the publication of his periodical *L'Estampe Originale* (1893–5), to which Lautrec contributed three lithographs, *Couverture* 1893 (Wittrock 3), *Aux Ambassadeurs* 1894 (Wittrock 58), and *Couverture (Album de Clôture)* 1895 (Wittrock 96). He also published *Le Café-Concert*, illustrated by Lautrec (Wittrock 18–28), in 1893 and Ibels; *Loïe Fuller* 1893 (Wittrock 17); and the album *Yvette Guilbert* 1894 (Wittrock 69–85). Later he was a founder of the decorating firm L'Artisan Moderne (Wittrock P.24). In 1906 he wrote *L'Imprimerie et les procédés de gravure au vingtième siècle*.

[2] *Le Divan Japonais* (Wittrock P.11). Cf. Letter 264.

264 *To Roger Marx*

[Paris] 19 January 1893

[1]My dear Marx,

The show for Maurin and me has been organized. We're showing simultaneously. My poster *Divan Japonais*[2] will appear tomorrow. I shall be very glad if you will print a one-line announcement of it on *Saturday*.[3]

One more thing: the *jury* of the Cercle Volney[4] eliminated me. I didn't know that when one paid a portion of the rent one had, or assumed, the right to throw the artists out. So I resigned. If you could call attention to the situation at some point, that would be my best revenge.

Cordially,
HTLautrec

Prov.: Schimmel
Pub.: GSF167

[1] In an envelope addressed to M. Roger Marx, 24 rue Saint-Lazare, E.V. [en ville].
[2] *Le Divan Japonais* (Wittrock P.11), was the first poster completed in 1893 and should be Wittrock P.6.
[3] Cf. Letter 263.
[4] Cf. Letter 215 Note 1.

265 *To Octave Maus*

[Paris, January 1893]

My dear Maus,

I am sending to Les xx[1] 1. *La Goulue entering the Moulin Rouge* (painting); 2. *Dans le lit* (painting); 3. *Bruant* (poster); 4. *Divan Japonais* (poster), plus two colour lithographs that I shall bring with me. I shall

let you know the dimensions of the two passe-partouts that have to be made, and we shall glue them at the last minute.

Cordially yours,
HTLautrec

Prov.: Brussels

¹ At the exhibition opening in February 1893 Lautrec exhibited seven items: 1. *La Goulue entrant au Moulin-Rouge* (Dortu P.423); 2. *Dans le lit (Au lit: Le Baiser)* (Dortu P.436); 3. *Aristide Bruant*, poster (Wittrock P.4); 4. *Le Divan Japonais*, poster (Wittrock P.11); 5. *La Goulue et sa sœur* (Wittrock 1); 6. *Flirt (L'Anglais au Moulin-Rouge)* (Wittrock 2); 7. *Première couverture pour l'Estampe Originale (Wittrock 3)*.

266 *To an Unidentified Correspondent*

[Paris, January 1893]

¹Marx² did in fact talk to me about your desire to have the mauve lady with the black hat.³ You can come to collect it ... at my studio *next Monday* ... 27 rue Caulaincourt. All I ask is that you do not show the picture until a month from now, because in order to cover myself with Goupil⁴ I said I was sending it to a show out in the provinces. I'm happy about your good opinion of my efforts ...

HTL

Prov.: Unknown
Source: Charavay, Catalogue October 1966, No. 31282

¹Fragment of a letter.
²Roger Marx, who had recently reviewed Lautrec's work in *Le Rapide*, 17 November and 3 December 1897.
³Lautrec may be referring to one of the following paintings: *La Femme au chapeau noir, Berthe la sourde* (Dortu P.373), or *Femme assise dans le jardin de M. Forest: Justine Dieuhil, de face* (Dortu P.394), but more likely *Jane Avril, La Mélinite, de face* (Dortu P.418), a portrait of Avril with a black hat and a mauve coat. It was in the collection of Frantz Jourdain, who may be the recipient of this letter.
⁴Lautrec's exhibition with Charles Maurin opened at Boussod, Valadon & Cie (Goupil) on 30 January 1893 and ran until 11 February 1893.

267 *To Arsène Portier*

[Paris, late January 1893]

My dear Sir,
Have you anything to do with the large pastel Mélinite¹ (green frame). If so, keep it. If not someone will come and get it at one o'clock.

Yours,
HTLautrec

Prov. Unknown
Source: Rendell, Catalogue 113, No. 296

[1] *(La) Mélinite.* Melinite, a French explosive first used about 1886, was the popular name for the French dancer, Jane Avril. Lautrec is probably referring to *Jane Avril entrant au Moulin Rouge* (Dortu P.417), exhibited at Boussod, Valadon & Cie.

268 *To François Gauzi*

[Paris] Saturday, [21 January 1893]

Old Boy,
 We will arrive in Toulouse on Tuesday morning. You know where to find us, 12 rue de l'Écharpe in Toulouse, Rachou's home. See you soon.

Young Boy
Lautrec

Prov.: Prov.: Rozès

269 *To Roger Marx*

[Paris] Friday, 27 January [1893]

[1]My dear Marx,
 TOMORROW, Saturday, our pictures will be hung and you'll be able to come and look at them. The opening is on Monday.[2]
 Maurin[3] and I both want you to come.

Yours,
HTLautrec

Prov.: Schimmel
Pub.: GSF168

[1] Written on letterhead of Goupil & Co., Tableaux, Objets d'art, Boussod, Valadon & Cie, Successeurs. Next to 'My dear Marx' there appears an ink stamp depicting an owl, which was the symbol used by Charles Maurin.
[2] The exhibition referred to is Charles Maurin and Henri de Toulouse-Lautrec—works—at M.M. Boussod et Valadon, 19 boulevard Montmartre, Monday, 30 January, to Saturday, 11 February 1893. Roger Marx's very intelligent review of this exhibition was published on 13 February 1893 in *Le Rapide.*
[3] Charles Maurin (1856–1914), French painter and printmaker and friend of Lautrec, Félix Vallotton, and Rupert Carabin. He developed innovative techniques in printmaking and at his instigation Lautrec later took up drypoint. His aquatint portrait of Lautrec appeared in *L'Estampe Originale*, vol. I (1893).

270 *To Octave Maus*

<div align="right">[Paris] 27 January, 1893</div>

My dear Maus,

 You will be receiving a package containing three prints (colour lithographs) by me.[1] I don't know whether I'll be able to get to Brussels for the opening of the exhibition. So I ask you please to have tabs glued on the three prints (on the top corners only) and have them placed under glass as best possible. Just glue them on Bristol-board supported by heavy cardboard. If Théo[2] is there he'll take care of it, or Lemmen,[3] or you yourself. Send me the bill from the Exhibition framer. Then return the proofs taken from a numbered printing for which I am responsible. One (the largest) serves as a commentary for a publication on which all the Young Artists are collaborating.[4] Be so kind, dear friend, as to tell me who could be our correspondent in Brussels. The director is Marty, at 17 rue de Rome, Paris. Write directly to him or to me. They'll send samples and rates. I think that won't be bad. For the other prints (*La Goulue* and *L'Anglais au Moulin Rouge*), the Maison Goupil at 19 bd Montmartre should be contacted. This is the only depository of my original prints. The price is 20 francs. My picture of la Goulue is for sale at 600 francs and the other (*Au lit*) at 400 francs.[5] When are Les XX opening. Write or telegraph. I'll try to be there and forgive me for all the bother.

<div align="right">Your
HTLautrec</div>

Prov.: Brussels

 [1] Cf. Letter 265 Note 1 (Wittrock 1, 2, 3).
 [2] Théo van Rysselberghe (cf. Letter 152 Note 1).
 [3] Georges Lemmen (1865–1916), a Belgian painter who exhibited with Les XX and La Libre Esthétique.
 [4] Lautrec is referring to his cover for *L'Estampe Originale*, a publication directed by André Marty. Beginning on 30 March 1893 and continuing until 1895, a total of nine albums with 95 original prints were issued.
 [5] *La Goulue entrant au Moulin Rouge* (Dortu P.423) and *Au lit: Le Baiser* (P.436). The first was sold to Charles Zidler, one of the owners of the Moulin Rouge, and the other to Charles Maurin.

271 *To Roger Marx*

<div align="right">[Paris, 30 January 1893]</div>

[1] My dear friend,
 Agreed.

<div align="right">Yours,
HTLautrec</div>

Prov.: Schimmel
Pub.: GSF169

 [1] Pneumatic letter addressed to Mr R. Marx, 24 rue Saint-Lazare, Paris 9ᵉ.

272 *To André Marty*

[Paris, 30 January 1893]

[1]My dear Marty,
 What is Yvette Guilbert's Paris address.[2] Send me the Japanese
papers.

Yours,
HTLautrec

Prov.: Private Paris I

[1] Carte-télégramme addressed to A. Marty, 17 rue de Rome.
[2] Yvette Guilbert's address from November 1891 to the autumn of 1894 was 2 rue Portalis.

273 *To an Unidentified Correspondent*

[Paris, early 1893]

My dear Friend,[1]
 If you can stop by my studio today at 3 o'clock, we could decide on
the visit to Carrière.[2]

Yours,
HTLautrec

Prov.: LA

[1] Possibly Demirgian (cf. Letter 274).
[2] Eugène Carrière (1849–1906), painter and printmaker, exhibited at the Salon in 1876 and years
after; Légion d'Honneur 1889, Société Nationale des Beaux-Arts 1890 and years after. Portraits of
Roger Marx 1888, Paul Gauguin 1890, Gustave Geffroy 1891. He was involved with *L'Estampe
Originale* from its inception and was listed in the prospectus with Lautrec early in 1893. His work
appeared in Album IV in 1893 and in Album IX in 1895.

274 *To Eugène Carrière*

[Paris] Monday [early 1893]

My dear Carrière,[1]
 May I come to introduce you to my friend Demirgian[2] tomorrow
Tuesday at 4 p.m. on the dot.
 Please drop me a line to let me know which day would be good for
you if you can't make it.

Yours,
HTLautrec

Prov.: Schimmel
Pub.: Carrière, p. 262

[1] Cf. Letter 273 Note 2.

[2] A friend of Lautrec's who, while at Bonnat's atelier with him, painted a portrait of him (Dortu I*c*.68).

275 *To an Unidentified Correspondent*

[Paris, January–February 1893]

Dear Maître,

Please issue orders for your portrait to be picked up on Monday morning. We shall display it on Tuesday from 3 to 5 o'clock at Joyant's place. We'll be happy to see if you can drop by on that day.

Yours,
HTLautrec

Prov.: AF

276 *To André Marty*

[Paris] Thursday (9 February 1893)

[1] My dear Marty,

The minister came yesterday.[2] I saw him only later. Fortunately Maurin was informed in time. For detail see Joyant.

Yours,
HTLautrec

N.B. We're going to remain open for another week. Please announce it.

Prov.: Private Paris I.

[1] Telegram addressed to A. Marty, 17 rue de Rome.

[2] Lautrec is referring to his joint exhibition with Charles Maurin at Boussod, Valadon et Cie., 19 boulevard Montmartre. Originally scheduled for 30 January to 11 February, 1893, it obviously remained open for another week.

277 *To André Marty*

[Paris, 10 February 1893]

My dear Marty,

We shall remain open all next week. You can announce this. I don't know whether I asked you to do so yesterday.[1] Thank you for the anti-Jury artists.

Cordially yours,
HTLautrec

Prov.: Private Paris I

[1] Cf. Letter 276. In a letter dated 3 March 1893, Camille Pissarro wrote to Lucien Pissarro: 'I saw Lautrec yesterday. He introduced me to Mr Marty, who publishes a magazine of prints, and who asked me to give him something for his forthcoming second issue. He also wants something from you. It would have to be something very straightforward. I don't know what I could give them. Perhaps a lithograph?' (Cf. Bailly-Herzberg, vol. 3, No. 880.) Camille submitted the drypoint *Paysage* for Album V (1894) and the lithograph *Baigneuses* for album IX (1895). Lucien submitted the woodcut *Ronde d'enfants* for album V (1894) of *L'Estampe Originale*.

278 *To his Mother*

[Paris, early February 1893]

My dear Mama,

I'm terribly sorry to see that you've been ill. Moreover, this is a time for sickness. Uncle Odon has stayed in his room for the past three days, but he is cured thanks to a strong purgative. I myself took a dose of castor oil yesterday, which I think will put an end to my intestinal rumblings. I'm going to work, with nothing organized yet and having had only the glaziers and the chimney sweeps to deal with, which is no fun.

My painting is still selling,[1] and I'm still not being paid. Bourges is very busy just now, which means that I never see him. I eat practically every meal with Papa, Aunt Odette, and M. Beyrolles, who is very pleasant. He has carried his kindness to the point of going to look at my work at the Goupil gallery[2] without seeming terrified. Papa is going to go hunting, I believe, with M. Potain, Pothain, or Pothin,[3] and as for me, I take leave of you with a hug.

Your boy,
Henri

Hug Grandma and my aunt and uncle, whose reception was courteous.

H

Prov.: Dortu
Pub.: HD, p. 123

[1] Cf. Letter 270 Note 5.
[2] Lautrec is referring to his exhibition with Maurin at the Boussod-Valadon gallery, the successor to the Goupil Gallery. Cf. Letters 269, 276, 277.
[3] Cf. Letters 196, 198.

279 To Roger Marx

[Paris] Wednesday [22 February, 1893]

[1] My dear Marx,

I'll come to your place tomorrow, Thursday, at 10 a.m., to discuss the cover with you.[2]

Cordially,
HTLautrec

Prov.: Schimmel
Pub.: GSF171

[1] Pneumatic letter addressed to M. Roger Marx, 24 rue Saint-Lazare, Paris 9ᵉ.
[2] This is the cover for the album *L'Estampe Originale*, which was to be published on 30 March 1893 (Wittrock 3). Roger Marx wrote the preface to it.

280 To Roger Marx

[Paris, probably 23 February 1893]

[1] Please wait for me. I'm bringing the proposed cover design.

HTL

Prov.: Schimmel
Pub.: GSF170

[1] Written on a visiting card (cf. Letter 279).

281 *To Gustave Geffroy*

<div align="right">[Paris] Sunday 26 February [1893]</div>

¹Dear Sir,²

We're meeting tomorrow, Monday, at Joyant's place at a quarter to 7. Afterwards we'll go to the Moulin.³ I hope it won't be an impossibility.

<div align="right">Cordially yours,
HTLautrec</div>

Prov.: Mayer

¹ Carte-télégramme addressed to 133 rue de Belleville.

² Gustave Geffroy (1855–1926), noted art critic and author. Lautrec illustrated his volume on Yvette Guilbert (Wittrock 69–85), published by André Marty in 1894. He also wrote *La Vie artistique* in eight series between 1892 and 1903, and the Preface for Julien Sermet, *Les Courtes Joies: Poésies* (Paris, 1897). The cover design was drawn by Lautrec (Wittrock 236).

³ Probably the Moulin Rouge.

282 *To Octave Maus*

<div align="right">[Paris, February–March 1893)</div>

My dear Maus,

Sell the *Divan Japonais* for 10 francs, with the condition that it be shown at the Antwerp Association pour l'Art¹ first. If the purchaser of the *Bruant* were willing to leave that on exhibition also, I should be much obliged. Please let me know about this. You can also send the three lithographs to Antwerp. Théo will moreover explain to you our project to create a panel composed of the first numbers of *L'Estampe Originale*.² Send me only my two paintings as soon the exhibition ends. Please answer.

<div align="right">Sincerely,
HTLautrec</div>

Prov.: Brussels

¹ The second Exposition Annuelle of the Association pour l'Art, Antwerp, May 1893. Lautrec exhibited seven items: 1. *Aristide Bruant (Violet)* (Wittrock P.4); 2. *Aristide Bruant (Noir)* (Wittrock P.4); 3. *Menu*—not identified but probably *La Modiste, Renée Vert* (Wittrock 4), used as a menu by the Société des Indépendants for a dinner on 23 June 1893; 4–7: cf Letter 265 Note 1, items 4–7.

² Antwerp also exhibited: Première livraison de 'L'Estampe Originale', comprising ten prints, including Lautrec's cover (Wittrock 3).

283 *To Octave Maus*

[Paris, February 1893]

My dear Maus,

I'm very late in answering your kind letter. I owe the framer in Brussels 12 francs. So please ask 12 francs for my *Bruant*, and we'll be even. I believe things have gone very well. M. Prangé[1] (of London) wants you to show some of my paintings. I ask you please to give him a very definite *no*.

<div align="right">Cordially yours,
HTLautrec</div>

Prov.: Brussels

[1] Probably an agent at this time, since he is mentioned as such by Aubrey Beardsley in a letter to Leonard Smithers *c.* 6 April 1896, (cf. Maas, p. 122). He later became art dealer in a major London gallery.

284 *To Roger Marx*

[Paris] Tuesday [7 March 1893]

[1]My dear Marx,

Please write down for me, *very legibly*, the name of your friend in Nancy[2] who wrote to me. I'd like to answer him.

<div align="right">Cordially,
HTLautrec</div>

Prov.: Schimmel
Pub.: GSF172

[1] Pneumatic letter addressed to M. R. Marx, 24 rue Saint-Lazare, Paris 9e.
[2] René Wiener.

285 *To André Marty*

[Paris, early March 1893]

My dear Marty,

Please insert the following notice: The Société des Artistes Indé-pendants will open its doors on Friday, 17 March for the inauguration of the ninth exhibition at the city of Paris Pavilion.[1]

The critics will be admitted on Thursday. Please name Mme Ymart

and my friend Gauzi.[2] I'll be much obliged to you for this. I shall try to be at the Pavilion if possible. In any case you'll see me on Friday at the vernissage.

<div align="right">Regards.
HTLautrec</div>

Rachou[3] also has a panel of flowers there. Vallotton[4] has one painting (*la Valse*) that's splendid. The other one will probably be taken down by the police.[5] Well, you'll see.

Prov.: Private Paris I

[1] Lautrec exhibited four paintings in this exhibition: *Un Coin du Moulin de la Galette*, No. 1243 (Dortu P.429); *Menu du dîner des Indépendants, La Modiste, Renée Vert*, No. 1244 (Wittrock 4); *Portrait de M. G. H. Manuel*, No. 1245 (Dortu P.377), *Portrait de M. Boileau*, No. 1246 (Dortu P.465).

[2] Victorine Henriette Imart Rachou (1864–1954), the wife of Henri Rachou, specialized in flower painting and was purported to be a student of Lautrec. A painting by her, owned by G. Séré de Rivières, was exhibited at the Musée Toulouse-Lautrec, Albi, in 1951 (*Nature morte*, No. 345; now Schimmel Collection). For François Gauzi, cf. Letter 143 Note 2.

[3] Henri Rachou; cf. Letter 71 Note 2.

[4] Félix Vallotton (1865–1925), a Swiss-born artist and printmaker active with the Nabis and artists of the Revue Blanche and a friend of Lautrec's.

[5] Vallotton's other painting was *Le Bain au soir d'été*, No. 1268. A large oil on canvas, it contains twenty-three or more women in various states of undress in and out of the water. It caused a real scandal. Cf. Koella, p. 65.

286 *To Roger Marx*

<div align="right">[Paris, Spring 1893]</div>

[1]My dear Marx,

This is to introduce my friend G. Morren,[2] who would like to have your friend Wiener show in Antwerp.[3]

<div align="right">Best regards,
HTLautrec</div>

Prov.: Schimmel
Pub.: GSF180

[1] Visiting card addressed to M. Marx, 24 rue Saint-Lazare, Paris 9ᵉ.

[2] George Morren (1868–1941), a Belgian artist who exhibited at the Association pour l'Art in Antwerp.

[3] Association pour l'Art, Antwerp, May 1893, the final exhibition of the Association where Lautrec exhibited. (Cf. Letter 282). Wiener did not exhibit.

287 *To René Wiener*

[Paris] 11 March 1893

Dear Sir,

In answer to your letter, I ask that you send me the sum of *one hundred* francs, the price of my sketch.[1] As I told Marx, I am available to do the retouching of the reduced photographs, if necessary.[2]

Please address your letters to me at 21 rue Fontaine Saint-Georges, my home.

Yours truly,
H. de Toulouse Lautrec

P.S. You can ask my friend H. Rachou, an artist with excellent taste, to draw the decorations. We talked about this with Marx.

Prov.: Nancy
Pub.: *Annales*, p. 221

[1] *Tom: Grand cormoran bronzé* (Dortu P.512). This painting was the cover design for a binding by Wiener of the book *L'Art impressionniste* by Georges Lecomte (Dortu P.534, R.1).

[2] The painting (P.512) was $16\frac{3}{8}''$ by $10\frac{7}{8}''$ and larger than the format of the planned binding. Lautrec prepared a watercolour $11\frac{3}{4}''$ by $7\frac{1}{2}''$ from a tracing of a photograph of the painting (Dortu A.212).

288 *To René Wiener*

[Paris] Tuesday, 14 March [1893]

Dear Sir,

Thank you for your letter of this morning, which I have just received. Yesterday I saw G. Lecomte[1] and told him about our work. He is very pleased about it, and asks only to see it when it is completed.

Please let me know personally or through Roger Marx where and when it can be seen.

Cordially yours,
H. de Toulouse Lautrec

Prov.: Nancy
Pub.: *Annales*, p. 222

[1] Cf. Letter 287 Note 1.

289 *To Gustave Geffroy*

[Paris, 21 March 1893]

[1]Monsieur G. Geffroy
 When are we going to visit the Diva? ...[2]
 And what about your text?[3]

 Regards,
 HTLautrec

Prov.: LA

[1] Written on a visiting card and mailed (envelope dated 21 March 1893).
[2] Lautrec is referring to Yvette Guilbert.
[3] For this article in *Le Figaro Illustré*, No. 40, July 1893, Lautrec painted two portraits of Guilbert (Dortu A.203–4) and included her in a third picture (Dortu P.477). Cf. Letter 306 Note 1.

290 *To René Wiener*

[Paris, March–May 1893]

Dear Sir,
 Here are two tracings, one of the line, which I ask that you follow *religiously*, keeping the whole thing *very vigorous*, especially the head and the *beak*. As for the ship, the photograph will give you the information. The bird's body is *dark green* with the hood feathers being lighter— the collar and the cheek are an orange-yellow—the eye is malachite green, the sky is dark ultramarine and the patch of water *on the right* is a *lighter ultramarine*, the water is *emerald* green; as for the boat and the sand keep the background leather.
 The inside of the beak is a *yellow grey*, lighter than the background of the leather and the throat is a *slightly creamy* white.
 I hope, Sir, that in this way you will be successful and I would like to know the outcome.

 Regards,
 H. de Toulouse Lautrec

Prov.: Nancy
Pub.: *Annales*, p.222

291 *To André Marty*

[Paris] Sunday, midnight [3 April 1893]

[1]My dear Marty,

I've just come from *Chincholle's*.[2] He is furious because he is accusing us of having stolen his title. I pointed out that his rag was called *l'Estampe* while ours is *l'Estampe originale*. I also told him you're ready to provide any explanation. Just wait. Forewarned is forearmed.

Chincholle's address is 10 rue Fontaine.[3]

Yours,
HTLautrec

Prov.: Private Paris I

[1] Telegram addressed to A. Marty, 17 rue de Rome, pressé (postmarked Monday, 3 April 1893).

[2] C. Chincholle, editor of *L'Estampe*, a journal founded in 1881 dealing with prints. In the 18 June 1893 edition he is clearly upset with the new *L'Estampe Originale* and states it is not the same as his. But by 10 December 1893 he has changed and wants it to continue.

[3] This was later the address of the livery stable owned by Lautrec's friend Edmond Calmèse.

292 *To his Mother*

[Paris, late April 1893]

My dear Mama,

For once the newspapers have come close to telling the truth. The *exanthematous typhus*[1] we're having is a disease that only attacks badly nourished people shut up in prisons or boarding schools. We luckier ones are safe from this highly limited epidemic. I'm still in a lazy mood and waiting for inspiration. Every day I go to the Bois and absorb as much oxygen as possible. I almost took the train to go and spend a week or so at Taussat, but I was afraid of not being able to come back. I shall be delighted to see if I can think of something to decorate the Rochegude Museum[2]: it would be comical to appear as a painter where I used to go barelegged as an altar-boy.

Calm yourself, then, fear nothing, and salaams[3] to all around you.

I kiss you.

Yours,
Henri

Prov.: Schimmel
Pub.: GSE114, GSF116

[1] An epidemic of typhus broke out on 29 March in Nanterre, the outskirts of Paris, and on 18 April an announcement regarding the study and naming of the microbe was made. It was called *diplococcus exanthematicus*.

[2] The home of Henry Paschal de Rochegude (1741–1834) in Albi, now the home of the municipal library. Rochegude had been a naval officer, writer, and political leader. Lautrec had presumably served Mass there in a private chapel before 1880.

[3] An Arabic expression of politeness, meaning 'peace be with you'.

293 *To André Marty*

[Paris] *Monday* [2 May 1893]

[1]My dear Marty,

Zandomeneghi[2] is having a one-man show at Durand-Ruel, opening on Wednesday.[3] Be there at 5 o'clock tomorrow, Tuesday, maybe we'll be able to introduce you to Degas. In any case Alexandre will give you materials for an article.

Yours,
HTLautrec

Prov.: Private Paris I

[1] Telegram addressed to A. Marty, 17 rue de Rome (postmarked Tuesday, 2 May 1893).

[2] Federico Zandomeneghi (1841–1917), an Italian painter who exhibited with the Impressionists in 1879, 1880, 1881, and 1886. Lautrec met him at Degas's, who introduced Zandomeneghi to Durand-Ruel. He lived near Lautrec on rue Tourlaque.

[3] The exhibition at Durand-Ruel ran from 3 to 20 May, 1893. Arsène Alexandre wrote the preface to the catalogue.

294 *To Roger Marx*

[Paris, May 1893]

My dear Marx,

Please don't forget my good friend Ricci, author of the *Piedmont Bride*[1] and a victim of back-stage Salon intrigues. You'll be doing a favour for

HTLautrec

P.S. The Goncourt book is out.[2] Perhaps this is the time to act.

Your
HTL

Prov.: Schimmel
Pub.: GSF181

[1] Ricci exhibited *La Mariée piémontaise*, No. 1505, at the Salon which had opened on 1 May.

[2] This may be a reference to *Études d'art. Le Salon de 1852. La Peinture à l'Exposition de 1855*, texts by Edmond and Jules de Goncourt, published in 1893 with a preface by Roger Marx about Goncourt and Modern Art. Lautrec wanted to propose the illustration of *La Fille Élisa* to Goncourt (Dortu A.237–52).

295 *To André Marty*

[Paris, mid-May 1893]

My dear Marty,

Have you written about the Zandomeneghi[1] show? We couldn't find anything. In any case please do so as soon as possible and send me the clippings. The show will be closing soon.

<div align="right">Cordially yours,
HTLautrec</div>

M. Chaix is interested in prints. Could you show him some examples?

Prov.: Schimmel
[1] Cf. Letter 293 Notes 2 and 3.

296 *To René Wiener*

[Paris] 27 May 1893

Dear Sir,

I was very interested in your bindings on exhibition at the Champ-de-Mars,[1] and I shall be very glad to add an interesting verso to the binding we have undertaken.

All I ask is that you send me the exact size of the board so that I can make a drawing with the proper page design.

It will be a month or two before I can send you my preliminary sketch, but I hope that it will combine with the work.

With my best regards.

<div align="right">Sincerely,
HTLautrec
27 rue Caulaincourt</div>

Prov.: Nancy
Pub.: *Annales*, p. 222

[1] The Société Nationale des Beaux-Arts Exhibition of 1893 opened at the Champ-de-Mars on 10 May 1893. Wiener exhibited nine bindings, four in collaboration with Victor Prouvé and four with Camille Martin. The ninth, No. 421, is listed *L'Art impressionniste, reliure en mosaïque de cuir* (René Vienner). Wiener had completed a first binding for this book designed by himself and showing Japanese influence.

297 *To Roger Marx*

[Paris] Friday [2 June 1893]

[1]My latest little work will go on display tomorrow. Please mention it. *Jane Avril au Jardin de Paris.*[2] Published by Kleinmann. Let it be talked about. I had a charming letter from Wiener.

Yours
HTLautrec

Prov.: Schimmel
Pub.: GSF173

[1] Pneumatic letter addressed to M. Roger Marx, 24 rue Saint-Lazare, Paris 9ᶜ.
[2] Wittrock P.6. Registered with the Bibliothèque Nationale on 8 May.

298 *To André Marty*

[Paris] *Friday* [2 June 1893]

[1]My dear Marty,

A new poster by me, *Jane Avril, Jardin de Paris,*[2] will be out tomorrow. Please write a few lines about it. Consignment with Kleinmann of the unlettered proofs.[3]

Yours sincerely,
HTLautrec

Joyant (Goupil et Cie) are asking for consignment of *L'Estampe.*[4] Go ahead.

Prov.: Private, Paris I

[1] Carte-télégramme addressed to A. Marty, 17 rue de Rome.
[2] Wittrock P6 State C.
[3] Wittrock P6 State A.
[4] *L'Estampe Originale.*

299 *To an Unidentified Correspondent*

[Paris] 2–6 [2 June 18]93

Cher Maître,[1]

Here are some addresses of friends of Bourges and myself who would be glad to enhance with their presence the brilliance of your performance.

I hope I will not arrive too late and beg you to receive, with my thanks, my most cordial handshake.

H de Toulouse Lautrec

Prov.: Schimmel
Pub.: GSE 160, GSF174

[1] Evidently an actor, perhaps André Antoine who opened on 12 June, 1893 at the Théâtre Libre as Karalyk in Heijerman's play *Abasvere*.

300 *To Édouard Kleinmann*

[Paris, June 1893]

[1]*One Jane Avril*
 M. Kleinmann

Prov.: Wittrock
[1] Written by Lautrec on his visiting card.

301 *To an Unidentified Correspondent*

[Paris, June 1893]

[1]*Good for 2 Jane Avril ...*

Prov.: Unknown
Source: Charavay, Catalogue April 1962, No. 28701
[1] Written by Lautrec on his visiting card.

302 *To André Marty*

[Paris, late June 1893]

My dear Marty,

Please send two prospectuses, preface and some subscription[1] forms to M. *Gérard, 51 rue St. Joseph, Toulouse*, on behalf of M. Gauzi. Did you see Chincholle's[2] pointed remarks in his latest issue on his own *Estampe* dated the 23rd of this month. There is not much harm in it and we can do nothing about it.

Regards,
HTLautrec

How many subscribers do you have?

Please be so kind as to send me an imprint of your *stamp by Charpentier.*[2]

Prov.: Schimmel

[1] For *L'Estampe Originale*.

[2] Cf. Letter 291 Note 2.

[3] Alexandre Charpentier (1856–1909), sculptor, medallist, printer, and decorator. He drew one four-colour lithograph, *La Fille au violon*, for the *L'Estampe Originale* album in 1894 and also designed the blind stamp that appeared on all the prints.

303 *To André Marty*

[Paris, June–July 1893]

Dear Sir,

Please give the bearer the litho[1] by me that you have in your possession, so that it can be reproduced in the issue of *l'Art Français*[2] being prepared by Alexandre and me.[3] I shall return it to you in three or four days.

Regards,
HTLautrec

Prov.: Burg
Pub.: Schang, p. 55

[1] *Jane Avril* (Wittrock 18).

[2] *L'Art Français*, 29 July 1893. This periodical was edited by Firmin Javel (cf. Letter 386).

[3] *Celle qui danse* by Arsène Alexandre, illustrated with eight works by Toulouse-Lautrec (Dortu P.414, P.416–18, D.3338; Wittrock 18, P.6, P.11).

304 *To Firmin Javel*

[Paris] 25 June 1893

Dear Sir,[1]

I received a request from M. Roques, editor of the *Courrier Français*, asking me for permission to reproduce my *Jane Avril* poster.[2] As you are the first one I authorized to make this reproduction, I have let him know he should come to an agreement with you for your copies to come out simultaneously so as not to make the thing stale.[3]

This letter gives you full power so that if the *Courrier* should pull a fast one on you, we would be able to give the editor a rap on the knuckles, you, I, and Kleinmann.[4]

Please accept my sincerest regards.

HTLautrec
27 rue Caulaincourt

Prov.: Schimmel
Pub.: GSE161, GSF175

[1] Firmin Javel (b. 1842), playwright, journalist, and director of the magazine *L'Art Français*, published from 1887 to 1901.

[2] *Jane Avril au Jardin de Paris* (Wittrock P6).

[3] In fact, a reproduction of it appeared in *Le Courrier Français* on 2 July 1893, and in *L'Art Français* only on 29 July.

[4] Édouard Kleinmann, a print-dealer and publisher whose shop was at 8 rue de la Victoire. Between about November 1893 and 1895 he served as publisher of, and repository for, Lautrec's prints, as is suggested by Letters 310, 341, 351, 546.

305 *To his Mother*

[Taussat] Saturday [August–September 1893]

My dear Mama,

Here I am back in Taussat, having had a magnificent and lively trip.[1] The last day was hard, the men had to steer the boat through regular rapids over the rocks. We covered the whole distance from Cazaux to Mimizan[2] on our own, camping out and preparing our own grub. The lazier ones slept at the hotel(?), but paid for their relative comfort with bedbugs[3] and other nasty things. As for me, I divided my pleasures. Bourges was with us. It was intensely hot but with two or three bathes a day we were able to put up with it. I'm going to go back down there in a couple of weeks with some cormorants.

I'll come to Malromé on Tuesday or Wednesday, perhaps Thursday. I kiss you.

Yours,

H.

The wine has arrived safely.

Prov.: Schimmel
Pub.: GSE163, GSF177

[1] Together with Bourges, Fabre, Viaud, and Guibert, Lautrec travelled by train to Cazaux and thence by boat to Mimizan. Cf. Appendix II.

[2] Towns in the Department of Landes, near the Atlantic coast of France.

[3] Lautrec uses the word 'babaous', perhaps derived from 'babou', a child's expression for an ugly black insect. He often used the related words 'ouax rababaou', which he had invented: cf Joyant I 212.

306 *To Gustave Geffroy*

Chez M. Fabre, Taussat, Gironde [September 1893]

Dear Mr Geffroy,

For the past week I have been living half naked in an isolated little house by the sea. I did receive *Le Figaro*,[1] but since the issue appeared after my departure I was unable to reach M. Valadon and thereby

obtain an order. I shall be back in Paris in two months or three at most. I can get to work when I arrive, and our issue can come out in February for Carnival.[2] *See Joyant and Valadon and write to me.* Whatever you do I'll back you up if need be. In any case we would find a publisher to do an individual instalment of our project and perhaps a lithograph. At Kleinmann's, 8 rue de la Victoire, you can see my latest lithographs,[3] which are quite satisfactory as a method.

Write to me. Regards.

HTLautrec

Prov.: LA

[1] Gustave Geffroy, 'Le Plaisir à Paris, les restaurants et les cafés-concerts des Champs-Élyseés', *Le Figaro Illustré*, No. 40, July 1893. Lautrec did seven illustrations for this article.
[2] Gustave Geffroy, 'Le Plaisir à Paris, les bals et le carnaval', *Le Figaro Illustré*, No. 47, February 1894. Lautrec did six illustrations.
[3] Lautrec drew forty-five lithographs during 1893, at least twenty of which were distributed by Kleinmann (Wittrock 3–47).

307 *To René Wiener*

Taussat, Tuesday [August–September 1893]

Dear Sir,

All the originals of *Le Figaro*[1] belong to M. Valadon.[2] I can only urge you to contact him and I believe that Goupil[3] will be glad to be rid of the intransigencies of this sort that it has communicated to its reluctant public.

I shall send you the verso of our binding without delay.

Very cordially yours,
HTLautrec
Villa Bagatelle
Taussat par Audenge
Gironde

Prov.: Nancy
Pub.: *Annales*, p. 223

[1] *Le Figaro Illustré* (Boussod, Valadon & Cie, Paris), No. 40, July 1893. Lautrec prepared seven illustrations for this issue: *M. Caudieux, Acteur de café-concert* (Dortu P.473), *Aux Ambassadeurs: Gens chics* (P.477), *A l'entrée des Ambassadeurs aux Champs-Élysées* (P.480); *M. Prince, Acteur de café-concert* (P.481), *La Roue* (P.483), *Yvette Guilbert*, (A.203–204).
[2] Editor of *Le Figaro Illustré* and also partner in Boussod, Valadon & Cie, art dealers. In October 1890, on the hospitalization of Théo van Gogh, Maurice Joyant became gallery director of Boussod-Valadon.
[3] Goupil and Co., art dealers and publishers of reproductions, had been succeeded by Boussod-Valadon in 1875. The firm was then called Goupil-Boussod et Valadon successeurs.

308 *To René Wiener*

[Taussat, September 1893]

My dear Sir,

Here is the verso of the cover I promised you,[1] with the tracing of the line. I believe that the track of the crab on the sand will look good made up and will lend itself well to the thermocautery.[2]

I should have liked to do something better.

But we will on another occasion.

Have you come to an agreement with the Goupil people[3] regarding my drawings?

I hope you will be pleased with my crab, and I hope to hear from you shortly with news about our cover.[4]

Best regards,
HTLautrec

Prov.: Nancy
Pub.: *Annales*, p. 233

[1] *Crabe sur le sable* (Dortu P.513), which appeared on the finished binding. Another study for the verso was *Crabe mangeant une raie* (P.514).

[2] A bookbinder's process used by the School of Nancy binders.

[3] Cf. letter 307, Note 3.

[4] The completed binding was exhibited Au Cercle pour l'Art, Brussels, in 1894 and purchased by the Musée des Arts Décoratifs de Bruxelles.

309 *To Maurice Denis*

Taussat via Audenge, Gironde [September 1893]

My dear Denis,[1]

Thank you for your pretty, or rather, *beautiful* book,[2] which is one of the most complete art curios to be executed in a long time. However, it's pointless for me to compliment you, you know my high opinion of you, and I appreciate your faith in the opinion of a primitive like me. Please also convey my thanks to your collaborator Gide,[3] whose address I was unable to obtain.

Very cordially yours,
HTLautrec

Prov.: Denis

[1] Maurice Denis (1870–1943), painter, illustrator, writer, member of Nabis group, and art theorist.

[2] *Le Voyage d'Urien* by André Gide, Librairie de l'Art Indépendant (Paris, 1893), included thirty lithographs by Denis in black and white and in colour, printed by Edw. Ancourt.

[3] André Gide (1869–1951), essayist, critic, novelist, dramatist, and winner of the Nobel Prize for Literature in 1947. This book was one of his earliest, a youthful work influenced by symbolism.

310 *To Édouard Kleinmann*

[Taussat, September 1893]

Don't forget to keep Denis's book[1] for M. Guibert.[2]

My dear Kleinmann,[3]

Before your departure, please send M. Fabre[4] in Taussat the volume of Gide illustrated by Denis. I shall pay you for it in Paris. I wish you a pleasant vacation. Has the *Revue Encyclopédique*[5] given the *Divan Japonais?* If so, please send it to me.

With best wishes,
HTLautrec

Prov.: Spiro

[1] Cf. Letter 309 Notes 1 and 2.
[2] Maurice Guibert: cf. Letter 194 Note 3.
[3] Édouard Kleinmann: cf. Letter 304 Note 4.
[4] Louis Fabre: cf. Letter 238 Note 3.
[5] A French periodical which did not use Lautrec's *Divan Japonais* (Wittrock P.11) at the time but did use the lithograph *Oscar Wilde et Romain Coolus* (Wittrock 146) in 1896. On 1 March 1893, Raoul Sertat wrote a review of the Toulouse-Lautrec–Charles Maurin exhibition at the Goupil Gallery in the *Revue Encyclopédique*. They may have considered illustrating it with the *Divan Japonais* which was published in January. Cf. Letter 264 Note 2.

311 *To André Marty*

Taussat [September 1893]

My dear Marty,

Buy the paper, it will always be useful. As for me, I'm not ready yet, and I shan't be returning to Paris until early in October. I'll try to hurry when I arrive, but don't want in any way to do something that's mediocre, so I'll need time.

The *Echo de Paris*[1] is going to publish a series of lithographs on the concerts by Ibels and me—a special issue will contain reductions of these lithographs. *Text by Montorgueil.*

I'm bringing you a subscriber for the first year of *L'Estampe.*[2] It's my friend *Louis Fabre (Villa Bagatelle, Taussat, Gironde).* Please send him the past issues as soon as possible, and let him know which method of payment is best for you.

Cordially yours,
HTLautrec

I've just come from San Sebastián and I saw the riot.[3]

Prov.: Wittrock

[1] 'Le Café-concert', texte de Georges Montorgueil, dessins de H. G. Ibels et H. de Toulouse-Lautrec, *L'Écho de Paris*, supplément illustré, 9 December 1893.

[2] *L'Estampe Originale.*

[3] On the night of 27 August a mutiny broke out against the head of government, Práxedes Mateo Sagasta. Lautrec was staying at the Hotel de Londres y de Inglaterra where much of the action took place. He watched the insurrection that night from his hotel room and checked out the next morning without returning to the casino (where he had gone every day) and without returning to another bullfight. (Cf. Peña, p. 45–7).

312 *To Gustave Geffroy*

21 rue Fontaine [Paris] 10 October [1893]

[1] My dear Geffroy,

Here I am back in Paris and wanting to see you so that we can talk about our *bals*.[2] Please be good enough to set a time and place for me at your convenience.

Best regards,
HTLautrec

Prov.: LD

[1] Envelope addressed to Monsieur G. Geffroy, 113 ou 133 rue de Belleville, Paris.

[2] 'Le Plaisir à Paris: Les Bals and le carnaval', *Le Figaro Illustré*, No. 47, February 1894 (text by Geffroy and illustrations by Lautrec).

313 *To his Mother*

[Paris, October 1893]

My dear Mama,

Guibert is forwarding you by freight a banana plant that was going to be thrown onto the rubbish heap. You will have to follow his instructions concerning this delicate tree. If it dies, well, too bad.

I'm working a little; it's very hard to get going again. It's so nice doing nothing. I think that temporarily Bourges will keep the apartment we are in, while waiting for a position near or far from Paris, but in any case outside Paris. He hates the idea of leaving me alone, but a change had to be expected, sooner or later. It was too good. I'm going to take a little apartment in the neighbourhood,[1] and try not to be bored. For the time being I'm keeping the maid, who's perfect. MUM'S THE WORD ABOUT THE SECRET.

I kiss you.

Yours,
H.

Herewith a product of Guibert's.

Prov.: Schimmel
Pub.: GSE157, GSF163

[1] At 7 rue Tourlaque (cf. Letter 318 Note 2).

314 *To his Mother*

[Paris, October 1893]

['Lautrec writes that nothing has happened since his return to interrupt his cooped-up life.]

... I paint during the day, and in the evening I dine with friends or with Gabriel. I'm going to collaborate on two newspapers that are being established,[2] so long as they don't go bankrupt.

[He has just bottled his wine]

... which is very interesting, but less interesting than drinking it.

 H

Prov.: Unknown
 Source: Privat, Catalogue, June 1955, No. 2923

 [1] Fragment of a letter.
 [2] Probably *L'Escarmouche*, first published on 12 November 1893, and *Le Rire*, first published on 10 November 1894.

315 *To Roger Marx*

[Paris] Thursday [19 October 1893]

[1] My dear Marx,

 Maurin[2] my accomplice and myself will have the honour of presenting tomorrow, Friday, at 9 a.m., a brand-new creation.[3] Please give orders to let us in. The work is *Maurin's* and will interest you considerably.

 Sincerely yours,
 HTLautrec

Prov.: Schimmel
Pub.: GSE166, GSF178

 [1] Addressed to M. Marx, 24 rue St Lazare.
 [2] Charles Maurin: cf. Letter 269 Note 3.
 [3] Cf. Letter 323 Note 1.

316 *To Georges Montorgueil*

[Paris, Autumn 1893]

[[1]Lautrec writes[2] of his anxiety and disapproval of the government's plan to take over the Pavillon of the city of Paris,[3] reserved until then for independent artists,[4] and turn it into a museum. Painters would have no place to show their works.]

... I don't need to remind you of the difficult beginnings of the Indépendants, their unflagging energy since 1884, their permanent success ...

[He approves]

... that freedom of exhibition which only the Société observes without restrictions so that for the sum of 1.25 francs a month any painter gets equal space in which to show ...

[He is angry at this society that is]

... only a fraction of art, destined to sink under the weight of the imbecility of its jury, which is imbecilic, just as all juries are ...

[He states a ruling that]

... a show open to everybody ...

[is a matter of public utility would have to be handed down, replacing]

... the propping up of that routine known as the Salon ...

[He says in any case he would like the Pavillon to be left to the Indépendants]

... until 1900 when it is to disappear and become part of the Exposition ...[5]

[He offers additional information, and notes that his address is 21 rue Fontaine.]

Prov.: Unknown
Source: Drouot, Auction 20 May 1976, No. 80

 [1]Fragment of a letter, probably written in the autumn of 1893.
 [2]Georges Montorgueil (1857–1933), a French author who wrote the text for *Le Café Concert album* published by *L'Estampe Originale*, André Marty, in 1893, lithographs by Lautrec (Wittrock 18–28) and Ibels. Among his many other books were *La Vie des boulevards* (1896), *La Parisienne* (1897), *Paris dansant* (1898), and *La Vie à Montmartre* (1899).
 [3]The Pavillon de la Ville de Paris was then situated behind the Palais de l'Industrie on Cours-La-Reine. Designed by Bouvard, it was built of iron, brick, and ceramic for the Exposition Universelle of 1878 and was then being used for various exhibitions.
 [4]The Société des Artistes Indépendants exhibited at the Pavillon in 1884, 1887, 1888, 1890, 1891, and 1892 and used it for the last time in 1893.
 [5]The Exposition Universelle de 1900. In March 1893 the commission definitely decided to keep the Exposition in the centre of Paris and in 1895–6 there was a debate over the destruction of the Palais de l'Industrie. It was demolished in 1898, with all around it, to provide space for the Grand Palais, Petit Palais, etc.

317 To Gustave Geffroy

[Paris] Monday [23 October 1893]

My dear Geffroy,

Pardon my delay in replying, but I would like to talk with you tomorrow, Tuesday, at 6 o'clock. I will come and look you up at the *Justice*[1] offices, and I hope not to have lost anything by having waited.

Yours,
HTLautrec

Prov.: Schimmel
Pub.: GSE164, GSF182

[1] *La Justice*, a liberal newspaper directed by Georges Clemenceau (1841–1929), for which Geffroy wrote regularly. Lautrec's letter is addressed to him at the offices of *La Justice* at 10 faubourg Montmartre.

318 To his Mother

[Paris] Monday [23 October 1893]

My dear Mama,

Long live Russia!!! And, strangely, there's such a patriotic or international fervour that this week-long 14 July hasn't been tiring. Of course I had to put up with being kept waiting here and there a half-hour at a time, but it was a question of the European balance of power[1] and I put a good face on it. The policemen themselves tried to be decent and that's not saying a little. Anyway, *they*'re leaving tomorrow, probably tired out. Now let us talk seriously. At a price of 800 francs I've rented for one year the ground-floor apartment in the house next to my studio,[2] same owner. this way I can look ahead, either to renting the ground-floor of my studio and moving in completely, or to finding another studio with an apartment. I doubt I could get the same space for the same price. The advantage is that I know the tenants, the concierge, the owner, etc. . . . For the time being Bourges will occupy our present apartment with his wife,[3] waiting for the probable position at *Suez* (20,000 francs), which is not to be sneezed at. He has plenty of pull and hopes to get it.

If you could make me a present of 6 small-size tablecloths and some table napkins you would oblige me very much, as I'm going to have to stock up. I'm keeping my old maid and find that with an outlay of forty francs a month I have all the advantage of having my clothes mended and lunching at home. I'm counting on taking possession of my quarters at the end of January, because they're going to renovate them under my direction.

I am working as much as possible under these conditions and I have a poster to do for the newspaper *Le Matin*.[4] I'm glad that M^lle the Cat is nice and amuses you a little.

I kiss you.

Your
H.

Mum's the word on the secret, of course.

P.S. Some very ordinary table knives would also be a great help. In sum, I'm getting married without a wife. The package has arrived in good shape.

Prov.: Schimmel
Pub.: GSE162, GSF176

[1] Lautrec is comparing the 14 July celebrations to those for the Russian visit. From 13 to 27 October a Russian naval squadron paid an official and ceremonial visit to Toulon. The Russian admiral and sailors arrived in Paris on 17 October, the first day of celebrations began on 18 October.

[2] At 7 rue Tourlaque, where Lautrec finally moved in January 1894.

[3] Cf. Letter 331 Note 1.

[4] *Au Pied de l'échafaud* (Wittrock P.8), made to advertise the serialization in *Le Matin* in autumn 1893 of the Abbé Faure's book of that title.

319 *To André Marty*

[Paris, November–December 1893]

My dear Marty,

Desboutin[1] told me that he wants to appear in the first issue of the second year of *l'Estampe*.[2] Talk to him about this. You'll find him between 3 and 4 at 15 rue Bréda.[3]

Regards,
HTLautrec

I should like four copies of the *Concert*[4] at market price. Have them sent to 21 rue Fontaine *with the invoice*.

Ducarre[5] asked me for a copy. Don't you think we should give it to him free of charge? See Ibels about this.

Prov.: Private, Paris I

[1] Marcellin Desboutin (1823–1904), French printmaker and friend of Degas and Lautrec. He presented an etched portrait of Degas to Lautrec ('A l'Ami Lautrec—Desboutin 1892', Collection Schimmel).

[2] *L'Estampe Originale*, vol. V, the first volume of 1894. Desboutin's prints never appeared in that volume or any other.

[3] Probably at La Souris, a lesbian restaurant on the rue Bréda.

[4] *Le Café-concert* (Wittrock 18–28).

[5] Pierre Ducarre, Director of Ambassadeurs and Alcazar d'Été, appeared in *Le Café-concert, Ducarre aux Ambassadeurs* (Wittrock 26).

320 *To an Unidentified Correspondent*

[Paris] Monday [27 November 1893]

My dear Sir,[1]

I shall be at my studio tomorrow, Tuesday, and the day after, Wednesday, from 3 to 4 o'clock. I should like to show you my drawings before taking them to M. Valadon's[2] place. Please be so kind as to tell me when you will be able to come, and tell me what your schedule is if these times would not be convenient for you.

Please drop me a line.

Regards,
HTLautrec

Prov.: Unknown
Source: Drouot, Auction 18 December 1985, No. 398

[1] Possibly René Wiener (cf. Letters 307, 308).
[2] Editor of *Le Figaro Illustré*. Reference is to the illustrations that would appear in February 1894 (cf. Letter 307 Note 2).

321 *To Gustave Geffroy*

[Paris, Tuesday, 28 November 1893]

My dear Geffroy,

I've just seen Joyant. who told me that he would come with you and that he was at our service. You'll only have to pick him up on the way. I will be home tomorrow Wednesday, Thursday, and Friday BETWEEN 4 AND 5 O'CLOCK. I hope that you will be able to come as the case is *pressing* and Valadon[1] would think me very much overdue.

Cordially yours,
HTLautrec

Prov.: Schimmel
Pub.: GSE165, GSF179

[1] Cf. Letter 320 Note 2.

322 *To Gustave Geffroy*

[Paris] Wednesday [November 29 1893]

[1]My dear Geffroy,

My designs[2] are too big to carry, but I'll be at my studio at *4 o'clock—today* and tomorrow, all afternoon. Come and see them, please.

Cordially yours,

HTLautrec

We must be ready on 2 December.

Prov.: Schimmel
Pub.: GSE167, GSF183

[1] Addressed to Geffroy's home at 133 rue de Belleville, Paris.
[2] These are six paintings made to be reproduced in colour to illustrate Geffroy's article, 'Le Plaisir à Paris: Les Bals et le carnaval', in *Le Figaro Illustré*, No. 47, February 1894.

323 *To his Mother*

[Paris, November 1893]

My dear Mama,

I'm very happy about your last letter, which shows we have done well not to show our hand. I'm very busy and printing with might and main.

I have just *invented* a new process[1] that can bring me quite a bit of money. Only I have to do it all myself. . . . My experiments are going awfully well. We have just founded a periodical.[2] In short, you can see all is well. There's only the bother of moving and getting settled in again, which is the cloud, not black but grey, on my horizon. Keep on not saying a word to anybody about all that business, and I kiss you.

Yours,

H.

Prov.: Schimmel
Pub.: GSE168, GSF184

[1] Shooting paint from a pistol at a canvas or more often a lithographic stone, thus producing a spatter effect (the so-called 'crachis'). Lautrec worked on it with Charles Maurin, and Geffroy brought it to Edmond de Goncourt's attention: cf the Goncourts' Journal, 2 September 1894.
[2] The newspaper *L'Escarmouche*, founded with Lautrec's encouragement by Georges Darien (1862–1921), a journalist and writer, on 12 November 1893. Lautrec published twelve lithographs in it in 1893 and 1894 (Wittrock 30–41).

323A *To his Mother*

[Paris, Autumn 1893]

[1]My dear Mama,

I don't have much to tell you … I have worked like a black having to keep watch over 3 machines and working flat on my *back* under the Printing Press.[2] I've finally finished and believe I have success at hand. Raoul has just announced to me his marriage,[3] you must have heard of it. That is good. It is still better than to remain stagnant. Write me a word to tell me if I can quickly send you little Dora. Mercy obliges me to remove her at once, for the neighbours have tried to poison her older sister and her mother—it would be regrettable. I will send her to you quickly and you can pick her up on the morning train. Boulett[4] will only be able to be kind to *her* because they are the same sex, but I would pity future burglars venturing in your corridors—her father is a formidable watchdog.

Henri

[Lautrec wrote above the salutation, near a drawing (not in Dortu) of a man's shirt:]

Answer quickly, have 6 red flannel shirts made for me, with wide collars and large buttons. All the buttonholes should be horizontal.[5]

Prov.: Unknown
Source: J. M. Maddalena, Catalogue 4 (1988), No. 97

[1] Fragment of a letter.
[2] Lautrec was working on many lithograph prints and posters at this time, including the hand-coloured *Loïe Fuller* (Wittrock 17), on which he assisted the printer. The working problems mentioned have not been explained.
[3] Raoul Tapié de Céleyran married in 1893, and his wife was pregnant with their first child Jacques in 1894. Cf. Letter 349 Note 2.
[4] Boulett is mentioned in Letter 442 and would seem to be a dog.
[5] Lautrec may be wearing one of these shirts in the portrait of him painted by Édouard Vuillard in 1897, *Portrait en pied de Toulouse-Lautrec* (Dortu Ic.74).

324 *To Gustave Geffroy*

[Paris, 1 December 1893]

[Giving Geffroy an appointment at the Grand Café where he will also meet Suzanne Valadon.[1]]

Prov.: Unknown
Source: Berès New York, Catalogue 5, 1941, No. 228

[1] Suzanne Valadon (1865–1938), artist, model for Renoir, Degas, and Lautrec, and mother of the artist Maurice Utrillo (1883–1955). Lautrec painted two portraits of her (Dortu P.249–50).

325 *To Octave Maus*

[Paris, December 1893]

[1]My dear Maus,

I'm not promising you anything as regards Degas, he's quite unapproachable. But I'd like to propose the following to you: Our magazine, *l'Escarmouche*[2] publishes original lithographs by Ibels, Vallotton, Bonnard, Anquetin, and me. At La Libre Esthétique[3] we could have a separate shop window for us magazine people, and our director, Darien, is very ready to go to Brussels for conferences. Will this be all right for you.

<div align="right">Regards,
HTLautrec</div>

Write to Darien about this

Prov.: Brussels

[1] Written on the letterhead of *L'Escarmouche*, 15 rue Baudin, Paris.

[2] *L'Escarmouche* (Directeur Georges Darien; Première année: No. 1, 12 November 1893; No. 8, 31 December 1893; Deuxième année: No. 1, 7 January 1894; No. 2, 14 January 1894): a weekly illustrated journal that published ten issues to which Lautrec contributed twelve illustrations (Wittrock 30–41).

[3] La Libre Esthétique, Première Exposition, Brussels, 17 February to 15 March 1894. From *L'Escarmouche* eleven original lithographs and two posters were exhibited numbers 473–85. These included two by Toulouse-Lautrec, *Mlle Lender et Baron* (Wittrock 33) and *Sarah Bernhardt* (Wittrock 37).

326 *To André Marty*

[Paris] Sunday [10 December 1893]

[1]Meeting tomorrow at SIX O'CLOCK at *La Justice* to decide on Yvette[2] with Geffroy. The matter is settled. I shall be in my studio until a quarter to six, and at Ancourt's in the morning.

<div align="right">Yours,
Lautrec</div>

Prov.: Private, Paris I

[1] Carte-télégramme to M. Marty, 17 rue de Rome.

[2] This appears to be Lautrec's initial letter regarding the Guilbert Album, a collaboration of Lautrec, Guilbert, Marty, and Geffroy. Cf. Letters 327, 328, 334, 337, 337A, 348, 354, 355, 356, 357, 358, 365, 366, 367, 368, 374, 374A, 376, 379, 380, 381, 382, 385.

327 *To André Marty*

[Paris] *Sunday* [10 December 1893]

[1]My dear Marty,

When you come to *La Justice* tomorrow MONDAY please bring with you some samples of your printer's type so that Geffroy can make a choice. He strongly recommended it.

Yours,
HTLautrec

Prov.: Private, Paris I

[1] Carte-télégramme addressed to A. Marty, 17 rue de Rome.

328 *To Gustave Geffroy*

[Paris] Friday [December 1893]

My dear Geffroy,

Marty is delighted to have your Yvette Guilbert plan executed. Prepare the plaquette when you can. I'll do the same for the drawings. Now, what do you want to entitle it. *Please drop me a line* about this for the announcement just plain 'Yvette' wouldn't be bad.

According to Yvette, a little bit Belgian. Take a look and let me have your answer.

Regards
HTLautrec
21 rue Fontaine

P.S. It seems that we're going to be in *Le Figaro* in February.[1]

Prov.: Private, New York I

[1] Cf. Letter 322 Note 2.

329 *To his Mother*

[Paris] 21 December 1893

My dear Mama,

I think I'll wait till the end of January to go to the lovely town of Albi. I have an enormous lot to do: two posters to deliver before 15 January and which are still not started.[1] I will also go to Brussels in February about the 4th or 5th,[2] almost upon returning from Albi, which will allow you to stay a little longer with the family. Louis is as well as can be expected. As for the rest of the family, I see only J.[3]

from time to time. He is very much improved and is less of a Quixote. Gabriel is working steadily. We have dinner together once or twice a week. I'm doing his portrait on Sundays.[4] We haven't had any snow yet here. At the printer's, I meet Prouho,[5] the widower, who has also turned to doing lithography and is a very nice fellow. M. de Mathan[6] also paid me a call and introduced me to his son, a painter. Other than that, I am doing nothing for him.

I kiss you and would like you to tell me what Kiki needs. Have it sent if you have an address, you can do that better than I.

<div align="right">Your
H.</div>

Prov.: Schimmel
Pub.: GSE169, GSF185

[1] Probably *Babylone d'Allemagne* (Wittrock P.12), issued in February 1894, and *Confetti* (Wittrock P.13).

[2] Lautrec was in Brussels and Amsterdam from about 12 to 21 February 1894: cf. Letters 335, 338, 342, 343, 344.

[3] Presumably Joseph Pascal.

[4] It shows him standing in a corridor of the Comédie Française, and was completed in 1894. It is now in the Albi Museum (Dortu P.521).

[5] Prouho was related to Louis Séré de Rivières, a relative of Lautrec's.

[6] Raoul de Mathan, an artist born in Albi, who specialized in Provençal landscapes.

330 *To his Mother*

<div align="right">[Paris, December 1893]</div>

My dear Mama,

Bourges is leaving in three days for these great operations and I am going to do my best to move in as soon as possible. All these mundane matters bore me to death, and my back really has to be to the wall before I do something about them. But my calculations were accurate, the maid and the apartment will cost me around 6 francs a day, which is the price of a mediocre hotel, so there's no reason for hesitation. Even if I have to move later. Your travel delays are putting me off until later, and I can easily go to see you there in Albi. Gabriel too. I should prefer to go at the end of January, after I've finished moving.

The Christmas issue of the *Figaro* isn't worth buying. We've just brought out an album on the *Café-concert*[1] which is selling well.

I kiss you,

<div align="right">Yours,
H.</div>

I've just been vaccinated, and it took. Incidentally, there's quite a bit of smallpox in Paris.

Prov.: Schimmel

[1] *Le Café-concert* (text by Georges Montorgueil, 22 lithographs, 11 by Lautrec (Wittrock 18–28) and 11 by H. G. Ibels), published by *L'Estampe Originale*, André Marty.

331 *To his Mother*

[Paris, December 1893]

My dear Mama,

Let us start with a *merry* (relatively) Christmas and happy New Year,[1] in other words best wishes of the season. Gabriel must have given you news of me, good news, moreover. It's too bad I can't go to Albi, because you will have to rush your Paris trip or not see me, which would be unpleasant for you and especially for me, since other than Gabriel, I don't see many people except for those who don't matter.

Now another theme. I've just made my year-end count. With the meagre Ricardelle harvest, I'll hardly make till April and then only by keeping to the straight and narrow. So, you will have to put the famous reserve, already dented, at my disposal. The best thing will be to deposit it, at the Crédit Lyonnais, for instance. Tell me what you think of all this and kiss the grandmas for me, to whom I'm going to write.

Your boy,
Henri

Prov.: Schimmel
Pub.: GSE158, GSF164

[1] Lautrec writes these phrases in English.

332 *To Mme R. C. de Toulouse-Lautrec*

[Paris] Friday, 29 December [1893]

My dear Grandma,

I intended to go and spend New Year with you, but it's impossible to leave Paris before the 15th, at which time I'm counting on coming to my home town to warm my feet by the fire for a little, a smile on my lips. Which again leaves me obliged to wish you a happy New Year by letter. You will be seeing, or have seen, the celebrated Doctor Gabriel, who will have told you about our numerous labours, he bloodthirsty, I a printer. He may have told you, perhaps, that since my friend Bourges is getting married I'm forced to change my apartment, which is not very amusing. But I have found very suitable quarters in the same house where my studio is.[1] I shall have the ineffable

pleasure of keeping my own household accounts and knowing the exact (?) price of butter. It's charming.

Please remember me to all and I kiss you, and count on me to see you soon.

Happy New Year.

Your respectful grandson,
H de Toulouse Lautrec
21 rue Fontaine and, after 15 January, 27 rue Caulaincourt

Prov.: Schimmel
Pub.: GSE170, GSF186

[1] Cf. Letter 318 Notes 2 and 3.

333 *To Roger Marx*

[Paris, 8 January 1894]

[1] My dear R. Marx,

Please have some large-size photographic paper sent to Ancourt. We have exhausted your supply. 83 faubourg Saint-Denis.

Yours,
HTLautrec

Prov.: Schimmel
Pub.: GSF187

[1] Written on the letterhead of Impressions lithographiques, J. Marie, Edward Ancourt & Cie, 83 rue du Fg-Saint-Denis, Paris 10ᵉ, in an envelope printed with the same information, and addressed to M. R. Marx, 24 rue Saint-Lazare, Paris 9ᵉ. This probably refers to the printing of *Aux Ambassadeurs*, which was to be published in *L'Estampe Originale* (Wittrock 58).

334 *To André Marty*

[Paris, January 1894]

My dear Marty,

This is to tell you two things. First, Ondet[1] asked me to use for the catalogue of Edmée Lescot the drawing of her that appeared in the *Café-Concert*[2] and was not erased. I myself have no objections, as I have already done the same thing for Jane Avril[3] in the *same Caf' Concert*.

2. Gallimard[4] wants you to create the Yvette volumes (for a good price, naturally). See Geffroy about this and make him stick to it.

<div style="text-align: right">

Yours,
HTLautrec
</div>

Prov.: Scott

[1] Georges Ondet, Éditeur, 83 faubourg Saint-Denis, publisher of sheet music and books relating to music. This was the same address as Lautrec's printer Ancourt and Stern.

[2] *Le Café-Concert* (Wittrock 18–28). Edmée Lescot; Parisian who danced in a Spanish style at the Ambassadeurs.

[3] *Jane Avril* (Wittrock 18), first song-sheet edition 1894.

[4] Librairie Gallimard, a French publishing house. They did not publish or distribute the Yvette Guilbert albums.

335 *To his Mother*

<div style="text-align: right">

[Paris] Friday [January 1894]
</div>

My dear Mama,

We're having a bone-chilling cold. 12° below zero. So I stayed in bed this morning like a marmot, not having the spunk to go to work. I've had your news through Gabriel, but I'm afraid you'll be as weatherbound in Bosc as in the Land of Furs. I still don't know a thing as regards my trip. It would be the end of January or the first of February that I'd come to Albi, and take off from there to spend a week in Belgium.[1] So, you can take it easy and not arrive in Paris until about 15 February. By merest chance I ran into the son of Mme Bourgaux, *née* Piédevache, who was so nice at Barèges of baneful memory. She can't have changed much. She's at Monte Carlo, to get over the death of her daughter. He paints.

I give you a chilly kiss and am going to have lunch.

<div style="text-align: right">

Yours,
H.
</div>

Bourges ought to be back on the 15th.[2]

Prov.: Schimmel
Pub.: GSE171, GSF188

[1] Cf. Letter 329 Note 2.

[2] He had recently married and was returning from his honeymoon.

336 *To Octave Maus*

[Paris, January 1894]

My dear Maus,

As soon as I join, you will receive from me *Bruant, Jane Avril, Caudieux*,[1] plus two top-notch Chérets:[2]

1. *The Eiffel Tower*
2. *The Rainbow*.

Later I shall send you a *Loïe Fuller* printed in a hand-done manner. The price of the Loïe print is 50 francs—all this for the Catalogue. Also, Marty is to send you the *Café-Concert* pictures[3] for showing at the Esthétique and for sale if possible. Please confirm to me that these various items have arrived safely.

<div align="right">Very cordially yours,
HTLautrec</div>

Ibels[4] is to send you a few small pastels, and he will tell you in advance.

<div align="right">Your HTL</div>

Prov.: Brussels

[1] La Libre Esthétique, Première Exposition, Brussels, 17 February to 15 March 1894. Lautrec exhibited Nos. 447–50: *Jane Avril* (Wittrock P.6); *Caudieux* (Wittrock P.7); *Bruant* (*avant lettre*) (Wittrock P.9); *Loïe Fuller* (Wittrock 17).

[2] Jules Chéret exhibited Nos. 88–93: *La Tour Eiffel* (affiche avant lettre); *L'Arc-en-ciel* (affiche avant lettre) (B.123, M.111); Quatre panneaux décoratifs: A. *La Pantomime* (B.60, M.53); B. *La Musique* (B.61, M.54); C. *La Comédie* (B.63, M.56); D. *La Danse* (B.62, M.55).

[3] No. 472, *Le Café-concert*, published by André Marty, suite of lithographs by H. G. Ibels and H. de Toulouse-Lautrec (Wittrock 18–28).

[4] Henri-Gabriel Ibels exhibited Nos. 237–39: *Comme on aime*; *L'Oubliée* (pastel); *L'Amour s'amuse* (suite de six lithographies).

337 *To André Marty*

[Paris, January 1894]

[1]My dear Marty,

I came to talk very seriously about our Yvette. Please be so kind as to fix a date for a meeting with me in the rue Caulaincourt, where I am now staying.[2] I have some proofs to be inserted into the text. I shall be at Ancourt's tomorrow afternoon, Tuesday, around three o'clock. Try to come.

<div align="right">Yours,
HTLautrec</div>

Prov.: Private, Paris I

[1] Addressed on letterhead of *La Patrie*, rue de Croissant 12, Paris 18ᵉ, a newspaper that became anti-Dreyfus later in the year and thereafter.

[2] Lautrec moved to 7 rue Tourlaque (27 rue Caulaincourt) in January 1894.

337A *To André Marty*

[Paris] Tuesday evening [early 1894]
[1]Arranging for an appointment to discuss the cost of this[2] publication.
Come meet next Saturday at my studio at 3 p.m. or between 2.30 and
3 would be fine. Thank you for your part.

HTLautrec
rue Caulaincourt

Prov.: Unknown
Source: Sotheby's, New York Auction, 3 and 4 November 1988, No. 582. Letter included
in a unique edition of *Au Pied du Sinaï* (Wittrock 187–201).

[1] Fragment of a letter.
[2] This letter is more likely discussing the Yvette Guilbert Album than *Au pied du Sinaï*, as suggested
by Sotheby's.

338 *To his Mother*

[Paris] Sunday [28 January or 4 February, 1894]
My dear Mama,

I've nearly finished moving out, the question of moving in remains.
I'm going to buy pots and pans, etc., etc., and when we see each other
again you'll let me use some of the money you have for me for these
extra expenses. I hope to get out of it for 500–600 francs. Maid's
furniture, kitchen utensils, crockery, wardrobe, etc. ... As for my new
quarters, they are spacious enough. I'm still hopeful about the little
dream town house, but the owner is reluctant about doing repairs.
Another subject. Tell Balade to send me some wine addressed to 7 rue
Tourlaque so I can have it bottled about the end of the month. Let
him fix it so I'll get it between the 10th and the 15th.

I'm going to Brussels around the 12th and will be back between the
15th and the 20th.[1] I don't think it would be at all convenient for me
to go to Albi at present and I'll wait for you. I'd prefer you to come
before 10 February, because I won't be away long and I'd very much
like to talk with you a little and *to see you*.

Try to arrange that. I'll go to see the grandmas at Easter with
Gabriel.

My poor head is full of numbers, although I've made some progress
in that direction.

I'm expecting Bourges at the end of February.[2]

Yours,
H.

Reply quickly.

Prov.: Schimmel
Pub.: GSE174, GSF191

[1] The first exposition of La Libre Esthétique, the successor to Les XX, opened on 17 February 1894. Lautrec showed four items: the posters *Jane Avril* (Wittrock P.6), *Caudieux* (Wittrock P.7), and *Bruant* (Wittrock P.9), and the lithograph *Loïe Fuller* (Wittrock 17). His work was also included in the albums *Le Café-concert* (Wittrock 18–28) and from *L'Escarmouche* (Wittrock 33 and 37). Cf. letters 339, 342, 344, 346.
[2] Cf. Letter 335 Note 2.

339 To Octave Maus

[Paris, early February 1894]

My dear Maus,

In my catalogue I forgot to include a small *Loïe Fuller* of mine. If possible, correct this oversight.[1] However, I believe I did tell you about a colour lithograph of Loïe, priced at 50 francs. In any case I'm going to have it sent to you directly at 27 rue du Berger.

Yours,
HTLautrec

Prov.: Brussels

[1] The oversight was corrected and the Loïe Fuller was included in the catalogue. Cf. Letter 336 Note 1.

340 To André Marty

[Paris] 7 February [1894]

My dear Marty,

I shall greatly appreciate your paying me on Monday or Tuesday for the *Loïe Fuller*,[1] which is 40 francs, and the cover,[2] which is 200 francs. I just got cleaned out, and I have to settle all my accounts. I'm counting on you.

Sincerely,
H. de Toulouse-Lautrec

The sooner the better.

Prov.: Schimmel.

[1] *Loïe Fuller* (Wittrock 17), published by Marty in 1893.
[2] Cover for *L'Estampe Originale* (Wittrock 13), published by Marty in 1893.

341 *To Édouard Kleinmann*

[Paris, 9 February, 1894]

Dear Sir,

Madame Jane Avril[1] will be at your place today at 1 o'clock. Will you please give her two of her posters.[2]

Yours truly,
HTLautrec

Prov.: Schimmel
Pub.: GSE175, GSF192

[1] Jane Avril (1868–1943), a popular dancer at the Moulin Rouge and other cabarets in the 1890s. As a friend and favourite subject, Lautrec portrayed her in twenty paintings, fifteen drawings, one lithograph, and two personal posters.
[2] *Jane Avril au Jardin de Paris* (Wittrock P.6).

342 *To Octave Maus*

[Paris] 9 February [1894]

My dear Maus,

When is the opening of La Libre Esthétique?[1] Please let me know the date as soon as possible so that I can make arrangements for my departure.

Very cordially yours—and answer me by return mail!!

H. de T. Lautrec
27 rue Caulaincourt

Prov.: Brussels

[1] The Exhibition opened on 17 February 1894.

343 *To his Mother*

Amsterdam, Thursday [15 February, 1894]

My dear Mama,

For three days we've been in the midst of Dutchmen[1] who hardly understand a word you say. Fortunately the little English I know and *pantomime* get us along. We're in Amsterdam which is an extraordinary city, *the Venice of the North*, because it's built on piles. We're travelling, Baedeker in hand, among the wonders of the Dutch masters, which are a mere nothing compared with nature, which is *unbelievable*. The amount of beer we're drinking is incalculable, and no less incalculable the kindness of Anquetin, whom I cramp with my small, slow person[2]

by keeping him from walking at his own pace, but who makes believe it doesn't bother him.

And soon all the details. Saturday or Sunday.

Yours,
Harry

Prov.: Schimmel
Pub.: GSE176, GSF193

[1] From 12 to 20 February, Lautrec travelled in Belgium and in Holland with the painter Anquetin and probably Joseph Albert. Cf. Letter 344.
[2] One of the few allusions to his deformed legs.

344 *To Octave Maus*

[Brussels, Friday] 16 February [1894]

My dear Maus,

Where is the La Libre Esthétique show being held? So that I can go there tomorrow morning around 9. I hope to see you there. I shall be very grateful to you if you invite my friend J. Albert[1] to the dinner in the evening. He is a student of P. de Chavannes, and my travelling companion, and I can't very well leave him alone. I thank you in advance, as I'm sure you will arrange it in the best way possible.

Yours,
HTLautrec

Friday at the *Grand Hotel*.

Prov.: Brussels
[1] Joseph Albert.

345 *To his Mother*

[Paris] Wednesday [21 February 1894]

My dear Mama,

I found your letters when I reached Paris last night and got the last one this morning. No comment, except that you know I'm with you in spirit if not in the flesh, and if I thought my presence would serve any purpose I'd be with you. Moreover, I am at your service when you want me—my disillusion in not finding you here was great, as you can very well imagine.

So, my *admirable* trip has a sad ending. It's useless to list for you the beautiful things I saw, with an experience of art acquired little by little, which means that I had a fine week-long lesson with Professors

Rembrandt, Hals, etc. The Belgians, as usual, were always nice. Anyway, we'll talk about all this again, a little more cheerfully, I hope. And I kiss you for everybody and for yourself.

<div align="right">
Yours,

H.

7 rue Tourlaque
</div>

Prov.: Schimmel
Pub.: GSE177, GSF194

346 *To Eugène Boch*

<div align="right">
[Paris] 21 February [1894]
</div>

[1]My dear Friend,

I'm just back from Brussels and Holland for the opening of 'La Libre Esthétique', which has replaced the Vingtistes. Maus,[2] more pompous than ever, was in charge of the thing. Tell MacKnight[3] to come and see me in Paris and perhaps we can organize something for him. The Indépendants[4] have no gallery and are having no luck trying to find somewhere to leave their daubs. Personally it's all the same to me as I'm wrapped up in lithography. The Peintres-Graveurs[5] have also been kicked out of Durand-Ruel's[6] and the official salons are of such little value ...

In sum, we'll try to muddle through, but I haven't much confidence.

Goodbye, my friend, and see you soon, I hope. Make the most of the sun, what there is of it; here it's as cold as Greenland.

<div align="right">
Yours,

HTLautrec

27 rue Caulaincourt
</div>

Prov.: Schimmel
Pub.: GSE178, GSF195

[1] The letter is addressed to Boch at Pollensa on the island of Mallorca.

[2] Octave Maus; cf. Letter 151 Note 1.

[3] W. Dodge MacKnight (1860–1950), an American painter, and, like Boch himself, a friend of van Gogh, in whose correspondence he is mentioned several times.

[4] The Société des Artistes Indépendants, founded in 1884, with whom Lautrec had exhibited annually from 1889 on. Cf. Letter 316.

[5] The Société des Peintres-Graveurs Français, founded in 1891. In 1893 Lautrec had exhibited two posters with them.

[6] Durand-Ruel; cf. Letter 163, Note 2.

347 To René Wiener

[Paris, Spring 1894]

Dear Sir,

I have not yet found the Yvette[1] of your dreams. All I have is drawings that are not sufficiently simple and which would not be worth executing. I shall show them to you on your next trip, but I hope that by then I will have sent you the real thing.

I am sending* the great sculptor Desbois[2] (70 rue des Plantes, Paris Montrouge) to you. This very great artist made my buckle. You would make the belt according to his designs and you would exhibit at the Champ-de-Mars together. I am the author of this marriage and I think it is a good one.

Sincerely and best regards,
HTLautrec

* Look him up if he has not already written to you.

Prov.: Nancy
Pub.: *Annales*, p. 224

[1] Yvette Guilbert portraits were included among the paintings and watercolours by Lautrec that Wiener was interested in acquiring from Boussod-Valadon. Cf. Letter 307.

[2] Jules Desbois (1851–1935), sculptor, winner of a Gold Medal at the Exposition Universelle, Paris 1889, had exhibited at the Champ-de-Mars in May 1893, No. 301.

348 To André Marty

[Paris] *Tuesday* [20 March 1894]

[1]My dear Marty,

Geffroy cannot come tomorrow, Wednesday. So our excursion is postponed to Thursday, same place, same time—six-thirty at *La Justice*, or 7 o'clock at 7 rue Tourlaque.

Yours,
HTLautrec

Prov.: Private, Paris I

[1] Telegram addressed to A. Marty, 25 rue d'Argenteuil au 'MATIN'.

349 *To his Mother*

[Albi] Monday [26 March 1894]

My dear Mama,

I'm forwarding a bulletin from Albi which, as you can well imagine, has little in it. Your mother is sprightly and Grandma Gabrielle is being very kind to me. Papa is hawking up phlegm and rubbing himself with oil of terebinth. We were invited today to Vigan,[1] but he lost his nerve at the last moment and I am going alone with Grandma.

Yesterday I attended all the archiepiscopal and papal benedictions. It was very beautiful. Fat Raoul[2] arrived with his wife, whose girth is also growing, but for other reasons.

The sewing machine has done marvels. The only one missing on parade is Toto, his leave having been postponed till later. No *significant* exchange yet between Papa and me.

I kiss you.

Your
HTL

La Vie Parisienne[3] came. Thanks.

Prov.: Schimmel
Pub.: GSE84, GSF85

[1] A town in the Department of Gard, on the road from Albi to Nîmes.
[2] Raoul Tapié de Céleyran, who had married Elisabeth de Lavalette. Their daughter Mary, later the Countess d'Attems, was the author of *Notre Oncle Lautrec* (cf. Bibliography). Their first child, Jacques, was born in 1894.
[3] A periodical of 'mœurs élégantes et choses du jour', founded in 1863.

350 *To Paul Durand-Ruel*

[Paris, 14 April 1894]

My dear Sir,[1]

I was astonished to find your card. But I had waited in vain for a model and was so sound *asleep* that I didn't hear you.

If you have something urgent to tell me, please drop me a line and my time will be yours.

In the morning, or any day after 5. Please forgive me for being asleep.

Yours,
H de T Lautrec

P.S. The fact that I intended to go to talk with you about our show[2] makes me regret my deafness all the more.

Prov.: Durand-Ruel

[1] Telegram addressed to Monsieur Durand-Ruel, 35 rue de Rome.
[2] Toulouse-Lautrec—Lithographies chez Durand-Ruel, 5–12 May 1894.

351 *To Édouard Kleinmann*

8 rue de la Victoire [Paris, April–May 1894]

[1] M. Kleinmann
is requested to give the bearer copies of the two Théâtre Libre pro-
grammes, proofs before letters.[2]

HTLautrec

Prov.: Schimmel
Pub.: GSE179, GSF197

[1] Written on the back of the card of P. Clauzel, art supply store, 33 rue Fontaine.
[2] i.e. for Luguet's *Le Missionnaire* (Wittrock 16) and Bjørnson's *Une Faillite* (Wittrock 15). The
Théâtre Libre was an avant-garde company founded by André Antoine in 1887. Cf. Letter 593
Note 2.

352 *To René Wiener*

[Paris, April–May 1894]

Dear Sir,
I have not forgotten you but I have been waiting now 8 long days
for a word from the Museum director to execute your matter.[1]
I shall try to finish up as quickly as possible but I cannot commit
myself to any date. It's the fault of the administrations. Ah France is
a wonderful country.
In any case you will have lost nothing by waiting.

Yours,
HTLautrec

Prov.: Nancy
Pub.: *Annales*, p. 225

[1] The 'matter' was probably the preparatory drawings for a binding on a set of *La Tauromachie de
Goya*.

353 *To René Wiener*

Dear Sir,

I am sending you—very late, alas—the project in question.[1] I believe it is satisfactory. Make the outlines green, the bones white, and the red quite laky. As a ground use the same greenish-yellow you used for the binding that is at the Champ-de-Mars with chestnut leaves.

Also, see if you can get the animal's horn to join at an angle, as in the drawing.

I apologize for being so late but it is the fault of the director of the Jardin des Plantes who kept me waiting for permission.

<div style="text-align:right">Yours sincerely,
HTLautrec</div>

Prov.: Nancy
Pub.: *Annales*, p. 225
 [1] The project was a binding for *La Tauromachie de Goya* (Dortu R.2, P.561, D.3684–6).

354 *To Gustave Geffroy*

[Paris, mid-May 1894]

[1]My dear Geffroy,

I'm leaving for London and would like to discuss our Yvette with you and I'd like to do it tomorrow at 6.30 at *La Justice*. Will you be there?

<div style="text-align:right">Yours,
HTL</div>

Prov.: LD.
 [1] Written on Lautrec's visiting card.

355 *To Gustave Geffroy*

[Paris, 18 May, 1894]

[1]My dear Geffroy,

I'll be at *La Justice* at 6 o'clock on whichever day you tell me. But

try to make it *Saturday* or *Sunday*, as I'm leaving for London,[2] and I'd like to talk with you about our Y.

<div align="right">Regards,
HTL</div>

Please reply.[3]

Prov.: LC

[1] Carte-télégramme addressed to Monsieur G. Geffroy, 133 rue de Belleville.
[2] He was in London by May 28 (cf. Letter 359).
[3] Written on side of page.

356 *To Gustave Geffroy*

<div align="right">[Paris, Wednesday, 23 May, 1894]</div>

[1]My dear Geffroy,

Yvette expects us on Friday for lunch. I hope you're free. The train leaves at *9.37*. *Gare St Lazare*. Meet me at *9.15* at the café in the station waiting-room.

<div align="right">Your
HTLautrec</div>

Please reply.

Prov.: LC

[1] Telegram addressed to Monsieur G. Geffroy, A la Justice, 10 fg Montmartre.

357 *To André Marty*

<div align="right">[Paris, 24 May, 1894]</div>

My dear Marty,

Be at the Napolitain[1] this evening at 6.30. I need to give you my final instructions. Tomorrow, Friday, I'm going to Vaux[2] with Geffroy to visit Yvette.[3] Meeting at 9.15 at the café in the waiting-room of the Gare St Lazare.

<div align="right">Best regards
HTLautrec</div>

Prov.: Private, Paris I

[1] The Café Napolitain, 1 boulevard des Capucines, popular with actors, actresses, journalists, and writers.
[2] Vaux-sur-Seine, near Meulan, where Guilbert had purchased her country home in 1893 from Léon Sari, the director of the Folies-Bergère.
[3] When the album was completed Geffroy signed and dedicated copy No. 65: 'The name Yvette Guilbert is for me the very dear memory of a collaboration with Lautrec, which afforded us a beautiful day in the country, with André Marty, our editor and friend, at Yvette's villa at Vaux-sur-Seine. Gustave Geffroy' (Collection Kunsthaus, Zurich).

358 *To René Wiener*

[Paris] 26 May [1894]

Dear Sir,

I am very happy to have satisfied you.[1]

We must hope that the result will be satisfactory. I am leaving for London:

Morelles Hotel, Craven Street[2]

 (Charing Cross)

You can send the 200 francs for the cover in question to me at that address.

Very cordially yours,
H. de T. Lautrec

Our Yvette Guilbert will appear in 10 or 12 days.

Prov.: Nancy
Pub.: *Annales*, p. 224

[1] Lautrec is referring to the drawings for the *Tauromachie* binding. Cf. Letters 352–3.
[2] William Morrell's Private Hotel, 1 Craven Street, Strand, W.C. By 1900 it was no longer in business.

359 *To René Wiener*

Morelles private hotel, Craven Street, Charing Cross, London,
Monday [28 May, 1894]

Dear Sir,

I duly received your cheque and thanking you for the speed with which you sent it to me, I greet you cordially.

HTLautrec

Prov.: Nancy
Pub.: *Annales*, p. 225

360 *To Alfred Natanson*

Morrell's private hotel, 1 Craven Street, Charing Cross, London,[1]
Tuesday, 5 June [1894]

My dear friend,[2]

I've bought a fox terrier from the London pound. After five days, the dogs are killed or sold. The Queen wants it that way. So for 10 shillings I've got a dog worth at least 5 louis.

It would be very kind if you would send the errand-boy to pick it up at the Gare du Nord tomorrow Wednesday at 5.30.

Give it a drink, feed it and so on and send it on again from the Gare d'Orléans to the following address: M. Victor, Cartage Contractor at the Langon Railway Station, Langon, Gironde,[3] C.O.D. In fact, I don't need to tell you who he is. Thadée will be responsible for enlivening the stay of this poor animal, who is named Judy, after Punch's wife. Warn Victor by sending a short telegram to Verdelais[4] so he'll be there.

I expect to be back around the 15th. I've been eating perfectly presentable grills and going to work a little . . . to salve my conscience.

Salaam-aleikums to Thadée. Greetings to the friends and you.

HTL

Prov.: Schimmel

[1] A hotel near Charing Cross Station close to the Charing Cross Hotel where Lautrec stayed on later visits to London. Cf. Letter 358 Note 2.

[2] Alfred Natanson (1873–19??), brother of Alexandre Natanson (1867–1936) and Thadée Natanson (1868–1951) and co-founder and director with them of *La Revue Blanche*, one of the leading journals of art and literature (1889–1903). His wife was the actress Marthe Mellot, the subject of Lautrec's last poster for *La Gitane*, a play by Jean Richepin at the Théâtre Antoine, 22 January 1900 (Wittrock P.30).

[3] Langon, a small town a short distance south-east of Bordeaux.

[4] Verdelais, a few miles north-west of Langon and the ultimate burial site of Lautrec.

361 *To René Wiener*

[Paris, mid-June 1894]

Dear Sir,

I am just back from London[1] and have not yet been able to deal with the matter in question. Agreed, but we shall have to find something new.[2]

I am going to try in any case. I am as ever at your service and your disposal.

HTLautrec

Prov.: Nancy
Pub.: *Annales*, p. 225

[1] On 2 July van Rysselberghe wrote to Lucien Pissarro: 'Did you know that Lautrec came back with us via Harwich and Antwerp? He fell in love with the scenery of the Escaut [Scheldt River], even though he saw only part of it because he slept a lot.' (Cf. Ashmolean Museum, Bailly-Herzberg III, p. 466.) There was a daily train from London to Harwich, the port for the Great Eastern steamers to Holland and Belgium (Antwerp).

[2] Lautrec and Wiener are abandoning a project, probably the Yvette Guilbert binding. Cf. Letters 307 and 347.

362 To Jules Chéret

[Paris] 18 June [1894]

Dear Sir,[1]

I have just returned from London and only belatedly received the letter telling me of your sorrow.[2] Let me once again assure you of all my sympathy and that I remain

Yours truly,
HTLautrec

Please remember me to Madame Chéret.

HTL

Prov.: Schimmel

[1] Jules Chéret (1836–1932), an artist primarily known for his poster designs totalling 1069 items. He set up his own lithography studio in 1866, ceding the printing part to Chaix in 1881 (Imprimerie Chaix). Lautrec printed nine posters at Chaix between 1893 and 1896: *Jane Avril* (Wittrock P.6), *Caudieux* (P.7), *Au pied de l'échafaud*, (P.8), *Aristide Bruant* (P.10), *Babylone d'Allemagne* (P.12), *Irish and American Bar, rue Royale* (P.18), *Cycle Michael* (P.25), *La Chaîne Simpson* (P.26), and *La Vache enragée* (P.27).

[2] Probably referring to the death of Chéret's brother, the sculptor Gustave Joseph Chéret, born in 1838, who died in Paris on 13 June 1894.

363 To Roger Marx

[Paris, 18 June, 1894]

My dear Marx,

Bravo for Fabre. Now it's Madori's[1] turn. I hear that M. Wiener is here. Where could I see him? Please drop me a line.

And regards,
HTLautrec

Prov.: Schimmel
Pub.: GSF196

[1] Possible Madaré, the poster-lettering designer and associate of the artist Jules Chéret. He died in 1894. Cf. Broido, p. xiii, and Letter 362 Notes 1 and 2.

364 *To René Wiener*

7 rue Tourlaque, Paris, 18 June [1894]

Dear Sir,

I waited in vain for the promised tracing. So my silence is self-explanatory.

I hope that you were nevertheless able to finish and I have too much confidence in you to be concerned about the outcome of our matter.[1]

Cordially yours
HTLautrec

[On this letter there is a drawing[2] of the design for the *Tauromachie* binding with the following writing:]

Texte Lautrec is explaining where to place the word Tauromachie by using
 the word 'texte' on his sketch]

Taura

Very bold

Here's what you did I believe, am I wrong?

Prov.: Nancy
Pub.: *Annales*, p. 226

[1] The completed binding was exhibited at the Exposition d'Art Décoratif de Nancy in 1894 and the Salon du Champ-de-Mars in 1895.
[2] Dortu 3684.

365 *To Théo van Rysselberghe*

[Paris, late June 1894]

My dear Théo,[1]

I went to the Neo. I.[2] to choose a canvas by you. *Le tennis*[3] or *the helmsman*[4] would be perfect for me. Pick the one that would be the least troublesome for you to give me. And thank you.

I'd like to be able to tell you funny stories about Paris. But we're in a presidential crisis,[5] that is, stupidly saddled with old service rags of the official-colour-print type. In short, all the cast off clothing of a booracracy in delirium. And for what?

I'd like to get out of here. But my book is keeping me tied up. It isn't finished yet.[6]—

Everything here is ugly and stinks.—And I swear to you, without flattery, that I miss our milk-hoo, Bus,[7] Cissy Loftus,[8] etc. and you too.

Regards to Olin.[9]

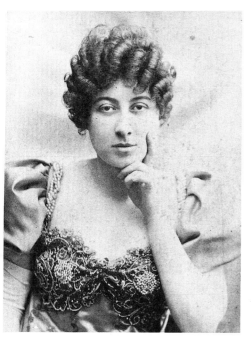

37. *Jane Avril* (Letter 341)

38. *Aristide Bruant* (Letter 393)

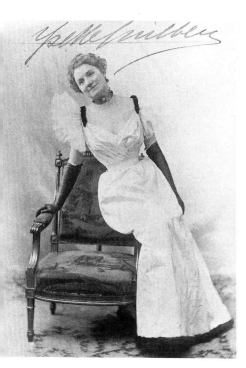

39. *Yvette Guilbert* (Letter 260)

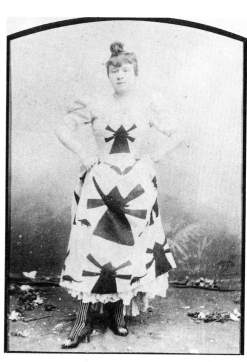

40. *La Goulue* (Letter 218)

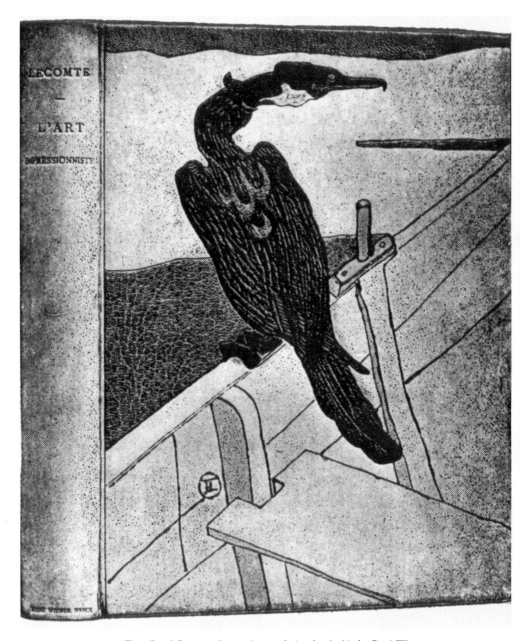

41. *Tom: Grand Cormoran*, Lautrec's 1893 design for the binder René Wiener

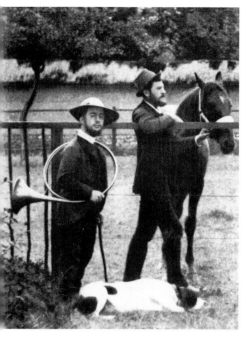

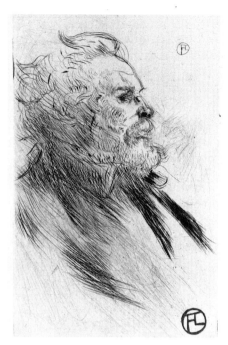

42. Lautrec with Louis Anquetin

43. Charles Maurin, portrayed by Lautrec in an 1898 dry-point

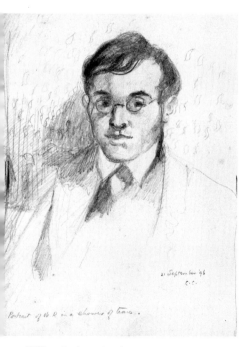

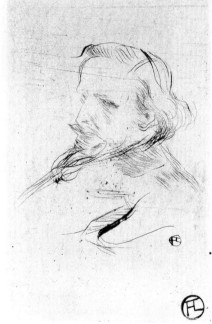

44. William Rothenstein, drawn by Charles Conder

45. Francis Jourdain, portrayed by Lautrec in an 1898 dry-point

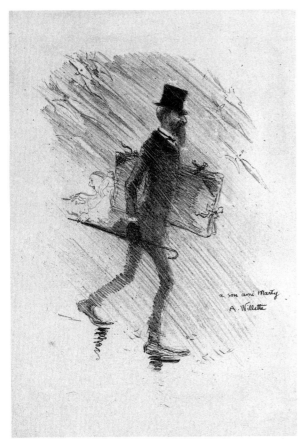

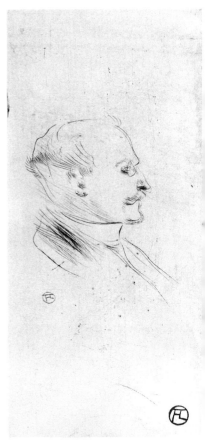

46. André Marty, in a lithograph by Adolphe Willette, c.1894

47. W. H. B. Sands, portrayed by Lautrec in an 1898 dry-point

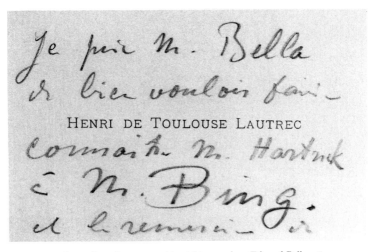

48. Letter from Lautrec, on his visiting-card, to Edward Bella, 1895

49. *Au Moulin Rouge,* February 1894 (Letter 306)

50. *Yvette Guilbert* July 1893 (Letters 289, 377)

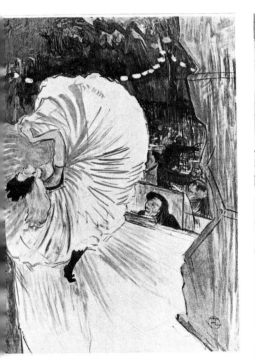

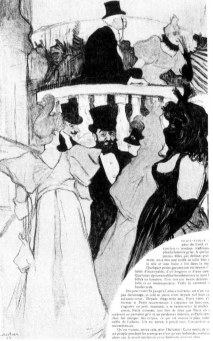

51. *La Roue,* July 1893 (Letter 377)

52. *Au Bal de L'Opéra,* February 1894 (Letter 306)

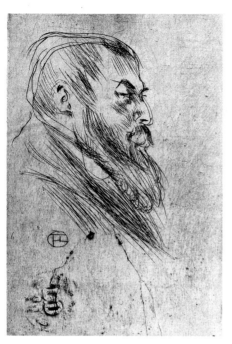

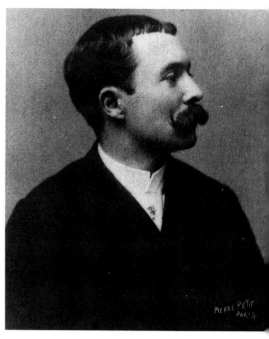

53. Tristan Bernard, portrayed by Toulouse-
Lautrec in an 1898 dry-point

54. Oscar Méténier

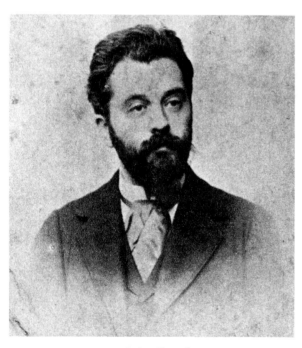

55. Arsène Alexandre

56. Oscar Wilde, drawn by
Lautrec in 1895 for
La Revue Blanche

57. Caricature by Lautrec of his friend Maurice Guibert, 1896

58. Ex-libris for Maurice Guibert designed by Lautrec in 1894

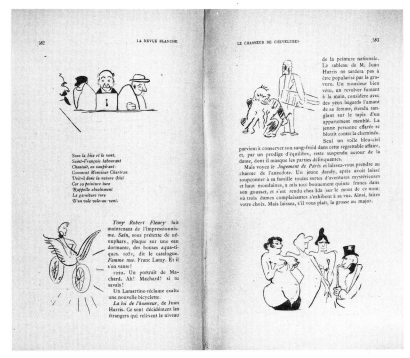

59. *Le Chasseur de chevelures:* drawings by Lautrec for *La Revue Blanche*, 1894

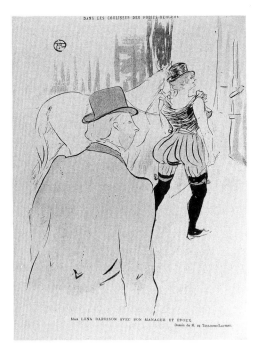

60. Lona Barrison and her husband, drawn by Lautrec
in 1896 for *Le Rire*

61. Lautrec's cover for an 1898 children's book

My respects to your Lady and to you, very cordially. Along with the lurking hope of starting all over again next year.

HTLautrec

Please give me Jager's[10] address.

Prov.: Schimmel

[1] Théo van Rysselberghe: cf. Letter 152 Note 1.

[2] The Neo-Impressionists, a group of impressionist and symbolist painters who exhibited together at the gallery of Le Barc de Boutteville, 47 rue Le Peletier, on a continuing and sporadic basis, the first exhibition in December 1891, the second in mid-1892, the third in December 1892, and the fourth in early 1893. A later exhibition took place from 25 October to 5 November. Among the group that included Lautrec were Anquetin, Vuillard, Gauguin, Bernard, Jeanne Jacquemin, Denis, Bonnard, *et al.* By January 1894 the group of Neo-Impressionists had moved to 20 rue Laffitte where some of the most notable work exhibited was by van Rysselberghe, Signac, and Pissarro.

[3] *La Partie de tennis*, a painting of two women playing tennis with a young girl watching was the work Lautrec chose. It remained with his mother at Malromé until her disposal of it.

[4] *Le Barreur* [The Helmsman]: Lautrec is obviously referring to van Rysselberghe's *L'Homme à la barre* (1892), now in the collection of the Musée d'Orsay, Paris.

[5] On 24 June Président Sadi Carnot was assassinated by an anarchist in Lyon, causing grave concern in France.

[6] The Yvette Guilbert book was still not completed by his associates. Cf. Letter 368 Note 3.

[7] It is uncertain, but Lautrec may be referring to his London visit. Two words are barely legible.

[8] Cissy Loftus (1876–1943), an English music-hall star, made her London debut in 1893 impersonating well-known actresses. Her act included an imitation of Yvette Guilbert (Yvette called her 'my first and charming imitator'). Lautrec drew and printed a lithograph of her, *Cecy Loftus* (Wittrock 113). She played in a burlesque version of *Don Juan* from 26 October 1893 to 16 June 1894.

[9] Pierre-Marie Olin, Belgian author and editor. A relative of Edmond Picard, he contributed poems and sketches to the French periodicals *L'Ermitage* and *La Revue Blanche* and was an editor for *La Wallonie* (1886–92), a leading Belgian Symbolist literary magazine. He was the subject of at least three portraits by van Rysselberghe, two paintings and an etching dated 7 February 1894.

[10] Cf. Letter 375.

366 *To Gustave Geffroy*

[Paris, 21 June 1894]

[1] My dear Geffroy,

As soon as you have the proofs of Yvette,[2] be so kind as to let me know. I'd very much like us to finish all that together.

Truly yours
HTLautrec

Prov.: Schimmel
Pub.: GSE180, GSF198

[1] Addressed to Geffroy at 133 rue de Belleville, Paris.
[2] Cf. Letter 367.

367 *To André Marty*

[Paris] Monday [late June 1894]

My dear Marty,

I shall sign the proofs tomorrow, Tuesday, from 3 to 4, at Ancourt's,[1] and I should like to see you there. My friend Huc[2] has promised to write a complete report[3] for you in *La Dépêche de Toulouse* of which he is the director. So we'll give him a copy, and that will be a very good advertisement for us. Have the documents and instructions sent to him when you feel the time is right to Toulouse at *La Dépêche*, 57 rue Bayard. So I'll see you tomorrow.

Yours,
HTLautrec

Prov.: Private, Paris I

[1] Lautrec is referring to the Yvette Guilbert album (Wittrock 69–95). There do not seem to be many signed proofs.

[2] A. Huc, one of the directors of *La Dépêche* together with R. Sans. Among its writers were Georges Clemenceau, Jean Jaurès, and Francisque Sarcey.

[3] 'Au Café-concert' by Homodei [Huc] in *La Dépêche de Toulouse*, 11 September, 1894, concerning the Yvette Guilbert album.

368 *To his Mother*

[Paris] Wednesday [27 June 1894]

My dear Mama,

Just about the time you receive my letter, Casimir[1] will be at the head of our beautiful country (barring a surprise). All this is very silly, and the log itself does not escape the vengeance of the frogs.[2] I'd like a change of scenery, and when I return from Rouen, which is to say in a week or ten days, I think I'll come and share in your fun and games. Guibert[3] and the dog will be part of the celebration. I'm purging the dog conscientiously, as he's a bit sickly. The fresh air will finish the process of curing him. My collaborators are getting on my nerves and I don't know how to get them moving. *My* work was finished a month and a half ago, while they're playing around.[4]

I have a wisdom tooth that's growing out and keeping me from thinking straight. I walk as much as possible with Tommy, that's the dog. Paul's son has the measles and Joseph[5] is of course manning the barricades, maybe with the thought that he's the stuff of which presidents are made.

The weather's warm and everything smells. I kiss you.

Yours,
H.

I've been to see the doctor, who may have given you news of me.

Prov.: Private Basle II

[1] Casimir-Périer, elected President of the Republic on 27 June 1894.

[2] Lautrec is probably referring to the fable *The Frogs who Asked for a King* (moral: it is better to have a harmless, inactive ruler than a violent and malicious one), from Aesop, Phaedrus, and La Fontaine. Lautrec's schoolbooks include Phèdre: *Fables ... suivies des imitations des fables de Phèdre par La Fontaine*, nouvelle édition par M. W. Dinn, Delagrave, Paris, 1875 (Collection Musée Toulouse-Lautrec, Albi).

[3] Maurice Guibert: cf. Letter 194 Note 3.

[4] Lautrec is referring to the Yvette Guilbert album.

[5] Paul and Joseph Pascal.

369 *To André Marty*

[Paris, Summer 1894]

My dear Marty,

Whose is this vacation house that you are sending me.
Drop me a line, please.

Yours,
HTLautrec

Try to come on Monday at 4.30.

Prov.: Private, Paris I

369A *To Théo van Rysselberghe*

[Paris, July 1894]

My dear Théo,

I'm going to Antwerp next week. My friend[1] and I will be in Brussels on Tuesday or Wednesday. I hope to see you there, ask you about the itinerary we should take, and maybe, I hope, get you to come along. Yeager[2] gave me news of you.

My best wishes to Mme Théo. Regards to you.

Your
HTL

Prov.: Schimmel

[1] Probably Robin Langlois (cf. Letter 431).

[2] Cf. Letters 365, 375.

370 *To his Mother*

[Paris, July 1894]

My dear Mama,

It's raining and too much. So, I'm going to Brussels to spend a day making enquiries about furniture.[1] My setting up house is progressing slowly, and so I'll try to finish soon so as to come and give you a hug. I'll come, according to what time is available, by boat or train. Everything's fine here. Papa looks to me like a Fabius Cunctator.[2] I've seen Louis but not Juliette yet. They've sent for Rosalie[3] to nurse the little one.

I'm rushing off, for time is pressing, and I kiss you.

Yours,
Henri

Prov.: Schimmel
Pub.: GSE 173, GSF 190

[1] Cf. Letter 375.
[2] A Roman general who employed prudent tactics; a temporizer or procrastinator.
[3] A domestic employee from the Château du Bosc (cf. Rodat, p. 126).

371 *To his Mother*

[Paris, July 1894]

Dear Mama,

Papa is back from Sologne and is supposed to have a talk with the individual in question. *Now* he has told me that he personally has no desire to sell but that he would bow to our wishes![1]

He was very polite, merely expressing some doubts about where to *invest* the funds (if the deal should go through). I shall arrive at Malromé on Friday or Saturday morning, and shall take a Favereau.

If you can come to meet me, I'll be happy to see you at the railway station. I shall telegraph you on the morning of my departure, and we can have a serious talk.

I am going to have my Paris mattress sent to Malromé, and I shall buy another one for here, as we agreed—if memory serves me right.

I'm going to try to see Louis so that I can leave with him.

Love and kisses,

Your
Henri

Prov.: Schimmel
Pub.: GSF128

[1] Lautrec is talking about the sale of the Ricardelle property.

372 *To his Mother*

[Paris, July 1894]

[1] ... I'm continuing to work ... as for *Le Rire*, my collaboration is still only in the planning stage ...

<div align="right">Henri</div>

Prov.: Unknown
Source: Stargardt, Auction 28 October 1955, Katalog 524, No. 444, and 14 November 1958, Katalog 540, No. 315

[1] Fragment of a letter.

373 *To his Mother*

[Paris, late July 1894]

My dear Mama,

Paul was astonishing last night, which confirms what I told you about him. It's doing him a lot of good. Louis is back, and is very busy. He has started to work on posters and circulars with a great deal of energy.

I won't come until Monday. Come TO LUNCH AND TAKE ME. I read in the *Courrier de Narbonne*: Ricardelle, *10,000 hectares sold, price not disclosed.*[1] I'll keep this issue for you. And there you are ...

<div align="right">Yours,
Harry</div>

Prov.: Schimmel
Pub.: GSE181, GSF199

[1] Lautrec's parents had acquired this estate around 1882 (cf. Letter 72 Note 1)

374 *To Roger Marx*

Château de Malromé, via St Macaire, Gironde [early August 1894]

[1] Our Yvette Guilbert is almost finished. Furthermore Marty is to see you in this connection.[2] I wanted to give you some prints and talk to you about Madaret.[3]

Prov.: Collection Paulette Asselain in 1980; present location unknown
Source: R-M, No. 86

[1] Fragment of a letter.
[2] Cf. Letters relating to the publication of the Yvette Guilbert album with Marty: 326, 327, 328, 334, 337, 337A, 348, 354, 355, 356, 357, 358, 365, 366, 367, 368, 374A, 376, 379, 380, 381, 382, 385.
[3] Cf. Letter 363 Note 1.

374A *To André Marty*

[Malromé, early August 1894]

My dear Marty,

When the Y. Guilbert appears, send my copies to me at the Château de Malromé, via St Macaire, Gironde, St Macaire railway station, and registered.

Please also send me, at that address, everything that's published on the subject.

Regards,
HTLautrec

Prov.: Private, Paris I

375 *To Théo van Rysselberghe*

Château de Malromé, via St Macaire, Gironde [early August 1894]
My dear Théo,

Thank you for the copper hooks that Verhaeren gave me when I was leaving.[1] I should be grateful if you would tell me how much I owe you for this. I asked Jaeger[2] to get some information about the peacock-feather fabric for which we had only a vague address: Manchester. Manchester is a big place.

As for the Deman[3] paper, I appreciate your telling me about it. Please tell me how much there will be for sale, or rather to give away, the size and the price. I'm asking you this because I have a few sheets of it in Paris, left over from *L'Estampe Originale*.

I'm leaving from here for Lisbon, returning via Madrid and Toledo.

My respects to Mme Théo and best wishes to you,

H. de Toulouse Lautrec

Prov.: Unknown
Source: Fontainebleau, Auction, 21 February, 1988, No. 28

[1] Lautrec had been in Brussels looking for furniture (cf. Letter 350).
[2] Lautrec had requested Jaeger's address (cf. Letter 365).
[3] Edmond Deman: cf. Letter 471 Note 1.

376 *To André Marty*

[Malromé, August 1894]

My dear Marty,

The book couldn't be better. Yvette wrote me a very nice note. As for the two Japanese vellum prints, they're ADMIRABLE.[1] Do the best you can with the advertising. Geffroy and you know better than I do what needs to be done. Keep my copy of my lithograph,[2] I'll pick it up on my return. And send me the clippings about *our* book.

And this winter at Bruant all of us.

Regards, and my respects to Mme Marty.

H de Toulouse-Lautrec
Château de Malromé, via St Macaire, Gironde

Prov.: Schimmel

[1] Lautrec is referring to the prints for the Guilbert album, all of which were also printed as trial proofs on Japan paper. A complete set of Japan proofs is in the collection at the Bibliothèque Nationale, Paris, a gift of the artist's mother.

[2] *Aux Ambassadeurs, Chanteuse au Café-Concert* (Wittrock 58). Cf. Letter 331 Note 1.

377 *To an Unidentified Correspondent*

[Arcachon, August 1894]

Dear Sir,

There were indeed touched-up drawings of Yvette Guilbert in the *Figaro*[1] in question, but none were doing the splits[2] as far as I know. These drawings were done on tracing paper pasted on Bristol-board or directly on Bristol-board. As regards their authenticity, I cannot guarantee it without seeing them. They were all purchased from me by Messrs Boussod and Valadon,[3] who disposed of them. In any case, in Brussels M. Théo van Rysselberghe will tell you whether or nor they're mine.

Yours faithfully,
H. de Toulouse-Lautrec

P.S. The drawings were signed with my monogram alone. HTL

Could you send to me at Villa Bagatelle, Taussat, Gironde, next Monday or Tuesday only (the only time I shall be there), Aladin and Palomides illustrated by Minne,[4] against reimbursement. Looking forward to receiving it, with my thanks.

HTL

Prov.: Bodmer

[1] *Yvette Guilbert* (Dortu A.203–4) appeared in *Le Figaro Illustré*, No. 40, July 1893.

[2] The correspondent is probably referring to *La Roue* (*The Cartwheel*) (Dortu P.483) from the same *Figaro* article, but not Guilbert.

[3] Boussod, Valadon & Cie. Cf. Letter 307.

[4] *Alladine et Palomides, Intérieur*, et *La Mort de Tintagiles, Trois Petits Drames pour Marionettes*, Edmond Deman, Editeur, Bruxelles, 1894. Illustrated by Georges Minne.

378 To André Marty

[Arcachon, August 1894]

My dear Marty,

Please have someone pick up from the *Revue Blanche*[1] a plate[2] that will be ready for you, and make about 50 sheets with imitation Japanese vellum at my expense and send the whole thing to me at Villa Richelieu, Arcachon, Gironde, before the 14th.

Thank you and please excuse the changes but you will do it better than anyone else.

Yours,
HTLautrec

[On the back of the letter Lautrec drew a layout for it and described the production of a menu as follows:]

With this arrangement—Menu—in Elzevir Roman type[3]—greenish-black, base yourself on the proportions of the plate.

Approximately—plate, menu, good.

Prov.: Private, Paris I

[1] *La Revue Blanche*, No. 32, June 1894, had published 'Le Salon du chasseur de chevelures illustré (text by Tristan Bernard and illustrations by Lautrec). It included the drawing called *Le Jugement de Pâris* (Dortu D.3501), later considered as an original lithograph, *Le Moderne Jugement de Pâris, Menu* (Delteil 69).

[2] Wittrock has excluded this from his catalogue, stating that it is not an original lithograph but a reproduction from a printing plate.

[3] The Elzevir roman type used in France at that time had been designed by Théophile Beaudoire in 1858.

379 To Théo van Rysselberghe

Villa Richelieu, Arcachon (Gironde) [August 1894]

My dear Théo,[1]

I'm on vacation here. A few too many people around. My friend who had the deserted place isn't there, so I'm planning to go to Spain[2] as soon as possible and would be very glad if you could give me Dario's[3] address, so that I can try to travel around a little with him. My book on Yvette is out.[4]

We're putting it on sale for 50 francs to advance purchasers before the end of the year. After 1 January it will cost 100 francs. Spread the word to enthusiasts. Have you finished the litho for *L'Estampe*?[5]

Regards to Olin,[6] and remember me with respect to Mme van Rysselberghe.

 Yours

HTLautrec

Please reply.

Prov.: Unknown
Source: Fontainebleau, Auction, 21 February, 1988, No. 27.
[1] Théo van Rysselberghe: cf. Letter 152 Note 1.
[2] Regarding this Spanish trip, cf. Letters 383-4.
[3] Darío de Regoyos y Valdés (1857–1913), a Spanish painter influenced by Pissarro, long-time exhibitor in Brussels, and friend of van Rysselberghe and Émile Verhaeren. He exhibited with Les XX from 1884, including the same years as Lautrec (1888, 1890, 1892, 1893), and with La Libre Esthétique in 1895.
[4] The Yvette Guilbert album, as previously discussed.
[5] van Rysselberghe prepared an etching, *Flotille de pêche*, for Album VII of *L'Estampe Originale* in 1894.
[6] Pierre-Marie Olin: cf. Letter 365 Note 9.

380 *To André Marty*

 [Arcachon, August 1894]
My dear Marty,
 The menus[1] are well done and were a big success. Bravo for our Yvette. Send the articles[2] to me at the Château de Malromé, via Saint Macaire, Gironde, for I'm leaving immediately for Burgos and Madrid.[3]
 Very cordially yours,
 H. de Toulouse Lautrec

Prov.: Private, Paris I
[1] Menu 'Le Jugement de Pâris': cf. Letter 378, Note 1.
[2] Reviews of the Yvette Guilbert album appeared immediately after publication, including *Le Figaro* (16 August, 1894) by Gaston Davenay, and *Paris* (18 August, 1894) by Arsène Alexandre.
[3] Cf. Letter 384.

381 *To André Marty*

 [Arcachon, August 1894]
[1] My dear Marty,
 Thank you for your kind letter. As for the payment of my litho,[2] I'm going to answer you frankly. Do you have a left-over copy of *the Carrière and the Renoir*[3] for the first year. If so, write the word *specimen*

on the back, and then we'll be even. Otherwise, you can pay me the 100 francs when I return to Paris. Keep sending the clippings to me at the Château de Malromé.

<div align="right">Regards,
HTLautrec</div>

I received a very nice letter from Yvette.[4] Keep the Guilbert things at your place.
 Send *them* to MALROMÉ.[5]

Prov.: Schimmel

[1] Written on letterhead, Café de la Place Thiers, F. Repetto, Arcachon.
[2] *Aux Ambassadeurs—Chanteuse au café-concert*, (Wittrock 58) was published in Album VI of *L'Estampe Originale* (1894).
[3] Carrière drew the lithograph *Tête* or *Mme Eugène Carrière* and Renoir drew the lithograph *Tête d'enfant* or *Pierre Renoir from the Front*, both of which appeared in Album IV of *L'Estampe Originale* in 1893.
[4] In the winter of 1894 the Symbolist writer and poet Jean Lorrain (1856–1906) wrote to Guilbert: 'I saw yesterday the horrible brochure illustrated by Toulouse-Lautrec "A la goose shit".' (Cf. Guilbert, *Mes lettres d'amour*, p. 44.)
[5] This is written in the left margin. Lautrec is referring to the above-mentioned lithographs (Note 3 above).

382 *To André Marty*

<div align="right">Château de Malromé [August 1894]</div>

My dear Marty,
 The two articles are perfect.[1] The one in *Le Figaro* exceeds all expectations. Is the *Revue Encyclopédique* going to remain asleep? I'm still at the same Malromé address.

<div align="right">With best regards,
HTLautrec</div>

If the *Revue Blanche* wrote something, please send it to me here. I'm leaving for Madrid.

<div align="right">H.</div>

Prov.: Schimmel
[1] Cf. Letter 380 Note 2.

383 *To his Mother*

San Sebastián, Sunday [September 1894]
[1]Everything is fine. Fabre is here with me and is accompanying me to Madrid. We'll be staying at the Hôtel de la Paix there.

Weather very beautiful. I went swimming in the Concha and watched the dunking of the king surrounded by bedizened officers. It was charming ...'

... Yours H

Prov.: Unknown
Source: Saffroy, Catalogue No. 3, 1959, No. 1924
[1] Fragment of a letter.

384 *To his Mother*

[Grand Hôtel de la Paix, Puerta del Sol, 11 & 12, Madrid] Wednesday
[September 1894]
My dear Mama,
 I received your letter upon arrival. After seeing a very fine bullfight on Sunday, we went to Burgos, where we inspected the marvels of the Cathedral and two monasteries. We travelled all night in a sleeping-car and here we are, in Madrid. I have letters of introduction and they're even going to sing my praises in the newspapers of the country, such being fame and journalism. I think we'll pull out on Saturday night or Sunday after going to Toledo. Send me everything *here*, newspapers, etc, letters.
 I kiss you.

Yours,
H.

Prov.: Schimmel
Pub.: GSE183, GSF201

385 *To Arsène Portier*

[Paris, Autumn 1894]

[1]Dear Sir,

It is indeed the Yvette[2] with the text by Geffroy which is in question. 50 francs to the public. 35 francs to you if I do not displease you.

HTLautrec

Prov.: Unknown
Source: Rendell listing, No. 631

[1] On the last page, in an unknown handwriting, are notes regarding the sale of works by Cassatt, Vidal, *et al.*
[2] Yvette Guilbert album (Wittrock 69–85).

386 *To his Mother*

[Paris, October 1894]

My dear Mama,

You probably know about the death of poor Nini,[1] who died on Saturday at the Hospital of the Infant Jesus after suffering terribly. I was told too late and wasn't able to go to the funeral. I went with Bourges yesterday to see Juliette and my aunt. These poor women are dejected and not at all theatrical. The comic note is supplied by Joseph who pictures himself as having had to bear it all and isn't far from imagining that it's he who's dead.

Bourges's wife has been hit hard by a bad case of pneumonia. She has lost a lot of weight but is in very good spirits—in a word, cured. As for my maid, the sickness was simply a stubborn constipation, so I had her thoroughly cleaned out, and she's beginning to get about. I have a very handy helper, the maid of one of my friends who lives in the house, and so I'm rid of that problem, too. I'm thinking of going to London for the opening of the poster exhibition at the end of the month,[2] but for only 2 days. Gabriel is here, happy and content, although Péan[3] as usual is replacing his staff in February. However, he has some very interesting work in view. It appears (just between us) that Odon's marriage is in the offing,[4] with plenty of money at stake; so much the better. I kiss you.

Yours,
H.

Be so kind as to send me a hamper of Chasselas and Malaga grapes. I'd like to give some to Robin,[5] who has put me up all this while.

Prov.: Schimmel
Pub.: GSE 184, GSF 202

[1] Evidently the nickname of a member of the Pascal family, otherwise unidentified.
[2] A Collection of posters, First exhibition 1894–5, Royal Aquarium, London. The catalogue was edited by the paper manufacturer Edward Bella and dated 23 October, 1894. Lautrec exhibited thirteen items, Nos. 120–30, 236, 237, including the poster *Confetti* (Wittrock P.13), which he designed for J & E. Bella. Item 131, *Malt Coffee*, was misattributed to him. Six of the Lautrec posters in the exhibition were from the collection of A. S. Hartrick (cf. Letter 398 Note 3). Lautrec attended the preview, according to Edward Gordon Craig (1872–1966), the English stage designer, producer, and artist, who wrote: 'I went there with Kid Nicholson before it was officially opened. We saw Lautrec there: He, who had recently done much to lend power to poster design (he followed Chéret!), was, I believe, in control of the French section of this exhibition; the best man for that, of course.' (Cf. Craig, p. 150.)
[3] Jules-Émile Péan (1830–98), a famous surgeon and teacher and the founder of the Hôpital International in the rue de la Santé, Paris. Gabriel did indeed leave his service in 1895, after four years with him.
[4] Odon Tapié de Céleyran later married Marguerite de la Portalière.
[5] See leter 497 Note 1.

387 *To Théo van Rysselberghe*

7 rue Tourlaque, Paris [October 1894]

My dear Théo,

Back from the South and Spain, where I saw Dario.[1] I'm leaving for London four days from now.[2] Could you be so kind as to give me the address of the dealer in copper works and lamps.[3] I have things to buy there. Please also tell me when you're coming to Paris and whether your house is going well. We must go and see it when it's finished since I and two of my friends[4] are very anxious to get some experience with modern furniture.

I believe that good old Marty[5] will stop in Brussels in the next few days and will go to see you.

Look forward to seeing you soon. Remember me to Mme Théo and to Olin.[6]

Regards,
HTLautrec

Prov.: Schimmel

[1] Darío de Regoyos y Valdés: cf. Letter 379 Note 3.
[2] This may have been the London visit when Lautrec met the American painter and printmaker James McNeill Whistler (1834–1903) and drew two, now lost, portraits (Dortu D.3883–4). Whistler's lithograph, *Danseuse*, had appeared in *L'Estampe Originale*, vol. IV (1893). Cf. Joyant I. 173–4.
[3] Probably Maple & Co, London. Cf. Letter 392 Note 3.
[4] Thadée Natanson was probably one of the two. Cf. Letter 397.
[5] André Marty.
[6] Cf. Letter 360 Note 9.

388 *To André Marty*

[Paris, October 1894]

[Making an appointment at the office of *La Revue Blanche*.]

Prov.: Unknown
Source: Berès New York, Catalogue 5, 1941, No. 227

389 *To Théo van Rysselberghe*

[Paris, October 1894]

Old friend,

I leave it to you. If your customer is rich, pick Chaix. If he's broke, Ancourt. If he's in a hurry, Chaix.[1] Anyway, I'll be there to help you. I'm waiting for you impatiently.

My respects to Madame and Mlle Elisabeth.[2]

<div align="right">Your
HTL</div>

Prov.: Unknown
Source: Fontainebleau, Auction, 21 February, 1988, No. 29
 [1] For Lautrec's printers Chaix and Ancourt cf. Letter 393 Note 3 and Letter 428 Note 1.
 [2] Elisabeth van Rysselberghe: cf. Letter 420 Note 4.

390 *To André Marty*

[Paris, 20 October, 1894]

[1] My dear Marty,

At 9 o'clock tomorrow, come. Don't forget Clemenceau's article.[2]

<div align="right">Your
HTL</div>

Prov.: Private, Paris I
 [1] Carte-télégramme addressed to M. Marty, 17 rue de Rome.
 [2] 'Au Café-concert' by Georges Clemenceau, *La Justice*, 15 September, 1894, concerning the Yvette Guilbert album (Wittrock 69–85).

391 *To André Marty*

[Paris, late October 1894]

My dear Marty,
 Please come for a talk with me tomorrow morning before 9. Urgent.

<div align="right">Cordially yours,
HTLautrec</div>

Prov.: Private, Paris I

392 *To Thadée Natanson*

<div align="right">Revue Blanche, 1 rue Laffitte [Paris, October 1894]</div>

My dear friend,[1]
 I went to the magazine's offices with Théo van Rysselberghe[2] to see you. Théo will give you *the real jewel* for your fireplace—he will be free *Monday* or *Tuesday*. Please drop me a line *as soon as possible* so that I can tell him where it will be and can get organized as regards my models.

<div align="right">Very cordially yours,
HTLautrec
7 rue Tourlaque</div>

P.S. Try to have the Maple[3] projects if possible, we *could check* them.[4]

Prov.: Unknown
Source: Gutekunst Kornfeld, Auction, 14 May, 1958, No. 127

 [1] Thadée Natanson: cf. Letter 360 Note 2 and Letter 536 Notes 2 and 3.
 [2] Cf. Letter 152 Note 1.
 [3] Maple & Co., 141–9 Tottenham Court Road, London, interior decorators and manufacturers of furniture and decorative arts. (Cf. Gauzi, p. 124.)
 [4] Lautrec was planning to visit the opening of the poster exhibition in late October, accompanied by van Rysselberghe. Cf. Letters 386 and 395.

393 *To Aristide Bruant*

[Paris, Autumn 1894]

Dear old pal Bruant,[1]
 Here are the states requested. As for the posters outside the regular run there were no good ones. In addition, the directors of the Eldorado[2] acted like swine and bargained with me on my price,[3] which was *below* the printing rates at Chaix.[4] So I worked personally for nothing.

For their sake I'm sorry they took unfair advantage of our good relationship to deceive me. Let's hope that next time we'll be smarter. Regards. When will the cover plates[5] be ready?

HTLautrec

Prov.: Lecomte
Pub.: Loncle No. 260

[1] Aristide Bruant (1851–1925), French entertainer, cabaret-owner, song-writer, author, and publisher. After a varied career he established his cabaret, Le Mirliton, in 1885, publishing his periodical of the same name from 1885 to 1906. He wrote many of the popular songs of the time, using them in his performances as one of the great entertainers of the period. His songs were published in three volumes; he wrote novels and plays; and he published another periodical, La Lanterne de Bruant, from 1897 to 1899. Lautrec exhibited some paintings at Le Mirliton in 1885, and four drawings appeared in Le Mirliton in 1886–7. Bruant was depicted by Lautrec in seven paintings, ten drawings, one lithograph, and four posters.

[2] A Parisian café-concert located at 4 boulevard de Strasbourg. The director had changed in September 1893, the new director being Mme Allemand. By December there were stories of a sale, and during the first three months of 1894 there were continuous booking and managerial problems. It closed in April for remodelling, not to reopen until November 1894. Lautrec printed a poster for Bruant to use for his appearance there (Wittrock P.5), but Bruant did not appear at Eldorado between 1892 and 1894, and may have never appeared there other than for a benefit performance on February 6, 1891. The poster was printed by Imp. Bougerie & Cie, 83 fg St Denis (Affiches Ancourt), a company that commenced poster-printing in 1894. It is almost a mirror image of the poster Ambassadeurs (Wittrock P.4) which Lautrec prepared for Bruant's appearance at the café-concert which occurred between mid-July and mid-August 1892. It has always been assumed that the two posters were printed during the same year, 1892.

[3] Possibly because Lautrec utilized a design that had been used some years before and had not created a new poster.

[4] Imprimerie Chaix, a printing company, successor in 1881 to Imp. J. Chéret, located at 20 rue Bergère. They printed eleven of Lautrec's posters between 1893 and 1896.

[5] Lautrec may be referring to the cover of Le Mirliton, 15 November, 1894, on which a reduction of his poster Aristide Bruant (Wittrock P.10), is used to announce the reopening of Bruant at the Mirliton. The same issue contains the announcement of the reopening of the Eldorado and the letter of resignation of the Mirliton's secretary, Fabrice Lémon, because of his involvement with Eldorado and other café-concerts. Bruant persuaded him not to resign.

394 *To an Unidentified Correspondent*

[Paris] 5 November [1894]

Dear Sir,

Please inform me personally of the meaning of the note, which I do not understand.

Yours faithfully
H. de Toulouse Lautrec
6 rue Tourlaque

Prov.: Schimmel

395 To William Rothenstein

[Paris, November 1894]

My dear Rothenstein,[1]

I'm writing to ask you two things.

1. M[me] Jeanne Jacquemin,[2] whose pastels you're familiar with, is showing at the Boutteville[3] gallery. I did the lithography, and if you think you can show it and, if possible, sell some of it, I'll put you in contact with her. Given the people you know in London, I'm certain it will be successful.

2. Marty[4] must have left for London, where he will pay you a visit. Tell him from me, please, to go to see Bella,[5] 113 Charing Cross Road, and nag him into sending me the promised posters (300).[6] I hope all this won't be too much trouble for you. I send you my best regards, something I wasn't able to do before my departure, to my great regret.

We were expecting you with Théo for dinner, but you didn't come. (?)

Yours,
HTLautrec

Prov.: Harvard

[1] William Rothenstein (1872–1945), an English painter and printmaker who met Lautrec in 1891 while studying in Paris. He was also a friend of Charles Conder and Louis Anquetin.

[2] Jeanne Jacquemin (b. 1865), French painter, follower of Puvis de Chavannes, and student of the occult sciences and the writings of Huysmans.

[3] Le Barc de Boutteville, a gallery located at 47 rue Le Peletier, Paris. Lautrec exhibited seven paintings there in December 1891. He is referring here to the third exhibition of November 1892 where Jacquemin exhibited her pastels along with Lautrec's lithographs.

[4] André Marty. Rothenstein had one lithograph, entitled *Portrait*, published in Marty's *L'Estampe Originale*, Album VIII, in December 1894.

[5] Edward Bella: cf. Letter 386 Note 2.

[6] In 1894 Lautrec had drawn the poster *Confetti* (Wittrock P.13). It was commissioned by J & E Bella of London and printed by Bella & de Malherbe of London and Paris. It was used as the frontispiece in the catalogue for the first Royal Aquarium poster exhibition which opened in London in October 1894.

396 To his Mother

[Paris, late 1894]

My dear Mama,

I beg your pardon for having been such a poor scribbler, but I'm up to my ears in work and a little fagged out meanwhile. Nothing but marches, counter-marches, appointments, etc., etc. I have even made my debut in a new line, that of stage-designer. I have to do the stage scenery for a play translated from the Hindustani called *Le Chariot de*

terre cuite.[1] It's very interesting, but not easy. Besides, no use counting one's chickens before they're hatched.

I'll try to come to Albi to say hello after the Odons have left. Would you be game to come back with us??? Gabriel would be with us. A thin coating of frozen rain punished Paris yesterday. All you could see was horses strewing the plain.

I kiss you.

Yours,
HTL

Prov.: Schimmel
Pub.: GSE186, GSF204

[1] Lautrec designed the set for the first act of *Le Chariot de terre cuite*, an adaptation by Victor Barrucand of a classical Hindu play, which opened at the Théâtre de l'Œuvre on 22 January, 1895. Lautrec also designed the programme (cf. Wittrock 89).

397 *To his Mother*

[Paris, late December 1894]

My dear Mama,

I'm very much pushed at the moment by my new calling of stage-designer. I have to run all over the place, collecting information. And it's quite absorbing. I think Papa must be moaning, if not officially, at least inwardly, there being a possibility of building in the Cité.[1] I believe the Prince of Monaco's business manager has written to him in this vein. If he hasn't mentioned it to you, don't bring up the risky subject, which is sure to make him fly off the handle. Grandmaison[2] looks very perky now he has his pockets lined. I don't know whether I'll be able to get away for New Year as the play opens some time in the first days of January.[3]

I have had a new photograph of myself and will send it to you soon. It looks very true to life.—Gabriel has a touch of the flu, but not me yet.

I kiss you.

Yours,
H.

I'm sending you Y. Guilbert in *Le Rire*.[4]

Prov.: Schimmel
Pub.: GSE187, GSF205

[1] The cité du Rétiro.
[2] Possibly Léonce Lorzeau de Grandmaison (1868–1927), a theologian who also wrote literary criticisms under the pseudonym of Louis des Brandes.
[3] Cf. Letter 396 Note 1.

⁴i.e. a drawing by Lautrec, published in *Le Rire*, No. 7, 24 December, 1894, which shows Yvette Guilbert singing 'Linger Longer Loo'.

398 *To Edward Bella*

[Paris 1895]

¹I beg Mr Bella² to be so very kind as to introduce M. Hartrick³ to M. Bing,⁴ and I thank him for his kindness, past, present, and future.

H. de T. Lautrec

Prov.: Schimmel
Pub.: GSE188, GSF206

¹Written by Lautrec on his visiting card.
²Cf. Letter 386 Note 2.
³A. S. Hartrick (1864–1950), an artist and illustrator of Scottish origin who met Lautrec in 1886 while both were at Cormon's studio. He wrote the preface for a collection of posters, *Second Exhibition Royal Aquarium* (London, 1896), and was on the honorary committee for both the first and second exhibitions. Cf. Letter 386 Note 2.
⁴Siegfried Bing (1838–1905), Parisian dealer in Japanese and Chinese works of art from the early 1870s, collector dealer in Japanese prints, publisher of the periodical *Le Japon Artistique*, and founder of the gallery L'Art Nouveau. For this gallery Lautrec prepared a window design to be manufactured by L. C. Tiffany, *Papa Chrysanthème* (Dortu V.1).

399 *To Arsène Alexandre*

[Paris, 21 January, 1895]

¹My dear Alexandre,²
Allow me to introduce M. Evenepoel³ who will be able, I think, to draw in *Le Rire*.

Yours,

TL

Prov.: Unknown
Source: Hyslop, p. 111

¹Written by Lautrec on his visiting card.
²Arsène Alexandre was artistic director of *Le Rire* (cf. Letter 423 Note 2).
³Henri Evenepoel (1872–99), Belgian artist: studied in Brussels, arriving in Paris in 1892; visited Lautrec's studio in January 1895 but did not see him again; met and was influenced by Henri Matisse; exhibited at the Salon in 1895, 1897, 1899; also made posters and prints.

400 *To Octave Maus*

[Paris, early February 1895]

My dear Maus,
 My show will include some things under glass and some posters.[1] Those under glass are 1 metre long. There will be two of them; the posters in the air.[2] That's all I shall have to give, my friend. Perhaps Wiener[3] will send some covers of mine. Who knows. In any case, regards to Théo and tell Lemmen[4] to give me back the list of things he asked me for and which I returned.

<div align="right">Cordially yours,
HTLautrec</div>

Prov.: Brussels

[1] Cf. Letter 401 Note 1 for catalogue listings.

[2] The posters would not be framed under glass.

[3] René Wiener exhibited five bindings (but none designed by Lautrec), Nos. 634–8: *Les Médailleurs de la Renaissance* (carton L. Guingot); *L'Art gothique* (carton R. Wiener); *La Mer* (carton A. Lepère); *Les Relieurs français*; *Études sur les filigranes*.

[4] Georges Lemmen; cf. Letter 270 Note 3.

401 *To Octave Maus*

[Paris, early February 1895]

My dear Maus,
 Here is my catalogue.[1]
1. *The Fair Miss May H.*
2. Various lithographs.

<div align="right">Yours,
HTLautrec</div>

Prov.: Brussels

[1] For La Libre Esthétique, Deuxième exposition, Brussels, 23 February to 1 April, 1895, Nos. 578–85; *The Fair Miss May H.* (Possibly Miss May Hilton) (Dortu P.572); *Cecy Loftus* (Wittrock 113); *Diverses lithographies*; *Le Pendu (avant lettre)*, (Wittrock P.15); *Confetti* (Wittrock P.13).

402 *To Léon Deschamps*

[Paris, February 1895]

[1]Received from M. L. Deschamps,[2] manager of *La Plume*, the sum of 50 francs for 25 Confetti[3] Bella posters.

<div align="right">H. de Toulouse Lautrec</div>

Prov.: Unknown
Source: **Berès**

[1] Addressed to Deschamps at the office of *La Plume*, 31 rue Bonaparte.
[2] Léon **Deschamps** (*c.* 1863–99), editor of *La Plume*, a literary and artistic periodical, from its inception on 15 April, 1889 until his death in 1899. A publisher of prints and posters and organizer of the Salon des Cent exhibitions, he published and exhibited works by Lautrec, Grasset, Mucha, Rops and many others. *La Plume* published an article on Lautrec by Maindron on 15 November, 1895.
[3] Wittrock P.13.

403 *To Octave Maus*

[Paris] Tuesday [February–March 1895]

My dear Maus,

Roger Marx will be at Libre Esthétique tomorrow at 2 o'clock—he would like to see you and come to an agreement with you regarding the photographs to be taken—for example of Serrurier's bedroom,[1] etc. This will be good for everybody. Try to be there if possible. I am writing to Théo[2] by the same post.

Yours,
HTLautrec[3]

Prov.: Brussels

[1] Georges Serrurier, architect, 38 rue de l'Université, Liège. La Libre Esthétique, Brussels, 23 February to 1 April, 1895, No. 558: *Une Chambre d'artisan, ensemble de mobilier et de décoration.*
[2] Théo van Rysselberghe.
[3] At about this time Lautrec drew a portrait of the French poet Stéphane Mallarmé (1842–98) (Dortu D.3907). It is dated 5 March, 1895. On 3 March Mallarmé wrote to the French author Octave Mirbeau (1850–1917), inviting him to the private funeral of the artist Berthe Morisot (1841–95) to be held on Tuesday, 5 March. The portrait may have been done at that event. (Cf. Lloyd, No. 190, p. 204.)

404 *To André Marty*

[Paris, March 1895]

My dear Marty,

Be so kind as to send Bella[1] the proof of the cover of *L'Estampe*[2] that we promised him. Bella writes to me that Roques[3] went to see him to ask that my posters be removed and replaced by some of Chéret's works that he sold.[4] The dogs are barking, the caravan is passing. I am passing,[5] and send you my best.

HTL

[6] Go after Guibert[7] again if he hasn't paid.

Prov.: Private, New York I.

[1] Cf. Letter 386 Note 1.
[2] *Couverture de l'Estampe originale* (*Album de Clôture*) *1895* (Wittrock 96), published late March 1895.
[3] Jules Roques.
[4] Thirteen of Lautrec's posters were exhibited at the Royal Aquarium, London, 1894–5: Nos. 120–30, 236–7. Number 131 was mistakenly credited to Lautrec. Fifty-four of Chéret's posters were also exhibited; Nos. 17–65, 212–16. The exhibition opened in late October 1894.
[5] Lautrec uses the Arab proverb commonly used in France, 'Les chiens aboient, la caravane passe' (Don't pay attention to petty criticism and jealousy or noisy disapproval, continue with what you feel is correct).
[6] This postscript is added at top left of letter.
[7] Maurice Guibert.

405 *To André Marty*

[Paris, 25 March, 1895]

[1]The *Loïe*[2] will be at Clauzel's.[3] Send someone to get it. Needless to say, it is 50 francs.

Yours,
HTLautrec

Prov.: Private Paris I

[1] Postcard addressed to Monsieur Marty, 17 rue de Rome, Paris.
[2] The colour lithograph *Loïe Fuller* (Wittrock 17), published by Marty in 1893, or one of the three paintings of her by Lautrec.
[3] P. Clauzel, 33 rue Fontaine St Georges, Paris, a picture-framer Lautrec had been using for many years.

406 *To Gustave Geffroy*

[Paris, 10 April, 1895]

[1]If you still want to see *Chilperic*[2] at Les Variétés,[3] we're having dinner tomorrow at 7 p.m. at 24 bd Poissonnière, at Désiré called César.[4] I'll be there with Coolus[5] and Guibert[6] I hope to see you there.

Prov.: Unknown
Source: Saffroy, Bulletin No. 69, June 1970, No. 6727

[1] Fragment of a letter. The full letter was written on a carte-télégramme and signed.
[2] *Chilpéric*, the operetta written by Hervé, opened in February 1895 at Les Variétés. Set in the Merovingian era, it starred Marcelle Lender playing the part of Queen Galswinthe. She danced the fandango and bolero. It is said that Lautrec dragged Coolus to the theatre more than twenty times to see her. He painted *Marcelle Lender* (Dortu P.626) and *Chilpéric* (Dortu P.627), and drew the lithographs *Lender dansant le pas du boléro dans Chilpéric* (Wittrock 103), *Lender de face, dans Chilpéric* (Wittrock 104), *Lender de dos, dansant le boléro dans Chilpéric* (Wittrock 105), *Lender saluant* (Wittrock 106), *Entrée de Brasseur, dans Chilpéric* (Wittrock 107).
[3] Le Théâtre des Variétés, 7 boulevard Montmartre; cf. Letter 249 Note 2.

[4] Restaurant Désiré, 26–8 boulevard Poissonnière (not 24 as Lautrec writes), a short walk from Les Variétés.

[5] Romain Coolus: cf. Letter 452 Note 2.

[6] Maurice Guibert.

407 *To René Wiener*

[Paris, April 1895][1]

Dear Sir,

Thank you so much for the ultimate in bookbinding.[2] I shall have one for you, *The disasters of war* by Goya.[3]

Yours,
HTLautrec

Prov.: Nancy
Pub.: *Annales*, p. 226

[1] Written on a postcard with this date visible.

[2] Lautrec used the term 'Le livre d'or de la reliure'.

[3] Lautrec had drawn *Los Disastros de la Guerra por Don Francisco Goya* (Wittrock 29), which had been printed in a very limited number.

408 *To an Unidentified Correspondent*

[Paris, May 1895]

Dear Sir,[1]

I had instructed A. Marty,[2] who was to see Bernard,[3] to give you an oral answer. He didn't do it—I'm very sorry. I give you full authorization for the reproductions of Zimm.[4] But this concerns Prince Poniatowski,[5] who *owns* the drawing. Talk to L'Heureux[6] or some other *manager* of the *Revue F. Américaine*.[7] I hope there won't be any hindrance.

Greetings and best wishes for your success.

H. de T. Lautrec

Prov.: Unknown
Pub.: Czwiklitzer (unpaginated)

[1] Possibly Camille Mauclair, who was helping to organize the *Revue Franco-Américaine* as art editor. He edited the art section in the second and third issues.

[2] André Marty.

[3] Tristan Bernard (cf. Letter 424 Note 4) was sports editor for the first and third issues of the *Revue Franco-Américaine* and wrote the article 'Zimmerman en Europe' in the first issue.

[4] Arthur A. Zimmerman (b.1869), an American cyclist who became American and European champion and was known as 'The King'. Lautrec drew his portrait, *Zimmerman et sa machine* (Dortu D.3936), and the lithograph (Wittrock 111), which was published to accompany the Tristan Bernard article in the *Revue Franco-Américaine*. Other Zimmerman portraits by Lautrec are Dortu D.3934, D.3935, D.3937, D.3938, D.3939.

[5] Prince André Poniatowski (1864–1954), related to Napoléon Ier through Countess Walewska (their son, Count Walewski, married a Poniatowski). He led a long and varied life which included founding and editing the *Revue Franco-Américaine*.

[6] Marcel L'Heureux, secretary to the editor and editor of the section of Les Lettres of the *Revue Franco-Américaine*.

[7] *La Revue Franco-Américaine*, a magazine especially designed for American readers to include work by all the younger men in art and literature. It published three issues, June, July, and August 1895. The first issue was delivered in May 1895 and included the writers Clemenceau, Schwob, Mallarmé, Capus, Bernard, Daudet, and Barrès and the artists Forain, Helleu, Lautrec, and Vallotton.

409 *To Tristan Bernard*

[Paris, Spring 1895]

[1] My dear Bernard,[2]

Allow me to introduce my friend Wenz.[3] Do for him whatever you would do for me.

Your
HTLautrec

Prov.: Unknown
Pub.: Charles-Bellett II, p. xii

[1] Written on Lautrec's visiting card.
[2] According to Charles-Bellet, this card was written to Paul Bernard, the brother of Tristan Bernard. However, Paul was the given name of Tristan who first used the name Tristan in print in the *Revue Blanche* of October 1891 for an article entitled 'Du symbole dans la chanson de café-concert'.
[3] Frédéric Wenz: cf. Letter 117 Note 4.

410 *To Édouard Dujardin*

[Paris, 31 May, 1895]

[1] My dear Dujardin,[2]

The drawing of Oscar Wilde[3] was painted exclusively for the article by Paul Adam, and has never been reproduced. The plate was sent to you inadvertently.[4]

I am very sorry.

Cordially yours,
HTLautrec

I had 3 Verlaines[5] pulled with the authorization of Anquetin, and I did not understand your curt note to Ancourt.

Prov.: LA

[1] Written on a telegram dated 31 May, 1895.
[2] Édouard Dujardin (1861–1949), one of the leading writers of the Symbolist movement and editor of *La Revue Wagnérienne*. He appears in many paintings and drawings by Lautrec, including Dortu P.420, P.427, D.3974, D.3975, D.4293.
[3] *Oscar Wilde* (Dortu D.3762), for 'L'Assaut malicieux' by Paul Adam, *La Revue Blanche*, No. 47, 15

May, 1895. Other portraits of Wilde by Lautrec are Dortu P.574, D.3917, D.3918, D.3999, D.4250, and Wittrock 146, all dated 1895–6. The relationship between Lautrec and Wilde (1854–1900) during this period is difficult to determine, as is the dating of his paintings and drawings. Nearly all the information on the subject derives from Joyant I. 175–8, which contains an overwrought and senseless comparison of the two and an attack on Wilde, but is short on fact and substance.

There is no positive evidence that Lautrec was in London in 1895, but the whereabouts of Wilde are well documented. He was arrested on 5 April and remained in prison until 7 May when he was released on bail prior to his second trial. He stayed with his mother in Oakley Street for a few days before moving to the Leversons where he remained until 25 May when he was sentenced to gaol at the conclusion of his second trial. Lautrec's drawing appeared in the *Revue Blanche* of 15 May 1895. The exact timing of the works by Lautrec, and whether they were done from life, has not been accurately determined. In a letter to Herbert Schimmel, dated 8 April, 1988, Rupert Hart-Davis states: 'I am certain that Lautrec's drawing of Wilde wasn't done in May 1895.' (Cf. Hart-Davis, pp. 389, 395, 396.)

The portrait of Wilde (Dortu P.574) was used for the preparatory sketch (Dortu D.4250) and the resultant lithograph (Wittrock 146) *Oscar Wilde et Romain Coolus*, the Théâtre de l'Œuvre programme for *Raphaël et Salomé*, double bill which opened on 11 February 1896.

[4] Cf. Letter 413.

[5] *Le Cavalier et le Mendiant, Verlaine and Moréas*, for Album I of *L'Estampe Originale* (1893), and *Portrait of Paul Verlaine (head and shoulders facing left)*, of an unknown date, were the two Verlaine prints by Anquetin. There are four portrait drawings of him by Anquetin in the Museum of Albi (Art Contemporain 7–10).

411 *To an Unidentified Correspondent*

[Paris, June 1895]

[1] I shall be very happy to have dinner with you on Saturday.
In the meantime very cordially your

HTL

Prov.: Schimmel

[1] Written on Lautrec's visiting card.

412 *To Édouard Dujardin*

[Paris, 6 June 1895]

[1] My dear Dujardin,

Alex Natanson[2] apologizes for not being able to come tomorrow. I am replacing him, agreeably with J. P. Sescau.[3] I hope there'll be some ladies.

Your
HTLautrec

Prov.: Schimmel
Pub.: GSE189, GSF207

[1] Addressed to Dujardin at 21 avenue Carnot.
[2] Alexandre Natanson: cf. Letter 360 Note 2.
[3] Paul Sescau, a photographer, with shops at 53 rue Rodier and 9 place Pigalle. He appears in several drawings, paintings, and lithographs by Lautrec (Dortu P.361, P.383, P.427, P.478, P.479, P.527, P.591, D.3679, D.3848, D.3974, D.4223, and Wittrock 94) and was one of the first to photograph the latter's works. Lautrec designed a poster for him in 1896 (Wittrock P.22).

413 To Lucien Muhlfeld

[Paris, June 1895]

My dear Muhlfeld,[1]

The decision of the *Revue*'s editorial board seems to me laudable but excessive. It might perhaps have been more worthwhile to show the same reservations when you thoughtlessly turned my Oscar Wilde plate[2] over to a half-cocked schoolboy magazine.[3] That plate being signed by me.

This time I had already taken my own precautions.

Yours cordially,
HTLautrec

Prov.: Schimmel
Pub.: GSF212

[1] Lucien Muhlfeld (1870–1902), managing editor and official literary critic of *La Revue Blanche*, 'dominated the history of *La Revue Blanche* during the years 1891–85' (cf. Jackson, A. B.).
[2] *Oscar Wilde* (Dortu D.3762). Cf. Letter 410.
[3] Lautrec cannot be referring to Dujardin's *La Revue Wagnérienne* which existed from 1885 to 1888. He may be referring to the literary, artistic, and political magazine *La Revue Indépendante*, 1884–95, although Dujardin was editor only from 1886 to 1889. Dujardin was later associated with the periodical *Fin de Siècle*, which is more likely to be the magazine in question.

414 To an Unidentified Correspondent

[Paris, June 1895]

Dear Maître,

It's for Saturday—see Sescau[1] so that we have dinner together, at

my house if you wish. Have a white dinner jacket and tint your face—
if possible.

<div align="right">

Your
HTLautrec
7 rue Tourlaque
27 rue Caulaincourt

</div>

Prov.: Schimmel
Pub.: GSE190, GSF208

[1] Cf. Letter 412 Note 3.

415 *To Tristan Bernard*

<div align="right">

[Paris] 2 July, 1895

</div>

[1]My dear Bernard,

I've seen M. Valdagne.[2] The cover[3] is going to be printed immedi-
ately. Should I ask a price from Ollendorf[4] or is this an indiscreet
question? Please drop me a word of advice. If the answer is yes, please
tell me what arrangements have been made.

<div align="right">

Yours,
HTLautrec

</div>

Prov.: Mayer

[1] Written on letterhead of *La Revue Blanche*, 1 rue Laffitte.
[2] Lucien-Louis (called Pierre) Valdagne (b. 1854), a popular French author, novelist, and playwright
of the period. Among his plays were *Allô! Allô!, La Peur de l'être, En rêve, Un oncle d'Amérique*, and
La Blague. He also wrote for *Le Figaro Illustré* and was one of the authors of *Les Minutes parisiennes*
published by Ollendorf.
[3] For Bernard's one-act play *Les Pieds nickelés*, for which Lautrec drew the lithographed cover
(Wittrock 95).
[4] Paul Ollendorff, editor, 28 bis rue de Richelieu, publisher of *Les Pieds nickelés*.

416 *To Léon Deschamps*

<div align="right">

[Paris, 12 July 1895]

</div>

Dear Sir,[1]

Write to me at 30 rue Fontaine, my new address.[2]

<div align="right">

Cordially yours,
HTLautrec

</div>

Prov.: Schimmel
Pub.: GSE 192, GSF 210

[1] Léon Deschamps: cf. Letter 402 Note 2.
[2] His new apartment, to which he moved from rue Caulaincourt and where he remained until 1897.

417 *To Léon Deschamps*

[Paris, Summer 1895]

Dear Sir,

I shall have the pleasure of dining with you this evening. My friend
A. Albert[1] will be coming with me.

Most sincerely,
HTLautrec

Prov.: Alphandéry
[1] Adolphe Albert: cf. Letter 152 Note 2.

418 *To Roger Marx*

[Paris] Saturday [20 July, 1895]

[1]At Sescau, 53 rue Rodier, tomorrow, Sunday, at 2 o'clock. I hope
things are ready. Best regards.

HTLautrec

I shall call on you tomorrow to introduce Manzi[2] to you.

Prov.: Schimmel
Pub.: GSF211
[1] Pneumatic letter addressed to M. R. Marx, 8 rue Picot, Paris 16ᵉ.
[2] Michel Manzi: cf. Letter 158.

419 *To an Unidentified Correspondent*

[Paris, 11 August 1895]

[LAUTREC WRITES ON 11 AUGUST, 1895 REGARDING THE BUSINESS OF AN UNPAID
BILL.]

Prov.: Unknown
Source: Drouot, Auction, 12 May, 1936, No. 203-2

420 *To Théo van Rysselberghe*

[Paris, August 1895]

Tomorrow should have your Verlaine.[1]

My dear Théo,

Please be so kind as to explain once more to my stupid paper-hanger how to hang faience tiles on the fireplace—plan, cross-section, and vertical section.[2] Doesn't Georges Lecomte[3] have one? designed by you?

I am leaving for a week in the country, so please write directly to this man, Werthmuller, 13 rue Ramey, Paris.

Respects to Mme van Rysselberghe and to the Infanta Doña Pepita (I think that stands for Elisabeth[4] (?))

Yours
HTL

Prov.: Schimmel

[1] This may be one of the Anquetin prints of Verlaine that Lautrec had pulled by Ancourt (cf. Letter 410 Note 5).

[2] Lautrec was trying to complete the decoration of his apartment.

[3] Georges Lecomte: cf. Letter 289 Note 1.

[4] Elisabeth van Rysselberghe, Théo's daughter.

421 *To his Mother*

[Paris, August 1895]

My dear Mama,

I'm writing to ask your forgiveness for my silence, but this silence was due to a state of irritation that *happily* is beginning to go away. I was right in the middle of moving.[1] Everything is almost finished, but I don't know anything more horrible than these moves in the heat, the dust, and other disagreeable things. Everything is ugly and uncomfortable, it's been said a *hotel* becomes an ideal at moments like these. Well, let's get back to the subject. Everything's about to be finished and on *Tuesday* I shall leave Le Havre with the faithful Guibert, which will get us to Malromé on Thursday or Friday. We'll stay two days and return by boat to Le Havre to get Bourges, who will make the journey with his wife. Which will make three trips by sea, one on top of the other. If I don't smell of codfish I'll be lucky. In any case, see you soon and I kiss you.

Yours,
H.

I'll keep in touch by telegram.

My address is now 30 rue Fontaine.

Prov.: Schimmel
Pub.: GSE191, GSF209

[1] i.e. from his apartment in the rue Caulaincourt to one at 30 rue Fontaine.

422 *To Joseph Ricci*

[Paris, August 1895]

My dear Ricci,[1]

This is to introduce my friend Maxime Dethomas,[2] a charming fellow and painter who doesn't talk about his painting, something that is very praiseworthy.

He would like you to introduce him to a few friends such as Botticelli, Uccello, and *tutti quanti*. Treat him as you'll treat me when I come.

I almost did this year, but I worked all summer long, which is ridiculous, and I'm going to take a little sea voyage,[3] to forget work for a while.

A kiss, and best wishes for your family happiness.

Your old pal,
HTLautrec

Prov.: Schimmel

[1] Addressed to Joseph Ricci, Peintre, 28 via San Dalmazzo, Turin.
[2] Maxime Dethomas (1867–1929), painter, printmaker, theatre designer, and one of Lautrec's closest friends and travelling companions.
[3] Cf. Letter 421.

423 *To Henri Albert*

[Taussat, 8 September, 1895]

My dear Albert,[1]

Arsène Alexandre[2]
20 rue Gérando
can tell you better than anyone else a lot of good things about me.

So contact him, and offer him the print of Lender[3] by way of reward. Send me the article,[4] if you can't get me the complete issue of *Pan*.[5]

Send it to Taussat, via Audenge, Gironde, until the 20th of this
month. After the 20th,
 Château de Malromé
 via St Macaire
 Gironde

<div align="right">
Cordially,

HTLautrec
</div>

Prov.: BN

[1] The envelope is addressed to Monsieur H. Albert, Directeur de Pan, 9 rue des Beaux-Arts, Paris.
Henri Albert was the Paris editor of the magazine *Pan*. The writing-paper and envelope are imprinted
with the seal of Maurice Guibert, designed in the Japanese style by Lautrec and also used by Guibert
as his bookplate.

[2] Arsène Alexandre (1859–1937), artistic director of the periodical *Le Rire*, critic, writer, and devoted
supporter of Lautrec.

[3,4] The lithograph *Marcelle Lender en buste* (Wittrock 99) was published in 1895 in *Pan* I p. 197. The
article by Alexandre appeared on p. 196. It was the third issue of 1895, covered the period September–
November 1895, and was issued in September.

[5] *Pan* was an avant-garde German magazine of literature and art, edited by Julius Meier-Graefe and
published between 1895 and 1900. Original works of art by other artists included Maurice Denis (III
p. 185), Maximilien Luce (IV p. 21), Charles Maurin (II p. 79), William Rothenstein (II p. 329), Théo
van Rysselberghe (IV p. 25), and Paul Signac (IV p. 9).

424 *To Arsène Alexandre*

<div align="right">
[Taussat, 8 September, 1895]
</div>

My dear Alexandre,[1]
 Henri Albert, Paris editor of the magazine *Pan*,[2] which is publishing
one of my prints,[3] will come to ask you for some facts on my paltry
self. Since you were the first one to speak well of me, I'm anxious that
you should be the one to trumpet my great deeds on the other side of
the Rhine.

<div align="right">
Cordially yours,

HTLautrec

Taussat near Audenge

Gironde
</div>

P.S. When is Tristan Bernard's[4] story appearing in *Le Rire*? Would
you be so kind as to have the last 4 issues of this rag sent to this
address? My family has mine and fails to forward them.

Prov.: Schimmel
Pub.: GSE193, GSF213

[1] The letter is addressed to him at 20 rue Gérando.
[2] Cf. Letter 423 Note 5.
[3] Cf. Letter 423 Note 3.
[4] Tristan Bernard (1866–1947), journalist, author, and playwright, a founder of *La Revue Blanche*
and director of Vélodrome Buffalo, the scene of bicycle races. Lautrec did a drypoint portrait of him

in 1898 (Wittrock 240) and cover illustrations for his plays *Les Pieds nickelés* in 1895 and *Le Fardeau de la Liberté* in 1897 (Wittrock 95 and 233).

425 *To Léon Deschamps*

Chalet Delis Moureau, 207 boulevard de la Plage, Arcachon
[September 1895]

My dear Deschamps,

For this time we'll fix the price of the poster[1] at 250 francs plus a certain number of unlettered proofs. As soon as you have the money, send it to me here. Do you have any news of the Journal Allemand?[2] Please write to them. In any case keep me informed.

Very cordially yours,
HTLautrec

How are Pellet,[3] Roques,[4] and Rops[5] getting along?

Prov.: Schimmel

[1] *Irish and American Bar, Rue Royale—The Chap Book* (Wittrock P.18), published in editions both before and with letters in 1895.

[2] Lautrec is referring to the publication *Pan* (cf. Letter 423).

[3] Gustave Pellet (1859–1919), a publisher and print-dealer whose shop was at 9 quai Voltaire. He published or distributed Lautrec's lithographs beginning in 1894, and in 1896 he published Lautrec's series of lithographs entitled *Elles* (Wittrock 155–65). He also published or distributed works by Lautrec's friends Louis Anquetin and Charles Maurin.

[4] Jules Roques.

[5] Félicien Rops (1833–98), Belgian symbolist painter, printmaker, and writer. Pellet published more than 400 of his prints, and Deschamps was preparing two exhibitions of Rops's work in the Salon des Cent for June and October 1896.

426 *To his Mother*

[Paris] Saturday [late September 1895]

My dear Mama,

I haven't much of importance to tell you. It's hot, hot, hot. I haven't had word from the Bertrand[1] couple and am not asking for it. My upholsterers are working slowly.

Madame Bourges has lost her dog, which swelled up and died. Our trip was wonderful, on a sea smooth as a pond.[2] Which didn't prevent

Fabre, who went with us, from puking his guts out. There's imagination for you!! Nothing of interest in sight.

I kiss you.

<div style="text-align:right">Yours
H</div>

Prov.: Schimmel
Pub.: GSE182, GSF200

[1] Raymond Bertrand de Toulouse-Lautrec (1870–1952), Lautrec's cousin, who married Louise de Turenne d'Aynac in 1895.
[2] From Arcachon to Le Havre.

427 *To Léon Deschamps*

<div style="text-align:right">[Paris] Friday, 11 [October 1895]</div>

Could you stop by tomorrow at 9.30 at Ancourt's. I'll be there.

Order a grained stone.

<div style="text-align:right">Yours,
Lautrec</div>

reply to 30 rue Fontaine

Prov.: Schimmel
Pub.: GSE195, GSF215

428 *To Léon Deschamps*

<div style="text-align:right">[Paris, October 1895]</div>

My dear Deschamps,

I'll come on Tuesday or Wednesday to *La Plume*. Make me an appointment for between 4 and 5 p.m. Or bring me the thing yourself at 11 a.m. to Ancourt's.[1] Please send me a note, at *30 rue Fontaine*, not 27 rue Caulaincourt.

<div style="text-align:right">Cordially yours,
HTLautrec</div>

Prov.: Schimmel
Pub.: GSE194, GSF214

[1] Edward Ancourt, an expert printer whose shop was at 83 rue du Faubourg Saint-Denis. Lautrec relied on his technical experience in printing many of his posters.

429 *To Léon Deschamps*

[Paris, 18 October, 1895]

Despite all our efforts our tests won't be completed until noon tomor-
row, Saturday. Come to Ancourt's at 11.30 a.m. You'll probably see
the thing.[1] If nothing goes wrong, we'll be able to print immediately.

Your
HTLautrec

Prov.: Unknown
Source: Berès

[1] *Irish and American Bar, Rue Royale—The Chap Book* (Wittrock P.18).

430 *To Léon Deschamps*

[Paris, October 1895]

My dear Deschamps,

I have heard nothing from Ancourt.[1] Go and see him and try to
hurry things along. Get me a *definite* appointment to do the proofs or
it will take two years.

Cordially,
H. de T. Lautrec
30 rue Fontaine

Prov.: Unknown
Source: Rendell, Listing No. 634

[1] Cf. Letter 428.

431 *To Madame Théo van Rysselberghe*[1]

30 rue Fontaine [Paris, Autumn 1895]

[2]My friend Robin,[3] who came to Brussels with me last year,[4] is
sending you today some preserves that are similar to your wonderful
Lemon Cheese. He asked me to give them to you, along with his
respects. I take advantage of this opportunity to send you mine as well
and to send my regards to Théo.

Prov.: Unknown
Source: Drouot, 18 December, 1987, No. 257.

[1] Marie-Philomène Andrée Monnom, who married Théo van Rysselberghe in 1889.
[2] Fragment of a letter.
[3] Robin Langlois: cf. Letter 497 Note 1.
[4] Lautrec visited Brussels in February 1894 for the Libre Esthétique exhibition. Cf. Letter 344.

432 *To André Marty*

[Paris] Tuesday [Autumn 1895]

My dear Marty,
 Come tomorrow at 8.30 a.m. to 30 rue Fontaine. I'd like to see you.

Yours
HTLautrec

Prov.: Private Paris I

433 *To Gustave Geffroy*

[Paris, 26 October, 1895]

[¹LAUTREC WRITES REMINDING GEFFROY OF HIS PROMISE TO GET HIM
INTO A REHEARSAL OF *LES AMANTS*² WHICH HE IS ANXIOUS TO SEE. HE
GIVES HIS CURRENT ADDRESS AND SIGNS.]

Prov.: Unknown
Source: Parke Bernet, Auction, 1–2 April, 1958, No. 596.
 ¹ Fragment of a letter.
 ² Cf. Letter 436, which was evidently a follow-up to this letter.

434 *To an Unidentified Correspondent*

[Paris, Autumn 1895]

¹Meet me at the bar² at 6.30 today or Monday. I want to talk to you
about *The Chap Book*³ poster.

Yours,
HTLautrec

Prov.: Simon
 ¹ Written on letterhead of *La Plume*, Salon des Cent, 31 rue Bonaparte.
 ² Probably the Bar Anglais or the *Irish and American Bar, rue Royale.*
 ³ *Irish and American Bar, Rue Royale*—*The Chap Book*, poster (Wittrock P.18). *The Chap Book* was an
American periodical, first published on 15 May, 1894 by Stone & Kimball from Cambridge, Mass.
The publishers moved to Chicago, Ill., in August 1894 where they continued to publish *The Chap
Book* under the name of Stone & Kimball and later Herbert S. Stone & Co. until 1898.

435 *To an Unidentified Correspondent*

[Paris] Tuesday [Autumn 1895]

Dear Sir,

I shall be at the Imprimerie Ancourt at 83 faubourg Saint-Denis until 3.15, and until 6.30 at the Bar Anglais, or later at the Irish and American, 23 rue Royale.

Yours,
HTLautrec

Prov.: LA

436 *To Gustave Geffroy*

[Paris, 3 November 1895]

[1]When will *Amants*[2] be opening?
Are you in the know?

Cordially yours
HTLautrec

Prov.: LD

[1] Postcard addressed to Monsieur G. Geffroy, 133 rue de Belleville, Paris.
[2] *Les Amants*, a comedy in four acts by Maurice Donnay (1860–1945), opened at the Renaissance in Paris on 5 November, 1895.

437 *To Léon Deschamps*

[Paris, November 1895]

[1]My dear Deschamps,

When will I be able to collect the King's gold?[2] Please drop me a line.

Regards,
HTLautrec
30 rue Fontaine

Prov.: Unknown
Source: Berès

[1] Telegram addressed to Monsieur L. Deschamps 31 rue Bonaparte.
[2] Cf. Letter 438.

438 To Léon Deschamps

Paris, 14 November, 1985

Received from *La Plume* the sum of two hundred francs for repro-
duction rights to a poster in folio size, *The Chap Book*.[1]

H. de Toulouse Lautrec

Prov.: Schimmel
Pub.: GSE196, GSF216

[1] The actual title is *Irish and American Bar, Rue Royale—The Chap Book* (Wittrock P.18). It was
published by the 'Affiches artistiques de la Plume' to advertise the American magazine *The Chap Book*.

439 To Maurice Joyant

[Paris] 16 November, 1895

Received from M. Joyant the sum of five hundred francs for my
painting Clown with tits.[1]

H. de Toulouse Lautrec

Prov.: Unknown
Pub.: Dortu, vol. I, p. 52

[1] Possibly *La Clownesse Cha-u-Kao* (Dortu P.580; cf. also P.581–3). Cf. Letter 447 Note 2.

440 To his Mother

[Le Bosc] *Wednesday* [November 1895]

My dear Mama,

Here I am at Le Bosc after a very good trip [with] Coste. Thank
you for Pierre. Everything's fine. Tomorrow morning we leave at
4 a.m. for Rodez and Millau, where two friends, Gabriel, Rocoul, and
Odon are waiting for us. With the two of us that makes 7.[1] We'll begin
by visiting M. de Lavalette at St-Jean du Bruel, after which we'll
go down the Tarn Gorge from Ste-Énimie to Millau.[2] Everybody's fine
here. The grannies are frisky and my uncle has a flowing, or rather a
Henri IV beard. Send my letters to Paris and tell yourself we're
waiting impatiently for you here, old and young alike. Your mama
sends you a kiss and me I send you a kiss too, you my Mama.

Yours,
H.

Aunt Alix is moving starting the 10th and would like you to give her
a hand.[3]

Prov.: Schimmel
Pub.: GSF217

¹ The seven persons on the trip were Henri de Toulouse-Lautrec, Gabriel Tapié de Céleyran, his brother Odon Tapié de Céleyran, Rocoul (whose name Lautrec has written on the reverse of the drawing D.3831 and the face of the drawing D.3832 in 1895 and is otherwise unknown), Coste (unknown), and two unidentified friends.
² The trip followed the following course: Le Bosc east to St-Jean de Bruel (51 miles), north to Ste-Énimie (21 miles), south-west down the Tarn river to Millau (24 miles), and then north-west to Rodez (30 miles). The distances actually travelled were probably substantially more. Stops were also made at Creissels and Roquebelle. Cf. Letter 441.
³ Cf. Letter 441, where the same move is mentioned.

441 *To his Mother*

30 rue Fontaine, Paris, Thursday [November–December 1895]
My dear Mama,

After a superb trip in all respects we arrived in Paris this morning. All is in order and my maid, though not forewarned of my coming, hadn't done anything at all unusual. I have a male kitten, weaned, from my cat. If you want it, it could be sent to you. Bourges is here with his wife, barely recovered from a bicycle crash but dying to ride again. Paris is dark and muddy, but I'm going to work hard. They're waiting for me in a number of places. Aunt Alix has asked me to urge you to go to Albi, where you could help with her move. I went to Creissels and Roquebelle,¹ where everybody was most kind, and enquired after you.

Another matter. Tell Balade to get another barrel ready to send so that we can bottle it. I have the space. According to my calculation, I drink a barrel and a half a year. I kiss you.

Yours,
H.

Papa really did go to the Montagne Noire,² and wrote from there. No other details.

Prov.: Schimmel
Pub.: GSE197, GSF218

¹ Villages in the Department of Aveyron, in south-central France, very near Millau. Cf. Letter 440.
² A mountain range on the extreme south-west of the Massif Central, approximately 30 miles south of Albi.

442 *To his Mother*

[Paris, November–December 1895]

My dear Mama,

You must have received the Boulett-Moras and Tourny[1] without forgetting the two of us. Together with Gabriel[2] I had to root them out of Guibert,[3] who is deep in les Délices de Capoue[4] and sunk in inertia. What's new that I can tell you? Gabriel is learning to ice-skate, under the motherly eye of Hogg, Mme Bompard, and M. Blignières. I'm living a monotonous life. I'm working on a big poster,[5] and I eat my meals at the Bar Américain,[6] which means that I'm living on roast beef. Tell Aunt Émilie that if she wants to give a gift to her *poster-phile* nephews she could get a copy of *Maîtres de l'affiche*.[7]

This title is perhaps a bit pretentious, and I'm embarrassed by it. It's published in serial form, illustration size, with four colour reproductions each month of all known posters, and it costs 28 francs. Contact the Imprimerie Chaix, 20 rue Bergère. Nothing new. I'm thinking of going to Albi, but I'd like to avoid the Os.

Hug the grandmothers and Papa for me, and give my regards to the others. I kiss you.

Yours,

H.

Prov.: Adhémar

[1] Lautrec may be referring to dogs (cf. Letter 323A).
[2] Gabriel Tapié de Céleyran.
[3] Maurice Guibert.
[4] Voluptuous Idleness, derived from Capua, an ancient city of Campania. Hannibal's soldiers were influenced by its luxury when they moved to winter quarters there after the battle of Cannae.
[5] Probably *La Revue Blanche* (Wittrock P. 16).
[6] Irish and American Bar, rue Royale.
[7] *Les Maîtres de l'Affiche*, a monthly periodical edited and published by l'Imprimerie Chaix, with preface by Roger Marx. Issued from November 1895 to August 1900, it contained 240 regular poster reproductions, plus 16 special plates, for a total of 256.

443 *To Maxime Dethomas*

[30 rue Fontaine, Paris, Autumn–Winter 1895]

My dear Dethomas,[1]

Miss Belfort[2] is asking around for a husband for her cat. Is your Siamese ready for this business? Drop me a line, if you please, and name a date. We'll be going to Sescau's at 2 o'clock, or elsewhere if you wish.

Your
HTLautrec

Prov.: Schimmel

Pub.: GSE198, GSF219
[1] Maxime Dethomas: cf. Letter 422 Note 2.
[2] May Belfort, an Irish singer who at this time performed at the café-concert 'Les Décadents' with a black cat in her arms; it is represented in Lautrec's lithographs of her (Wittrock 114, 115, 117, 118, and poster P.14).

444 *To an Unidentified Correspondent*

[Paris, Winter 1895]

[1]Dear Sir,
Do come to my studio on Monday at 4 o'clock, we'll try to settle the matter.
I'll be happy to oblige you if possible.

Yours,
HTLautrec
27 rue Caulaincourt
3rd floor

Prov.: Unknown
Source: Goldschmidt
[1] This note was included with a volume of *Histoires naturelles* (Wittrock 202–24), inscribed by Lautrec and later (in 1904) by Jules Renard to the dealer Henri Saffroy. Lautrec also drew an elephant with his monogram. It has been suggested by F. Arnaud of the Librairie Saffroy that this volume was inscribed to the editor, dealer, and collector Henri Saffrey and not to the manuscript dealer Henri Saffroy. On 26 December 1895 Renard wrote: 'Descaves wants to persuade me that I shall need fifty Histoires Naturelles to make a volume. Lautrec suggests that he illustrate eight of them and that we sell a hundred copies at 25 francs apiece. We would share the profit.'

445 *To Félix Fénéon*

[Paris] Monday [December 1895]

My dear Fénéon,[1]
I shall be very glad to open the door of my studio to you between 4.30 and 5 today.
I'll give you the poster[2] and we'll talk about painting.

Regards,
HTL

Prov.: Karpmen-Boutet
[1] Félix Fénéon (1861–1944), a critic most closely associated with the Symbolist and Neo-Impressionist artists and writers. Involved with Maximilien Luce and the Anarchists, he was gaoled in 1894. He became associated, as secretary to the editor, with *La Revue Blanche* and his writing as a regular position first appeared in February 1895. Lautrec first sketched him in late 1894 (Dortu D.3665, D.3666) for the 1895 lithograph *Programme pour Le Chariot de terre cuite* (Wittrock 89). Later in 1895 he included his portrait in the painting *Baraque de la Goulue à la Foire du Trône: La Danse mauresque* (Dortu P.591), and he drew portraits of him (D.3807, D.3965, D.4223, and D.4257) in 1895 and 1896.
The superb biography of Fénéon (cf. Halperin, 1988) best and most completely describes the

relationship between him and Lautrec, accurately discussing and analysing Lautrec's portraits of him, including occasional mistaken identification of him as the dancer Valentin 'Le Désossé' (cf. Wittrock P.1). He recognized Lautrec's work very early and wrote of the paintings he exhibited with the Indépendants in 1889 and also reviewed the Lautrec–Maurin exhibition of 1893 in the periodical *L'Endehors*. According to the biographer, 'When Lautrec began making posters the critic was enthusiastic, giving Lautrec his highest praise'. His enthusiasm was most evident when writing about *Reine de Joie* (cf. Wittrock P.3). In 1893 he lived on the rue Lepic, a short distance from Lautrec's studio (27 rue Caulaincourt/7 rue Tourlaque), moving in the spring of 1894 to an even closer location at 4 passage Tourlaque. The personalities and activities of Lautrec and Fénéon were extremely disparate although they did, over the years, have friends and acquaintances in common, including Charles Maurin, Édouard Dujardin, Théo van Rysselberghe, and of course the Natansons. It seems that it was during the *Revue Blanche* period that they were most likely to have had social contacts.

[2] Lautrec may be referring to his poster *La Revue Blanche* (Wittrock P.16), published in late 1895. It is unlikely that he would refer to the *Chariot de terre cuite* programme as an 'affiche'.

446 *To an Unidentified Correspondent*

[Paris, January 1896]

My dear Sir,

Please contact M. Joyant, 9 rue Forest, Paris, who handles my affairs, and give your order directly to him. As for the paintings to be exhibited,[1] M. Joyant knows what he has to do. Please contact him on this matter as well.

I appreciate your high regard for my works, and I remain,

Faithfully,
H. de Toulouse Lautrec
30 rue Fontaine

P.S. The drawing sold by Messrs Boussod and Valadon belongs to them, including reproduction.

Prov.: Albi

[1] Cf. Letter 447 Note 2.

447 *To an Unidentified Correspondent*

[Paris, early January 1896]

The rue Forest is near 128 bd de Clichy.

Dear Sir,[1]

I have hung several pictures and drawings in the studios at 9 rue Forest.[2]

So, if you like, come on Sunday, 12 January, between 1 and 4 p.m.
I shall be there with M. Joyant to do the honours.

> With my personal regards,
>
> HTLautrec

Prov.: LC

[1] Possibly Léon Deschamps (cf. Letter 458).

[2] The address of Joyant's gallery, Manzi-Joyant, was 9 rue Forest, where an exhibition of paintings, lithographs, and posters opened in January 1896. Among the paintings exhibited were *La Femme tatouée* (Dortu P.551), *Femme qui tire son bas* (P.553), *La Clownesse* (P.581), *Au Moulin-Rouge: La Clownesse Cha-U-Kao* (P.583), *Miss May Belfort* (P.586), *Miss May Belfort* (P.587), *Femme au repos* (P.597), and *Elles—La Glace à main* (P.632).

448 *To Édouard Dujardin*

[Paris, 20 January, 1896]

[1] Dear Maître,

Joze[2] has asked us to postpone our meeting to Friday. Please let me know if this is all right.

> Your
>
> HTLautrec

Prov.: Schimmel
Pub.: GSF222

[1] Pneumatic letter addressed to M. Dujardin, 21 rue Carnot, Paris 17e.

[2] Victor Joze, author of the novels *La Reine de joie*, *Babylone d'Allemagne*, and *La Tribu d'Isidore*. Lautrec designed the posters for the first two and did the cover illustration for the third (Wittrock P.3, P.12, 234).

449 *To Mme R. C. de Toulouse-Lautrec*

[Paris, January 1896]

My dear Grandma,

I thank you for the appetizing pâtés that Mama brought me on your behalf. We're going to feast on them as heartily as we know how, while drinking to your health.

I'm hard at work all day long and am very happy to have a schedule to keep. Foreigners are definitely most kind to painters. I have just sold two paintings to King Milan of Serbia.[1] I'll be able to put Painter to the Court of Sofia on my cards, which would be all the more absurd since Milan has fallen. He seems to be taking it very well and is no longer in fear of the yataghans of the anarchists, who did get Stambulov.[2] What news to tell you except that my Pascal cousins have embarked on an affair that doesn't seem to me to make sense and

which, as I see it, they'll have a hard time getting out of with a whole skin. Perhaps they thought they were making a clever deal? . . .

Please kiss Papa for me, and I kiss you.

Your respectful grandson,

Henri

Prov.: Schimmel
Pub.: GSE201, GSF223

[1] The King of Serbia, Milan IV, lived in exile in France under the name of the Count of Takovo after his abdication in 1888. One of the paintings he bought was *Au Moulin Rouge: La Clownesse Cha-U-Kao* (Dortu P.583), the other was *Au cirque: Dans les coulisses* (Dortu P.321).

[2] Stefan Stambulov (1854–95), a leading figure in Bulgarian politics, murdered in Sofia in 1895.

450 To Léon Deschamps

[Paris] Friday [8 February, 1896]

My dear Deschamps,

Please have the drawing picked up before 4 o'clock today. Don't forget the address of the photographer. Sescau, 53 rue Rodier.

Good luck.

Regards,

HTLautrec

Prov.: Schimmel

451 To Maurice Guibert

[Paris, 25 February, 1896]

[1]1 2 3 4 5 6 7 8 9 10[2]

9.30 83 fg St. Denis[3]

Prov.: Schimmel

[1] Carte-télégramme addressed to Maurice Guibert, 13 rue Bosio, Auteuil.

[2] On the telegram form, under the numbers, is a portrait of Guibert (Dortu D.4212).

[3] The address of Edward Ancourt's print shop.

452 *To Gustave Geffroy*

[Paris, 4 March, 1896]

[1]My dear Geffroy,
 You're invited to dinner on Tuesday, 10 March, at 7.30, at the home of Th. Natanson, 9 rue St Florentin. I'll be there with Coolus.[2]

Yours,
HTLautrec

Reply to Th. Natanson

Prov.: Schimmel

 [1] Telegram addressed to Monsieur Geffroy au Journal 106 rue Richelieu.
 [2] Romain Coolus (René Weil) (1868–1952), author of light sentimental comedies, and a dramatic critic for *La Revue Blanche*. Lautrec included him with Oscar Wilde in his lithograph *Oscar Wilde et Romain Coolus: Programme pour Raphaël et Salomé* (Wittrock 146).

453 *To Léon Deschamps*

[Paris] Monday [16 March, 1896]

[1]My dear Deschamps,
 If possible, tomorrow at 11 a.m. at Ancourt's offices, or 5 p.m. at *La Plume*.

Yours,
HTLautrec

Prov.: Iskian
 [1] Telegram addressed to Monsieur L. Deschamps, 31 rue Bonaparte.

454 *To A. Arnould, Countersigned by Lautrec*

[Paris] 18 March [18]96

M. Arnould,[1]
 Monsieur de Toulouse-Lautrec asks me to tell you that he authorizes you to reproduce all the posters of your choice, on condition that you show him the proofs before printing them.

Cordially,
Edw. Ancourt
Seen and approved
HTLautrec

Prov.: Schimmel
Pub.: GSE273, GSF302

 [1] A dealer in prints and posters. In his catalogue of June 1896, Lautrec was represented by three posters; *May Belfort* (Wittrock P.14), *La Revue Blanche* (Wittrock P.16), and *Troupe de Mlle Eglantine* (Wittrock P.21). Lautrec also drew the lithograph for the cover of the catalogue, *Débauche* (Wittrock 167).

455 To Léon Deschamps

[Paris] Sunday [22 March, 1896]

[1]My dear D.,

Accepted in principle.[2] Come to Chaix's place tomorrow, Monday, at 3 o'clock, and we'll have a chat.

Your
HTLautrec

Prov.: Schimmel
Pub.: GSF224

[1] Pneumatic letter addressed to M. Deschamps, c/o *La Plume*, 31 rue Bonaparte, Paris 6ᵉ.
[2] This concerns an exhibition at the XXᵉ Salon des Cent of Lautrec's *Elles* series, to be exhibited for the first time as a full set. The exhibition opened on 22 April, 1896 under the auspices of Deschamps's *La Plume* (Wittrock 155, 4th state 155–65).

456 To Léon Deschamps

[Paris, 23 March, 1896]

[1]I shall come to *La Plume* tomorrow, Tuesday, at 9.30 in the morning.

Your
HTLautrec

Prov.: Schimmel
Pub.: GSF225

[1] Pneumatic letter addressed to M. Deschamps, 31 rue Bonaparte, Paris 6ᵉ.

457 To Gustave Geffroy

[Paris, 13 April, 1896]

[1]My dear G.,

Can one go with you to the play *L'Œil Crevé*[2] at the Variétés.[3] A word please to 30 rue Fontaine.

Yours
HTLautrec

Prov.: Schimmel

[1] *Carte-lettre* addressed to Monsieur G. Geffroy au Journal 106 rue de Richelieu, Paris.
[2] A musical extravaganza in three acts, words, and music by Hervé (Florimond Ronger, 1825–92), who also wrote *Chilpéric*.
[3] Théâtre des Variétés, 7 bd Montmartre, where the show opened on 18 April, 1896, starring Brasseur, Guy, M(é)aly, and Lavallière.

458 *To Léon Deschamps*

[Paris, 20 April, 1896]

[1]My dear Deschamps,
 The letter of invitation to come to rue Forest[2] was indeed for you. We are counting on seeing you there.

Cordially
HTLautrec

Prov.: Schimmel
Pub.: GSE202, GSF226
 [1]Carte-télégramme addressed to Monsieur L. Deschamps 31 rue Bonaparte 31.
 [2]Possibly Letter 447.

459 *To Léon Deschamps*

[Paris, 23 April, 1896]

[1]Please keep the drawing (not the proof, the drawing) of the reclining woman[2] away from the light, because the tracing paper would crack in the sunlight.

Yours,
HTLautrec

Prov.: LA
 [1]Carte-télégramme addressed to Monsieur Deschamps, 31 rue Bonaparte.
 [2]Lautrec is probably referring to the drawing for *Femme sur le dos, lassitude*, lithograph from the *Elles* series (Wittrock 165). The drawing for this lithograph is Dortu D.4120. The exhibition of the *Elles* series, directed by Deschamps, opened at *La Plume*, 31 rue Bonaparte, on 22 April, 1896.

460 *To Léon Deschamps*

[Paris, May 1896]

[1]My dear Deschamps,
 Please give the bearer the drawing intended for the German newspaper.[2] *Le Rire* needs a drawing on the Barrisons.[3] I'll do another one for you as soon as possible for the newspaper in question, for which up-to-dateness should not be of much importance.

Cordially yours,
HTLautrec

Prov.: Unknown
Source: Goldschmidt
 [1]Written on the letterhead of F. Juven & Cie, Éditeurs, 10 rue Saint-Joseph, Paris, the publishers of *Le Rire*.

[2] Lautrec may be referring to d'Aubecq's *Die Barrisons*, published in Berlin in January 1897. It contained illustrations by T. T. Heine, Chéret, Réalier-Dumas, F. Vallotton, and others. There was no Lautrec drawing.

[3] The five Barrison sisters were possibly the first group of girl dancers and singers to be presented in France. They were of similar build and dressed alike, but there were reports that they were not really sisters. Their names were Lona, Sophia, Inger, Olga, and Gertrude and they were a sensation, appearing in white petticoats in the Meine Kleine Katze number, singing in childish voices 'Would you like to see my pussy?' before revealing the kittens they were holding. Lona, the oldest, married their press agent, William Fleron, a flamboyant man who wore yellow kid gloves, a silk hat, and tails. Lautrec drew them in *Dans les coulisses des Folies Bergère: Mrs. Lona Barrison avec son manager et époux* (Dortu D.4114), which appeared in *Le Rire*, No. 84, 13 June, 1896.

461 *To his Mother*

[Paris, late May–early June 1896]

My dear Mama,

I've been fooled again by the concierge of the new place, but I have finally found, for 1,600 francs, *don't tell a soul*, an extraordinary apartment.[1] I hope to end my days in peace there. There's a country-sized kitchen, trees, and 9 windows giving out on the gardens. It's the whole top floor of a little town house next to M[lle] Dihau's;[2] we will be able to have musical evenings. It was M[lle] Suermond,[3] unmarried, I saw. Perhaps that's happiness. Chi lo sa.[4] In any case she's still a good and open friend without the least pretension of being something special like that poor Suzanne. Her husband is indeed to be pitied for having a treasure like that.

I kiss you.

Yours,
H.

You must have received my *Figaro*.[5]

Prov.: Schimmel
Pub.: GSE210, GSF234

[1] This was 5 avenue Frochot, where Lautrec moved from his apartment at 30 rue Fontaine. For a party on 15 May, 1897 Lautrec lithographed an invitation, 'Invitation à une tasse de lait' (Wittrock 183), using this address.

[2] The sister of Désiré and Henri Dihau, and like them a musician and a friend of Lautrec's. They lived at 6 rue Frochot. Lautrec painted two portraits of her, *Mademoiselle Dihau au piano* (Dortu P.358) and *La Leçon de chant: Mademoiselle Dihau et Madama Jeanne Favereau* (P.658).One could come out of the front door of 5 avenue Frochot, cross the small avenue, and pass to the rear entrance of the building facing 6 rue Frochot.

[3] Mlle Suermond: cf. Letters 56, 56.

[4] 'Who knows?'

[5] Lautrec drew four illustrations for the story 'Les Deux Sœurs légendaires' by Romain Coolus, in *Le Figaro Illustré*, No. 74, May 1896. Cf. Dortu D.4122–4125.

462 *To his Mother*

Paris, Friday [May–June 1896]

My dear Mama,

I thought I'd told you I'd be back from London in two days. I stayed there from Thursday to Monday. I was with a team of bicyclists who've gone to defend the flag on the other side of the Channel.[1] I spent 3 days outdoors and have come back here to make a poster advertising *The Simpson's Lever Chain*,[2] which may be destined to be a sensational success.

After two days of rain, Paris has again become something of an oven. I'd very much like to go and get a breath of fresh air. Another thing: Guibert and I have rented a chalet for the Arcachon season. If you can send us a half-barrel of wine, it would have to be to the address of M. Brannen, the estate agent at Arcachon, who would have it bottled. I'm taking my maid. Guibert may bring his ball and chain[3] along, but I don't think so.—If you send the wine, let me know about it so *I can plan accordingly*. Another thing, you remind me of the properties you have put at my disposal—a bundle of cash. If you can send me *500 francs*, it will put me in a position to pay off some debts before I leave, and the sooner the better. Another thing: I don't know when I'll be able to move in, but I think it will not be until October.[4] Another thing: no need to say anything about my trip to London because, as you can well imagine, I had no time to spend with Raymond,[5] nor any intention of doing so.[6]

I kiss you warmly.

Yours,
Henri

Prov.: Schimmel
Pub.: GSE204, GSF228

[1] The meet was organized by Louis Bouglé, the sales manager of the company that manufactured the Simpson bicycle chain. He later worked for Sands, the English publisher of *Paris Magazine*, writing 'Cycling Notes' under the name of 'Spokes'. Lautrec accompanied him to England making sketches of bicycle racers.

[2] Cf. Wittrock P.26, registered at the Bibliothèque Nationale, Paris, 12 June, 1896.

[3] Cf. Letter 194 Note 4.

[4] This move apparently did not take place, since he did not move to avenue Frochot until January. Cf. Letters 471 and 472.

[5] One of Lautrec's cousins, Raymond de Toulouse-Lautrec.

[6] It may have been on this visit to London that Lautrec introduced Émile Verhaeren to Charles Ricketts (1866–1931). 'October 2, 1914. Poor Verhaeren.... We had not met for fifteen or twenty years, when he called at Beaufort Street together with Toulouse-Lautrec' (cf. Ricketts, p. 217). Ricketts and his fellow English artist Charles Shannon (1863–1937) moved in 1894 to Beaufort Street where they remained until 1898. On 28 August, 1896 Verhaeren's *Poèmes* (*Nouvelle Série*) were published in Paris by Mercure de France and Verhaeren signed a copy 'A H de Toulouse-Lautrec, mon ami' (Collection Schimmel).

463 To Henri Nocq[1]

[Mid 1896]

[2]I think that in order to have an answer to all your questions we need only look at William Morris[3]—despite Pre-Raphaelism and numerous reminiscences—this man has produced books that are readable and objects that can be used.

We could summarize the following *desideratum*: Fewer artists and more *good workers*. In a word: more craft.

As for the posters, Chéret eliminated the black, it was wonderful. We put it back, it's not too bad. Think whatever you want.

As for the public, it would be entitled to criticize (even though I may pay no attention) if it were paying. However, since it is not paying
. . .

Prov.: Unknown
Pub.: Nocq, p. 46

[1] Henri Eugène Nocq (b. 1868), French sculptor, medallist, and decorator. This letter was written in answer to his enquiry to a group of artists and artisans. Answers were received by direct interview and by letter. Lautrec painted two portraits of Nocq (Dortu P.638–9).
[2] Fragment of a letter.
[3] William Morris (1834–96), distinguished English poet, artist, decorator, manufacturer, designer, printer, and socialist. He was an originator and contributor to the *Oxford and Cambridge Magazine*. He helped found the manufacturing firm of Morris, Marshall, Faulkner and Co, and his activities in this direction brought a revolution in taste to Britain. He was a founder of the Socialist League. He started the Kelmscott Press, designing its type, ornamental letters, and borders from which were issued fifty-three books. During all this time he was writing poetry and publishing verse translations, mixed prose and verse, prose romances, and socialist propaganda. He was one of the most important influences during the last half of the nineteenth century.

464 To W. H. B. Sands, London

[Paris, 6 July, 1896]

Dear Sir,[1]

I have learned through Spoke[2] that you want to write to me about a book. I will be in Paris for 4 more days, at 30 rue Fontaine. Thank you for your friendly letter and in the hope of hearing from you,

Cordially yours,
H. de T. Lautrec

P.S. Please pay my respectful compliments to Mrs Sands.

Prov.: Schimmel
Pub.: SCI

[1] W. H. B. Sands, director of the London publishers Bliss, Sands & Co, 12 Burleigh Street, Strand. Lautrec etched a portrait of him early in 1898 (Wittrock 247), signing a proof 'A Spoke'.
[2] Cf. Letter 462 Note 1.

465 *To Léon Deschamps*

[Paris, July 1896]

[1]My dear Deschamps,

Then have someone pick up the poster[2] and the picture on *Monday*.[3] The *place closes* at *noon* and you won't find anybody there.[4] As soon as you receive some money for *The Chap Book*, let me know. Indicate that it should be forwarded.

Yours,
HTLautrec

Prov.: Unknown
Source: Berès

[1] Carte-télégramme addressed to Monsieur L. Deschamps, 31 rue Bonaparte.
[2] Probably *La Passagère du 54: Promenade en yacht* (Wittrock P.20), commissioned by Deschamps.
[3] Possibly the drawing *La Passagère du 54* (Dortu, D.4254).
[4] The printer of the poster was Imp. Bougerie & Cie, 83 fg St Denis.

466 *To his Mother*

[Arcachon] Wednesday [August 1896]

My dear Mama,

I've just spent two days on board the Johnston steamer[1] and I've watched the *deep-sea fishing*. It's extraordinary and I won't launch into trivial descriptions. But think of it, they throw back into the sea by the shovelful 300 francs' worth of unwanted fish a day. They keep only the best. The sailors are very nice and had us eating formidable fish soups. Don't say a word about all this *to a living soul*, because we had to give our word, Guibert and I, not to talk about it even to Fabre and Viaud. M. Johnston is overwhelmed by requests and wouldn't know where to begin if he once half-opened the door. What you tell me about the harvest isn't very cheerful. We'll talk about it in person. I kiss you.

Yours,
H.

Prov.: Schimmel
Pub.: GSE205, GSF229

[1] A commercial fishing boat owned by Johnston. The Johnstons were an important Bordeaux family involved in commerce, politics, and the arts.

467 *To his Mother*

[Arcachon, September 1896]

My dear Mama,

I received your letter this morning. No news here. Sail, sleep, eat. Fishing unsuccessful despite our united efforts. We shall come on Monday or Tuesday in a week or so, but at our leisure, as Guibert and his brother are keeping the chalet—and are having their cook come down. I would think that pulling a fast one on the cousin is part of this arrangement. She's at her father's and will stay there for the month of September. I am sending Marie back to her beloved studies. Louis has thanked me for the remittance, which arrived safely.

As for me, have 2,000 francs to draw on for 10 September. It's all that's needed at this time.

Yours,
Henri

Prov.: Schimmel
Pub.: GSE206, GSF230

468 *To his Mother*

Taussat, 19 September [1896]

My dear Mama,

I've come back here and am getting ready to visit you with Guibert toward the end of the week. From there I'll leave for Paris by way of Toulouse. I'll let you know by letter or telegram when we are to arrive. Be so kind as to send me 500 francs in 100-franc notes *immediately* by registered letter to pay my bills.

We had splendid weather at Ste-Eulalie.[1] The birds were very active but didn't catch many fish, though they even went for the pike, which is very creditable.

I kiss you.

Yours,
Henri

Prov.: Schimmel
Pub.: GSE207, GSF231

[1] Sainte-Eulalie-en-Born, in the Department of Landes, near the Atlantic coast of France.

469 *To an Unidentified Correspondent*

[Paris, 1896]

My dear Sir,[1]

I beg leave to inform you that I have some Aube[2] posters at your disposal, stamped impressions, at M. Ancourt's at a price of 50 francs for 50. I would appreciate it if you would send me the impression of my little American poster.[3] We can make an exchange on this one.

By the way, I'll be at Ancourt's tomorrow, Wednesday, at 11 o'clock.

Very faithfully yours,

H. de T. Lautrec

Prov.: Schimmel
Pub.: GSE205, GSF232

[1] Probably a dealer in posters.
[2] Issued in 1896 to advertise *L'Aube*, an illustrated magazine (Wittrock P.23).
[3] i.e. *Au concert* (Wittrock P.28), commissioned by the Ault & Wiborg Co., a Cincinnati ink manufacturer, and issued in 1896.

470 *To Rupert Carabin*

[Paris, late 1896]

[1] Cannot be at Ancourt's tomorrow morning.
Will be there Thursday.

Yours,
HTLautrec

Prov.: Merklin
[1] Addressed to Carabin, rue Richomme, 16 Paris.

471 *To Edmond Deman*

[Paris, 2 December, 1896]

My dear Sir,[1]

Thanks for the paper. I haven't tried it yet. I have had a Lender proof[2] sent to you. For you 30 francs, for the public 50 francs. This vulgar detail is simply to make sure you don't let it go for less.

Would you be in favour of exhibiting some drawings that have

appeared in *Le Rire*? Or would you advise me to send this lot to the Libre Esthétique?[3] Let me know, please.

<div align="right">Cordially yours,
HTLautrec</div>

Address: *30 rue Fontaine*

Prov.: Schimmel
Pub.: GSE209, GSF233

[1] Edmond Deman (1856–1918), a Brussels publisher who had printed works by Mallarmé, Gustave Kahn, Verhaeren, and other Symbolist writers.
[2] Lautrec may be referring to *Blanche et noir* (Wittrock 153). Cf. Letter 472.
[3] The drawings were exhibited at La Libre Esthétique. Cf. Letter 474.

472 *To Edmond Deman*

<div align="right">[Paris] Monday, 4 January, 1897</div>

Dear Sir,

I can show you tomorrow the printing we discussed at our last meeting.[1] It is clearly understood that I am selling you twelve copies at thirty francs each, for a total of three hundred and sixty francs. I have printed three additional copies which I shall keep for myself and shall not sell.[2] It is clearly understood that you are categorically denied the right of reproduction. Please send me a telegram to 5 avenue Frochot, or give the bearer a note, agreeing to meet me at the Imprimerie Ancourt.

At 11 in the morning, please.

<div align="right">Yours very truly,
H. de Toulouse Lautrec</div>

Acknowledge receipt of this note.

Prov.: BN

[1] In his previous letter to Deman (cf. Letter 471) Lautrec discusses a Lender proof. It seems to coincide with his lithograph *Blanche et noir* (Wittrock 153), a portrait of Marcelle Lender exhibited at La Libre Esthétique in February 1897 (cf. Letter 474).
[2] *Blanche et noir* was printed by Ancourt in twelve numbered impressions and some proofs.

473 *To Octave Maus*

[Paris] Tuesday, 2 February, 1897

My dear Maus,

Am I excluded from La Libre Esthétique?[1] Why? Please answer immediately to 5 avenue Frochot, Paris.

And cordially yours
HTLautrec

P.S. I didn't receive any warning or notice. ???

Prov.: Brussels

[1] La Libre Esthétique, Quatrième Exposition, Brussels, 25 February to 1 April, 1897.

474 *To Octave Maus*

[Paris, February 1897]

[1]My dear Maus,

I'm sending you two last works:[2]

Polaire	250 francs
Lona Barrison et son mari	250
2 lithographs printed in 12 examples	
Blanche et Noir	50 francs
Femme couchée	50 francs

plus the Pellet collection,[3] which you'll have to discuss with him.

Cordially yours,
Lautrec
5 avenue Frochot

I'm sending you the two lithos directly. Please place them under glass, without a frame, and with a simple grey paper edging. I'll pay the framer when I come. When is the opening?

Prov.: Brussels

[1] On letterhead: 9 rue Forest (boulevard de Clichy), the address of the Galerie Manzi-Joyant.

[2] La Quatrième Exposition, La Libre Esthétique, Brussels, 25 February to 1 April 1897. Lautrec exhibited Nos. 195–210: *Polaire*, Drawing (Dortu D.3768); *Lona Barrison et son mari*, Drawing (Dortu D.4114); *Blanche et noir*, Lithograph (Wittrock 153); *Femme couchée*, Lithograph (Wittrock 154); *Elles*, album of 11 lithographs and a cover, Edition G. Pellet (Wittrock 155–165: 155 was cover and frontispiece).

[3] Lautrec sent Maus items by other artists published by Gustave Pellet, his publisher of the *Elles* Series. Included in the exhibition were Pellet editions for: Léon Fauche (colour lithographs, Nos. 245–6): *Le Lever* and *Fleurs*; Pierre-George Jeanniot (colour lithographs, Nos. 297–8): *Le Lever* and *Le Conseil de revision*; Louis Legrand (eaux-fortes, Nos. 352 and 358–9): *Le Fils du Charpentier*; *Sous les figuiers*; and *Maler inviolata*; Maximilien Luce (colour lithographs, Nos. 375–7): *Camaret*; *Saint-Tropez*; and *La Mer à Camaret*; Alexandre Lunois (colour lithographs, Nos. 378–9): *Au Burrero* and *Juana Fernandez*; Félicien Rops (Nos. 466–7): *Eritas similes deo* (colour gravure) and *La Buveuse d'absinthe* (lithograph).

475 *To an Unidentified Correspondent*

[Paris, 22 or 23 February, 1897]
[1]I am leaving on Wednesday for Brussels[2] until Monday. If M. Cassan[3] comes while I'm away, please contact my friend *Albert*, but *let him know in advance*... He would show you the model, and you can give him all the necessary explanations ...

H. de Toulouse-Lautrec
5 avenue Frochot

Prov.: Unknown
Source: Charavay, Catalogue June 1979, No. 38198

[1] Fragment of a letter.
[2] Lautrec was going to visit the opening of La Libre Esthétique, Quatrième Exposition, in Brussels, opening on Thursday, 25 February, 1897.
[3] M. Cassan of Imp. Cassan Fils, Toulouse, publishers and printers of posters. They printed Lautrec's poster *Le Tocsin*, commissioned by the newspaper *La Dépêche de Toulouse* in 1895. Cf. Wittrock P.19.

475A *To an Unidentified Correspondent*[1]

[Paris] 15 April, 1897
[[2]Regarding the delivery of ten lithographs and six cul-de-lampes:]

Monsieur ... illustrations for the book by M. Clemenceau[3] ... 10 lithograph drawings hors texte at 100 francs each stone and 6 cul-de-lampes priced at 25 francs *each*.... H. de Toulouse-Lautrec.

Prov.: Unknown
Source: Sotheby's New York Auction, 3 and 4 November, 1988, No. 582. Letter included in a unique copy of *Au pied du Sinaï* (Wittrock 187–201)

[1] The recipient is probably the publisher Henri Floury. In letter 480 Lautrec writes to his mother that his publisher owes him 1,200 francs.
[2] Fragment of a letter.
[3] Georges Clemenceau (1841–1929), French statesman. Although a medical school graduate, he accepted his first political appointment in 1870, remaining in politics until 1893 which is believed to be the year he met Lautrec. In 1880 he established the newspaper *La Justice* which he controlled until 1897. He joined *L'Aurore* in 1897, campaigning for Dreyfus. He re-entered politics in 1902, remaining a most important figure until his retirement in 1920. His literary production of several books and one play were of minor importance in his career and include, in addition to *Au pied du Sinaï* (1898), *La Mêlée sociale* (1895), *Le Grand Pan* (1896), *Les Plus Forts* (1898), and *Le Voile du bonheur* (1901). Cf. letters 477, 478, 480, 489.

476 *To his Mother*

[Paris, May 1897]

My dear Mama,

I've delayed writing to you, but I did come close to buying you a *splendid* horse. Unfortunately I spotted it too late and I'm afraid it would have cost more than you'd have been willing to pay. I've had dinner twice with M^me Bourgaux, who is delightful. She'll be staying at Pérey's and is going to paint(?).

I can finally go out in the morning and I'm taking a fresh-air cure.[1]

I have two or three big deals with bicycle companies,[2] things are all right, all right.

Tell me again the amount I'm to be reimbursed for the chair.[3] Your rug doesn't arrive till tomorrow.

I've chartered the Dutch boat for 20 June to 5 July.[4] So I think we'll be seeing each other again at Malromé on 14 July.[5]

The matter of the horse is still on the agenda. I'm working on it. Little kisses for all.

Your boy,
H.

Prov.: Schimmel
Pub.: GSE203, GSF227

[1] The exact nature of the illness or cure is not known.

[2] Possibly as a result of his bicycle posters in the prior year, but nothing seems to have come of this.

[3] Cf. Letter 486.

[4] Probably to visit Walcheren and Antwerp.

[5] Cf. Letter 480.

477 *To Georges Clemenceau*

[Paris, 1 May, 1897]

[1]Dear Sir,

May I come tomorrow, Sunday, at 10 a.m., or Monday at 1 a.m., so that you can give me the subject of the two stories to be illustrated.[2]

Please reply to 5 avenue Frochot.

Cordially yours,
H. de Toulouse Lautrec

Prov.: Clemenceau

[1] Telegram addressed to Monsieur Clemenceau, 8 rue Franklin.

[2] *Au pied du Sinaï* published in 1898. Lautrec contributed two lithograph wrappers and thirteen lithograph illustrations (Wittrock 187–201), of which one wrapper and ten illustrations appeared in the regular edition.

478 *To his Mother*

[Paris, May 1897]
[1]I'm not wasting my time and I am in a period that's even somewhat excessive from the point of view of work. I'm working on a book with Clemenceau against the Jews[2] and this evening I may get an agreement on another matter.[3] Unfortunately, these very solvent businessmen ask for payment dates that are very spread out. Still, it's not bad. I'm also fighting the obsessions of Coquelin Cadet,[4] who wants his portrait done. You would think that everyone has the soul of a groundhog and doesn't wake up until spring. . . . They are bottling the wine tomorrow . . .

Henri

Prov.: Unknown
Source: Drouot, 19 and 20 November, 1987, No. 232

[1] Fragment of a letter.
[2] *Au pied du Sinaï* (cf. Letter 477 Note 2).
[3] Lautrec is probably referring to his negotiations with W. H. B. Sands of London regarding the production of *Treize Lithographies* (Wittrock 249–61). Cf. Letter 464.
[4] Ernest Coquelin, called Coquelin Cadet (1848–1909), actor at the Comédie-Française, Variétés, Odéon, and younger brother of Constant Coquelin (1841–1909). Lautrec never painted a portrait of him. According to Gauzi he frequented René Grenier's studio in order to see Lili Grenier; Lautrec probably met him there. (Cf. Gauzi, pp. 137–8.)

479 *To Unidentified Correspondents*

5 avenue Frochot [Paris, early May 1897]
Henri de Toulouse-Lautrec will be very flattered if you will be kind enough to come for a cup of milk on Saturday, 15 May, 1897, at around 3.30 after noon.[1]

HTL

Prov.: Albi

[1] Lautrec drew, wrote, and lithographed this *Invitation à une tasse de lait* (Wittrock 183), a portrait of himself with a cow and a small bird. On the Museum of Albi's print the year 1897 has been added by Lautrec after the printing. Cf. J. Sagne, 'Invitation à boire une tasse de lait', *Gazette des Beaux-Arts*, Paris, February 1988.

480 *To his Mother*

[Paris, May 1897]

My dear Mama,

Terrible heat, which has hit us all of a sudden. I'm winding every-
thing up and am going to face the move, or rather moves.[1] I had dinner
the day before yesterday at Bonnefoy's with Louis and Joseph who
were rather distant with each other.

My friend Joyant has definitely bought the Goupil gallery.[2] I'm
finishing a book with Clemenceau on the Jews.[3] My publisher owes
me 1,200 francs. He'll give me 300 of it tomorrow. Let me know if
you can advance me 500 francs on the 900 balance. Repayable in six
months. If you can't, I'll make other arrangements. I hope to place my
maid in a good house. I'm sweating like a bull and kiss you.

Your Boy,
Henri

Forgive all the figures, but business is business.

P.S. I'm thinking of painting a portrait of a friend of mine at Malromé.
I've naturally invited the model himself, M. Paul Leclercq.[4] A young
man of the world and of the best. This way you'll have the pleasure
of my company. I shall go first to Burgundy.

Yours,
H.

Prov.: Schimmel
Pub.: GSE211, GSF235

[1] To his apartment at 5 avenue Frochot and his studio at 15 avenue Frochot.
[2] Cf. Letter 482.
[3] Cf. Letter 478.
[4] Paul Leclercq (1871–1957), writer, one of the founders of *La Revue Blanche*. Lautrec did indeed
paint his portrait in 1897, but in Paris, not Malromé (Dortu P.645).

481 *To W. H. B. Sands, London*

[Paris, 2 June, 1897]

Dear Sir,

Thank you for Venus and Apollo.

I have spoken of your book to several persons who will write to
you.

I am thinking a great deal of our book to be done. However, I do
not think that I will be ready before Christmas. It will be good enough
if we have finished by then.—I will have the best writers for that:

Geffroy,[1] Descaves,[2] Tristan Bernard,[3] etc. We could do an English edition and a French edition.

My respects to Mrs Sands

<div align="right">

Yours truly
HTLautrec

</div>

I shall perhaps be over soon.[4]

<div align="right">

Your
HTL

</div>

Prov.: Schimmel
Pub.: SC2

[1] Cf. Letter 281 Note 2.
[2] Lucien Descaves (1861–1949), novelist, dramatist, critic. His best novels have a background of social history and were written after 1887 when he broke away from Zola and Naturalism.
[3] Cf. Letter 424 Note 4.
[4] Lautrec wrote this phrase in English.

482 *To his Mother*

<div align="right">

Charing Cross Hotel, London [8 June, 1897]

</div>

My dear Mama,

You are going to be a little astonished to learn that I am in London partying for two days.

I came with my friend Joyant who is helping his London associate set up shop.[1] I've seen a lot of business settled and have good hopes for my exhibition next year.[2] To give you an example—the master-artist Degas having authorized the publication of an album of his work at 1000 francs a copy,[3] I saw 34 advance orders come in the same afternoon.

London has turned itself over to the carpenters who are installing bleachers all the way up to the chimneys so people can watch the gracious old lady pass.[4] As for me, I'm on my way back to Paris to finish my move,[5] happily delayed.

Thank you for the 500 francs and the clothes which arrived safely. I kiss you in English.

<div align="right">

Yours,
Henri

</div>

Prov.: Schimmel

[1] Joyant was establishing a branch of his firm, the Goupil Gallery, at 5 Regent Street, London.
[2] 'Portraits and Other Works by M. Henri de Toulouse-Lautrec' at The Goupil Gallery, 5 Regent Street, London SW. The catalogue contained seventy-eight items. The exhibition was previewed on Saturday, 30 April, 1898, and opened by invitation on 2 May, 1898.
[3] Degas, *Vingt Dessins 1861–1897* (n.d.), twenty colour reproductions by a process invented by

Joyant's partner Manzi. Degas supervised the printing and autographed each album. (Cf. Rewald, *Impressionism*, p. 628, item 59.)

[4] The celebration of Queen Victoria's Diamond Jubilee took place on 22 June, 1897. On 9 February, 1897, while having dinner with Jules Renard, Tristan Bernard, and Alphonse Allais, Lautrec said that he was waiting for the death of old Victoria, and that as soon as the news came he would make off for London to see a spectacle unique in this century.

[5] The move of his apartment from 30 rue Fontaine to 5 avenue Frochot.

483 *To William Rothenstein*

[London, 9 June, 1897]

[1]My dear R,

When can I visit you at your studio. I am here for one day. What is the address of Charles Conder,[2] and that of Ranger Gull.[3]

Cordially yours,
HTLautrec
Charing Cross Hotel

Prov.: Harvard

[1] Postcard addressed to Rothenstein, 53 Glebe Place, London SW.

[2] Charles Conder (1868–1909), English painter, decorator, and lithographer, a friend of Lautrec's. He appeared in the paintings *Jane Avril sortant du Moulin Rouge* (Dortu P.414), *Au Moulin Rouge: Les Deux Valseuses* (Dortu P.428), *Charles Conder* (Dortu P.462), *Aux Ambassadeurs: Gens chics* (Dortu P.477), *Femme mettant son corset* (Dortu P.617), the drawing *Monsieur Charles Conder* (Dortu D.3441), and the lithographs *La Loge au Mascaron Doré* (Wittrock 16) and *La Danse au Moulin Rouge* (Wittrock 181). Conder's studio was at 44 Glebe Place.

[3] Ranger Gull, also known as Guy Thorne, English art critic and writer, whose article 'Charles Conder's Exhibition' appeared in *The Poster*, No. XII, vol. II, London, June–July 1899. He wrote novels under the name C. Ranger-Gull.

484 *To William Rothenstein*

[London, 9 June, 1897]

Agreed for Wednesday 1 o'clock.

Yours,
HTLautrec

Prov.: Harvard

485 *To his Mother*

[Paris, June 1897]

[¹Lautrec writes after his visit to London paid for by La Maison Goupil. He feels optimistic about his prospects there as a result of his visit. He discusses the superiority of the English character over the French, more specifically the difficulty of getting money from the French. He is very busy, bills are pouring in. He has just bought a barrel of white wine. He hopes to get away from Paris soon. Masons are banging away at the house from six in the morning on.]

I have all the luck, I send you a sweaty kiss.

Yours,
Henri

Prov.: Unknown
Source: Parke-Bernet, Auction 1714, 27 November, 1956, No. 587
 ¹Fragment of a letter.

486 *To his Mother*

[Summer 1897]

My dear Mama,

We're cooked. It's impossible to stay out of doors. It's roasting even in the boat. Which didn't prevent us from going out at high noon to chase the mullet that come in to spread out along the shore. In two casts of the net we took 150 of them. Fabre is staying in the country at his brother's, near Paris, which means we are reduced to saying painful things to each other, which doesn't really happen. I've received the socks in good shape. Thanks.

Be so kind as to send 200 francs *to me* directly. And 100 francs to Louis at 32 rue des Mathurins, which he must be waiting for. I'd rather send the thing to the upholsterer myself, as I have to specify certain details. So that will make 300 francs in all. If you can send us some Chasselas grapes it would help us put up with the temperature. Goodbye, dear Mama, and see you soon, I hope. I kiss you.

Yours,
H.

Prov.: Schimmel
Pub.: GSE212, GSF236

487 *To his Mother*

[Paris, early November 1897]

My dear Mama,

I don't have much news to tell you, since I see practically nobody except Gabriel.

We spent All Souls' Day at Blois, which is really quite a beautiful thing.

I fight every day against sleep in order to go to the printing shop, against laziness in order to work with a reliable model whom I was finally lucky enough to hire. It's tough to get back to work, and what I'm doing up to now doesn't interest me much. But it's a necessary stage.

I had dinner yesterday with Guibert, who has won out over his finally tamed cousin. Bourges is having an attack of lumbar rheumatism and his wife is devotedly giving him rubs.

I'm finally going to get settled within the next few days. I'll write to Balade, or, rather, you write to him. Please send the two big barrels to avenue Frochot No. 5.[1] The superintendent will accept them and have them taken down.

Goodbye, dear Mama, you definitely should be here, it's very trying to be without a home at my age. I kiss you.

Yours,

H

Keep on sending letters to the rue Fontaine address.

Prov.: Mayer

[1] Lautrec was finally about to finish the move to 5 avenue Frochot first mentioned in January (cf. Letter 461 Note 1).

488 *To his Mother*

[Paris, November 1897]

My dear Mama,

I sympathize with you about your neuralgia. I've been a little knocked out myself, but by too good a dinner. So I only got what I deserved.

I haven't completely moved in yet and am still sleeping at rue Fontaine.[1] The wine arrived safe and sound. I'm busy organizing an exhibition in London for the spring.[2] Don't say anything about it on account of my more or less epileptic cousins, whom I don't care to take out. Bourges must have written you about poor Joseph's clothes. I long more and more to see you in Paris, because the evenings are

empty indeed for us old bachelors. In a word, see you soon, I hope; as for going to Albi, I can't dream of it for the moment. I kiss you.

<div align="right">Yours,
H.</div>

Prov.: Schimmel
Pub.: GSE213, GSF238

[1] On Lautrec's move from rue Fontaine to avenue Frochot, cf. Letters 477 and 482.
[2] It was held at the Goupil Gallery (now owned by Manzi, Joyant, and Co) in London, in May 1898.

489 To A. Berthier

L'Aurore[1] 142 rue Montmartre, Paris [17 November, 1897]
Dear Sir,[2]

I am unable to do a drawing that quickly and moreover have never done any *current events*. It's not my style. If you need me for anything else (from a professional point of view) feel free to write to me about it.

At your disposal.

<div align="right">Yours very truly,
H. de Toulouse Lautrec</div>

Prov.: Schimmel
Pub.: GSF237

[1] The newspaper *L'Aurore* had just been founded and was edited by Ernest Vaughan. It would seem that an editor had requested a news illustration, perhaps related to the Dreyfus affair. Clemenceau, the political editor, had already written articles concerning the affair on 2 and 10 November. On 15 November, Mathieu Dreyfus had denounced Esterházy in an open letter to the Minister of War and on 16 November, Esterházy had asked for an investigation of the charges. In *L'Aurore* of 30 November and 2 December Clemenceau took a firm stand and raised serious questions regarding Esterházy. Zola's polemic *J'accuse* was to appear in *L'Aurore* of 13 January, 1898. (Cf. Bredin, pp. 203–57, which cover the period 1 November, 1897 to 13 January, 1898.)
[2] A. Berthier, secretary to the editor of *L'Aurore*.

490 To Unidentified Correspondents

<div align="right">[Paris, early December 1897]</div>
<div align="center">New Year's Day
now is the time
the child young and sincere
(old song)[1]</div>

Prov.: BPL

[1] Lautrec drew, wrote, and lithographed this *Le Compliment du Jour de l'An* (Wittrock 238), a small

caricature of himself with a man and woman greeting each other. The Boston Public Library's print is dedicated to L. Deschamps 1897/1898.

491 *To W. H. B. Sands, London*

<div align="right">[Paris] Saturday, 25 December, 1897</div>

Dear Sir,

I have received the cheque for 12 pounds[1] through M. Joyant and thank you for it. I am thinking about the future book and will write to you about it.

<div align="right">Yours truly,
H. de Toulouse Lautrec</div>

Prov.: Schimmel
Pub.: SC3

[1] Probably for the cover drawing for *The Motograph Moving Picture Book* (Dortu 4442). Cf. Letter 523 Note 3.

5

ARTIST
The Last Years, Breakdown, and the End

CHRONOLOGY
1898–1930

1898	January	Paris	Writes to Roger Marx from 15 avenue Frochot, his final studio.
	January	Paris	Starts executing lithographs for *Treize Lithographies* which continues until April.
	January	Paris	Writes to Sands.
	25 January	Paris	'Mon Premier Zinc.' 'Bonjour Monsieur Robin.'
	Early February	Paris	Writes to de Montcabrier, Robin Langlois.
	February	Paris	Eight dry-point etchings.
	February	Paris	Writes to Roger Marx, Sands.
	March	Paris	Writes to Frantz Jourdain, Sands, A. Natanson, Louis Fabre, Deschamps.
	April	Paris	Writes to Sands.
	18–19 April	Paris	Exhibits at his studio. *Invitation à une exposition*, 14 avenue Frochot.
	20 April	Paris	Floury publishes *Au pied du Sinaï*.
	25–30 April	London	Visits, stays at Charing Cross Hotel, meetings with Sands, preview of one-man exhibition at Goupil Gallery.
	May	London	Goupil exhibition open to public.
	May	London	Exhibits at the International Society of Sculptors, Painters and Engravers Art Congress
	May	London	Bliss, Sands publishes *Yvette Guilbert (Série anglaise)*.
	11 May	Paris	Writes to Sands.

	June–July	Paris	Writes to Bernheim-Jeune, Arnould.
	November	Paris	Writes to Émile Straus, H. Heymann, Kleinmann, Pellet.
	November	Paris	Exhibits at Galerie des Mathurins with Anquetin, Maurin, and others.
	December	Paris	Writes to Roger Marx, Firmin Gémier.
1899	January	Paris	Lautrec's mother leaves Paris with her brother Amédée about 3 January.
	4 January	Paris	Berthe Sarrazin writes first of reports to Lautrec's mother which she continues sending throughout January.
	January	Paris	*Histoires naturelles* published by Floury.
	16 January	Paris	Writes to Durand-Ruel.
	16 January	Paris	Writes request for gift for Gabriel Tapié de Céleyran.
	19 January	Paris	Writes to mother: 'Having me spied on by maids'.
	27 January	Paris	Writes to Durand-Ruel.
	8 February	Paris	Lithograph *Le Chien et le perroquet* dated on stone.
	10 February	Paris	Invites Calmèse and Calmèse's mother to dinner.
	13, 15 February	Paris	Lautrec's mother hires two male nurses.
	14 February		Sarrazin writes to Lautrec's mother, now back in Paris.
	Some time between 27 February and 13 March	Paris	Confined for alcoholic cure in the clinic of Dr Sémalaigne, 16 avenue de Madrid, Neuilly, also known as 'La Folie St James'. Internment probably lasts until 17 May.
	17 March	Neuilly	Writes to Joyant asking for lithographic stones, watercolours, etc.
	March	Neuilly	*Le Cirque* drawings started.
	12 April	Neuilly	Writes to Joseph Albert that he has seen his mother. 'Tell Maurice his album is growing.'
	17 April	Neuilly	Telegram to mother, back in Albi.

	20 April	Neuilly	Writes to mother in Paris. Discusses his studio and Robin.
	Probably 17 May	Paris	Released from institution.
	19 May	Paris	Writes about meeting with Antoine and Gémier.
			Leaves for Albi with Louis Pascal.
	20 May	Albi	Arrives. Letter by Aunt Émilie describes it.
	June	Le Crotoy	Travels with Paul Viaud.
	11 July	Le Havre	Writes to Joyant about visiting Granville.
	July	Taussat	Stays at Villa Bagatelle. Writes to Joyant, Frantz Jourdain.
	October	Paris	Member of the Poster Section 1900 Fair.
	28 October	Paris	Writes to Sands. Discusses *Le Cirque* album.
	11 November	Paris	Writes and plans dinner with Jacques Bizet.
1900	7 January	Paris	Writes to Tristan Bernard for theatre tickets.
	3 February	Paris	Writes to Sands.
	February	Paris	Makes drawings and dates them February 1900 in a copy of Nicholson's *Types de Londres* published by Floury.
	5 March	Paris	Writes to Marcel Luguet for theatre tickets.
	27 March	Paris	Writes to Joyant. Asks for 'more than very carefully worded concealments.'
	May	Paris	Exhibits at Exposition Universelle Centennale et Décennale de la Lithographie.
	30 June	Le Havre	Writes to Joyant.
	July	Bordeaux Arcachon Taussat	
	September	Taussat	
	October	Taussat	
	October	Malromé	
	23 November	Bordeaux	Writes to Joyant for money.
	6 December	Bordeaux	Writes to Joyant about shipment of paintings, staying at rue Caudéran.

	December	Bordeaux	Exhibits at Exposition d'Art Moderne.
	23 December	Bordeaux	Writes to Joyant with Christmas greetings and about *Messaline* programme.
	December	Bordeaux	Writes to grandmother with New Year greetings from 66 rue Caudéran.
1901	January–April	Bordeaux, Malromé	
	31 March	Bordeaux	Writes to Joyant about sale of some paintings.
	16 April	Bordeaux	Writes to Joyant about his return to Paris.
	Late April	Paris	Returns to Paris to organize his works and possessions.
	4 June	Paris	Receives payment for painting from Joyant.
	July	Bordeaux	Returns from Paris.
	23 July	Taussat	Writes to mother at Malromé: 'We'll be there soon.'
	20 August	Malromé	Arrives.
	9 September		Dies and is buried at St André-du-Bois. Later transferred to Verdelais.
1912	December	Albi	Death of Alphonse de Toulouse-Lautrec.
1930		Malromé	Death of Adèle de Toulouse-Lautrec.
		Le Vésinet	Death of Maurice Joyant.
		Albi	Death of Gabriel Tapié de Céleyran.

492 *To Roger Marx*

[Paris, early January 1898)

My dear Marx,

When will you have a morning free? I need to talk to you. I take this opportunity to wish you a happy and prosperous new year.

HTLautrec
15 avenue Frochot

Prov.: Schimmel
Pub.: GSF239

493 *To his Mother*

[Paris, early 1898]

My dear Mama,

I haven't written to you sooner because I'm in a rare state of lethargy. I'm relishing my avenue Frochot quiet so much that the least effort is impossible for me. My painting itself is suffering, in spite of the works I must get done, and in a hurry. Also no ideas and therefore no letters. What is there to say to you about the death of Aunt Isaure?[1] She's better off having finished with the vegetative existence she'd been dragging out for so long. The fowl and Co. were appreciated and I thank you for them, again. Pass along my thanks to all concerned. Gabriel told me that Aunt Alix was sending me a present intended to enhance the beauty of my home. Thank her in advance. I'll do it myself directly as soon as I'm a bit more awake. There you are, my dear Mama, a very quiet accounting. Will I become a stay-at-home? Anything can happen and I have only one trip to London[2] in April to make me budge.

On that I kiss you.

Yours,
Henri

Prov.: Schimmel
Pub.: GSE214, GSF240

[1] The sister of Alexandre Léonce Tapié de Céleyran (Lautrec's maternal grandfather) and widow of Charles Séré de Rivières.
[2] For the opening of his exhibition at the Goupil Gallery.

494 *To W. H. B. Sands, London*

15 avenue Frochot [Paris, mid-January 1898]

Dear Sir,

I beg your pardon for writing so late, but I have been busy settling my family in Paris and I have not had any time. I think that 30 personalities are too many for your book; 20 would be better,[1] and we would be more certain of success. For 300 copies like Polaire,[2] this will cost 33 francs to print, not counting the paper.

I will take *100 francs per drawing* for myself from you. See what you would be able to give to pay the writers. Send me the figures and be assured that that will be for the best. I intend to come to London in the spring, but my friend Joyant will be coming in a few days.—

When you write to me, if you could quote the price for a small, very

select exhibition room for two weeks in March or April, you would be *doing me a service*. Please present my respects to Mrs Sands and believe me,

> Yours truly,
> H. de T. Lautrec

[Note at the top of the letter by a person in Sands's office:]

> 15 February [18]98

Better no text. Cannot use Yvette G. Say 200 or 250 at 1 or 2 G's per copy.? French ed or suggest paying L— a royalty per copy of Fr. edn. sold.

Prov.: Schimmel
Pub.: SC4

[1] At about the same time the French artist Ferdinand Bac (1859–1952) and French author Léon Xanrof (1867–1953) were preparing a similar project, *Interviews fantaisistes—Tout le théâtre* (Flammarion, Paris, n.d.). It consisted of twenty portraits of actors and actresses, together with facsimiles of fictitious letters supposedly written by the performers in response to a request by the creators. Of the twenty, seven were included in, or discussed for, Lautrec's album, and another four had appeared in other works by him. The similarity of the two books is noteworthy, although the Bac–Xanrof one did not include original prints.
[2] *Polaire* (Wittrock 248).

495 *To W. H. B. Sands, London*

> [Paris] 14 January 1898

Dear sir,

I have received your proof,[1] which is very good. If you can keep the background *whiter* and the hair of the seated lady a little less heavy, this will be better. I am sending you a Sarah Bernhardt with the text.*
I believe that the text is worth 100 francs per article.

Please let me know your opinion.

> Yours truly,
> HTLautrec
> 15 avenue Frochot

*By A. Byl

Prov.: Schimmel
Pub.: SC5

[1] Reference to the drawings being done for the cover design of *The Motograph Moving Picture book* (cf. Letters 523 Note 3).

496 To Robert de Montcabrier

My dear Robert,[1]
If I may give you a piece of friendly advice, don't count on money from this periodical.[2] They've swallowed up drawings of mine worth a fair amount of money for which they've never paid me. I'm not saying this to discourage you, but finish your studies first before you take up this lousy profession of painter, which costs more than it brings in. I know what I'm talking about.

Regards,
Henri

Prov.: Unknown
Pub.: Charles-Bellet, p. 27

[1] Robert de Montcabrier (b.1882), a young distant cousin of Lautrec's, was an aspiring artist whom Lautrec began advising at the end of 1897. He also frequented the avenue Frochot studio during Lautrec's last years.
[2] Le Courrier Français.

497 To Robin Langlois

[Paris, early 1898]

My dear Friend,[1]
On Wednesday I'm coming to pick you up at 11 o'clock. Jourdain[2] and I have an understanding on the matter.

Cordially yours,
HTLautrec
15 avenue Frochot

Prov.: Schimmel
Pub.: GSE215, GSF241

[1] Robin Langlois, an engineer, was a long-time friend and neighbour of Lautrec, who may have known him since boyhood (cf. Letter 21). In 1893 Lautrec dedicated a proof of his poster Jane Avril (Wittrock P.6) 'Pour Robin', and his drawing of the Duc de Nemours in 1894 (Dortu D.3623) was on paper embossed J. Robin-Langlois, Ingénieur, 30 rue Fontaine, Paris. He later dedicated his first dry-point to him, Bonjour Monsieur Robin (Wittrock 239), dated in the plate 25 January 1898. He remained a confidant to the end.
[2] Francis Jourdain (1876–1958), French designer, decorator, and painter, later wrote several books on modern artists, including three on Lautrec (1948, 1951, 1952). He was also the subject of a dry-point in 1898 (Wittrock 243).

498 *To Roger Marx*

[Paris, 19 February 1898]

My dear Marx,
 I will have the portrait of Sescau[1] collected for you tomorrow morning, Sunday. Give the necessary orders.

Sincerely yours,
HTLautrec

Prov.: Schimmel
Pub.: GSE216, GSF243
 [1] *M. Paul Sescau, photographe* (Dortu P.383).

499 *To Roger Marx*

[Paris, 23 February 1898]

My dear Marx,[1]
 I shall come at 10 a.m. on Friday with Albert and P. Leclercq, who will bring you his book,[2] and I will talk to you about Péan[3] and our committee.

Cordially yours,
HTLautrec

Prov.: Schimmel
Pub.: GSF242
 [1] Pneumatic letter addressed to M. R. Marx, 105 rue de la Pompe, Paris 16ᵉ.
 [2] *L'Étoile rouge*, Mercure de France (Paris, 1898). The printing was completed on 15 December 1897. Lautrec drew the cover lithograph (Wittrock 289).
 [3] Dr Jules-Émile Péan had died on 30 January 1898.

500 *To W. H. B. Sands, London*

15 avenue Frochot, Paris, 25 February 1898
Please send me the paper samples.
Dear Sir,
 Your letter makes a lot of sense and I am sending you the list already written by my collaborator Byl to whom you are indebted for the following articles at the price agreed upon of 100 francs (100 francs each):

Sarah
Coquelin
Calvé
Polaire

Yvette Guilbert
Rostand

That is, 600 francs. He will do the other 19 in the form of medallions (short style) in the dimensions you indicate to him, and naturally for a proportionately lower price.—write to me about this as soon as possible. He is now ready to remove from Yvette Guilbert and any others which you point out to us everything which could be harmful to the sale of the book.

I am sending you Polaire (text), and you will have those noted above as soon as there are clean copies.

I am also sending you the drawings of the following:

Sarah
Yvette
Polaire
Anna Held
Polin
May Belfort
Émilienne d'Alençon
Granier

As for the originals, they have been done directly on stone. Each stone costs 3 francs.—

Write to me as soon as possible and believe me.

Cordially yours,
H de Toulouse Lautrec

Prov.: Schimmel
Pub.: SC6

501 *To W. H. B. Sands, London*

[Henry's Hotel, 11 rue Volney, Paris, 28 February [189]8]
Dear sir,

I have sent you a proof of Yvette Guilbert on paper which is not bad. If you have better paper, send me samples.

For Byl's payment, you can send me the cheque when the six articles which have been started are delivered. For the medallions, he will do them at the price of 50 francs (two pounds).

With respect to Yvette Guilbert, do you want different designs or proofs of the same one? On which paper? Please reply as soon as possible.

Yours truly,
HTLautrec

Prov.: Schimmel
Pub.: SC8

502 *To W. H. B. Sands, London*

[Paris] 1 March [1898]

Dear Sir,

I am sending you Calvé, Coquelin, and Rostand. Please send me the cheque for 600 francs for Byl as soon as you can. He is a very gentlemanly type and does not ask for money, but I believe he will be very glad to get it. I will send you the proofs of my drawings tomorrow or the day after.

Yours truly,
H. de Toulouse-Lautrec

Prov.: Schimmel
Pub.: SC10

503 *To W. H. B. Sands, London*

[Paris] Saturday [probably 5 March 1898]

Dear Sir,

I thank you on behalf of 'Byl' for the cheque for 600 francs.

We will have the 25 ready for the end of the month if nothing unexpected happens. I am sending you the drawings which have already been done of the following artists:

Polaire (you already have this)	1
May Belfort	2
Anna Held	3
Polin	4
Sarah Bernhardt	5
Émilienne d'Alençon	6
Granier?	
I shall do a better one[1]	7

I have yet to do the following in a final form:

Calvé
Rostand } for which Byl has done the text.
Coquelin

Byl will do the medallions at the price of 25 francs.

I will send you two new drawings of Yvette tomorrow. If you wish, they will print them here on the first paper which I sent you and which is not bad. If you have better, send us the paper or let us know so they can send you the stones (as you like)—

I do not have any ideas yet about the French edition, but it would

be better to print everything at the same time.— Please send the exact size of the margin which you want for the book and for Yvette.

<div align="right">
Yours truly,

H de Toulouse Lautrec
</div>

Byl suggests the following names for your selection in order to continue. Write to me about this.

1.	Réjane √	10.	Sybil Sanderson √
2.	Febvre √	11.	Ackté—
3.	Louise Marsy √	12.	Marguerite Ugalde
4.	Balthy—	13.	Brasseur Jr.
5.	Hading √	14.	Antoine
6.	Guitry—	15.	Mounet-Sully √
7.	Cléo de Mérode— √	16.	Catulle Mendès √
8.	Invernizzi—	17.	Little Tich?
9.	Delna √		

If you think of anything better, let us know.

<div align="right">
Yours truly,

HTL
</div>

Please send the text on Yvette so that it can be corrected.

Prov.: Schimmel
Pub.: SC11

[1] Lautrec probably drew *Jeanne Granier, de profil à gauche*, (Wittrock 264) and *Jeanne Granier, de profil à droite* (Wittrock 265) before the final lithograph (Wittrock 250) was chosen for publication.

[2] Lautrec and Sands discussed numerous persons during the preparation of the *Treize Lithographies* series. Following are brief descriptions of them together with references to the paintings and drawings listed in Dortu and the lithographs and posters in Wittrock:

Polaire (Algeria 1879–1939). Singer, actress—café-concerts and theatre. Dortu P.594, D.3768; Wittrock 248.

May Belfort (Ireland). Singer—café-concerts, music halls, Dortu P.585, P.586, P.587, P.588, P.589, A.229, A.230, D.3894; Wittrock 114, 115, 116, 117, 118, 119, 252, P.14.

Anna Held (Poland 1871–1918). Singer—café-concerts, music halls. Dortu D.3890, D.3891; Wittrock 88, 145, 251.

Polin (Paris 1863–?). Actor, singer—café-concerts. Wittrock 261.

Sarah Bernhardt (Paris 1844–1923). Actress—theatre. Dortu D.3451; Wittrock 37, 249.

Émilienne d'Alençon (Paris 1869–?). Actress—theatre, café-concerts. Dortu P.615; Wittrock 34, 253.

Jeanne Granier (Paris 1852–1939). Actress—theatre. Dortu P.576, P.577, D.3518, D.3595, D.4017, D.4607; Wittrock 250, 264, 265.

Emma Calvé (Madrid 1858–1942). Singer—opera, Wittrock 269.

Edmond Rostand (Marseille 1868–1918). Playwright. Wittrock 267.

Constant Coquelin, Aîne (Boulogne-sur-Mer 1841–1909). Actor—theatre. Dortu D3904; Wittrock 254.

Réjane (Paris 1856–1920). Actress—theatre. Dortu D.3573, 3658; Wittrock 44, 266.

Frédéric Febvre (Paris 1833–1926). Actor—theatre. Never depicted by Lautrec.

Louise Marsy (Paris 1866–1942). Actress—theatre. Dortu D4051, 4052, 4054, 4089, 4090, 4091, 4237; Wittrock 260.

Louise Balthy (Bayonne 1867–?). Actress, singer—café-concerts and reviews. Wittrock 152, 256.
Jane Hading (Marseille 1859–1941). Actress—theatre. Wittrock 255, 262, 263.
Lucien Guitry (Paris 1860–1925). Actor—theatre, Dortu P.576, 577, A227, D.3972; Wittrock 259.
Cléo de Mérode (Belgium 1875–1966). Dancer—opera. Wittrock 258.
Joséphine Invernizzi (Milan). Singer—opera. Never depicted by Lautrec.
Marie Delna (Mendon 1875–1932). Singer—opera. Never depicted by Lautrec.
Sybil Sanderson (United States 1865–1903). Singer—opera. Wittrock 257.
Aino Ackté (Finland 1876–1944). Singer—opera. Never depicted by Lautrec.
Marguerite Ugalde (Paris 1862–?). Singer—opera and musicals. Never depicted by Lautrec.
Albert-Jules Brasseur (Paris 1862–1932). Actor—theatre. Dortu P.627, D.3326, 3829; Wittrock 31, 107, 331.
André Antoine: cf. Letter 593 Note 2.
Jean Mounet-Sully (Bergerac 1841–1916). Actor—theatre. Wittrock 45.
Catulle Mendès (Bordeaux 1841–1909). Playwright, poet and novelist. Dortu D.3046, 4284, 4285, 4287, 4288, 4289, 4290, 4291, 4292, 4293.
Little Tich (Harry Relph) (England 1868–1928). Actor, dancer—music halls. Never depicted by Lautrec.

504 *To W. H. B. Sands, London*

[Paris] 8 March [1898]

Dear Sir,
 I am sending you two drawings of Yvette Guilbert[1] as Pessima— and in the role of the *old grandmother*.

Yours truly,
HTLautrec

Prov.: Schimmel
Pub.: SC12

[1] *Yvette Guilbert, Pessima* (Wittrock 274) and *Yvette Guilbert, chanson ancienne, 1ᵉ planche* (Wittrock 260) or *Planche publiée* (Wittrock 276).

505 *To Frantz Jourdain*

[Paris] Saturday, 12 March [1898]

Dear Sir,[1]
 I thank you for your kind invitation, but I have caught some kind of flu which completely prevents me from going out in the evening.
 Believe my regrets and present, please, all my excuses to Mme Jourdain.
 My cordial greetings to you and your son.[2]

HTLautrec

Prov.: Schimmel
Pub.: GSE217, GSF244

[1] Frantz Jourdain (1847–1935), French architect, writer, and art critic, also played an active role in the organization of several exhibitions and first wrote on Lautrec in *La Plume*, 15 November 1893, and then in 1895 (cf. Jourdain, pp. 209–13).

[2] Francis Jourdain: cf. Letter 497 Note 2.

506 To W. H. B. Sands, London

[Paris] Monday [14 March 1898]

Dear Sir,

I am sending you one more Yvette Guilbert. I will answer the other questions tomorrow.

Yours truly,
H. de T. Lautrec

Prov.: Schimmel
Pub.: SC14

507 To W. H. B. Sands, London

[Paris] 16 March 1898

Dear Sir,

The Yvette Guilbert which you suggested to me is not yet completely ready. Send me the text in order to have it arranged by Byl immediately.

The Goupil company cannot undertake to produce lithographic impressions. They do only aquatints and photo-engraving. I am also sending you my printer's price for printing and paper.—

My exhibition[1] will open in Regent Street at Boussod-Valadon on 1 May. I will be in London about 20 or 23 April.—

I will have several more drawings to send you in 3 or 4 days—Calvé, Rostand, etc. The printer has asked for a higher price for this printing because it is necessary to dampen the paper first.—

If your company can send me the fees for the drawings already delivered, you would be doing me a service, for I have a great deal to pay at this moment. Pardon me if this is indiscreet.

Yours truly,
H T Lautrec
15 avenue Frochot

Prov.: Schimmel
Pub.: SC15

[1] Cf. Letter 533, Note 1.

508 *To W. H. B. Sands, London*

[Paris] Friday, 18 March [1898]

Dear Sir,

I am sending you the Yvette Guilbert which you requested.

Yours truly,

HTLautrec

I have several medallions by Byl which I will send you as soon as possible.

Prov.: Schimmel
Pub.: SC17

509 *To W. H. B. Sands, London*

[Paris] 20 March [1898]

Dear Sir,

Thank you for your cheque for 500 francs. You should have received one more Yvette. That makes 6. I will make 2 more as you request. At the same time I am sending you the following medallions by Byl:

Balthy
Mounet-Sully
M. L. Marsy
Émilienne d'Alençon*
Jane Hading*
Polin*

I have put an asterisk next to those which have already been drawn.

I have likewise finished Constant Coquelin for which you have the text. I will have the stones for Yvette sent to you tomorrow morning, Monday. The price of each stone is 2.50 or 3 francs according to the proof. The account for this will be payable as a sum total at the end.—

For the French edition, please write to Floury[1] in order to establish the conditions. I think that he will go along. If not, I will find something else.

Yours truly,

H. de Toulouse Lautrec

Byl is chasing Yvette Guilbert. He will send you two different articles, one critical and the other flattering; you will be able to choose.

HTL
20 March

P.S. For the stones, there will also be the expenses of the trials to be paid. I will write to you about the above.[2]

Prov.: Schimmel
Pub.: SC18

[1] Henri Floury, publisher, of 1 boulevard des Capucines, Paris, had a long association with Lautrec. He published Georges Clemenceau's *Au pied du Sinaï*, printed on 20 April, 1898 and illustrated by Lautrec (Wittrock 187–201). In 1899 he published Jules Renard's *Histoires naturelles*, also illustrated by Lautrec (Wittrock 202–24) and printed by Henry Stern. In 1926 and 1927 he published Joyant's two-volume biography and catalogue of Lautrec.

[2] On the back of the envelope Lautrec wrote: 'You should have the proofs—M. Polin, May Belfort, Anna Held, Sarah Bernhardt, É. d'Alençon, Polaire, Granier? Sent at some time in a registered package.'

510 *To W. H. B. Sands, London*

[Paris] 22 March [1898]

Dear Sir,

Today I am sending you Byl's text and you should have received the 6 stones. I have made another one.

Yours truly,
H T Lautrec

[Note at the top in a different hand, probably that of W. H. B. Sands:]

[London] 24 March, [1898]

I have just received six stones this morning. I am waiting for two more. I paid 20-0-6 for these six stones. Can you give me 'on a/c' for everything, that is, the drawings already done. I believe that these 20-0-6 are for other drawings, because you have told me 'to pay for the stones as a whole at the end'.

Prov.: Schimmel
Pub.: SC20

511 *To Frantz Jourdain*

[Paris, late March 1898]

Dear Sir,

Despite my good intentions I was unable to escape yesterday. When I recovered my freedom it was twelve-thirty a.m., a little late to come for tea.

Please present my apologies to Madame Jourdain. I promise you I won't go back on my word again in the future.[1]

Cordially,
HTLautrec

Prov.: Wallace

[1] Cf. Letter 505.

512 *To Alexandre Natanson*

[Paris, late March 1898]

Dear Director of X revues,[1]

I shall be very pleased to enhance your get-together with the brilliance of my presence.

My most respectful greetings to Madame Natanson and to the young ladies.

Yours truly,
HTLautrec

Prov.: Unknown
Pub.: Erasmushaus, Auction 62, 6, 7 May 1986, No. 757

[1] Alexandre Natanson: cf. Letter 360 Note 2.
[2] The unrecorded illustration on this letter is of a dog chasing a mouse. A similar dog appears in many lithographs of 1898–9 (Wittrock 267, 293, 296, 298–302, 304, 306, 313, 320, 322).

513 *To Louis Fabre*

[Paris, late March 1898]

[1]My dear Fabre,

I'm having dinner this evening in town, but I shall be at Natanson's house at 9 o'clock. Come, we'll be waiting for you.

HTLautrec

Prov.: Unknown
Source: Stargardt, Auction 20, 21 June 1972, Katalog 599, No. 914

[1] Fragment of a letter. The full letter preceded the message to Fabre written later the same day: cf. Letter 514.

514 *To Louis Fabre*

[Paris, late March 1898]

[1] My dear Fabre,

Be at the Bar Anglais, *no. 23* rue Royale, this evening at 9 o'clock. From there we'll go to Natanson's house, where you are expected with your music.

Regards,
HTLautrec

I'll be at home this afternoon.

Prov.: BN

[1] Delivered by hand. Addressed to Monsieur Fabre 63 rue Lepic—Réponse.

515 *To an Unidentified Correspondent*

[Paris, March 1898]

Dear Angel,[1]

I've invited Guitry[2] to lunch on Tuesday or Wednesday. Which is your day? Make arrangements with him and send a message to me at av. Frochot so that it will be waiting for me when I get back to town on Monday evening.

Yours,
HTL

Prov.: Unknown
Pub.: Scriptorium, 1973

[1] Lautrec had never used this salutation before, nor did he again.
[2] Lucien Guitry (1860–1925), eminent French actor and father of the equally eminent Sacha Guitry (1885–1957). Lautrec drew his portrait for his series *Treize Lithographies* (Wittrock 259).

516 *To W. H. B. Sands, London*

[Paris] Sunday, 27 March [1898]

Dear Sir,

In accordance with your letter, we will do Balthy instead of Delna. That's right, isn't it.—

Send me in duplicate the list of articles which Byl has delivered, for

even though I keep the books well, I am always afraid of making a mistake. Once again, do you prefer Sybil Sanderson or Ackté?—

I am sending you the text for Guitry today and the form of wording for received on account. Is an invoice stamp necessary, or is this sufficient.—?—

The other two stones of Yvette are ready. I will send them tomorrow—Monday. I will provide a separate accounting as a whole for the price of the stones and the proofs.—Cordially.

Yours truly,
H. de Toulouse Lautrec

Prov.: Schimmel
Pub.: SC22

517 *To W. H. B. Sands, London*

[Paris] 27 March 1898
Received from Mr Sands the sum of 600 francs for 6 drawings of Yvette Guilbert on stone.

There remain two drawings to be done which have not been delivered at the same price, that is, 100 francs each.

H. de Toulouse Lautrec
15 avenue Frochot

Prov.: Schimmel
Pub.: SC23

518 *To Léon Deschamps*

[Paris, 28 March 1898]
Urgent

[1]My dear Deschamps,

Can you come to Weber's[2] at a quarter past 6 on Tuesday evening. I have to talk to you. If you can't, please set another time for me.

Yours,
H. de T. Lautrec
15 av. Frochot

Prov.: Unknown
Source: Berès

[1] Postcard addressed to Monsieur L. Deschamps, 31 rue Bonaparte, Paris.

[2] Café Weber, 21 rue Royale, founded in 1865 and frequented by musicians, artists, and writers including Alphonse and Léon Daudet, Coppée, Proust, Forain, Debussy, Curnonsky. It was sold by Weber in 1878 and passed through various owners. In 1895 it was sold to one of the owners of Le Doyen and Café de la Paix. It went out of business in 1961.

519 To Alexandre Natanson

[1][Paris] Friday [1 April 1898]

All my apologies for my misbehaviour last night. I fell asleep before getting dressed, and didn't wake up until an outrageous hour. You're entitled to demand a print from me as a penalty.

My respects to your wife and to you.

HTLautrec

Prov.: Schimmel

[1] Carte pneumatique fermée addressed to Monsieur A. Natanson 60 av. du Bois de Boulogne.

On 2 April 1898 the French painter Charles Angrand (1854–1926) wrote to his fellow artist Paul Signac (1863–1935): '... But you seem to me to be concerned more about Lautrec. I appreciated very much some finds with unusual colours, which, naturally, I should have wished to be more orderly. Nevertheless, he explained to me one evening, like the refined fantastic that he is, that what he wanted was the joy of producing these delicate little successes, without going to too much trouble. Isn't he going to put on a pantomime shortly at a major circus? Coming from him, that doesn't surprise me in the least.... If I reminded you of Rivière's lithos, with which I'm not very familiar, and those of Lautrec, with the unusual charm of their colours, which I enjoy, it was because I was sincerely impressed by yours, and because I know that you're very enthusiastic about new investigation.... (cf. Lespinasse.) Little has been written regarding the relationship between Lautrec and Angrand or Signac, and since Angrand left Paris on the death of his father in 1896, it is not clear when he last saw or spoke to Lautrec and which of Lautrec's lithographs he is referring to. There is no information regarding Lautrec's preparing a circus pantomime at this time.

520 To W. H. B. Sands, London

[Paris] 1 April [1898]

Dear Sir,

Enclosed I am sending you the bill for the stones for Y. Guilbert, the preparatory proofs, and the stones plus packing.

I have made a separate accounting, for I do not know whether you want to have the other 20 drawings printed here or in London which then means that you again owe me personally for 3 Yvettes at 100 francs, that is, 300 francs. Tell me since I have to pay the printer immediately.—

Instead of Ackté, I have done Cléo de Mérode. The subject is more sympathetic. Monday or else Tuesday you will have the proofs of the

Cléo and Sybil Sanderson. I have divided the two accounts in order to avoid confusion. I will go to see Yvette myself for her signature.

Yours truly,

H. de T. Lautrec

Prov.: Schimmel
Pub.: SC25

521 *To W. H. B. Sands, London*

[Paris, 4 April 1898]

Dear Sir,

I am sending you the drawings of Cléo de Mérode and Sybil Sanderson.

Yours truly,

H T Lautrec

Prov.: Schimmel
Pub.: SC27

522 *To W. H. B. Sands, London*

[Paris, early April 1898]

I send you back the copy with the *erasures* of Yvette herself and the medallion of Sybil Sanderson.[1]

Yours truly,

HTLautrec

Prov.: Schimmel
Pub.: SC28

[1] Lautrec wrote this letter in English except for the word 'ratures' ('erasures').

523 *To W. H. B. Sands, London*

[Pavillon d'Armenonville,[1] Paris] Thursday, 7 April [189]8

Dear Sir,

I have received your cheque of Saturday for 500 francs and thank you. I have thereby received from you 600 francs for Byl, 500 once for myself and 500 francs another time for myself (1600 francs in all); this means 8 drawings of Yvette paid for and 200 francs in advance on the book *(from these two hundred francs I have taken 65 francs for the stones,*

proofs, and wrapping to Stern);[2] this therefore means 135 francs on account for the drawing portion of our 20 medallions. I am mentioning this detail for you in order not to confuse the two matters. Please send me the text for Yvette so that Byl can retouch it if necessary according to your directions. As for the cover, how do you want it? In lithograph or by the same process as that for the Nursery Toy Book.[3] In black or in colour? I will see Yvette at once for her signature. Will a single autograph signature be sufficient?

Yours truly,
H. de Toulouse Lautrec

P.S. Telegraph me instructions for the cover.

H.T.L.

Return the Sybil Sanderson text to me. Byl has a better one. I will send you the medallion for Cléo de Mérode.

Prov.: Schimmel
Pub.: SC29

[1] A restaurant in the Bois de Boulogne, east of the main entrance of the Jardin d'Acclimatation—described by Karl Baedeker in his edition of Paris and environs, Leipzig, 1900 as a 'Restaurant of the highest class, pleasantly situated'.

[2] Henry Stern, 83 faubourg St Denis, Paris, a printer of many of Lautrec's lithographs who remained his associate to the end and to whom Lautrec dedicated numerous proofs.

[3] *The Motograph Moving Picture Book*, published by Bliss, Sands & Co., 12 Burleigh Street (London, 1898), with cover design specially drawn for the book by H. de Toulouse-Lautrec and illustrations by F. J. Vernay, Yorick, etc. This is a children's toy book, in which a special transparency is to be moved slowly over the illustrations to give the illusion of moving pictures. A French version entitled *Le Motographe Album d'images Animées* was printed by Clark & Cie, 225 rue st Honoré (Paris, 1899), using the same cover and illustrations as the earlier English edition.

The study for the cover design is illustrated in Dortu D.4442, together with two photographs of the drawing touched up with ink and water colour (D.4433–4), which were probably used as research for the colours to be used. Dortu incorrectly dates these 1899 together with D.4561 and D.4577, studies for the parrot in the drawing. Other drawings—*A Parrot on a Perch* (D.4385) and *Heads of Parrots* (D.4386, D.4413), dated 1898—are probably additional studies for the cover although Dortu does not say. The study for the cover design was originally in the collection of W. H. B. Sands. In June 1914 it was exhibited at the Galerie Manzi Joyant in Paris, No. 147 from Collection de M. S. [Sands]. It was also in the collection of Maurice Joyant and M. G. Dortu.

524 *To W. H. B. Sands, London*

[Paris, 7 April 1898]
[1] As regards the titles for the Yvette prints, I had put them on the stones, but they were probably erased.

Send me proofs and you'll have everything back by return mail.

Yours truly,
HTLautrec

Prov.: Unknown
Source: Elliott

[1] Postcard addressed to M. Sands Esq., 12 Burleigh Street, Strand London W. Angleterre.

525 *To W. H. B. Sands, London*

[Paris, 10 April 1898][1]

Please give me the address of Henri Perrin and Co. I haven't heard of them. Letter follows.

Yours truly,
HTLautrec

[Note at the top also by Lautrec:]

Stone cannot leave until Wednesday morning. Impossible before this.

Prov.: Schimmel
Pub.: SC30

[1]Card posted on 11 April 1898.

526 *To W. H. B. Sands, London*

[Paris] Sunday [10 April 1898]

Dear Sir,

An hour ago I sent you a note to tell you that I hadn't heard of Henri Perin. I finally found on my bills Hernu Péron.[1] As the company has not told me anything further, I will go on Tuesday and will write to you tomorrow on the other questions in your letter of today. Best to you.

Yours truly,
H de Toulouse Lautrec

Prov.: Schimmel
Pub.: SC31

[1] Hernu Péron, an international import-export transportation company formed in 1802. After using various names, in 1882 it took the name A. Henry & Cie which it retained until 1890 when for the first time it was called Hernu Péron & Cie after two of the principal partners, Albert Hernu and Charles Péron. In 1894 it became an English company with offices in numerous places including London and Paris. It remained associated with the English until 1935, when the English branch was taken over by British Railways and the French branch became Hernu Péron, as it exists today.

527 *To W. H. B. Sands, London*

[Paris, 13 April 1898]

Dear Sir,

I am sending the proofs of Yvette back to you. My cover is not
finished. I have not had time to go and see Hernu and Péron. I will
write to you tomorrow.

Yours truly,
HTLautrec

Prov.: Schimmel
Pub.: SC32

528 *To Unidentified Correspondents*

14 avenue Frochot [Paris, early April 1898]
[1]Henri de Toulouse-Lautrec requests the honour of your visiting, on
April , his paintings departing for London, from 1 to 5 p.m.

14 avenue Frochot

Prov.: Albi

[1] Lautrec drew, wrote, and lithographed this *Invitation à une exposition* (Wittrock 281), a portrait of
a young woman and a trained poodle. It was used as an invitation for a viewing of his paintings on
18 and 19 April 1898.

529 *To W. H. B. Sands, London*

[Paris] Saturday [probably 16 April 1898]

Dear Sir,

I finally have the 500 francs from Hernu and Péron. They had sent
someone to my home and had not found me. Thus I have received
from you the following:

500 francs
500 francs
500 francs, that is, 1500 francs
and Byl 600 francs—

Today Byl is going to deliver to me the remaining medallions from
the list of 28 March. I have seen Yvette Guilbert, who will arrive in
London in a few days. Her debut will be on 2 May, the day my
exhibition opens. I will arrive in London on Monday, 25 April, and
we will talk. Yvette told me that she will sign whatever is wanted. Do
you want her to sign on autograph paper for the current edition and

you can make a transfer. I have sent you the cover. It is good. I have left space for the letter in white.

Please reply to me and tell me if you can send me the proofs of Byl's text in order to show them to Yvette.

Yours truly,
H. de Toulouse-Lautrec

Prov.: Schimmel
Pub.: SC33

530 *To an Unidentified Correspondent*

[Paris, 18 April 1898]

[[1]Lautrec asks permission to go to her house for the purpose of autographing. He talks about the show of his pictures that is to open that same afternoon at 14 avenue Frochot[2]]

and I have to greet the ambassadors and other big cheeses who will inevitably flock to it.

With my compliments and respects to your devotion,
H. de Toulouse-Lautrec

Prov.: Unknown
Source: Matarasso, December 1947, No. 87

[1] Fragment of a letter, almost certainly written to Yvette Guilbert. Cf. Letter 529.
[2] Cf. Letter 528 Note 1.

531 *To W. H. B. Sands, London*

[Paris] Sunday [probably 24 April 1898]

Dear Sir,

I am sending you Byl's last medallions. I am sorry that the cover could not be used. I will have Yvette sign an autograph paper today and you will need only to have it transferred to stone. I will also sign in the same way.

Yours truly,
HTLautrec

Prov.: Schimmel
Pub.: SC34

532 *To [W. H. B. Sands, London]*

[London, 30 April 1898]

[1]Goupil Gallery
5 Regent Street

Henri De Toulouse Lautrec

Saturday 30

Prov.: Schimmel
Pub.: SC35

[1] Lautrec's visiting card, with the gallery, address, and date in his handwriting. This card was among Sands's possessions and was to be used as a pass to the exhibition preview, 'Portraits and other works by M. Henri de Toulouse-Lautrec', at the Goupil Gallery, 5 Regent Street, London SW. The catalogue contained seventy-eight items. The exhibition was previewed on Saturday, 30 April and opened by invitation on 2 May, 1898.

533 *To [W. H. B. Sands, London]*

[London, 2 May 1898]

[1]Goupil Gallery
5 Regent Street

Henri De Toulouse-Lautrec
Admit Two

Monday 2

Prov.: Schimmel
Pub.: Sc37

[1] Lautrec's visiting card, with the gallery, address, date, and admission in his handwriting. This card and two similar cards were among Sands's possessions and were to be used as a pass to the exhibition opening.

[2] Sometime after the opening, four paintings and one lithograph were transferred to the International Society of Sculptors, Painters, and Engravers Art Congress which also opened in London in May 1898. The President of the Society at that time was James McNeill Whistler and the exhibition included Manet's *Execution of Maximilian* [sic], Whistler's *Rose and Silver—The Princess of the Land of Porcelain*, and Degas's *Café chantant*, among 717 entries.

Lautrec, mistakenly listed as F. De Toulouse Lautrec and alphabetically under D was represented by *Jane Avril at the entrance of the Moulin Rouge* (Dortu P.247), an otherwise unidentified portrait of Jane Avril, probably *Jane Avril, la Mélinite, de face* (Dortu P.418), *Quadrille at the Moulin Rouge* possibly *La Goulue entrant au Moulin Rouge* (Dortu P.423), an unidentified pastel, and the colour lithograph *The Country Party* [*Partie de campagne*] (Wittrock 228).

534 *To W. H. B. Sands, London*

[Paris] 11 May 1898

Dear Sir,

I am sending you two lithographs, Horse and Dog.[1] could you show them to Mr Brown[2] and ask him if, with these proofs *hand-coloured* there, or others in the same style, it would be possible to do something and on what terms. I would prefer a limited edition on very beautiful paper, each proof between two and four pounds—half and half, that is with 50% discount. Please send a word, and many friendly greetings.

Yours truly,

HTLautrec

Prov.: Schimmel
Pub.: SC39

[1] Probably *Le Cheval et le colley* (Wittrock 285). Other possibilities are *Le Cheval et le colley, 2ᵉ Planche,* (Wittrock 322) or *Le Cheval et le chien à la pipe* (Wittrock 321).

[2] Possibly Ernest Brown, London art dealer, first with the Fine Art Society and then with Ernest Brown and Phillips, who in 1930 re-issued the Sands Yvette Guilbert series, donating the stones, upon completion, to the Toulouse-Lautrec Museum in Albi, France.

535 *To W. H. B. Sands, London*

[Paris, 20 May 1898]

Dear Sir,

Have you received the two drawings of the horses? I would be much obliged if you would tell me as soon as possible, as I'm going to leave for the country.

Yours truly,

HTLautrec

Prov.: Schimmel
Pub.: SC40

536 To Édouard Vuillard

<div align="right">Paris (Spring 1898)</div>

My dear Vuillard,[1]
 Can't have you over for lunch tomorrow. I forgot that I had agreed
to have lunch in town with Th.[2] and Misia.[3] All the same, I'll be at my
studio from 9 to 11.30a.m.

<div align="right">Best regards,
HTLautrec</div>

I hope to see you there.

Prov.: Salomon

 [1] Édouard Vuillard (1868–1940), French painter and printmaker, a friend of Lautrec's and many
artists of his era. He worked with the artists of *La Revue Blanche*, most closely with P. Bonnard and
K.-X. Roussel (others included M. Denis and F. Vallotton). He painted three portraits of Lautrec in
1896–7 (Dortu Ic73, Ic74, and Ic75). This letter is addressed to him at 56 rue des Batignolles, Paris,
although it was from 96 rue des Batignolles that Vuillard wrote to Vallotton on 7 November 1897.
(Cf. Guisan, p. 170, no. 110).
 [2] Thadée Natanson: cf. Letter 360 Note 2.
 [3] Misia Natanson (1872–1950). With her first husband, Thadée, she gathered into their circle many
of the most talented people of her time including the artists and writers of *La Revue Blanche*. Among
the closest of these were Lautrec, Vuillard, Bonnard, Renoir, Mallarmé, and Valéry. Later, with her
second husband, the newspaper tycoon Alfred Edwards, and her third husband, the artist José Sert,
her circle included Chanel, Cocteau, Colette, Debussy, Diaghilev, and Stravinsky. She appeared in
many Lautrec paintings, including Dortu P.567–569, P.593, P.599, P.641–642, P.655, P.672 and the
posters *La Revue Blanche* (Wittrock P.16) and *Au concert* (Wittrock P.28).

537 To W. H. B. Sands, London

<div align="right">[Paris] 30 May [1898]</div>

Dear Sir,
 I would be very much obliged if you could tell me whether you
have received all of the stones (15) and the last 4 proofs. I am leaving
for the sea and have to put everything in order here. Please send me a
word.

<div align="right">Yours truly,
H. de T. Lautrec</div>

Prov.: Schimmel
Pub.: SC41

538 *To W. H. B. Sands, London*

[Paris, 7 June 1898]

Dear Sir,

Keep Balthy for the present. So much the better if you can publish it. Write to me about this.

Yours truly,
HTLautrec

Prov.: Schimmel
Pub.: SC43

539 *To Hippolyte Heymann*

[Paris, late Spring 1898]

My dear Heymann,[1]

Macaire is asking for the pictures. I shall have them picked up tomorrow at a time to be specified by you unless you bring them to me before 8 a.m. I'll offer you the cup of friendship.

Regards,
HTLautrec

Prov.: Schimmel

[1] Hippolyte Heymann (1845–1910), a broker–dealer in art who dealt with Degas and Monet but had a poor relationship with Pissarro.

540 *To Alexandre Bernheim-Jeune*

[Paris, 18 June 1898]

[1]Dear Sir,[2]

The picture is here.[3] At which address should it be sent to you? Please give me the number of the rue Pierre Charron again.

With my best wishes,
H. de Toulouse Lautrec

Prov.: Bernheim

[1] Postcard addressed to Monsieur Bernheim 8 rue rue [*sic*] Laffitte, Paris.

[2] Alexandre Bernheim-Jeune (1839–1915). In 1863 he established the Paris gallery of his family firm which had been founded in Besançon in 1795. It became one of the world's leading art dealers, a position it still maintains. First located at 8 rue Laffitte, then at 25 boulevard de la Madeleine, and now at 83 fauborg St Honoré and 27 avenue Matignon, Paris. Toward the end of the nineteenth century he was joined in the business by his sons Josse and Gaston.

[3] Bernheim-Jeune had loaned paintings for the Lautrec exhibitions in London in May. (Cf. Letter 532 Note 1). This may have been the return of one of them.

541 *To A. Arnould*

<div align="right">Paris, 19 July 1898</div>

[1]... Please draw up a statement of prints in which we have a one half interest with M. Stern ... I have given M. Hessèle[2] a note ... asking for information about said prints ...

<div align="right">H. de Toulouse-Lautrec</div>

Prov.: Unknown
Source: Stargardt, Auction, 16, 17 February 1971, Katalog No. 880

[1] Fragment of a letter. The full letter was written on the letterhead of the printer Henry Stern.
[2] Probably the print-dealer Charles Hessèle, 13 rue Laffitte, Paris.

542 *To Édouard Kleinmann*

<div align="right">[Paris, 1898]</div>

[1]My dear Kleinmann,[2]
Please entrust [*Polaire*][3] to the employee of M. Moline.[4]
See the latter for terms of sale.

<div align="right">Yours,
HTLautrec</div>

Prov.: Schimmel
Pub.: GSE200, GSF221

[1] Written on a correspondence card of the Galerie Laffitte, 20 rue Laffitte.
[2] Édouard Kleinmann: cf. Letter 304 Note 4.
[3] Probably the drawing published in *Le Rire*, No. 16, 23 February 1895 (Dortu D.3768). Kleinmann published a limited edition on some of Lautrec's drawings done between 1895 and 1897 that had appeared in *Le Rire*.
[4] The director of the Galerie Laffitte and a publisher and dealer of prints. In 1899 he published Bonnard's four-panel colour lithograph screen, *La Promenade des nourrices, frise de fiacres*.

543 *To Édouard Kleinmann*

<div align="right">[Paris, 1898]</div>

My dear Kleinmann,
Please give M. Rousselot a copy of each of my posters which belong to me, and let him have a list of all those I have done.

<div align="right">Yours,
HTLautrec</div>

Prov.: Schimmel
Pub.: GSE199, GSF220

544 *To Émile Straus*

[Paris] Tuesday [8 November 1898]

[1]Dear Sir,[2]

I shall not be able to be at home tomorrow at 4 o'clock[3] to show you *the Forains*.[4] I shall be there at 4 o'clock the day after tomorrow, Thursday, and I hope to see you there, at 15 avenue Frochot.

My respectful greetings to Mme Straus and to you.

H. de T. Lautrec

Prov.: Schimmel
Pub.: GSE218, GSF245

[1] Addressed to Straus at his home at 104 rue de Miromesnil.

[2] Émile Straus (1844–1929), lawyer (his clients included the Rothschilds) and editor of *La Critique*. His wife Geneviève (1845–1926), formerly married to the composer Georges Bizet, was the daughter of the composer Fromental Halévy, and the mother of Jacques Bizet (1872–1922). Cf. Letter 586. She married Straus in 1886 and continued conducting a leading salon in Paris frequented by figures in the arts, literature, politics, and finance including Forain, Proust, and later many Dreyfusards. She was one of Proust's models for the Duchesse de Guermantes in *Du côté de chez Swann* [*Swann's Way*]. Cf. Adams, p. 26.

[3] Lautrec was probably at the opening of the exhibition at the Galerie des Mathurins, Théâtre des Mathurins, 36 rue des Mathurins, which opened on 9 November 1898. He was exhibiting there with Anquetin, Maurin, and others.

[4] Jean-Louis Forain, (cf. Letter 151 Note 2), a frequenter of Mme Straus's salon until October 1897 when his position as an anti-Dreyfusard caused him to break with the Straus's. In February 1898 with Caran d'Ache he formed the anti-semitic periodical *Psst!*, to which he contributed a drawing almost every week until September 1899. (Cf. Painter, p. 279). It was probably Straus who had requested Lautrec, as a friend of Forain's, to bring the drawings in question.

545 *To Hippolyte Heymann*

[Paris, 11 November 1898]

Dear Sir,[1]

Just come at 3.15 tomorrow, Saturday, to my studio at 15 avenue Frochot.

Cordially yours,
HTLautrec

Friday evening

Prov.: Unknown
Source: Rendell, Listing No. 458

[1] Hippolyte Heymann: cf. Letter 539 Note 1.

546 *To Édouard Kleinmann*

[Paris] 15 November 1898

My dear Kleinmann,[1]

Between now and the 30th[2] of this month, please make up a package of all my prints stored at your place. I want to collect *everything* I have outside. Stern[3] will call during the day to pick them up. If you could make a complete list for me you'd be doing me a favour. However, I think I have an old list you made. If you have a bit of money to give us that would also make us happy.

Very cordially yours,
H. de Toulouse Lautrec

Prov.: Wittrock

[1] Édouard Kleinmann: cf. Letter 304 Note 4.
[2] Lautrec was gathering his prints from his various publishers. Cf. Letters 547, 550, 551.
[3] Henry Stern: cf. Letter 523 Note 2.

547 *To Gustave Pellet*

[Paris] 15 November 1898

Dear Sir,[1]

On the 30th of this month my printer, Stern,[2] will come to your place and please have prepared for delivery to him *all* the unsold copies on deposit with you. Also, please be good enough to pay him for those that have been sold. He will give you a formal receipt signed by me.

Believe me, sir, very sincerely yours,
H. de Toulouse Lautrec
15 avenue Frochot

[In another hand at top of letter:]
Replied on the 16th

Prov.: Schimmel
Pub.: GSE219, GSF246

[1] Gustave Pellet: cf. Letter 425 Note 3.
[2] Henry Stern: cf. Letter 523 Note 2.

548 *To Maurice Le Barbier de Tinan*

[Paris] Monday [late November 1898]

Dear Sir,[1]

I was very fond of your son.[2] Please tell Madame de Tinan that I share in your sorrow. My sincere condolences to you personally.

H. de Toulouse Lautrec
15 av. Frochot

Prov.: Schimmel

[1] Maurice Théodore Le Barbier de Tinan.

[2] Jean de Tinan (1874–18 November 1898), a French symbolist author who started at *L'Art Indépendant*, eventually joining the followers of Gide at *Le Centaure* and *Le Mercure de France*. Lautrec drew the lithograph cover for his book *L'Exemple de Ninon de Lenclos amoureuse* in 1898 (Wittrock 288). His death was described as 'aristocratic and regrettable' by Henry Bataille in *Têtes et pensées* (Paris, 1901). The proof printing of the cover at the Museum of Albi included a statement written by de Tinan in blue pencil: 'Mon cher Ami, Je ne dis oui ni non, c'est idiot.'

549 *To Roger Marx*

[Paris, 28 November 1898]

[1] My dear Friend,

Could you send me the name of the charming keeper of the Musée Guimet[2] who received us most kindly. I completely forgot to read it when I had your introduction sent in to him, for which I thank you again.

Yours,
H de T Lautrec
15 avenue Frochot

Prov.: Schimmel
Pub.: GSE220, GSF247

[1] Addressed to Marx at his home, 105 rue de la Pompe.

[2] The keeper was L. de Milloué. The Musée Guimet, situated on the Place d'Iéna, a collection presented to the State in 1886 by Em. Guimet of Lyons consisted mainly of a museum of religions of India and Eastern Asia, but included a library and collections of oriental pottery and antiquities.

550 *To a Publisher*

Paris, 30 November 18[98]

[To the publisher of his posters demanding a settling of accounts, apologizing that he is—perhaps too much—a businessman, also mentions Yvette Guilbert.]

H.T.Lautrec

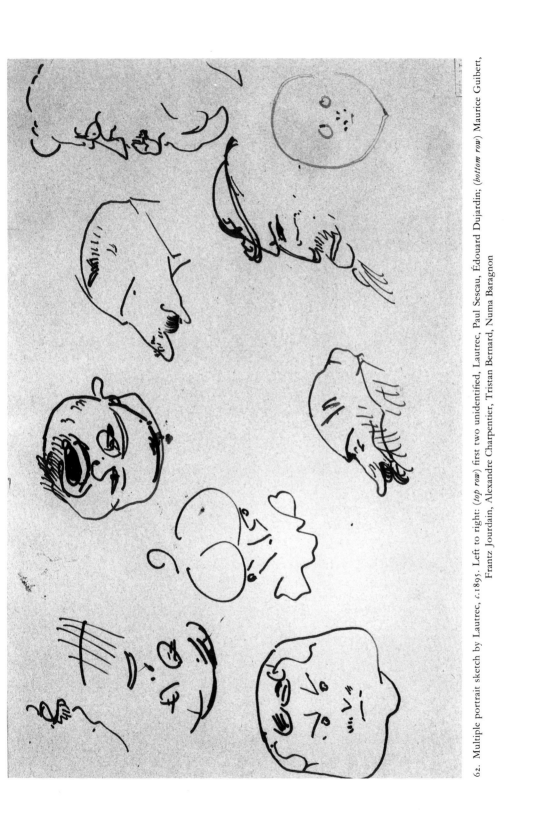

62. Multiple portrait sketch by Lautrec, c.1895. Left to right: (*top row*) first two unidentified, Lautrec, Paul Sescau, Édouard Dujardin; (*bottom row*) Maurice Guibert, Frantz Jourdain, Alexandre Charpentier, Tristan Bernard, Numa Baragnon

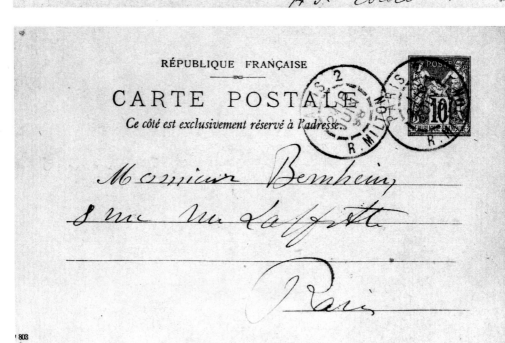

63. Lautrec's 1898 postcard to Alexandre Bernheim-Jeune

65. 14–15 avenue Frochot, Lautrec's last studio in Paris

64. 5 avenue Frochot, Lautrec's last apartment in Paris

66. Arcachon: Boulevard de la Plage, with Hôtel Richelieu on right and Café Repetto directly opposite

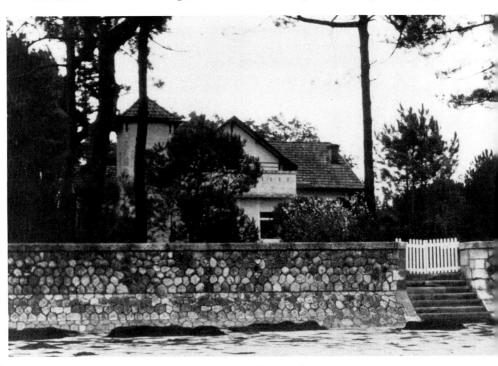

67. Taussat: Villa Bagatelle

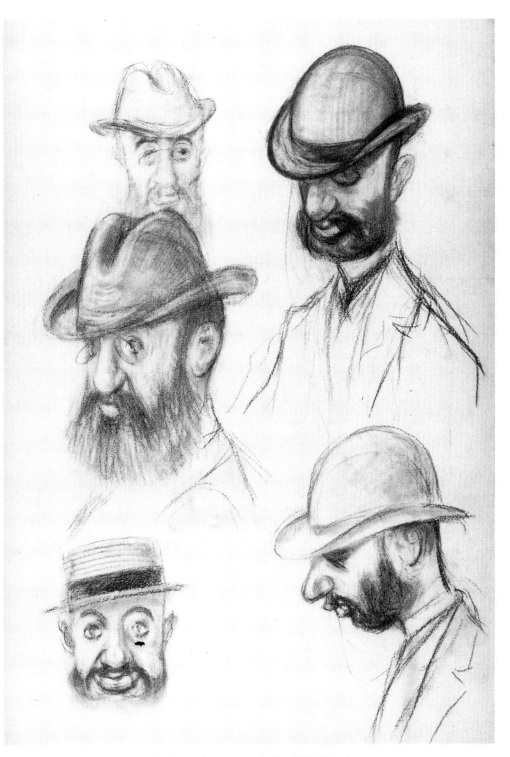

68. Lautrec in 1901, sketched by Michel Manzi

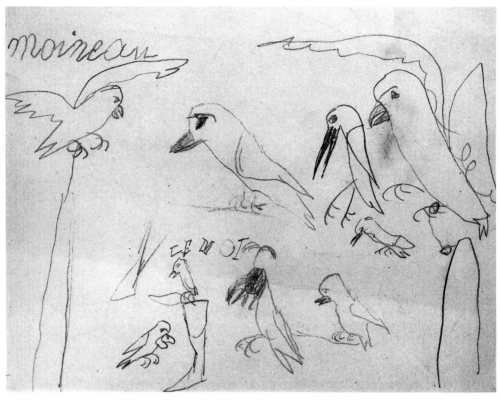

69. *Sparrow* (*Moineau*), 1871 (one of Lautrec's earliest childhood sketches)

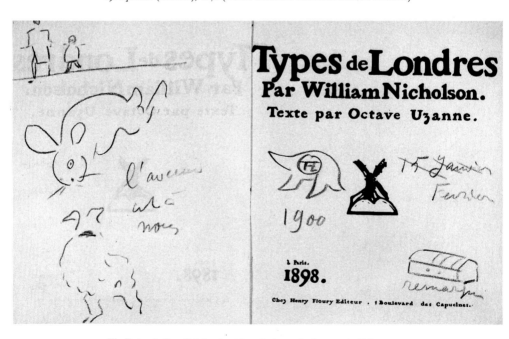

70. *The Future Is Ours* (*L'Avenir est à nous*), drawn by Lautrec in February 1900

<div style="text-align:center">✝</div>

Le Comte et la Comtesse ALPHONSE DE TOULOUSE LAUTREC MONFA ;

La Comtesse R. DE TOULOUSE LAUTREC MONFA, douairière, Madame TAPIÉ DE CELEYRAN ;

Le Comte et la Comtesse CHARLES DE TOULOUSE LAUTREC MONFA, Le Comte et la Comtesse ODON DE TOULOUSE LAUTREC MONFA, Monsieur et Madame A. TAPIÉ DE CELEYRAN ;

Le Comte RAYMOND DE TOULOUSE LAUTREC MONFA, Mademoiselle ODETTE DE TOULOUSE LAUTREC MONFA, fille de la Charité, Monsieur ROBERT DE TOULOUSE LAUTREC MONFA, Monsieur et Madame RAOUL TAPIÉ DE CELEYRAN et leurs enfants, Le Docteur TAPIÉ DE CELEYRAN, Monsieur et Madame ODON TAPIÉ DE CELEYRAN, Monsieur et Madame EMMANUEL TAPIÉ DE CELEYRAN et leur fille, Mademoiselle GENEVIÈVE BEATRIX, GERMAIN et MARIE TAPIÉ DE CELEYRAN, Messieurs OLIVIER et ALEXIS TAPIÉ DE CELEYRAN ;

Le Vicomte et la Vicomtesse DE GUALY DE St-ROME et leur famille, Madame PASCAL et ses enfants, Le Baron et la Baronne DE RIVIÈRES et leurs enfants, Madame THÉRÈSE DE RIVIÈRES, dame du Sacré-Cœur, Monsieur et Madame GUSTAVE ALIBERT et leurs enfants, Monsieur et Madame JULES LAROMIGUIÈRE et leurs enfants ;

Ont l'honneur de vous faire part de la perte douloureuse qu'ils viennent d'éprouver en la personne de

Monsieur Henri-Marie-Raymond de TOULOUSE LAUTREC MONFA,

leur Fils, Petit-Fils, Neveu, Cousin, Germain et Cousin, décédé au CHATEAU DE MALROMÉ, le 9 Septembre 1901, dans sa trente-septième année, muni des Sacrements de l'Église.

<div style="text-align:right">𝕻𝖗𝖎𝖊𝖟 𝖕𝖔𝖚𝖗 𝕷𝖚𝖎 !</div>

CHATEAU DE MALROMÉ, par St-Macaire (Gironde).

71. Death notice, 9 September 1901

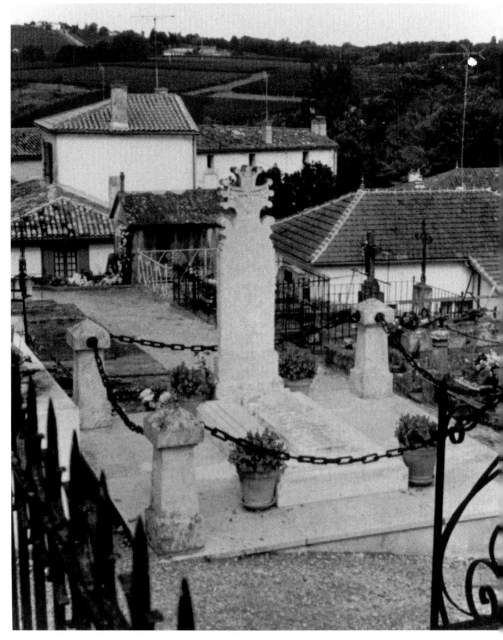

72. The Toulouse-Lautrec cemetery plot, Verdelais, France:
Henri/de Toulouse/Lautrec/Monfa/1864–1901/Comtesse/de Toulouse/Lautrec-Monfa/Née Adèle/Zoë Tapié/de
Céleyran/1841–1930/Adeline Cromont

Prov.: Unknown
Source: Hamilton, Auction, 11 December 1975, Catalogue No. 93, No. 250

[1] The catalogue dates the letter 1888, which is obviously incorrect.

551 To Gustave Pellet

[Paris] 30 November 1898

Dear Sir,

On 8 July 1897, you took 25 impressions in black (*Brasserie Interior*)[1] at a net price of 10 francs and 12 impressions of *Women in the Loge* at 20 francs net. You have sold 2 impr. of *Brasserie*, making 20 francs, and one impression of *The Loge*[2] at 20 francs. Making a total of 40 francs.

You advanced me 200 francs on the lot, 160 now outstanding. Therefore I am leaving you 8 impressions of *The Loge* on deposit and taking back the rest.

Very truly yours,
H. de Toulouse Lautrec

Prov.: Schimmel
Pub.: GSE221, GSF248

[1] Probably the lithograph *A la Souris, Madame Palmyre* (Wittrock 184).
[2] The lithograph *La Grande loge* (Wittrock 177), published in January 1897.

552 To Firmin Gémier

[Paris] 4 December 1898

[1] My dear Gémier,[2]

Please be so kind as to find a seat[3] for Mlle d'Enguin and one of her friends.

Sincerely yours,
H. de T. Lautrec

Prov.: Unknown
Source: Kornfeld

[1] Written by Lautrec on his visiting card.
[2] Firmin Gémier (1865–1933), an actor who appeared at many Parisian theatres including the Libre, the Odéon, and the Antoine. Lautrec drew him twice (Dortu D.3661 and D.4344) and included him in the lithographs *Antoine et Gémier dans une faillite* (Wittrock 43) and *Programme du Bénéfice Gémier* (Wittrock 235).
[3] Gémier was to open on 9 December at the Théâtre Antoine in Brieux's *Résultat des courses*.

553 *To Marie Dihau*

[Paris, Autumn 1898]

Mlle,[1]

Today it's my fault, or rather that of the circumstances. And the most amusing part is that I had arranged to meet a friend at 11 a.m. at your place.[2] So I'll come and get him there.

I promised him a bit of Sigurd[3] performed by you, and I have no doubt that barring unexpected or expected events you would refuse to let him hear it.[4] See you at 11, and forgive me.

Your typical painter,
HTLautrec

0.01 gr.[5]
Valerianate 0.15 gr.
m
for one tablet
Prepare 10
of the same, to be taken
every two hours
until relief is obtained

Prov.: BN

[1] Marie Dihau (1843–1935) (cf. Letter 461 Note 2), a pianist and singer who performed at the Colonne and Lamoureux concerts in Paris. On 26 June 1927 Maurice Joyant wrote to Lautrec's mother: '... And yesterday I saw Mr Bellet, of Albi, who settled and wrapped up the matter of Miss Dihau. The papers were signed before an attorney, and the money was paid. So, thanks to you (the good lady must not suspect that), the Museum now owns four beautiful portraits ... and a beautiful drawing, *Gueule de Bois*' (Collection Schimmel). He is referring to the purchase from Marie Dihau of four paintings and one drawing for the Toulouse-Lautrec Museum in Albi. They purchased *Mademoiselle Dihau au piano Dortu* (P.358), *M. Désiré Dihau, Basson de l'Opéra* (P.379), *M. Désiré Dihau, Basson de l'Opéra* (P.380), *M. Henri Dihau* (P.381), and *Gueule de bois* (D.3092).

[2] 6 rue Frochot (cf. Letter 461, Note 2).

[3] *Sigurd*, a very popular French opera composed by Ernest Reyer (1832–1909) whose work was influenced by Richard Wagner. It was first performed in 1884 in Brussels and its first Parisian performance was in June 1885. It remained continuously in the repertory and had played 165 times by the end of 1899.

[4] Lautrec means the opposite of what he wrote.

[5] On the last page of the letter, in a different handwriting, is the prescription for Valerianate, at that time an antidote for spasms, epilepsy, hysteria, and nervous disorders. On 22 December 1898 Dr H. Bourges gave Lautrec the following prescription (Collection Schimmel):

'1. One teaspoon of ammonia valerianate solution in a cup of linden-blossom tea. Take morning and evening for one month.

2. In case of continued insomnia, take one of the following tablets at bedtime: Sulphonal – 1 gram For one No. 6 tablet.

22 December 1898 Dr H, Bourges'

554 To Roger Marx

[Pavillon d'Armenonville Paris] 5 December [189]8

My dear Marx,

Could you receive Albert,[1] my friend Bouglé,[2] and myself on Thursday morning at 10. We will come to see your knick-knacks and to thank you for your introductions. Albert intends to bring you some prints of his own vintage to thank you for your kindness.

My regards to Madame Marx,

And to yourself,
HTLautrec

A note to 15 av. Frochot please.

Prov.: Schimmel
Pub.: GSE222, GSF249

[1] Probably Adolphe Albert. Lautrec had recently completed his portrait *Le Bon graveur, Adolphe Albert* (Wittrock 297), registered at the Bibliothèque Nationale, 19 November 1898.
[2] Louis Bouglé: cf. Letter 462 Note 1.

555 To Bernard Jalabert

[Paris, 13 January 1899]

[1] Send number three registered letter urgent 15 repeat fifteen avenue Frochot, letter follows, will reimburse end of month.[2]

Henri de Toulouse-Lautrec

Prov.: Schimmel
Pub.: GSF250

[1] Telegram addressed to Bernard Jalabert, Coursan (Aude).
[2] Lautrec sent this telegram unbeknownst to Berthe Sarrazin and his mother, but evidently received a response. Cf. GSE248, 249, 250 or GSF277, 278, 279, Appendix IV.

556 To Robin Langlois

[Paris, January 1899]

My dear Robin,

Come and see me at rue de Douai[1] as soon as you can. I'll be waiting for you there.

Your devoted,
HTL

Prov.: Schimmel
Pub.: GSE 223, GSF251

[1] The apartment of Lautrec's mother at 9 rue de Douai, which she had begun renting around 1893.

557 *To Paul Durand-Ruel*

[Paris] 16 January 1899

Dear M. Durand-Ruel,

I am pleased to remit to you payment[1] for my arrears I owe you. Please give me a receipt, and be so kind as to give my paintings to the bearer of this letter.

Thank you very much.

Yours sincerely,
H. de Toulouse Lautrec
9 rue de Douai

Prov.: Durand-Ruel

[1] Lautrec was out of money on 15 January 1899, but on 16 January, his friend Calmèse is reported to have located some moneylenders who may have supplied Lautrec with the needed funds. Cf. GSE250, 251, Appendix IV.

558 *To his Family*

[Paris] 16 January 1899

My cousin Gabriel[1] having cared for me day and night during the nervous breakdown caused by mother's unexpected departure,[2] I ask my family to give him a magnificent commemorative gift.[3]

H. de Toulouse-Lautrec

Prov.: Maison Natale

[1] Gabriel Tapié de Céleyran: cf. Letter 8 Note 2.

[2] His mother left Paris in early January. Cf. Appendix IV, Letters of Berthe Sarrazin. In letters dated 16 and 17 January 1899, she describes Lautrec's state of mind and his relationship with Gabriel at this time.

[3] No gift was given to Gabriel as a result of this note. Cf. notes of interview between Bertrand du Vignaud de Villefort and H. D. Schimmel, May 1987. In a letter to Lautrec's mother on 26 June, 1927, Maurice Joyant suggests that Malromé and its contents were to be left to Gabriel: '... After you, what will become of your remaining works by Henri, and of the collection of works of art that Henri called the Private Collection, and which is either at Malromé or at your home?? I should be heartbroken if all that were parcelled out among individuals who will inevitably sell the works sooner or later. Couldn't they remain at Malromé? If, as I suspect, you're going to leave Malromé to Gabriel?'... (Collection Schimmel). Malromé and its contents were inherited by Séré de Rivières after the death of Lautrec's mother and Gabriel in 1930.

559 *To his Mother*

[Paris] 19 January 1899

My dear Mother
or mama, ad libitim

After my efforts to protect your peace and quiet, you took the liberty of *having me spied on by maids.*[1] From now on I shall come to your house only as a guest.

Please send me a FIXED (I said fixed) monthly payment, which you can *give to Georges*[2] or to his bank.

P.S. Jalabert's not at all up-to-date accounts can therefore be demanded by HIM Georges. Happy New Year, and despite everything your devoted son,

HENRI

Prov.: Schimmel

[1] Berthe Sarrazin, his mother's housekeeper, had been watching him and reporting his activities from at least as early as 4 January. Cf. Appendix IV.
[2] Georges Séré de Rivières. Cf. GSE253, Appendix IV, dated 18 January 1899, in which Sarrazin describes Lautrec's actions leading up to this letter.

560 *To his Mother*

[Paris, late January 1899]

My dear Mama,

I have wired you to send me 100 francs so I won't be obliged to beg from the concierge, who is a rude man—by telegraph if possible. Everything is pretty much all right except for the weather. It's raining.

Kiss you.

Yours,
Henri

Prov.: Schimmel
Pub.: GSE224, GSF252

561 *To Paul Durand-Ruel*

Paris, 27 January 1899

Received from M. Durand-Ruel the sum of one hundred and thirty francs,[1] to be credited against what I am to deliver to him.
Paris, 27 January, 1899

Henri de Toulouse Lautrec

Prov.: Durand-Ruel

[1] Lautrec was completely out of money. On the morning of 27 January, 1899, he owed 24.40 francs for gas, 22 to the laundress, 61 to the bistro Père François, and 19 to a paint dealer, a total of 126.40 francs. Although his breakdown was far advanced by this time, by 3 February 1899 he had turned over 120 francs to Berthe Sarrazin and was once again out of money. Cf. GSE; Letters 261–8; appendix IV.

562 *To Edmond Calmèse*

9 rue de Donai [Paris, 10 February 1899]

Monsieur Edmond Calmèse[1]
Monsieur de Toulouse Lautrec requests the pleasure of the company of M. Calmèse and his mother *at dinner* tonight,[2] Friday, 10 February.
Respects and kind regards.

H. de Toulouse Lautrec

Prov.: Schimmel
Pub.: GSE225, GSF253

[1] The proprietor of a livery stable at 10 rue Fontaine, one of Lautrec's constant drinking companions during this time.
[2] Staying at the apartment of his mother, who returned to Paris in early February, he could step out of the back door and would be in the rear yard of 10 rue Fontaine. In Berthe Sarrazin's letters (cf. Appendix IV) the adverse effect of this close physical proximity is continually made obvious.

563 *To Robert de Montcabrier*

[Paris, February–March 1899]

[1] My dear Robert,
Shan't be able to work Sunday. No model. I've substituted it with a portrait in town.
So no lunch.[2]

Regards,
Henri

Prov.: de Montcabrier
Pub.: Beaute I, p. 178

[1] This message was written on Lautrec's visiting card, as to de Montcabrier (cf. Letter 496, and Beaute, who wrote a long explanation as to the dating and meaning of the note).

[2] De Montcabrier says he received this note on the Saturday night prior to the Sunday Lautrec was placed in Dr Sémelaigne's clinic. He was supposed to paint with Lautrec at the avenue Frochot studio and then have lunch at the rue de Douai apartment of Lautrec's mother. Early in March 1899 Ernest Dowson (1867–1900), the English poet, wrote from Paris to his publisher Leonard Smithers: 'Toulouse-Lautrec you will be sorry to hear was taken to a lunatic asylum yesterday' (cf. Flower, p. 406, Number 386). This note was written on a postcard, the month and year clearly printed but the day not legible (cf. Baker Library, Dartmouth College, New Hampshire, U.S.A.). Arthur Symons (cf. Letter 589 Note 1) writes that the same information was written to him by Dowson in a letter dated 7 March 1899. Symons quotes a text almost identical to that of the Baker Library manuscript (cf. Symons, p. 98).

564 *To Maurice Joyant*

Madrid[1] [Paris] 17 March 1899

Dear Sir,

Thank you for your kind letter. Come to see me. Bis repetita placent.[2]

Yours

T.L.

Send me some grained stones and a box of watercolours with sepia, brushes, litho crayons, and good-quality India ink and paper.

Come soon and send Albert[3] as a courier.

Bring a camera, the garden is absolutely splendid, with Louis XV statues. It was a lovers' meeting-place.[4]

Prov.: Unknown
Pub.: Joyant[5] I, p. 216[6]

[1] The sanitorium of Dr Sémelaigne, in the Saint-James quarter of Neuilly, was located at 16 avenue de Madrid. Known as La Folie Saint-James, it was designed by the architect François-Joseph Bélenger between 1775 and 1780 for Baron de Saint-Gemmes (later Saint-James). The garden had a number of follies, fake Greek temples, Chinese pagodas, and romantic grottos. It was used as a clinic from 1844 by Dr Pinel, Dr Sémelagine's father-in-law.

[2] 'It's worth repeating'. Probably the request for a visit from Joyant.

[3] Joseph Albert.

[4] Charles Conder wrote to William Rothenstein in an undated letter from about the middle of March: 'It is very sad about poor Lautrec—shutting him up when he is no more mad than you or I. We all hope to get him out. They do *not* do all things better in France and I for one think it somewhat of a barbarous country.' In another letter on 13 March he wrote: 'There is a beastly rude article by Arsène Alexandre in the *Figaro* of yesterday. It seems hard to hit a man when he is down—and it makes one rather sick with the French.' (Cf. Rothenstein, J., p. 155, and Letter 634 Note 1.) According to Joyant, Lautrec did not agree with Conder's opinion. Cf. Letter 576.

[5] Cf. Letter 69 Note 1.

[6] Probably as a response to this letter, Joyant wrote to Lautrec's mother (Collection Schimmel):

9, rue Forest

Dear Madam, (Boulevard de Clichy)

Thank you for your news of Toulouse. I'm not sending him any drawing materials since you've given him enough for the time being. If you go to Neuilly, please be so kind as to tell the doctor that I'll see him next Tuesday afternoon before three-thirty, and I'll try to bring Albert, who I think will still be in Paris. There's no need to worry about the vaseline that he put on the canvases; and one of these days I'll go to see how his paintings are doing.

Respectfully yours,

M. Joyant

565 *To Georges Séré de Rivières*

16 avenue de Madrid, Neuilly, Tuesday [late March–April 1899]

My dear Georges,

You've probably learned from the newspapers[1] about my confinement in Neuilly in the hospital run by the very likeable Dr Sémelaigne. Come and see me and we'll have a few laughs. Bring me some books, if you have any.

Regards and sincerely, notwithstanding

H. de T Lautrec

Prov.: Schimmel

[1] Possibly 'Une guérison' by Arsène Alexandre in *Le Figaro* of 30 March 1899; or 'La Vraie Force' by Alexandre Hepp in the *Le Journal* of 20 March 1899; or 'Le Secret du bonheur' by Edmond Lepelletier in the *L' Écho de Paris* of 28 March 1899.

566 *To Joseph Albert*

16 avenue de Madrid [Paris] 12 April 1899

Dear old pal Albert,

I saw my mother. There's still a little friction, but I believe things will be all right. Go and see her and ask for a written authorization, in the proper form, allowing you to take me out, ostensibly for urgent errands—things I have to do as regards the Jury and printing arrangements for 1900,[1] for example. I'm in the posters section and I need to sign things. Come and visit me if you can. Adèle[2] will write anything that's wanted, moreover.

Yours,

Lautrec

Regards to the other brothers,[3] and tell Maurice his album is growing.[4]

The director is not here, the request has to be made to M. Teinturier, his deputy.

Prov.: Unknown

Pub.: Joyant I, p. 220[5]

[1] The Exposition Universelle of 1900 where Lautrec had been asked to serve on the poster section jury and committee.

[2] Adèle de Toulouse-Lautrec. It is very unusual for Lautrec to refer to his mother by her given name. Joseph Albert did not call her Adèle but wrote to her 'Dear Madam' (18 January, 1899.) (Collection Schimmel).

[3] Adolphe Albert, Henri Albert.

[4] The series of circus drawings: cf. Letter 584.

[5] Cf. Letter 69 Note 1.

567 *To Berthe Sarrazin*

16 avenue de Madrid, Neuilly[1] [12 or 13 April 1899]
Dear Madam,[2]

I beg you to come to 16 avenue de Madrid *in the morning* and bring a pound of good *ground coffee*. Also bring me a bottle of rum. Bring me the whole lot in a locked valise, and ask to speak to me.

Very truly yours,
H. de Toulouse Lautrec

Bring me all the mail. Newspapers, printed matter, etc.[3]

Prov.: Schimmel
Pub.: GSE226, GSF254

[1] Cf. Letter 564 Note 1.
[2] A housekeeper, Berthe Sarrazin, sent by Lautrec's mother to take care of her apartment on the rue de Douai. (Cf. the prefatory note to the publication of her letters in GSE, p. 212, and GSF p. 254 and Appendix IV. She forwarded this letter to Lautrec's mother: cf. GSE270, GSF299, Appendix IV No. 34.
[3] On 14 April 1899 Maurice Joyant visited Lautrec and then wrote to Lautrec's mother (Collection Schimmel):

Friday, 14 April 1899
Dear Madam.

I have just been to see Toulouse and I'm giving you the latest news.

I find that he's getting better all the time, and that at the same time his energy seems to be returning. His desire for freedom is growing stronger. He wanted me to take him out so that he could correct some alleged proofs, but it was only because he wanted freedom and a walk. I understand his desire but the only thing to do is to delay it.

But I have to say that his desire to be free is going strong, and continuously, and with a spirit of consistency that points toward a final return of health. I believe that you are going to go through quite a difficult period: a period of reconciling this growing desire for freedom with the need to continue the treatment; and lastly, the most difficult thing will be to organize his life a little when he is released.

I took care of sending him certain items that he needed in order to work; and I have just sent a note to Berthe telling to bring some chocolate *before*.

I don't know Nys, the dealer in Japanese dolls; I know that Albert was familiar with this matter; you could talk to him about it when he returns from Burgundy, that is eight to ten days from now.

Respectfully yours,
M. Joyant

568 *To his Mother*

[Neuilly, 16 April 1899]
Madame A. de Toulouse, rue de Manège, Albi.
Worried. Give me news of Grandma[1] and orders for Berthe.

H. de Toulouse Lautrec Neuilly
16 avenue de Madrid

Prov.: Schimmel
Pub.: GSE227, GSF255

¹ His grandmother had been ill. This text was to be sent as a telegram. Cf. GSE271, GSF300; Appendix IV.

569 *To his Mother*

[Neuilly, 17 April 1899]

Albi de Paris — 17 12:10 PM Worried: Give me news of Grandma.
Henri.

Prov.: Schimmel

¹ Typed on telegram form addressed to Madame de Toulouse rue du Manège, Albi.

570 *To Georges Séré de Rivières*

[Neuilly] Saturday [April 1899]

My dear Georges,
 Come and see me at 5 o'clock on Tuesday or Wednesday. Let me know in advance so I'll be here. I have to talk to you.
 I'm counting on you completely.

Yours,
Henri
16 av. de Neuilly¹

Prov.: Schimmel

¹ Lautrec wrote this address meaning 16 avenue de Madrid, Neuilly.

571 *To his Mother*

[Neuilly, 20 April 1899]

My dear Mama,
 I've just seen Georges¹ who is to bring you here. Be so kind as to give the keys of my studio to my friend Robin,² who will keep them for me, since only he knows every nook and cranny of my studio.
 Looking forward to your visit, I kiss you.

Yours,
Henri

Prov.: Schimmel
Pub.: GSE228, GSF256

¹ Georges Séré de Rivières: cf. Letter 3 Note 5.
² Robin Langlois: cf. Letter 497 Note 1.

572 *To his Mother*

[Neuilly] Tuesday [late April or early May 1899]

My dear Mama,

On Thursday I won't be coming to rue de Douai as Georges is taking me to Rueil[1] for lunch. So try to come in the afternoon. We'll arrange our little affairs so as not to miss each other.

I kiss you.

Yours truly,
Henri

I have an appointment at the printer's[2] on Friday. Could you have me to lunch? Even if it is meatless?

Prov.: Schimmel
Pub.: GSE229, GSF257

[1] Where Georges Séré de Rivières had an estate. Cf. Appendix IV, No. 36.
[2] Either Henry Stern, 83 faubourg St Denis, who in 1899 was printing *Histoires naturelles* (Wittrock 202–224) and most of Lautrec's last lithographs, or E. Malfeyt, 8 rue Fontaine, who was printing *Petite fille anglaise (Miss Dolly)* (Wittrock 324) and whose printing establishment was very near Lautrec's mother's apartment on the rue de Douai where he wished to lunch.

573 *To his Mother*

[Neuilly] Tuesday [late April or early May 1899]

My dear Mama,

My workman Stern will come to rue de Douai to pick up the studio keys and bring me different things. Have Berthe go along with him. In the state we're in, ALAS, we couldn't be too careful. I continue to bear my misfortune patiently. Take care of all my errands and come often. The Prisoner.

Yours,
Henri

Bonnefoy came with his whole family. The Dr will come soon.

P.S. Don't forget my table-knives.

Have someone ask Robin where you can buy fruit-flavoured *Eau Moscovite*.[1] It's harmless and very refreshing. I'll drink it *gladly*.

Prov.: Schimmel
Pub.: GSE230, GSF258

[1] Lautrec was forbidden to drink alcoholic beverages after his internment in the sanatorium.

574 *To an Unidentified Correspondent*

[Paris, mid-May 1899]

Lautrec is out of gaol[1] and would like to shake the hands of Antoine and Gémier[2] before leaving—telegraph 9 rue de Douai[3]—I'm at Weber's place every day from 6 to 7.[4]

Prov.: Unknown
Source: Kornfeld

[1] Lautrec had been released from Dr Sémelaigne's clinic about 17 May and was to leave Paris for a family visit where he arrived on 20 May.
[2] Actors André Antoine (cf. Letter 593 Note 2) and Firmin Gémier (cf. Letter 552 Note 2) were both appearing at the Théâtre Antoine during this period.
[3] His mother's apartment.
[4] Café Weber (cf. Letter 558 Note 2). This is the first indication that Lautrec may have started drinking again as soon as he was released.

575 *To an Unidentified Correspondent*

[Albi] 24 May 1899

My dear Sir,

I have been away from Paris on business.[1] I'll be back within the next week.[2] Count on me for your payment.

Yours,
H. de Toulouse Lautrec

Prov.: Doucet

[1] Lautrec had been released from Dr Sémelaigne's clinic on or about 17 May and went to Albi soon afterwards.
[2] Cf. Letters 576–582. It appears he did not get back until October.

576 *To a Journalist*

Le Crotoy, 22 June 1899

My dear Friend,

I intend to get back to Paris one of these days, and we shall discuss your article about me. In any case, if you are in a hurry go and see Arsène Alexandre, who is very well informed about me, better than I am myself. This letter will serve as your introduction, if necessary. During the difficult period I am just coming out of, Alexandre was the

most faithful and best of friends, and he has got things back in order again.[1] Everything he tells you will be right.

<div align="right">Cordially yours,
H. Lautrec</div>

Prov.: Unknown
Pub.: Joyant I, p. 228[2]

[1] Arsène Alexandre wrote the article 'Une guérison' (A Recovery] in *Le Figaro* of 30 March 1899. It was the best and fairest description of Lautrec's breakdown.
[2] Cf. Letter 69 Note 1.

577 *To Himself*

<div align="right">[Le Crotoy, Spring–Summer 1899]</div>

[1]H. de Toulouse-Lautrec
15 Avenue Frochot
At the corner of Rue Victor Massé

Prov.: Schimmel

[1] Lautrec addressed this envelope to himself on the envelope of the Hôtel de la Marine, J. Clery au Crotoy (Somme). On leaving Le Crotoy after 22 June he went to Le Havre where he remained until going to Taussat in mid-July. Oscar Wilde arrived at Le Havre, Hotel Tortoni, about 23 June and remained in the area until his return to Paris about 1 July. Although there is no corroborating information this may have been the last time these two met. Wilde wrote from Paris on 3 July to his publisher Leonard Smithers asking for six large-paper and fifteen small-paper copies of his soon-to-be-published *An Ideal Husband*. Lautrec was included on Wilde's list of recipients of the small-paper edition. Cf. Hart-Davis p. 805, n. 1.

578 *To Maurice Joyant*

<div align="right">Hôtel de l'Amirauté, Le Havre, [Tuesday] 11 July 1899</div>

Dear Sir,

We received the painting material. Today I did a sanguine drawing, based on an English girl from the Star,[1] which I shall send you tomorrow by registered post. Please forewarn the Administration. Met Guitry and Brandès:[2] we're planning to be in Granville[3] in two days and will keep you posted.

Regards from the old 'chump'[4] and me.

<div align="right">Yours,
T.L.</div>

Prov.: Unknown
Pub.: Joyant I, p. 229[5]

[1] *L'Anglaise du 'Star' du Havre* (Dortu D.4445).

2 Lucien Guitry (1860–1925) and Marthe Brandès (1862–1930), stars of the French theatre, both of whom appeared in Lautrec's earlier works.
3 A town in the Department of Manche, Lower Normandy, about 85 miles from Le Havre.
4 Paul Viaud.
5 Cf. Letter 69 Note 1.

579 To Maurice Joyant

Le Havre, Tuesday, July 1899[1]

Dear Sir,

Yesterday I sent you by registered post a panel with the head of the Barmaid at the Star.[2] Let it dry and have it framed. Thank you for the good financial news. I trust my guardian[3] must be pleased with his ward. I am writing to Maître X . . .[4] at the same time. We are leaving today for Granville.

Regards from Viaud and me.

Yours,
Lautrec

Prov.: Unknown
Pub.: Joyant I, p. 229[5]

1 This letter was written after Letter 578 (dated Tuesday, 11 July 1899).
2 L'Anglaise du 'Star' du Havre. (Dortu P.684).
3 Either Paul Viaud or the attorney appointed to handle his financial affairs.
4 Joyant may have edited out the name of a lawyer mentioned by Lautrec.
5 Cf. Letter 69 Note 1.

580 To Maurice Joyant

Villa Bagatelle, c/o Mr. Fabre, Taussat, July 1899

Dear Sir,

Received your letter in good order. We are here until further notice.

I have a whaleboat that formerly belonged to the customs and a sailor named Zakarie. We go fishing every day. Viaud sends you his love, and me too.

Yours,
Lautrec

Prov.: Unknown
Pub.: Joyant I, p. 230[1]

1 Cf. Letter 69 Note 1.

581 *To Frantz Jourdain*

[Taussat, Summer 1899]

Dear Sir,

I find it very difficult to comply with your request.[1] I have already refused to belong to the hanging committee. On the other hand, if there is a *jury*, I refuse CATEGORICALLY. I'll never deviate from this decision. Send me the regulations anyhow to Villa Bagatelle at Taussat, Gironde. I would very much like to co-operate with you, but after books on lithography such as the one by M. Bouchot[2] of the Cabinet des Estampes, I have to be extremely cautious, especially in matters where the old clan has a say.

Cordially yours and a handshake for your son,

HTLautrec

Prov.: Schimmel
Pub.: GSE232, GSF260

[1] Evidently to send some of his prints to the Exposition Universelle of 1900, in the organization of which Jourdain played an active part.

[2] i.e. Henri Bouchot (1849–1906), conservator of the Cabinet des Estampes, Bibliotèque Nationale. In *La Lithographie* (Paris, 1895), pp. 209–10, he had written of the artists in *L' Estampe Originale* group, and of Lautrec himself, in derogatory terms.

582 *To his Mother*

[Taussat] Sunday [Summer 1899]

My dear Mama,

We were glad to get the things you sent and we're getting ready to do them honour. We went to Arcachon where Damrémont[1] greeted us with an air of embarrassment ...?... Yet another victim. Celibacy does have its charms. The poor fellow pained me. He had a look on his face like the gentleman who had just shit in his pants as he forced himself to utter amenities that didn't come off.

I've lost one of my cormorants, who must have bitterly rued the day he left me, because the inhabitants of Audenge greeted him with gunshot and he bit the dust.[2] Have you sent the straw wrapping? If not, do. A little package of keys will come to your address. Keep it. It will be the keys to my studio. I'll come to stay for 24 or 48 hours on Friday or Saturday, with Viaud. I'm beginning to get my skin back, but I've been cruelly peeled.

I kiss you.

Yours,

H.

Prov.: Schimmel

Pub.: GSE233, GSF261

[1] The son of Charles Denys Damrémont (1783–1837), a well-known general, and the commodore of a yacht which Lautrec led to victory in a regatta at Arcachon. Cf. his father's letter to Joyant, quoted in Joyant I. 88.

[2] The story is told in greater detail in Joyant II. 87–8. Audenge: a town in the Department of Gironde, near Taussat.

583 *To Unidentified Correspondents*

[Paris, Autumn 1899]

[1]THE WEBER CLUB OF 30

		Sport	Artists' Side	Writers' Side	Scientists' Side
[2]1	Lautrec	Lasserre	Lautrec	Rivoire	Tapié
2	Fidèle Viaud	"	Loysel	Toulet	Ballay
3	Dr G.	Caderonesse	id.	Curnonsky	Wurtz
4	Caderonesse	Giraud	Joyant	Leclercq	Bourges
5	Joyant	Tourneau	Raquin	De La Salle	Danel
6	Albert	Viaud	Dethomas		Robin
7	Ballay		Castera		
8	Wurtz		id.		
9	Bourges		Montesquiou		
10	Lasserre		id.		
11	id.		Lebey		
12	Tourneau		Albert		
13	Giraud		Baragnon		
14	Leclerq				
15	La Salle				
16	Rivoire				
17	Loysel				
18	Raquin				
19	Loysel				
20	Dethomas				
21	Toulet				
22	Curnonsky				
23	Montesquiou				
24	id.				
25	Lebey				
26	Castera				
27	id.				
28	Baragnon				
29	Danel				
30	Robin				

Prov.: Unknown
Source: Dortu D.4627

[1] This list of thirty persons, prepared by Lautrec, includes on bottom right of the page a drawing of a pair of dice, a dice cup, and one playing card (Dortu D.4627). Weber refers to café Weber (cf. Letters 518 Note 2). The 'Club' refers to those persons, friends of Lautrec, who frequented Weber. It has been written that the various groups visiting there each occupied a special section of the bar when they gathered.

[2] 1. Henri de Toulouse-Lautrec; 2. Paul Viaud (cf. Letter 243 Note 2); 3. Dr Gabriel Tapié de Céleyran (cf. Letter 8 Note 2); 4. Caderonesse; 5. Maurice Joyant (cf. Letter 69 Note 2); 6. Joseph Albert (cf. Letter 152 Note 3); 7. Noël Eugène Ballay (b. 1847). Doctor in the navy; 8. Robert Wurtz, Professor of Medicine; 9. Dr Henri Bourges (cf. Letter 100 Note 5); 10. Lasserre; 11. Lasserre; 12. Tourneau; 13. Étienne Giraud, wealthy amateur sportsman, interested in bicycles, skiing, auto, and boats; 14. Paul Leclercq (cf. Letter 480 Note 4); 15. Louis de La Salle (1877 (?)–1915), poet; 16. André Rivoire (1872–1930), poet, dramatist; 17. Jacques Loysel (d. 1925), sculptor; 18. Octave Raquin, architect; 19. Loysel; 20. Maxime Dethomas (cf. Letter 422 Note 2); 21. Paul-Jean Toulet (1867–1920), journalist, poet, novelist; 22. Curnonsky (Maurice Sailland, 1872–1956), writer, gourmet; 23. Robert de Montesquiou (1855–1921), aesthete, artist, poet; 24. Jacques de Montesquiou; 25. André Lebey; 26. Gaston de Castera, artist; 27. Carlos d'Avezac de Castera, artist; 28. Louis-Nicolas (Numa) Baragnon, journalist, *Revue Blanche*; 29. Danel; 30. Robin Langlois (cf. Letter 497 Note 1). Lautrec spent much of his life with some of these people, while his relationship with some others is unknown. It is interesting to note two of his less well-known friendships:

Paul-Jean Toulet was introduced to Lautrec in 1892 and later wrote: 'Lautrec is deformed, with legs that are too short. He expresses himself with hatred in a gruff and plaintive tone.' Later, in an article on Louis de La Salle, he wrote: 'Toulouse-Lautrec was capable of coarse and penetrating remarks, and when the occasion arose he painted anything and anyone with the acute eye for which he was known. Working on La Salle's portrait, he endowed him with a face that was an extraordinary likeness, the face of a peacetime non-commissioned officer, a re-enlistee, well maintained, with a moustache slicked down with Picon, a man of great courage when it came to engaging in combat with women. 'Eh', the artist said, pointing to the half-finished portrait, "white slave trade, isn't he."' There is no recorded portrait of La Salle, although the portrait known to Dortu (P.432) as *Monsieur X* comes close to the description. In recent years that has been thought to be a sketch for *Monsieur Delaporte* (Dortu P.464). Cf. Paul-Jean Toulet, 1926, 1968.

584 *To W. H. B. Sands, London*

[Paris, 28 October 1899]

Dear Sir,

Here is the letter in question as you wished. All is going well and I hope to hear from you soon. We are working again and I have a book of 20 to 25 colour plates about the circus which is going to be published by Joyant Manzi and Co.[1]

Yours truly,
H. de T. Lautrec

Prov.: Schimmel
Pub.: SC45

[1] Lautrec had been out of Dr Sémelaigne's Institution for about five months. It was during his stay that he had started the series of circus drawings, the first twenty-two of them being published in

1905, in an album with notes by Arsène Alexandre entitled *Toulouse-Lautrec au cirque: Vingt-deux dessins aux crayons de couleur*, Goupil & Cie, Manzi Joyant & Cie, Éditeurs, Imprimeurs, Successeurs.

585 *To W. H. B. Sands, London*

Paris, 28 October 1899

I declare by these presents that I have sold to Mr Sands, publisher in London, the portrait of Polaire[1] which was reproduced in the *Paris Magazine* and this drawing therefore belongs to Mr Sands with all rights.

Henri de Toulouse Lautrec
15 avenue Frochot, Paris

Prov.: Schimmel
Pub.: Sc46

[1] *Polaire* (Wittrock 248) was reproduced in *Paris Magazine*, London, December 1898.

586 *To Jacques Bizet*

[Paris] Friday [11 November 1899]

Dear Maître,[1]
Here's the list of the fish to be obtained.

Eels	*1 pound*
2 gurnets	
1 hake	
1 sole	
1 small lobster	

Supplies

Garlic—Cayenne pepper—olive oil.

Have all this ready at 5 o'clock on Sunday. We'll be there, Viaud and I, at a quarter past 6. Our compliments to Mme Bizet and you.

HTLautrec

15 av. Frochot,[2] passing then to Weber's[3] to make the final preparations.

Prov.: Wallace

[1] The envelope addressed by Lautrec to Monsieur J. Bizet 72 Bd. Malesherbes, Paris. Jacques Bizet (1872–1922), son of composer Georges Bizet and Geneviève Bizet (Mrs Émile Straus; cf. Letter 544), was a schoolmate of Marcel Proust at the Lycée Condorcet beginning 1887. He was one of the founders of the periodical *Le Banquet* together with Proust, Daniel Halévy (1892–1962), and Robert Dreyfus (1873–1937).
[2] Lautrec's studio.
[3] Café Weber, 21 rue Royale.

587 *To the Child of Louis Fabre*

[Paris] 31 December, 1899

For the future little
Fabre[1]
With the compliments of
H. de Toulouse-Lautrec
 personally
and the customary good wishes
 31 December 1899[2]

Prov.: Unknown
Pub.: *Gazette des Beaux-Arts*, Paris, March 1968, p. 192.

[1] Louis Fabre: cf. Letter 238 Note 3.
[2] Lautrec wrote this as a dedication in a children's book, *Le Prince Lilliput, Conte bleu*, by Étienne Ducret (Nouvelle Librairie de la Jeunesse, 1899), illustrated by Lothar Meggendorfer.

588 *To Tristan Bernard*

[Paris] 7 January 1900

My dear Bernard,[1]
 Is it possible to get two tickets for the Athénée[2] and one for the Grand Guignol.[3] If so, send them to my cousin Pascal[4] at the *Providence Incendie*, 12 rue de Grammont,[5] and thanks from your

HTLautrec

Prov.: Unknown
Source: Elliott

[1] Tristan Bernard: cf. Letter 424 Note 4.
[2] Athénée, 9 rue Boudreau. Tristan Bernard's play *La Mariée du touring-club* had opened on 8 December 1899.
[3] Grand Guignol: 20 bis rue Chaptal. Madel and Tomy's review *La Revue Fin de Siège* had opened on 19 December 1899 after the close of the play *Octave* by Bernard.
[4] Louis Pascal.
[5] An insurance company.

589 *To W. H. B. Sands, London*

Paris, 3 February 1900

Dear Sir,
 I think that we could hardly ask for better than the *Daily Mail*[1] has done.

I shake your hand cordially and thank you for your support in this affair.

Yours truly,
HTLautrec

[2]P.S. In addition, they have promised an article of correction. Please send it to me.

Yours,
HTL

Prov.: Schimmel
Pub.: SC47

[1] The *Daily Mail*, established in 1896, was a popular newspaper often referred to as part of the Yellow Press. According to Holbrook Jackson in his volume *The Eighteen Nineties*, its sensationalism openly fanned the Jingoist flames that led to the Boer War. In July 1900 Arthur Symons (1865–1945), the English critic, editor, and poet, wrote: 'To be quite frank, I fear it would do a lot of harm to my reputation if I were to write for the "Daily Mail" and I am obliged, if only as a matter of business, to think about that.'
[2] Written above the salutation.

590 *To Marcel Luguet*

[Paris] 5 March 1900

M. Luguet[1]
 Please be so good as to find a place for Dr David, the bearer of this note. Two seats next to one another or a box.[2] Thanks in advance.

H. de Toulouse Lautrec

Prov.: Mellon

[1] Marcel Luguet, Secretary General of the Théâtre-Antoine, wrote *Le Missionnaire* which played at Théâtre Libre on 25 and 26 April 1894. Lautrec drew the lithograph programme cover (Wittrock 16).
[2] *L'Empreinte* by Abel Hermant and *Poil de carotte* by Jules Renard opened on 2 March 1900 and played until 5 April, 1900 at the Théâtre-Antoine.

591 *To Maurice Joyant*

[Paris] 27 March [1900]

My dear Friend,
 Viaud and I are at a loss to explain why manager Jalabert is turning a deaf ear. Sell anything at any price. That's straightforward. Answer me with something more than very carefully worded concealments but my situation here is untenable;

Yours truly,
HTLautrec

Prov.: Unknown
Pub.: Dortu I, p.53

[1] Joyant did not publish this letter although it was in his possession together with those he did publish. His relationship with Lautrec seems to have deteriorated substantially.

592 *To Maurice Joyant*

[Le Havre] 30 June [1900]

[1] Old Chump,

The Stars and the other bars are being closely watched *by the police*, it can't be helped. So I'm heading for Taussat, (Gironde), by the Worms Company, this evening. Have *The Studio*[2] sent to me. But if it isn't too much trouble for you, last month's ...

And regards to both of you ...

HTL and Co.
There's nothing more limited

Prov.: Unknown
Pub.: Joyant I, p. 231,[3] Dortu SD31

[1] At the top of this letter is a drawing titled *Henri et Christophe*, showing Lautrec, Christopher Columbus, and one of Columbus's ships (Dortu SD31).

[2] *The Studio*, an English art magazine founded by Charles Holme in 1893 and specializing in the new movements in modern art. The May 1900 issue contained at least three articles of interest to Lautrec. 'Studio Talk Brussels' by F. K. discussed the Libre Esthétique exhibition of 1–31 March. Lautrec had not exhibited, and the discussion was mainly concerned with Henri Evenepoel, Henry Van de Velde, A. J. Heymans, G. Serrurier-Bovy, Louis Rhead, and Henri Rivière. Other articles that may have been of interest to Lautrec were 'The Ornamentation of Textiles' by Octave Maus and 'A French Caricaturist—Louis Morin' by Henri Boucher, which contained information on Le Chat Noir.

[3] Cf. Letter 69 Note 1.

593 *To André Antoine*

Bordeaux[1] [July 1900]

Monsieur Antoine,[2]

So you are decorated![3]

It is an honour for the house, and that always gives pleasure.

Affectionately,
HTLautrec

Prov.: Schimmel
Pub.: GSE234, GSF262

[1] Lautrec and Viaud stopped at Bordeaux on their way to Taussat, where they spent the summer.

[2] André Antoine (1858–1943), an actor and producer who had formerly directed the Théâtre Libre (1887–95) and now directed the Théâtre-Antoine (1897–1906). He was depicted in three lithographs, *Au Théâtre Libre: Antoine dans l'Inquiétude* (Wittrock 41), *Antoine et Gémier dans Une Faillite* (Wittrock 43), and *Yahne et Antoine dans L'Âge difficile* (Wittrock 93), and three drawings, *Antoine dans l'Inquiétude* (Dortu D.3659, D.3660) and *Antoine et Gémier* (D.3661).

[3] Antoine was decorated with the Légion d'Honneur on 15 January 1900 (information from the Musée National de la Légion d'Honneur).

594 *To Michel Manzi*

[October 1900]

My dear Manzi,
 Congratulations without commentary,[1] and we will share in your success.

Yours,
HTLautrec

Prov.: Schimmel
Pub.: GSE235, GSF263

[1] Manzi was decorated with the Légion d'Honneur on 14 October 1900 (information from the Musée National de la Légion d'Honneur).

595 *To Rupert Carabin*

Villa Bagatelle, Taussat, Gironde [October 1900]

Raw meat[1]
 I have a *praying* mantis for you. I'll send it to you at any place you want. It's a nice size.

Regards,
HTLautrec

Everything's fine.

Canrobert[2]

Prov.: Unknown
Pub.: Coquiot, p. 117

[1] Lautrec's slang name for Carabin.
[2] An allusion to the well-known order of the day by Maréchal Canrobert (1809–95).

596 To Rupert Carabin

[Malromé] 17 October [1900]

Raw meat[1]

I am sending you today two praying mantises in good condition and carefully wrapped.

That's all I was able to do for you.

Regards and see you soon.

HTLautrec
Château de Malromé, via Saint Macaire, Gironde

Prov.: Merklen
[1] Cf. Letter 595.

597 To Maurice Joyant

23 November [1900]

My dear Friend,

Please send the entire amount in the B.[1] account to the Crédit Lyonnais of Bordeaux. It's the end of the year.

You must know what's left for you to do.

Yours truly,
HTLautrec

Prov.: Unknown
Pub.: Dortu I, p. 53[2]

[1] When Lautrec was released from Dr Sémelaigne's institution, by family agreement, his income was divided into two parts: the first (A) was his family allowance, the second (B) his own earnings.
[2] Cf. Letter 69 Note 1.

598 To Maurice Joyant

[Bordeaux, 6 December 1900]

Dear Sir,

I am working very hard. You will soon have some shipments. To which address should they be sent: boulevard des Capucines or rue Forest? Orders.

I am taking advantage of the situation in asking you for two or three copies of the play of L'Assommoir.[1] Send everything to rue de Caudéran, Bordeaux.[2] La Belle Hélène[3] is charming us here, it is admir-

ably staged; I have already caught the thing. Hélène is played by a fat t[art] named Cocyte.[4]

Viaud sends you his love, and so do I.

<div style="text-align: right">

Yours,

T.L.

</div>

Prov.: Unknown
Pub.: Joyant I, p. 233[5]

[1] *L'Assommoir*, the play based on Émile Zola's novel (1877), was written by W. Busnach and O. Gastineau. It was revived on 1 November 1900 at the Théâtre de la Porte St Martin and starred Lucien Guitry and Suzanne Desprès. Lautrec did one painting, *L'Assommoir* (Dortu P.713), and one drawing (Dortu D.4648) based on this play.

[2] Lautrec is referring to 66 rue de Caudéran where he remained for some time (cf. Letters 600, 603). On 1 February 1901 Charles Angrand wrote to Paul Signac: 'What's Lautrec doing?' Signac replied on February 8 1901: 'Lautrec is a boarder in a brothel in Bordeaux, the city where he was turned out to pasture.' Signac may be referring to this address. (Cf. Lespinasse, p. 134).

[3] *La Belle Hélène*, the opéra-bouffe by H. Meilhac and L. Halévy, with music by J. Offenbach, had been revived in Paris early in the year and Lautrec had drawn the lithograph *Madame Simon Girard, Brasseur and Guy* (Wittrock 331). In reality it is Dastrez, not Guy, in the lithograph. The version referred to here was performed at the opera in Bordeaux.

[4] Lautrec made one painting, *Mademoiselle Cocyte* (Dortu A.265), and four drawings (Dortu D.4640–3).

[5] Cf. Letter 69 Note 1.

599 *To René Princeteau*

<div style="text-align: right">

[Bordeaux, December 1900]

</div>

My dear Friend,

Which day can I visit you in Libourne, at your convenience.

Please let me know.

I'd like to show you my work and hug you.

<div style="text-align: right">

TOULOUSE-LAUTREC

</div>

Prov.: Unknown
Pub.: Martrinchard, p. 62.

600 *To René Princeteau*

<div style="text-align: right">

[Bordeaux, December 1900]

</div>

My dear Friend,

I am still awaiting you at 66 Cauderan-Street [*sic*] and at 6 o'clock always at the Café de Bordeaux.

I'm training my arms the better to squeeze you against my broad chest, and I'm going to show you some painting, I need say no more!

 Affectionately,
 Toulouse-Lautrec

Greetings and regards to everybody in your circle, and especially to your good mother. I wanted to look you up in Libourne, but I had an attack of rheumatism in my shoulders. Fortunately it's better now!

Prov.: Unknown
Pub.: Martrinchard, p. 61

601 To Maurice Joyant

 [Bordeaux, mid-December 1900]
My dear Maurice,

Do you have photographs, good or bad, concerning de Lara's *Messaline*.[1] I am fascinated by this opera, but the more documentation I have the better it will be. The press said very kind things about my daubings.[2] I hug you.

 Yours,
 T.L.

Prov.: Unknown
Pub.: Joyant I, p. 234[3]

[1] An opera by Isidore de Lara, playing at the opera in Bordeaux. Lautrec made six paintings based on it (Dortu P.703–8) and three drawings (Dortu D.4637–9).

[2] Lautrec is probably referring to the article 'Exposition moderne à Bordeaux' by Paul Berthelot in the December issue of *La Petite Gironde*.

[3] Cf. Letter 69 Note 1.

601A To Maurice Joyant

 [Bordeaux, late December 1900–January 1901]
[1]'I'm doing great painting, I'm not asking for dough.[2] Don't ignore me.[3]

Prov.: Unknown
Source: Sagne, Jean, *Toulouse-Lautrec* (Fayard, Paris, 1988)

[1] Written on a letter from Paul Viaud to Joyant, possibly a fragment of the text.

[2] This does not agree with all earlier and later communications.

[3] Lautrec's relationship with Joyant was rapidly changing and he would now write to him 'Dear Sir' rather than 'My Dear Friend'. Joyant continued a relationship with Lautrec's mother and father and the last thirty years of his life were based on his earlier friendship with the artist.

602 *To Maurice Joyant*

Bordeaux, 23 December 1900

Dear Sir,

A Merry Christmas and happy new year.[1]

Send me without delay the programme and the texts for *L'Assommoir*[2] and *Messaline*,[3] and above all the 'dough' that will allow us to run around.

I chat with you.

Yours,
T.L.

Prov.: Unknown
Pub.: Joyant I, p. 234[4]

[1] This sentence is written in English.
[2] Cf. Letter 598 Note 1.
[3] Cf. Letter 601 Note 1.
[4] Cf. Letter 69 Note 1.

603 *To Mme R. C. de Toulouse-Lautrec*

66 rue de Caudéran, Bordeaux[1] [December 1900]

My dear Grandma,

I'm at Bordeaux and wish you a happy New Year. I share your opinion of the fogs of the Gironde, but I'm so busy that I've hardly any time to think about it. I'm working all day long. I'm showing 4 pictures at the Bordeaux Exhibition[2] and am having success.

I hope that will please you a little. I wish you a prosperous year, and from a ghost like me that counts double, for what my wishes are worth.

I kiss you.

Your respectful grandson,
Henri

Prov.: Schimmel
Pub.: GSE236, GSF264

[1] Lautrec and Viaud remained at Bordeaux from about December 1900 to May 1901. Cf. Letters 597–606.

[2] The Exposition d'Art Moderne at Imberti, reviewed by P. Berthelot in *La Petite Gironde*, December 1900. Cf. Letter 601 Note 2.

603A To Maurice Joyant

Bordeaux, 25 January, 1901

[1]Answer my question, payment for album,[2] I'm fed up.

Prov.: Unknown
Source: Sagne Jean, *Toulouse-Lautrec* (Fayard, Paris, 1988)

[1] Written on a telegram, possibly a fragment of the text.
[2] Probably the Circus Album (cf. Letter 584, Note 1).

604 To Maurice Joyant

Bordeaux, 31 March 1901

Dear Sir,

I read in the *New York Herald* that there are some paintings by me, a sale organized by Mancini.[1] Will you be kind enough to look about the prices and write me about.[2]

I'm having pains in my calves, but I'm receiving electrical treatments. I have received the Papal blessing, there is the Bishop of Bordeaux. He looks like Groult.[3]

Same address,
Truly yours,
H.T.L.

Prov.: Unknown
Pub.: Joyant I, p. 234[4]

[1] Sale on 25 April 1901 of a collection of modern paintings owned by Mr Depeaux of Rouen at Drouot. Paul Chevallier and Durand-Ruel-Mancini were involved. Four Lautrec paintings (Nos. 60–3) were sold: *En meublé* (Dortu P.365), 3,000 francs; *La Pierreuse* (Dortu P.407), 2,100 francs; *À sa toilette* (Dortu P.392), 4,000 francs; *Gens chic* (Dortu P.477), 1,860 francs.
[2] This sentence is written in English.
[3] Camille Groult, a well-known art collector.
[4] Cf. Letter 69 Note 1.

605 To Maurice Joyant

[Bordeaux] 2 April 1901

Dear Sir,

I'm living on nux vomica,[1] so Bacchus and Venus are forbidden. I paint and even sculpt. If I get bored, I write poetry.

Yours,
H.

Prov.: Unknown
Pub.: Joyant I, p. 236[2]

[1] The seed contained in the pulpy fruit of an East Indian tree, which yields the poison strychnia. It is used in medicine as a stimulant and tonic.
[2] Cf. Letter 69 Note 1.

606 To Maurice Joyant

Bordeaux, 16 April 1901

Dear Sir,

I am very satisfied, I think you will be even more satisfied with my new paintings 'about' *Messaline*.[1]

I dispatched the Gros Narbre[2] with two chameleons who rolled their eyes terribly. We had coffee together at the station, and, like Saint John the Baptist, the forerunner, he is going to announce my arrival to you.

Yours truly, and tell X[3] how much I appreciate his encouragement.

Yours,
T.L.

Prov.: Unknown
Pub.: Joyant I, p. 236
[1] Cf. Letter 601 Note 1.
[2] Lautrec's nickname for Maxime Dethomas.
[3] Joyant may have edited out a name mentioned by Lautrec.
[4] Cf. Letter 69 Note 1.

607 To Maurice Joyant

[Paris] 4 June 1901

Received from Maurice Joyant the sum of three thousand francs, the amount for my picture Jane Avril, blue overcoat[1] sold by Portier.[2]

This is a receipt.

4 June 1901
H de Toulouse Lautrec

Prov.: Unknown
Pub.: Dortu I, p. 52[3]

[1] *Jane Avril sortant du Moulin Rouge* (Dortu P.414) or *Jane Avril entrant au Moulin rouge* (Dortu P.417).
[2] Cf. Letter 145 Note 2.
[3] Cf. Letter 69 Note 1.

608 *To his Mother*

[Letter from P. Viaud[1] to Adèle de Toulouse-Lautrec with a note written by
Lautrec at end]

<div align="right">Taussat, 23 July 1901</div>

Dear Madam,

The General was unwise to alarm you about Henri. It's true that
the trip tired him a little, but thank goodness, that's all over & the
good news is that he's begun to eat & so I'm not pushing him to get
to Malromé, for since the sea whets his appetite, I believe it's better
to wait a few days before moving him.

Consequently, I calculate that we are not likely to go to Malromé
before the middle of next week, I'll let you know in time.

Henri, who for a time in Paris showed almost no interest in returning
to Taussat, is now delighted to be here.

<div align="right">My respectful regards,
P. Viaud</div>

Regards to Mme Pascal.

Dear Mother,
 We'll be there soon.
 Viaud will let you know.
 Loves and affections.

<div align="right">HTLHenri[2]</div>

Prov.: Schimmel
Pub.: GSF265

[1] Cf. Letter 243 Note 2.
[2] Lautrec had less than seven weeks to live. This may be his last letter still in existence.

Appendix 1

The letters included in this Appendix are evidenced by entries or notations in exhibition, dealer or auction house catalogues or in references made in the writing of others.

609 *To Achille*

Albi, Tarn

[1]A letter to the book dealer Achille,[2] from whom Lautrec is ordering for his cousin Odon Tapié de Céleyran *The Complete Adventures of Casanova de Seingalt*.[3]

Prov.: Unknown
Source: Stargardt, Auction, 10 April 1959, Katalog 542, No. 581

 [1] Fragment of a letter.
 [2] Achille Heyman, owner of a Parisian bookshop located at 3 rue Laffitte, Paris, that was also one of the Léon Deschamps distributors of *La Plume*.
 [3] Giacomo Casanova de Seingalt (1725–98), an Italian author whose memoirs, written in French, give an account of his adventures and love affairs.

610 *To Albert, Adolphe*

[1]Letter from Toulouse-Lautrec to Adolphe Albert dated 21 January 1895.

Prov.: 1951 loan to Bibliothèque Nationale from Marcel Guiot; present location unknown.
Source: Œuvre Graphique de Toulouse-Lautrec, Bilbiothèque Nationale, Paris, 1951 No. 236

 [1] On letterhead of Renée Vert, Parisian milliner, friend of Lautrec and lover of Adolphe Albert. She appears in Lautrec's lithograph *La Modiste—Renée Vert* (Wittrock 4). Together with Albert she formed a collection of sheet music by Désiré Dihau with lithograph covers by Lautrec (Collection Schimmel).

611 *To Arnould, A.*

Paris, 22 May 1896

[1]Lautrec asks him to make the hair of Eglantine a little greyer.

Prov.: Unknown.
Source: Publication notes, GSE273, n. 1

 [1] Cf. Letter 454.

612 *To Bernard, Tristan*

Lautrec asks Bernard for a meeting.

Prov.: Unknown.
Source: Kundig, Auction, 17 June 1946, No. 340.

613–616 *To Boch, Eugène*

Four letters[1]

Prov.: Unknown
Source: Retrospective Anna & Eugène Boch, Musée des Arts et Métiers, La Louvière,
11–31 October 1958, p. 16, Item C

[1] No additional information as to the nature of these four letters is available. They may have included letters 86, 346.

617 *To Bruant, Aristide*

[1] He asks him to come to pose and to see his poster.

Prov.: Unknown
Source: Œuvre Graphique de Toulouse-Lautrec, Bibliothèque Nationale, Paris, 1951,
No. 228.

[1] Probably written in Paris in 1892.

618 *To Bruant, Aristide*

[Paris, 1892]

Lautrec writes regarding a meeting with Ducarre.[1]

Prov.: Unknown
Source: Information from Mme Privat to L. Goldschmidt

[1] Pierre Ducarre (b. 1830), director of the Ambassadeurs. Lautrec drew the poster *Ambassadeurs: Aristide Bruant* (Wittrock P.4) and the lithograph *Ducarre aux Ambassadeurs* (Wittrock 26).

619 To Dujardin, Édouard

[1]Lautrec is questioning an opening at *La Plume*, speaks of Alexandre Natanson and of various meetings.

Prov.: Unknown
Source: Drouot, Auction, 17 November 1934, No. 159.
[1]Probably written in June 1895. Cf. Letter 412.

620 To Marx, Roger

[1]... So have someone photograph Hiroshigie's[2] Owl. Bing[3] has a rare copy of it ...

H. T. Lautrec

Prov.: Unknown
Source: Tausky, Catalogue Été 1952, No. 20175

[1] Written in Paris, possibly in July 1895.
[2] Hiroshige (1797–1858), the last major master of the Japanese Ukiyo-E School. He published in the fields of figure prints, actors, and girls, but landscape prints were his best-known works.
[3] Siegfried Bing: cf. Letter 398 Note 3.

621 To Marx, Roger

[1]On the letterhead of the Pavillon d'Armenonville.

My dear Marx, climb into your conveyance and come and visit me

Prov.: Collection Paulette Asselain in 1980; present location unknown
Source: Exhibition Donations Claude Roger-Marx, Musée du Louvre, Cabinet des dessins, Paris, 27 November 1980 to 19 April 1981, No. 87

[1] Probably written in December 1898. Cf. Letter 554.

622 To his Mother

[Paris, September 1891]

Lautrec says that he is

... working with enthusiasm to the extent that my haemorrhoids ...
... introduced Gabriel[1] to Bourges[2] and Claudon[3]...

He says he has been initiated into the auction rooms ... He is coming to take care of [someone] and signs

Yours Henry

He adds

If you can send me the promised ... this is the right time

and signs

Yours Isaac[4]

Prov.: Unknown
Source: Information from Mme Privat to L. Goldschmidt.

[1] Gabriel Tapié de Céleyran.
[2] Henri Bourges.
[3] Claudon: Cf. Letter 79.
[4] Reference to Genesis 22: 7 ff.

623 To his Mother

[Paris]

... I have even sold a painting to a Bordelais which only proves that all the fools are not in Charenton[1] ...

Prov.: Unknown
Source: Information from Mme Privat to L. Goldschmidt

[1] A well-known mental hospital near Paris.

624 To Princeteau, René

[1] He has passed his examination, he is very proud of it and beside himself at being free for art.

Prov.: Unknown
Source: Martinchard, p. 66

[1] Probably written in November or December 1881.

625–626 To Tapié de Céleyran, Mme L.

[1878, 1879]

... Rise up and pray for me ...

[Paris]

... Painting continues not to be worth a full 5% ...

Prov.: Unknown
Source: Information, on two letters, from Mme Privat to L. Goldschmidt

627 *To Tapié de Céleyran, Mme L.*

June 1884

Lautrec refers to 'Art which shuns me'[1] and announces his decision not to enter the competition at the École des Beaux-Arts.

Prov.: Unknown
Source: Information from Mme Privat to L. Goldschmidt GSE57, n. 4

[1] This may be Letter 94.

628 *To Toulouse-Lautrec, Charles de*

... visit to Solesmes[1] ...

Letter with two drawings.

Prov.: Unknown.
Source: Information from Mme Privat to Lucien Goldschmidt

[1] A town in the Department of Sarthe.

629–631 *To Toulouse-Lautrec, Mme R. C.*

[1878, 1879]

... My legs are very right and without shortening ...

[Paris 1887]

... The garden where I will work all summer ...

... Preparing to go to Brussels carrying the purple flag of the Impressionist painters ...

Prov.: Unknown
Sources: Information, on three letters, from Mme Privat to L. Goldschmidt.

632 *To an Unidentified Correspondent*

He asks someone (Maître) not to forget his friends Ricci and Rachou in reporting on the Salon.

Source: Maison Charavay. Note in Charavay file states: '1 page octavo 1920's Drouot'

633 *To an Unidentified Correspondent (critic)*

January 1896
An invitation to come see some paintings and drawings 9 rue Forest[1]

Prov.: 1951 Loan to Bibliothèque Nationale from Marcel Guiot; present location unknown.
Source: Œuvre Graphique de Toulouse-Lautrec, Bilbiothèque Nationale, Paris, 1951, No. 237

[1] This may be Letter 447.

634 *To an Unidentified Correspondent*

Lautrec accepts an invitation and says
Please thank your son for all the nice things he has said about me.

Prov.: Unknown
Source: Charavay, Catalogue, March 1966, No. 30902-2

635 *To an Unidentified Correspondent*

[1]This is to remind you of your promise to my friend Fabre to use your influence on his behalf for the colonies ... I am still in Taussat before fleeing to even more leaden skies ...

H. T. Lautrec

Prov.: Unknown
Source: Charavay, Catalogue, July 1949, No. 22846
[1] The catalogue entry states that this letter was written from Arcachon.

636 *To an Unidentified Correspondent*

Lautrec sends invitation to lunch with Guitry.[1]

Prov.: Unknown
Source: Kundig, Auction, 17 June 1946, No. 341
[1] Cf. Letter 515

637 *To an Unidentified Correspondent*

Letter without a place or date.

Prov.: Unknown
Source: Gutekunst, Auction, 15 November 1950, No. 297

638 *To an Unidentified Correspondent*

Ordering a copy of an art book.

Prov.: Unknown.
Source: Berès, New York, Catalogue 3, 1939, No. 195

Appendix II

Notes written by Henri Bourges concerning the summer 1893 vacation trip[1]

Henri's[2] trip to the lakes of Les Landes[3]
with Toulouse-Lautrec, Guibert,
Louis Fabre, and Viaud[4]—1893

The five of us left on Monday morning, with two sailors and a canoe (on a truck) on the La Teste to Cazeaux railway line. From Cazeaux, we crossed the entire lake, then travelled along the river that connects it with the lake of Biscarros. We slept at Biscarros. We slept in the tent. We had brought supplies with us for the entire trip. We bought chickens, lamb, and fresh vegetables. Our sailors cooked better than the cook. The sailors and the boat belong to one of my friends. We had wine in a cask.

On the second day we went from Parenthis to Ste-Eulalie.

On the fourth day we went down the canal, with great difficulty, because of the rapids and the waterfalls. We walked almost the entire time, lifting our boat over the difficult passages.

We slept in Mimizan, in the hotel. From here we left this morning by train. The railway connects up with the Bayonne–Labouheyre line.

The notes include a hand-drawn map of the area with the following remarks:

The map is my doing: Here you are:

The name Pond of Sanguinet is used for the eastern part of the Pond of Cazeaux, but there is no natural boundary.

The water of the ponds is completely sweet. It turns brackish only in the canal that connects the Pond of Aureilhan with the sea. The tide can be felt only in this canal.

The west side of the ponds is bordered by large dunes planted with pines, which extend in tiers as far as the ocean 5 to 7 kilometres away.

Along the ocean beach there is a Customs post every 5 kilometres.

I didn't see the coast.

This is not the season for hunting wild fowl.

Pine forests.

The others stayed in Mimizan in order to go to the ocean.

[1] Cf. Letter 305.

[2] Henri Bourges (referring to himself).

[3] This trip, as described, was a standard vacation experience at that time in the Arcachon area. It is described by Paul Joanne in *Bordeaux, Arcachon, Royan, Soulac-les-Bains* (Guides Diamant; Hachette, Paris, 1883), pp. 84–7, and later in *Les Pyrénées* (Guides pratiques Conty) and K. Baedeker, *Le Sud-Ouest de la France*.

[4] Henri de Toulouse-Lautrec, Maurice Guibert, Louis Fabre, Paul Viaud.

The Ponds of Cazeaux and Parenthis would each take up half the area of the Bassin d'Arcachon.

Bourges's original spelling is included above. However the correct spellings for the various map locations are Cazaux, Biscarosse, Parentis.

Appendix III

These letters are the balance of the correspondence published in *The Henri de Toulouse-Lautrec W. H. B. Sands Correspondence*. They include letters written by W. H. B. Sands, Arthur Byl, Henry Stern, and Yvette Guilbert and concern the production of the *Yvette Guilbert* and *Treize Lithographies* albums of 1898.

Prov.: Schimmel
Pub.: SC7, 9, 13, 16, 19, 21, 24, 26, 36, 38, 42, 44

III. 1 *To H. de Toulouse-Lautrec, Paris*

12 Burleigh Street, Strand,
London, 28 February 1898

My Dear Sir,

Thank you for your letter.

I think that it will be better if Mr Byl writes the other ones something like the following:

Something like this—four lines.

If Mr Byl would like to write the medallions, we could always amplify them later like the other ones.

Please tell me whether he wants me to pay him immediately or when he is finished. Now I have Sarah B. and Y. G.—I am waiting for you to return Y. in order to point out what should be removed.

You tell me, 'send the paper samples'. I did not understand what you would like—is this the paper on which they must be printed or the drawings which you already sent me viz. Sarah B. and Polaire? Please explain in your next letter.

I now think that you will have the 25 drawings ready to print towards the end of March—however, could you give me 6 drawings of Yvette G. immediately, that is, in two or three weeks.

I think that these drawings would be in great demand at the beginning of May when she will be here. This would be something for both of us, and also a little publicity—all the better—for you, because it will be fashionable society which will see them. Please excuse my handwriting and my French,

Cordially,
WHBS

III. 2 *To H. de Toulouse-Lautrec, Paris*

[London] 1 March 1898

Dear Sir,

Thank you for your letter.

If it is possible, I would like the 6 drawings of Yvette Guilbert from you on paper because it is almost absolutely necessary to have them printed here in London—the sale will be in two or three weeks and we must be ready to print a large quantity immediately and to have them ready at our fingertips. Can you give me 6 drawings like the one which you already sent me—it doesn't matter which ones—on paper. I am certain that they will be very successful.

Mr Byl—I would like only 4 lines at the most or perhaps 6 for the medallions—I find that his price of 50 francs is a little high for so little. I should like to economize on the text so that I can spend more on the paper, the binding, and the advertisements, in the newspapers, the posters, etc.

You can see that for an edition of 250 copies—at 30 shillings—we will be getting up to 13/12 per copy, almost 20 shillings—that is, 25 francs. This brings 250 pounds in all. Do you think that he will do these medallions for 25 francs each? If not, I think that we will have to write several lines here in English culled from the newspapers, etc. As for the French edition, I would like to print 100 copies at 50 francs and pay you 15% as a royalty.

You understand that it is you and your drawings which are important—the text is not very necessary—and the less that we spend on the text, the more we will be able to put into the drawings.

When will you be coming to London? The weather is beautiful now! You must come to see us.

Very cordially,
WHBS

III. 3 *To H. de Toulouse-Lautrec, Paris*

London, 13 March 1898

Dear Sir,

I now have 4 'Yvette's'—my idea is to make an album—how many drawings do you think will be necessary? As I have told you, 6 in my opinion—and I will return the article on her so that Byl can remove something. This article must be more on the subject of her successes—for example, that she had been singing for ? years—that she lives in an apartment in ? Street. That she is married to ? That she likes birds, cats, and things like that—that her profession is ? What type of song she likes best—particularly that she has sung at La Scala—little things like that.

In addition, I would like to have you furnish me with an 'estimate'.

A. How much would it cost, for paper, printing, etc., in order to print

200–250–300–350 in the same size as the drawings which you sent to me? *No binding*, that can be done here.

B. How much for the stones? This is because I also have an idea that printing a large number of smaller ones would succeed—what do you think?

C. Do you think that she would want to sign? That would be something. She will be here in London at the beginning of May, so we must launch the book in the middle of April.

If it is possible for the printing to be done in Paris, I think that the name 'Goupil' will be on the binding. That company does not work in London, does it?

<div style="text-align: right">My devoted compliments
W. H. B. Sands</div>

Please write immediately if it would displease you if we print *a large quantity*, low cost, costing 3 francs or 5 francs?—naturally, you would share in the profits beyond the cost of the stones and the drawings. I think that this is a good idea.

III. 4 *To H. de Toulouse-Lautrec, Paris*

<div style="text-align: right">[London] 18 March 1898</div>

Lautrec:

For the other book—I believe that you have already done six—you are in the process of also doing Calvé, Rostand, Coquelin, Granier; this will be Réjane, Marsy, Febvre, Hading, Delna, Sanderson, Mendès, and Sully, for sure; this will be 18 in all, and we will be able to decide about the others when you are in London.

<div style="text-align: center">[No signature] [W. H. B. Sands]</div>

III. 5 *To W. H. B. Sands, London*

<div style="text-align: right">[Paris] 21 March 1898</div>

Dear Mr Sands,

I changed the Yvette Guilbert biography along the lines you indicated. The second version contains four new pages which will be tied into the fifth and following pages of the first version. I believe that in this way, Yvette will be happy to give you her signature. If she does not agree, you could make use of the first version which is more complete and more amusing— there are some humorous details never before published which might amuse your clients. Nothing more intimate or more complex has been done on Yvette Guilbert. In the final analysis, the choice is up to you.

Thank you and best regards.

<div style="text-align: right">Arthur Byl</div>

III. 6 *To H. de Toulouse-Lautrec, Paris*

[London] 25 March 1898

Dear Sir,

Balthy is not in my list of eighteen drawings—since Byl has done Balthy, we will have to substitute it for Delna—and I think that we will also have to have Ackté instead of Catulle Mendès—and also, in order to have 20, Antoine and Guitry. What do you think?

In great haste.

Yours truly,
W. H. B. Sands

III. 7 *To H. de Toulouse-Lautrec, Paris*

[London] 28 March 1898

Dear Sir,

Thank you for your letter.

The list should include

1. Bernhardt	13. Ackté
2. Rostand	14. Held
3. Coquelin	15. Granier
4. Calvé	16. Febvre
5. Polaire	17. Antoine
6. d'Alençon	18. Réjane
7. Polin	19. Sanderson
8. Hading	20. Belfort
9. Marsy	
10. Balthy	
11. Mounet-Sully	
12. Guitry	

⎬ articles already done

WHBS

III. 8 *To W. H. B. Sands, London*

Proofs and preparation of 8 stones (Yvette Guilbert drawings)	40.00
Value of the 8 stones at 2 francs, 40 centimes each	19.20
First packing case	3.90
Second packing case	1.60
	64.70

[Paris] 1 April 1898
Henry Stern

III. 9 *To Arthur Byl, Paris*

[London] 1 May 1898

Mr Byl

Dear Mr Byl,

 Mr Lautrec told me that he has given you 100 francs for 4 medallions. There are then 9 remaining for payment and I am sending you a cheque for 225 francs. For the present, I have enough medallions, because I have not yet decided about the other drawings. Therefore, I would not need other medallions at present. I will write to you about this later.

 Please, Sir, be assured of my most respectful sentiments.

W. H. B. Sands

III. 10 *To H. de Toulouse-Lautrec at 317, Charing Cross Hotel, London*

Carlsbad, 6 May [18]98

Dear Sir,

 We are in Carlsbad! The lady had such pains that the doctors made her leave Paris immediately!

 I have had to postpone my season in London until next year, my dear husband preferring that I take care of myself at once! So much for that!

Friendly greetings
Yvette (Guilbert)

III. 11 *To H. de Toulouse-Lautrec, Paris*

[London] 31 May 1898

Cheque for 300 francs enclosed

Dear Sir,

 I have received 4 stones.

 Balthy I am afraid will be no use, so I am returning it to MM Stern. I think that MM Stern must have made a mistake in charging 5 fr. each for 15 tirages. I am writing to them on the matter.

 On 1 May I wrote to Byl that I did not require any more medallions for the present, so I shall not be able to use the two on Held & Belfort. I wrote this very distinctly, so I cannot understand why he has done or is doing any more. Belfort is quite unknown here, except to a few, all about Held that is necessary I can write myself.

 I now have 14 drawings which will be enough for the moment. We can arrange for some others in the autumn.

[No signature] [W. H. B. Sands]

III. 12 *To W. H. B. Sands, London*

[Paris] 14 June [18]98

Dear Sirs,

Mr de Toulouse Lautrec asked me to write to you in order to justify the price which you find too high for the 15 stones which I sent to you on 25 May last.

I am sure that anyone else would have asked you for 6 francs per stone instead of 5 francs. All of the stones were prepared twice, cleaned, and double-wrapped.

Believe me, dear sirs, that I am not attempting to make you pay more than my clients, for I work a great deal less expensively than my colleagues, and in asking for 75 francs for 15 stones with drawings, I do not think that there is anything to be said against that.

In the hope of hearing from you, believe me, dear sirs, your devoted

Henry Stern
83 faubourg St. Denis, Paris

Note by person in Sands's office:

Send corrected inv. only ordered 14 stones June 18/98

Appendix IV

The following letters are from Berthe Sarrazin, a housekeeper of Mme de Toulouse-Lautrec, the artist's mother. She had been sent to Paris to take care of her apartment on rue de Douai. Upon the departure of the Countess she was entrusted with the protection of Lautrec, to keep an eye on him, and to prevent him from distributing furniture, silver, or wine belonging to his mother. She was to report to the Countess in Albi, and most of the letters are addressed to her. When the news appears too difficult to relate, Berthe writes to Adeline, the faithful chambermaid who had helped educate Lautrec.

She writes as she speaks, without striving for effect. For the benefit of clarity the editors have followed neither her unorthodox spelling nor her absence of punctuation. Passages of no relevance to Lautrec or his family have been ommitted.

Prov: Schimmel
Pub.: GSE238–272, GSF267–301 (the Letter dated 2 February 1899 was not previously published)

IV. 1 *To Mme la Comtesse de Toulouse-Lautrec*
7 rue de Manège, Albi, Tarn

Paris, 4 January 1899

Madame la Comtesse,

When I got back in the evening yesterday I went to Monsieur Henri's. He was getting himself ready for coming to dinner. I told him that Madame had left. He was very angry. He swore and pounded the floor with his cane. He took a carriage. He came to the house, he rang the bell so hard he almost broke it. The concierge told him there wasn't anyone there. He didn't even say a word. He left to look for Monsieur Gabriel. Stern told me he had sent a telegram to his aunt. I waited for Monsieur till 11 o'clock in his studio. Seeing he hadn't come home, I went back to go to bed. He returned at midnight. The concierge got him to go to bed this morning. I went over at 8 o'clock. He was a good deal calmer, though he keeps on saying things that aren't sensible. He again burned some newspapers in the toilet bowl, but he's much better just the same.

He made me look for the keys to the apartment. He thinks he has lost them. He's getting back his memory a little. I think that in a few days the trouble will have disappeared. He told me he didn't understand what kind of fast one they were pulling on him, why Madame hadn't warned him, that when there was something happening in the family he was always told first . . .

... He hasn't come back yet. I am still going to have the turkey roasted. I think Monsieur Gabriel will come to dinner ... Madame should get some rest and calm herself. I think it will all turn out very well. I will do my best to justify Madame's confidence and will do the best I can to take care of Monsieur Henri ...

Berthe Sarrazin

IV. 2 *To Mlle Adeline Cromont*

at Madame la Comtesse de Toulouse's
7 rue du Manège
Albi, Tarn

[Paris] Wednesday, 9.30 [5 January 1899]

My dear Adeline

I'm very much of your opinion about this unfortunate turkey. It's still on my hands. Nobody came to dinner. It's a bad luck turkey. I haven't any desire to eat it, either. Monsieur has been gone since this morning. I don't know what's going on. He hasn't come back. He had given me his word to come for dinner. He had set the table for four and no one showed up. I've just come from his studio and no sign of him. There's a telegram there for him and one here. I forgot to tell Madame that Mme Pascal has been here with her daughter-in-law. She was very much surprised that Madame had left without telling her. Cécile also came this evening and asked me questions. She would have very much liked to know but I didn't say a thing. She said she'd know tomorrow from Madame de Bernard. She made all kinds of guesses. I'll tell you about it when I get back.

My poor Adeline, Monsieur isn't any better. He had another litre of turpentine delivered. I took it back. All he does is buy a lot of things, old pastry-moulds, spoons for 20 francs at the paint shop; but I'm going to take them back and tell them not to deliver anything else ...

the 5th, 12 o'clock

I was very much worried again this morning, Monsieur hadn't come back by 10 o'clock. I took a carriage. I went to Monsieur Gabriel's, who told me he knew where he was. He gave him all the money in a lump sum and I don't think he's got any left now. This morning he came back at 10.30. I asked him for money for coal. He told me that tomorrow he'll get some. So, during his night out he spent a thousand francs. Don't tell Madame ...

Your friend,
Berthe Sarrazin
9 rue de Douai

IV. 3 *To Mme la Comtesse de Toulouse-Lautrec*

7 rue du Manège
Albi, Tarn

Paris, 6 January [1899]

Madame la Comtesse

There's nothing new. Monsieur is still about the same, better if anything, although he's still not entirely in his right mind. He is still buying a lot of knick-knacks, even dolls. Tonight we are having people to dinner, 6 places. I don't think it will be like the night before last. I'm doing a fish, a rabbit and the cold turkey and a pineapple ice. Monsieur wanted lobster 'à l'américaine', bouillabaisse, goose-livers in sauce, but I made him understand that it was too complicated and that I was all by myself. Monsieur has received Madame's letter. He is very pleased. He read it to me. Everything's all right. As I hadn't any more money, Monsieur gave me 100 francs. I'm marking it all down. Madame will go over it when she gets back.

I'm very busy with Monsieur. Yesterday I went over eight times. This morning I stayed until noon ...

Berthe

IV. 4 *To Mme le Comtesse de Toulouse-Lautrec*

7 rue du Manège
 Albi, Tarn

Paris, Saturday, [7 January] [1899]

Madame la Comtesse,

I received Madame's good letter this morning, which consoled me a little and at the same time saddened me, because I see that Madame is still as unhappy as ever. It would be the same if she was here. Monsieur is still about the same, except that he doesn't touch the fire any more, on the other hand, all he does is buy all sorts of knick-knacks. This morning, for 172 francs, a man brought him some little figures, made of painted plaster apparently, besides this he gave the masseur a present a 100 francs and paid the bill, which looked to me like 70 francs. In short, in an hour nearly 400 francs. He has a lot of money. He got plenty of it by telegraph money-order. It makes me very sad to see him throwing away so much money uselessly, not to mention that I'm not always there and can't see everything.

My dinner went off very well. Seven people came. I hadn't made much for so many, and so there wasn't anything left over, except a little turkey which I gave to the concierge. I had enough of it.

The gentlemen stayed until midnight to smoke and sing. While this was going on Monsieur Henri slept near the fire. When he woke up he wanted to lie down in Madame's bed. I got it ready for him. Afterwards he wanted me to get him 4 flannel shirts. Nothing would do but that I find them. Finally everyone left. Nobody stayed but Monsieur Albert, who offered to go along with Monsieur to his studio and they left. This morning I went over at 8

o'clock. Monsieur didn't want to let me in. I went back at 10 o'clock and the things happened that I have just told Madame about above. I shall go back at 5 o'clock. Monsieur asked me if I'd heard anything from Madame. I told him no. He told me he'd received good news from you. He no longer remembered having read me the letter. I asked Monsieur if he'd answered it, he told me: 'no, never, it would have to wait'. I think he's very much put out because Madame isn't here.

I'd like to do something, but I can't do more than I am doing. As for Calmèse, I went to see him the day Madame left and told him not to come. An hour afterwards he was at Monsieur's. As for Gabrielle, she hasn't shown up again, nor Stern, either. Until tomorrow, then, Madame, and have courage.

<div style="text-align: right">Berthe</div>

IV. 5 *To Mme la Comtesse de Toulouse-Lautrec*

7 rue du Manège
Albi, Tarn

<div style="text-align: right">Paris, 8 January [1899]</div>

Madame la Comtesse,

There's nothing new. Monsieur is still the same thing. He is still buying antiques, varnishing his pictures with glycerine and rubbing them down with a sock. This morning his face was red and swollen like the other day. He has his lunch at Boivin's with Monsieur Bouchef . . .

. . . Stern came this morning. He stayed with Monsieur all morning. He didn't mention Madame at all . . .

. . . He seems to be going on drinking. If it could only be kept away from him for a week or so he would be cured. He is quieter and doesn't touch the stove any more. He doesn't disinfect any more and the only irrational thing he does is buy old junk. He spends a lot of money. The shopkeepers take advantage by selling him all sorts of dirty old stuff . . .

Monsieur Gabriel told me he had given him a thousand francs and the next morning, when I asked him for money for coal, Monsieur told me he was going to get some money by mail, that he didn't have any, and I know that Monsieur got money by a telegraph money-order. I think I told Madame that Monsieur had given me 100 francs for expenses . . .

IV. 6 *To Mlle Adeline Cromont*

7 rue due Manège
Albi, Tarn

<div style="text-align: right">Paris, 9 January [1899]</div>

My dear Adeline,

I got your short letter this morning . . . Monsieur continues to be calmer. He talks less nonsense, too. He came to have lunch this morning with

Monsieur Sescau. Monsieur Maurin was to have come, too, but he didn't. They waited for him until 1 o'clock. Yesterday Monsieur spent the day with Monsieur Albert...

It is easy to see that Madame isn't here and they make themselves at home. Monsieur didn't buy anything yesterday. I don't think he has any more money. He keeps on rubbing his pictures with vaseline and glycerine. I'm very much afraid he's going to spoil them all ... Tell Madame that things are much better and that she can come back. I think Monsieur would be very glad ...

IV. 7 *To Mme la Comtesse de Toulouse-Lautrec*

7 rue du Manège
Albi, Tarn

Paris, 10 January [1899]

Madame la Comtesse,

I wish I could give Madame better news, but unfortunately it's the same story. However, Monsieur is calmer at the moment. He talks very sensibly at times but you mustn't go against him. For example, yesterday at lunch he wanted to put rum into the dish of orange preserves. I wanted to stop him and he put me in my place in no uncertain terms. He said he was the master. You always have to approve, to say yes all the time, otherwise he's not bad. All he talks about is giving presents to everybody. Monsieur keeps on making a mess of his linen. He takes all of it out of the chest, throws it all on the floor. This morning I gave him 8 pocket handkerchiefs. At 10 o'clock when I returned he didn't have one of them left. He puts vaseline on his pictures and wipes it off with his handkerchiefs...

... [Monsieur Mallet] tells me that Monsieur is telling everybody to buy things on his account and that for 2 years Monsieur hasn't paid his bills, that he had a big bill which he didn't dare present for fear of offending Monsieur...

... At 11.30 [Calmèse] had his stable-boy come to get Monsieur. I think they were to have lunch together. I'm going to go back a little later. I am staying as long as possible at his place. He talks and talks and he doesn't go out. He forgets to drink. If one could be with him all the time to keep him busy perhaps he wouldn't think about drinking any more ...

... I only bring eggs which Monsieur eats raw mixed with rum. That can't do him any harm. And coffee every morning...

IV. 8 *To Mlle Adeline Cromont*

7 rue du Manège
Albi, Tarn

Paris, 11 January 1899

6 p.m.

My dear Adeline,

I haven't written to you sooner, but Madame must have given you the news. It's not very good. It's still the same thing. What are we going to do about Monsieur Henri? He can't keep it up this way forever. However, nobody does anything about it. I never see Monsieur Gabriel or anybody. It's strangers, mostly Calmèse, who take care of him. They both drink, one as much as the other. Poor Monsieur is always the same. Every time he sees me he shows me his hand and tells me it's all right, it's well again. He doesn't remember anything at all. This morning he asked me if Madame knew he burned his hand. He doesn't touch the fire any more. He doesn't even light the newspapers any more. He didn't buy anything today or yesterday...

... I've just been to Monsieur's place. Calmèse was sleeping on the couch with his dog. Monsieur Montcabrier was there, too, you know, the little young man who often comes. Monsieur kept pestering me for rum. I gave him the rest of the bottle that was in the cupboard...

IV. 9 *To Mme la Comtesse de Toulouse-Lautrec*

7 rue du Manège
Albi, Tarn

Paris, 11 January 1899

Madame la Comtesse,

I was glad to receive Madame's letter this morning with the 100-franc note, but I wasn't worried since Monsieur had given some money. I haven't spent all of it yet. I thank Madame very much. Monsieur is much better but he still can't remember a thing. For instance, I asked him if he'd had any news. He told me he'd received a telegram, that things were going to get better for him. This was the wire that Madame sent the day after she left. He thinks that's today. He also found the envelope again of the telegram which announced a money-order. He sent me to the office to tell them to bring the money to the house. I went there. I thought it was another money-order, but not at all. Monsieur had got the money on 6 January. They told me at the post office that Monsieur hasn't much of a memory if he can't remember receiving a thousand francs; then he was furious and sent me to fetch Monsieur Calmèse. I pretended to go there. I said he wasn't there; he wanted to throw the telegraph girls into gaol.

Monsieur is still angry with Madame. He told me this morning that Madame had left him right in the middle of work, that he had done everything

to keep Madame but that she had wanted to go travelling, that her leaving had upset him and made him sick, that he was going to write an outspoken letter: he even wanted to send a telegram but a minute later had forgotten all about it. That terrible Calmèse is always around and never leaves Monsieur. They have lunch and dinner together.

The woman who sells wine across the way [at the Père François] told me that Monsieur was afraid at night. He came to fetch their boy at 1 o'clock in the morning to have him search all the corners of his studio to see whether anybody was hiding there. He told them he was at odds with his family, that his family wanted to have him locked up and that he was afraid they'd take him away while he was asleep. He never says anything like that to me . . .

IV. 10 *To Mme la Comtesse de Toulouse-Lautrec*

7 rue de Manège
Albi, Tarn

Paris, 12 January 1899

Madame la Comtesse

Monsieur hasn't paid his October rent. The concierge had me look at the bill. It's for 409 francs, 85 centimes. She hasn't got the January bill ready yet, but she thinks it's pretty much the same. The concierge at our house still hasn't been paid for postage costs. She told me she had sent 2 registered letters, which makes 80 centimes.

Monsieur is still the same as ever. He talks a lot. I again stayed the whole morning at the studio. Monsieur told me that he was having lunch with some cousins, magistrates. I think it's with Monsieur de Rivières. . .

I am reopening my letter. I have seen Monsieur de Rivières in the street. I talked to him. He told me that he thought Monsieur was much better, that they had had lunch together, that he had written to Madame under the dictation of Monsieur, so that Madame should set her mind at rest. I think that things are going to be better.

Berthe

IV. 11 *To Mlle Adeline Cromont*

7 rue du Manège
Albi, Tarn

Paris, 13 January 1899

Dear Adeline,

I don't know whether you have received your coffee glass, . . . Monsieur Henri, who was better yesterday, today is in a state. All he did all night was go in and out of the house. This morning he'd already left by 7 o'clock. I went looking for him. He was with Calmèse at the wine seller's in the rue Fontaine. He was furious with Madame over not having heard from her. He

told me he'd never set foot in the apartment again, that he would rent smaller lodgings and would keep me in his service. He thinks that Madame will never come back again. He is very worried.

I have just come away from Monsieur, whom I left with Mr Bouchef in his studio. I shall go back again by and by ...

IV. 12 *To Mlle Adeline Cromont*

7 rue du Manège
Albi, Tarn

Paris, 14 January 1899

My dear Adeline,

Still nothing good to report. I told you that Mr Henri was in a sad state all day yesterday. I went back in the evening. Big Gabrielle was there. That dirty bag told him that I had sent her a telegram telling her not to come again on orders from Madame, and so Monsieur is even more angry with Madame. You see how much you can trust that dirty woman. She must be pestering Monsieur for money. He asked me if I had any. I replied that Madame hadn't left me any. Then he sent me with a letter to Monsieur Robin's. There wasn't anybody there. His concierge, Monsieur's concierge, told me that Monsieur had done nothing but come in and out all night. He wasn't happy about it because it kept him from his sleep. Monsieur stayed all morning at Calmèse's. They had lunch together at the tobacconist's across from the livery stable. Monsieur received two telegrams this morning which the concierge brought to him at Calmèse's. I went to take him a letter to Mr Sescau's. I spoke to him. He told me he thought he was worse, that he didn't know what was going to happen. I came back to the studio with the answer. That Gabrielle was there, with Calmèse and, I think, Gabrielle's boy-friend. A fine lot, as you see, Monsieur is going to be worse than ever tonight, what a pity, my God!

I'm glad that Monsieur hasn't any more money, since those people only hang around him for that. When they see he hasn't any more they'll let him alone, perhaps. Madame shouldn't give him any for a while to see what they'll do. Monsieur told Mr Sescau that he was going to call them to account, that he would get 3,000 francs tomorrow ...

Berthe Sarrazin

Give Madame whatever news you think fit.

IV. 13 *To Mme la Comtesse de Toulouse-Lautrec*

7 rue du Manège
Albi, Tarn

Paris, 15 January 1899

Madame la Comtesse,

Monsieur hasn't paid his rent. When the concierge presented him with the bills he said that he was not on good terms with his family, that a week from now it would be taken care of. All he did was send some telegrams. He got one from Coursan. Monsieur told me he was going on a trip. He is going to go to Coursan with 2 detectives and get his due. He said that Madame doesn't understand it very well, that his father doesn't attend to things and that he's being robbed. Monsieur continues not to sleep at night. The other night he went to Monsieur Robin's at 3 o'clock in the morning. This morning at 4 o'clock he went out. He sent a girl selling newspapers to look for me at 6 o'clock. I was very scared. I thought that something had happened. But no such thing. Monsieur was busy drinking at the tobacconist's with a hackney coachman. Stern came this morning as he does every Sunday. I think they went to have lunch together. Tomorrow I'll go to Monsieur Bourges's as Madame told me.

I'll write at greater length tomorrow. I'm afraid of missing the post. I hope that Madame is well and wish her courage.

Berthe Sarrazin

IV. 14 *To Mme la Comtesse de Toulouse-Lautrec*

7 rue du Manège
Albi, Tarn

Paris, 16 January 1899

Madame la Comtesse,

I've just come from Monsieur Bourges's, whom I told what was going on. He told me he couldn't do a thing, that I'd have to go to Monsieur Gabriel's. So I went to Monsieur Gabriel's, but he had left. I'll go back tomorrow morning. Monsieur is somewhat better but is very much put out because of the money. He told me this morning that Calmèse had found him moneylenders at thirty per cent. There's a danger they'll get him to do something really foolish. I've just come from his place. There were 2 men there I didn't know. He sent me away. Gabrielle is waiting at Père-François' until 4 o'clock. Monsieur is supposed to go and fetch her and I have to go back myself. So, Monsieur asked me if I had the keys to the yard. He wanted me to get some white muscat wine. I had to take 2 small bottles of muscat to the tobacconist's and a bottle of blue label. I am very much concerned. He promises wine to everybody, to Big Gabrielle, to the stable-boy. He says that it's his. I haven't given anything to anybody yet. Fortunately he forgets about it.

Now he doesn't want to see Monsieur Gabriel any more. He told me that if he came I should throw him out, that he was a spy. He also told me he had just asked Mademoiselle de Rivières[1] to marry him, that he will have a magistrate for a father-in-law, that he will have them give an account of everything. But you mustn't pay any attention to what Monsieur says. He forgets about it a minute later. Madame mustn't worry about it. I will do my best to take care of her interests and Monsieur Henri's, although if I listened to him I'd be spending all of 500 francs a day. I'm going to try and find M. Gabriel tomorrow morning. Will Madame be so good as to give my regards to Adeline: until tomorrow, Madame.

<div style="text-align: right">Berthe</div>

[1] Interviewed by Robert Sadoul in 1964 (cf. *Nouvelles Littéraires*, 8 October 1964), Aline Séré de Rivières said she was not told of Lautrec's proposal at that time. She was portrayed by Lautrec in the 1897 lithograph *Au Bois* (Wittrock 185), as indicated in the M. Loncle Sale Catalogue.

IV. 15 *To Mlle Adeline Cromont*

7 rue du Manège
Albi, Tarn

<div style="text-align: right">Paris, 17 January [1899]</div>

My dear Adeline,

I'm still terribly bothered by all these goings-on. When will it all end? Monsieur was much better last night. He asked me himself to come and sleep in the studio last night. So I went. He came home at midnight. He got up 2 or 3 times and finally at 5 o'clock he told me he was going for a walk. You can imagine how much I slept. I've had a toothache come on me and something's the matter with one of my eyes ...

... This morning Monsieur is still in an awful mess. He had me take 6 bottles of wine to Calmèse's. I went to the wine merchants; he was sitting with 2 dirty sluts. That pig Calmèse, they should put him in gaol. He's going to be the death of poor Monsieur.

This morning I went to see Monsieur Gabriel. He said he was going to write to Madame. Monsieur Bourges told me I didn't have to tell Madame everything that happened, that I should tell her things were improving because Madame would get all worked up. I really don't know where all this will end. My poor Adeline, all of Monsieur's friends blame Madame for having gone away, for having left her son in this condition in the hands of strangers. Just between us, Adeline, I think they're right. Madame's place should be here. Poor Monsieur isn't bad. On the contrary, he has never been nicer than now. He's always promising me something. This morning he told me he was going to settle an income of 3,000 francs on me. I couldn't help laughing. I saw in a minute that he was going to take offence.

Don't show my letter to Madame whatever you do. Say that Monsieur is feeling better and I will write tomorrow ...

<div style="text-align: right">Berthe Sarrazin</div>

IV. 16 *To Mme la Comtesse de Toulouse-Lautrec*

7 rue du Manège
Albi, Tarn

Paris, 18 January 1899

Madame la Comtesse,

Nothing new, if anything for the better. Monsieur looks well. However, unfortunately he still drinks a little. As long as he goes to Calmèse's, it will always be the same. If there were some way of stopping him, if Madame would write. It's true that Monsieur hasn't anyone else. You never see any of his friends any more. There's only Calmèse and Gabrielle, who never leave him. Monsieur is giving everything in his studio, all the knick-knacks, to Calmèse and Gabrielle. He has even given them the pillow from his bed. I don't know where this new craze will end. Monsieur never comes to the rue de Douai. He says he'll never set foot there again; when I talk about Madame and say that she's going to come back, he says he doesn't want Madame to return. Another time he says that you have to be lenient, that Madame is sick. He changes ideas 20 times in 2 minutes. I don't pay any attention to what he says, but at the bottom he's very angry with Madame for not being here. He doesn't work at all any more. He doesn't even rub on glycerine. All he talks about is his money. He is going to force his uncle to make an accounting. He says that Madame has been favouring the steward, that the matter has been put in the hands of the public prosecutor. It's Monsieur de Rivières who's taking care of that. He tells all these things in the bars.

Monsieur always asks me if Madame has written to me. He asks to see the letters. If Madame would only write a letter that I could show Monsieur, to see what he'll say. Madame should feel easier in her mind. Things if anything are better rather than worse. If Madame could come back perhaps things might be entirely better.

Berthe

IV. 17 *To Mlle Adeline Cromont*

7 rue du Manège
Albi, Tarn

Paris, 19 January [1899]

My dear Adeline,

I didn't want to write today because there's nothing new, but I thought that Madame would be too unhappy if she didn't have some news. I saw Monsieur this morning for 5 minutes. He had just come home with Gabrielle, who had been waiting for him since 8 o'clock in the morning. Yesterday she waited all afternoon at Père François' but Monsieur didn't come back. She wasn't able to get any money out of him and that's why she was so bright and early this morning.

I saw Monsieur Albert last night. I talked to him. He told me he would

put a stop to it. It's terrible just the same to have Monsieur in the clutches of that slut. She has walked off with all the small objects she was able to carry. I came back twice this afternoon to Monsieur's, but he wasn't there. I'm going to go there once more when I post my letter. I wanted to ask you, Adeline, where you've put the pongee silk to mend Monsieur Henri's overcoat. Tell me ...

<div align="right">Berthe</div>

IV. 18 *To Mlle Adeline Cromont*

7 rue du Manège
Albi, Tarn

<div align="right">Paris, 20 January 1899</div>

My dear Adeline,

As I told you I would last night, on the way back from posting my letter I went there again. He was at Père François' with Gabrielle and Stern, I wouldn't dare tell you how drunk. This morning I went at 8 o'clock. He didn't let me in. The wine seller's boy told me he had brought some shortbread (you know how he likes his shortbread!) and that he had two women in bed with him, Gabrielle and another one. I went back at 11 o'clock but he had bolted the door. I wasn't able to do the housework. I've just been to Calmèse's. He told me that he didn't want to be bothered with Monsieur any more, that he disgusted him, that he had done what he could but that he saw it was hopeless, that he had been very nasty to him yesterday morning. He told me he had been having lunch with these two women at the tobacconist's across the way since 11 o'clock and it was 2 o'clock now. He's going to make another mess of it tonight. He didn't have any money last night. Gabrielle said at the bar that all he had left was 22 sous. I don't know if Monsieur Robin lends him money or if Monsieur Henri has given him some to keep for him. However, the fact remains that he gave him 50 francs ...

... Everybody is amazed that he can keep up such a life. It would be better if poor Madame doesn't know about it. Now then, Adeline, it's an act of charity to keep her in the dark. What can you do? There's nothing to do but wait till he drops, which perhaps will happen before long. You ask me if he's working. He doesn't do a stroke any more ...

... He doesn't talk about Madame, or if he does mention her, it's more often bad than good. His friends are tired of him. I never see anybody any more. I don't think Monsieur Gabriel has very much to do with him ...

<div align="right">Berthe</div>

IV. 19 *To Mme la Comtesse de Toulouse-Lautrec*

7 rue du Manège
Albi, Tarn

Paris, 21 January 1899

Madame la Comtesse,

I wasn't able to do Monsieur's housework yesterday. He didn't let me in all day. I went there 6 times. He went to Monsieur Robin's to spend that night. I went this morning and saw Monsieur as he was going out. He told me to get some wine, which I did. Today Monsieur is fidgety and preoccupied. All he does is talk about putting somebody in gaol. I don't know who. He is very reserved with me. I think that Gabrielle must have got him worked up.

I should warn Madame that Monsieur Robin is completely hostile towards her. He says that it's the family's fault if Monsieur is like this, that he's been abandoned, that no one cares about him, that he's greatly to be pitied and that he's sorry for him. I think that Monsieur is going to stay with them, but I don't think that will last long. Monsieur will change his mind quickly. I said yesterday to Adeline that Monsieur had drunk a lot again. Today he looked better. If he can stay at Monsieur Robin's he'll drink less, but as I just told Madame, that won't last for long.

Berthe Sarrazin

IV. 20 *To Mme la Comtesse de Toulouse-Lautrec*

7 rue du Manège
Albi, Tarn

Paris, 22 January 1899

Madame la Comtesse,

Monsieur again spent the night at Monsieur Robin's. I was on the lookout for him when he went out this morning. He's always in an angry mood and has a restless look. He told me he was going to have a lot of people put in gaol, that he would be out of debt in 3 weeks. It's his family and the friends of his family that he's angry with. He doesn't go to the studio much any more. I haven't been back since the other day. He told me to go there this afternoon, that he would be there. I asked the concierge for the rent bills, which I am putting in the letter. I'll go tomorrow where Madame told me about the silver, although there's no danger here. Monsieur never comes here and I wouldn't have let him take it anyway, even though this will be safer.

I've just come from the livery stable. I think Monsieur is having lunch with Mr Calmèse at his mother's.

As Madame can see, it's still the same old thing. There isn't much improvement. However, Monsieur is drinking less and, since he is spending the night at Monsieur Robin's, he doesn't get up again to drink. He still has a red face all the same. We'll have to be patient, poor Madame. May God have pity. I

ask Him often enough. Eventually He will answer our prayers. Let's not lose courage...

<div align="right">Berthe Sarrazin</div>

IV. 21 *To Mme la Comtesse de Toulouse-Lautrec*

7 rue du Manège
Albi, Tarn

<div align="right">Paris, 23 January 1899</div>

Madame la Comtesse,

I have done what you told me. I took the silver this morning to Madame de Vismes. Madame will find the list of what I took in the letter. Monsieur is still very much in an angry mood. This morning he came to the concierge's at the rue de Douai. He said he was going to have all the house locks changed. I was afraid he'd do it while I was gone and so I hurried to get back. I went to Monsieur's studio. He was there. He has got a hold of a tiny little dog[1] at Père François'. He has bought a nursing bottle and has put the errand-boy in his studio to take care of the dog all day long. I've sent the errand-boy away and I am going to go there. That's why I'm in such a hurry to write a few words to Madame. Monsieur is still spending the night at Monsieur Robin's. He's always talking about putting everybody in gaol. I will write to Madame again tomorrow.

<div align="right">Berthe Sarrazin</div>

[1] This is the dog Pamela that Joyant mentions (I. 213–14).

IV. 22 *To Mme la Comtesse de Toulouse-Lautrec*

7 rue du Manège
Albi, Tarn

<div align="right">Paris, 24 January 1899</div>

Madame la Comtesse,

I was rushed yesterday when I was writing to Madame. I don't know whether I said that Monsieur finally let me into his place on Sunday evening. He is still sleeping at Mr Robin's, but now that there's the little dog he wants me to stay in the studio all day to take care of it, but I'm taking it to the rue de Douai in the kitchen.

I saw Monsieur this morning. I waited until he came out of Monsieur Robin's. I asked if Monsieur had any news. He told me that Madame had written to him. He seemed angry. He told me he didn't want what Madame wanted, and ended by saying he was going to the Law Courts. I thought he looked bad, his skin yellow, his lips full of yellow crust, too, and a little thin. However, he seemed to me to be less overexcited than on Sunday and

yesterday. It's true he was only just going out and hadn't had anything to drink. Monsieur stayed the whole day yesterday with Calmèse. He had his lunch and dinner with him. I told Madame how I took 6 bottles of white wine. Monsieur wanted me to take another 6 this morning. I didn't take them. I'm going to see if Monsieur remembers. I'll say that I forgot. Gabrielle has dropped out of sight. I think Monsieur Robin and Calmèse must have got him to drop her by telling him she was stealing. Good riddance. But on the other hand there's still this Calmèse. Monsieur never leaves him and they drink all day. Monsieur never thinks of anything else any more. He doesn't work at all either. He's always at Calmèse's place or at the tobacconist's. He doesn't get angry with me, on the contrary, he's very nice, but he got into an argument with his concierge at the avenue Frochot and he also came here to our concierge at the rue de Douai to make suggestions about his letters ...

<div align="right">Berthe</div>

IV. 23 *To Mlle Adeline Cromont*

7 rue du Manège
Albi, Tarn

<div align="right">Paris, 25 January 1899</div>

My dear Adeline,

I still haven't anything really good to tell you. Monsieur is still just the same, rather worse just lately. Yesterday, in the evening, he came to rue de Douai to see the dog. He looked all around the apartment. He opened the dining-room sideboard. He made me make him a package of two tins of goose-liver, a little tin of truffles, the last of the German sausage. He also wanted a pot of jam, but that made it too big. He told me to take everything that was left to M. Robin's. I said I would, but I didn't take anything this morning. I have hidden everything. I'll say there isn't any more. I went to the studio this morning at 8 o'clock. I didn't think Monsieur would be there, but he was, although he had spent the night at M. Robin's. But you should have seen him! Good God, he really scared me. He had laid down on the bed with all his clothes on. He wasn't able to walk. I took off his shoes. I wanted to put him to bed, but he flew into a rage. Finally, little by little, things quietened down. He told me I had made him lose 30,000 francs, that Madame Bourges had commissioned a picture and that she didn't want it any more, that it was all my fault. I had to go out for a moment and when I came back he'd forgotten all about it. He spoke to me about M. Gabriel, with whom he's very angry, and his uncle. He told me all about them till I thought he'd never stop. Calmèse again sent his stable-boy to see what Monsieur was doing (he can't let him alone), although he had told me he didn't want any more to do with him. Now, you see! Monsieur told Batiste, the stable-boy, to get an errand-boy and come and take all the wine he wanted from the cellar, that

it was his, that he was making a present of it because he was marrying his daughter, but you can imagine I don't want to let him get away with that. Perhaps I'll have to give him a basketful just the same. I'll try to do the best I can.

Monsieur hasn't got a sou left. Calmèse told me he had lent him 15 francs yesterday. I don't dare to ask him for money for the gas. There's 24 francs, 20 centimes owing for that and 22 to the laundress. Tell it to Madame. My dear Adeline, I still have a little money of my own. If Madame wants me to, I'll advance some of it. I've spent everything that madame sent me and what Monsieur has given me, too . . .

<div align="right">Berthe</div>

IV. 24 *To Mlle Adeline Cromont*

7 rue du Manège
Albi, Tarn

<div align="right">Paris, 26 January 1899</div>

My dear Adeline,

I received your letter this morning. I see that you're not calm and that you must be worrying very much. But what can you do? You might be even unhappier here, although I wish with all my heart that you had come back. I assure you I find the days long. But nothing has improved. Yesterday Monsieur was drunk all day and couldn't stand on his feet. He spent the night at Monsieur Robin's and this morning he looked better. He's always with that Calmèse. He is lunching there. I'll go and take a look by-and-by. I still have the little dog. He's an awful bother to me, all he does is cry. When I'm not there he does his business all over the place. The concierge is afraid the other tenants will complain. I'm going to try to put him at Calmèse's, if Monsieur is willing. Cécile came last night. I wasn't there. I'm very glad she didn't find me in. She told the concierge she was leaving for Albi for several days. She came to see if Madame had come back so as to get some news. Maybe you're going to see her turn up one of these days. Tell Madame, Adeline, that Père François has demanded I pay 61 francs that Monsieur owes him. A paint-dealer has also been here with a bill for 19 francs, but that isn't urgent. He can wait. It's very cold. It has been freezing for two days . . .

<div align="right">Berthe Sarrazin</div>

IV. 25 *To Mme la Comtesse de Toulouse-Lautrec*

7 rue du Manège
Albi, Tarn

<div align="right">Paris, 27 January 1899</div>

Madame la Comtesse,

I think that Monsieur is feeling better. I wasn't able to see him this morning. It was Monsieur Robin who told me that Monsieur was to go to Crotoy

yesterday evening with Monsieur Joyant. I got his case packed but he didn't come back. I think he must have forgotten. I went to Monsieur Robin's this morning. Monsieur wasn't either there or at his studio.

I don't know where he must have spent the night. I was very worried. I went back several times. Finally I learned he was having lunch with Monsieur Calmèse. I must go back this evening to Monsieur Robin's. Other than this there's nothing new. I've managed to get rid of the dog. He is at Calmèse's place. Adeline was to have told Madame about Monsieur's gas bill. It's 24 francs, 40 centimes and the laundress's, 22 francs. If I'm able to see Monsieur tonight, I'll ask him for some money, but I don't think he has any.

Monsieur told me about having heard from Madame, but said he'd give me the news later, that for the time being he couldn't say anything, it was too serious. He doesn't talk quite so much nonsense. I think it would go away if Monsieur could get back to work and if he weren't always with that Calmèse. But one can't do anything about that.

Berthe Sarrazin

IV. 26 *To Mme la Comtesse de Toulouse-Lautrec*

7 rue du Manège
Albi, Tarn

Paris, 28 January [1899]

Madame la Comtesse,

I saw Monsieur last night at 9 o'clock at Monsieur Robin's. He hadn't drunk much. This morning, at 8 o'clock, he was better. He had had a good night. But at 11 o'clock he wasn't so good. I've just left him at the tobacconist's with a hackney coachman. They were just about to go into town with a gentleman with a red moustache whom I didn't know. I'd like to be able to tell Madame things are better, but I don't dare to yet. That is, Monsieur has changed. He doesn't talk about kerosene any more, he talks a little more sensibly. Despite this I don't think he's well. He looks sick. However, Monsieur Calmèse tells me he eats a lot. He has a boil on his neck, but it isn't serious. Monsieur Mallet has learned about it. Now all he talks about is his boil. He puts muslin with a poultice on his neck like a scarf. He has either lost all his scarves, or had them stolen.

Monsieur is still angry with his uncle, Monsieur Tapié. He says he's a scoundrel, that he turned Madame against him, that he has had a grudge against him for a long time, that Madame has given him a better deal, that he will make him pay. In short, a lot of stuff that I don't remember very well now since I don't pay any attention. He's always talking about taking a trip. I think he wants to go and be with Madame again. Madame asks me why Monsieur made a scene with his concierge for no reason. He imagines there are burglars and that they've been in his studio. He hasn't been there for two

days. I think he's afraid and that's why he sleeps at Monsieur Robin's. I'm sending you a note that Monsieur has given me for his concierge.

As for the masseur, he hasn't been back since the day Monsieur paid him and gave him a present of 100 francs. I saw him in the street and told him Monsieur was out of his mind, that he shouldn't be taking his money. He told me he was a poor fellow, that he had six children, that the money would do him a lot of good, in short, he didn't want to give it back ...

<div style="text-align: right">Berthe Sarrazin</div>

IV. 27 *To Mme la Comtesse de Toulouse-Lautrec*

7 rue du Manège
Albi, Tarn

<div style="text-align: right">Paris, 29 January 1899</div>

Madame la Comtesse,

I received your registered letter with 150 francs safely this morning. I will go and pay the insurance tomorrow morning, also Monsieur's gas. It's still the same old thing with Monsieur. He's still spending the night at Monsieur Robin's, but he wants to come to rue de Douai to sleep. This morning he wanted me to find a locksmith to have all the locks changed. I am going to have to give up the keys to stop him. Monsieur Robin is egging him on to do it. I took advantage of it being Sunday to say that I couldn't find one, whereupon he left to look for one himself. He can't have found one for he hasn't come back. It's two o'clock. I'm going to see where he is before finishing my letter.

I've just seen Monsieur. He was still eating lunch in rue Fontaine with Stern. He spoke to me about the locksmith. I said I was going to look and see if I could find the keys, and that he should wait a little. He wanted a tin of goose-livers. I said there weren't any left at all ...

<div style="text-align: right">Berthe Sarrazin</div>

IV. 28 *To Mme la Comtesse de Toulouse-Lautrec*

7 rue du Manège
Albi, Tarn

<div style="text-align: right">Paris, 30 January [1899]</div>

Madame la Comtesse,

I have just received the telegram. I will go tomorrow morning to Monsieur Gabriel's to look for the keys. I was obliged to give the one I had to Monsieur last night. He absolutely wanted to have other locks installed. Monsieur came

to spend the night at rue de Douai. That night poor Monsieur was like a child. He looked into every nook and cranny, he wanted to take everything to Monsieur Robin's. Each thing he found he tucked under his arm. He said 'just fits the pipe'. When he had too many things he gave them back to me. I put them back in place. He forgot all about them a minute later. I relit the gas heater to warm up a little although Monsieur made a roaring fire in Madame's bedroom. It's very cold, we have snow today for the first time. Monsieur Robin came to get Monsieur for lunch and I went to pay the gas and insurance. I'll keep a list of what I spend each day on a sheet of paper which I'll send to Madame tomorrow or later as Madame asks me to. Monsieur is still very much at odds with his uncle, M. Tapié. He says the inheritance is being illegally withheld which is reducing him to great poverty, that he has to live by loans and begging on account of him. But he is going to take a trip in the Midi and then he'll make them laugh on the other side of their faces. He has also got a grudge against Monsieur Gabriel. He told me if he came, to drive him out with a broom, or lock him up in a bedroom and go and fetch him and he'd give M. Gabriel what was coming to him. Madame can see that Monsieur is still talking nonsense. However, there are times when he talks very well. Luckily he isn't down on me, on the contrary, he speaks well of me to everybody. I don't cross him, either. I do what I can for him, to be agreeable. I think that if Madame came back Monsieur would be very happy. He tells everybody that he hasn't a mother any more, nor any family, that he is in the deepest of poverty. People pity him, they believe it's true . . .

<div align="right">Berthe Sarrazin</div>

IV. 29 *To Mlle Adeline Cromont*

7 rue du Manège
Albi, Tarn

<div align="right">Paris, 31 January [1899]</div>

My dear Adeline,

I was still very worried this morning. Monsieur didn't come back to spend the night at rue de Douai as he had promised me. I waited for him all night. This morning at 8 o'clock I went to Monsieur Gabriel's. I wanted to see him very much but they wouldn't let me come up, claiming it was too early. Nevertheless Monsieur Gabriel had brought down the key so it would be given to me. At 10 o'clock, Monsieur sent me a letter for a locksmith, telling me to go right away to his studio. Monsieur had had his bolts taken out. So I told the locksmith to just pretend to fix them (which he did). Reassure Madame about the burglars, Adeline. There aren't any at all. Right now Monsieur has persecution mania. He has been robbed just the same. He no longer has his watch nor his beautiful scarf. His tie-pin has disappeared, too. Tell Madame that nonetheless he has some money. He told me that some art

dealers have lent it to him. It's Calmèse who is in charge of his wallet. He's in good hands, as you can see . . .

I went to Monsieur Mallet's to ask how he felt about Monsieur. He told me that he was much better, that he judged him to have been very well for the last week, that to be sure he was still talking irrationally but that, in his view, he had always done that. Monsieur knows that Madame's brother[1] came to get Madame. You could have knocked me down with a feather this morning. He asked me if I hadn't seen a tall gentleman with spectacles and a grey beard. I told him no. I don't know who is stirring him up against his relatives. He is still furious with Monsieur Gabriel. He told me he had dined facing him last night and didn't even smile at him. If he comes here, to go and get Monsieur Calmèse to throw him out. He kept on repeating this to me . . . Monsieur told me he was going to write to the Department of Public Health, that he didn't want to pay unless he could have his house repaired, that he had almost been asphyxiated by the toilets . . .

<div align="right">Berthe</div>

[1] ie. Amédée Tapié de Céleyran.

IV. 30 *To Mlle Adeline Cromont*
7 rue du Manège
Albi, Tarn

<div align="right">Paris, 1 February 1899</div>

My dear Adeline,

I don't know what to tell you. It's still the same old thing. Monsieur keeps on drinking and now and then becomes disagreeable. Monsieur Mallet says he thinks he's better, but as for me, I don't think so. For two nights now I don't know where he has been sleeping. He came this morning to rue de Douai with the dog. He calls her Pamela. Poor Monsieur went rummaging in all the drawers again, even among your things. He wanted to take your knife, my poor Adeline. I don't think he'll ever come out of it until he stops seeing that demon Calmèse. He sticks with him every minute. He never goes to his studio any more. He's at the tobacconist's all day long, where they eat. This morning he made me take 2 bottles of white wine, one muscat, the jar of English jam you had bought and even the last bit of ham that was in the kitchen cupboard. Luckily he didn't see the one wrapped up in cloths. He would have made me take that one, too. How will it all end, my poor Adeline . . .

<div align="right">Berthe Sarrazin</div>

IV. 31 *To Mme la Comtesse de Toulouse-Lautrec*

7 rue du Manège
Albi, Tarn

[Paris, 2 February 1899]

Madame la Comtesse,

Just a quick little note. Monsieur is in the kitchen cooking ham. He is still the same, very over-excited, he has beaten up the little concierge, he wanted to fire me.

I went to send a telegram to Monsieur's father. He asks him why his brother-in-law came to Paris. Postage-paid answer. This is why I was able to post my little note. I'll write more tomorrow.

Berthe

IV. 32 *To Mme la Comtesse de Toulouse-Lautrec*

7 rue du Manège
Albi, Tarn

Paris, 3 February [18]99

Madame la Comtesse,

As I told Madame yesterday, Monsieur stayed in the kitchen all afternoon, cooking the ham that was in the cloths. I thought he hadn't seen it, but he knew very well that it was there. He put in a bottle of white wine, one of red, some vinegar, some rum and so much pepper and salt and so on that it wasn't edible. He made me take it to Calmèse's with 3 bottles of wine. I've told Madame how Monsieur was bad at times. He came back like a wild man. I'd never seen him so violent. He wanted to hit the little concierge. He took him by the arm and shook him as hard as he could, meanwhile calling him all sorts of bad names. He accused him of not taking proper care of the house and to me he said all kinds of nonsense, that he would have me put in gaol with his family. I was so frightened that I'm still sick over it today. He says he's going to have all the furniture sold in the street. There are debts and they are going to seize the furniture. He does it on purpose. Finally he said such awful things that I couldn't help crying. When he saw I was crying that made him sorry. He begged my pardon, saying that it was his family he was angry with, but since none of his family was there it was I who had to bear the brunt, but that he bore me no grudge. Monsieur spent last night here. He didn't sleep. He kept the fire burning all night long. The wood won't last for long. He stayed until noon. He cleaned out the gas stove by running a lit candle over it. In sum, he did all sorts of crazy things that would take too long to tell.

The other night they almost took him to the police station. It was Guichard, the barkeeper, who told me that. He had just taken a room in the rue Pigalle. There was another gentleman and two loose women. The other gentleman

left shortly after. Monsieur, however, stayed to pay, but didn't have any money. It did him no good to say that he was the Count of Toulouse. The landlord wouldn't listen. Then Monsieur came to wake up Guichard who lent him the 3 francs, 50 centimes that were owing. Monsieur hasn't any money at all any more. I asked him for gas money. He gave me 20 francs which makes 120 francs I have received from Monsieur ...

<div align="right">Berthe</div>

IV. 33 To Mme la Comtesse de Toulouse-Lautrec

Cité du Rétiro 5, Hotel Pérey
Paris

<div align="right">Paris, Tuesday 14 [February 1899]</div>

Madame la Comtesse,

I've had trouble this morning. This man is as stupid as a goose.[1] I don't think he'll be able to keep on looking after Monsieur. He lets him drink, he doesn't at all know how to handle him. Furthermore, I didn't dare tell Madame by word of mouth that he wasn't decent to me, and that's why I don't want to spend the night here any more. They went to the Brasserie de la Souris in the rue Bréda.[2] Monsieur told the proprietress of this dirty dive to send for wine, I don't know how many bottles. Two of them came with baskets, a man and a woman. I didn't want to give them anything. She sent back a little boy with a letter that he wanted to deliver to me personally. I didn't want to let him in, but I was afraid she might watch out for Monsieur and that he might learn about it. That would leave me in a fine kettle of fish. I miss Andrieux very much. He wouldn't have let Monsieur go into that place ...

Monsieur ate well at lunch but that fool of a man didn't bring him home until 1.30. I had given up waiting. It's agreed that they'll come back at 7 o'clock for dinner. They're left by carriage ...

<div align="right">Berthe</div>

[1] A guardian hired by Lautrec's mother to replace Andrieux. She must have fired the former as a result of this letter and hired a M. Briens, on 15 February, instead.

[2] Now the rue Henri Monnier. Lautrec had done a lithographic portrait of the proprietress, Mme Palmyre, in 1897 (Wittrock 184).

IV. 34 To Mme la Comtesse de Toulouse-Lautrec

7 rue du Manège
Albi, Tarn

<div align="right">Paris, 13 April [1899]</div>

Madame la Comtesse,

I've just seen Monsieur Henri. He is still the same, if anything better, above all very calm. He received me nicely and was glad to see me. I had got a letter

from Monsieur by post this morning. I am attaching it to my letter so that
Madame may see it. I brought some coffee, the chocolate drops, and the
handkerchiefs. Pierre[1] complains there still aren't enough of them, that
Monsieur dirties a lot of them. I didn't bring the rum, as Madame can well
imagine, but I told Monsieur that I had brought some but that the doorkeeper
took it away from me when I came in. Whereupon he told me to take the
bottle back on the way out because the doorkeeper would drink it, to his
health. Monsieur was to have gone out yesterday for a walk but, I don't
know why, they wanted to have the keeper go along with him, whereupon
Monsieur flew into a rage and didn't want to go out. He wanted Pierre to
go along with him. Monsieur told me that Madame was going to return soon,
that he had got word that his grandmother was feeling better . . .

<div align="right">Berthe Sarrazin</div>

[1] One of the wardens at the asylum in Neuilly.

IV. 35 *To Mme la Comtesse de Toulouse-Lautrec*

7 rue du Manège
Albi, Tarn

<div align="right">Paris, 17 April [1899]</div>

Madame la Comtesse,
 I went to see Monsieur Henri this morning, since I received no letter from
Madame. There are three letters that Monsieur Henri had sent me, one by
M. Joyant, another by M. Dihau, and another by post. He finds that time
hangs heavy. I have brought him what he asked for, namely, lavender
water, chocolate, coffee, biscuits, powdered cinnamon, lime juice, the six
handkerchiefs that were left and 4 prs. of socks. I found Monsieur very well.
He seemed to me to be very much more rational than before. He spoke very
well to me of Madame and his grandmother. He was very much concerned
to know that she was worse. He quickly wrote the telegram that I sent
yesterday . . .
 I went to Mlle Dihau's to give her the news, as Madame told me to.

<div align="right">Berthe S.</div>

IV. 36 *To Mme la Comtesse de Toulouse-Lautrec*

7 rue du Manège
Albi, Tarn

<div align="right">Paris, 20 April [1899]</div>

Madame la Comtesse,
 . . . I'm glad that Madame Tapié continues to improve and that Madame
is coming back on Monday. I have just seen Monsieur Henri. I took him a

little pot of orange jam from the grocery and different things that I went to get from his studio. Monsieur continues to get better and better. He is to go out this afternoon with Monsieur de Rivières, who is taking him to visit a property that his father-in-law has left him. Pierre told me that Monsieur no longer speaks ill of Madame as he did at the beginning, which shows that he is becoming completely rational.... He also told me that he had asked Madame de Vismes and M. Joyant to write to Madame. Léon took Pamela to Monsieur Henri. He thought she was very pretty. She recognized him right away and couldn't make enough fuss over him ...

<div style="text-align: right">Berthe Sarrazin</div>

Appendix v

Documents and letters relating to the death of Henri de Toulouse-Lautrec, including letters of his father, Alphonse de Toulouse-Lautrec.

v. 1 *From Count Alphonse de Toulouse-Lautrec to René Princeteau*

Paris, Wednesday evening [4 September 1901]

My dear René,

I expect to leave as early as possible tonight, or tomorrow at the latest, to visit my poor son Henri. He has no strength left, because he has completely stopped eating and does nothing except drink, frugally, rum grogs and a little port. No strength is to be gained from these drinks, which have been a poison for him, given the quantities he drank in the past. His legs have been useless for the past few months—he was dragging himself along. His arms were still strong, however, and he was able to paint energetically. Just yesterday he asked for some easels and brushes, but his hands refused to serve him. His limbs are now practically paralysed, and he has become very deaf.

If he lasts until the first autumn frosts, he will not survive them, because it's his lungs that are diseased. Three months ago several experts diagnosed him as consumptive. So the end is very near, and if you want to see him again, go to Malromé. Of course it would be better if I could call and pick you up, but any delay may cause me to arrive too late.

I hope to see you soon, my dear friend René. I have rented a small ground-floor apartment for eight hundred francs. It is at No. 41 rue Boissière, near the Trocadéro, and the owner is a delightful man, Dr Arbel Fauconnier, an enthusiast of the arts and an extremely skilful amateur photographer.

Best regards,

Lautrec

Prov.: Unknown
Pub.: Martrinchard, p. 67

v. 2 *From Count Alphonse de Toulouse-Lautrec to René Princeteau*

Malromé, Monday, 3.30 p.m., 9 September[1] 1901

My dear friend, your protégé of old at Pérey's, who benefited so greatly from your example, lavished so cordially under the lamp of the dear old boarding-

house, when we were all young and full of hope, is now going to be a source of great grief for you. Reality has been for all of us very harsh, in every sort of disappointment . . .

My son Henri—'the little one', as you called him—died this morning at 2.15. I had arrived four or five hours earlier, and I witnessed the unforgettable and horrible sight of the best person you could wish to meet, mourned in advance by everyone who, like you, was able to realize what a treasure of rectitude and friendship he was when one got to know him. I saw him, but he could not see me, as his wide eyes could no longer see anything after three or four days of quiet, gentle delirium. He made practically no recriminations against anything or anyone, despite the suffering he must have endured because of his appearance, which made people turn around for a second look, more in pity than in scorn.

His sufferings are over. Let us hope that there is another life where we shall meet again, without hindrance to eternal friendship.

I almost telegraphed to tell you that I was passing through Libourne yesterday, on the express train, at around 4.30. But it's better that you did not see your jovial comrade disfigured by grievous anguish, perhaps more for us who have lost him than for him whose sufferings are now over.

Rest assured of my warm friendship, which will never be lessened by separation.

<div align="right">Lautrec</div>

Prov.: Unknown
Pub.: Martrinchard, p. 68
 [1] An error in Martrinchard prints the date for this letter as 18 September.

v. 3 *From Count Alphonse de Toulouse-Lautrec to Michel Manzi*

<div align="right">Malromé, 15 September [19]01</div>

Dear M. Manzi,

Your funeral wreath arrived exactly as if to say your heart was with us during the sorrowful interval before the final separation from the only surviving of my two sons, a token as precious as it was ephemeral from both of you, because you are One with Joyant, united in the same tutelary sentiment towards him who was deprived of his just heritage, even if not on that account despairing.

These flowers from Paris deserved a more prompt expression of thanks. Flowers from Paris, I say, conquering flowers, it might be said, assuring artistic fame whatever form it may take among its many forms and revelations, displeasing perhaps the average idlers who may think that making money is all there is to an honest education.

Sincerity, it means everything.

They may criticize the brief works of the deceased, not old in years, but matured by so many trials, native to him and accidental as well.

He believed in his rough sketches, and you with him.

Thanks to your support he has been recognized and he owes it to you for having suppressed the malevolent opposition.

Joyant said to his schoolmate: He's a sensitive soul ... to which a father may be permitted to add, an inoffensive one.

Between us there was never one of those flashes of feeling in which rancour replaces sweetness in the father–son relationship.

There you have the intimate side. He is your child for having fostered his art.

<div align="right">Lautrec</div>

Prov.: Schimmel
Pub.: GSE237, GSF266

v. 4 *From Count Alphonse de Toulouse-Lautrec to M. de la Panouse*

<div align="right">Le Bosc, September 1901</div>

My dear Friend,

You are too much so [a friend] to be even a bit angry with me for not having thanked you yet for your quick sympathy in the terrible ending of a miserable destiny.

Who suffered more, the father or the son? He with his physical disabilities, distressing misfortunes made all the more painful for him by the fact that he would have liked the elegant, active life of all healthy, sports-loving persons, or I, the 'author' of days so sad, numbered, discounted, cut short.

Despite his premature physical wear and tear, I didn't see him as an 'old man'.

If of the two of us he suffered the more, being humiliated in his structure made not to captivate (hardly the word) but to pass unnoticed through the indifferent or hostile crowd, I had only the mental torture, the ceaseless blame for not having refrained ... It was acute, my paternal compassion, and growing, and very far from being dulled, despite the praises of his warm friends, who have remained faithful through the trial.

Thank you from the bottom of my heart.

<div align="right">Alphonse de Toulouse-Lautrec
September 1901</div>

Prov.: Unknown
Pub.: Attems, p. 266

V. 5 *From Count Alphonse de Toulouse-Lautrec to Maurice Joyant*

[Paris] 22 October 1901

To M. Joyant,

I'm not making a generous gesture in giving you all my paternal rights, if there are any as heir of whatever our deceased produced; your brotherly friendship had so quietly replaced my weak influence that I am being logical in continuing this charitable role for you if you so desire, simply for the satisfaction of your kind-heartedness toward your classmate; so I have no plans to change my opinion and, now that he is dead, praise to the skies something that during his life I could regard only as audacious, daring studio sketch studies.

Alphonse de T.-L.

Prov.: Unknown
Pub.: Joyant I, p. 132

Genealogical Chart

Originally prepared in 1968–9 by Herbert D. Schimmel and Lucien Gold-schmidt with the assistance of Marc Tapié de Céleyran (1896–1985), the son of Raoul Tapié de Céleyran (1868–1937), for publication in the *Unpublished Correspondence of Henri de Toulouse-Lautrec* (cf. Bibliography).

This revised chart includes corrections, additions, and changes supplied by Bertrand du Vignaud de Villefort (b. 1950), the grandson of Gabriel Tapié de Céleyran (1869–1930) and Anne de Toulouse-Lautrec (1873–1944).

Note on the Use of the Genealogical Chart

Marriage between members of the three principal families connected with that of Toulouse-Lautrec-Monfa is indicated by names shown in small capitals. The names of the partners are repeated in the charts of both families concerned. Descendants of these unions are to be found in the chart of the father's family.

Toulouse-Lautrec-Monfa

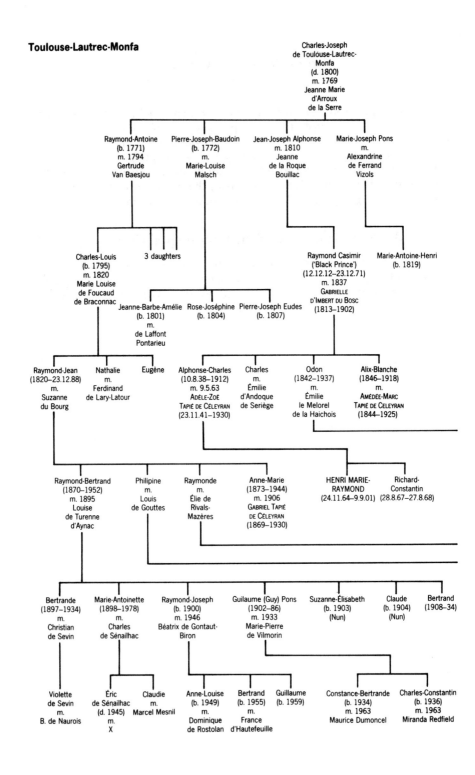

| Raymond (b. 1874) | Odette (1876–1962) (Nun) | Bernard | Robert (b. 1887) m. Yvonne Bamberger |

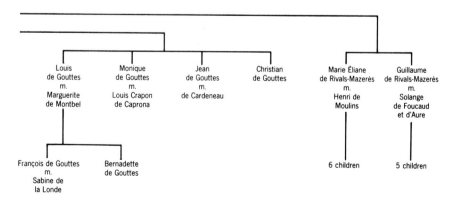

| Louis de Gouttes m. Marguerite de Montbel | Monique de Gouttes m. Louis Crapon de Caprona | Jean de Gouttes m. de Cardeneau | Christian de Gouttes | Marie Éliane de Rivals-Mazerès m. Henri de Moulins | Guillaume de Rivals-Mazerès m. Solange de Foucaud et d'Aure |

| François de Gouttes m. Sabine de la Londe | Bernadette de Gouttes | | | 6 children | 5 children |

Tapié de Céleyran

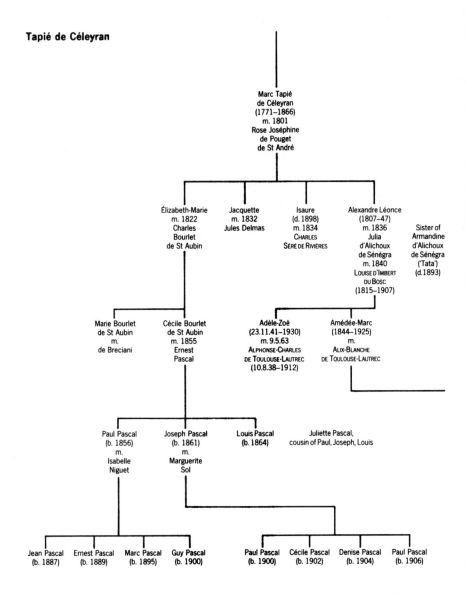

Marc Tapié
de Céleyran
(1771–1866)
m. 1801
Rose Joséphine
de Pouget
de St André

Élizabeth-Marie
m. 1822
Charles
Bourlet
de St Aubin

Jacquette
m. 1832
Jules Delmas

Isaure
(d. 1898)
m. 1834
CHARLES
SÉRÉ DE RIVIÈRES

Alexandre Léonce
(1807–47)
m. 1836
Julia
d'Alichoux
de Sénégra
m. 1840
LOUISE D'IMBERT
DU BOSC
(1815–1907)

Sister of
Armandine
d'Alichoux
de Sénégra
('Tata')
(d.1893)

Marie Bourlet
de St Aubin
m.
de Breciani

Cécile Bourlet
de St Aubin
m. 1855
Ernest
Pascal

Adèle-Zoë
(23.11.41–1930)
m. 9.5.63
ALPHONSE-CHARLES
DE TOULOUSE-LAUTREC
(10.8.38–1912)

Amédée-Marc
(1844–1925)
m.
ALIX-BLANCHE
DE TOULOUSE-LAUTREC

Paul Pascal
(b. 1856)
m.
Isabelle
Niguet

Joseph Pascal
(b. 1861)
m.
Marguerite
Sol

Louis Pascal
(b. 1864)

Juliette Pascal,
cousin of Paul, Joseph, Louis

Jean Pascal
(b. 1887)

Ernest Pascal
(b. 1889)

Marc Pascal
(b. 1895)

Guy Pascal
(b. 1900)

Paul Pascal
(b. 1900)

Cécile Pascal
(b. 1902)

Denise Pascal
(b. 1904)

Paul Pascal
(b. 1906)

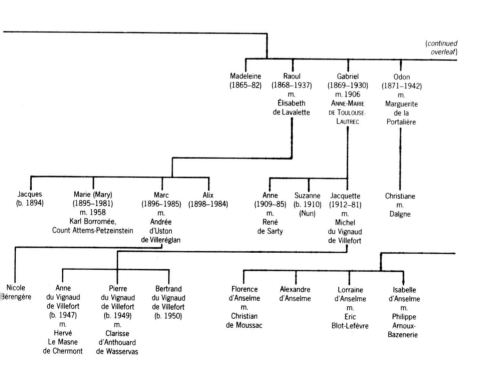

(continued
overleaf)

Madeleine
(1865–82)

Raoul
(1868–1937)
m.
Élisabeth
de Lavalette

Gabriel
(1869–1930)
m. 1906
ANNE-MARIE
DE TOULOUSE-
LAUTREC

Odon
(1871–1942)
m.
Marguerite
de la
Portalière

Jacques
(b. 1894)

Marie (Mary)
(1895–1981)
m. 1958
Karl Borromée,
Count Attems-Petzeinstein

Marc
(1896–1985)
m.
Andrée
d'Uston
de Villeréglan

Alix
(1898–1984)

Anne
(1909–85)
m.
René
de Sarty

Suzanne
(b. 1910)
(Nun)

Jacquette
(1912–81)
m.
Michel
du Vignaud
de Villefort

Christiane
m.
Dalgne

Nicole
Bérengère

Anne
du Vignaud
de Villefort
(b. 1947)
m.
Hervé
Le Masne
de Chermont

Pierre
du Vignaud
de Villefort
(b. 1949)
m.
Clarisse
d'Anthouard
de Wasservas

Bertrand
du Vignaud
de Villefort
(b. 1950)

Florence
d'Anselme
m.
Christian
de Moussac

Alexandre
d'Anselme

Lorraine
d'Anselme
m.
Eric
Blot-Lefèvre

Isabelle
d'Anselme
m.
Philippe
Arnoux-
Bazenerie

Tapié de Céleyran (*continued*)

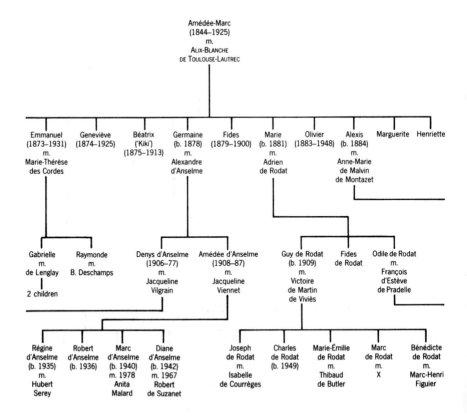

Amédée-Marc
(1844–1925)
m.
ALIX-BLANCHE
DE TOULOUSE-LAUTREC

Emmanuel
(1873–1931)
m.
Marie-Thérèse
des Cordes

Geneviève
(1874–1925)

Béatrix
('Kiki')
(1875–1913)

Germaine
(b. 1878)
m.
Alexandre
d'Anselme

Fides
(1879–1900)

Marie
(b. 1881)
m.
Adrien
de Rodat

Olivier
(1883–1948)

Alexis
(b. 1884)
m.
Anne-Marie
de Malvin
de Montazet

Marguerite Henriette

Gabrielle
m.
de Lenglay

2 children

Raymonde
m.
B. Deschamps

Denys d'Anselme
(1906–77)
m.
Jacqueline
Vilgrain

Amédée d'Anselme
(1908–87)
m.
Jacqueline
Viennet

Guy de Rodat
(b. 1909)
m.
Victoire
de Martin
de Viviès

Fides
de Rodat

Odile de Rodat
m.
François
d'Estève
de Pradelle

Régine
d'Anselme
(b. 1935)
m.
Hubert
Serey

Robert
d'Anselme
(b. 1936)

Marc
d'Anselme
(b. 1940)
m. 1978
Anita
Malard

Diane
d'Anselme
(b. 1942)
m. 1967
Robert
de Suzanet

Joseph
de Rodat
m.
Isabelle
de Courrèges

Charles
de Rodat
(b. 1949)

Marie-Émilie
de Rodat
m.
Thibaud
de Butler

Marc
de Rodat
m.
X

Bénédicte
de Rodat
m.
Marc-Henri
Figuier

D'Imbert du Bosc

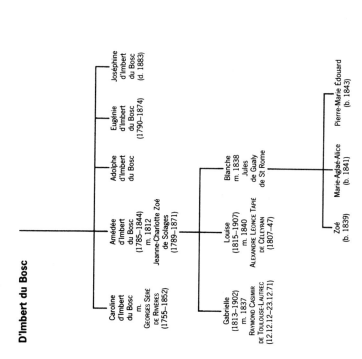

Caroline
d'Imbert
du Bosc
m.
GEORGES SÉRÉ
DE RIVIÈRES
(1755–1852)

Amédée
d'Imbert
du Bosc
(1785–1844)
m. 1812
Jeanne-Charlotte Zoé
de Solages
(1789–1871)

Adolphe
d'Imbert
du Bosc

Eugénie
d'Imbert
du Bosc
(1790–1874)

Joséphine
d'Imbert
du Bosc
(d. 1883)

Gabrielle
(1813–1902)
m. 1837
RAYMOND CASIMIR
DE TOULOUSE-LAUTREC
(12.12.12–23.12.71)

Louise
(1815–1907)
m. 1840
ALEXANDRE LÉONCE TAPIÉ
DE CÉLEYRAN
(1807–47)

Blanche
m. 1838
Jules
de Gualy
de St Rome

Zoé
(b. 1839)

Marie-Aglaé-Alice
(b. 1841)

Pierre-Marie Édouard
(b. 1843)

Séré de Rivières

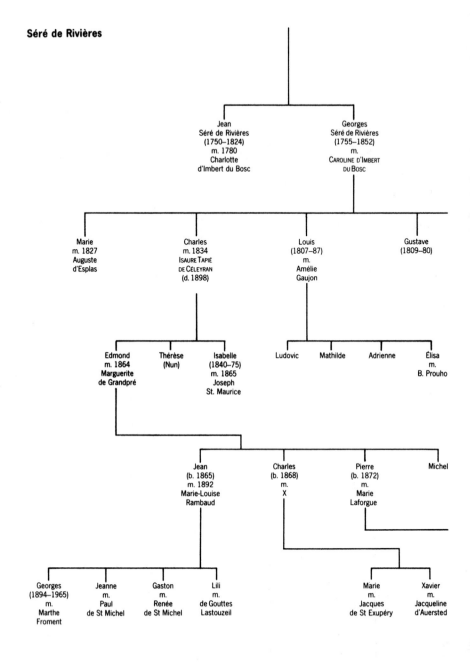

Jean
Séré de Rivières
(1750–1824)
m. 1780
Charlotte
d'Imbert du Bosc

Georges
Séré de Rivières
(1755–1852)
m.
CAROLINE D'IMBERT
DU BOSC

Marie
m. 1827
Auguste
d'Esplas

Charles
m. 1834
ISAURE TAPIÉ
DE CÉLEYRAN
(d. 1898)

Louis
(1807–87)
m.
Amélie
Gaujon

Gustave
(1809–80)

Edmond
m. 1864
Marguerite
de Grandpré

Thérèse
(Nun)

Isabelle
(1840–75)
m. 1865
Joseph
St. Maurice

Ludovic

Mathilde

Adrienne

Élisa
m.
B. Prouho

Jean
(b. 1865)
m. 1892
Marie-Louise
Rambaud

Charles
(b. 1868)
m.
X

Pierre
(b. 1872)
m.
Marie
Laforgue

Michel

Georges
(1894–1965)
m.
Marthe
Froment

Jeanne
m.
Paul
de St Michel

Gaston
m.
Renée
de St Michel

Lili
m.
de Gouttes
Lastouzeil

Marie
m.
Jacques
de St Exupéry

Xavier
m.
Jacqueline
d'Auersted

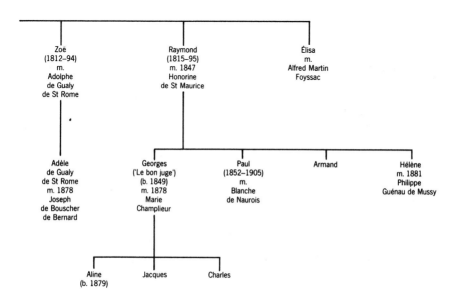

Zoë
(1812–94)
m.
Adolphe
de Gualy
de St Rome

Raymond
(1815–95)
m. 1847
Honorine
de St Maurice

Élisa
m.
Alfred Martin
Foyssac

Adèle
de Gualy
de St Rome
m. 1878
Joseph
de Bouscher
de Bernard

Georges
('Le bon juge')
(b. 1849)
m. 1878
Marie
Champlieur

Paul
(1852–1905)
m.
Blanche
de Naurois

Armand

Hélène
m. 1881
Philippe
Guénau de Mussy

Aline
(b. 1879)

Jacques

Charles

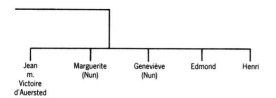

Jean
m.
Victoire
d'Auersted

Marguerite
(Nun)

Geneviève
(Nun)

Edmond

Henri

Select Bibliography

ADAMS, WILLIAM H. *A Proust Souvenir* (Vendome Press, New York, 1984).

ADHÉMAR, JEAN. *Toulouse-Lautrec, Lithographies, Pointes sèches: œuvres complètes* (Arts et Métiers Graphiques, Paris, 1965).

ADRIANI, GÖTZ. *Toulouse-Lautrec, Gemälde und Bildstudien, Kunsthalle Tübingen, 1986–1987* (Dumont, Cologne, 1986).

——*Toulouse-Lautrec, Das gesamte graphische Werk* (Dumont, Cologne, 1986).

ANQUETIN, LOUIS. *De l'art* (Nouvelles Éditions Latines, Paris, 1970).

ANTOINE, ANDRÉ. *Mes Souvenirs sur le Théâtre-Libre* (Arthème Fayard & Cie, Paris, 1921).

——*Mes Souvenirs sur le Théâtre Antoine et sur l'Odéon* (Grasset, Paris, 1928).

ARNOULD, A. *Catalogue d'affiches artistiques françaises et étrangères* (Paris, 1896).

L'ART INDÉPENDANT. Exhibition Catalogue (Brussels, 1889).

LES ARTS INCOHÉRENTS. Catalogues of Annual Exhibitions (2 vol.; Paris, 1886, 1889).

ASSOCIATION POUR L'ART. Catalogues of Annual Exhibitions (2 vol.; Antwerp, 1892, 1893).

ASTRE, ACHILLE. *H. de Toulouse-Lautrec* (Nilsson, Paris, 1926).

ATTEMS, COUNTESS. *See* Tapié de Céleyran, Mary.

BAEDEKER, KARL. *Paris and its Environs* (Leipzig, London, Paris, 1876, 1888, 1889, 1898, 1900).

——*Le Sud-Ouest de la France* (Leipzig, 1897).

——*London and its Environs* (London, 1889, 1899).

BAILLY-HERZBERG, JANINE. *Correspondance de Camille Pissarro*: i. *1865–1885*; ii. *1886–1890*; iii *1891–1894* (Presses Universitaires de France, Paris, 1980; Éditions du Valhermeil, Paris, 1986, 1988).

LE BARC DE BOUTTEVILLE. *Peintres Impressionnistes et Symbolistes.* Exhibition Catalogue (Paris, 1892).

BATAILLE, HENRY. *Têtes et pensées* (Ollendorf, Paris, 1901).

BEARDSLEY, AUBREY. *See* MAAS, HENRY.

BEAUTE, GEORGES. *Il y a cent ans: Henri de Toulouse-Lautrec* (Pierre Cailler, Geneva, 1964).

——*Toulouse-Lautrec vu par les photographes, suivi de témoignages inédits* (Edita S.A., Lausanne, 1988).

BÉNÉDITE, LÉONCE. *Catalogue sommaire des peintures et sculptures du Musée National du Luxembourg* (Paris, nd).

BÉNÉZIT, EMMANUEL. *Dictionnaire critique et documentaire des peintres, sculpteurs, dessinateurs et graveurs.* (10 vols.; Grund, Paris, 1976).

BERNARD, TRISTAN. *Mémoires d'un jeune homme rangé* (Revue Blanche, Paris, 1899).

——'Toulouse-Lautrec sportman', *L'Amour de l'art*, 4 (Paris, 1931).

BLOCK, JANE. *Les XX and Belgian Avant-Gardism 1868–1894* (UMI Research Press, Ann Arbor, Michigan, 1894).

BRAUN, SIDNEY D. *Dictionary of French Literature* (Philosophical Library, New York, 1958.

BREDIN, JEAN-DENIS. *The Affair: The Case of Alfred Dreyfus* (George Braziller, New York, 1986).

BROIDO, LUCY. *The Poster of Jules Chéret* (Dover Publications, New York, 1980).

BROOKLYN MUSEUM. *Belgian Art 1880–1914* (Brooklyn Museum, 1980).

BRUANT, ARISTIDE. *L'Argot au XX^e siècle: Dictionnaire français–argot* (Flammarion, Paris, 1901).

CAPRONI, GIORGIO, and LUGANA, G. M. *L'opera completa di Toulouse-Lautrec* (Rizzoli, Milan, 1969).

CARCO, FRANCIS. *La Belle Époque au temps de Bruant* (Gallimard, Paris, 1954).

——*Nostalgie de Paris* (J. Ferenczi & Fils, Paris, 1945).

CARRIÈRE, JEAN-RENÉ. *De la vie d'Eugène Carrière* (Édouard Privat, Toulouse, 1966).

Catalogue Musée Toulouse-Lautrec, 5th edn. (Imprimerie Coopérative du Sud-Ouest, Albi, 1986).

CATE, PHILLIP D. Exhibition Catalogue, *The Popularization of Lautrec: An essay in Henri de Toulouse-Lautrec: Images of the 1890's* (Museum of Modern Art, New York, 1985).

——*The Graphic Arts and French Society 1871–1914* (Rutgers University Press, New Brunswick, New Jersey, 1985).

——and HITCHINGS, SINCLAIR. *The Color Revolution: Color Lithography in France 1890–1900* (Rutgers University Art Gallery and the Boston Public Library, New Brunswick, New Jersey, 1978).

Centenaire de la lithographie, 1795–1895 Exhibition Catalogue (Paris, 1895).

CHARLES-BELLET, L. *Le Musée d'Albi* (Syndicat d'Initiative, Albi, 1951).

——*Toulouse-Lautrec, ses amis et ses maîtres* (Musée d'Albi Exhibition Catalogue, Albi, 1951).

CHARPENTIER, THÉRÈSE. *L'École de Nancy et la reliure d'art* (Éditions du Pays Lorrain, Nancy, 1960).

CHARTRAIN-HEBBELINCK, MARIE-JEANNE. 'Les Lettres de van Rysselberghe à Octave Maus', *Bulletin des Musées Royaux des Beaux-Arts de Belgique*, 15/1–2 (1966).

CINOTTI, MIA. *Zandomeneghi* (Bramante, Busto Arsizio, Milan, 1960).

CLEMENCEAU, GEORGES. *Au Pied du Sinaï* (H. Floury, Paris, 1898).

COOPER, DOUGLAS. *Paul Gauguin: 45 Lettres à Vincent, Théo et Jo van Gogh* (Staatsuitgeverig and Bibliothèque des Arts, 's-Gravenhage and Lausanne, 1983).

COQUIOT, GUSTAVE. *H. de Toulouse-Lautrec* (Auguste Blaizot, Paris, 1913).

——*Lautrec, ou Quinze ans de mœurs parisiennes, 1885–1900* (Ollendorff, Paris, 1921).

COURSAGET, RENÉ and GAUTHIER, MAX. *Cent ans de théâtre par la photographie* (L'Image, Paris, 1947).

CRAIG, EDWARD GORDON. *Index to the Story of My Days* (Viking Press, New York, 1957).

CURNONSKY. *Toulouse-Lautrec Submersion* (edited for M. Knoedler et Cie by Arts et Métiers Graphiques, Paris, 1938).

CZWIKLITZER, CHRISTOPHE. *Lettres autographes de peintres et sculpteurs du XV^e siècle à nos jours* (Editions Art-C.C., Basle, 1976).

DARRACOTT, JOSEPH. *The World of Charles Ricketts* (Methuen, New York, 1980).

DELTEIL, LOYS. *Le Peintre-Graveur illustré, XIX^e et XX^e siècles, x–xi. Henri de Toulouse-Lautrec* (Loys Delteil, Paris, 1920).

DESGRAVES, LOUIS, and DUPEUX, GEORGES. *Bordeaux au XIX^e siècle* (Fédération Historique du Sud-Ouest, Bordeaux, 1969).

DORTU, MME GEORGES. *Toulouse-Lautrec et son œuvre*, i–vi (Collector's Editions, New York, 1971).

——GRILLAERT, MADELEINE and ADHÉMAR, JEAN. *Toulouse-Lautrec en Belgique* (Quatre Chemins-Editart, Paris, 1955).

DOWSON, ERNEST. *see* Flower, Desmond.

DURAND-RUEL. Exhibition Catalogue (Société de Peintres-Graveurs Français, Paris, 1893).

EVENEPOEL, HENRI. *See* Hyslop, Francis E.

FLOWER, DESMOND, and MAAS, HENRY. *The Letters of Ernest Dowson* (Cassell & Co., London, 1967).

GAUZI, FRANÇOIS. *Lautrec et son temps* (David Perret, Paris, 1954).

GEFFROY, GUSTAVE. *Yvette Guilbert: Texte, orné par Toulouse-Lautrec*, (L'Estampe Originale, Paris, 1894).

——*Clemenceau* (Georges Crès et Cie, Paris, 1918).

GERVEX, HENRI. *Souvenirs recueillis par Jules Bertaut* (Flammarion, Paris, 1924).

GIBSON, FRANK. *Charles Conder: His Life and Work* (John Lane, Bodley Head, London, 1914).

GOGH, VINCENT VAN. *The Complete Letters of Vincent van Gogh* (New York Graphic Society, Greenwich, Connecticut, 1958).

GOLDSCHMIDT, LUCIEN, and SCHIMMEL, HERBERT D. eds. *Unpublished Correspondence of Henri de Toulouse-Lautrec* (Phaidon, London, 1969).

——*Henri de Toulouse-Lautrec: Lettres 1871–1901* (Gallimard, Paris, 1972).

GONCOURT, EDMOND and JULES DE. *Journal des Goncourt 1851–1895* (9 vols., Charpentier, Paris, 1887–96).

GUILBERT, YVETTE. *La Chanson de ma vie (Mes Mémoires)* (Grasset, Paris, 1927).

——*Mes Lettres d'amour* (Denoël et Steele, Paris, 1933).

——and SIMPSON, HAROLD. *Yvette Guilbert: Struggles and Victories* (Mills and Boon Ltd, London, 1910).

GUISAN, GILBERT, and JAKOBEC, DORIS. *Félix Vallotton: Documents pour une biographie et pour l'histoire d'une œuvre*: i. *1884–1899*; ii. *1900–1914*; iii. *1914–1921* (Bibliothèque des Arts, Geneva, 1973, 1974, 1975).

GUITRY, SACHA. *Lucien Guitry raconté par son fils* (Ch. Gerschel, Paris, 1930).

——*If Memory Serves* (Doubleday, Doran & Co., Garden City, New York, 1936).

HALPERIN, JOAN UNGERSMA. *Félix Fénéon and the Language of Art Criticism* (UMI Research Press, Ann Arbor, Michigan, 1967, 1980).

——*Félix Fénéon: Aesthete and Anarchist in Fin-de-Siècle Paris* (Yale University Press, New Haven and London, 1988).

HART-DAVIS, RUPERT. *The Letters of Oscar Wilde* (Harcourt, Brace & World, Inc., New York, 1962).

HARTRICK, ARCHIBALD STANDISH. *A Painter's Pilgrimage* (Cambridge University Press, Cambridge, 1939).

HARVEY, SIR PAUL. *The Oxford Companion to English Literature*, 3rd edn. (Oxford University Press, London, 1946).

——and HESELTINE, JANET E. *The Oxford Companion to French Literature* (Oxford University Press, London, 1959).

HELD, ANNA. *Mémoires* (La Nef de Paris, Paris, 1954).

HESSE, RAYMOND. *Histoire des sociétés de bibliophiles en France de 1820 à 1930* (L. Giraud-Badin, Paris, 1929, 1931).

HILLAIRET, JACQUES. *Dictionnaire historique des rues de Paris et Supplément* (Éditions de Minuit, Paris, 1963, 1972).

HUISMAN, PHILIPPE, and DORTU, MME GEORGES. *Lautrec par Lautrec* (Edita Lausanne, La Bibliothèque des Arts, Paris, 1964).

HYSLOP, FRANCIS E. *Henri Evenepoel à Paris: Lettres choisies 1892–1899* (La Renaissance du Livre, Brussels, 1972).

——*Henri Evenepoel, Belgian Painter in Paris, 1892–1899* (Pennsylvania State University Press, University Park and London, 1975).

JACKSON, A. B. *La Revue Blanche (1889–1903)* (M. J. Minard, Lettres Modernes, Paris, 1960).

JACKSON, HOLBROOK. *The Eighteen Nineties* (Grant Richards, London, 1913).

JEDLICKA, GOTTHARD. *Henri de Toulouse-Lautrec* (Bruno Cassirer, Berlin, 1929).

JOANNE, PAUL. *Guides Diamant: Paris, Bordeaux, Archachon, Royan, Soulac-les-Bains* (Hachette, Paris, 1883–94).

JOURDAIN, FRANTZ. *Les Décorés, ceux qui ne le sont pas* (Simonis-Empis, Paris, 1895).

JOYANT, MAURICE. *Henri de Toulouse-Lautrec 1864–1901* (H. Floury, Paris): i. *Peintre* (1926); ii. *Dessins—estampes—affiches* (1927).

KNAPP, BETTINA. *Le Mirliton* (Nouvelles Éditions Debresse, Paris, 1965).

——and CHIPMAN, MYRA. *That Was Yvette* (Holt, Rinehart and Winston, New York, 1964).

KNIGHTSBRIDGE. *International Society of Sculptors, Painters and Engravers: Knightsbridge Exhibition of International Art*, Exhibition Catalogue (London, 1898).

KOELLA, RUDOLF. *Félix Vallotton im Kunsthaus Zurich* (Zurich, 1969).

LANDRE, JEANNE. *Aristide Bruant* (Nouvelle Société d'Édition, Paris, 1930).

LECLERQ, PAUL. *Autour de Toulouse-Lautrec* (H. Floury, Paris, 1921).

LEROY, GEORGE. *Music Hall Stars of the Nineties* (British Technical and General Press, London, 1952).

LESPINASSE, FRANÇOIS. *Charles Angrand, Correspondances 1883–1926* (Rouen, 1988).

LA LIBRE ESTHÉTIQUE. Catalogues of Annual Exhibitions, 9 vols. (Brussels, 1894–1902).

LLOYD, ROSEMARY. *Selected Letters of Stéphane Mallarmé* (University of Chicago Press, Chicago and London, 1988).

MAAS, HENRY, DUNCAN, J. L., and GOOD, W. G. eds. *The Letters of Aubrey Beardsley* (Cassell & Co., London, 1970).

MACK, GERSTLE. *Toulouse-Lautrec* (Alfred A. Knopf, New York, 1938).

MAINDRON, ERNEST. *Les Affiches illustrées* (H. Launette & Cie, Paris, 1886).

——*Les Affiches illustrées* (G. Boudet, Paris, 1896).

MALHOTRA, RUTH, et al. *Das Frühe Plakat in Europa und den U.S.A.*, ii. *Frankreich und Belgien* (Gebr. Mann, Berlin, 1977).

MAROTTE, LÉON. *Henri de Toulouse-Lautrec: Soixante-dix réproductions de Léon Marotte* (Helleu et Sergent, Paris, 1930).

MARSOLLEAU, LOUIS, et BYL, ARTHUR *Hors les lois* (P. V. Stock, Paris, 1898).

MARTIN, JULES. *Nos artistes: Portraits et biographies*, (L'Annuaire Universel, Paris, 1895).

——*Nos auteurs et compositeurs dramatiques* (Flammarion, Paris, 1897).

——*Nos artistes: annuaire de théâtres* (Ollendorff, Paris, 1901).

MARTRINCHARD, ROBERT. *Princeteau 1843–1914* (Bordeaux, 1956).

MATTHEWS, ANDREW JACKSON. *La Wallonie, 1886–1892: The Symbolist Movement in Belgium* (King's Crown Press, New York, 1947).

MAUS, MADELEINE OCTAVE. *Trente années de lutte pour l'art 1884–1914* (L'Oiseau Bleu, Brussels, 1926).

MÉRODE, CLÉO DE. *Le Ballet de ma vie* (Pierre Horay, Paris, 1955).

MÉTÉNIER, OSCAR. *Aristide Bruant au Mirliton* (Paris, 1893).

MILNER, JOHN. *The Studios of Paris, The Capital of Art in the Late Nineteenth Century* (Yale University Press, London, 1988).

MOFFET, KENWORTH. *Meier-Graefe as Art Critic* (Prestel, Munich, 1973).

MONTORGUEIL, GEORGES. *Le Café-Concert* (L'Estampe Originale, Paris, 1893).

THE MOTOGRAPH MOVING PICTURE BOOK. (Bliss, Sands & Co., London, 1898).

LE MOTOGRAPHE, ALBUM D'IMAGES ANIMÉES. (Clarke & Cie, Paris, 1899).

MURRAY, GALE BARBARA. 'Henri de Toulouse-Lautrec: A Checklist of Revised Dates, 1878–1891, *Gazette des Beaux Arts* (Paris, February 1980).

——*Toulouse-Lautrec: The Formative Years, 1878–1891* (Oxford University Press, 1990).

NATANSON, THADÉE. *Un Henri de Toulouse-Lautrec* (Pierre Cailler, Geneva, 1951).

NICHOLSON, WILLIAM, and UZANNE, OCTAVE. *Types de Londres* (H. Floury, Paris, 1898).

NOCQ, HENRI. *Tendances nouvelles: Enquête sur l'évolution des industries d'art* (H. Floury, Paris, 1896).

OBERTHUR, MARIEL. *Cafés and Cabarets of Montmartre* (Gibbs Smith, Inc., Peregrine Smith Books, Salt Lake City, 1984).

PAINTER, GEORGE D. *Proust: The Early Years* (Little, Brown and Co., Boston, 1959).

PAULHAN, JEAN. *F. F. ou le critique* (Gallimard, Paris, 1945).

PERRUCHOT, HENRI. *La Vie de Toulouse-Lautrec* (Hachette, Paris, 1958).

PISSARRO, CAMILLE. *See* Bailly-Herzberg, Janine; Rewald, John.

POLAIRE. *Polaire par elle-même* (Eugène Figuière, Paris, 1933).

PONIATOWSKI, PRINCE. *D'un siècle à l'autre* (Presses de la Cité, Paris, 1948).

POTIN, FELIX. *500 Célébrités contemporaines* (Félix Potin, Paris, n.d.).

QUÉANT, GILLES. *Encyclopédie du théâtre contemporain* (Publications de France, Paris, 1957).

RENARD, JULES. *Histoires naturelles* (H. Floury, Paris, 1899).

——*Journal* (Gallimard, Paris, 1935).

REWALD, JOHN. *The History of Impressionism*, rev. edn. (The Museum of Modern Art, New York, 1961).

——*Post Impressionism from van Gogh to Gauguin*, rev. edn. (Museum of Modern Art, New York, 1978).

——ed. *Camille Pissarro. Lettres à son fils Lucien* (Albin Michel, Paris, 1950).

RICKETTS, CHARLES. *Self-portrait taken from the Letters and Journals of Charles Ricketts, R.A. collected and compiled by T. Sturge Moore, edited by Cecil Lewis* (Peter Lewis, London, 1939).

RODAT, CHARLES DE. *Toulouse-Lautrec: Album de famille* (Hatier, Fribourg, 1985).

ROTHENSTEIN, JOHN. *The Life and Death of Conder*, (J. M. Dent and Sons, London, 1938).

ROTHENSTEIN, WILLIAM. *Men and Memories: Recollections of 1872–1900* (Faber and Faber, London, 1931).

ROUCHON, ULYSSE. *Charles Maurin (1856–1914)* (Peyriller, Rouchon & Gamon, Le Puy-en-Velay, 1922).

ROUSSOU, MATEI. *André Antoine* (L'Arche, Paris, 1954).

ROYAL AQUARIUM. *A Collection of Posters* , Exhibition Catalogues: 2 vols. (London, 1894–5, 1896).

RYSSELBERGHE, THÉO VAN. *Rétrospective Théo van Rysselberghe* (Musée des Beaux-Arts, Ghent, 1962).

SALOMON, JACQUES. *Vuillard* (Albin Michel, Paris, 1945).

——*Auprès de Vuillard* (La Palme, Paris, 1953).

SCHANG, F. C. *Visiting Cards of Celebrities* (Fernand Hazan, Paris, 1971).

——*Visiting Cards of Painters* (Wittenborn Art Books, Inc., New York, 1983).

SCHIMMEL, HERBERT D., and CATE, PHILLIP D. *The Henri de Toulouse-Lautrec W. H. B. Sands Correspondence* (Dodd, Mead & Company, New York, 1983).

SERT, MISIA NATANSON. *Misia* (Gallimard, Paris, 1952).

SIMOND, CHARLES. *La Vie parisienne à travers le XIX^e siècle: Paris de 1800 à 1900*, iii. *1870–1900* (E. Plon, Nourrit et Cie, 1900–1).

SKINNER, CORNELIA OTIS. *Elegant Wits and Grand Horizontals* (Houghton Mifflin Company, Boston, 1962).

SOUBIES, ALBERT. *Almanach des spectacles* (Librairie des Bibliophiles, Paris, 1875–1914).

STUCKEY, CHARLES F. *Toulouse-Lautrec Paintings*, Exhibition Catalogue (Art Institute of Chicago, 1979).

SYMONS, ARTHUR. *From Toulouse-Lautrec to Rodin* (John Lane, Bodley Head Ltd, London, 1929).

TAPIÉ DE CÉLEYRAN, MARY. *Notre Oncle Lautrec*, 3rd edn. (Pierre Cailler, Geneva, 1963).

THOMSON, RICHARD. *Toulouse-Lautrec* (Oresko Books Ltd., London, 1977).

——'Toulouse-Lautrec and Sculpture', *Gazette des Beaux-Arts* (February 1984).

TOULET, PAUL-JEAN. *Notes d'art* (Le Divan, Paris, 1924).

——*Notes de littérature* (Le Divan, Paris, 1926).

——Exhibition catalogue (Bibliothèque Nationale, Paris, 1968).

TOULOUSE-LAUTREC, HENRI DE. *Yvette Guilbert*, text by Arthur Byl (Bliss, Sands and Co., London, 1898).
——and DEVISMES, ÉTIENNE. *Cocotte* (Éditions du Chêne, Paris, 1953).
VENTURI, LIONELLO. *Les Archives de l'Impressionnisme* (Durand-Ruel, Paris, New York, 1939).
LES VINGT. Catalogues of Annual Exhibitions, 10 vols. (Brussels, 1884–93).
WAHL, ROGER. *La Folie Saint-James* (Chez l'auteur, Neuilly-sur-Seine, 1955).
WELSH-OVCHAROV, BOGOMILA. *Vincent Van Gogh: His Paris Period 1886–1888* (Victorine, Utrecht and The Hague, 1976).
——*The Early Works of Charles Angrand and his Contact with Vincent van Gogh* (Victorine, Utrecht and The Hague, 1971).
WILDE, OSCAR. *See* Hart-Davis, Rupert.
WITTROCK, WOLFGANG. *Toulouse-Lautrec: The Complete Prints* (Sotheby's Publication, London, 1985).
ZÉVAÈS, ALEXANDRE. 'Aristide Bruant', *La Nouvelle Revue Critique* (Paris, 1943).

Periodicals

L'Amour de l'Art, No. 4 (Paris, 1931).
Annales de l'Est, 5ᵉ Série, No. 3 (Berger-Levrault, Nancy, 1962).
Le Chat Noir: Organe des Intérêts de Montmartre (Rodolphe Salis, Directeur, Paris, 1882–93).
Le Courrier Français (Jules Roques, Directeur, Paris, 1884–1900).
L'Escarmouche (George Darien, Directeur, Paris, 1893–4).
L'Estampe et l'Affiche (Édouard Pelletan, Éditeur, Paris, 1897–9).
Le Figaro Illustré (Boussod-Valadon & Cie, Éditeurs, Paris, 1893–6).
Les Maîtres de l'Affiche (Roger Marx, Paris, 1896–1900).
Le Mirliton (Aristide Bruant, Directeur, Paris, 1885–1906).
Pan (Verlag Pan, Berlin, 1895–1900).
Le Panorama: 'Nos jolies actrices'; 'Paris s'amuse'; 'Les Cafés-Concerts' (1895–6?); 'Paris la Nuit' (1896–7?) (Librairie d'Art Ludovic Baschet, Éditeur, Paris).
Paris Illustré (Boussod-Valadon & Cie, Paris, 1888).
La Plume (Léon Deschamps, Directeur, Paris, 1889–99).
The Poster (London, 1898–1901).
Revue d'Art Dramatique, Nouvelle Série, Tome 3 (Paris, Jan.–Mar. 1898).
La Revue Blanche (Alexandre Natanson *et al.*, Directeurs, Paris, 1891–1903).
Revue-Franco-Américaine (André Poniatowski, Éditeur, Paris, 1895).
Le Rire (Félix Juven, Directeur, Paris, 1894–1901).
Le Théâtre (Goupil & Cie, Paris, 1898–1900).
La Vie Artistique (Gustave Geffroy, E. Dentu, and H. Floury, Éditeurs, Paris, 1892–1903).

Index of Recipients

General Index

Toulouse-Lautrec, Alphonse-Charles de, Comte (father) 6, 11, 12, 15, 16, 19, 49, 56, 63, 67, 68, 75, 76, 78, 80, 81, 82, 83, 84, 85, 86, 88, 89, 90, 92, 95, 96, 97, 99, 100, 102, 103, 104, 105, 106, 107, 111, 112, 114, 116, 117, 118, 120, 123, 127, 132, 133, 136, 137, 140, 143, 145, 146, 147, 150, 151, 152, 153, 154, 155, 156, 167, 170, 172, 176, 177, 178, 180, 181, 201, 239, 250, 264, 407

Toulouse-Lautrec, Charles de (uncle) 5, 18, 19, 20, 27, 37, 57, 65, 69, 70, 93, 99, 101, 129, 144, 175, 177

Toulouse-Lautrec, Émilie, née Andoque de Seriège (aunt, wife of Charles) 5, 27, 31, 48, 49, 65, 70, 144

Toulouse-Lautrec, Émilie, née Le Melorel de La Haichois, 'Aunt Odette' (wife of Odon) 5, 20, 28, 40, 42, 48, 49, 69, 71, 90, 98, 100, 130, 186, 201, 264

Toulouse-Lautrec, Gabrielle, Comtesse de, née Imbert du Bosc (paternal grandmother) 5 n., 15, 29, 40, 49, 60, 65, 81, 116, 118, 120, 122, 151, 239

Toulouse-Lautrec, Odette (cousin) 19, 28, 31, 90

Toulouse-Lautrec, Odon de (uncle) 5, 19, 20, 28, 29, 31, 37, 39, 40, 42, 62, 71, 75, 77, 84, 87, 88, 90, 97, 100, 123, 130, 177, 186 n., 201, 264

Toulouse-Lautrec, Raymond de (cousin) 19, 21, 28, 31, 37, 62, 85, 90, 123, 278, 294

Toulouse-Lautrec, Raymond-Casimir de, Comte 'Black Prince' (grandfather) 4, 5 n.

Toulouse-Lautrec au Cirque 360, 369 n.

Tourneau 358, 359

Treclau, Tréclau, Treclo (pseudonyms of T.-L.) 112, 125; see also Tolav-Segroeg

Treize Lithographies 381, 382, 383, 384, 385

Turenne d'Aynac, Louise de (wife of Raymond-Bertrand de Toulouse-Lautrec) 279 n.

Tyro (dog) 41, 49

Ugalde, Marguerite 321, 322 n.

Urbain (valet) 6

Valadon, M. 214, 215, 223

Valadon, Suzanne 225

Valdagne, Lucien-Louis (Pierre) 273

Valéry, Paul 337 n.

Vallotton, Félix 197 n., 205, 226, 270 n., 293 n., 337 n.

Vary, Hélène 127 n., 138 n., 147 n., 152 n.

Vaughan, Ernest 309 n.

Vaux-sur-Seine 242, 243 n.

Veber, Jean 10 n.

Verdelais 244

Verhaeren, Émile 168, 171, 171 n., 190, 252, 255 n., 294 n., 299 n.

Verlaine, Paul 270, 271 n.

Verrier, M. (physician) 12, 13, 81

Vert, Renée 203 n., 205 n., 372 n.

Viaud, Paul 183, 214 n., 296, 355 n., 356 n., 357, 358, 359 n., 360, 362, 364 n., 367 n., 368 n., 371, 379

Vié, Dr 8, 9 n., 53

Vie Artistique, La 203 n.

Vie Moderne, La 64

Vie Parisienne, La 239

Vigan 239

Vignaud de Villefort, Jacquette, née Tapié de Céleyran 37

Vignaud de Villefort, Michel 37

Villefranches, M. and Mme 40

Villiers-sur-Morin 95, 104 n., 105

Vingtistes, Les (or Les XX) 116, 119 n., 120 n., 122 n., 124 n., 125 n., 131, 134, 140, 171 n., 190, 195, 198, 234 n., 237, 255 n.

Viroulet, Mme 45, 46, 47

Virtain, M. and Mlle 45, 46

Volney, see Cercle Artistique et Littéraire

Voltaire, Le 169 n.

Vuillard, Édouard 225 n., 337 n.

Wallonie, La 247 n.

Walsh, John Henry, 'Stonehenge' 18, 19 n.

Weber, Louise, 'La Goulue' 156, 166, 169, 170, 185, 186 n., 195, 196 n., 198, 334 n.

Wenz, Frédéric and Jeanne 94 n., 270

Whistler, James McNeill 259 n., 335 n.

Wiener, René 194, 204 n., 205, 206 n., 210 n., 211, 223 n., 245, 266

Wilde, Oscar 217 n., 270, 271 n., 272 n., 290 n., 355 n.

Wurtz, Robert 94, 358, 359 n.

Xanrof, Léon 316 n.

Yvette Guilbert (album) 95, 226, 227, 231, 232, 233, 241, 242, 247 n., 248, 249 n., 251, 252, 253, 255 n., 256 n., 260 n., 382, 383, 384

Zandomeneghi, Federico 209, 210

Zibeline (ferret) 26

Zidler, Charles 198 n.

Zimmerman, Arthur A. 269